AS·251	Romanian Air Meet Scrapbook	163
AS·252	Basil Lee Rowe Collection, 1917–1973	163
AS·253	Benjamin Ruhe Collection	164
AS·254	Herbert H. Rust Photograph Collection	164
AS·255	SAAB Scrapbook, 1926–1976	165
AS·256	St. Louis Centennial Scrapbook, October 3–9, 1909	165
AS·257	Savoia-Marchetti Scrapbook	166
AS·258	Anton Schlein Portfolio	166
AS·259	Blanche Stuart Scott Memorabilia, Circa 1935–1969	166
AS·260	2nd Aviation Instruction Center, France, Scrapbook	167
AS·261	2nd Mapping Squadron Alaskan Scrapbook	
	A.K.A. George H. Fisher, Jr., Scrapbook	167
AS·262	Albert W. Seypelt Collection, 1892–1941	168
AS·263	Charles S. Sheldon II Papers, 1934–1980	169
AS·264	Dale B. Sigler Early Naval Aviation Scrapbook	169
AS·265	Elton R. Silliman Papers, 1930–1982	170
AS·266	S. Fred Singer Papers	170
AS·267	Skylab Collection *A.K.A.* McDonnell-Douglas Astronautics	
	Company Collection	171
AS·268	*Skylab IV* Pilot's Flight Data File	
	A.K.A. William R. Pogue Collection, 1966–1974	172
AS·269	Ernest Smith and Emory Bronte Flight Scrapbook	172
AS·270	Lowell H. Smith Collection, 1920s–1930s	173
AS·271	Sopwith Aircraft Scrapbooks	173
AS·272	Robert Soubiran Collection	174
AS·273	Charles I. Stanton, Sr., Papers, 1917–1977	174
AS·274	Thomas E. Steptoe Scrapbooks	175
AS·275	A. Leo Stevens and Edward R. Boland Memorabilia	175
AS·276	Paul R. Stockton World War I Aviation Scrapbook	176
AS·277	Paul Studenski Collection	177
AS·278	George P. Sutton Collection, Circa 1945–1958	177
AS·279	Norman Sweetser Photograph Album	178
AS·280	Louise M. Thaden Collection	178
AS·281	Third Paris Salon Glass Plate Photonegative Collection	179
AS·282	Time-Life *Epic of Flight* Series Collection	180
AS·283	Tiros Satellite Documents, 1959–1970	180
AS·284	Harold H. Tittman Scrapbook	181
AS·285	Henry E. Toncray Scrapbook	181
AS·286	Thomas Towle Ford Trimotor Collection	182
AS·287	TranSlides Aeronautical History Color Slide	
	Collection, 1957–1967	182
AS·288	Travel Air Negatives, 1925–1942	183
AS·289	Juan T. Trippe Collection, 1917–1968	184
AS·290	Mary E. "Mother" Tusch Scrapbooks	185
AS·291	*United States Women in Aviation, 1940–1985* Photographs	185
AS·292	*United States Women in Aviation through World War I* Collection	186
AS·293	United Technologies Corporation Collection, 1929–1984	186
AS·294	Ralph H. Upson Papers, 1911–1968	187
AS·295	U.S. Air Force Pre-1954 Official Still Photograph	
	Collection, 1861–1953	188
AS·296	U.S. Army Air Service, Engineering Division, Scrapbook	
	A.K.A. Horace W. Karr Scrapbook	188
AS·297	U.S. Army Balloons World War I Scrapbook	189
AS·298	U.S. Navy ZR-1 Airship Photographs and Scrapbooks	
	A.K.A. U.S.S. *Shenandoah* Collection	189

AS·299 U.S. Organizing Committee for the Bicentennial of Air and Space Flight Records, 1982–1984 190
AS·300 U.S. Space Program Collection, Circa 1950–1974 190
AS·301 U.S. Supersonic Transport Collection I
A.K.A. Robert K. Friedman Collection, Circa 1960–1975 191
AS·302 U.S. Supersonic Transport Collection II
A.K.A. Bernard J. Vierling Collection, Circa 1952–1979 192
AS·303 J.D. Van Vliet Photograph Collection 193
AS·304 Victor Vernon Scrapbooks 193
AS·305 Alfred V. Verville Papers, 1911–1968 194
AS·306 *Voyager* 2 Uranus Moon and Ring Images 194
AS·307 Charles D. Walcott Scrapbook 195
AS·308 Charles F. Walsh Scrapbooks 196
AS·309 Washington, D.C., Aerial Photograph (World War I) Scrapbook 196
AS·310 E.D. "Hud" Weeks Collection 197
AS·311 Alfred R. Weyl and Peter Grosz Collection 197
AS·312 Arthur Whitten-Brown Collection
A.K.A. Nancy Hamilton Donation 198
AS·313 Paul H. Wilkinson Papers, Circa 1944–1984 198
AS·314 Leo J. Windecker Projects Collection 199
AS·315 *Wings of Gold: How the Aeroplane Developed New Guinea* Collection 200
AS·316 Women Flyers of America Collection, 1940–1955 200
AS·317 George W. Wood, Jr., Diaries 201
AS·318 Works Projects Administration Airport Inspection Trip Scrapbook
A.K.A. George L. Lewis Scrapbook 201
AS·319 World War I Aces Scrapbook 202
AS·320 World War I Aviators Photographs and Autographs
Scrapbook *A.K.A.* Marvin M. Green Scrapbook 202
AS·321 World War II Aerial Reconnaissance Photographs
A.K.A. James A. Hedgpeth, Jr., Collection 203
AS·322 World War II Army Surplus Collection, 1944–1945 203
AS·323 World War II Photograph Collection
A.K.A. Harry Brosius Photograph Collection 204
AS·324 Wright Brothers' 1903 Flyer Restoration Albums 204
AS·325 Wright Brothers' 1903 Flyer Restoration Files 205
AS·326 Wright Field Propeller Test Reports, Circa 1921–1946 205
AS·327 Wright Field Technical Documents Library, Circa 1915–1955 206
AS·328 Wright/McCook Fields Aircraft Project Books, 1920–1925 206
AS·329 Wright/McCook Fields Still Photograph Collection, 1918–1971 207
AS·330 Wright Medal Presentation Scrapbook 207
AS·331 Alexa Von Tempsky Zabriskie Scrapbook 208
AS·332 Zeppelin Photographs 208

Planetarium 210
AS·333 Planetarium Slide Collection 211

Public Affairs Office 212
AS·334 Public Affairs Press Photograph Collection 213
AS·335 Public Affairs Press Slide Collection 213

Publications Office 214
AS·336 Publications Office Photographs 215

Registrar's Office 216

AS.337 Registrar's Accession Files 217

Special Events Office 218

AS.338 Special Events File 219

Creators Index 220

Forms and Processes Index 229

Subject Index 232

Illustrations following page 128

Acknowledgments

Many people helped with the production of this volume. Thanks to Photographic Survey Project staff Deborah Kapper and Mike Frost, who helped edit and produce this volume, and to the staff and management of the Smithsonian Institution Archives, especially Susan Glenn, James Steed, and Paul Theerman, who provided editorial assistance.

The administrators, curators, historians, and collections managers of the National Air and Space Museum offered assistance and advice to the project staff. Their cooperative spirit and informed assistance made this volume possible. Particular thanks are due to Dana Bell, Susan Ewing, Melissa Keiser, Paul Silbermann, Patti Williams, and Larry Wilson of NASM Archives, and to Tom Soapes.

Finally, thanks to the staff and management of the Smithsonian Institution Libraries and the Smithsonian Institution Press. SI Press staff editors Amy Pastan and Duke Johns and designer Linda McKnight merit a special thank you.

Introduction

The *Guide to Photographic Collections at the Smithsonian Institution: National Air and Space Museum* is the fourth volume of a series documenting the Smithsonian's vast holdings of photographs. This volume provides a comprehensive overview of nearly 2 million photographs found in 338 photographic collections at the National Air and Space Museum (NASM). Many of the collections previously were unknown outside of their own divisions.

These collections serve many purposes, recording museum artifacts, activities, exhibits, and staff, as well as documenting the history of air and space flight. The images represent the work of both professional and amateur photographers using a wide range of photographic processes and formats.

Scope of the *Guide*

This *Guide* focuses on still photographs, defined here as images captured by the action of radiation (usually light) on a photosensitive surface, often by means of a camera, lens, mirror, or other optical device. The term "photography" thus includes photonegatives, photoprints, phototransparencies, and direct positive processes. Architectural plans, audio recordings, drawings, graphic prints, manuscripts, motion-picture footage, photomechanical prints, videotapes, and xerographic copies are mentioned only when they were found in collections that also contain photographs.

Both organic and assembled collections are represented in this volume. Organic collections include photographs by a single person, organization, or corporation. Assembled collections are photographs gathered from disparate sources around a central purpose or theme.

Preparation of the *Guide*

To develop the collection descriptions in this volume, the project staff visited each NASM office. With the assistance of museum staff, they identified, located, and examined all collections that contained photographs. Using a collection-level survey form based on the MARC-VM (Machine Readable Cataloging-Visual Materials) format, the project staff gathered data on access policies, copyright, location, origins, ownership, physical characteristics, subject contents, and other pertinent data for each collection.

Descriptive subject terms are taken directly from collection captions and finding aids, from NASM style guides and reference sources (see the subject index for a listing), or from the Library of Congress Prints and Photographs Division subject heading list, *Topical Terms for Subject Access*. Photographers' names were checked in name authority sources listed in the introduction to the creators index.

During the preparation of this guide series, a hierarchical authority file of photographic process and format terminology was created to facilitate consistent image identification and description. This authority file forms the basis for the forms and processes index found at the end of the guide.

A collection description was drafted from each completed survey form and submitted to the division curators and custodians for review. The descriptions were then edited and combined to form this volume.

Organization and Use of the *Guide*

Following a brief overview of NASM, there are introductions to each curatorial division or support office, describing its research objectives and collecting policies within the overall bureau framework. Each introduction also provides policies for reference use of the collections, including restrictions; access information including the address, telephone number, a contact person's name or title, and hours of operation; the number of collections; the total number of images; major subjects documented in the holdings; photographic processes represented; and other kinds of materials included, such as manuscripts and objects.

The heart of this *Guide* is a collection-level description or "entry" for each collection found within the curatorial divisions or support offices. Each collection is identified by a collection title and by an alphanumeric code assigned by the writers of the *Guide*. The code consists of a two-letter abbreviation for the bureau in which the collection may be found; in this volume, AS stands for the National Air and Space Museum. Other codes were used in previous volumes of this series to represent other Smithsonian bureaus. The number following the two-letter code indicates the sequence of that collection within the bureau. The table of contents outlines the arrangement of divisions/offices and collection titles and refers readers to them by this alphanumeric code.

The *Guide* is extensively indexed, providing precise access to specific photographic collections. There are three separate indexes: a creators index; a forms and processes index; and a subject index. Terms in each index are keyed to the alphanumeric collection codes. Strategies for index searches may be found at the beginning of each index.

Collection Level Descriptions

Collection descriptions vary in length, reflecting the size, coherence, and complexity of the collections described. More diverse and eclectic collections demand longer descriptions to provide appropriate descriptive detail. Each collection-level description is itself a complex arrangement of information organized as follows:

Collection Code. The unique alphanumeric code assigned to this collection.

Collection Name. The full title by which the collection is known in the museum. The phrase "A.K.A." (also known as) following a collection name indicates an alternative name by which staff may refer to the collection.

Dates of Photographs. The dates used are inclusive, describing the period during which the images in the collection were produced. These dates do not describe the period during which the non-photographic materials were produced, nor do they describe the dates of other generations of images which may exist in other repositories, for example, original photonegatives in other museums. Researchers wishing to determine the dates of original negatives which were used to create copy images in Smithsonian collections should look at the dates listed in the subject description.

Collection Origins. This section gives the name, dates, and a capsule biography of the collection creator or assembler. It explains when, by whom, and for what purpose a collection was created. If a single person or organization produced these materials as an organic collection, he (or it) will be identified as the collection creator.

If the collection is assembled or artificial, the collection origins field will list names of specific photographers and other creators whose work is included in the collection. When "Unknown" appears in the field, it means no information exists on the collection origins, either within the division's records or as clear internal evidence within the collection itself.

Physical Description. The total number of photographs in the collection is given first. This number may change over time as a collection continues to grow or is weeded down. Next, all photographic processes and formats are listed. Unusual photograph sizes and support materials are noted, as are the presence of photo albums, scrapbooks, and notebooks. Other materials found with the photographs, such as archival document types or specimens, are also listed.

Subjects. This field opens with a broad summary of the range of subject dates, geographic areas, and major subject emphases in the collection. This summary may be followed by more specific descriptions of cultural groups, genres (such as landscapes and portraits), geographic locales, individuals and their occupations or disciplines, and topical information (such as activities, animals, events, objects, and themes) represented in the collection.

Arrangement. This section identifies the major series into which a collection may be arranged. If the series are few, they will be listed by name. If the series are many, their number and organizing principle will be identified, for example, "Into 25 series by year of creation." Suborganization within series may be noted if it aids in locating photographs (for example, "Series 2, photographic portraits, arranged chronologically by subjects' dates of birth"). When a collection consists mainly of other types of materials (non-photographic), all the series that contain photographs are indicated.

Captions. All information accompanying photographs will be described in this field, including cutlines and album labels. When similar descriptive categories are used in most captions, the categories used will be noted, for example, "With location and date."

Finding Aids. This includes descriptions of the registers, indexes, and other guides used by the division staff to search the collection. When a finding aid has a title, a full citation is given. When a finding aid uses standard categories of data to describe photographs, those data elements and any cross-referencing will be noted, for example, "A card catalog that lists subject, negative number, and source of the image."

Some major forms of finding aids, and their definitions as used in this *Guide,* include the following:

Authority file: A list of approved names and terms to be used in describing a collection.

Card catalog: An item-level index on cards that may include cross-references and broader and narrower terms.

Container list:	A box-by-box or drawer-by-drawer list of materials to be found in each container, often further divided into folder-by-folder listings.
Guide entry:	A brief summary description of a collection as it would appear in a published guide to a repository's holdings or a database.
Index:	An alphabetical list of terms used to identify and locate all items relating to that term.
Inventory:	A list organized by document types (forms of material) or occasionally by subject or creator.
List:	An item-level enumeration in sequential order.
Log book:	An item-level list of photographs created by a photographer as he or she works, sometimes called a "shot log." It can include an image number; date; technical information, such as light conditions, filters used, camera settings, and film used; a brief summary of the subject in the photographer's own words; and the purpose of the shot.
Register:	An inventory of all collection document types, usually in a book or ledger format.

Restrictions. The last section of the collection-level entry lists any special restrictions that limit access to, or use of, a collection, for example, "For reference only. No copying allowed." Restrictions also may appear in the "Collection Origins" field, if the creator, in the process of creating the images, caused the restrictions, for example, "This copyrighted collection was created for a planned publication." Restrictions may be due to copyright status, donor wishes, preservation issues, privacy legislation concerns, patent or trademark status of the subject matter, or security concerns, for example, insurance photographs of high value items.

Abbreviations

The following abbreviations are used throughout the book:

A.K.A.	Also Known As. This phrase is used to indicate alternate titles of collections, or alternate names (pseudonyms) of collection creators or photographers.
Anon.	Anonymous. The creator of the images or the collection is unknown.
NASA	National Aeronautics and Space Administration.
NASM	National Air and Space Museum.
OPPS	Office of Printing and Photographic Services.
POP	Printing-Out Paper (photoprints).
SI	Smithsonian Institution.

Public Access

Appointments are required for any collections not on public exhibition. The accuracy of the information in the *Guide* will change over time, as collections grow and divisions reorganize. Calling ahead will save researchers time and trouble searching for collections and staff that have moved. With the exception of NASM Archives, museum departments and offices do not have full-time reference staff. Researchers should allow ample time for scheduling appointments, locating collections, and creating copy images.

Recommended times for research appointments are stated in the division introductions, as are appropriate addresses and phone numbers. Written requests for appointments should explain the purpose and scope of the research project, and any publication or exhibition plans. Most Smithso-

nian offices are open to the public from 10 a.m. to 5 p.m., Monday through Friday, except federal holidays.

Handling Photographs

Researchers must respect the requests of staff members to ensure preservation of Smithsonian photographic collections. Gloves may be required while working with these collections. Since photographs are fragile, researchers should not bend or touch photographic emulsions. Only pencil should be used for note-taking near photographs. Researchers may not eat, drink, or smoke while working near photographs. Following completion of research, individual photographs must be returned to their original position in the collection. Future availability of these collections depends upon the care with which they are treated today.

Photoduplication Service

Unless restricted, xerographic or photographic copies of images in Smithsonian collections are available to researchers once written permission has been obtained from the appropriate division. Restricted materials may require additional clearance. If the copyright is held outside the Smithsonian, the researcher is responsible for obtaining necessary permissions.

Permission forms for reproduction of NASM photographs are available from NASM Archives. There are separate forms for photographs to be used in books or periodicals; films or videos; electronic media; advertising; and other media. Fees vary according to these categories. The Smithsonian requires that two copies of all publications with NASM photographs be furnished at no cost to the museum.

All permissions are issued for one time use only; subsequent uses require additional authorization. Photographs may not be used to show or imply NASM or Smithsonian endorsement of any commercial product or enterprise, or to indicate that NASM or the Smithsonian concurs with the opinions expressed in, or confirms the accuracy of, any text accompanying these images. No photographs may be cropped, overprinted, or altered without prior permission, and each must be accompanied by the division's preferred caption and credit line.

Other Related Publications

This volume follows three photographic guides, the *Guide to Photographic Collections at the Smithsonian Institution: National Museum of American History* (1989, ISBN 0-87474-927-1); *Guide to Photographic Collections at the Smithsonian Institution: National Museum of Natural History, National Zoological Park, Smithsonian Astrophysical Observatory, and Smithsonian Tropical Research Institute* (1991, ISBN 1-56098-033-8); and *Guide to Photographic Collections at the Smithsonian Institution: Cooper-Hewitt Museum, Freer Gallery of Art, Hirshhorn Museum and Sculpture Garden, National Museum of African Art, National Museum of American Art, National Portrait Gallery, Sackler Gallery of Art, and Office of Horticulture* (1992, ISBN 1-56098-188-1). There are also two non-photographic guides: the *Finders' Guide to Prints and Drawings in the Smithsonian Instutution* (1981, ISBN 0-87474-317-6) and the *Finders' Guide to Decorative Arts in the Smithsonian Institution* (1985, ISBN 0-87474-636-1). All these publications can be purchased by contacting the Smithsonian Press at Department 900, Blue Ridge Summit, Pennsylvania 17294-0900; or call (717) 794-2148. Refer to the ISBN when ordering.

The Photographic Imagery of Air and Space Flight

The photograph collections at the National Air and Space Museum, which include over 1,700,000 images, illustrate many aspects of aviation, including aerial photography, early flight, aviators, air races and record flights, airline and aircraft manufacturing companies, military aviation, and the space program. The photographs, while produced for a variety of purposes, provide an invaluable source for the study of aviation history, just as they educated people about aviation's development at the time they were made. Just as photography in the 19th century brought people knowledge of the wider world and helped them accept the changes of industrialization and urbanization,[1] photography has brought the reality of air and space flight to many people, long before they were able to witness it in person. Beginning in the 1850s, but much more significantly in the 20th century, photography has served as an agent of cultural assimilation by encouraging acceptance of and support for air and space flight.

Aerial Photography

The revolutionary technologies of photography and flight have been connected since the mid-19th century, when Nadar took the first aerial photographs, in a balloon over Paris, in 1858.[2] In 1860 Boston photographer J. William Black made the first successful aerial photographs in the United States. Aerial photography for military intelligence was proposed during the Civil War,[3] and it was soon used for mapping and other information.

Since that time scientists have continued to refine aerial photography, which, like the airplane itself, played a significant role in World War I and II. More broadly, the airplane and aerial photographs (as well as the maps made from them) shaped the 20th century conception of land and space. NASM collections contain examples of aerial photography taken from balloons,[4] military reconaissance photography in World War I and II,[5] and non-military mapping with aerial photography.[6] Collection AS·111 illustrates the continuing attempts to improve military aerial photography, while the Center for Earth and Planetary Studies (CEPS) images of the Earth taken by automatic satellites, collections AS·1 and AS·2, represent the extension of aerial photography to space flight.

Early Airplane Flight

Photographs provided the unassailable proof of the Wright brothers' 1903 flight, and the images are still how we conceptualize this first powered, sus-

tained, and controlled flight. The Wrights photographed their flight experiments between 1898 and 1911 to document their progress and provide proof of their accomplishments.[7] Collection *AS·325* has copy images of the 1903 flight (the originals are at the Library of Congress). Photographs disseminated through newspapers and postcards supplied the great demand for images of flight in the first two decades of the 20th century, before most of the country could see, much less fly in, an airplane.

Many collections with photographs as well as newspaper clippings provide examples of this early flight imagery. There are images of early gliders,[8] activities of the Wright brothers after 1908,[9] and early U.S. Army aviation.[10] These collections also contain images of early air meets and shows. Collection *AS·143* contains 120 copy images of postcards of a 1910 air meet, mainly portraits of aviators and images of aircraft in flight.

NASM contains many collections documenting the activities of aviation pioneer Glenn H. Curtiss and his employees.[11] When Curtiss attempted to rebuild and fly the Langley Aerodrome in 1914 and 1915, in an effort to prove it the first successful airplane and win his court case against the Wrights, he had photographers document the flights.[12] While the images show clearly that the Aerodrome is flying, they could not prove the aircraft was exactly the same as when Langley tried to fly it.

Aviators, Record Flights, and Races

The 1920s and 1930s brought increasing popularity to air flight, as aviators became heroes, and record flights and races drew much publicity. This public support was essential to the races, stunt flights, and distance and endurance record flights which encouraged technological developments and expanded the performance abilities of aircraft. Since the first international airplane meet, which occurred in Reims, France, in 1909, "organizers realized that competition . . . was the key to advancement of aircraft design."[13] The Gordon Bennett race, the first American transcontinental flight, the Pulitzer races, and other events were sponsored by newspaper owners to improve aviation as well as make headlines.[14] Photographs played a crucial role in publicizing events and aviators, as illustrated in many NASM collections.[15]

Some collections provide documentation on specific flights or events: the 1924 flight around the world by U.S. Army pilots,[16] a 1947 around-the-world flight made in Piper Cubs,[17] and the Bendix races.[18] Images of high-altitude balloon flights, undertaken for scientific research but highly publicized, are also included.[19]

While men such as Charles A. Lindbergh became the most famous aviation heroes, the publicity surrounding Amelia Earhart[20] and other women pilots helped people accept women in this non-traditional role. Photographs of women aviators are represented in several collections.[21] Although limited to a much smaller audience, African American aviators also used photography to publicize and gain support for their activities, as illustrated in *AS·63*.

Corporate Photography

Like the sponsors of races, record flights, and individual aviators, companies such as aircraft manufacturers and airlines used photography extensively for advertisements, press publicity, and internal records. These photographs served to establish corporate images for the public, customers, and employees and executives of the companies themselves.[22] After World

War I, aircraft manufacturers and early airlines faced a limited market as well as a poor image due to extensive press coverage of aircraft accidents. Aviation companies needed to create an image of safety and convenience to attract customers, which they attempted through various types of publicity.[23]

AS·130 contains 142,000 photographs of the Glenn L. Martin Company, documenting research and development and production of Martin aircraft, as well as personnel, social functions, public events, and visitors. Bonanza Airlines photographs in *AS·244* show employee activities and public events such as company sports, ground-breaking ceremonies, meetings, parties, and tours, in addition to record images of aircraft and operations.

Company photographs document the transition from the pioneer manufacturers (such as Glenn H. Curtiss and the Wright brothers) and early, small airlines (such as Colonial Airlines, National Air Transport, Long Island Airlines) to their consolidation into fewer, larger, international corporations like Curtiss-Wright, Pan-American, Republic, and Goodyear-Zeppelin.[24] They also document the development of experimental prototypes into mass-produced models, distinguishing the successful types of aircraft from the failures.[25]

Military Photography

The U.S. armed forces have used aviation photography extensively, both for internal information and external relations with the government and the public. Additionally, many military pilots created their own photographic records of their experiences. World War I images at NASM primarily appear in personal collections of scrapbooks created by individual pilots.[26] Similar personal collections document World War I experiences in Russia,[27] Germany,[28] and Italy.[29] There are also photographs taken by individual World War II servicemen.[30]

NASM's photo collections illustrate the armed forces' increased use of publicity photography in World War II as compared to World War I. During World War II the Office of War Information continued the government-sponsored documentary photography begun in the New Deal programs of the 1930s. The U.S. Navy hired prominent photographer Edward L. Stechen as director of the U.S. Naval Photographic Institute. combat photography. During World War I Steichen photographic division of the Army Expedition aerial photography, and between the wars he w As part of his photographic work in World War to Victory" and "Power in the Pacific" exhibits Art, where he later became director of the Depa

Official military photography is best repre tion, *AS·295*, which contains over 145,000 in photographs document U.S. and foreign aircr record purposes, a substantial amount illustrate War scenes for public relations. There are also menting aviation research at the Wright Field en which include thousands of military photograp information.[32]

Space Program Photography

NASA greatly expanded the tradition of militar raphy. Throughout its existence NASA has cre

of photography. Widely disseminated through the press and private publications, this imagery has shaped the public conception of the space program. The images have presented the detailed technological activities of NASA, as well as space scenes seen by astronauts and unmanned spacecraft, sights to which few other than NASA personnel could ever have direct access.[33] The publicity has served to provide NASA with continuing public support and government funding.[34] Part of this massive publicity effort has been transferred to NASM.[35]

Other NASM Photographs

While much of the photography associated with air and space flight has been directed toward the public and has served to encourage acceptance and support, the archival record at NASM also contains many less public images. Despite such famous catastrophies as the *Hindenberg* fire, Amelia Earhart's disappearence, and the explosion of the *Challenger*, the mass of publicity photographs presents a view of linear, progressive history, with on-going improvement from Kitty Hawk to the Space Shuttles.[36] The body of NASM photographs, taken in whole, provides a different view.

NASM collections bear witness to the laborious process of experimentation and failure before the successes were achieved, as well as the efforts that amounted to nothing. Images document the work of unsuccessful experimenters with airplanes before the Wrights, such as Samuel P. Langley, James Means, and Hiram Maxim,[37] as well as the abortive helicopter trials of the Berliners and Henry E. Toncray.[38] There are photographs of airphibians and convertoplanes[39] and other experimental aircraft that never made it into production, as well as the United States' supersonic research,[40] Dow Chemical Company's experiments with plastic aircraft frames,[41] and Goodyear Aerospace Corporation's attempt to reintroduce the airship in the 1970s.[42] Although the majority of NASM's photographs were taken in the United States, some images illustrate European aeronautical superiority in the 1900s and 1910s.[43]

Several collections document the early, disastrous history of the U.S. Air Mail Service.[44] NASM photographs also illustrate lesser-known tragedies, including the first airplane fatality,[45] the many World War I and II pilots who did not survive,[46] and the civilian pilots who also lost their lives in aircraft.[47]

Joan Redding

Notes

1. See Martha A. Sandweiss, ed., *Photography in 19th Century America* (Fort Worth: Amon Carter Musem, 1991), especially Martha A. Sandweiss's essay "Undecisive Moments: The Narrative Tradition in Western Photography" and Peter Bacon Hales's "American Views and the Romance of Modernization," as well as Hales's *Silver Cities: The Photography of American Urbanization, 1839–1915* (Philadelphia: Temple University Press, 1984).

2. *Encyclopedia of Photography,* ed. by Bernard E. Jones (London: Cassell, 1911; New York: Arno Press, 1974), 11.

3. Tom D. Crouch, *The Eagle Aloft: Two Centuries of the Balloon in America* (Washington, D.C.: Smithsonian Institution Press, 1983), 340–341.

4. *AS·36* and *168.*

5. *AS·35, 56, 258, 309,* and *321.*

6. *AS·163.*

7. See Arthur G. Renstrom, *Wilbur & Orville Wright, Pictorial Materials: A Documentary Guide* (Washington, D.C.: Library of Congress, 1982), xi–xii, as well as Orville Wright, "How We Made the First Flight," reprinted in *The Wright Brothers: Heirs of*

Prometheus, ed. Richard P. Hallion (Washington, D.C.: Smithsonian Institution Press, 1978). For a discussion of the Wright brothers' attitudes about publicity in the first years after 1903, see Terry Gwynn-Jones, *Farther and Faster: Aviation's Adventuring Years, 1909–1939* (Washington, D.C.: Smithsonian Institution Press, 1991), xiv–xv.

8. *AS·53* and *191.*
9. *AS·79* and *80.*
10. *AS·77.*
11. *AS·56, 57, 58, 88, 89,* and *241.*
12. *AS·171* and *307.*
13. Gwynn-Jones, 7. This book discusses the celebrity of aviators and demonstrates how races and record flights from Reims up to World War II advanced airplane technology.
14. Henry Serrano Villard, *Blue Ribbon of the Air: The Gordon Bennett Races* (Washington, D.C.: Smithsonian Institution Press, 1987); Eileen F. Lebow, *Cal Rodgers and the Vin Fiz* (Washington, D.C.: Smithsonian Institution Press, 1989); Gwynn-Jones, 140–141.
15. *AS·38, 68, 102, 109, 127, 135, 142, 143, 158, 160, 181, 189, 213, 229, 252, 256,* and *277.*
16. *AS·50.*
17. *AS·108;* other record flights are represented in *AS·91, 199, 269,* and *312.*
18. *AS·61.*
19. *AS·22* and *221.*
20. This is discussed in the Earhart biography by Doris L. Rich, *Amelia Earhart: A Biography* (Washington, D.C.: Smithsonian Institution Press, 1989).
21. *AS·173, 230,* and *280.*
22. For a discussion of corporate photography, see Carol Squiers, "The Corporate Year in Pictures," in *The Contest of Meaning: Critical Histories of Photography,* ed. Richard Bolton (Cambridge: MIT Press, 1989), 207–218.
23. See Henry Ladd Smith, *Airways: The History of Commercial Aviation in America* (reprint, Washington, D.C.: Smithsonian Institution Press, 1991); John Bell Rae, *Climb to Greatness: The American Aircraft Industry, 1920–1960* Cambridge, Mass: MIT Press, 1968, especially pp. 16–18, 77–78; Patricia Ann Michaelis, "The Development of Passenger Service on Commercial Airlines, 1926–1930" (Ph.D. dissertation, University of Kansas, 1980), 5, 98–129.
24. For the consolidation of airlines, see Smith, especially pp. 131–146, and Michaelis, 214–237. For a specific example see Robert W. Rummel, *Howard Hughes and TWA* (Washington, D.C.: Smithsonian Institution Press, 1991), 32. For mergers in the aircraft manufacturing industry, see Rae, 39–48.
25. *AS·39, 59, 60, 87, 94, 98, 110, 114, 125, 130, 148, 152, 176, 183, 184, 185, 214, 229, 244, 255, 257, 271, 288, 289, 293,* and *332.*
26. *AS·70, 112, 113, 115, 120, 124, 126, 128, 129, 149, 186, 188, 232, 235, 248, 260, 272, 276,* and *284.*
27. *AS·9* and *123.*
28. *AS·126.*
29. *AS·157.*
30. *AS·44, 119,* and *317.*
31. Steichen's World War II images are in collection *AS·10.*
32. *AS·326–329.*
33. Astronomical images are contained in collections *AS·1, 2, 31, 145, 306,* and *333.*
34. For a discussion of space policy and public support, see Martin J. Collins and Sylvia D. Fries, eds., *A Spacefaring Nation: Perspectives on American Space History and Policy,* (Washington, D.C.: Smithsonian Institution Press, 1991).
35. *AS·1, 2, 15, 18, 20, 25, 45–47, 164, 206, 267, 300,* and *306.*
36. See, for example, C.D.B. Bryan, *The National Air and Space Museum* (New York: Harry N. Abrams, Inc., 1979).
37. Photos of the Aerodrome are in many collections (see the subject index); James Means photographs are in *AS·191;* and Hiram Maxim images are in *AS·187.*
38. *AS·62* and *285.*
39. *AS·82* and *147.*
40. *AS·302.*
41. *AS·314.*
42. *AS·132.*
43. *AS·104, 137, 153, 160, 217, 281, 282,* and *311.*
44. *AS·80, 273, 274,* and *277.*
45. *AS·70* and *190.*
46. These are present in most of the personal collections cited above in footnotes 23–27.
47. *AS·41, 63, 71, 81, 118, 127, 144, 308,* and *312.*

THE NATIONAL AIR AND SPACE MUSEUM

Martin Harwit, Director

The National Air and Space Museum (NASM) researches and exhibits the history, science, and technology of air and space flight, with emphasis on U.S. contributions. The museum staff cares for the largest collection of historic aircraft in the world; many significant types of aircraft engines; numerous spacecraft including rockets; 2,000 aerospace models; and related artifacts.

NASM's holdings were originally part of the Department of Anthropology, Division of Mechanical Technology, from 1887 to 1919. They were then transferred to the Department of Arts and Industries, Division of Mechanical Technology, where they stayed from 1919 to 1931. From 1931 until 1946 the present NASM collections were under the care of the Division of Engineering. During this time the collections were part of the United States National Museum and were housed in the Arts and Industries Building and various temporary buildings around the Mall. Curator Paul Garber (1899–1992), who joined the Smithsonian in 1920 and served in various positions until his death, gathered a significant part of the NASM's collection, including the Wright 1903 Flyer and the *Spirit of St. Louis.*

On August 12, 1946, Congress enacted Public Law 722 to create the National Air Museum as a separate Smithsonian bureau. The museum was created to "memorialize the national development of aviation; collect, preserve, and display the aeronautical equipment of historic interest and significance; serve as a repository for scientific equipment and data pertaining to the development of aviation; and provide educational material for the historical study of aviation."

In 1958 Congress set aside NASM's present site for a building for the new museum. The museum's name was changed to the National Air and Space Museum in 1966, and in 1971 Congress appropriated $40 million to fund a new building on the Mall for NASM's collections. Gyo Obata was selected as the architect, and work began on the building in November 1972. The museum opened to the public on July 1, 1976.

The museum includes three curatorial departments—the Aeronautics Department, the Art Department, and the Department of Space History—as well as the Center for Earth and Planetary Studies; the Laboratory for Astrophysics; and a major Archives and Library. NASM's building also includes the Albert Einstein Planetarium and the Samuel P. Langley Theater. The museum's Garber Facility in Silver Hill, Maryland, is used for the storage and conservation of aircraft and spacecraft as well as for archival storage and research.

Center for Earth and Planetary Studies

Center for Earth and Planetary Studies
National Air and Space Museum
Smithsonian Institution
Washington, D.C. 20560
Rosemary Steinat, Data Manager
(202) 357-1457
Hours: Monday–Friday, 10 a.m.–4 p.m.

Scope of the Collections

There are two collections with 193,200 images.

Focus of the Collections

The Center for Earth and Planetary Studies (CEPS) is one of the nine regional Planetary Image Facilities established across the United States by NASA. The facilities provide the public and scientific community access to copies of the photographs taken by manned U.S. space missions and copies of the digitally transmitted images sent by unmanned probes. The majority of images document the Earth, the Moon, and Mars, with lesser coverage of other planets and satellites of the solar system.

Photographic Processes and Formats Represented

There are color dye coupler photonegatives, photoprints, phototransparencies, and slides and silver gelatin photonegatives, photoprints, and phototransparencies.

Other Materials Represented

The department also contains maps of the planets and satellites.

Access and Usage Policies

The collections are available by appointment. No copies may be made, but researchers will be guided to the government office or private establishment from which copies may be obtained.

Publication Policies

Arrangements must be made with the government office or private establishment from which copies are obtained.

AS·1

Planetary Image Facility Earth Images

Dates of Photographs: 1968–Present

Collection Origins

NASA created the collection during several of its programs and transferred copies of the images to NASM, which makes them available for scientific research. The photographs were taken during the following space missions: *Apollo* 7 and 9 (1968–1969)—photographs taken by astronauts using hand-held Hasselblad cameras; *Skylab 2, 3,* and 4 (1973–1979)—including high-resolution photographs taken by automatic camers as well as images taken by Hasselblad cameras; the Apollo-Soyuz Test Project (1975)—photographs taken by Hasselblad cameras; Landsat satellites (1972–)—photographs from automatic cameras; and the Shuttle Transportation System (1981–)—including Hasselblad and satellite photographs. Part of this collection is stored at the Garber Facility and is described in collections *AS·45, AS·46,* and *AS·47.*

The photographs are reproduced on NASM's Archival Videodisc 6. For ordering information contact NASM Archives at the following address: Archives Division, Room 3100, National Air and Space Museum, Smithsonian Institution, Washington, D.C. 20560. Each videodisc has its own ISBN, which must be used when ordering: Videodisc 1, 0-87-4749328; Videodisc 2, 0-87-4749336; Videodisc 3, 0-87-4749344; Videodisc 4, 0-87-4749379; Videodisc 5, 0-87-4749360; Videodisc 6, 0-87-4749395. Videodisc 7 is not yet available.

Physical Description

There are 77,780 photographs including color dye coupler photonegatives, photoprints, and phototransparencies and silver gelatin photonegatives, photoprints, and phototransparencies.

Subjects

The photographs are images of the Earth from space, taken during *Apollo* 7 and 9; *Skylab 2, 3,* and 4; the Apollo-Soyuz Test Project; and Space Shuttle missions. The images show geographical features, such as continents, oceans, and mountains, as well as cloud patterns. The images cover much of the Earth, including several hundred early Landsat photographs of China and Egypt. There are also some images of satellite deployments from the shuttle cargo bay. A photograph from this collection is reproduced in this volume's illustrations section.

Arranged: By mission, then format, then image number.

Captioned: With image number; some also with camera and film information, location, and mission.

Finding Aid: 1) List of missions including description of the mission, number of images, and type of photographs taken. 2) Database on which the Photo Librarian can conduct searches, which should be requested in advance.

Restrictions: Access to 70mm images is restricted due to their fragility. All images are for reference only; no reproductions may be made. The Center can direct researchers to other sources for copies.

AS·2

Planetary Image Facility Lunar and Planetary Images

Dates of Photographs: 1964–Present

Collection Origins

NASA created the collection from the photographs taken by American interplanetary probes and satellites, primarily for scientific research and secondarily for press releases. NASM houses the images and makes them available to researchers. The photographs were taken during the following programs: the Apollo, Lunar Orbiter, Ranger, and Surveyor flights to the Moon, including manned and unmanned craft, with Hasselblad (hand-held) and mounted mapping and panoramic cameras; the *Mariner 10* voyage to Mercury; the trips to Venus by *Magellan,* launched from the Space Shuttles, and the Soviet craft *Venera 15* and *16* (approximately 15 images); the Mariner and Viking voyages to Mars; the Pioneer and Voyager flights to Jupiter and Saturn; and the *Voyager 2* trip to Uranus and Neptune. The lunar images are reproduced on

NASM Videodisc 6. For information on how to order the videodisc, see the *Collection Origins* field of *AS·1*.

Physical Description

There are 115,450 photographs including color dye coupler photonegatives, photoprints, phototransparencies, and slides and silver gelatin photonegatives, photoprints, and phototransparencies. Other materials include maps.

Subjects

The photographs document the Moon and the planets of the Earth's solar system, with their natural satellites. The images include distant views of the entire planet as well as closer views of surface features. Bodies shown include Mercury; Venus; Mars and its satellites, Deimos and Phobos; Jupiter and its satellites; Saturn and its rings and satellites; and Uranus and Neptune and their satellites. Two photographs from this collection are reproduced in this volume's illustrations section.

Arranged: In two series. 1) Press release photographs, chronologically. 2) Scientific data images, by planet, then by mission, then by feature, image number, or location.

Captioned: Press release photographs with date and subject; some scientific data images with date, feature, location, and mission.

Finding Aid: List of missions including description of the mission, number of images, and type of photographs taken.

Restrictions: For reference only; no reproductions may be made. The Center can direct researchers to other sources for copies.

Department of Aeronautics

Department of Aeronautics
National Air and Space Museum
Smithsonian Institution
Washington, D.C. 20560
Tom D. Crouch, Chairman
Dominick A. Pisano, Deputy Chairman
(202) 357-2515
Hours: Monday–Friday, 10 a.m.–5 p.m.

Scope of the Collections

There are eight photographic collections with approximately 27,800 images.

Focus of the Collections

The photographs document international aircraft from the beginning of the history of flight to the present, especially aircraft in the holdings of NASM. Other aircraft documented include National Air Races entries, Russian and Soviet aircraft, propeller-driven airliners and transports, and U.S. Navy aircraft from World War II. There are also images of flight clothing and equipment.

Photographic Processes and Formats Represented

There are color dye coupler photonegatives, photoprints, phototransparencies, and slides and silver gelatin photonegatives and photoprints.

Other Materials Represented

The department also contains articles, blueprints, catalogs, charts, contracts, correspondence, diagrams, diaries, engineering drawings, legal documents, magazine clippings, manuals, manuscripts, maps, military records, newspaper clippings, notes, pamphlets, personnel lists, press releases, regulations, reports, reprints, technical information forms, and xerographic copies.

Access and Usage Policies

The collections are open by appointment. Researchers should call or write the curator in advance, describing their research topic, the type of material that interests them, and their research aim.

Publication Policies

Researchers must obtain permission from the Smithsonian Institution and may also have to obtain permission from the copyright holder, which is not necessarily the Smithsonian. The preferred credit line is "Courtesy of the National Air and Space Museum, Smithsonian Institution." The photographer's name, if known, also should appear.

AS·3

Aeronautics Department Aviation Clothing File

Dates of Photographs: Circa 1914–1980s

Collection Origins

NASM staff assembled the collection. C.G. Sweeting, former curator of flight materiel in the Aeronautics Department, later added to and reorganized the collection in preparation for his books: 1) *Combat Flying Clothing: Army Air Forces Clothing During World War II.* Washington, D.C.: Smithsonian Institution Press, 1984. 2) *Combat Flying Equipment: U.S. Army Aviators' Personal Equipment, 1917–1945.* Washington, D.C.: Smithsonian Institution Press, 1989. Sweeting specialized in the history of military uniforms and weapons. He spent much of his career in the U.S. Air Force, where he helped establish the Air Defense Command Museum in Colorado and served as curator at the Air Force Space Museum at Cape Canaveral, Florida, before joining the Smithsonian in 1970. Some of the photographs were published in the books cited above. The collection is now located at NASM Archives.

Physical Description

There are 3,500 silver gelatin photoprints. Other materials include catalogs, manuals, regulations, reports, and xerographic copies.

Subjects

The photographs document international flight clothing and equipment from World War I to the 1980s. Countries represented include Canada, England, France, Germany, Italy, Japan, the U.S.S.R., and the United States. Objects shown include body armor, boots, flight suits, gloves, headgear, helmets, insignia, medals, oxygen equipment, pressure suits, protective clothing, shoes, survival gear, and uniforms.

Arranged: Loosely by type of equipment and country.

Captioned: Some with date and subject.

Finding Aid: No.

Restrictions: Yes. Contact NASM Archives, National Air and Space Museum, Smithsonian Institution, Washington, D.C., 20560, (202) 357-3133.

AS·4

Aeronautics Department Curators' File

Dates of Photographs: 1940s–Present

Collection Origins

NASM's Aeronautics Department curators assembled the collection as an information file documenting the departmental holdings of aircraft and other artifacts. The files contain photographs and written material on the construction and operation of each aircraft as well as its conservation treatment or reconstruction at the museum. Studios represented include OPPS and the U.S. Air Force.

Physical Description

There are 14,000 photographs including color dye coupler photonegatives, photoprints, phototransparencies, and slides and silver gelatin photonegatives and photoprints. Other materials include articles, charts, correspondence, diagrams, engineering drawings, manuals, maps, newspaper clippings, notes, reports, technical information forms, and xerographic copies.

Subjects

The photographs document the aircraft and other artifacts held by NASM's Aeronautics Department. The images show airplanes, airships, balloons, gliders, helicopters, kites, and missiles, in exhibits, in flight, and on the ground, as well as aircraft details and parts. Many of the images document conservation and reconstruction performed at the Garber Facility.

Arranged: Alphabetically by manufacturer or name.

Captioned: Most with manufacturer and model.

Finding Aid: No.

Restrictions: Available to qualified researchers, by appointment only. Contact the Department of Aeronautics, National Air and Space Museum, Smithsonian Institution, Washington, D.C., 20560, (202) 357-2515.

AS·5

Aircraft of NASM Photograph Collection

Dates of Photographs: 1970s–1980s

Collection Origins

NASM staff created the collection to document the museum's accessioned aircraft after they had been restored.

Physical Description

There are 30 color dye coupler phototransparencies.

Subjects

The photographs document NASM aircraft, some on exhibit in the museum. Aircraft depicted include a Dassault Falcon, Lockheed Sirius, North American X-15, Northrop Gamma, Pitts Special, Sikorsky XR-4, Wittman *Buster,* and the Wright 1903 Flyer.

Arranged: Alphabetically by manufacturer.

Captioned: On envelopes with manufacturer and model.

Finding Aid: No.

Restrictions: Available by appointment only. Contact the Department of Aeronautics, National Air and Space Museum, Smithsonian Institution, Washington, D.C., 20560, (202) 357-2515.

AS·6

Eglin Air Force Base Phototransparency Collection

Dates of Photographs: Circa 1950s–1960s

Collection Origins

Unknown.

Physical Description

There are 140 color dye coupler phototransparencies.

Subjects

The photographs document aircraft and activities at the Eglin Air Force Base in Valparaiso, Florida. There are images of helicopters, jets, and transports; interiors of aircraft; and U.S. Air Force personnel watching flights and working on aircraft.

Arranged: No.

Captioned: No.

Finding Aid: No.

Restrictions: Available by appointment only. Contact the Department of Aeronautics, National Air and Space Museum, Smithsonian Institution, Washington, D.C., 20560, (202) 357-2515.

AS·7

National Air Races Photograph Collection

Dates of Photographs: 1940s

Collection Origins

Unknown. Begun in 1920, the National Air Races were an annual, week-long event including formation flying, parachute drops, aerobatic displays, and races. The event included two privately sponsored, closed-circuit speed races: the Pulitzer Trophy race held from 1920 to 1925 and the Thompson Trophy race held from 1930 to 1939. Along with other competitions, the National Air Races fostered the development of aircraft in the 1920s and 1930s but ended during World War II.

Physical Description

There are 450 photographs including silver gelatin photonegatives and photoprints.

Subjects

The photographs document the National Air Races in the 1940s including images of aircraft, on the ground

and in flight; pilots; and winners receiving trophies. Pilots portrayed include Charles Brown, Cook Cleland, Jacqueline Cochran, Joseph C. De Bona, Ben McKitten, Betty Skete, and Roscoe Turner.

Arranged: No.

Captioned: On envelopes with names.

Finding Aid: No.

Restrictions: Available by appointment only. Contact the Department of Aeronautics, National Air and Space Museum, Smithsonian Institution, Washington, D.C., 20560, (202) 357-2515.

AS·8

Stephen Piercey Slide Collection

Dates of Photographs: 1986

Collection Origins

Stephen Piercey, a commercial photographer specializing in aviation, created the collection to document older airplanes still in use in the 1970s and 1980s. Beginning in 1973, Piercey made over 150 flights in propeller-driven aircraft. He worked as chief photographer for the British aviation journal *Flight International* and in 1978 formed his own magazine, *Propliner*. He published two books of photographs: 1) *Sky Truck*. London: Osprey Publishing Ltd., 1984. 2) *Sky Truck 2*. London: Osprey Publishing Ltd., 1986.

Physical Description

There are 420 color dye coupler slides (copies).

Subjects

The photographs document propeller-driven airliners and transports still in use in the 1970s and 1980s, mainly in Canada, England, and South America. Aircraft shown include the Boeing 707, Bristol Britannia, Douglas DC-6, Lockheed Super Constellation, and Martin Mars. Many images illustrate the aircraft being used for such purposes as crop-dusting and hauling freight; others depict aircraft parts such as cockpits, engines, and exhaust systems.

Arranged: No.

Captioned: With manufacturer and model.

Finding Aid: No.

Restrictions: No. Contact the Department of Aeronautics, National Air and Space Museum, Smithsonian Institution, Washington, D.C., 20560, (202) 357-2515.

AS·9

Russian/Soviet Aeronautical Archives

Dates of Photographs: Circa 1910s–Present

Collection Origins

Aeronautics Department curator Von Hardesty assembled the collection from various sources to serve as a reference file for staff and public use. Large groups of copied material came from the following sources: Boris V. Drashpil (1902–1987), a collector of material on Russian World War I aviation; the Rodina Historical Museum in Howell, New Jersey, which collects material on the Russian Imperial Navy; and Curtiss Aeroplane Company, which supplied the Russian Navy with about 70 seaplanes between 1912 and 1917. The collection also contains the personal papers, including original photographs, of K.N. Finne (1877–1957), an Imperial Russian Army flight surgeon, donated by his family. The collection will continue to grow for several years until it is transferred to the National Air and Space Museum Archives.

The photographs have appeared in the following publications: 1) Dorothy Cochrane, Von Hardesty, and Russell Lee. *The Aviation Careers of Igor Sikorsky*. Seattle: University of Washington Press, 1989. 2) K.N. Finne. *Igor Sikorsky, the Russian Years*. Edited and translated by Von Hardesty. Washington, D.C.: Smithsonian Institution Press, 1987. 3) Alexander Riaboff. *Gatchina Days: Reminiscences of a Russian Pilot*. Edited by Von Hardesty. Washington, D.C.: Smithsonian Institution Press, 1986. Photographers and studios represented include K.N. Finne; Glenn H. Curtiss Museum of Local History (Hammondsport, NY); Peter Grosz; National Maritime Museum (London); Rodina Historical Museum; Soviet Naval Museum; Time-Life; and Victor V. Uitgoff.

Physical Description

There are 9,000 photographs including color dye coupler photonegatives, photoprints, phototransparencies, and slides and silver gelatin photonegatives and photoprints. Other materials include contracts, correspondence, diaries, legal documents, magazine clippings, manuscripts, maps, military records, newspaper clippings, notes, personnel lists, reprints, and xerographic copies.

Subjects

The photographs document Russian and Soviet aviation from the late 1890s to the 1970s, especially Russian military aviation from the early 1900s through World War I. Activities and events documented include aircraft construction, aircraft crashes, balloon inflations and launches, bomb explosions, bomb loading, manned kite ascensions, military church services, salvaging trips, and training. There are images of lessons at Gatchina Military Flying School (located near St. Petersburg), Glenn H. Curtiss's aircraft demonstrations in Russia, Mikhail M. Gromov's 1937 Moscow-to-San Francisco flight, Imperial Russian Army and Navy troop maneuvers and reviews, and Imperial Russian Navy air operations on the Baltic and Black Seas.

Aircraft shown include Grigorovich and Russian Curtiss seaplanes; Russian Dorniers, Farmans, Nieuports, and Spads; Sikorsky aircraft including helicopters and the Ilya Muromets; and Soviet World War II and contemporary aircraft. There are also many images of ships, mainly of the Russian and Soviet navy, especially aircraft carriers (including balloon ships) and battleships, as well as submarines. Equipment and facilities documented include airfields, airplane and balloon hangars, airplane factories, an anti-aircraft battery on a train car, hydrogen generators, soldiers' quarters, and a submarine factory. There are images of Gatchina Military Flying School, Sevastopol Naval Air Station, and Vladivostok harbor, as well as aerial views of St. Petersburg and aerial reconnaissance photographs.

Groups portrayed include Imperial Russian Army and Navy enlisted men and officers, especially the Imperial Russian Army Balloon Corps and World War I aviators, and Soviet air force pilots in World War II. Individuals portrayed include Nina Bouroff, Valery Chkalov, Mikhail M. Gromov, Sigismund Levnensky, Grand Duke Alexander Mikhailovich, Czar Nicholas II, and Igor I. Sikorsky. There are also photographic reproductions of Russian and Soviet aviation insignia, posters, sheet music, and stamps.

Arranged: Partly by source, then by type of material and date; the collection will probably be rearranged.

Captioned: Some with date, location, negative number, subject, and source.

Finding Aid: Preliminary folder list to part of the collection. A new finding aid is in preparation.

Restrictions: Available by appointment only. Contact the Department of Aeronautics, National Air and Space Museum, Smithsonian Institution, Washington, D.C., 20560, (202) 357-2515.

AS·10

Edward J. Steichen World War II Navy Photograph Collection

Dates of Photographs: Circa 1941–1945

Collection Origins

Photographer Edward J. Steichen (1879–1973) created the collection. A prominent pictorialist at the turn of the century, Steichen helped found the Photo-Secession with Alfred Steiglitz. During World War I he commanded the photographic division of the U.S. Army Expeditionary Forces, where he learned aerial photography. He turned to fashion photography after the war, publishing in *Vogue* and *Vanity Fair*. During World War II Steichen served as director of the U.S. Naval Photographic Institute, overseeing all combat photography, and organized the "Road to Victory" and "Power in the Pacific" exhibits at the Museum of Modern Art (MOMA). From 1947 to 1962 he directed MOMA's Department of Photography, organizing almost 50 shows including "The Family of Man."

Physical Description

There are 290 photographs including color dye coupler phototransparencies and silver gelatin photonegatives.

Subjects

The photographs document U.S. Navy aircraft and aviation activities during World War II. Activities illustrated include aerial combat, aircraft carrier landings and take-offs, bombings, explosions, flights, and signal exchanges. Aircraft shown include a Curtiss SB2C

Helldiver, Douglas SBD Dauntless, and Grumman F6F Hellcat. There are photographs of aircraft carriers including details of bridges and flight decks, as well as images of ships in dry dock and a task force. There is also an image of Pearl Harbor in 1944.

Arranged: No.

Captioned: With subject.

Finding Aid: No.

Restrictions: Available by appointment only. Contact the Department of Aeronautics, National Air and Space Museum, Smithsonian Institution, Washington, D.C., 20560, (202) 357-2515.

Department of Art

Department of Art
National Air and Space Museum
Smithsonian Institution
Washington, D.C. 20560
Susan Lawson-Bell, Museum Specialist
(202) 357-1494
Hours: Monday–Friday, 10 a.m.–5 p.m.

Scope of the Collection

There is one photographic collection with 2,500 images.

Focus of the Collection

The photographs reproduce NASM's accessioned art objects, which relate to the theme of flight, from 17th century ballooning to contemporary aviation and space flight.

Photographic Processes and Formats Represented

There are color dye coupler phototransparencies and silver gelatin photoprints.

Other Materials Represented

The department also contains decorative arts, drawings, fiber arts, graphic prints, paintings, sketchbooks, and sculptures.

Access and Usage Policies

The collection is closed to researchers until all the department's holdings have been photographed.

Publication Policies

Researchers must obtain permission from the Smithsonian Institution as well as from the copyright holder, which is not necessarily the Smithsonian. The preferred credit line is "Courtesy of the Art Department, National Air and Space Museum, Smithsonian Institution." The artist's and photographer's names must be included. There are restrictions on cropping and presentation.

AS·11

Art Department Photograph Collection

Dates of Photographs: 1986–Present

Collection Origins

Museum specialist Susan Lawson-Bell (1961–) created the collection to document NASM's accessioned art holdings. Lawson-Bell, who received a B.F.A. from the Maryland Institute in 1983, has worked in NASM's Art Department since 1985. Photographers represented include NASM Photography Laboratory staff members Mark Avino and Caroline Russo.

Physical Description

There are 2,500 photographs including color dye coupler phototransparencies and silver gelatin photoprints.

Subjects

The photographs reproduce NASM's accessioned art holdings, dating mainly from the 20th century and relating to the theme of flight. There are about 3,500 works including decorative arts, drawings, fiber arts, graphic prints, paintings, original photographs, sketchbooks, and sculptures. Styles represented include abstract, photo-realist, and representational; themes include 17th through 19th century ballooning, airplane flight from the turn of the century to the present, and the development of space travel and NASA space programs.

Artists whose work is reproduced include Valerio Adami, Paul Arlt, Franz Bader, Frank W. Benson, Chesley Bonestell, Howard Russell Butler, Paul Calle, Albert W. Christ-Janer, Howard C. Christy, Alan E. Cober, Hereward Lester Cooke, Mario Cooper, Lamar Dodd, Rowland Emett, Richard Estes, Henri Farré, Keith Ferris, Fred Freeman, Morris Graves, Theodore Hancock, Peter Hurd, Mitchell Jamieson, Chet Jezierski, Rolf Klep, Hugh Laidman, Richard Lippold, Robert T. McCall, John T. McCoy, Franklin McMahon, Dale Meyers, Lowell Nesbitt, Alejandro Otero, Jack Perlmutter, Charles Perry, William S. Phillips, Clayton Pond, Norman Rockwell, Paul Sample, Eric Sloane, Nicholas Solovioff, Ingo Swann, Alma W. Thomas, Frank Wootton, and James Wyeth.

Arranged: By negative number.

Captioned: With accession number; artist's name, life dates, and nationality; credit information; date; dimensions; markings; media; support; and title.

Finding Aid: 1) Published catalog in preparation. 2) Videodisc in preparation.

Restrictions: No access.

Department of Space History

Department of Space History
National Air and Space Museum
Smithsonian Institution
Washington, D.C. 20560
Gregg F. Herken, Chairman
(202) 357-2828
Hours: Monday–Friday, 10 a.m.–5 p.m.

Scope of the Collections

There are 19 photographic collections with approximately 21,500 images.

Focus of the Collections

The photographs document the history of international rocketry and space flight, from ancient Chinese fireworks to the NASA Space Shuttle program. Topics covered include astronomy and telescopes; computers used in aerospace design and operations; NASA manned and unmanned projects; NASM space artifacts and exhibits; scientific research balloons; the Soviet space program; and 20th century rocket development, especially the V-2 and other World War II devices. There are many portraits of astronauts and other aerospace figures.

Photographic Processes and Formats Represented

There are color dye coupler photonegatives, photoprints, phototransparencies (some on glass), and slides; color dye diffusion transfer photoprints; and silver gelatin photonegatives, photoprints, and slides.

Other Materials Represented

The department also contains accession records, correspondence, exhibit catalogs, loan records, newspaper clippings, notes, pamphlets, press releases, reports, and xerographic copies.

Access and Usage Policies

The collections are available by appointment only. Researchers should call or write to the curator in advance, describing their research topic, the type of material that interests them, and their research aim.

Publication Policies

Researchers must obtain permission from the Smithsonian Institution and may also have to obtain permission from the copyright holder, which is not necessarily the Smithsonian. The preferred credit line is "Courtesy of the National Air and Space Museum, Smithsonian Institution." The photographer's name, if known, also should appear.

AS·12

"Beyond the Limits" Photograph Collection

Dates of Photographs: 1988–1989

Collection Origins

NASM Space History Department curator Paul E. Ceruzzi (1949–) created the collection to document the NASM exhibit "Beyond the Limits: Flight Enters the Computer Age" and for use in lectures. Ceruzzi, who received a Ph.D. in American Studies from the University of Kansas in 1981, specializes in the history of computers and computing. "Beyond the Limits," which opened in 1989, documents the use of computers in all areas of aeronautics and space flight.

Many of the photographs appeared in Ceruzzi's related book: *Beyond the Limits: Flight Enters the Computer Age.* Cambridge: Massachusetts Institute of Technology Press, 1989. Part of the collection is housed in the NASM Archives on the Mall. There is also a "Beyond the Limits" exhibit records file in the Space History Department.

Physical Description

There are 2,900 photographs including color dye coupler photoprints, phototransparencies, and slides and silver gelatin photonegatives and photoprints.

Subjects

The photographs document the seven topical galleries of the NASM exhibit "Beyond the Limits": design, aerodynamics, computer-aided manufacturing, flight testing, air operations, flight simulators, and space operations. Activities documented include astronauts training with flight simulators, computer-aided manufacturing with robots, and men and women operating and wiring computers. Computer-designed aircraft depicted include the Boeing 737, Snark missile, Lockheed SR-71, and Northrop YB-49.

Computers shown include the CAD/CAM; Cray-1; Felsenthal slide rules; guidance systems for the Apollo, Gemini, and Minuteman projects; IBM 7090; Radio Shack pocket computer; Sketchpad; and Whirlwind. There are also images of computer parts such as a Megabit memory chip, as well as photographic reproductions of computer patents. Many images depict computer screens during design and flight simulation programs. People portrayed include pilot Luis de Flo-

rez, Helmut Hoelzer, and rocket scientist Wernher von Braun. There are also installation views of the exhibit and images of transporting and setting up a full-scale mock-up of the computer-designed Grumman X-29 aircraft.

Arranged: In two parts. 1) Slides kept in the Space History Department, in three series: a) exhibit images, by gallery; b) installation photographs; c) X-29 images. 2) Photographs kept in NASM Archives, arranged by exhibit gallery.

Captioned: Some with date, negative number, and subject.

Finding Aid: Database listing format, script number, negative number, source, and subject. Printouts can be obtained for single records or caption lists of related subjects.

Restrictions: Available by appointment only. Contact Paul E. Ceruzzi, Curator, Department of Space History,.National Air and Space Museum, Smithsonian Institution, Washington, D.C., 20560, (202) 357-2828.

AS·13

Computer History Slide Set

Dates of Photographs: Circa 1985

Collection Origins

Staff of the Computer Museum in Boston created the collection as a published slide set documenting the history of computers. The set can be obtained from the Computer Museum, Museum Wharf, 300 Congress St., Boston, Massachusetts, 02210, (617) 426-2800.

Physical Description

There are 50 color dye coupler duplicate slides.

Subjects

The photographs document the development of computers from early calculating machines to contemporary technology. Calculating devices and computers

shown include Herman Hollerith's tabulator and sorter for the 1890 census, the IBM 7030, the Massachusetts Institute of Technology's Whirlwind, personal computers, and slide rules. Computer parts depicted include cathode ray tubes, magnetic discs, silicon wafers, transistors, and vacuum tubes.

Arranged: Chronologically.

Captioned: With subject.

Finding Aid: Script listing subject of each slide.

Restrictions: Available by appointment only. No copies can be made. Contact Paul E. Ceruzzi, Curator, Department of Space History, National Air and Space Museum, Smithsonian Institution, Washington, D.C., 20560, (202) 357-2828. Copies of the slide set can be purchased from the Computer Museum, listed in *Collection Origins*.

AS·14

Early Rocketry Photograph Collection

Dates of Photographs: 1940s–Present

Collection Origins

NASM Space History Department curator David H. DeVorkin (1944–) assembled the collection with material from NASM Archives collections, the armed forces, and private companies and institutions in preparation for a forthcoming book on early rocketry. DeVorkin, who received a Ph.D. from the University of Leicester in 1978, specializes in the history of astronomy and modern astrophysics. Photographers and studios represented include the Applied Physics Laboratory; William Baum; the Deutsches Museum; William Dow and Nelson Spencer of the University of Michigan; Charles Johnson, Frances Johnson, and Ernst Krause of the Naval Research Laboratory; U.S. Air Force Air Materiel Command; and Fred Wilscheusn.

Physical Description

There are 1,800 copy photographs including silver gelatin photonegatives and photoprints. Other materials include correspondence and xerographic copies.

Subjects

The photographs document early rocketry, primarily the German V-2 program and U.S. rocket development during and after World War II. V-2 missiles are shown during construction and launches. There are images of V-2 damage including craters. There are also images of the facilities at Peenemünde and American confiscation of the technology. American projects documented include Aerobee rockets, Project Bumper, and Viking rockets, with images of facilities, flights and launches, and instruments such as altimeters, spectrographs, and telescopes. There are portraits of General Electric and U.S. Army personnel. There are also photographic reproductions of diagrams of rockets and spectrographs.

Arranged: Alphabetically by source.

Captioned: With negative number; folders with source and subject.

Finding Aid: Database listing negative number, source, subject, and type of image.

Restrictions: Available by appointment only. Contact David H. DeVorkin, Curator, Department of Space History, National Air and Space Museum, Smithsonian Institution, Washington, D.C., 20560, (202) 357-2828.

AS·15

Enterprise Photograph Collection

Dates of Photographs: 1976–1990

Collection Origins

NASM staff created the collection to document activities involving the Space Shuttle *Enterprise,* which NASA transferred to the museum. After the transfer, NASA conducted a series of tests, mostly of rescue procedures, on the shuttle. NASA also supplied historical photographs of the *Enterprise* in operation.

Physical Description

There are 2,270 photographs including color dye coupler photonegatives, photoprints, and slides and silver gelatin photoprints.

Subjects

The photographs document the operation of the Space Shuttle *Enterprise,* its transfer to NASM, and NASA's subsequent tests on it. The shuttle is shown in operation on a Boeing 747 carrier, separating from the carrier in flight, and on a launch pad. There are also portraits of the crew. Images of the transfer to NASM show the shuttle at the Dulles International Airport Space Center being prepared for and placed in storage. Rescue procedure tests documented show people exiting the shuttle by means of a ladder, rope, slide, and stairs, as well as a truck spraying the shuttle.

Arranged: No.

Captioned: No.

Finding Aid: No.

Restrictions: Available by appointment only. Contact the Department of Space History, National Air and Space Museum, Smithsonian Institution, Washington, D.C., 20560, (202) 357-2828.

Subjects

The photographs document international space programs from 1957 to the present. The photographs are primarily from the Soviet Union; others are from Europe and Japan. Most of the images show equipment and facilities including launch vehicles, research centers, satellites, and spacecraft. There are also images of activities such as flights and training, portraits of astronauts and other personalities, and views of the Earth from space.

Arranged: By negative number.

Captioned: With negative number.

Finding Aid: Database listing country, description, SI negative number, source, subject, and title.

Restrictions: Available by appointment only. The original sources retain the copyright for most of the images. Contact Cathleen S. Lewis, Curator, Department of Space History, National Air and Space Museum, Smithsonian Institution, Washington, D.C., 20560, (202) 357-2828.

AS·16

International Space Programs Slide Collection

Dates of Photographs: 1985–Present

Collection Origins

NASM Space History Department curator Cathleen S. Lewis (1958–) assembled the collection primarily for use in lectures. Lewis, who received an M.A. in Russian and East European studies from Yale in 1983, specializes in the history of the Soviet space program and international cooperation in space. Many of the images are from Soviet publications.

Physical Description

There are 440 color dye coupler slides (mainly copy images).

AS·17

Manned Space Flight Exhibit Photographs

Dates of Photographs: 1965–1986

Collection Origins

NASM Space History Department assistant curator Derek W. Elliott (1958–) created the collection to document several NASM exhibits on which he worked. Elliott, who received an M.A. from the University of California, Berkeley, in 1985, specializes in the history of manned space flight and public policy aspects of the space program. Studios represented include NASA, OPPS, and Science House (Manchester, Massachusetts).

Physical Description

There are 70 photographs including color dye coupler photonegatives, photoprints, and phototransparencies and silver gelatin photonegatives and photoprints.

Subjects

The photographs document several NASM exhibits on topics such as Project Apollo artifacts, food used in space, and NASA administrators. Apollo artifacts shown include instruments, a space suit, and a vehicle. Images of food used in space, including exhibit installation photographs, show Apollo, Gemini, Skylab, and Space Shuttle astronauts eating and NASA workers preparing and packaging food. The NASA administrators exhibit images include a photograph of the *Surveyor 3* satellite, installation views showing busts and photographic portraits, and a portrait of James E. Webb with Lyndon B. Johnson.

Arranged: By exhibit.

Captioned: Some with date, negative number, and subject.

Finding Aid: No.

Restrictions: Available by appointment only. Contact the Department of Space History, National Air and Space Museum, Smithsonian Institution, Washington, D.C., 20560, (202) 357-2828.

AS·18

Manned Space Flight Exhibit Subject Files

Dates of Photographs: 1965–Present

Collection Origins

NASM Space History Department assistant curator Derek W. Elliott created the collection to document his research in the history of manned space flight. For a biography of Elliott, see *Collection Origins* in *AS·17*. Studios represented include Martin Marietta Corporation, NASA, and Union-Carbide.

Physical Description

There are 1,200 photographs including color dye coupler photoprints and phototransparencies, color dye diffusion transfer photoprints, and silver gelatin photoprints. Other materials include correspondence, news releases, notes, pamphlets, and reports.

Subjects

The photographs document NASA's manned space flight programs from Project Mercury to the present, as well as related NASM artifacts. Programs documented include Apollo, Gemini, Mercury, Skylab, and the Space Transportation System. Spacecraft depicted include artificial satellites; the Lunar Module; Manned Maneuvering Units; the Space Shuttles *Atlantis, Challenger, Columbia, Discovery,* and *Enterprise;* and Soviet Soyuz spacecraft.

Activities documented include extra-vehicular activities, flights, in-flight experiments, landings, launches, meals in space, radio communication, recoveries, spacecraft construction and repairs, and tests of equipment. Artifacts shown include cola "Space Cans," food for use in space, instruments, medical kits, sample containers, and space suits. Astronauts portrayed include Guion S. Bluford, Jr., James D.A. van Hoften, Ronald E. McNair, George D. Nelson, and Robert L. Stewert.

Arranged: By program and flight.

Captioned: Most with date and subject.

Finding Aid: No.

Restrictions: Available by appointment only. Contact the Department of Space History, National Air and Space Museum, Smithsonian Institution, Washington, D.C., 20560, (202) 357-2828.

AS·19

Miscellaneous Photographs *A.K.A.* Allan A. Needell Miscellaneous File

Dates of Photographs: 1980s

Collection Origins

NASM Space History Department curator Allan A. Needell (1950–) assembled the collection from several sources. Many of the images were sent by NASA and other organizations for publicity purposes;

a few document NASM exhibits. Needell, who received a Ph.D. in 1980 from Yale University, specializes in the history of modern physical sciences and of space science. Studios represented include Hughes Aircraft Company, Lockheed Missiles & Space Company, NASA, and the U.S. Navy.

Physical Description

There are 21 photographs including color dye coupler photoprints and phototransparencies and silver gelatin photoprints.

Subjects

The photographs show celestial objects and NASA spacecraft, including photographic reproductions of diagrams and drawings. Celestial objects shown include comets such as Halley's Comet, as well as Jupiter and its satellite Callisto, taken from the probes *Voyager* 1 and 2. There are images of a Galileo probe carrier and artists' conceptions of proposed NASA craft.

Arranged:　No.

Captioned:　Some with subject.

Finding Aid:　No.

Restrictions:　Available by appointment only. Contact Allan A. Needell, Curator, Department of Space History, National Air and Space Museum, Smithsonian Institution, Washington, D.C., 20560, (202) 357-2828.

Physical Description

There are 640 photographs including color dye coupler photoprints and slides and silver gelatin photoprints and slides.

Subjects

The photographs document NASA manned space flight programs, including Apollo, Gemini, Mercury, Skylab, and the Space Transportation System, as well as some Soviet programs. Activities documented include flights, launches, and landings. Artifacts and facilities documented include food used in space, NASA space centers, and spacecraft such as *Friendship* 7 and Space Shuttles. There are portraits of NASA personnel and other people, including astronaut Frederick D. Gregory, president John F. Kennedy, and rocketry pioneer Robert H. Goddard. There are also photographic reproductions of diagrams, drawings, and models of spacecraft, as well as photographs of the Earth and other planets taken from spacecraft.

Arranged:　No.

Captioned:　Some with date and subject.

Finding Aid:　No.

Restrictions:　Available by appointment only. Contact the Department of Space History, National Air and Space Museum, Smithsonian Institution, Washington, D.C., 20560, (202) 357-2828.

AS·20

NASA Historical Photograph Collection

Dates of Photographs:　1960s–1980s

Collection Origins

NASM Space History Department assistant curator Derek W. Elliott created the collection to document NASA history, primarily for use in lectures. For a biography of Elliott, see *Collection Origins* in AS·17. Studios represented include Movie Newsreels, NASA, and OPPS.

AS·21

NASM Activities Photographs *A.K.A.* Derek W. Elliott Work Photographs

Dates of Photographs:　1982–1988

Collection Origins

NASM Space History Department assistant curator Derek W. Elliott created the collection to document his work and NASM events. For a biography of Elliott,

see *Collection Origins* in *AS·17.* Photographers represented include Dane Penland.

Physical Description

There are 160 photographs including color dye coupler photonegatives, photoprints, and slides; color dye diffusion transfer photoprints; and silver gelatin photoprints.

Subjects

The photographs show NASM assistant curator Derek W. Elliott at work and NASM artifacts, exhibits, and facilities. Elliott is portrayed at his desk; giving a demonstration to children; in a staff group portrait; with astronauts Edwin E. Aldrin, Jr., and Jack Schmitt; with the Lunar Module and the Space Shuttle *Enterprise;* and working with artifacts. NASM exhibits and facilities shown include the Apollo to the Moon gallery, a display of star and sun emblems, and NASM's Garber Facility. There are also photographic reproductions of space art.

Arranged: No.

Captioned: Some with date, negative number, and subject.

Finding Aid: No.

Restrictions: Available by appointment only. Contact the Department of Space History, National Air and Space Museum, Smithsonian Institution, Washington, D.C., 20560, (202) 357-2828.

AS·22

Race to the Stratosphere Photograph Collection

Dates of Photographs: 1930s–1988

Collection Origins

NASM Space History Department curator David H. DeVorkin assembled the collection from NASM Archives collections as well as private companies and institutions in preparation for his book: *Race to the Stratosphere.* New York: Springer-Verlag, 1989. For a biography of DeVorkin, see *Collection Origins* in

AS·14. Studios represented include Dow Chemical, Franklin Institute, National Geographic Society, Science Service, University of Illinois, and Wide World Photos.

Physical Description

There are 700 photographs including silver gelatin photonegatives and photoprints (most copies).

Subjects

The photographs document high-altitude balloon flights of the 1930s, mostly in the United States. Balloons documented include *Explorer I* and *II, FNRS,* and a Soviet balloon. Balloons are shown during construction, crashes, flights, and landings, as well as in exhibits such as the 1933 Century of Progress Exposition in Chicago. There are also images of gondola interiors. There are portraits of balloon crews including Orvil A. Anderson, Chester Fordney, William E. Kepner, Paul Kipfer, Auguste Piccard, T.G.W. Settle, and Albert W. Stevens. There are also photographic reproductions of diagrams of balloons and newspaper stories of flights.

Arranged: By chapter of the book.

Captioned: With negative number; folders with subject.

Finding Aid: No.

Restrictions: Available by appointment only. Contact David H. DeVorkin, Curator, Department of Space History, National Air and Space Museum, Smithsonian Institution, Washington, D.C., 20560, (202) 357-2828.

AS·23

Space History Department Artifact Replica Files

Dates of Photographs: 1990–Present

Collection Origins

NASM Space History Department collections manage-

ment specialist Amanda J. Young assembled the collection to direct the public to makers of space artifact replicas, as an alternative to borrowing NASM objects. Photographers and studios represented include L. Badford Ashmore, Jr., and Guard-Lee, Inc.

Physical Description

There are 40 color dye coupler photoprints.

Subjects

The photographs document miniature models and replicas of space artifacts, including Apollo, Gemini, and Mercury spacecraft; a Hubble Space Telescope; a Space Shuttle, including interior views; and space suits.

Arranged: No.

Captioned: With subject.

Finding Aid: No.

Restrictions: No. Contact Amanda J. Young, Department of Space History, National Air and Space Museum, Smithsonian Institution, Washington, D.C., 20560, (202) 357-2828.

AS·24

Space History Department Artifact Request Files

Dates of Photographs: 1965–Present

Collection Origins

NASM Space History Department staff created the collection to document loans of NASM artifacts to other institutions. The borrowing institutions send photographs back to NASM showing the transportion and use of the objects. Studios represented include the Aviodome (Netherlands), Greater Manchester Museum of Science and Industry (England), International Space Hall of Fame, NASA, National Museum of Science and Technology (Canada), Patrick Air Force Base, the Planetarium (Ireland), Power House Museum (Australia), Science Museum (England), Swiss Transport Museum (Switzerland), U.S. Naval Academy, and Wright-Patterson Air Force Base.

Physical Description

There are 625 photographs including color dye coupler photonegatives, photoprints, and slides; color dye diffusion transfer photoprints; and silver gelatin photoprints. Other materials include correspondence, exhibit catalogs, loan records, newspaper clippings, and pamphlets.

Subjects

The photographs document NASM artifacts that have been loaned to other institutions. There are photographs of artifacts being installed, packed, stored, and transported, as well as images of exhibit installations, openings, and related artifacts and exhibits at the borrowing institutions. NASM objects shown include instruments, satellites, spacecraft, space food, space suits, and training equipment from the Apollo, Gemini, Mercury, Saturn, and Space Transportation System programs. Other objects depicted include miniature models of a lunar lander and Space Shuttle, as well as Chinese and Soviet spacecraft. There are images of exhibits and openings at institutions in the United States and other countries such as those listed in *Collection Origins*.

Arranged: Alphabetically by borrowing institution.

Captioned: Most with subject.

Finding Aid: No.

Restrictions: No. Contact Alice Jones or Amanda J. Young, Department of Space History, National Air and Space Museum, Smithsonian Institution, Washington, D.C., 20560, (202) 357-2828.

AS·25

Space History Department Slide Collection

Dates of Photographs: Late 1960s–Present

Collection Origins

Frank H. Winter and other NASM Space History De-

partment curators created the collection primarily for use in presentations. Winter, who received a B.A. in 1978 from the University of Maryland, specializes in the history of rocketry and astronautics from ancient China to World War II. Studios represented include NASA, OPPS, and Rockwell International.

Physical Description

There are 4,500 photographs including color dye coupler slides and phototransparencies on glass and silver gelatin slides.

Subjects

The photographs document international rocket and space history. Activities and projects documented include rocketry pioneer Robert H. Goddard's experiments, NASA programs, NASM building construction and exhibits, the Soviet space program, V-2 missile development, and World War II rocketry. Facilities and objects shown include pre-20th century fireworks and rockets, launch vehicles, NASA space centers, satellites, Space Shuttles, and space suits. There are astronomical images of the Moon and planets, as well as portraits of African Americans in astronautics, astronauts, and rocketry pioneers. There are also many photographic reproductions of diagrams, engravings, magazines, posters, space art, and television program scenes. Science fiction illustrated includes *Amazing Stories* magazine, *Buck Rogers* comics, and "Star Trek" television shows.

Arranged: Loosely by date and subject.

Captioned: Some with date, negative number, and subject.

Finding Aid: No.

Restrictions: Available by appointment only. Contact Frank H. Winter, Curator, Department of Space History, National Air and Space Museum, Smithsonian Institution, Washington, D.C., 20560, (202) 357-2828.

AS·26

Space Telescope History Project Image Collection

Dates of Photographs: Circa 1960s–1980s

Collection Origins

Members of the Space Telescope History Project (STHP), a joint activity of NASM and the Johns Hopkins University History of Science Department, partly sponsored by NASA, created the collection for research purposes in the mid-1980s. Duplicate slides were also made for use in lectures. Photographers and studios represented include Convair, F.K. Edmondson, Ford Library, Grumman Corporation, NASA, Perkin-Elmer, J.L. Russell, J.N. Tatarewicz, and the University of Wisconsin. Some of the photographs have been published in the following book: Robert W. Smith. *The Space Telescope: A Study of NASA, Science, Technology and Politics.* Cambridge: Cambridge University Press, 1989. Some have also appeared on the BBC show "Horizon" and in newspapers and magazines such as *Florida Today, Optics and Photonics,* and *Science.*

Physical Description

There are 5,000 photographs including color dye coupler photoprints, phototransparencies, and slides and silver gelatin photoprints.

Subjects

The photographs document the history of space telescopes from the 1940s to the present. Activities documented include construction, dedications, inspections, launches, operations, simulations, tests, and transportation of equipment and telescopes. Telescopes depicted include the Grumman Large Space Telescope, Grumman X-Ray Telescope, Hubble Space Telescope, Optical Telescope Assembly, Orbiting Astronomical Observatory, and SDTV. Parts shown include focal plane assemblies, light baffles, and mirrors. Other artifacts shown include computers, a High Gain Antenna, a Saturn launch vehicle, Space Shuttles, test apparatus, and tools such as a computer-controlled mirror polisher.

People portrayed include Fred Best, Robert C. Bless, Gene Buckholtz, Arthur D. Code, Army officer James L. Fletcher, president Gerald R. Ford, astronaut Shannon W. Lucid, Navy officer Bruce McCandless, astronaut George D. Nelson, scientist Hermann Oberth, James B. Odom, Rocco Petrone, Lyman Spitzer, J. Tatarewicz, and Charles Teleki. There are also photographic reproductions of diagrams, drawings, and models of cameras, photometers, and telescopes; of graphs; and of magazine and newspaper advertisements and stories.

Arranged: By STHP accession number.

Captioned: With STHP accession number; some also with date and subject.

Finding Aid: 1) Database listing date, donor, format, source, STHP accession number, and subject. 2) Bound printout of database, arranged by accession number. 3) Xerographic copies of photographs in binders with STHP accession number.

Restrictions: Available by appointment only. Reproduction rights for many of the images are retained by the original source. Contact Robert W. Smith, Historian, Department of Space History, National Air and Space Museum, Smithsonian Institution, Washington, D.C., 20560, (202) 357-2828.

AS·27

Stars Gallery Working File

Dates of Photographs: 1930s–Present

Collection Origins

NASM Space History Department curator David H. DeVorkin assembled the collection in preparation for an exhibit on astronomy. For a biography of DeVorkin, see *Collection Origins* in *AS·14*.

Physical Description

There are 500 photographs including color dye coupler phototransparencies and silver gelatin photonegatives and photoprints (most copies).

Subjects

The photographs document astronomy since the 1930s, including images of astronomical instruments and celestial bodies. There are images of observatories such as Kitt Peak National Observatory and Mount Wilson, as well as many types of telescopes. Celestial bodies shown include galaxies, nebulae such as Eta Carinae and Orion, stars such as the Sun, and star clusters. There are also coronagraphic images, photographic reproductions of space art, and portraits of astronomers such as Edwin Hubble.

Arranged: By subject.

Captioned: With negative number; folders with subject.

Finding Aid: No.

Restrictions: For reference only; no reproductions may be made. Contact David H. DeVorkin, Curator, Department of Space History, National Air and Space Museum, Smithsonian Institution, Washington, D.C., 20560, (202) 357-2828.

AS·28

James A. Van Allen Photograph File

Dates of Photographs: 1957–1961

Collection Origins

James A. Van Allen (1914–), a physicist working on upper atmosphere, cosmic ray, and geophysical research, created the collection to document his work in the late 1950s and early 1960s. Van Allen received a Ph.D. in physics from the University of Iowa (1939), served as a research fellow in nuclear physics (1939–1941) and as a physicist (1941–1942) at the Carnegie Institute, worked in the applied physics laboratory at Johns Hopkins University (1942, 1946–1950), and became a professor and later head of the department of physics and astronomy at the University of Iowa (1951–).

Van Allen led several scientific expeditions in the Antarctic, Arctic, and Atlantic and Pacific oceans between 1949 and 1957, and he held positions with the National Academy of Sciences, National Advisory Committee for Aeronautics, NASA, National Science Foundation, Office of Naval Research, and the President's Scientific Advisory Committee. Van Allen sent duplicate photographs from his files to NASM Space History Department curator Allan A. Needell to create this collection. Studios represented include the U.S. Navy and the University of Iowa.

Physical Description

There are 23 photographs including color dye coupler photoprints and silver gelatin photoprints. All are copies.

Subjects

The photographs document James A. Van Allen's work in radio astronomy during the late 1950s and early 1960's. Activities documented include assembling a rocket head, constructing satellites, and inflating and

releasing a Navy "rockoon" (balloon/rocket assemblage). Objects shown include instruments such as radio receivers, a Navy radio antenna, a rockoon, and a U.S. Air Force rocket. There are photographic reproductions of a diagram of a Soviet probe and readings from receivers, as well as a portrait of Van Allen with German rocket scientist Wernher Von Braun.

Arranged: No.

Captioned: Some with date and subject.

Finding Aid: No.

Restrictions: Available by appointment only. Contact Allan A. Needell, Curator, Department of Space History, National Air and Space Museum, Smithsonian Institution, Washington, D.C., 20560, (202) 357-2828.

AS·29

"Where Next, Columbus?" Exhibit File

Dates of Photographs: 1990–1992

Collection Origins

NASM Space History Department curator Valerie Neal assembled the collection in preparation for NASM's 1992 exhibit "Where Next, Columbus?" which commemorates the Columbus Quincentenary and the International Space Year. After receiving a Ph.D. from the University of Minnesota in 1979, Neal worked as publications project manager for Essex Corporation, an aerospace support contractor, from 1980 to 1989. At Essex she wrote and edited NASA publications as well as serving on the management team for four Space Shuttle/Spacelab missions. Neal also taught at the University of Alabama from 1987 to 1989, before coming to NASM. Studios represented include Archivo General de las Indias (Spain); Biblioteca Nacional (Spain); Boeing Corporation; General Dynamics; General Electric; Jet Propulsion Laboratory, California Institute of Technology; Library of Congress; Martin Marietta Corporation; Museo del Ejercito (Spain); NASA; National Maritime Museum (England); OPPS; and SAIC.

Physical Description

There are 500 photographs including color dye coupler photoprints, phototransparencies, and slides and silver gelatin photonegatives and photoprints. Many of the photographs are copies. Other materials include xerographic copies of photographs.

Subjects

The photographs document historical and contemporary exploration of the Earth and other planets, including explorers, sites of exploration, and technology. Historical artifacts shown include arms and armor, astronomical devices, globes, graphic prints and paintings of explorers and exploring missions, manuscript pages, maps, and miniature models of ships. There are many images of NASA space exploration, including activities and events such as Apollo lunar landings and space walks; Viking missions to Mars; and Voyager missions to the outer planets. NASA equipment depicted includes Moon vehicles, spacecraft, and space suits. There are also NASA images of Earth from space. Contemporary experimental technology shown includes several different Mars rovers (vehicles for collecting samples and exploring the surface of Mars) and solar sails. Some images are photographic reproductions of artists' conceptions of exploration technology.

Arranged: Alphabetically by subject and numerically to correspond to exhibit units.

Captioned: On an accompanying sheet with description of subject, negative number, source, and type of image.

Finding Aid: Item-level catalog listing description of subject, negative number, source, and type of image.

Restrictions: Many of the images may not be reproduced; copies must be requested from the original source. Contact Valerie Neal, Curator, Department of Space History, National Air and Space Museum, Smithsonian Institution, Washington, D.C., 20560, (202) 357-2828.

AS·30

W-17 Sensor Photographs

Dates of Photographs: Circa 1960, 1991

Collection Origins

NASM Space History Department chairman and military space curator Gregg F. Herken asembled the col-

lection to document the W-17 infrared early warning sensor. Aerojet Engineering Corporation built the sensor for the U.S. Air Force around 1960 as part of the Missile Infrared Detection and Surveillance (Midas) program. It was later donated to NASM. Photographers and studios represented include Aerojet and NASM staff.

Physical Description

There are 14 photographs including color dye coupler photoprints and silver gelatin photoprints. Other materials include accession records.

Subjects

The photographs document the W-17 infrared early warning sensor, showing it as originally built and as it appeared when donated to NASM. The later images document the object from all sides, showing corrosion damage. There is also a photographic reproduction of a diagram of the sensor with the parts labeled.

Arranged: No.

Captioned: Some with subject.

Finding Aid: No.

Restrictions: Available by appointment only. Contact Gregg F. Herken, Chairman, Department of Space History, National Air and Space Museum, Smithsonian Institution, Washington, D.C., 20560, (202) 357-2828.

Laboratory for Astrophysics

Laboratory for Astrophysics
National Air and Space Museum
Smithsonian Institution
Washington, D.C. 20560
Howard A. Smith, Chairman
(202) 357-4932
Hours: Monday–Friday, 10 a.m.–4 p.m.

Scope of the Collection

There is one collection with 30 images.

Focus of the Collection

The photographs reproduce digitized (computer) images of infrared galaxies and infrared star formation regions.

Photographic Processes and Formats Represented

There are color dye coupler photoprints and phototransparencies.

Other Materials Represented

The department also contains digitally stored information on computer tapes and xerographic copies.

Access and Usage Policies

The collections are open to researchers by appointment. Researchers may request additional printouts and photographic images, as well as copies of the image information on electronic media.

Publication Policies

Researchers must obtain permission from the Smithsonian Institution. The preferred credit line is "Courtesy of the Laboratory for Astrophysics, National Air and Space Museum, Smithsonian Institution."

AS·31

Laboratory for Astrophysics Digitized Image Collection

Dates of Photographs: 1991

Collection Origins

Howard A. Smith, senior astrophysicist and department chairman, created the collection to document his work with spectroscopic images for publication purposes. Smith, who received a Ph.D. in 1976 from the University of California, Berkeley, specializes in ground- and space-based infrared spectroscopy, molecular clouds and star formations, active galaxies, and instrument development.

The collection resulted from an ongoing project in which Smith used computers to create spectroscopic images of the infrared emission from active and interacting galaxies, then manipulated and interpreted the images to determine the excitation mechanisms. Most of the images were created with "charge-coupled devices" (CCDs), which are light-sensitive arrays of silicone chips that convert photons of light gathered by a telescope into electrical signals. These electronic detectors are linked directly to online computers, where the data is stored digitally and later converted into analog format (television signals). The images can then be manipulated, enhanced, interpreted, and photographed.

Physical Description

There are 30 photographs including color dye coupler photoprints and phototransparencies. The photographs were originally digitized images made with CCDs. Other materials include computer tapes and xerographic copies.

Subjects

The photographs document the L1048 infrared star, as well as other infrared sources, shown with different exposures and manipulations of the spectrographic image.

Arranged: No.

Captioned: With information on type of exposure and manipulation.

Finding Aid: No.

Restrictions: Available by appointment only. Images may be accessed by requesting electronic copies from the Laboratory.

Collections Maintenance Division

Collections Maintenance Division
National Air and Space Museum
Garber Facility, Building 10
3904 Old Silver Hill Road
Suitland, Maryland 20746
Alfred J. Bachmeier, Chief
(301) 238-3407
Hours: Monday–Friday, 9 a.m.–3:15 p.m.

Scope of the Collection

There is one photographic collection with approximately 50,000 images.

Focus of the Collection

The photographs document NASM artifacts including aircraft parts, armaments, clothing, and equipment.

Photographic Processes and Formats Represented

There are silver gelatin photonegatives and photoprints.

Other Materials Represented

No.

Access and Usage Policies

Available to NASM staff only; however, copies of images of specific museum artifacts may be ordered by the public.

Publication Policies

Researchers must obtain permission from the Smithsonian Institution to reproduce an image. The preferred credit line is "Courtesy of the National Air and Space Museum, Smithsonian Institution." The photographer's name, if known, also should appear.

AS·32

Accessions Photograph File

Dates of Photographs: 1977–Present

Collection Origins

NASM Collections Maintenance staff created the photographs to document NASM accessioned artifacts for adminstration and control purposes. Staff members photograph NASM objects when they are accessioned.

Physical Description

There are 50,000 photographs including silver gelatin photonegatives and photoprints.

Subjects

The photographs document most of NASM's 30,400 artifacts (except for aircraft and spacecraft), including flight-related items from the 19th century to the present. There are images of aircraft parts, especially engines and propellers, and rocket engines.

Equipment and instruments shown include communication devices; emergency and protection gear; navigational instruments; supplies used in space such as food containers, medical kits, and sample collecting tools; telescopes; and training equipment such as flight simulators.

Flight clothing shown includes military uniforms, especially air force uniforms from around the world; pressure suits; space suits; and World War II pilots' jackets. Armaments depicted include ammunition; anti-aircraft guns; bomb launchers and sights; bombs, missiles, and rockets; cannons; gun turrets; and machine guns. Other artifacts illustrated include artifical satellites; hang gliders; kites; lunar rocks; memorabilia such as insignia, flags, and medals; models of aircraft and spacecraft including wind-tunnel models; and rockets built by Robert H. Goddard and pre-20th century rocket-propelled devices. There are also photographic reproductions of NASM's collection of aeronautical and space art.

Arranged: In two series, then by accession number. 1) Photonegatives. 2) Photoprints.

Captioned: With the accession number of the object photographed.

Finding Aid: Inventories in the NASM Registrar's Office list objects by category, including accession number and description.

Restrictions: Open to NASM staff only; the public may order copy images of specific museum artifacts.

Multicultural Outreach Office

Multicultural Outreach Office
National Air and Space Museum
Washington, D.C. 20560
M. Antoinette Amos, Multicultural Outreach Officer
(202) 357-1427
Hours: Monday–Friday, 10 a.m.–5 p.m.

Scope of the Collections

There are two photographic collections with approximately 300 images.

Focus of the Collections

The photographs document activities and events involving minorities at NASM and the museum's IMAX theater.

Photographic Processes and Formats Represented

There are color dye coupler photoprints and silver gelatin photoprints.

Other Materials Represented

There is also a manuscript and a pamphlet.

Access and Usage Policies

Available by appointment only. Researchers should call or write in advance, describing their research topic, the type of material that interests them, and their research aim.

Publication Policies

Researchers must obtain permission from the Smithsonian Institution to reproduce an image. The preferred credit line is "Courtesy of the National Air and Space Museum, Smithsonian Institution." The photographer's name, if known, also should appear.

AS·33

Multicultural Outreach Events Photograph Notebook

Dates of Photographs: 1989–Present

Collection Origins

National Air and Space Museum Multicultural Outreach staff created the collection to document museum events involving minorities for documentation purposes and publications.

Physical Description

There are 290 silver gelatin photoprints, some on contact sheets.

Subjects

The photographs document NASM activities and events since 1989 involving minorities, primarily African Americans. Events shown include Black History Month lectures, concerts, receptions, and visits to exhibits such as "Black Wings: The American Black in Aviation." People portrayed include astronauts Guion S. Bluford, Jr., and Mae Jemison; retired Air Force general Benjamin O. Davis, Jr.; and Ted Robinson; as well as African American school children and students of the "City Lights" and "Say Yes to a Youngster's Future" programs.

Arranged: By event.

Captioned: Most with OPPS negative number.

Finding Aid: No.

Restrictions: No.

AS·34

Multicultural Outreach IMAX Theater Photograph Notebook

Dates of Photographs: Circa 1985

Collection Origins

NASM staff created the collection to document the Langley Theater, the museum's facility for showing IMAX films, for documentation and publicity purposes.

Physical Description

There are nine photographs including a color dye coupler photoprint and silver gelatin photoprints. Other materials include a manuscript and a pamphlet.

Subjects

The photographs show the NASM building exterior, the equipment for showing IMAX films, and the Langley Theater.

Arranged: No.

Captioned: Some with subject.

Finding Aid: No.

Restrictions: Available by appointment only.

NASM Archives

Archives Division, Room 3100
National Air and Space Museum
Smithsonian Institution
Washington, D.C. 20560
Dr. Thomas F. Soapes, Supervisory Archivist
(202) 357-3133
Hours: Monday–Friday, 10 a.m.–5 p.m.

NASM Archives
Garber Facility, Building 12
3904 Old Silver Hill Road
Suitland, Maryland 20746
Marilyn Graskowiak, Archivist, Manager of Building 12
(301) 238-3480
Hours: Monday–Friday, 8:30 a.m.–4:30 p.m.

Scope of the Collections

There are 298 photographic collections with approximately 1,400,000 images.

Focus of the Collections

The photographs document the history of air and space flight, from 19th century balloons to contemporary aerospace technology. There are images of aircraft and spacecraft from around the world, events and races, and military operations, as well as portraits of prominent figures in the field of air and space flight. Particularly well-documented topics include NASA programs, U.S. Air Force operations before 1954, the U.S. Army engineering facility at Wright-Patterson Air Force Base, V-2 missiles, and World War I pilots, as well as specific airlines, individuals, and manufacturers.

Photographic Processes and Formats Represented

There are albumen photoprints; ambrotypes; collodion gelatin photoprints (POP); color dye coupler photonegatives, photoprints, phototransparencies, and slides; color dye transfer separation phototransparencies on glass; cyanotypes; dye diffusion transfer photoprints; kallitypes; platinum photoprints; silver gelatin dry plate lantern slides and photonegatives; silver gelatin photonegatives, photoprints, phototransparencies, and slides; and tintypes. Formats represented include cabinet cards, cartes-de-visite, contact prints, and stereographs.

Other Materials Represented

The Archives also contains advertisements, affidavits, albums, announcements, applications, articles, artifacts, audiotape cassettes, awards, banners, bibliographies, books, bumper stickers, business cards, bylaws, calendars, catalogs, certificates, charts, checklists, color samples, computer printouts, contracts, correspondence, diagrams, diaries, drawings, engineering drawings, examination study guides, financial records, flight data records, flight logbooks, flight logs, floor plans, forms, graphic prints, greeting cards, identification cards, invitations, journals, ledgers, legal documents, licenses, lists, magazine clippings, magazines, manuals, manuscripts, map cases, maps, membership cards, membership lists, menus, military orders, military records, minutes, motion-picture film footage,

motion-picture films, news bulletins, newsletters, newspaper clippings, notebooks, notes, paintings, pamphlets, passenger lists, passports, patents, periodicals, petitions, phonograph records, photomechanical postcards, photomechanical prints, plans, plaques, postage stamps, posters, press releases, proceedings, programs, proposals, publications, regulations, reports, reprints, resolutions, resumes, schedules, scrapbooks, site drawings, specifications, speeches, tickets, transcripts, transparencies, videotape cassettes, and xerographic copies.

Access and Usage Policies

The collections are stored at two locations: the Garber Facility in Silver Hill, Maryland, and the NASM building on the Mall. Researchers must make an appointment to use collections at the Garber Facility; appointments are also encouraged at the archives on the Mall. Researchers should call or write in advance, describing their research topic, the type of material that interests them, and their research aim.

Publication Policies

Researchers must obtain permission from the Smithsonian Institution and may also have to obtain permission from the copyright holder, which is not necessarily the Smithsonian. Many of NASM's photographs are in the public domain, so the museum can provide permission to publish. In other cases, NASM may be able to provide information on how to reach the copyright holder. The preferred credit line is "Courtesy of the National Air and Space Museum, Smithsonian Institution." The collection name, negative number, and photographer's name, if known, also should appear.

AS·35

Aerial Photographic Reconnaissance Collection *A.K.A.* Samuel L. Batchelder Collection

Dates of Photographs: 1860s–1945

Collection Origins

Samuel L. Batchelder assembled the collection to document the history of aerial reconnaissance photography. Batchelder served at the U.S. Army Air Forces Intelligence School in Harrisburg, Pennsylvania, and at the Joint Photographic Reconnaissance Center in Mendenham, England. Photographers represented include Arthur Powers. NASM Archives assigned the collection accession number 1986-0005.

Physical Description

There are 2,230 photographs including albumen photoprints, color dye coupler phototransparencies, and silver gelatin photoprints, some mounted in albums. Other materials include diagrams, manuals, and publications.

Subjects

The photographs are primarily aerial views of Europe, as well as some of Africa and the United States, taken during World War I and II. There are also images of aircraft, military equipment and structures, ordnance, and soldiers. Aerial views include Salzburg, Austria; the Belgian coast; England; Āk'ordat (Agordat), Ethiopia; Beauvais, Cambrai, and Wizernes, France; Bad Kissingen, Berlin, Bielefeld, Bonn, Munich, and Stuttgart, Germany; Genova, Palermo, and Trieste, Italy; Tunis, Tunisia; and Shreveport, Louisiana, in the United States. Aircraft documented include Lockheed F-5 Lightnings and Supermarine Spitfires. Ordnance and structures documented include an American Civil War mobile mortar gun, obstructions, and pontoon bridge; a railroad bridge in Siberia; and tanks. Soldiers are portrayed attending classes, marching, and receiving medals.

Arranged: Photographs alphabetically by geographic location and then chronologically. The rest by publication and then date or by document type.

Captioned: Most with date and location.

Finding Aid: Folder list.

Restrictions: The collection, located at the Garber Facility, is available by appointment only.

AS·36

Aeronautical History Scrapbooks

Dates of Photographs: Circa 1900–1932

Collection Origins

Unknown. Studios represented include B.F. Goodrich Rubber Company, International Film Service, Underwood and Underwood, and the U.S. Army Signal Corps. NASM Archives assigned the collection accession number XXXX-0402.

Physical Description

There are 700 photographs including albumen stereographs and silver gelatin photoprints, mounted in scrapbooks. Other materials include announcements, magazine clippings, and newspaper clippings, also mounted in the scrapbooks.

Subjects

The photographs document several types of aircraft including airplanes, airships, and balloons. Airplanes shown include a Dornier Do X and a Supermarine S.6 racer. There are images of American, British, French, and German airships such as the *Graf Zeppelin, Roma,* U.S.S. *Akron,* U.S.S. *Los Angeles,* and U.S.S. *Shenandoah.* There are detailed construction, flight, and interior images of the *Akron* and *Graf Zeppelin.* Other images show airships being launched, in crashes, in hangars, and moored to ships. Balloons are shown ascending, being filled with hydrogen, and being inspected. There are also images of British navy officers training in rigging balloons, a military balloon drill, and U.S. Army Signal Corps balloon equipment.

Arranged: In scrapbooks by subject. There are photographs in about half of the volumes.

Captioned: A few with subject.

Finding Aid: List of volumes.

Restrictions: The collection, located at the Garber Facility, is available by appointment only.

AS·37

Aircraft of the National Air and Space Museum Collection

Dates of Photographs: 1970s–1981

Collection Origins

Former NASM Department of Aeronautics curator Claudia M. Oakes assembled the collection from NASM's holdings as well as outside materials for use in the following publication: Claudia M. Oakes. *Aircraft of the National Air and Space Museum, Smithsonian Institution.* Washington, D.C.: Smithsonian Institution Press, 1976, 1981, 1985, 1992. Studios represented include the Bell Aircraft Corporation, Boeing, OPPS, United Press International, the U.S. Air Force, and the U.S. Navy. NASM Archives assigned the collection accession number 1986-0046.

Physical Description

There are 340 silver gelatin photoprints. Other materials include correspondence and manuscripts.

Subjects

The photographs document aircraft displayed at NASM, including interiors and parts; flights; and people including passengers, pilots, and World War II aircraft crews. Types of aircraft depicted include airliners, airships, balloons, bombers, fighters, gliders, and helicopters.

Arranged: In two series by type of material. 1) Correspondence and manuscripts, alphabetically by manufacturer and model. 2) Photographs, by negative number.

Captioned: With negative number; some also with manufacturer and model.

Finding Aid: Folder list.

Restrictions: The collection, located at the Garber Facility, is available by appointment only.

AS·38

Aircraft of the 1930s Photograph Collection A.K.A. Lois Kuster Scrapbook

Dates of Photographs: 1930s

Collection Origins

Unknown. Lois Kuster, whose father bought the collection, donated it to NASM, where it received accession number 1989-0004.

Physical Description

There are 2,000 silver gelatin photoprints, mounted in an album.

Subjects

The photographs document 1930s aircraft, primarily American airliners and experimental, military, and sport aircraft, usually shown from several angles. There are images of autogyros, biplanes, monoplanes, and seaplanes. Manufacturers represented include Bellanca, Consolidated, Douglas, International, Laird, and Lockheed (including the *Winnie Mae*). Many of the aircraft shown are marked with company names such as Columbia Broadcasting System and Texaco. There are also some images of events such as air races and crashes, as well as portraits of aviators such as Amelia Earhart and Roscoe Turner.

Arranged: No.

Captioned: No.

Finding Aid: No.

Restrictions: The collection, located at the Garber Facility, is available by appointment only.

AS·39

Aircraft Radio Corporation Records *A.K.A.* Gordon White Collection, Circa 1924–1982

Dates of Photographs: Circa 1940s–1969

Collection Origins

The Aircraft Radio Corporation (ARC) created the collection to document its operations. Established in the 1920s in Boonton, New Jersey, as a division of the Radio Frequency Labs, ARC developed airborne receivers for the Civil Aeronautics Administration's low-frequency navigation ranges. The Stromberg-Carlson Company of Rochester, New York, agreed in 1929 to produce the receivers, which ARC then marketed. The same year James H. Doolittle made the first flight completely guided by instruments, using ARC equipment. ARC equipment was also used in the first radio-equipped scheduled airmail flights and the first U.S. Army Air Corps standard radio-beacon receiver. ARC produced radios used in many Allied fighter aircraft during World War II and communication and navigation equipment for light civilian aircraft after the war. In 1959 Cessna Aircraft Company acquired ARC, which continued its operations in Boonton as a subsidiary. Studios represented include Ludwig Lab. Gordon White donated the collection to NASM, where it received accession number 1987-0023.

Physical Description

There are 195 photographs including color dye coupler photoprints and silver gelatin photoprints. Other materials include charts, contracts, correspondence, engineering drawings, financial records, laboratory notebooks, ledgers, manuscripts, motion-picture film footage, pamphlets, and patents.

Subjects

The photographs document Aircraft Radio Corpora-

tion (ARC) events, facilities, and products including construction and testing. Events documented include a display of new products, an open house, and social gatherings of executives (such as ARC president Vernon W. Deinzer) and their wives. Facilities documented include laboratories, offices, and workrooms. Products such as radio instruments and microcircuits are shown in detailed construction steps (being cleaned, examined under magnifiers, heated, sealed, and weighed), as well as in tests with before and after views. There is also an image of a Sikorsky helicopter.

Arranged: In six series by company division or document type.

Captioned: Some with date and subject such as name of instrument or part.

Finding Aid: Box list.

Restrictions: The collection, located at the Garber Facility, is available by appointment only.

AS·40

Aircraft Recognition Training Materials *A.K.A.* U.S. Navy Recognition Training Slides Collection, 1950s

Dates of Photographs: 1950s

Collection Origins

The U.S. Navy created the collection for use in training personnel to recognize and identify international aircraft. NASM Archives assigned the collection accession number XXXX-0161.

Physical Description

There are 2,590 silver gelatin slides.

Subjects

The photographs document international civil and military aircraft of the 1950s including British, Cana-

dian, French, and Soviet airliners, bombers, fighters, and transports. There are also images of ships and submarines.

Arranged: No.

Captioned: With date, manufacturer, and model.

Finding Aid: No.

Restrictions: The collection, located at the Garber Facility, is available by appointment only.

AS·41

Aircraft Scrapbook Material *A.K.A.* Claude A. Grimm Collection

Dates of Photographs: 1930–1940s

Collection Origins

Claude A. Grimm created the collection to document his career as an aviation instructor. In the 1930s, Grimm, president of Eyerly Aircraft Corporation, operated flying and gliding schools in Inglewood, Oakland, and Vallejo, California; Boise, Idaho; and Salem, Oregon. He also served as a sales manager for several flight schools. NASM Archives assigned the collection accession number XXXX-0238.

Physical Description

There are 100 silver gelatin photoprints, mounted in scrapbooks. Other materials include business cards, magazine articles, and newspaper clippings, also mounted in the scrapbooks.

Subjects

The photographs document aircraft, primarily gliders, and aviation-related equipment and facilities. There are images of the Evans All-Steel Glider and other gliders, in flight, in tow, and taking off. Equipment and facilities documented include cables, drogue parachutes, hangars, hooks, locker rooms, a radio tester, and shops with tools. There is also a portrait of Will Rogers standing on a seaplane, identified as the last photograph taken before his death.

Arranged: No.

Captioned: A few with subject.

Finding Aid: No.

Restrictions: The collection, located at the Garber Facility, is available by appointment only.

AS·42

Allison Photograph Collection

Dates of Photographs: 1972

Collection Origins

The collection was created to document Operation Linebacker II, the last strategic bombing campaign of the Vietnam War. Ordered by President Nixon in December 1972, the operation was an attempt to force North Vietnam to negotiate. The photographs are reproduced on NASM's Archival Videodisc 2. For information on how to order the videodisc, see the *Collection Origins* field of *AS·1*.

Physical Description

There are 185 silver gelatin photoprints. Other materials include maps and newspaper clippings.

Subjects

The photographs document preparations for the U.S. Air Force's Operation Linebacker II bombing missions over , North Vietnam. Activities illustrated include U.S.A.F. personnel attending briefings, loading bombs, maintaining aircraft, and running to aircraft. Airplanes such as the Boeing B-52 Stratofortress are shown arriving at Andersen Air Force Base in Guam, landing, and taking off. Facilities shown include airfields, buildings with some interior views, and tents. There are also images of aerial combat on a radar screen and portraits of commanders and crew members.

Arranged: By videodisc frame number.

Captioned: With subject.

Finding Aid: Caption database with subject and

videodisc frame number. Printouts can be obtained for single photographs or caption lists of photographs with related subjects.

Restrictions: No. The collection is located at the NASM Archives on the Mall. Researchers are encouraged to call or write for an appointment.

AS·43

American Astronautical Society Records, 1953–1977

Dates of Photographs: 1973

Collection Origins

American Astronautical Society (AAS) member James G. Allen of the University of Colorado assembled the collection in preparation for a history of the organization. A professional organization formed in 1953, the AAS promoted exploration of space based on scientific research. Members were prominent engineers and scientists in aerodynamics, astronautics, medicine, and related fields. In 1978 the University of Colorado Library donated the collection to NASM, where it received accession number XXXX-0163.

Physical Description

There are 20 silver gelatin photoprints. Other materials include business records, correspondence, financial records, manuscripts, membership lists, newspaper clippings, and periodicals.

Subjects

The photographs document American Astronautical Society (AAS) events such as ceremonies and meetings. People portrayed include James M. Beggs, William Hines, AAS president Paul Richards, and Willard F. Rockwell, Jr.

Arranged: In nine series by subject and document type. Photographs are in series nine.

Captioned: With date; some also with names.

Finding Aid: Item list.

Restrictions: The collection, located at the Garber Facility, is available by appointment only.

AS·44

American Volunteer Group Collection *A.K.A.* Larry Pistole Collection

Dates of Photographs: Circa 1987

Collection Origins

Larry Pistole produced copy photonegatives of original photoprints documenting the history of the American Volunteer Group (AVG), known as the "Flying Tigers." NASM later printed the photonegatives and retained most of the photoprints, assigning them accession number 1987-0075. Pistole then donated the photonegatives to the AVG.

Organized in 1941 by Claire L. Chennault, a former Army Air Corps officer, the AVG consisted of discharged U.S. military personnel who formed a mercenary air unit to defend China against Japanese air attacks. The AVG began operating in July 1941 and first engaged in combat that December, intercepting a Japanese raid near Kunming, China, and shooting down at least four bombers. In July 1942 the AVG joined the U.S. Army Air Forces as the China Air Task Force (CATF), under the command of Chennault, who was recalled to duty and promoted to brigadier general. The AVG's fighter squadrons were then assigned to the 23rd Fighter Group, Tenth Air Force. In March 1943 the CATF became the Fourteenth Air Force, with added medium and heavy bombers. The unit continued to operate in the China-Burma-India theater until the end of World War II.

Physical Description

There are 3,355 copy silver gelatin photoprints.

Subjects

The photographs document American Volunteer Group (AVG) aircraft, artifacts, members, and surroundings between 1941 and 1944. Activities and

events shown include crashes, painting emblems on jackets, recreation such as dancing and swimming, riding bicycles, and studying maps. There are many portraits of pilots and crews with aircraft. Artifacts depicted include bags, flight suits, guns, hats, jackets, miniature model aircraft, swords, tobacco pipes, and uniforms, as well as several versions of the AVG tiger emblem. Some of the images show artifacts and photographs in displays and clothing being modeled. Equipment and facilities illustrated include housing, jeeps, ships, and trucks. Burmese and Chinese civilians are shown digging, driving oxcarts, and playing Western instruments at a soldier's dance. There are also cityscapes, landscapes, and images of railroad tracks and villages in Burma (now Myanmar) and China. Other people portrayed include 1920s aviators with their aircraft.

Arranged: No.

Captioned: No.

Finding Aid: Folder list.

Restrictions: The collection, located at the Garber Facility, is available by appointment only.

AS·45

Apollo Mission Images Collection, 1968–1972

Dates of Photographs: 1968–1972

Collection Origins

Astronauts of the Apollo space flights created the collection to document their missions. In 1959 NASA planned the Apollo programs for lunar exploration, accelerating the development after President Kennedy's 1961 call for a lunar landing by the end of the decade. Unmanned flights *(Apollos 4, 5, and 6)* began in November 1967. The first manned launch *(Apollo 7)* occurred in October 1968; the first to orbit the Moon *(Apollo 8)* in December 1968; and the first lunar landing *(Apollo 11)* in July 1969. Between 1969 and 1972 NASA conducted five lunar landings *(Apollos 12, 14, 15, 16, and 17)* between 1969 and 1972, with one mission aborted due to an explosion *(Apollo 13)*. A total of 12 astronauts landed on the moon, conducting a

number of experiments and bringing back lunar rocks and soil for analysis. The photographs were taken with hand-held 70mm Hasselblad cameras, metric mapping cameras, and panoramic mapping cameras. This collection is part of NASM's Center for Earth and Planetary Studies materials (described in *AS·1*). It is stored at NASM Archives, where it was assigned accession numbers XXXX-0110 through 0113 and 1985-0014. Some of the photographs are reproduced on NASM's Archival Videodisc 6. For information on how to order the videodisc, see the *Collection Origins* field of *AS·1*.

Physical Description

There are 70,410 photographs including color dye coupler photoprints and phototransparencies and silver gelatin photoprints and phototransparencies (some enlarged and enhanced). Other materials include motion-picture film footage.

Subjects

The photographs document NASA missions *Apollo 4* through *17*. There are images of spacecraft during flight, the Earth from lunar orbit, and the Moon from orbit and from its surface.

Arranged: In four series by type of photography, then by mission, then by frame number. 1) Hasselblad photography. 2) Rectified panoramic photography. 3) Panoramic photography. 4) Metric photography.

Captioned: With videodisc frame number, mission, and type of photograph.

Finding Aid: 1) Box list. 2) Caption database listing subject and videodisc frame number for some of the photographs. Printouts can be obtained for single photographs or caption lists of photographs with related subjects.

Restrictions: The collection is located at the Garber Facility, available by permission of NASM's Center for Earth and Planetary Studies and by appointment only.

AS·46

Apollo Program Mission Files

Dates of Photographs: 1962–1969

Collection Origins

NASA created the collection to document the Apollo program, particularly *Apollo 8, 12,* and *13.* For a history of the program, see *Collection Origins* in *AS·45.* Studios represented include NASA and OPPS. This collection is part of NASM's Center for Earth and Planetary Studies materials (described in *AS·1*). It is stored at NASM Archives, where it was assigned accession number XXXX-0153.

Physical Description

There are three photographs including a color dye coupler photoprint and silver gelatin photoprints. Other materials include books, correspondence, periodicals, press releases, and reports.

Subjects

The photographs show NASA astronauts, equipment, and spacecraft. Spacecraft documented include an Apollo capsule, being examined by astronauts Eugene Cernan and John W. Young on board the recovery ship U.S.S. *Princeton,* and the Mercury capsule *Friendship 7,* on display at the National Air Museum (predecessor of NASM). There is also an image of a pressurized ball.

Arranged: By subject.

Captioned: With subject.

Finding Aid: Box list.

Restrictions: The collection, located at the Garber Facility, is available by appointment only.

AS·47

Apollo-Soyuz Test Project Images Collection, 1975

Dates of Photographs: 1975

Collection Origins

Astronauts of the Apollo-Soyuz Test Project created

the collection to document their mission. The first cooperative international spaceflight, Apollo-Soyuz took place from July 15 to 24, 1975. The United States and the Soviet Union joined a three-man Apollo spacecraft with a two-man Soyuz spacecraft in orbit around the Earth. After exchanging gifts and goodwill messages, the crews carried out joint experiments. This collection is part of NASM's Center for Earth and Planetary Studies materials (described in *AS·1*). It is stored at NASM Archives, where it was assigned accession numbers XXXX-0107 through 0109.

Physical Description

There are 14,650 photographs including color dye coupler photonegatives, photoprints, and phototransparencies. Other materials include motion-picture film footage.

Subjects

The photographs document the Apollo-Soyuz Test Project. There are images of clouds, the Earth, and the spacecraft.

Arranged: In two series by document type, then by frame number. 1) Earth photography. 2) Motion-picture film footage.

Captioned: No.

Finding Aid: Box list.

Restrictions: The collection is located at the Garber Facility, available by permission of NASM's Center for Earth and Planetary Studies and by appointment only.

AS·48

A. Francis Arcier Collection, 1890–1969

Dates of Photographs: 1930–1968

Collection Origins

Aircraft designer A. Francis Arcier (1890–1969) created the collection to document his personal and professional activities. Born in London, Arcier worked for Wittemann Aircraft Corporation (1919–1925) and

Fokker Aircraft Corporation (1925–1928) before emigrating to America. He then served as an engineer for General Airplanes Corporation (U.S. Fokker) from 1928 to 1930 and Waco Aircraft Company from 1930 to 1947. From 1948 until his retirement in 1963 he was an advisor at Wright-Patterson Air Force Base in Dayton, Ohio. Photographers represented include Air Technical Service Command and the Institute of the Aeronautical Sciences. NASM Archives assigned the collection accession number XXXX-0072.

Physical Description

There are 150 photographs including cyanotypes and silver gelatin photonegatives, photoprints, and phototransparencies. Other material includes articles, correspondence, engineering drawings, financial records, job applications, magazine clippings, manuscripts, newspaper clippings, scrapbooks, and technical reports.

Subjects

The photographs document A. Francis Arcier's work as an aircraft designer. There are photographic reproductions of aircraft drawings and publicity pictures. Events documented include a banquet, a National Aircraft Show, and presentations. Arcier is portrayed at his desk, at presentations and other events, and with a miniature model aircraft. There are also group photographs of Bristol Aeroplane Company staff.

Arranged: In 13 series by type of material. Photographs are in series 10, by assigned number.

Captioned: With subject; some also with date.

Finding Aid: Folder list.

Restrictions: The collection, located at the Garber Facility, is available by appointment only.

AS·49

Armament Files

Dates of Photographs: 1910s–Present

Collection Origins

NASM Archives and Aeronautics Department staff

members, especially C.G. Sweeting and Karl Schneide, assembled the collection to document the development of aeronautical armaments. Much of the written material and some of the photographs came from Wright-Patterson Air Force Base, where an Army aviation engineering base began operating in 1917. The base designed, developed, and tested aircraft and equipment. In the 1970s the base began transferring the older records, some of which arrived at NASM in 1981. Studios represented include the Air Force Central Museum, Central News Photo Service, International Film Service, National Archives, OPPS, Underwood and Underwood, and Western Newspaper Union.

Physical Description

There are 2,050 photographs including color dye coupler photoprints and silver gelatin photoprints. Other materials include engineering drawings, magazine clippings, manuals, newspaper clippings, pamphlets, press releases, regulations, reports, and xerographic copies.

Subjects

The photographs document domestic and foreign aeronautical armaments from the 1910s to the present, especially during World Wars I and II. Activities documented include bombing, installing parts, loading ammunition and bombs, simulated bombing, testing, and transporting equipment. Countries whose armaments are shown include France, Germany, Great Britain, Italy, Japan, the Soviet Union, and the United States. Weapons shown include anti-aircraft guns; bombs, missiles, and rockets; cannons; and machine guns of such makes as Hotchkiss, Maxim, and Vickers. Other objects depicted include aircraft, ammunition, bomb sights, bomb-controlling mechanisms, bomb launchers, flares, gun turrets, searchlights, and training equipment. There are also aerial photographs of bomb damage, especially damage caused by Allied bombing in Europe and the Pacific in World War II.

Arranged: By armament, then country, then date.

Captioned: With date and type of armament; some also with negative number and source.

Finding Aid: No.

Restrictions: No. The collection is located at the NASM Archives on the Mall. Researchers are encouraged to call or write for an appointment.

AS·50

Leslie P. Arnold Douglas World Cruiser Scrapbook

Dates of Photographs: 1924

Collection Origins

Leslie P. Arnold (1894–1961) created the collection to document the U.S. Army Air Service flight around the world in 1924. Arnold, who received a B.A. from Norwich University in 1924, served as an Army pilot from 1917 to 1928, and he later became an airline executive. He traveled as pilot Lowell H. Smith's mechanic on the 1924 flight, which also included Frederick L. Martin, Erik H. Nelson, Leigh Wade, and their mechanics. The Army team set out from Seattle to circle the globe in four Douglas World Cruisers, stopping in Alaska, Tokyo, Hong Kong, Saigon (now Ho Chi Minh City), Calcutta, Bangkok, Constantinople (now Istanbul), Paris, England, Iceland, Greenland, Boston, New York, and Chicago. Martin, who began as the flight commander, dropped out after his aircraft crashed in Alaska, and Smith took over command. Smith and the other pilots completed the flight and arrived back at Seattle, although Wade missed part of the trip while replacing his wrecked aircraft.

Physical Description

There are 390 silver gelatin photoprints, mounted in a scrapbook. Other materials include newspaper clippings, also mounted in the scrapbook.

Subjects

The photographs document the activities of U.S. Army pilots during their 1924 global flight and scenes from places they visited. The pilots are shown flying over cities, landscapes, and water; landing and taking off; meeting welcoming committees and crowds; preparing for flights; refueling; and repairing the aircraft. There are many images of the aircraft (shown with both landing wheels and pontoons) including details of a baggage compartment, gas tank, and motor mounting. Local scenes documented include an Aleut with a shelter on the Aleutian Islands; docks and oil wells in Alaska; an English aerodrome in Baghdād, Iraq; people in kayaks and villages in Iceland; rice paddies in China; and ships and street scenes in Bangkok, Thailand.

Arranged: Chronologically.

Captioned: Most with subject.

Finding Aid: No.

Restrictions: The collection is kept in the Ramsey Room at the NASM Archives on the Mall. Researchers must be accompanied by a staff member and are encouraged to call or write for an appointment.

AS·51

Rudy Arnold Photograph Collection

Dates of Photographs: 1930s–1950s, 1986

Collection Origins

Rudy Arnold (1902–1966) created the collection during his work as a professional aviation photographer. Arnold began his career as a print drier in 1918. He then attended the New York School of Photography before going to work for *New York Graphic* magazine, where he learned to fly and began taking aerial photographs. After leaving the *Graphic* in 1928, he became official photographer at Floyd Bennett Field in Brooklyn. Later Arnold opened his own office, eventually operating at La Guardia Field. He took photographs for aviation publications; for companies such as Douglas, Grumman, and Republic Aircraft; and for magazines such as *Life, Look,* and *Saturday Evening Post.* Photographs from the collection were published in the following book: E.T. Wooldridge. *Images of Flight: The Aviation Photogaphy of Rudy Arnold.* Washington, D.C.: Smithsonian Institution Press, 1986.

Physical Description

There are 10,000 photographs including color dye coupler phototransparencies and silver gelatin photonegatives.

Subjects

The photographs document aircraft, aviation figures, and news events from the 1930s through the 1940s, with a few from the 1950s. Manufacturers whose air-

craft are shown include Aeronca, Brewster, Curtiss, Douglas, Focke-Wulf, Grumman, Hall, Lockheed, Martin, North American, Pitcairn, Republic, Sikorsky, Spartan, and Vought. People portrayed include Rudy Arnold and pilots Louis Blériot, Arthur C. Bussy, Douglas Corrigan, Frank W. Fuller, Jr., Howard Hughes, Richard Merrill, Wiley Post, and Andy Stinis. There are also many aerial photographs and images of aircraft crashes.

Arranged: In two series by process and format. 1) Silver gelatin photonegatives, then by subject in three subseries: a) aircraft; b) biographical; and c) other subjects; then alphabetically. 2) Color phototransparencies, then in two subseries: a) aircraft and b) other subjects.

Captioned: Aircraft with date, manufacturer, and model; other images with date and subject.

Finding Aid: No.

Restrictions: No. The collection is located at the NASM Archives on the Mall. Researchers are encouraged to call or write for an appointment.

AS·52

Autographed Photograph Collection

Dates of Photographs: Circa 1905–1984

Collection Origins

NASM staff assembled the collection from several donations and assigned part of it accession numbers XXXX-0371 and XXXX-0441.

Physical Description

There are 125 photographs including color dye coupler photoprints and silver gelatin photoprints.

Subjects

The photographs are autographed portraits of aviation personalites including the following: astronauts Michael Collins, John H. Glenn, Jr., and Virgil I. Grissom; aviators John Alcock, Louis Blériot, Jacqueline

Cochran, Randy Cunningham, Luis de Florez, Amelia Earhart, Christopher W. Ford, Frank M. Hawks, Charles S. ("Casey") Jones, Charles A. Lindbergh, Earl Ovington, Clyde Pangbourne, Louise M. Thaden, Jules Védrines, Al Welsh, and Arthur Whitten-Brown; composer John Philip Sousa; explorers Roald Amundsen and Richard E. Byrd; generals Italo Balbo, James H. Doolittle, and William ("Billy") Mitchell; inventors Thomas A. Edison, Orville Wright, and Wilbur Wright; manufacturers Giovanni G.L. Caproni di Taliedo and Ferdinand von Zeppelin; meteorologist James H. Kimbal; museum curator Paul E. Garber; publisher Robert J. Collier; sculptor Gutzon Borglum; U.S. president Dwight D. Eisenhower; and Mario de Bernardi, Francesco de Pinedo, and Albert Rawlins.

There are also portraits of the following groups: Walter H. Beech, Charles A. Lindbergh, Frank M. Hawks, Edward V. ("Eddie") Rickenbacker, and Evelyn ("Bobbie") Trout; Lawrence D. Bell and Ed Yaak; Jack H. Lambie and Richard Merrill; and Charles M. Manly and S.C. McCoy. Other groups portrayed include NASA's astronaut class of 1984 and the pilots of the 1926 U.S. Army-Pan American flight. There are also a few images of aircraft including a Granville Gee Bee, a Loening Air Yacht, and a Nieuport Type 20.

Arranged: No.

Captioned: With autograph; most also with date and printed name.

Finding Aid: Partial list of names.

Restrictions: The collection is kept in the Ramsey Room at the NASM Archives on the Mall. Researchers must be accompanied by a staff member and are encouraged to call or write for an appointment.

AS·53

William Avery Collection

Dates of Photographs: 1891–1904, Circa 1970s

Collection Origins

The collection was possibly created by William Avery, who was involved in hang gliding at the turn of the century. Avery, a carpenter, helped build aviation pioneer Octave Chanute's glider and piloted it in 1896. With his brother Frank he later built a glider from

Chanute's plans and flew it at the Louisiana Purchase Exposition in 1904. He was a member of the Early Birds, an organization of pilots who flew before December 17, 1916.

Physical Description

There are 185 photographs including color dye coupler photoprints, cyanotypes, silver gelatin dry plate lantern slides and photonegatives, and silver gelatin photonegatives and photoprints. Other materials include articles, correspondence, magazines, and pamphlets.

Subjects

The photographs document hang gliding in the late 19th and early 20th centuries, especially at the 1904 Louisiana Purchase Exposition. Hang glider pilots portrayed include William Avery, Octave Chanute, Augustus M. Herring, and Percy Pilcher. There are images of their gliders, including Chanute's Albatros and Otto Lilienthal's gliders. Equipment shown includes launching trestles. There are also landscapes, waterscapes of Niagara Falls, and images of a polar bear.

Arranged: No.

Captioned: Some with subject.

Finding Aid: Item list to the lantern slides, with date, format, identification reference, and subject.

Restrictions: The collection is kept in the Ramsey Room at the NASM Archives on the Mall. Researchers must be accompanied by a staff member and are encouraged to call or write for an appointment.

AS·54

Aviation and *Aviation Week* Photograph and Report Collection

Dates of Photographs: Circa 1920–1951

Collection Origins

McGraw-Hill of New York, the publisher of the magazine *Aviation and Aeronautical Engineering* (1916–1947), popularly known as *Aviation,* and its successors, created the collection as source materials for publication. The magazine began as a biweekly trade publication for aircraft builders and pilots. In 1947 McGraw-Hill combined *Aviation* with the company's weekly *Aviation News* into a single weekly called *Aviation Week.* In 1960 the magazine became *Aviation Week and Space Technology.* Edward P. Warner edited the magazines during much of their existence. Photographers and studios represented include Dick Whittington Photography, International News, National Aeronautic Association, North American Aviation, Pan American, Pix Incorporated, and the U.S. Navy. NASM Archives assigned the collection accession number XXXX-0415.

Physical Description

There are 930 photographs including silver gelatin photonegatives and photoprints. Other materials include correspondence, engineering drawings, financial records, manuscripts, and reports.

Subjects

The photographs document aircraft development and aeronautic events between 1920 and 1950. Construction images include engine construction and tests, French aircraft construction, the conversion of Hudson Motor Car Company to aircraft production in World War II, the inspection of Martin B-26 Marauder parts, and the manufacture of inflatable rafts. There are portraits of men welding in a machine shop and women assembling Rolls Royce engines for British World War II fighters. Aircraft engine parts depicted include carburetors, connecting rods, crank cases, gaskets, gears, generators, ignitions, and pistons. Makes of engines shown include Fredrickson, Hispano-Suiza, Martin, Packard, Rausenberger, Roberts, Rolls Royce, and Sturtevant. Equipment depicted includes airport accessories such as hangar doors, heating systems, fire extinguishers and trucks, and signal lights; radar apparatus; Sperry instruments; and wind-tunnel models. Facilities documented include airports, factories, and a Goodyear drafting room. Other activities shown include aerial advertising, children attending a model airplane contest, fishing from aircraft, flying freight into Nicaragua, pilot training, and using aircraft as ambulances. There are also aerial photographs of Washington, D.C. Several photographs from this collection are reproduced in this volume's illustrations section.

Arranged: By subject.

Captioned: Some with date and subject.

Finding Aid: Box list.

Restrictions: The collection, located at the Garber Facility, is available by appointment only.

AS·55

Aviation Societies and Clubs Scrapbook

Dates of Photographs: 1911–1949

Collection Origins

The collection was created to document the buildings of aviation associations in England, France, Germany, and the United States, from the early period of flight to the post-World War II years. The Institute of Aeronautical Sciences donated it to NASM, where it received accession number XXXX-0269.

Physical Description

There are 70 silver gelatin photoprints, mounted in a scrapbook. Other materials include charts, floor plans, and maps, also mounted in the scrapbook.

Subjects

The photographs document the buildings, including exteriors and interiors, of aviation associations in Europe and the United States. Associations documented include the Aero Club de France, Aero Club von Deutschland, Institute of Aeronautical Sciences, Lilienthal Gesellschaft, Rangsdorf Aviation Club, Royal Aero Club, and the Royal Aeronautical Society. Interior views include bedrooms, council rooms, foyers, and libraries. Artifacts depicted include aviation books and posters and miniature aircraft models.

Arranged: Grouped by club or society.

Captioned: With name of club or society.

Finding Aid: No.

Restrictions: The collection, located at the Garber Facility, is available by appointment only.

AS·56

Aviation Training Schools Scrapbooks *A.K.A.* Theodore C. Macaulay Collection

Dates of Photographs: 1908–1918

Collection Origins

Theodore C. Macaulay (1888–1965) created the collection to document his work as an aviation instructor before and during World War I. Macauley learned to fly at the San Diego Curtiss aviation school in 1912. He later taught at the San Diego school (1912–1914); at the Royal Canadian Air Force school at Toronto (1914–1915); the Curtiss school in Newport News, Virginia (1915–1916); and the U.S. Army Signal Corps flight training schools at Rockwell Field in San Diego and Taliaferro Field in Fort Worth (1917–1918). In World War II Macaulay served as a colonel and received the Legion of Merit, retiring with a physical disability at the end of the war. NASM Archives assigned the collection accession number XXXX-0326.

Physical Description

There are 850 silver gelatin photoprints, mounted in albums.

Subjects

The photographs document activities at the flight training schools where Theodore C. Macaulay taught. Activities documented include boating to and from aircraft; flight training in dual-control aircraft; formation flying; lifting an aircraft from the water onto a U.S. Navy ship with a crane; overhauling engines; parachute jumping; recreation such as playing tug-o-war and swimming; stunt flying such as going under a bridge; and taking off and landing, usually in water. Events illustrated include air shows and aircraft crashes. Aircraft depicted include airships, balloons, and land and seaplanes such as Curtiss flying boats. Aircraft parts pictured include canopies, crankshafts, engines, frames, and wheels.

Facilities documented include airfields (one with World War I posters), construction and repair shops, hangars, supply rooms, and tents. There is a portrait of Lincoln Beachey in Puerto Rico and group portraits of

Asian students, cavalry officers with horses, pilots with life jackets and other flight clothes, a rural Illinois family, and soldiers in uniform. There are aerial photographs of cities such as Dallas and Fort Worth, Texas, and Washington, D.C., including the Capitol, Union Station, and the Washington Monument; a coastal town; farmland; and a waterfront with trains. There are also images of coal-loading docks at Newport News, Virginia, and motorcycles.

Arranged: Chronologically.

Captioned: A few with date and subject.

Finding Aid: No.

Restrictions: The collection, located at the Garber Facility, is available by appointment only.

AS·57

Ralph S. Barnaby Papers

Dates of Photographs: 1911–1980

Collection Origins

Pioneering glider aviator Ralph S. Barnaby (1893–1986) created the collection to document his career. The first licensed glider pilot, Barnaby made the first successful glider launching from an airship and directed the U.S. Navy's first school for glider pilots. He served as president of the Early Birds, an organization of pilots who flew before December 17, 1916; helped organize the Soaring Society of America; and wrote a number of books on gliders and paper airplanes. Photographers and studios represented include Curran Machine Works, Curtiss Aerophoto, Mary Feik, and Franklin Institute. NASM Archives assigned the collection accession number 1987-0048.

Physical Description

There are 65 photographs including color dye coupler photoprints and silver gelatin photoprints. Other materials include awards, charts, correspondence, manuscripts, and newspaper clippings.

Subjects

The photographs document aviation activities in

which Ralph S. Barnaby participated. Aircraft shown include airplanes, such as a Benoist, and balloons. Events documented include air shows, Army aircraft tests, Lincoln Beachey's flight in the 1911 race from New York to Philadelphia, and meetings of groups such as the American Legion, the Early Birds, the Golden Eagles, and the Wings Club. There are also portraits of Barnaby, Bud Morris, and World War I soldiers.

Arranged: By subject and type of material.

Captioned: A few with subject.

Finding Aid: Item-level transfer list.

Restrictions: The collection, located at the Garber Facility, is available by appointment only.

AS·58

George W. Beatty Papers

Dates of Photographs: Circa 1910–1951

Collection Origins

George W. Beatty (1888–1955) created the collection to document his aviation career, particularly between 1910 and 1912. After working as a mechanic and linotype operator, Beatty began an association with a New York gliding club in 1909 and helped build an unsuccessful Santos-Dumont Demoiselle-type airplane. In 1911 he attended the Wright aviation school and received a pilot's license. Over the next few years he carried passengers, flew in exhibitions, and taught flying in England and the United States. In 1914, in collaboration with the Handley-Page aircraft company, he established an aviation school near London that trained military pilots during World War I. After the war he returned to the United States, where he served as superintendent of the Hughes Printing Company until his death. Photographers represented include F.N. Birkett, Joseph Burt, Thomas F. Campbell, and A.P. Lane. NASM Archives assigned the collection accesssion numbers 1989-0013 and 1991-0069.

Physical Description

There are 325 silver gelatin photoprints. Other material includes banners, correspondence, newspaper clippings in a scrapbook, and a plaque.

Subjects

The photographs document George W. Beatty's aviation experiences and early 1910s aviation events. Aircraft shown include Breguet, Farman, and Wright biplanes and Blériot, Deperdussin, Etrich, Hanriot, Martinsyde, and Morane Saulnier monoplanes. Several aircraft are shown after crashes. There are images of Beatty's flight school near London and an Indian motorcycle. Events documented include air meets at College Park airport, Maryland; the London Aerodrome; Mineola, New York; and Princeton, New Jersey. People portrayed include aviators such as Beatty, Walter L. Brock, F.W. Gooden, Claude Graham-White, Louis Noel, Thomas O.M. Sopwith, and Pierre Vierrier; flight students; and members of the Early Birds club in 1951. There are also aerial views of a city.

Arranged: Part chronologically.

Captioned: A few with subject.

Finding Aid: Partial item-level transfer list.

Restrictions: The collection, located at the Garber Facility, is available by appointment only.

AS·59

Beech Aircraft and Gates Learjet Public Relations Collection *A.K.A.* Vern Modeland Collection, 1965–1975

Dates of Photographs: 1965–1975

Collection Origins

Vern Modeland created the collection during his tenure as public relations director at Beech Aircraft and Gates Learjet corporations. Founded by Walter Beech in 1932 in Wichita, Kansas, Beech Aircraft Corporation produced small single and twin-engine aircraft for the private, commercial, and military markets. In 1980 Raytheon acquired the company. Lear Jet, originally the Swiss American Aviation Corporation, was founded by William Lear in 1960. The company moved to Wichita in 1962, changing its name to

Lear Jet Corporation. In 1967 Gates Rubber Company acquired Lear Jet and three years later renamed it Gates Learjet Corporation. The company pioneered in the corporate jet market. NASM assigned the collection accession number 1987-0063.

Physical Description

There are 1,365 photographs including color dye coupler photoprints and silver gelatin photonegatives and photoprints. Other materials include audiotape cassettes, correspondence, manuscripts, motion-picture film footage, pamphlets, plans, and scrapbooks.

Subjects

The photographs document Beech and Lear aircraft, construction, and parts. Airplanes depicted include the Beech AT-10, Bonanza, Super 18, and U-21, as well as Lear Jets and Learstars. Parts shown include cowlings, engines, and wheels.

Arranged: By subject.

Captioned: Most with manufacturer and model.

Finding Aid: No.

Restrictions: The collection, located at the Garber Facility, is available by appointment only.

AS·60

Beech Model 17 Photographs

Dates of Photographs: Circa 1930–1950s

Collection Origins

Beech Aircraft Corporation created the collection to document the production of the Beech 17 Staggerwing. For a history of the company, see *Collection Origins* in *AS·59*. The company's Model 17, a four or five-person cabin biplane, was called the Staggerwing due to the position of its wings. In 1932 the first Staggerwing flew faster than 200 m.p.h., faster than most military aircraft at the time. By 1939 modifications of the aerodynamic design, engines, and landing gear had increased the aircraft's top speed to 250 m.p.h. During World War II the 17 Staggerwing served as the U.S. Army Air Forces UC-43, the U.S. Navy GB, and the British

Royal Air Force Traveller. After the war, Beech briefly produced the G-17S as the final Staggerwing model. NASM Archives assigned the collection accession number XXXX-0196. The photographs are reproduced on NASM's Archival Videodisc 7. For information on how to order the videodisc, see the *Collection Origins* field of *AS·1*.

Physical Description

There are 1,380 photographs including silver gelatin photonegatives and photoprints.

Subjects

The photographs document the design, production, shipment, and uses of the Beech 17 Staggerwing, a four- or five-person cabin biplane. Activities documented include constructing aircraft on production lines, crating and delivering parts, and repairing aircraft. Parts depicted include ailerons, cowlings, engines, fuselage frames, instrument panels, interiors, landing gear, and oil systems. Many different types of Staggerwings are shown, including aircraft outfitted as ambulances; owned by Canada, China, and the U.S. Army; with camouflaged exteriors; and with pontoons. There are also photographic reproductions of advertisements and engineering drawings, as well as portraits of Walter H. Beech and Charlotte Frye with her Staggerwing.

Arranged: By assigned number.

Captioned: On envelope with assigned number; some also with date and subject.

Finding Aid: Caption database listing some dates and subjects and videodisc frame number. Printouts can be obtained for single photographs or caption lists of photographs with related subjects.

Restrictions: No. The collection is located at the NASM Archives on the Mall. Researchers are encouraged to call or write for an appointment.

Collection Origins

The Bendix Corporation created the collection to document the Bendix air races. Established in 1931 as part of the National Air Races held in Cleveland, the Bendix races were cross-country events, open to men and women, designed to improve aircraft design and pilot skill. Two race routes were flown: from Burbank, California, to Cleveland and from New York to Los Angeles. The races were suspended during World War II but resumed in 1946 with the addition of jet-engine and reciprocating-engine competitions. Bendix races continued until 1962. Photographers and studios represented include Acme, Bendix Corporation, Fred T. Loomis, and Wide World Photos. NASM Archives assigned the collection accession number 1988-0115.

Physical Description

There are 1,150 photographs including color dye coupler phototransparencies and silver gelatin photonegatives, photoprints, and slides. Other materials include advertisements, correspondence, financial records, manuscripts, newspaper clippings, programs, and speeches.

Subjects

The photographs primarily document Bendix winners receiving the trophy, as well as other entrants, their aircraft, and miniature models of the aircraft. Entrants and winners portrayed include Francis T. Brown, Jacqueline Cochran, Douglas Davis, Joseph C. De Bona, James H. Doolittle, Amelia Earhart, Frank W. Fuller, Jr., James H. Haizlip, Ben O. Howard, Paul Mantz, Blanche Noyes, Louise M. Thaden, Roscoe Turner, James Wedell, and William T. Whisner, Jr.

Arranged: By date and subject.

Captioned: Most with names.

Finding Aid: Item-level transfer list.

Restrictions: The collection, located at the Garber Facility, is available by appointment only.

AS·61

Bendix Air Races Collection, 1931–1982

Dates of Photographs: 1931–1965

AS·62

Berliner Helicopter Scrapbooks

Dates of Photographs: Circa 1902–1925

Collection Origins

Emile Berliner (1851–1929) and his son Henry A. Berliner (1895–1970) created the collection to document their attempt to build a workable helicopter. Emile Berliner, after inventing a telephone transmitter and gramophone in the 1870s and 1880s, began experimenting with helicopters in 1903. He was later joined by Henry, who received a B.S. in mechanical engineering from the Massachusetts Institute of Technology in 1918 and served in the U.S. Army Air Service in 1918 and 1919. The Berliners experimented with several types of helicopters until 1925, creating machines that rose from the ground but could not sustain controllable flight. NASM Archives assigned the collection accession number XXXX-0247.

Physical Description

There are 85 photographs including collodion gelatin photoprints (POP) and silver gelatin photoprints, mounted in scrapbooks. Other materials include correspondence, diary entries, newspaper clippings, and notes, mounted or written in the scrapbooks.

Subjects

The photographs document several experimental helicopters designed by Emile and Henry A. Berliner between 1903 and 1925. The helicopters are shown being built, flying several feet off the ground with men holding on, and after crashing. There are also images of a motor boat.

Arranged: Roughly chronologically.

Captioned: With date and subject.

Finding Aid: No.

Restrictions: The collection, located at the Garber Facility, is available by appointment only.

AS·63

"Black Wings" Collection

Dates of Photographs: 1983

Collection Origins

Aeronautics Department curators Von D. Hardesty and Dominick A. Pisano assembled the collection for the exhibit "Black Wings: The American Black in Aviation." Sources of materials include Benjamin O. Davis, Jr., Albert E. Forsythe, Joseph Hardy, Harold Hurd, the Schomberg Center, and the U.S. Air Force. NASM copied the original prints and returned them to the sources. The photographs appear in the exhibit's companion book: Von Hardesty and Dominick Pisano. *Black Wings: The American Black in Aviation*. Washington, D.C.: Smithsonian Institution Press, 1983.

Physical Description

There are 1,000 photographs including silver gelatin photonegatives and photoprints. Other materials include correspondence and manuscripts.

Subjects

The photographs document African American involvement in aviation. Activities and events documented include African American World War II soldiers conducting maintenance work, loading bombs, and training; the Pan-American Goodwill Flight and transcontinental flight of C. Alfred Anderson and Albert E. Forsythe, with their aircraft, *The Spirit of Booker T. Washington;* and a soldiers' jazz combo performance. Groups portrayed include African American flying clubs, civilian pilot training classes at Tuskegee Institute and other schools, the Fahey Committee with President Harry S Truman, the first African-American class at Curtiss-Wright Aeronautical School, the 99th Fighter Squadron, the 617th Bombardment Squadron, the 332nd Fighter Group, Tuskegee students, and a USO entertainment group of African American performers.

Individuals portrayed include astronauts Guion S. Bluford, Jr., and Charles F. Bolden, Jr.; boxer Joe Louis; flight instructors Noel F. Parrish and Linkwood Williams; flight school director Cornelius R. Coffey; generals William E. Brown, Jr., Benjamin O. Davis, Jr., and Daniel James, Jr.; pilots James Herman Banning, Sidney Brooks, Jesse L. Brown, Willa B. Brown, Bessie Coleman, John W. Greene, Jr., Charles B. Hall, C.D. Lester, Neal Loving, Grover C. Nash, William J. Powell, George S. Roberts, John C. Robinson, Chauncey E. Spencer, and Dale L. White; first lady and stateswoman Eleanor Roosevelt; singer Ella Fitzgerald; and U.S. president Dwight D. Eisenhower.

Arranged: In the order the photographs appear in the book.

Captioned: With negative number.

Finding Aid: No.

Restrictions: Many of the images are copyrighted; no images may be reproduced for commercial purposes. The collection is located at the NASM Archives on the Mall. Researchers are encouraged to call or write for an appointment.

Captioned: With date, subject, and negative number.

Finding Aid: Caption database listing date, subject, and negative number. Printouts can be obtained for single photographs or caption lists of photographs with related subjects.

Restrictions: The collection, located at the Garber Facility, is available by appointment only.

AS·64

Maitland B. Bleecker Collection, 1926–1937

Dates of Photographs: 1926–1930

Collection Origins

Engineer Maitland B. Bleecker (1903–) created the collection to document the development of the Curtiss-Bleecker helicopter. Bleecker, who became a pilot in 1919, received a B.S. from the University of Michigan in 1924. In 1924 and 1925 he worked as an engineer at the Langley Field, Virginia, for the National Advisory Committee for Aeronautics (NACA), and in 1926 joined Curtiss-Wright, where he worked for most of his career. He worked on the Curtiss-Bleecker helicopter there between 1926 and 1930. Bleeker donated the collection to NASM Archives, where it received accession number 1991-0029.

Physical Description

There are 280 silver gelatin photoprints. Other materials include drawings, newspaper clippings, pamphlets, reports, and scrapbooks.

Subjects

The photographs document the Curtiss-Bleecker helicopter including details of parts and images of tests. Parts depicted include the cockpit, controls, door, engine, fuel tanks, fuselage, gears, instruments, rotor blades, and wheels. There are images of laboratories, testing equipment, a wind tunnel, and wind-tunnel models. There is also a portrait of Maitland B. Bleecker. A photograph from this collection is reproduced in this volume's illustrations section.

Arranged: By type of material.

AS·65

Warren M. and Catherine C. Bodie Collection

Dates of Photographs: 1920s–1970s

Collection Origins

Aircraft enthusiasts Catherine C. and Warren M. Bodie assembled the collection to document many types of aircraft. The Bodies transferred the collection to NASM in several donations. Photographers and studios represented include Warren M. Bodie; Convair; Folland Aircraft, Ltd.; J.M. Sullivan; the U.S. Air Force; and Van Rossen. NASM Archives assigned the collection accession numbers XXXX-0003–5, 1986-0031, 1987-0017, 1988-0030, 1989-0018, and 1992-0001.

Physical Description

There are 1,470 photographs including silver gelatin photonegatives and photoprints.

Subjects

The photographs document international commercial, military, and private aircraft produced between the 1920s and 1970s. There are also images of an Atlas missile taking off and portraits of pilots including Frederick Christensen, Jr., Thomas B. Dugan, Clark Gable, Charles A. Lindbergh, Wiley Post with his Lockheed Vega, George E. Preddy, and Ralph Virden, as well as the Lockheed P-38 Lightning pilots of the U.S. Army Air Forces 94th Fighter Squadron and the 20th Fighter Group.

Arranged: Most alphabetically by manufacturer.

Captioned: Most with date, image number, manufacturer, and model.

Finding Aid: 1) Lists of most of the collection giving image number, manufacturer, and model. 2) Caption database to part of the collection listing manufacturer, model, and source. Printouts can be obtained for single photographs or caption lists of photographs with related subjects.

Restrictions: Part of the collection is located at the NASM Archives on the Mall, where researchers are encouraged to call or write for an appointment, and part is located at NASM's Garber Facility, where an appointment is necessary.

AS·66

John Bodine Autographed Photograph Collection

Dates of Photographs: Circa 1910–1970

Collection Origins

John Bodine assembled the collection from autographed photographs of aviation figures. Many of the photographs are inscribed to Bodine, who received them mainly in the 1950s and 1960s. Earlier images are addressed to other people, especially Edgar N. Gott. Gott (1887–1947), who received a B.S. from the University of Michigan in 1909, served as vice president and general manager of Boeing Airplane Company (1915–1922); president of Boeing (1922–1925); vice president of Fokker Aircraft Corporation, New Jersey (1925–1926); and later president of Keystone Aircraft Corporation and Huff-Daland. Photographers and studios represented include Bell Aircraft Corporation, Harris & Ewing, R.R. Martin, Nichols Studio, Paramount Studios, Peter Ray, the U.S. Air Force, the U.S. Navy, A. Vestby, and Wide World Photos.

Physical Description

There are 120 photographs including color dye coupler photoprints and silver gelatin photoprints. Other materials include correspondence.

Subjects

The images are autographed photographs of the following aviation personalities: astronauts John H.

Glenn, Jr., and Alan B. Shephard, Jr.; aviation pioneer Alberto Santos-Dumont; executives John K. Northrop and Leonard Povey; generals James H. Doolittle and William ("Billy") Mitchell; goverment official Ernest S. Hensley; humorist Will Rogers; pilots Bernt Balchen, Jacqueline Cochran, Frank T. Coffyn, Amelia Earhart, Herbert O. Fisher, Claude Grahame-White, James H. Haizlip, Raoul Lufbery, Hanna Reitsch, Edward V. ("Eddie") Rickenbacker, Lowell H. Smith, and Roscoe Turner; and scientist Willy Ley.

Arranged: No.

Captioned: With signature; some also with date and printed name.

Finding Aid: No.

Restrictions: The collection is kept in the Ramsey Room at the NASM Archives on the Mall. Researchers must be accompanied by a staff member and are encouraged to call or write for an appointment.

AS·67

Herbert P. Boen Lockheed Collection

Dates of Photographs: 1970s

Collection Origins

Herbert P. Boen, a former Lockheed Corporation employee, assembled the collection to document Lockheed aircraft. The original images from which these copy materials were produced are located at Lockheed's Rye Canyon facility in Los Angeles, where Boen worked.

Physical Description

There are 420 silver gelatin photoprints. Other materials include engineering drawings.

Subjects

The photographs document Lockheed aircraft from the 1920s and 1930s. Specific airplanes shown include Howard Hughes's Lockheed 14 airliner, with images of Hughes and the parade after his 1938 flight around the world; a Lockheed Orion belonging to the *Detroit News* with camera equipment; and the U.S. Air Force

VC-121 Presidential Constellation, with exterior and interior views. There are images of aircraft construction and tests including factories, parts, wind-tunnel models, and workers.

Arranged: In looseleaf notebooks by model or other subject.

Captioned: Most with model or other subject.

Finding Aid: No.

Restrictions: The collection, located at the Garber Facility, is available by appointment only.

AS·68

Leslie and Marguerite Bowman Papers, 1923–1987

Dates of Photographs: Circa 1925–1980s

Collection Origins

Lorraine Bowman assembled the collection to document the careers of her parents, Leslie Bowman (1899–1987) and Marguerite Bowman (1901–1985). After their marriage in 1919, the Bowmans ran an auto repair business until Leslie became an aeronautical engineer. He worked at Kinner Airplane and Motor Corporation (1923–1931), Waco Aircraft Company (1930–1936), and Booth-Henning (1936–1939), before starting his own aircraft sales and repair business, Aircraft Sales Company. He learned to fly in 1924 and participated in the National Air Races and aerobatic contests in the 1920s and 1930s, as well as making test and demonstration flights.

Marguerite Bowman, a charter member of the Ninety-Nines (an organization of women pilots) and the National Air Race Association, set women's speed records and took aerobatic titles in the 1930s. The Bowmans' daughter Lorraine became the youngest licensed pilot when she learned to fly at age 12. During World War II the Bowmans operated one of the few civilian training schools for U.S. Navy fighter pilots. After the war they retired from aviation and ran a big-game outfitting business in the 1950s and 1960s. Photographers and studios represented include Arrow Studio, Dick Wittington Photography, International

Commercial Photo Company, H.B. Miller, and W.D. Smith. NASM Archives assigned the collection accession number 1991-0042.

Physical Description

There are 210 photographs including color dye coupler photoprints, color dye diffusion transfer photoprints, and silver gelatin photoprints. Other materials include correspondence, licenses, logbooks, magazines, maps, membership cards, newspaper clippings, and pamphlets.

Subjects

The photographs document Leslie and Marguerite Bowman's aviation activities, mostly from the 1920s through the 1940s. Activities and events illustrated include air races; a carnival; an engine exhibit; cargo delivery, demonstration, and test flights; glider meets; and pilot training in World War II. Aircraft depicted include airplanes such as the Curtiss P-1, Ford Trimotor, Kinner Airstream biplane, Ryan Navion, Simplex Red Arrow, Stinson Voyager, Waco C, and Waco F, as well as gliders and training aircraft. Groups portrayed include cowboys, a four-piece band, racing pilots, and U.S. Navy officer classes. Individuals portrayed include pilots Johnny Blum, Leslie Bowman, Lorraine Bowman, Marguerite Bowman, Charles A. Lindbergh, Myrtle Mantz, Gladys O'Donell, Phoebe F. Omlie, and Leigh Wade. There are publicity photographs showing aircraft uses such as airliners carrying passengers and a small airplane carrying a veterinarian to a ranch. There are also images of trophies.

Arranged: By subject and type of material.

Captioned: Some with date and subject.

Finding Aid: Folder list.

Restrictions: The collection, located at the Garber Facility, is available by appointment only.

AS·69

Walter J. Boyne Papers, Circa 1950s–1985

Dates of Photographs: 1961–1978

Collection Origins

Former NASM director Walter J. Boyne (1929–) created the collection. Boyne received an M.B.A. from the University of Pittsburgh in 1963 while serving in the U.S. Air Force from 1952 to 1974. After retiring from the Air Force he joined NASM, serving as assistant curator of aeronautics (1974–1975), curator of aeronautics (1975–1978), executive officer (1978–1980), assistant director (1980–1982), deputy director (1982–1983), and director (1983–1986). The photographs appear in the following publications by Boyne: 1) *Boeing B-52: A Documentary History.* London: Jane's, 1981. 2) *Phantom in Combat.* Washington, D.C.: Smithsonian Institution Press, 1985. Studios represented include McDonnell Aircraft Corporation and the U.S. Air Force. NASM Archives assigned the collection accession numbers 1985-0003 and 1985-0005.

Physical Description

There are 30 photographs including color dye coupler photoprints and silver gelatin photoprints. Other materials include audiotape cassettes, charts, correspondence, diagrams, manuscripts, newspaper clippings, notes, and a videotape cassette.

Subjects

The photographs document airplanes including Boeing B-52s and McDonnell F-4 Phantoms.

Arranged: By subject and type of material.

Captioned: Some with date and subject.

Finding Aid: Folder list.

Restrictions: The collection, located at the Garber Facility, is available by appointment only.

AS·70

Arthur Raymond Brooks Collection

Dates of Photographs: 1917–1988

Collection Origins

World War I ace Arthur Raymond Brooks (1895–

1991) created the collection to document his personal and professional life. After graduating from the Massachusetts Institute of Technology in 1917, Brooks joined the U.S. Army Signal Officer Reserve Corps, attended the School of Military Aeronautics with the Canadian Royal Flying Corps (RFC), and trained in Texas with the U.S. Army 139th Aero Squadron. In 1918 he went to France, where he became flight commander of the 22nd Aero Squadron and received the Distinguished Service Cross. After the war Brooks was promoted to captain, serving until 1927. He then worked at Florida Airways Corporation (which became part of Eastern Airways), participated in early air mail operations, and served on the Aeronautics Branch of the Department of Commerce. In 1928 Brooks joined Bell Laboratories, where he supervised air operations and the testing of electronic navigational aids. Brooks's World War I Spad XIII is in the NASM collection. Photographers and studios represented include Panoramic Camera Co., H.L. Summerville, and the U.S. Army Signal Corps. NASM Archives assigned the collection accession numbers 1988-0051 and 1989-0104.

Physical Description

There are 1,870 photographs including color dye coupler photoprints and silver gelatin photonegatives and photoprints, most mounted in scrapbooks. Other materials include charts, corresondence, diaries, financial records, logbooks, maps, military records, and newspaper clippings, some also mounted in the scrapbooks.

Subjects

The photographs document Arthur Raymond Brooks's personal life and professional activities, primarily during World War I. Personal photographs show activities such as playing polo, swimming, and traveling; cars and houses; and family members and friends. World War I military activities documented include a balloon deflation; cavalry maneuvers; field repairs of aircraft; funerals; leisure activities such as games and sports; loading wounded soldiers onto trains; machine gun training; President Woodrow Wilson radioing directions to aircraft in Washington, D.C.; Red Cross canteen service; a ship evacuation drill; soldiers (some wounded) marching; and training at a Canadian Royal Flying Corps (RFC) base and in Texas.

Equipment and facilities depicted include aerial gunnery balloons; aircraft such as Brooks's Spad XIII showing the 22nd Aero Squadron insignia, as well as many aircraft crashes; airfields; camps; cemeteries; hospitals; a line of cars and trucks; RFC ambulances; trenches; troop trains; and warships. Scenes of France include beaches, bombed buildings, city streets, the Eiffel Tower with a Ferris wheel in the background,

French people, a hay wagon, and parades. There are aerial photographs of Nuevo Laredo, Mexico; San Antonio, Texas; and Versailles, France, during the signing of the peace treaty in 1919. Later images include biplane aerobatics; Brooks with a Ford Trimotor; the Curtiss NC-4 (first airplane to cross the Atlantic, 1919); the restoration of a Spad at NASM including a portrait of Brooks at NASM exhibits; and a U.S. Army Air Service exhibit.

Arranged: By type of material.

Captioned: Some with name or subject and negative number.

Finding Aid: Partial folder list.

Restrictions: Access to the correspondence is restricted. The collection, located at the Garber Facility, is available by appointment only.

tivities as a test pilot. Woodward is shown flying aircraft, reviewing flight data, and wearing flight clothes. Other people portrayed include Stanley Herbert, Henry J. Kaiser, Bill Lansing, Eugene O'Donnell, Ralph O. Romaine, and Zeus Soucek. Aircraft shown include a Brewster F2A Buffalo, Bermuda, and SB2A Buccaneer; McDonnell FD-1 Phantom, XHJD-1 Whirlaway, XP-67, and XRH-1 Assault Helicopter; and Vought F4U Corsair. Events documented include air shows in Pennsylvania and New Jersey and an exhibit at La Guardia Field, New York.

Arranged: No.

Captioned: With date and subject.

Finding Aid: No.

Restrictions: The collection, located at the Garber Facility, is available by appointment only.

AS·71

E. Woodward Burke Scrapbook

Dates of Photographs: 1939–1945

Collection Origins

Colleagues of E. Woodward Burke (1914–1945) assembled the collection as a tribute to Burke after his death and presented it to his son, Stephen W. Burke. E. Woodward Burke became a U.S. Navy aviation cadet in 1935. In 1939 he left the Navy to become chief test pilot for the Brewster Aeronautical Corporation. He died in an airplane crash. Stephen W. Burke donated the collection to NASM, where it received accession number XXXX-0217.

Physical Description

There are 30 photographs including color dye coupler photoprints and silver gelatin photoprints, mounted in a scrapbook. Other materials include correspondence, also mounted in the scrapbook.

Subjects

The photographs document E. Woodward Burke's ac-

AS·72

Giovanni G.L. Caproni di Taliedo Collection

Dates of Photographs: Circa 1917–1921

Collection Origins

Count Giovanni G.L. Caproni di Taliedo (1932–) assembled the collection and donated it to NASM. Caproni, who received a doctorate in economics and communications from the University of Rome, is the curator of the Caproni di Taliedo Aeronautical Museum and the president of Caproni Vizzola Costruzzioni Aeronaitiche Spa. The photographs are reproduced on NASM's Archival Videodisc 2. For information on how to order the videodisc, see the *Collection Origins* field of *AS·1*.

Physical Description

There are 60 silver gelatin photoprints.

Subjects

The photographs document American student bomber pilots training at Foggia, Italy, during World War I. Most of the images are portraits, showing pilots

dressed in various flight clothes and uniforms, some writing. There are also images of aircraft, such as Caproni biplane and triplane bombers, and of aircraft crashes, barracks, cars, and equipment.

Arranged: By videodisc frame number.

Captioned: With subject.

Finding Aid: Caption database listing subject and videodisc frame number. Printouts can be obtained for single photographs or caption lists of photographs with related subjects.

Restrictions: No. The collection is located at the NASM Archives on the Mall. Researchers are encouraged to call or write for an appointment.

AS·73

D.H. Carey Scrapbooks

Dates of Photographs: 1918–1931

Collection Origins

D.H. Carey donated the collection to NASM, which assigned it accession number XXXX-0289.

Physical Description

There are 500 silver gelatin photoprints, mounted in albums.

Subjects

The photographs document British naval aviation, including aircraft, airfields, and ships, in the post-World War I period. Aircraft depicted include airships and balloons as well as Bristol fighters, Faireys, Nieuports, Parnall Puffins, Sopwith Camels, and Telliers. There are also images of German aircraft such as Albatroses and Brandenburgers. Aircraft parts documented include engines such as the Eagle and Sunbeam, guns, and instrument panels. Other transportation images include a fire truck, motorcycles, and ships. There are images of exploding bombs and smoke bomb tests. Aerial photographs of England show the Crystal Palace grounds, Isle of Grain, Rochester, and Sheerness. Facilities documented include air stations and hangars. People portrayed include Royal Air Force of-

ficers and other pilots and soldiers. There are photographic reproductions of charts of flight data, drawings of engines, and tables indicating aircraft performance. There are also family photographs of people at picnics, a dance, and a wedding; in rowboats; and playing tennis; as well as cars, cats, and houses.

Arranged: No.

Captioned: Some with subject including manufacturer and engine or model name.

Finding Aid: No.

Restrictions: The collection, located at the Garber Facility, is available by appointment only.

AS·74

Cyril F. Caunter Collection, 1902–1986

Dates of Photographs: 1918–1977

Collection Origins

Technology historian Cyril F. Caunter assembled the collection in preparation for his unpublished book, "Rotary Aero Engines, 1900–1918." Caunter served as a curator at the Science Museum, London, and published several works on automotive and aeronautical engines. In the 1970s, NASM engine curator Robert Meyer attempted unsuccessfully to have "Rotary Aero Engines" published by the Smithsonian Institution Press. Studios represented include French Pictorial Service, National Museums of Canada, OPPS, and Siemens Archives. NASM Archives assigned the collection accession number 1988-0073.

Physical Description

There are 65 silver gelatin photoprints. Other materials include correspondence, magazine clippings, manuscripts, and newspaper clippings.

Subjects

The photographs document rotary aircraft engines, engine parts, and test effects on engines between 1900 and 1918. Engines depicted include a Chevolair D-6,

Gnome, and Siemens-Shuckert. There is also an image of an engine being installed in an aircraft in Paris during World War I.

Arranged: By subject (mainly engine model) and type of material.

Captioned: Some with engine model or other subject.

Finding Aid: Folder list.

Restrictions: The collection, located at the Garber Facility, is available by appointment only.

AS·75

Mary Charles Papers, 1931–1965

Dates of Photographs: Circa 1931–1937

Collection Origins

Aviator Mary Charles assembled the scrapbook to document aviation events in the Los Angeles area between 1931 and 1937. Charles learned to fly from U.S. Naval Reserve pilots at Santa Monica in 1929. She flew in the 1931 Cleveland Air Races but finished last because of engine problems. Charles served on the Los Angeles aerial police force and as a captain in the Women's Air Reserve, a group of flyers organized to provide medical treatment to areas inaccessible by roads. She was also a spokeswoman for Gilmore Oil Company and a member of the Women Peace Officers Association, the Ninety-Nines, and the OX-5 Club. Studios represented include Field Studios and Hurrel. NASM Archives assigned the collection accession numbers XXXX-0241 and XXXX-0468.

Physical Description

There are 180 silver gelatin photoprints. Other materials include correspondence, licenses, manuscripts, newspaper clippings, pamphlets, and scrapbooks.

Subjects

The photographs primarily portray pilots including Florence L. ("Pancho") Barnes, Mary Charles, Amelia Earhart, Ruth Elder, Burdette D. Fuller, Mary Higgins,

Roy O. Hunt, Matilde Moisant, Gladys O'Donnell, Harriet Quimby, and Roscoe Turner, as well as members of the Women's Air Reserve. There are also images of the airship U.S.S. *Macon* and a plaque for the Aero Policewomen's Association of California.

Arranged: No.

Captioned: Some with autograph or date and subject.

Finding Aid: No.

Restrictions: The collection, located at the Garber Facility, is available by appointment only.

AS·76

Charles W. Chillson Papers

Dates of Photographs: 1949–1954

Collection Origins

Propulsion expert Charles W. Chillson (1910–) created the collection primarily to document his association with the American Rocket Society (ARS). After receiving a B.S. in mechanical engineering from Stanford University in 1931, Chillson studied chemical engineering at the California Institute of Technology while working with the U.S. Army Air Corps Engineering Division to develop a controllable-pitch propeller (1931–1936). He then became an engineer and project designer at Curtiss-Wright's Propeller Division, where he was promoted to chief researcher in 1940. He became chief engineer of the new Rocket Department in 1947, after receiving the Collier Trophy for his propeller work. In 1950 Chillson joined the ARS board of directors as program chairman, later becoming vice-president (1951), president (1952–1955), and fellow (1956). In 1971 he donated the collection to NASM, where it received accession number XXXX-0008. Studios represented include the Aerojet Engineering Corporation and the U.S. Navy.

Physical Description

There are 50 photographs including silver gelatin photonegatives and photoprints. Other materials include

address lists, correspondence, engineering drawings, manuscripts, newspaper clippings, pamphlets, and programs.

Subjects

The photographs document activities of the American Rocket Society (ARS). Propulsion experiments illustrated document flame patterns and spray formed by intersecting streams of water. There are images of missiles and rockets; as well as rocket parts, including a liquid hydrogen and oxygen engine; and rocket testing equipment, including cameras. Individuals portrayed include Robert H. Goddard, Harry F. Guggenheim, and Charles A. Lindbergh. There are also group photos of ARS members.

Arranged: In eight series by business activity or meeting.

Captioned: Most with subject.

Finding Aid: Folder list.

Restrictions: The collection, located at the Garber Facility, is available by appointment only.

AS·77

Carl H. Claudy Collection

Dates of Photographs: 1906–1909, 1930s

Collection Origins

Carl H. Claudy (1879–1957), the official photographer at the U.S. Army airfield at Fort Myer, Arlington, Virginia, created the collection to document Army aircraft tests between 1906 and 1909, including the Wright aircraft flights in 1908 and 1909. Claudy also worked for the *New York Herald* and wrote children's and photography books. NASM received the collection in 1957.

Physical Description

There are 580 photographs including silver gelatin dry plate photonegatives and silver gelatin photonegatives and photoprints.

Subjects

The photographs document tests of aircraft, including airplanes, airships, balloons, and kites, at the Fort Myer Army base in Arlington, Virginia, between 1906 and 1909, as well as later aviation activities. Activities and events documented include an airplane being transported by a wagon, airships and balloons being inflated and flown, Alexander Graham Bell's tetrahedral kite trials, reporters following aircraft in cars, spectators watching flights, and the Wright aircraft flights including the crash that killed Army lieutenant Thomas E. Selfridge (the first airplane fatality). There are detailed views of aircraft parts including airframes, engines, gondolas, and rudders. Aviators and inventors portrayed include Thomas S. Baldwin, Alexander Graham Bell, Glenn H. Curtiss, A. Roy Knabenshue, Augustus M. Post, and Thomas E. Selfridge.

Arranged: No.

Captioned: No.

Finding Aid: List of general subjects.

Restrictions: The collection is kept in the Ramsey Room at the NASM Archives on the Mall. Researchers must be accompanied by a staff member and are encouraged to call or write for an appointment. Publications must credit photographer Carl H. Claudy.

AS·78

Henri-Marie Coanda Papers *A.K.A.* G. Harry Stine Collection, 1920–1961

Dates of Photographs: Circa 1920s–1950s

Collection Origins

Engineer Henri-Marie Coanda (1885–1972) created the collection to document his work in agriculture, aviation, and water conversion. Born in Bucharest, Romania, Coanda studied in Berlin and Paris, where he was a member of the first class of L'École Superieure

d'Aeronautique. He invented a jet aircraft concept in 1910, and in 1932 he discovered the Coanda effect, in which jet streams create vacuums by following curves. He was also responsible for over 250 patents in the fields of agricultural equipment, energy conservation, prefabricated housing, and water conversion and conservation. The collection was acquired by G. Harry Stine, who donated it to NASM. NASM Archives assigned the collection accession number XXXX-0170. Studios represented include Studio Bondy.

Physical Description

There are 300 photographs including silver gelatin dry plate lantern slides and silver gelatin photonegatives and photoprints. Other material includes articles, charts, correspondence, engineering drawings, financial records, newspaper clippings, periodicals, and reports.

Subjects

The photographs document agriculture on Henri-Marie Coanda's farm and scientific experiments. Agricultural photographs document crops such as grain and grapes and show field workers with tools. There are photographs showing patterns of flowing material, probably related to water conversion tests. There are also images of engines, technical instruments, and unidentified machinery, as well as portraits of men standing with an airplane and working in laboratories.

Arranged: No.

Captioned: No.

Finding Aid: Folder list.

Restrictions: The collection, located at the Garber Facility, is available by appointment only.

AS·79

Frank T. Coffyn Scrapbooks

Dates of Photographs: Circa 1880–1935

Collection Origins

Pioneer aviator Frank T. Coffyn (1878–1960) created the collection to document his career. Coffyn took flight lessons from the Wright brothers in Dayton, Ohio, and became a member of the original Wright flying team. In 1912 he made flights throughout the country and piloted the first seaplane in New York City, flying under the Brooklyn and Manhattan bridges. Coffyn participated in a number of meets and races from the 1910s through the 1930s and spent his later years as an aviation consultant. Photographers represented include Jimmy Hare. NASM Archives assigned the collection accession number XXXX-0065.

Physical Description

There are 200 photographs including an albumen photoprint and silver gelatin photonegatives and photoprints, mounted in scrapbooks. Other materials include correspondence and newspaper clippings, also mounted in the scrapbooks.

Subjects

The photographs document Frank T. Coffyn's flights and other aviation events. Aircraft shown include a Burgess seaplane and a Wright Model B. There are images of aircraft being launched from a rail, being transported, floating on water, flying, landing, and taking off. Aircraft parts, an early motion-picture camera, and a race car are also shown, as well as aerial shots of bodies of water and fields.

Events documented include an Aero Club of Michigan meet (1911), an Asbury Park, New Jersey, meet (1910), the first seaplane flight in New York City (1912), and the National Air Races in Chicago (1930). Besides Coffyn, people portrayed include airship pioneer A. Roy Knabenshue; executive Walter Brookins; general Henry H. ("Hap") Arnold; inventors Orville and Wilbur Wright; pilots Arch Hoxsey, Earl Ovington, and Arthur P. Warner; writer Cy Caldwell; and Tex Millman and William Whitney. There are also portraits of airplane passengers, ground crews, and soldiers at a U.S. Army Signal Corps aviation school in Texas.

Arranged: Loosely chronologically.

Captioned: Most with date and subject.

Finding Aid: No.

Restrictions: The collection, located at the Garber Facility, is available by appointment only.

AS·80

College Park Airport Collection *A.K.A.* Fred C. Knauer Collection, 1903–1986

Dates of Photographs: 1911–1969

Collection Origins

Fred C. Knauer assembled the collection to document the history of the College Park (Maryland) Airport and the establishment of its museum. Often considered the world's oldest continuously operating airport, the College Park Airport was established in 1909 when Orville and Wilbur Wright used the site for giving flight instruction to the U.S. Army Signal Corps. The airport operates today as a single-runway, general aviation facility and is designated as a historic landmark. Fred C. Knauer contributed to the preservation of the airport and the establishment of a historical museum there in the late 1960s. He donated the collection to NASM, where it received accession number 1987-0087. Studios represented include the U.S. Air Force and the Works Projects Administration.

Physical Description

There are 630 photographs including collodion gelatin photoprints (POP); color dye coupler photonegatives, photoprints, phototransparencies, and slides; and silver gelatin photonegatives, photoprints, and slides. Other materials include correspondence, maps, newspaper clippings, pamphlets, proposals, a scrapbook, and site drawings.

Subjects

The photographs document the history of Maryland's College Park Airport including aircraft, events, facilities, and grounds. Aircraft depicted include Henry A. Berliner's helicopter, Curtiss aircraft, Rex Smith's airplane, and Wright Flyers. Events documented include air shows, airmail flights, ceremonies, and the first firing of a machine gun from an airplane (1912). There are aerial photographs of the airfield, along with photographic reproductions of architectural drawings and plans of buildings, hangars, and the museum. People portrayed include Henry H. ("Hap") Arnold, Henry A. Berliner, Benjamin D. Foulois, Fred C. Knauer, T.S.C. Lowe, Oscar L. Motte, and John J. Pershing.

Arranged: No.

Captioned: A few with subject.

Finding Aid: Folder list.

Restrictions: The collection, located at the Garber Facility, is available by appointment only.

AS·81

Charles Collyer Scrapbook and Memorabilia

Dates of Photographs: 1923–1929

Collection Origins

Aviator Charles B.D. Collyer (1898–1928) created the collection to document his activities in the 1920s. Collyer joined the U.S. Army Air Service in World War I and served as a flight instructor. After the war he served as a pilot for the Air Mail Service and the Sky Writing Corporation of American, a test pilot for the Sikorsky manufacturing company, and president of Aviation Service Corporation. In 1923 he and John Henry Mears flew around the world in a record 23 days. Collyer was killed in a crash while attempting another record flight. Eleanor Scott Libbey donated the collection to NASM, where it received accession number 1991-0009.

Physical Description

There are 15 silver gelatin photoprints, mounted in a scrapbook. Other materials include correspondence, map cases, maps, log books, and newspaper clippings, some also mounted in the scrapbook.

Subjects

The photographs document Charles B.D. Collyer's aviation activities, especially his 1923 around-the-world flight. There are portraits of Collyer, John Henry Mears, and passengers. Aircraft documented include Collyer's Lockheed Vega, named the *City of New York,* and Pan American airliners. There is also an image of skywriting.

Arranged: No.

Captioned: Most with subject.

Finding Aid: Item-level transfer list.

Restrictions: The collection, located at the Garber Facility, is available by appointment only.

Arranged: By subject. Photographs are in one series.

Captioned: With subject; some also with date.

Finding Aid: Lists of engineering drawings.

Restrictions: The collection, located at the Garber Facility, is available by appointment only.

AS·82

Continental, Inc., Records, 1941–1955

Dates of Photographs: 1948–1952, ND

Collection Origins

Continental, Inc., created the collection as its company archives. Formed in 1945, Continental developed the Airphibian, an aircraft that converted into an automobile. Designed by Continental president Robert E. Fulton, the Airphibian first flew in November 1946. In 1950 it became the first roadable aircraft to receive a Civil Aeronautics Administration Approved Type Certificate. The aircraft failed to find a market, however, and the company folded in 1954. Studios represented include OPPS. NASM Archives assigned the collection accession number XXXX-0059.

Physical Description

There are 200 silver gelatin photonegatives and photoprints (some copies). Other materials include advertisements, articles, correspondence, engineering drawings, manuscripts, and reports.

Subjects

The photographs document the facilities and products of Continental, Inc., and a group of famous aviation figures. There are images of aircraft including the Continental Airphibian, parts of the Airphibian, and aircraft testing equipment. People portrayed include Charles A. Lindbergh, scientist Max Valier, airship designer Melvin Vaniman, scientist Wernher von Braun, engineer Theodore von Kármán, rocket financier Fritz von Opel, manufacturer Chance M. Vought, and aviator Charles F. Walsh. There is also a portrait of King Victor Emmanuel III of Italy.

AS·83

Harry D. Copland Slides

Dates of Photographs: Circa 1929–1933

Collection Origins

Harry D. Copland (1896–1976) assembled the collection to illustrate lectures he gave as an instructor at a Curtiss aviation school. Copland served in World War I as a radio officer with the British Blockade Runners and flight commander of 203 Squadron, British Royal Flying Corps. After the war he barnstormed in the United States and Canada, served as an airmail pilot, and operated his own company, Interstate Airways, Inc. From 1929 to 1932 he worked as district manager of the New England Flying Service, directing flight operations at a Curtiss school and organizing schools in Michigan and Massachusetts. Copland traveled to China and Japan in 1933 to demonstrate a twin-engine bomber seaplane for Consolidated Aircraft Corporation. In 1935 he helped establish the Air Traffic Control system for the Civil Aeronautics Authority. During World War II Copland served as commanding officer of the 19th Air Force Basic Flying Detachment, and he also served in Korea. After retiring from the Air Force he became director of Florida's State Aviation Department. NASM Archives assigned the collection accession number XXXX-0439.

Physical Description

There are 220 silver gelatin dry plate lantern slides.

Subjects

The photographs document airplane construction, airports, the history of flight, scenes of Japan, and weather conditions. Aircraft documented include airships, balloons, and gliders, as well as Curtiss and Wright biplanes and Lockheed aircraft. Aircraft parts

depicted include cabin interiors, cockpits, distributors, engines, fuselages, gauges, instrument panels, propellers, and wings. There are images of airport floodlights and clouds. There are photographic reproductions of diagrams of aircraft construction, aircraft flight paths, airflow patterns, and birds in flight, as well as of weather maps. Photographs of Japan show gardens, people, rivers, and temples.

Arranged: In five series by lecture or subject, then by assigned number.

Captioned: With subject.

Finding Aid: Caption lists.

Restrictions: The collection, located at the Garber Facility, is available by appointment only.

AS·84

Cross Section of Aviation Personnel Scrapbooks *A.K.A.* Kenneth Boedecker Scrapbooks

Dates of Photographs: 1936–1962

Collection Origins

Kenneth J. Boedecker (1892–1981) of Curtiss-Wright Corporation assembled the collection to document personnel working in aviation and related fields. Boedecker attended the Polytechnic Institute in Brooklyn, New York, and began his career as a mechanic. He became chief inspector for Lawrence Aero Engine Corporation in 1916, and he served in the U.S. Navy during World War I. When Lawrence merged with Wright Aeroplane Corporation in 1923, Boedecker became field service engineer, then service manager in 1927, and general service manager in 1930. There he helped develop the Wright Whirlwind engine. In 1927 he inspected Lindbergh's aircraft, as well as those in the Pacific Air Race, and he participated in the Ford reliability tours. He donated the collection to NASM, where it received accession number XXXX-0323.

Physical Description

There are 12,140 silver gelatin photoprints, mounted in albums.

Subjects

The photographs portray people working in aviation fields such as aircraft construction, airlines, and the military. Occupations portrayed include designers, editors, executives, flight attendants, mechanics, military officers, pilots, public relations officials, secretaries, and teachers. Airlines whose employees are portrayed include Air India, American Airlines, Braniff Airways, Capital Airlines, Dixie Airlines, Eastern Airlines, Hanford Airlines, K.L.M. (Royal Dutch Airlines), Los Angeles Airways, National Airlines, Northwest Airlines, Pan American Airways, Pennsylvania Central Airlines, Trans World Airlines, United Airlines, and Wyoming Air Service. Aircraft manufacturers whose employees are portrayed include Beech Aircraft Corporation, Boeing Airplane Company, Clark Aircraft Corporation, Curtiss-Wright Corporation, Douglas Aircraft Company, Grumman Aircraft Engineering Corporation, Hughes Aircraft Company, Lockheed Aircraft, Glenn L. Martin Company, Seversky Aviation Corporation, Vought Sikorsky Aircraft, Waco Aircraft Company, and Wright Aeronautical Corporation.

There are portraits of employees of aircraft parts and materials firms such as Bakelite Corporation, Bell Telephone Laboratories, B.G. Spark Plugs, Gulf Refining Company, Kollsman Instrument Company, Pacific Airmotive, Phillips Petroleum Company, Pitcairn Aviation, Pureoil Company, Republic Steel Corporation, Rolls Royce, and Sperry Gyroscope Company. Airports whose employees are portrayed include Detroit City Airport, La Guardia Field (New York), Iranian airports, and Municipal Airport in Chicago. There are portraits of government and military workers at bureaus such as the Civil Aeronautics Authority, U.S. Army Air Corps, U.S. Coast Guard, U.S. Department of Commerce, and U.S. Navy. There are also portraits of the staff of the Associated Press, *Aviation* magazine, Biltmore Travel Agency, *Flying* magazine, *Life* magazine, National Biscuit Company, New York University, *Popular Aviation* magazine, and Walt Disney Productions.

Arranged: Chronologically, then partly alphabetically by subject's name.

Captioned: With autograph, date, firm, location, and name.

Finding Aid: 1) List of volumes showing dates. 2) Indexes to some of the volumes listing firm, name, and page.

Restrictions: The collection, located at the Garber Facility, is available by appointment only.

AS·85

Tom D. Crouch Collection, Circa 1906–1983

Dates of Photographs: Circa 1906–1983

Collection Origins

Historian and NASM curator Tom D. Crouch (1940–) assembled the collection to document his research in early aviation at NASM. Crouch taught high school (1967–1969), served as director of education for the Ohio Historical Society (1969–1972), directed the Ohio American Revolutionary Bicentennial Committee (1972–1974), and became an associate curator at NASM (1974) before receiving a Ph.D. in American history from Ohio State University (1976). Crouch worked at the National Museum of American History from 1985 to 1989, when he returned to NASM to become chairman of the Aeronautics Department. Some of the photographs appear in the following publications by Crouch: 1) *A Dream of Wings: Americans and the Airplane, 1875–1905.* New York: Norton, 1981. 2) *The Eagle Aloft: Two Centuries of the Balloon in America.* Washington, D.C.: Smithsonian Institution Press, 1983. Photographers and studios represented include Beech Aircraft Corporation; C.J. MacCartee, Sr.; NASA; and OPPS. NASM Archives assigned the collection accession number 1985-0012.

Physical Description

There are 2,750 photographs including color dye coupler photoprints, collodion gelatin photoprints (POP), and silver gelatin photonegatives and photoprints. Other materials include catalogs, correspondence, magazines, manuscripts, and pamphlets.

Subjects

The photographs document aircraft and aviation activities, events, and figures. There are images of airships; balloons; commercial aircraft such as the Boeing 307 Stratoliner; early aircraft such as Benoist air-planes, Burgess-Wright seaplanes, and Curtiss flying boats; experimental aircraft; gliders; hang gliders; helicopters; rockets and spacecraft such as Apollo rockets; and World War II aircraft such as the Brewster SB2A Buccaneer; as well as the Ryan NY-P *Spirit of St. Louis.*

Activities and events documented include aircraft construction showing equipment, factories, parts, and tests; aircraft crashes; early flights; Robert H. Goddard's rocket experiments; and Smithsonian aircraft exhibits in the Arts and Industries building and NASM. People portrayed include James Gordon Bennett, Jr., Glenn H. Curtiss, and Wernher von Braun.

Arranged: Partly by type of material; photographs are in first three boxes.

Captioned: With negative number; a few also with subject.

Finding Aid: No.

Restrictions: The collection, located at the Garber Facility, is available by appointment only.

AS·86

John S. Curtis Collection

Dates of Photographs: 1929–1932

Collection Origins

Aviator John S. Curtis created the collection to document aircraft between 1929 and 1932, as well as his flying activities in that period. Curtis was a member of the Quiet Birdmen. Photographers represented include Bruce M. Bigelow. NASM Archives assigned the collection accession number 1989-0001.

Physical Description

There are 250 photographs including silver gelatin dry plate photonegatives and silver gelatin photonegatives and photoprints. Other materials include correspondence, a flight log, newspaper clippings, and a radio license.

Subjects

The photographs primarily document aircraft of the

late 1920s and early 1930s, as well as aircraft equipment and facilities. Aircraft depicted include autogyros and airplanes such as the Boeing 247 and F4B; Curtiss Condor, F7C-1, Falcon, Fledgling, Robin, and Travelair; Douglas DC-3; Ford Trimotor; Granville Gee Bee R-1; Northrop Alpha; Pitcairn Sport Mailwing; Stinson R; Vought O2U Corsair; and Waco C-6, F-7, RNF, Straightwing, and UEC. Equipment and facilities documented include airports, hangars, instrument panels, a Super Wasp radio set, and a Viking Flying Boat Company building. There are also images of a parachute drop and portraits of pilots.

Arranged: Part alphabetically by manufacturer and model.

Captioned: Most photonegatives on the envelope with manufacturer and model.

Finding Aid: Item-level transfer list.

Restrictions: The collection, located at the Garber Facility, is available by appointment only.

AS·87

Curtiss Eagle Sightseeing Flights Scrapbook *A.K.A.* George A. Page, Jr., Scrapbook

Dates of Photographs: Circa 1920

Collection Origins

The collection was created to document sightseeing flights made in a Curtiss Eagle, an early cabin biplane, by government officials, especially congressmen, and their families. George A. Page, Jr., donated the collection to NASM, where it received accession number XXXX-0341. Studios represented include Curtiss Aeroplane and Motor Company.

Physical Description

There are 140 silver gelatin photoprints, mounted in an album.

Subjects

The photographs document sightseeing flights made in a Curtiss Eagle, an early cabin biplane, by government officials and their families in Washington, D.C. The photographs show children, men, and women in front of the Eagle, some holding flowers to drop from the aircraft. There are also aerial shots of Washington, D.C., showing the Capitol and the Washington Monument.

Arranged: Chronologically.

Captioned: Some with flight number.

Finding Aid: No.

Restrictions: The collection, located at the Garber Facility, is available by appointment only.

AS·88

Curtiss Flying School Photograph Collection *A.K.A.* Alpha R. Clemens Photograph Collection, Circa 1912–1915

Dates of Photographs: Circa 1912–1915

Collection Origins

Alpha R. Clemens, service manager at the Curtiss Aeroplane Company plant in Hammondsport, New York, assembled the collection during World War I to document early aviation activities of pioneer aviator Glenn H. Curtiss (1878–1930). Beginning as a bicycle, motorcycle, and engine designer, Curtiss had founded a manufacturing company by 1902 and in 1904 supplied engines for Thomas Baldwin's airship experiments. In 1907 Curtiss helped form the Aerial Experiment Association, and in 1910 he founded the first public aviation schools. He invented the aileron (1909), the dual-control trainer (1911), and the water-landing airplane (1911).

In 1909 Curtiss began the Herring-Curtiss Company with partner Augustus M. Herring. Producing

powered airplanes, the company soon became involved in patent suits filed by the Wright brothers. When Herring left the company a short time later he also filed suit against Curtiss, who fought the cases. In 1914 he modified and flew Samuel P. Langley's Aerodrome in an unsuccessful effort to defeat patent infringement claims by the Wright brothers. In 1929 Curtiss merged his company with the Wright Aeronautical Corporation, finally ending the legal disputes. Anna B. Clemens, wife of Alpha R. Clemens, donated the collection to the Smithsonian in 1953, and it received accession number XXXX-0022.

Physical Description

There are 315 silver gelatin photoprints. Other materials include pamphlets.

Subjects

The photographs document Curtiss aircraft, factories, flight schools, and personnel, mainly in Hammondsport, New York. Aircraft illustrated include pushers, seaplanes, tractors, and triplanes, including the Curtiss D, E, F, G, McCormick, and Tadpole, as well as the modified Langley Aerodrome. There are images of patent models of aircraft and aircraft parts including engines and wheels. Facilities shown include Curtiss aviation school buildings and hangars. People portrayed include aviator Lincoln Beachey, Glenn H. Curtiss, aviation school students, mechanics, pilots, and spectators. Activities documented include building, floating, flying, landing, and moving aircraft, as well as playing tug-of-war.

Arranged: By image number.

Captioned: With date, name of aircraft, and image number.

Finding Aid: No.

Restrictions: The collection, located at the Garber Facility, is available by appointment only.

AS·89

Glenn H. Curtiss Collection

Dates of Photographs: 1908–Circa 1915

Collection Origins

Glenn H. Curtiss, pioneer aviator, aeronautical engineer, and manufacturer, created the collection to document his aviation and business activities. For a biography of Curtiss, see *Collection Origins* in *AS·88*. Glenn H. Curtiss, Jr., donated the collection to the Smithsonian in 1963, and NASM Archives assigned it accession number XXXX-0053.

Physical Description

There are 100 photographs including silver gelatin photonegatives and photoprints. Other materials include correspondence, engineering drawings, financial records, legal documents, manuscripts, newspaper clippings, patents, programs, and reports.

Subjects

The photographs document Glenn H. Curtiss's business and flying activities. Aircraft depicted include the Aerial Experiment Association biplanes *June Bug* and *Silver Dart,* the Langley Aerodrome, the flying boat *America,* and U.S. Navy airships. Aircraft are shown being transported, floating on water, flying, landing, and taking off. People portrayed include aviation school students, mechanics, pilots, and spectators. There are also images of events and facilities including christenings and hangars.

Arranged: By subject.

Captioned: Some with subject.

Finding Aid: Box list.

Restrictions: The collection, located at the Garber Facility, is available by appointment only.

AS·90

Glenn H. Curtiss Motorcycles Scrapbook *A.K.A.* Clara Studer Collection

Dates of Photographs: 1903–1907

Collection Origins

The collection was created to document motorcycles made by Glenn H. Curtiss, later an aviator and aircraft builder. For a biography of Curtiss, see *Collection Origins* in *AS·88*. Clara Studer donated the collection to NASM, where it received accession number XXXX-0330.

Physical Description

There are 65 photographs including collodion gelatin photoprints (POP), cyanotypes, and silver gelatin photoprints, mounted in a scrapbook. Other materials include advertisements, correspondence, and newspaper clippings, also mounted in the scrapbook.

Subjects

The photographs document the motorcycles made by Glenn H. Curtiss in the early 1900s. There are images of motorcycles with side-cars, with wicker passenger chairs, and with two seats. Motorcycles are shown being ridden by men and women, including one with five people on it. There are also images of aircraft, automobiles, a Curtiss workshop, engines and other parts, and an Indian motorcycle. There are portraits of Glenn H. Curtiss, his employees, and a Curtiss company baseball team. A photograph from this collection is reproduced in this volume's illustrations section.

Arranged: No.

Captioned: No.

Finding Aid: No.

Restrictions: The collection, located at the Garber Facility, is available by appointment only.

AS·91

Curtiss NC-4 Collection *A.K.A.* Richard K. Smith Collection, Circa 1918–1969

Dates of Photographs: Circa 1950–1969

Collection Origins

Richard K. Smith, former curator at NASM's Department of Aeronautics, assembled the collection in preparation for the museum's celebration of the 50th anniversary of the first transatlantic flight. In 1917 the U.S. Navy and Curtiss Aeroplane and Motor Corporation began developing a flying boat to cross the Atlantic and serve as an anti-submarine patrol craft in Great Britain. The first model, NC-1, flew in October 1918, followed by NC-2 in April 1919, both with four engines. On May 16, 1919, two new models—the three-engined NC-3 and the four-engined NC-4—and the NC-1 took off from Newfoundland under Commander John H. Towers, headed for the Azores. The NC-1 was unable to complete the flight, and the NC-3 landed early and taxied the remaining 200 miles. The NC-4 completed the flight, then went on to Lisbon, Portugal, and reached Plymouth, England, on May 31. After publicity tours in the United States, the NC-4 was donated to the Smithsonian Institution. Studios represented include OPPS and the U.S. Navy. Some of the photographs appeared in the following: Richard K. Smith. *First Across! The U.S. Navy's Transatlantic Flight of 1919.* Annapolis, Maryland: Naval Institute Press, 1973. NASM Archives assigned the collection accession number XXXX-0418.

Physical Description

There are 140 copy silver gelatin photoprints. Other materials include correspondence, manuscripts, maps, and newspaper clippings.

Subjects

The photographs document the attempted flights of the Curtiss NC-1, NC-3, and NC-4 flying boats from Newfoundland to Europe in May 1919. Events documented include the aircraft taking off and flying, an aircraft being loaded onto a ship, ceremonies in Lisbon, Portugal, and a parade in Plymouth, England. There are portraits of the crews and a photograph of a medal.

Arranged: Partly by subject.

Captioned: Some with subject.

Finding Aid: No.

Restrictions: The collection, located at the Garber Facility, is available by appointment only.

AS·92

Curtiss NC-4 Design, Construction, and Testing Reports, Circa 1918–1969

Dates of Photographs: 1968

Collection Origins

The collection was assembled to document the development of the Curtiss NC-4 by Curtiss Aeroplane and Motor Corporation and the U.S. Navy. For a history of the project, see *Collection Origins* in *AS·91*. The Navy donated the collection to NASM, where it received accession number XXXX-0422. Studios represented include OPPS and the U.S. Navy.

Physical Description

There are 420 silver gelatin photoprints (some copy). Other materials represented include charts, diagrams, financial records, and reports.

Subjects

The photographs document the construction and testing of the Curtiss NC-4 seaplane and its reconstruction at the Smithsonian Institution in the 1960s. Images of the original construction document the NC-4 in many stages of production, including building the hull, constructing parts, and installing the engines. Parts depicted include engines, instruments, joints, machine gun mounts, propellers, radio sets, and tanks. There are photographic reproductions of diagrams and plans of the aircraft. The reconstruction images show the NC-4 being transported to NASM, examined, handled with cranes, and assembled.

Arranged: In volumes by subject.

Captioned: A few with negative number or subject.

Finding Aid: List of contents of each volume.

Restrictions: The collection, located at the Garber Facility, is available by appointment only.

AS·93

Curtiss-Wright Corporation Propeller Division Records, Circa 1940–1957

Dates of Photographs: 1946–1953

Collection Origins

The Propeller Division of the Curtiss-Wright Corporation created the collection to document its experiments in rocket propulsion between 1943 and 1957. Formed in 1929 by the merger of Curtiss Aeroplane and Motor Corporation and Wright Aeronautical Corporation, the Curtiss-Wright Corporation had three main divisions: the Curtiss-Wright Airplane Division, which manufactured aircraft frames until closing in 1951; the Wright Aeronautical Corporation, which produced engines; and the Curtiss-Wright Propeller Division, which produced propellers. The Propeller Division began conducting rocket experiments in 1943, collaborating with rocketry pioneer Robert H. Goddard (1882–1945) until his death. Goddard left Curtiss-Wright the use of his rocket patents, and the experiments continued based mainly on Goddard's work. NASM Archives assigned the collection accession number XXXX-0419.

Physical Description

There are 2,520 silver gelatin photoprints. Other materials include correspondence, engineering drawings, financial records, forms, and reports.

Subjects

The photographs document rocket propulsion experimentation at Curtiss-Wright Corporation, including images of rocket parts, test apparatus, and test results. Equipment and facilities documented include Propeller Division buildings, monitoring instruments, and a simulator chassis. Rocket parts depicted include engines, gear trains, injection systems, pumps, and thrust chambers, often photographed before and after tests and showing damage. Rocket tests documented include temporary installations, trial runs, and water tests.

Arranged: Chronologically, by type of material, and

by type of part tested. Photographs are in boxes 10, 11, and 12.

Captioned: With date, image number, and subject.

Finding Aid: Box list.

Restrictions: The collection, located at the Garber Facility, is available by appointment only.

AS·94

Curtiss-Wright Corporation Records

Dates of Photographs: 1908–1950

Collection Origins

Curtiss-Wright Corporation created the collection as its corporate archives. For a history of the company see *Collection Origins* in *AS·93*. The collection also contains records of the previous Curtiss and Wright companies and the Keystone Aircraft Corporation, which was acquired by Wright in 1928 and operated as the Keystone Division of Curtiss-Wright until 1932. The Curtiss-Wright Corporation conducted its major operations in Buffalo, New York, and St. Louis, Missouri. The NASM Archives assigned the collection accession numbers XXXX-0067 and 1987-0029. About 6,000 of the images are on NASM Archival Videodisc 7. For information on how to order the videodisc, see the *Collection Origins* field of *AS·1*.

Physical Description

There are 172,400 photographs including silver gelatin dry plate photonegatives and silver gelatin photonegatives and photoprints. Other materials include catalogs, charts, correspondence, engineering drawings, financial records, legal documents, motion-picture film footage, pamphlets, patents, proposals, publications, and reports.

Subjects

The photographs document the facilities, operations, personnel, and products of the Curtiss-Wright Corporation, as well as other aircraft and equipment including World War II military aviation.

Types of aircraft documented include airships, biplanes, bombers, fighters, gliders, helicopters, jet racers, monoplanes, and triplanes, with an emphasis on Curtiss, Huff-Daland, Keystone, and Loening products. There are also images of aircraft made by Fairchild, Fokker, and Martin. The aircraft are shown being constructed, fueled, repaired, and tested, as well as crashing, flying, formation flying, landing, and taking off.

Aircraft tests documented include aileron, fuselage load, impact, paint, skid, and vibration examinations. Parts illustrated include ailerons, brace struts, camshafts, cockpits, cowlings, engines, fuselages, gear trains, instrument panels, propellers, retractable landing gear, turrets, and valves. There are also images of ammunition and guns. Facilities shown include aircraft factories in cities such as Bristol (England), Buffalo (New York), and Columbus (Ohio); airfields such as McCook Field in Ohio; Curtiss aviation schools; hangars; machine shops; wheel shops; and wind tunnels. There are also images of transportation such as aircraft carriers and railroad trains.

Individuals portrayed include aviators Lincoln Beachey, Eugene Ely, Walter E. Lees, and Charles A. Lindbergh; executives William J. Crosswell, Glenn H. Curtiss, Burdette S. Wright, and Theodore P. Wright; engineer Richard T. Smith; and Pete Jensen, Art Lyn, L.T. Marks, Steve McGordon, J.B. Park, Marshall Reid, and Stan Young. Groups portrayed include the Curtiss-Wright board of directors, factory workers, flight crews, a graduating class of pilots, mechanics, passengers, U.S. Army officers, U.S. government officials, and women pilots. Activities documented include painting nose art, sewing cloth parts, starting propellers, and weighing baggage.

Arranged: In eight series by Curtiss-Wright Corporation division or type of material. Photographs are in series 1, Keystone Aircraft Corporation, and series 8, photograph and negative collection, by negative number.

Captioned: Most with date, model number, negative number, and subject.

Finding Aid: 1) Box list. 2) Caption list to series 8 listing date, model number, negative number, and subject. 3) Videodisc photographs are included in NASM's caption database, which lists date, subject, and videodisc frame number. Printouts can be obtained for single photographs or caption lists of photographs with related subjects.

AS·95

William M. Davenport Photographs

Dates of Photographs: 1944–1946

Collection Origins

William M. Davenport created the collection to document two aircraft he flew. Davenport served in the U.S. Navy during World War II. In 1946 he formed Long Island Airlines, which flew between New York City and eastern Long Island and, during the winter, from Miami to several islands. Davenport donated the collection to NASM, where it received accession number 1990-0005.

Physical Description

There are three oversize silver gelatin prints.

Subjects

The photographs document two amphibian aircraft flown by William M. Davenport between 1944 and 1946. The Grumman J4F Widgeon is shown floating in a New York City harbor. An aircraft of the Naval Air Transport Service Squadron VR-2 is shown in two images, one with Davenport.

Arranged: No.

Captioned: With background information, date, donor, and manufacturer and model.

Finding Aid: No.

Restrictions: The collection, located at the Garber Facility, is available by appointment only.

AS·96

Curtiss La Q. Day Scrapbooks

Dates of Photographs: Circa 1914–1925

Collection Origins

Aviator Curtiss La Q. Day (1895–1972) created the collection to document his early career. At age 17 Day became one of America's youngest licensed pilots. A group of businessmen in his hometown of Gibson, Illinois, formed the La Q. Aeroplane Company to promote his career, and Day began performing at air shows. In 1916 he became an instructor at the Wright aviation school in Long Island, New York. In World War I he served in the French air force Cherisienne Escadrille, and in 1925 he flew for the French in the Moroccan War. Day then retired from flying and entered the hotel business, later writing for the *New Yorker* and *Readers Digest*. Studios represented include Potter. NASM Archives assigned the collection accession number XXXX-0292.

Physical Description

There are 120 silver gelatin photoprints, mounted in scrapbooks. Other materials include correspondence, financial records, newspaper clippings, posters, and tickets, also mounted in the scrapbooks.

Subjects

The photographs document Curtiss La Q. Day's aviation activities in France, Morocco, and the United States. There are portraits of Day, the Cherisienne Escadrille, and other pilots and officers with aircraft, as well as Moroccan cavalry, children, men, and women. There are also images of Moroccan buildings and landscapes. Events documented include aircraft crashes, air meets, and stunt flights.

Arranged: Chronologically.

Captioned: Some with subject.

Finding Aid: No.

Restrictions: The collection, located at the Garber Facility, is available by appointment only.

AS·97

Defense Advisory Committee on Women in the Services (DACOWITS) Collection, 1975–1987

Dates of Photographs: 1982–1983

Collection Origins

Members of the Defense Advisory Committee on Women in the Services (DACOWITS) created the collection to document the organization's activities. Established by the U.S. Department of Defense in 1951, DACOWITS created and implemented policy relating to women in the military, aiming to increase their recruitment. Since the 1950s DACOWITS has increased its involvement in other issues relating to women in the services.

Margaret M. Scheffelin (1928–), a DACOWITS member between 1982 and 1984, created some of the collection. Schefflin served as a consultant with the California State Department of Education's Program Evaluation and Research Division before she was appointed to the Committee. She donated the first part of the collection to NASM. The entire collection received accession numbers 1986-0007, 1987-0046, and 1988-0101.

Physical Description

There are 30 photographs including color dye coupler photoprints, color dye diffusion transfer photoprints, and silver gelatin photoprints. Other materials include computer printouts, correspondence, magazine clippings, manuscripts, minutes, newspaper clippings, pamphlets, and reports.

Subjects

The photographs primarily document a 1983 DACOWITS dinner. There are portraits of Margaret M. Scheffelin; Edward Scheffelin, her husband; and Julia Scheffelin, her daughter. There is also an image of a sign welcoming Scheffelin to Travis Air Force Base in California.

Arranged: In seven series by type of material. Photographs are in box 6.

Captioned: With date, event, and names.

Finding Aid: Box list.

Restrictions: The collection, located at the Garber Facility, is available by appointment only.

AS·98

Dornier Do X Aircraft Scrapbook

Dates of Photographs: 1931

Collection Origins

The collection was created to document the construction and flight of the Dornier Do X, built by Claude Dornier. The 12-engine flying boat flew from Berlin to New York in 1931. A.E. Verville donated the collection to NASM, where it received accession number XXXX-0233.

Physical Description

There are 21 silver gelatin photoprints, mounted in an album.

Subjects

The photographs document the construction and flight of the Dornier Do X, a 12-engine flying boat. The aircraft is shown being towed, in flight over a harbor and mountains, on a field surrounded by a crowd, on water with boats, and under construction in a factory. There are also images of the cockpit. People portrayed include aircraft construction workers and spectators at flights.

Arranged: No.

Captioned: No.

Finding Aid: No.

Restrictions: The collection, located at the Garber Facility, is available by appointment only.

AS·99

Frederick C. Durant III Collection

Dates of Photographs: 1960–1970s

Collection Origins

Former NASM assistant director Frederick C. Durant III (1916–) created the collection to document his career and research. After receiving a B.S. in chemical engineering from Lehigh University in 1939, he worked for the E.I. DuPont Company and then served as a U.S. Navy pilot from 1941 to 1946. After the war Durant held the following positions: director of engineering at the Naval Air Rocket Test Station (1948–1951); consultant (1952–1954); director of the Maynard Ordnance Test Station (1954–1955); executive at the AVCO-Everett Research Laboratory (1957–1959); director of public and government relations in the research division of AVCO Corporation (1959–1961); and senior representative of Bell Aerosystems Company (1961–1964). He joined NASM in 1964. Studios represented include NASA, OPPS, and United Press International. NASM Archives assigned the collection accession number XXXX-0084.

Physical Description

There are 3,000 photographs including color dye coupler photoprints and silver gelatin photonegatives and photoprints. Other materials include correspondence, engineering drawings, magazine clippings, manuscripts, newspaper clippings, pamphlets, press releases, and reports.

Subjects

The photographs primarily document NASA manned space flight and other types of rocketry and spacecraft. Aircraft and spacecraft depicted include miniature model rockets; NASM holdings; the SAAB 35 Draken; satellites; and spacecraft of the Apollo, Gemini, and Mercury programs. There are images of NASA activities such as demonstrating, eating, and preparing space food; launching spacecraft; and training; as well as space walks. NASA equipment shown includes Hasselblad cameras, space suits, and space suit prototypes. There are also images of the Earth from space and of the Moon's surface.

Arranged: Partly alphabetical by correspondent or subject.

Captioned: Some with date and subject.

Finding Aid: No.

Restrictions: The collection, located at the Garber Facility, is available by appointment only.

AS·100

Eagle Squadron Photograph Collection

Dates of Photographs: 1941–1942

Collection Origins

The collection was created to document the second American Eagle Squadron, formed in England in 1941 and transferred to the U.S. Army Air Forces in 1942. The photographs are on NASM's Archival Videodisc 2. For information on how to order the videodisc, see the *Collection Origins* field of *AS·1*.

Physical Description

There are 11 silver gelatin photoprints.

Subjects

The photographs document activities of the second American Eagle Squadron. Activities shown include briefings and pilots running to aircraft. Aircraft depicted include Hawker Hurricanes and Supermarine Spitfires. There are images of equipment and building interiors. There are also portraits of pilots wearing the British Distinguished Flying Cross, Eagle Squadron shoulder patches, and U.S. Army Air Forces uniforms.

Arranged: By videodisc frame number.

Captioned: With subject.

Finding Aid: Caption database listing subject and videodisc frame number. Printouts can be obtained for single photographs or caption lists of photographs with related subjects.

Restrictions: No. The collection is located at the NASM Archives on the Mall. Researchers are encouraged to call or write for an appointment.

AS·101

Ira C. Eaker Collection

Dates of Photographs: Circa 1910–1970s

Collection Origins

Ira C. Eaker (1896–1987) created the collection to document his military career. Eaker, who received an A.B. in journalism at the University of Southern California in 1933, joined the U.S. Army in 1917, served during World War I, and entered the Air Service in 1920. He commanded the Army's 1927 Good Will Flight to South America, and in 1929 he set an endurance record. Eaker advanced to lieutenant general, commanding the U.S. Eighth Air Force in the British Isles and then the Allied Air Forces in the Mediterranean during World War II. After retiring from the service in 1947, he served as a vice president of Hughes Tool Company (1947–1957) and Douglas Aircraft (1957–1961). He was also a founding president of the U.S. Strategic Institute. Studios represented include the U.S. Air Force. The photographs are on NASM's Archival Videodisc 2. For information on how to order the videodisc, see the *Collection Origins* field of *AS·1*.

Physical Description

There are 1,060 photographs including albumen photoprints, color dye coupler photoprints, and silver gelatin photoprints, mounted in albums.

Subjects

The photographs document Ira C. Eaker's career, primarily his U.S. Army service in World War I and II. Equipment, facilities, and vehicles documented include aircraft, balloons, military bases, ships, and a streetcar. Events documented include aircraft crashes, dances, parades, and social functions. Pilots and officers portrayed include Frank A. Armstrong, Jr., Henry H. ("Hap") Arnold, James H. Doolittle, Ira C. Eaker, Arthur T. Harris, Curtis E. LeMay, Douglas MacArthur, and William R. Smith. There are also portraits of Eaker's family, the Eighth Air Force staff, local people of places where Eaker served such as China and the Philippines, and soldiers.

Arranged: By videodisc frame number.

Captioned: With videodisc frame number.

Finding Aid: Caption database giving subjects for most of the images and videodisc frame number. Printouts can be obtained for single photographs or caption lists of photographs with related subjects.

Restrictions: The collection is located at the NASM Archives on the Mall, and a few of the photographs are kept separately in the Ramsey Room, where researchers must be accompanied by a staff member. Researchers are encouraged to call or write for an appointment.

AS·102

Early Aviation (Circa 1910) Scrapbook

Dates of Photographs: 1910–1911

Collection Origins

Unknown. NASM Archives assigned the collection accession number XXXX-0299.

Physical Description

There are 50 silver gelatin photoprints, mounted in an album.

Subjects

The photographs document aircraft, aviation activities, events, and people in the United States in 1910 and 1911. Events documented include a 1911 Chicago air meet; Claude Graham-White's landing and take-off on Executive Avenue in Washington, D.C.; and the International Aviation Tournament at Belmont Park, New York, in 1910. Aircraft manufacturers and models represented include the Antoinette, Baldwin, Blériot, Curtiss, Santos-Dumont Demoiselle, Farman, Frisbee, Hamilton, and Wright. Equipment and facilities documented include an announcement board, barographs, and hangars. People portrayed include Arch Hoxsey and other pilots and spectators. There are also photographic reproductions of an air meet program, barographs showing altitude data, and charts of aircraft entry information.

Arranged: Chronologically.

Captioned: Most with subject.

Finding Aid: No.

Restrictions: The collection, located at the Garber Facility, is available by appointment only.

AS·103

Early Aviation Photographs *A.K.A.* Frank H. Russell Collection

Dates of Photographs: 1902–Circa 1910s

Collection Origins

Frank H. Russell probably created the collection, which documents the early aircraft industry. Russell, who received an A.B. from Yale in 1900, served as manager at the Wright Company (1910–1911) and the Burgess Company (1911–1918). He then became vice president of Curtiss and Curtiss-Wright corporations (1918–1931), which he left to become vice president of E.G. Budd Manufacturing Company (1931–1935). NASM Archives assigned the collection accession number XXXX-0332.

Physical Description

There are 140 silver gelatin photoprints, mounted in albums.

Subjects

The photographs document early aircraft and aircraft construction. There are images of aircraft made by Blériot, Burgess, Curtiss, and Wright. Parts depicted include body framework and engines. Construction activities illustrated include men working at lathes, a woman sewing fabric, and workers putting fabric on wings. Equipment and facilities shown include hangars, offices, and shop interiors with power tools. There are also images of air shows and aircraft crashes, flights, and landings and take-offs on water.

Arranged: No.

Captioned: A few with manufacturer and model or other subject.

Finding Aid: No.

Restrictions: The collection, located at the Garber Facility, is available by appointment only.

AS·104

Early Aviation Scrapbook

Dates of Photographs: Circa 1909–1914

Collection Origins

Unknown. Studios represented include Brown Bros. NASM Archives assigned the collection accession number XXXX-0291.

Physical Description

There are 245 silver gelatin photoprints, mounted in a scrapbook. Other material includes photomechanical postcards, also mounted in the scrapbook.

Subjects

The photographs document American, British, French, and German aircraft between 1909 and 1914. Aircraft shown include airships, balloons, seaplanes such as Benoist flying boats and Loening Aeroboats, and tractor biplanes. Aircraft parts shown include engines and propellers. Construction activities illustrated include building the airframe, engine, and struts and hoisting an aircraft onto landing gear with a crane. Events shown include an aeronautical exposition in Paris, aircraft crashes, and demonstration flights. Facilities documented include hangars, laboratories, offices, and seaplane launching rails.

Arranged: No.

Captioned: Some with subject; a few also with parts labeled.

Finding Aid: No.

Restrictions: The collection, located at the Garber Facility, is available by appointment only.

AS·105

Arnold Egeland Airlines Collection

Dates of Photographs: 1950s–1970s

Collection Origins

Photographer Arnold Egeland created the collection to document international airlines. Egeland traveled to airports throughout the world to find aircraft representing over 300 airlines. He donated the collection to NASM, where it received accession number 1991-0025.

Physical Description

There are 1,270 photographs including color dye coupler photoprints and silver gelatin photoprints. Other materials include advertisements, correspondence, lists, newsletters, pamphlets, and route maps.

Subjects

The photographs document aircraft of airlines throughout the world from the 1950s to the 1970s.

Arranged: Alphabetically by airline.

Captioned: No.

Finding Aid: Folder list giving airlines represented.

Restrictions: No. The collection is located at the NASM Archives on the Mall. Researchers are encouraged to call or write for an appointment.

AS·106

Ellington Field Scrapbooks *A.K.A.* W.H. Frank Scrapbooks

Dates of Photographs: 1917–1918, Circa 1950s

Collection Origins

W.H. Frank donated the collection to NASM, where it received accession number XXXX-0342. Photographers represented include Al Bachman and OPPS staff.

Physical Description

There are 240 silver gelatin photoprints (some copies), mounted in albums.

Subjects

The photographs document activities, aircraft, equipment, and facilities at Ellington Field, Texas, during World War I. There are portraits of a band marching near airplanes, hospital corps members practicing first aid, and students attending a gunnery class. Other activities documented include constructing aircraft, erecting field radios, filling a gas tank from a railroad car, fueling airplanes from a gas truck, installing an engine, and receiving radio transmissions. Aircraft documented include airplanes such as the Curtiss JN-4 and a kite balloon. Aircraft parts shown include aileron controls, cables, connections, and joints. Equipment and facilities documented include barracks, a dining room, field lights, a gun room, hangars, hospital interiors, a machine shop, miniature model aircraft on strings, an officers' mess hall, a photographic laboratory, power tools, radio school classrooms, and a YMCA building. There are aerial views of Ellington Field in Texas and of Hawaii. There are also images of aircraft crashes, French ace Georges Guynemer's funeral, a downed German aircraft, and U.S. soldiers.

Arranged: No.

Captioned: Some with subject.

Finding Aid: No.

Restrictions: The collection, located at the Garber Facility, is available by appointment only.

AS·107

Engine Design Reports

Dates of Photographs: Circa 1910s–1940s

Collection Origins

NASM staff assembled the collection from documents about engine design and endurance testing, produced mostly between 1927 and 1946. Many of the documents were produced by Aviation Manufacturing Corporation, Daniel Guggenheim Airship Institute Library, Samuel D. Heron (a designer of piston engines), and the U.S. War Department. Studios represented include the Aviation Manufacturing Corporation. NASM Archives assigned the collection accession number XXXX-0195.

Physical Description

There are 35 silver gelatin photoprints. Other materials include engineering drawings, manuals, pamphlets, and reports.

Subjects

The photographs document aircraft engines, engine testing, and parts. Engines shown are from aircraft of the 1910s. There are also images of parts from later engines, including air induction systems, engine controls, exhaust pipes, flywheels, gauges, and instrument panels. There are images of apparatus to examine corrosion and fatigue. There are also portraits of people at an exhibit of miniature model airplanes.

Arranged: No.

Captioned: Some with date or subject.

Finding Aid: No.

Restrictions: The collection, located at the Garber Facility, is available by appointment only.

AS·108

Clifford V. Evans, Jr., and George W. Truman Scrapbook

Dates of Photographs: 1947

Collection Origins

The collection was created to document preparations

for the first around-the-world flight in Piper Cubs, piloted by Clifford V. Evans, Jr., and George W. Truman, in July 1947. Evans attended American University and the University of Maryland and served as a captain in the U.S. Army Air Forces during World War II. Truman, a motorcycle racing champion, served as a flight instructor during World War II. The aircraft, Evans's *City of Washington* and Truman's *City of Angels,* were christened at Washington National Airport with water from the Atlantic and Pacific oceans. NASM Archives assigned the collection accession number XXXX-0226.

Physical Description

There are 90 silver gelatin photoprints, mounted in a scrapbook. Other materials include newspaper clippings and press releases, also mounted in the scrapbook.

Subjects

The images are publicity photographs of preparations for the 1947 around-the-world flight of Clifford V. Evans, Jr., and George W. Truman in Piper Cubs. There are portraits of Evans and Truman looking at maps; making drift meters; posing with their aircraft, called the *City of Washington* and the *City of Angels,* with equipment such as life rafts, and with their families; and working on motors. There are also images of the christening ceremony and a Piper Cub in flight. A photograph from this collection is reproduced in this volume's illustrations section.

Arranged: Chronologically.

Captioned: Most with subject.

Finding Aid: No.

Restrictions: The collection, located at the Garber Facility, is available by appointment only.

AS·109

Exhibition Flight Collection, Circa 1911–1973

Dates of Photographs: 1973

Collection Origins

NASM curators Robert C. Mikesh and Claudia M. Oakes assembled the collection in preparation for a book to accompany the 1973 NASM exhibit, "Exhibition Flight." The photographs were published in the following: Robert C. Mikesh. *Exhibition Flight.* Washington, D.C.: Smithsonian Institution Press, 1973. Studios represented include OPPS and the U.S. Navy. NASM Archives assigned the collection accession number XXXX-0423.

Physical Description

There are 55 copy silver gelatin photoprints.

Subjects

The photographs document air shows and the participating aircraft. Airplanes documented include the Curtiss JN-4, the Grumman F8F Bearcat, and racers such as the Granville Gee Bee, the Laird LC-DW-500 Super Solution, and the Supermarine S-6B. Some aircraft are shown on exhibit at the Smithsonian Institution. Events documented include air races, biplane barnstorming and stunts including a night flight with flares and a race between an airplane and an automobile, endurance and speed record flights, and passenger rides. There are also photographic reproductions of paintings of aviators Lincoln Beachey and Harriet Quimby.

Arranged: No.

Captioned: A few with subject.

Finding Aid: No.

Restrictions: The collection, located at the Garber Facility, is available by appointment only.

AS·110

Fairchild Industries, Inc., Collection, 1919–1980

Dates of Photographs: Circa 1920–1970s

Collection Origins

Fairchild Industries, Inc., along with its predecessors and subsidiaries, created the collection primarily as public relations material and secondarily as documentary records of its operations. Sherman M. Fairchild (1896–1971), who invented an aerial camera, founded the company to conduct aerial photography. It subsequently evolved into a variety of corporations through acquisitions, diversification, and mergers, including the following: Fairchild Aerial Camera Corporation, the original company, founded in 1920; Fairchild Aviation Corporation, formed in 1925, which manufactured airframes and engines; Fairchild Engine and Airplane Corporation, formed in 1936, which built trainers and transports through World War II and expanded into drones and missiles, nuclear-powered aircraft, armaments, and materials processing; Fairchild Stratos Corporation, formed in 1961 when Fairchild acquired Hiller Aircraft and Republic Aviation corporations, which developed space applications; and Fairchild Industries, Inc., formed in 1971 after acquiring Swearingen Aviation Corporation, which diversified into electronics and communications. In 1987 Fairchild ended its aircraft production, and in 1989 Banner Industries bought out the company. Studios represented include Associated Photographers, Fairchild Industries, Graphic Studio, Keith Cole Studio, OPPS, Trans World Airlines, Western State Aviation, and Wide World Photos. Fairchild Industries donated the collection to NASM Archives, which assigned it accession numbers 1989-0060 and 1990-0047.

Physical Description

There are 50,550 photographs including color dye coupler photoprints, phototransparencies, and slides and silver gelatin photonegatives and photoprints. Other materials include annual reports, charts, correspondence, financial records, magazines, manuals, manuscripts, motion-picture films, newsletters, newspaper clippings, pamphlets, press releases, phonograph records, schedules, test reports, and videotape cassettes.

Subjects

The photographs document Fairchild Industries operations and products, as well as outside activities and aircraft. Fairchild aircraft depicted include the 12E4, 341, 1099, C-119 Flying Boxcar, F-27, F-105, FC-2, FH-1100, J-5, M-230, Tip Turbojet, UH-5, and XF-84H, as well as Hiller helicopters. There are also images of Boeing, Cessna, and Douglas aircraft, as well as the Dassault Mirage V, Hawker P.1127, Seversky BT-8, and Sikorsky S-40. Aircraft interiors, miniature models, parts, and prototypes are also depicted. Equipment and facilities shown include airfields, assembly lines, construction tools, and factories. Events

documented include air shows; company tours such as a Western trip with executives fishing, gambling, hunting, and wearing cowboy outfits; and meetings. Company operations illustrated include aerial photography and aircraft construction and testing. There are aerial photographs of New York City. There are images of airmail, military, and passenger aircraft made by Fairchild, as well as Fairchild airplanes and helicopters crop dusting, stringing electric lines, and transporting cargo.

Arranged: In series by company name, then by type of material, then by date.

Captioned: Most with subject; some also with Fairchild negative number and studio.

Finding Aid: 1) Item-level transfer lists. 2) Partial box lists.

Restrictions: The collection, located at the Garber Facility, is available by appointment only.

AS·111

Fairchild KS-25 High Acuity Camera System Documentation, 1956–1967

Dates of Photographs: Circa 1960s

Collection Origins

Fairchild Camera and Instrument Corporation created the collection to document the development of its KS-25 aerial camera system for the U.S. Department of Defense between 1956 and 1967. For a history of Fairchild Industries, see *Collection Origins* in *AS·110*. In the mid-1950s the Department of Defense requested an aerial photography system that would use smaller cameras on high-speed aircraft at high altitudes. Fairchild developed the KS-25 High Acuity Camera System, which used a wide-angle, 24" focal-length lens capable of producing high-resolution transparencies. James G. Baker of Spica, Inc., designed the lens, for which he secured a patent. Don Welzenbach donated the collection to NASM, which assigned it accession

number 1986-0028.

Physical Description

There are 14 photographs including silver gelatin photoprints and phototransparencies. Other materials include correspondence, engineering drawings, and reports.

Subjects

The photographs document the Fairchild KS-25 High Acuity Camera System. There are images of the camera, equipment used to test it, and men working with the equipment, as well as aerial views of a suburban housing development.

Arranged: By document type; photographs are in box 1.

Captioned: No.

Finding Aid: Folder list.

Restrictions: The collection, located at the Garber Facility, is available by appointment only.

AS·112

58th Aero Squadron Scrapbook *A.K.A.* Nelson Coon Scrapbook

Dates of Photographs: 1917–1918

Collection Origins

Nelson Coon, a member of the 58th Aero Squadron, created the collection to document his wartime experiences. Coon enlisted in the U.S. Army in July 1917 and joined the 58th when it was activated in August 1918. Renamed the 470th Aero Construction Squadron, the squadron served in England and France. Coon donated the collection to NASM, where it received accession number XXXX-0275.

Physical Description

There are 85 silver gelatin photoprints, mounted in an album.

Subjects

The photographs document Nelson Coon's World War I unit, the 58th Aero Squadron, and the areas surrounding his military bases, especially in England and the southern United States. Army activities documented include constructing buildings, cutting hair, serving on K.P. duty, and playing dice. Base facilities shown include barracks, a carpenter shop, mess halls, and a switchboard in the power house. Images of England include a beach, buildings, landscapes, Roman ruins at Salisbury, sheep, Stonehenge, and villages. U.S. cities shown include New Orleans, Louisiana; Newport News and Richmond, Virginia; and San Antonio, Texas. There are also images of a horse and wagon; Texas landscapes showing cactus, oil wells, and sandstorms; and a Virginia farmhouse.

Arranged: Chronologically.

Captioned: Most with date, location, and subject.

Finding Aid: No.

Restrictions: The collection, located at the Garber Facility, is available by appointment only.

AS·113

1st Aero Squadron Scrapbooks *A.K.A.* Richard T. Pilling Scrapbooks

Dates of Photographs: 1917–1919

Collection Origins

The collection was created to document the activities of the 1st Aero Squadron, a U.S. Army unit that served in France during World War I. Richard T. Pilling donated the collection to NASM, where it received accession number XXXX-0239.

Physical Description

There are 840 silver gelatin photoprints, mounted in albums.

Subjects

The photographs document the U.S. Army 1st Aero Squadron in World War I. Aircraft manufacturers represented include Breguet, Bristol, Fokker, Halberstadt, Hannoveraner, Junkers, Le Pere, Nieuport, Sopwith, Spad, Voisin, and Zeppelin. Other military equipment and vehicles documented include boats, captured guns and tanks, a ferry barge, a German observation balloon, gun emplacements, guns, a streetcar on a beach, a submarine, trains, transport ships, a truck train, wagons, and a wind gauge at a hangar.

There are many portraits of American soldiers, including William H. Neely, Robert Palmer, and a group of officers, shown conducting maneuvers, eating in cafes and restaurants, getting shoeshines, laying signal panels on the ground, lying on beds in barracks, painting a footlocker, posing with aircraft, recovering in a hospital, riding on a train and a transport ship, and shooting. Other portraits include French civilians, German soldiers, and Red Cross doctors and nurses. Events documented include airplane crashes; a band concert on a ship; a funeral procession; and an Army carnival including foot races, a horse show, machine shop display, and a mock air battle.

French towns pictured include Nancy, Paris, Tours, Verdun, and Versailles. Structures shown in exterior and interior views include bridges, castles, cathedrals, farms with windmills, hangars including a Zeppelin hangar under construction, headquarters of the 1st Aero Squadron, hotels, houses, military hospitals, theaters, and train stations. There are also aerial views and landscapes of airfields, bombed buildings, the Brittany coast, city streets and squares, countryside, a field with an ox and plow, graves, the Rhine river, and trenches. Several photographs from this collection are reproduced in this volume's illustrations section.

Arranged: Roughly chronological.

Captioned: Some with location and subject.

Finding Aid: No.

Restrictions: The collection, located at the Garber Facility, is available by appointment only.

AS·114

First Pan American Airways Transatlantic Passenger Flight Scrapbook *A.K.A.* William J. Eck Scrapbook

Dates of Photographs: 1939

Collection Origins

William J. Eck created the collection to document his flight to Europe as a passenger on the first Pan American Airways transatlantic commercial flight. A banker and local government official in Hackensack, New Jersey, Eck served as secretary of the Equitable Trust Company, vice president of Chase National Bank, Hackensack city treasurer, member of the Hackensack City Council, and assistant to the vice president of Southern Railway. Eck was a passenger on the 1939 flight of the Pan American airliner *Dixie Clipper,* which flew from New York to Portugal and France and back. Studios represented include Star Staff. NASM Archives assigned the collection accession number XXXX-0309.

Physical Description

There are 120 silver gelatin photoprints, mounted in a scrapbook. Other materials include baggage claim tickets, correspondence, maps, and newspaper clippings, also mounted in the scrapbook.

Subjects

The photographs document the first Pan American Airways transatlantic flight, including the flying boat *Dixie Clipper,* and the places it visited. There are portraits of the crew and passengers including William J. Eck receiving his ticket, passengers eating, the pilot in the cockpit, and the flight attendants. There are aerial views of New York City and commercial photographs of the Azores islands (including the harbor, an ox cart, and windmills); Marseilles (including the airport), Paris (including buildings and monuments), and other cities in France; and Lisbon, Portugal.

Arranged: Chronologically.

Captioned: Most with subject.

Finding Aid: No.

Restrictions: The collection, located at the Garber Facility, is available by appointment only.

AS·115

Gardiner H. Fiske Scrapbook

Dates of Photographs: 1917–1919

Collection Origins

Gardiner H. Fiske created the collection to document his military service during World War I. After receiving a B.A. from Harvard University in 1914, Fiske enlisted as a flying cadet in Boston in April 1917 and trained at Issoudun and Clermont-Ferrand, France. In January 1918 he was commissioned as a 1st lieutenant in the 20th Aero Squadron. Fiske was discharged in 1919. In the 1920s he became a cotton broker with P.T. Jackson & Company and served on the city airport commission in Boston. NASM Archives assigned the collection accession number XXXX-0227.

Physical Description

There are 140 photographs including silver gelatin photoprints and photonegatives, mounted in a scrapbook. Other materials, also mounted in the scrapbook, include correspondence, maps, military orders, and newspaper clippings.

Subjects

The photographs document Gardiner H. Fiske's flight training and service in Europe during World War I. There are images of the 20th Aero Squadron aircraft, in flight and on the ground. There are photographic reproductions of the insignia of the 11th, 20th, 96th, and 166th Aero Squadrons, which were members of the First Day Bombardment Group, along with a map of the Group's strikes. There are portraits of civilians in towns such as Châteaudun, France; members of the 20th Aero Squadron with their aircraft, including Fiske; and soldiers shown at a table drinking wine, in front of a German shop, on steps with baggage, and

with civilians in France. Other surroundings shown include a cemetery, Liverpool harbor with ships, and military bases. There are also aerial views, probably reconnaissance photographs, some showing falling bombs, and images of automobiles and trains.

Arranged: No.

Captioned: Some with date and subject (mostly illegible).

Finding Aid: No.

Restrictions: The collection, located at the Garber Facility, is available by appointment only.

AS·116

Flight Safety Foundation Collection *A.K.A.* Jerome Lederer Collection, 1925–1965

Dates of Photographs: 1945

Collection Origins

Jerome F. Lederer and other staff of the Flight Safety Foundation (FSF) created the collection to document the foundation's activities. Lederer, FSF's technical director, received an M.S. in aeronautical engineering from New York University in 1925. Lederer worked for the U.S. Air Mail Service as an engineer (1926–1927) and director of aeronautical technology (1927–1929); for Aeronautical Insurance Underwriters as chief engineer (1929–1940); and for the Civil Aeronautics Board as director of the Safety Bureau (1940–1942) and in the Airline War Training Institute (1942–1944). He served as technical director at FSF from 1948 to 1967. Founded in 1945, the FSF was dedicated to improving safety in aviation by advising airlines on accident investigation, airport safety, operational precautions, and weather forecasting. Lederer left FSF to become safety director at NASA, serving until 1974 when he began teaching at the Institute for Safety and Systems Management at the University of Southern California. NASM Archives assigned the collection accession number XXXX-0410.

Physical Description

There are three silver gelatin photoprints. Other material includes charts, correspondence, financial records, news' bulletins, pamphlets, posters, and reports.

Subjects

The photographs are aerial views of Friedrichshagen and Solingen, Germany, including a metal factory. The images show the areas before air raids to illustrate a strategic bombing report.

Arranged: By subject. Photographs are in box three.

Captioned: With location and subject.

Finding Aid: Box list.

Restrictions: The collection, located at the Garber Facility, is available by appointment only.

AS·117

Flodin Photograph Collection *A.K.A.* Isle of Grain Photograph Collection

Dates of Photographs: Circa 1918–1920

Collection Origins

The collection was created to document aircraft at the British Isle of Grain test facility during World War I. The collection's name is now the "Isle of Grain Photograph Collection." The images are reproduced on NASM's Archival Videodisc 2. For information on how to order the videodisc, see the *Collection Origins* field of *AS·1*.

Physical Description

There are 220 silver gelatin photoprints.

Subjects

The photographs document aircraft and aircraft tests

at the Isle of Grain in England. Activities and events documented include aircraft crashes and flights, deck trials on an aircraft carrier, and transporting aircraft. Aircraft, primarily seaplanes, are shown during flights, on airfields, on piers, on water, and outside hangars. There are images of aircraft parts such as flotation gear and machine guns.

Arranged: By videodisc frame number.

Captioned: With subject.

Finding Aid: Caption database listing subject and videodisc frame number. Printouts can be obtained for single photographs or caption lists of photographs with related subjects.

Restrictions: No. The collection is located at the NASM Archives on the Mall. Researchers are encouraged to call or write for an appointment.

newspaper clippings, posters, and reprints, also mounted in the scrapbook.

Subjects

The photographs document balloon flights and stunts by the Flying Allens, from the 1930s to the 1970s. There are also images of ca. 1910 airships, balloons, and biplanes.

Arranged: No.

Captioned: No.

Finding Aid: No.

Restrictions: The collection, located at the Garber Facility, is available by appointment only.

AS·118

Flying Allens Scrapbook, Circa 1933–1979

Dates of Photographs: Circa 1950s–1970s

Collection Origins

The collection was created to document the careers of the Flying Allens, a family of stunt balloonists. In 1875 three Allen brothers, Ira, Comfort, and Martin, began performing balloon ascents and parachute jumps. Sons of Martin and Comfort later took over the act. Comfort's son Edward (Captain Eddy) continued performing stunts until the 1970s, when he was over 80 years old. In the 1930s Edward's four children, Eddie Jr., Gloria, Florence, and Arlene, became the third generation of balloonists, although Gloria was killed in a parachute jump in 1937. Maureen Stamback donated the collection to NASM, where it received accession number 1985-0013.

Physical Description

There are 30 photographs including color dye coupler photoprints and silver gelatin photoprints (some copies), mounted in a scrapbook. Other materials include bumper stickers, correspondence, magazines,

AS·119

Flying Tigers Photographs A.K.A. Walter W. Pentecost Collection

Dates of Photographs: Circa 1941–1942

Collection Origins

Walter W. Pentecost created the collection to document the delivery and assembly of Curtiss P-40 Warhawk fighters to the American Volunteer Group, or Flying Tigers, in Burma just before World War II. For a history of the Flying Tigers, see the *Collection Origins* field of *AS·44*. An employee of the Intercontinent Corporation, Pentecost served as an advance man for the American Volunteer Group and supervised the assembly of the P-40 aircraft. The photographs are reproduced on NASM's Archival Videodisc 2. For information on how to order the videodisc, see the *Collection Origins* field of *AS·1*.

Physical Description

There are 85 silver gelatin photoprints.

Subjects

The photographs document the delivery and assembly of about 100 Curtiss P-40 Warhawk fighters at the American Volunteer Group base in Rangoon, Burma (now Myanmar). Activities documented include construction of hangars and housing, initial assembly, and testing the aircraft. Much of the work shown is being performed by local people. There are also images of equipment, facilities, and supplies such as crated parts, hangars and other buildings, and trains.

Arranged: By videodisc frame number.

Captioned: With subject.

Finding Aid: Caption database listing subect and videodisc frame number. Printouts can be obtained for single photographs or caption lists of photographs with related subjects.

Restrictions: No. The collection is located at the NASM Archives on the Mall. Researchers are encouraged to call or write for an appointment.

AS·120

Harold Fowler World War I Scrapbook

Dates of Photographs: 1917–1919

Collection Origins

World War I ace Harold Fowler (1879–1959) created the collection to document his service during the war. Born in England, Fowler graduated from Columbia University in 1908. In 1913 he became a secretary to Walter Hines Page, the U.S. ambassador to England, and in 1915 he joined the British Royal Flying Corps. When the United States entered the war Fowler transferred to the U.S. Army Air Service and rose to the rank of commanding colonel. Many of the images are commercial photographs of European and World War I scenes. Studios represented include Blazek and C.O. Cauch. NASM Archives assigned the collection accession number XXXX-0277.

Physical Description

There are 285 silver gelatin photoprints, mounted in a scrapbook. Other materials include photomechanical postcards, also mounted in the scrapbook.

Subjects

The photographs document World War I scenes and Harold Fowler's family. Military activities and events documented include aerial combat, airplane crashes, an airship crash, bomb explosions, and submarine sinkings, as well as soldiers loading guns and wiring a communication trench. Military equipment and vehicles documented include airplanes, ammunition, balloons, German guns and submarines, motorcycles, a searchlight, ships, and tanks. Surroundings shown include airfields, bombed buildings, cemeteries (including the grave of Quentin Roosevelt), and landscapes. There are also aerial photographs of cities. People portrayed include European civilians such as girls of Alsace, French marshal Ferdinand Foch, U.S. general John J. Pershing, pilots, soldiers, and Kaiser Wilhelm II. There are also many images of corpses, mainly Germans. Family photographs include a fireplace decorated with flags, dead game birds, a house, hunters, and wagons.

Arranged: No.

Captioned: Some with subject.

Finding Aid: No.

Restrictions: The collection, located at the Garber Facility, is available by appointment only.

AS·121

Ira F. Fravel Collection, 1917–1932

Dates of Photographs: 1919–Circa 1930s

Collection Origins

Ira F. Fravel created the collection to document his service in the balloon division of the U.S. Army Air Service after World War I. Fravel joined the Army in 1900 and graduated from the General Service and Staff College at Ft. Leavenworth, Kansas, in 1904. During World War I he served with the American Expeditionary Force in France, and he remained in Europe

after the war. He later was the commander of Ross Airfield in Arcadia, California. Studios represented include Clinedinst. Kathie J. Walsh donated the collection in 1991, and it received accession number 1991-0056.

Physical Description

There are 35 silver gelatin photoprints. Other materials include correspondence and newspaper clippings.

Subjects

The photographs primarily document Ira F. Fravel's service in Europe after World War I. There are cityscapes and landscapes in France and Germany, including structures such as the Arc du Triomphe de l'Etoile in Paris, the Cologne Cathedral, a governor's house in Germany, and monuments. There are also images of the Rhine river. There are portraits of Fravel and other soldiers, as well as images of U.S. Army balloons and horse races.

Arranged: By type of material, then chronologically.

Captioned: Some with subject.

Finding Aid: No.

Restrictions: The collection, located at the Garber Facility, is available by appointment only.

AS·122

George C. Furrow Papers

Dates of Photographs: Circa 1910–1920s

Collection Origins

Army pilot George C. Furrow created the collection to document his activities. Joining the Army in 1917, Furrow became commanding officer at the Aberdeen Proving Ground, Maryland, and Luke Field in Hawaii. He served as a flying instructor and, after retiring from active duty, joined the Air Corps Reserves. L.D. Furrow donated the collection to NASM, where it received accession number 1992-0005. Photographers and studios represented include E.H. Cunningham and Edgeworth.

Physical Description

There are 580 silver gelatin photoprints, most mounted in scrapbooks. Other materials, some also mounted in scrapbooks, include correspondence, diaries, licenses, logbooks, manuals, maps, and military records.

Subjects

The photographs document George C. Furrow's U.S. Army service and private activities. Individuals portrayed include Furrow, aviator Ruth Law, and actress Mary Pickford. Groups portrayed include Army officers and their families, Army squadrons, children with Santa Claus, Hawaiians, Mexicans, and a minstrel troupe. Officers and their families are portrayed at beaches, at home, in boats, and with automobiles and children's pedal cars. Events documented include aircraft crashes and an Army-Navy football game. Images of Army camps show artillery ranges, barracks, mess halls, and officers' houses. There are images of aircraft, military equipment, railroad car guns, ships, and tanks. Places documented include Honolulu and other parts of Hawaii; Mexican towns; San Benito, Texas; and the Texas-Mexican border region. There are aerial photographs of San Diego and coastal regions. Animals shown include coyotes, leopards, longhorn cattle, rattlesnakes, and tarantulas. Plants depicted include cactus and palm trees.

Arranged: No.

Captioned: A few with subject.

Finding Aid: Folder list.

Restrictions: The collection, located at the Garber Facility, is available by appointment only.

AS·123

Gatchina Days: Reminiscences of a Russian Pilot Photographs

Dates of Photographs: 1984–1990

Collection Origins

Alexander Riaboff (1895–1984) created the collection

to document his activities as a Russian pilot. Riaboff graduated from the Gatchina Military Flying School, located 25 miles from St. Petersburg, and joined the Imperial Russian Air Force just before the Revolution. In 1918 he joined the anti-Communist forces and for the next two years took part in their retreat eastward across Siberia. In 1920 he and his wife escaped to China and three years later emigrated to the United States. Curator of aeronautics Von Hardesty assembled the material and edited the manuscripts for publication in the following book: Alexander Riaboff. *Gatchina Days: Reminiscences of a Russian Pilot.* Edited by Von Hardesty. Washington, D.C.: Smithsonian Institution Press, 1986. NASM Archives assigned the collection accession number 1990-0067.

Physical Description

There are 95 copy silver gelatin photoprints.

Subjects

The photographs document Alexander Riaboff's experiences as a young pilot in Russia between 1916 and 1923. Activities illustrated include Riaboff's participation in World War I, the Russian Revolution, and the Russian civil war, as well as his training at Gatchina Military Flying School and Odessa. There are also portraits of his family.

Arranged: In the order they appear in the book.

Captioned: With page number, negative number, source, and subject.

Finding Aid: No.

Restrictions: No. The collection is located at the NASM Archives on the Mall. Researchers are encouraged to call or write for an appointment.

AS·124

J. Rome Gately Scrapbook

Dates of Photographs: 1914–1918

Collection Origins

J. Rome Gately, who served in the U.S. Navy during World War I, created the collection to document his wartime experiences. Gately served at San Francisco, California; Brunswick, Georgia; and Bay Shore, New York. William R. Gately donated the collection to NASM, where it received accession number 1987-0055.

Physical Description

There are 285 silver gelatin photoprints, mounted in a scrapbook. Other materials include newspaper clippings and military orders, also mounted in the scrapbook.

Subjects

The photographs document the military activities of J. Rome Gately and his fellow U.S. servicemen during World War I. Activities and events documented include aircraft crashes, a band marching, and U.S. armed forces personnel marching in streets and playing cards. Transportation vehicles shown include airships, biplanes, ships, and trains. Buildings and facilities shown include shipyards, a train station, U.S. Navy barracks, and a zoo. People portrayed include children and women, probably Gately's family, and servicemen in flight clothes. There are also aerial photographs and landscapes.

Arranged: By image number.

Captioned: With image number; a few also with subject, handwritten.

Finding Aid: No.

Restrictions: The collection, located at the Garber Facility, is available by appointment only.

AS·125

German Commercial Zeppelins Scrapbooks

Dates of Photographs: 1900–1938

Collection Origins

Unknown. Studios represented include Associated Press. NASM Archives assigned the collection accession number XXXX-0252.

Physical Description

There are 410 photographs including cyanotypes and silver gelatin photoprints, mounted in scrapbooks. Other materials, some also mounted in the scrapbooks, include advertisements, articles, a book, charts, diagrams, flight data records, maps, newspaper clippings, passenger lists, passenger regulations, photomechanical postcards, and schedules.

Subjects

The photographs document commercial Zeppelin flights, mainly in Germany in the 1930s. There are images of early airships from around 1900, the *Graf Zeppelin,* and the *Hindenburg,* with their interiors including bars, control rooms, a crew's mess hall with a portrait of Adolf Hitler, dining rooms, engine gondolas, gas cells, kitchens, passenger cabins, radio equipment, and smoking rooms. People shown include airship designer Hugo Eckener with a Zeppelin crew, boxer Max Schmelling returning by Zeppelin after his victorious fight with Joe Louis, members of an Italian youth organization looking at a Zeppelin, passengers at the entrance to a hangar in Frankfurt am Main, Captain H. von Schiller, and workers constructing Zeppelins and loading provisions. Events documented include airship take-offs, landings, and crashes; a funeral for crew members; and the *Hindenburg* in flight over the stadium during the 1936 Olympics in Berlin. There are aerial photographs of airships in flight and cities, harbors, and landscapes worldwide. There are also photographic reproductions of cartoons showing life aboard airships, as well as an image of a package delivered by Zeppelin. Two photographs from this collection are reproduced in this volume's illustrations section.

Arranged: By subject.

Captioned: Most with subject; some also with date.

Finding Aid: No.

Restrictions: The collection, located at the Garber Facility, is available by appointment only.

AS·126

German World War I Scrapbook

Dates of Photographs: 1908–1919

Collection Origins

Willy Stuppe, a German soldier who served as a motorcycle rider in World War I, created the collection to document his experiences, as well as those of his brother Alfred, a pilot, before and during the war. Willy Stuppe gave the scrapbook to Martha Heller Power, who gave it to Kevin Skinner. Skinner donated it to NASM, where it received accession number 1991-0037.

Physical Description

There are 450 silver gelatin photoprints, most mounted in an album.

Subjects

The photographs document Germany military activities in World War I. Activities illustrated include cavalry marching and soldiers drilling, eating in restaurants, loading bombs onto aircraft, and swimming. Aircraft depicted include a balloon and airplanes such as a Fokker F.III, Gotha G.IV, and an L.V.G. C.III. There are portraits of an army platoon, a machine gunner in an aircraft, medical staff and wounded soldiers at a hospital, and pilots with frostbite. Other war images include aircraft crashes, bombed buildings, bombs, a motorcycle, and trenches. There are aerial pictures of cities and clouds. There are also pre-war images of Germany including cityscapes, houses in the country, landscapes, public performances, and rivers, as well as portraits of German soldiers Alfred and Willy Stuppe as children and of a bride and groom.

Arranged: No.

Captioned: Most with date, place, and subject in German.

Finding Aid: No.

Restrictions: No. The collection is located at the NASM Archives on the Mall. Researchers are encouraged to call or write for an appointment.

AS·127

Howard W. Gill Scrapbooks

Dates of Photographs: 1908–1912

Collection Origins

Pioneer aviator Howard W. Gill (1883–1912) created the collection to document his career. Gill learned to fly in 1910 from instructors Cliff Turpin and Alan H. Walsh and received Fédération Aéronautique Internationale (FAI) license 29. The same year he joined Hillery Beachey and engine manufacturer Harry Dosch to produce, under permission from Glenn H. Curtiss, a nickel-plated aircraft called the Gill-Dash. The Gill-Dash was the first airplane without a front rudder, a modification later adopted by Curtiss and the Wrights. In 1911 and 1912 Gill worked as an instructor for the Wright company and then for the Burgess Company. He also helped finance and edit *American Weekly Aviation Magazine*. He held the flight endurance record at the time of his death in a crash during a performance. NASM Archives assigned the collection accession number XXXX-0253.

Physical Description

There are 480 silver gelatin photoprints, mounted in scrapbooks. Other materials include correspondence, invitations, newspaper clippings, a pin, photomechanical postcards, and ribbons, also mounted in the scrapbooks.

Subjects

The photographs document the aviation activities of aviator and engineer Howard W. Gill. Aircraft depicted include airships, balloons, and the Gill-Dash airplane. There are also details of aircraft and images of parts such as engines. Construction activities documented include constructing and repairing aircraft and inflating an airship. Factory facilities shown include the general assembly area, metal-fitting department, offices, paint shop, radiator department, and sewing department. Events documented include aircraft crashes, aircraft races, air shows, car races, and parades.

Arranged: No.

Captioned: No.

Finding Aid: No.

Restrictions: No. The collection is located at the NASM Archives on the Mall. Researchers are encouraged to call or write for an appointment.

AS·128

J. Guy Gilpatric Photograph Collection

Dates of Photographs: Circa 1912–1918

Collection Origins

Aviator J. Guy Gilpatric (1896–1950) created the collection to document his activities before and during World War I. At age 16 Gilpatric became the youngest licensed pilot at the time. In 1912 he set the altitude record and in 1913 participated in the New York Times Aerial Derby. He also worked for Glenn H. Curtiss and served in the U.S. Army Air Service during World War I. During the 1930s he published a number of books. The photographs are reproduced on NASM's Archival Videodisc 2. For information on how to order the videodisc, see the *Collection Origins* field of *AS·1*.

Physical Description

There are 175 silver gelatin photoprints.

Subjects

The photographs document J. Guy Gilpatric's flying activities before and during World War I. Aircraft shown include airships and airplanes such as a Morane Saulnier Parasol, as well as Lafayette Escadrille and U.S. Army airplanes. Combat images show artillery, bombed buildings, corpses, and trenches. Other surroundings shown include hangars and streets. There are also aerial reconnaissance photographs. There are portraits of Gilpatric as an instructor and as a U.S. Army aviator, along with other Army pilots, infantrymen, and members of the Lafayette Escadrille.

Arranged: By videodisc frame number.

Captioned: With subject.

Finding Aid: Caption database listing subject and videodisc frame number. Printouts can be obtained for single photographs or caption lists of photographs with related subjects.

Restrictions: No. The collection is located at the NASM Archives on the Mall. Researchers are encouraged to call or write for an appointment.

AS·129

J. Guy Gilpatric Scrapbooks

Dates of Photographs: Circa 1915–1917

Collection Origins

Aviator J. Guy Gilpatric created the collection to document his flying activities. For a biography of Gilpatric, see the *Collection Origins* field of *AS·128*. NASM Archives assigned the collection accession number XXXX-0220.

Physical Description

There are 490 silver gelatin photoprints, mounted in scrapbooks. Other materials include newspaper clippings, also mounted in the scrapbooks.

Subjects

The photographs document aircraft of the 1910s, J. Guy Gilpatric's flying activities, his friends, and World War I scenes. Aircraft manufacturers and models represented include Benoist flying boats; Curtiss JN-2, JN-3, and JN-4; Farman; Heinrich; Letord 4; Nieuport; Niles Looper; Paulson B-2; Sloan; Spad XIII; Voisin; and Zeppelin airships. Places documented include the Curtiss aviation school in Toronto; Garden City, New Jersey; and Hempstead and Mineola, New York.

Activities and events documented include aerobatics, aircraft construction and crashes, aviation exhibits, and a bullfight. Individuals portrayed include Swedish-Canadian pilot Frithiof G. Ericson, Gilpatric, Canadian engineer John A.D. McCurdy, and U.S. pilot Arthur R. Smith. Groups portrayed include construction crews, flight students, and the staff of Curtiss Aeroplane and Motor Company.

World War I scenes illustrated include battlefields, bomb craters, bombed buildings, corpses, soldiers, and trenches; European towns and villages, probably French and German, with local people and soldiers; and military camps and equipment including bombs, guns, and tanks. There are also aerial reconnaissance photographs depicting roads and geographic features.

Arranged: Loosely by date and subject.

Captioned: A few with date and subject.

Finding Aid: No.

Restrictions: The collection, located at the Garber Facility, is available by appointment only.

AS·130

Glenn L. Martin Company Photograph Archives

Dates of Photographs: Circa 1935–1965

Collection Origins

The Glenn L. Martin Company created the collection to document its operations. The company's founder, Glenn L. Martin (1886–1955), established an airplane factory in 1909 and incorporated it as the Glenn L. Martin Company, in Santa Ana, California, in 1911. The next year the company moved to Los Angeles, where it built sports aircraft and military aircraft for the U.S. Army and foreign countries. In 1916 Martin merged with the Wright Company, forming the Wright-Martin Aircraft Corporation. The merger dissolved the same year, leaving the Glenn L. Martin Company of Cleveland, which built Martin bombers. In 1929 the factory moved to Middle River, Maryland. In the 1930s Martin built commercial flying boats and during World War II supplied military aircraft for the U.S. Army and Navy.

Physical Description

There are 142,000 photographs including color dye coupler photoprints and silver gelatin photonegatives and photoprints.

Subjects

The photographs document Glenn L. Martin Company operations from the 1930s to the 1960s, particularly research and development. Activities documented include aircraft construction, repairs, and tests; missile launches; and staff training. Martin aircraft depicted include the 139W, 156 Clipper, 170, A-30, AM-1 Mauler, B-10B, B-26 Marauder, B-57 Canberra, PBM, Viking missile, PB2M, XB-51, and XBTM. There are images of equipment, facilities, and materials includ-

ing factories, laboratories, offices, testing apparatus, and tools. Aircraft parts shown include armaments, cabins, cargo compartments, cockpits, engines, heat shields, instruments, landing gear, power plants, propellers, turrets, and wings. There are also publicity images of displays, personnel, social functions, and visitors.

Arranged: Photonegatives by negative number; photoprints by aircraft or activity shown.

Captioned: Photonegatives on the envelope with negative number and subject; some photoprints with negative number.

Finding Aid: Incomplete registers, arranged by date and negative number, listing date, model, negative number, and title.

Restrictions: The Glenn L. Martin Company retains the copyright; researchers must obtain permission from the company to publish the photographs. The collection is located at the NASM Archives on the Mall. Researchers are encouraged to call or write for an appointment.

AS·131

Goddard Report of August 1929 Photographs

Dates of Photographs: 1929

Collection Origins

Rocketry pioneer Robert H. Goddard (1882–1945) created the collection to document some of his experiments in 1929. After receiving a Ph.D. in physics from Clark University in 1911, Goddard began conducting rocket and jet propulsion research with the support of the Smithsonian Institution while teaching at Clark. In 1926 he launched the first liquid-propellant rocket. With additional funding from the Guggenheim Foundation, he moved his research to New Mexico, where he worked until 1940. During World War II Goddard worked in Annapolis, Maryland, developing jet engine systems for the Navy. The photographs originally accompanied a written report, but its location is no

longer known. The photographs are reproduced on NASM's Archival Videodisc 2. For information on how to order the videodisc, see the *Collection Origins* field of *AS·1*.

Physical Description

There are 400 silver gelatin photoprints, bound into booklets.

Subjects

The photographs document a series of Robert H. Goddard's rocket experiments in 1929. The images show equipment and test apparatus, Goddard's laboratory and outdoor experiment sites, and rockets and rocket parts. There are portraits of Goddard with his rockets.

Arranged: By illustration number (presumably keyed to missing report).

Captioned: With illustration number; on caption database with illustration and videodisc frame number.

Finding Aid: Caption database lists illustration and videodisc frame number. Printouts can be obtained for single photographs or caption lists of photographs with related subjects.

Restrictions: No. The collection is located at the NASM Archives on the Mall. Researchers are encouraged to call or write for an appointment.

AS·132

Goodyear Aerospace Collection, 1968–1983

Dates of Photographs: Circa 1980

Collection Origins

Goodyear Aerospace Corporation created the collection to document its activities in the 1970s and early 1980s. The original Goodyear Tire and Rubber Company (GTRC) produced balloons for the U.S. Army before World War I. After the war, GTRC acquired Zeppelin airship patent rights to create the Goodyear-Zeppelin Corporation (GZ) as a division to produce

balloons and airships. When all of the company's U.S. Navy rigid airships crashed soon after they came into use, GZ began making non-rigid airships (blimps). Since World War I, GZ and its successor, Goodyear Aerospace Corporation, have produced over 300 airships. After an unsuccessful attempt to revive its market in the 1970s, Goodyear Aerospace was bought by the Loral Corporation in 1987 and continued as a Loral division. NASM Archives assigned the collection accession number 1988-0128.

Physical Description

There are 19 color dye coupler photoprints. Other materials include advertisements, Congressional hearing transcripts, and pamphlets.

Subjects

The photographs show aircraft such as a Boeing B-52 using a tactical munitions dispenser, a container which releases many small ordnance items.

Arranged: No.

Captioned: Some with subject.

Finding Aid: Item list.

Restrictions: The collection, located at the Garber Facility, is available by appointment only.

AS·133

Goodyear Balloon School Collection

Dates of Photographs: Circa 1917–1918

Collection Origins

The collection, possibly created by the Goodyear Tire and Rubber Company or the U.S. Navy, documents a Goodyear balloon school which trained Navy personnel during World War I. The collection is reproduced on NASM Archival Videodisc 7. For information on how to order the videodisc, see the *Collection Origins* field of *AS·1*.

Physical Description

There are 45 silver gelatin photoprints.

Subjects

The photographs document operations at a Goodyear balloon training school during World War I. Activities documented include balloon flights and objects being parachuted. Equipment and facilities documented include balloons and baskets, buildings, hangars, and tents. There are also portraits of students.

Arranged: By videodisc frame number.

Captioned: With videodisc frame number.

Finding Aid: Caption database listing videodisc frame number.

Restrictions: No. The collection is located at the NASM Archives on the Mall. Researchers are encouraged to call or write for an appointment.

AS·134

Goodyear ZPG-3W Collection

Dates of Photographs: Circa 1959–1970s

Collection Origins

Unknown. Thomas R. Jakmides donated the collection to NASM, where it received accession number 1989-0075. Studios represented include Goodyear.

Physical Description

There are 285 photographs including color dye coupler photoprints and silver gelatin photoprints. Other material includes parts-breakdown forms.

Subjects

The photographs document the Navy Type ZPG-3W, an airship made by Goodyear in the late 1950s for the U.S. Navy. Construction images include men and women sewing seams and packing fabric for transportation. The airship is shown being delivered to the Navy, being released, in flight, and in hangars. Images of the airship interior include bunks, the cockpit, and the kitchen. There are also photographs of other Navy airships and portraits of Goodyear employees and executives, Navy officers, and sailors.

Arranged: By subject.

Captioned: Some with subject.

Finding Aid: Item list.

Restrictions: The collection, located at the Garber Facility, is available by appointment only.

AS·135

Hans Groenhoff Photograph Collection

Dates of Photographs: 1933–1967

Collection Origins

Hans Groenhoff (1906–1985) created the collection during his career as an aviation photographer. An immigrant from Germany, Groenhoff studied law at the University of Heidelberg before coming to New York in 1927. Already a pilot, Groenhoff began taking pictures when he inherited two cameras. By 1937 his photographs began appearing regularly in aviation publications, and he became a staff photographer for Frank Tichenor Publications, publishers of *Aero Digest* and *Sportsman Pilot.* Operating at New York area airports, Groenhoff worked later as a free-lance photojournalist, publishing aviation articles and pictures in such magazines as *Colliers, Esquire, Life,* and *Saturday Evening Post,* as well as creating publicity shots for manufacturers such as Aeronca, Beech, Cessna, Grumman, and Piper.

Before World War II Groenhoff demonstrated light aircraft for the U.S. Army while photographing the early military aircraft, and during the war he took pictures of U.S. aircraft for magazines and newspapers, the armed forces, and manufacturers. Groenhoff continued his free-lance work after the war and in 1954 moved to Florida, where he specialized in publicity for new Piper, Beech, and Cessna aircraft. Shortly afterward he began working for the Bahamas Ministry of Tourism, taking aerial views of the islands. He moved to the Bahamas in 1966 and soon retired from active work. These photographs have appeared in numerous publications such as the following: 1) Hans Groenhoff. "Planes Are Photogenic." *Air Trails Pictorial* (April 1948): 30–31, 98–100. 2) E.T. Wooldridge.

Focus on Flight: The Aviation Photography of Hans Groenhoff. Washington, D.C.: Smithsonian Institution Press, 1985.

Physical Description

There are 17,230 photographs including color dye coupler phototransparencies and silver gelatin photonegatives and photoprints (most contact sheets).

Subjects

The photographs document aircraft and aviation events, primarily in the 1930s and 1940s, as well as the Caribbean region in the 1960s. Aircraft shown include an Aeronca C-3 on floats, Aeronca Chief, Arrow Sport, Beech 17 Staggerwing, Boeing 307 Stratoliner, Cessna Skymaster, Douglas DC-4 prototype, Fairchild 24 on floats, Goodyear blimp, Grumman Gulfhawk, Lockheed Electra, Lockheed Vega, Martin B-10, Piper Cub on skis, Rhönsperber sailplane, Ryan SC, Savoia Amphibian, Stinson Reliant, Waco CTO Taper Wing, and Waco OX biplane. Airfields and facilities depicted include the aviation building at the New York World's Fair in 1939, a blimp hangar, a Piper aircraft factory, and Roosevelt Field in New York. There are also aerial views of Florida; the Newark, New Jersey, airport; and New York City. Events documented include the All-American Air Maneuvers in Miami; Cleveland Air Races; early paratrooper training; glider meets in the Catskills and Elmira, New York; opening day at La Guardia Field in New York City; and ship-to-shore transatlantic airmail flights. People portrayed include aviators Jacqueline Cochran, Frank T. Coffyn, Luis de Florez, Ruth Nichols, Alex Papana, and Alford J. Williams; cartoonist Zack T. Mosley; and executives Howard Hughes and Paul W. Kollsman. There are also photographs, including aerial views, of the Bahamas; Barbados; Curaçao; Kingston, Jamaica; and Trinidad.

Arranged: In four series by format. 1) Contact prints, by roll and frame number. 2) Photoprints, by frame number. 3) Photonegatives, by roll and frame number. 4) Phototransparencies, some alphabetically by manufacturer and some grouped by location.

Captioned: No.

Finding Aid: List of contact prints, giving subject of each roll.

Restrictions: No. The collection is located at the NASM Archives on the Mall. Researchers are encouraged to call or write for an appointment.

AS·136

Grumman SA-16 Albatross Crash Research Collection, 1951–1985

Dates of Photographs: 1980

Collection Origins

James A. O'Neill assembled the collection to document his research on the 1952 crash of a U.S. Air Force Grumman SA-16 Albatross. The airplane was flying on a night navigation mission from Mountain Home Air Force Base, Idaho, to the San Diego Naval Air Station. After encountering problems, the seven-member crew parachuted to safety, and the Albatross, on automatic pilot, flew about 20 miles before crashing in the Panamint Range in California. The wreckage remained in the mountains, where O'Neill examined and photographed it in 1980. Studios represented include the U.S. Navy. NASM Archives assigned the collection accession number 1989-0129.

Physical Description

There are 30 photographs including color dye coupler photoprints and slides and silver gelatin photoprints (some copy). Other material includes correspondence, magazine clippings, and reports.

Subjects

The photographs document the wreckage of a U.S. Air Force airplane, a Grumman SA-16 Albatross, in 1980. There are images of men examining the wreckage and of the surrounding mountains. There are also copy photographs of a Grumman F4F Wildcat fighter in World War II and a Grumman SA-16 Albatross in 1955.

Arranged: Correspondence chronologically. Photographs separate, unarranged.

Captioned: A few with subject.

Finding Aid: Item-level transfer list.

Restrictions: The collection, located at the Garber Facility, is available by appointment only.

AS·137

Terry Gwynn-Jones Slide Collection

Dates of Photographs: Circa 1983

Collection Origins

Terry Gwynn-Jones (1933–), an Australian aviation historian, assembled the collection in preparation for his book: *The Air Racers: Aviation's Golden Era, 1909–1936*. London: Pelham Books, 1984. Before joining Australia's Department of Civil Aviation, Gwynn-Jones spent fourteen years as a fighter pilot and jet instructor in the British, Canadian, and Australian air forces. With pilot Denys Dalton he set an around-the-world speed record for piston-engined aircraft in 1975. He has published several books on aviation and contributed to the Time-Life *Epic of Flight* series. The images in the collection are copies of original silver gelatin lantern slides, which were collected by Gwynn-Jones and hand-tinted by Rosie Bonwick. The photographs are reproduced on NASM's Archival Videodisc 2. For information on how to order the videodisc, see the *Collection Origins* field of *AS·1*.

Physical Description

There are 150 color dye coupler slides (copies).

Subjects

The photographs document aviation in Australia, Europe, and the United States from 1909 to the 1930s, primarily at air races. Aircraft shown include Antoinettes and other airplanes made by Blériot, Boeing, Deperdussin, Douglas, Farman, Fokker, Morane, Sopwith, Travel Air, and Vickers, as well as balloons. Aviators portrayed include Louis Blériot, Glenn H. Curtiss, Arthur E. Goebel, Claude Grahame-White, Howard Hughes, Hubert Latham, Louis Paulhan, and Jules Védrines. There are images of aircraft crashes, flights, and hangars.

Arranged: By videodisc frame number.

Captioned: No.

Finding Aid: Caption database listing videodisc frame number.

Restrictions: Terry Gwynn-Jones retains the copy-

right. For commercial uses of the images, written permission must be received from him at the following address: 14 Garnet Street, Clayfield/Brisbane, Queensland 4011, Australia. The collection is located at the NASM Archives on the Mall. Researchers are encouraged to call or write for an appointment.

AS·138

Andrew G. Haley Papers, 1939–1967

Dates of Photographs: 1944–1958

Collection Origins

Attorney Andrew G. Haley (1904–1966) created the collection to document his involvement with astronautics and space law. After receiving an L.L.B. from Georgetown University Law School in 1928, Haley helped draft communication law as a Congressional aide, worked for the Federal Radio Commission and its successor the Federal Communications Commission from 1933 to 1939, and then entered private practice. In 1942 he became a major in the U.S. Army Air Forces' Judge Advocate General's Office. After his discharge the same year he founded the Aerojet Engineering Corporation (later Aerojet-General Corporation), serving as its president and managing director until 1945. Haley then became involved in promoting space exploration, serving in the International Astronautical Federation (IAF) as vice president (1951–1953), president (1957–1958), and general counsel (1959–1966); in the American Rocket Society as vice president (1953), president (1954), and counsel (1955–1963); and in the IAF's International Academy of Astronautics and International Institute of Space Law, both of which he helped found in 1960. Studios represented include Northrop Aircraft. NASM Archives assigned the collection accession number XXXX-0200.

Physical Description

There are 75 silver gelatin photoprints. Other materials include correspondence, financial records, flight logs, legal documents, magazine clippings, manuals, manuscripts, maps, membership lists, minutes, newspaper clippings, newspapers, notes, pamphlets, periodicals, programs, reports, and scrapbooks.

Subjects

The photographs are of aircraft, spacecraft, and people associated with Andrew G. Haley. Aircraft and spacecraft documented include the CAS "Charm" High Altitude Rocket at an exhibit and the Northrop MX-324, the first American rocket-driven military airplane. People portrayed include an Egyptian man, people in a sleigh in Czechoslovakia, and Vladimir Kopal. There are also photographic reproductions of journal articles.

Arranged: By subject.

Captioned: Some with date and subject.

Finding Aid: Folder list.

Restrictions: The collection, located at the Garber Facility, is available by appointment only.

AS·139

Randolph F. Hall Papers, 1917–1970

Dates of Photographs: 1933–1948

Collection Origins

Aeronautical engineer and inventor Randolph F. Hall created the collection to document his personal and professional activities. Hall began his career in 1915 as a draftsman at the Thomas Brothers Aeroplane Company and became an engineer at Standard Aircraft Corporation in 1917. During World War I, while serving in the technical branch of the U.S. Air Service, he earned degrees in mathematics and mechanical engineering at the American Expeditionary Forces University in France. After the war Hall became assistant engineer at the Thomas-Morse Aircraft Corporation, and in 1928 he formed Cunningham-Hall Aircraft Corporation with Francis E. Cunningham and James C. Dryer. Hall left Cunningham-Hall in 1941 to join Bell Aircraft Corporation, where he stayed until his retirement in 1959. During his career, Hall received over 40 patents, including a high-lift wing used in the Guggenheim Safe Aircraft Competition of 1929. NASM Archives assigned the collection accession number XXXX-0169.

Physical Description

There 55 silver gelatin photoprints. Other materials include charts, correspondence, manuscripts, newspaper clippings, periodicals, reports, and scrapbooks.

Subjects

The photographs document aircraft development tests and bird flight. Tests illustrated include miniature aircraft models and wings in smoke and wind tunnels. Birds such as auks, finches, gannets, and puffins, are shown flying, landing, and turning. There are also photographs of a missile launcher and portraits of men playing catch on a military base and searching for a crash.

Arranged: By subject.

Captioned: Some with date and subject.

Finding Aid: No.

Restrictions: The collection, located at the Garber Facility, is available by appointment only.

AS·140

William J. Hammer Collection

Dates of Photographs: 1900–1973

Collection Origins

Engineer William J. Hammer (1858–1934) created the collection to document his involvement in aeronautical technology of the late 19th and early 20th centuries. Hammer attended high school in Newark, New Jersey, worked under Thomas A. Edison from 1879 to 1896, and became a consulting electrical engineer in New York, where he associated with such aviation pioneers as Samuel P. Langley, Hiram S. Maxim, Alberto Santos-Dumont, and Ferdinand von Zeppelin. He belonged to the Aero Club of America from 1905 until 1908, when he and other members, in protest against the club's emphasis on ballooning, left to form the Aeronautical Society of New York. The society's advocacy of aeronautical science influenced American avia-

tion, and, although the society disbanded in 1918, its members continued to support aeronautical experimentation. Hammer collected material on technology throughout his life. This portion of his collection, donated by IBM in 1961, relates to the early years of flight. These photographs were used in the 1960 National Air Museum exhibit, "The Beginnings of Flight." Photographers and studios represented include G.V. Buck, Maurey Garber, Gates-Day Aircraft Corporation, Edwin Lerick, and OPPS. NASM Archives assigned the collection accession number XXXX-0074. The collection is reproduced on NASM's Archival Videodisc 2. For information on how to order the videodisc, see the *Collection Origins* field of *AS·1*.

Physical Description

There are 540 photographs including collodion gelatin photoprints (POP), color dye coupler photoprints, and silver gelatin photoprints (some copies). Other materials include articles, correspondence, newspaper clippings, and scrapbooks.

Subjects

The photographs document early aircraft, aviation events, and aviators. Aircraft depicted include airplanes such as Blériots, a Breguet 14, a Caproni, a Spad, and Wright Flyers; airships such as the U.S.S. *Akron;* balloons; gliders; and man-lifting kites such as Alexander Graham Bell's tetrahedral kite. Some of the images are close-ups of aircraft construction showing details such as the placement of wing struts. Events documented include the first U.S. aeronautical exhibit in 1906 and an international balloon competition in Paris in 1900, including aerial shots of Paris. People portrayed include William J. Hammer and aviators Harold N. Brown, Luis de Florez, and Wilbur Wright. A photograph from this collection is reproduced in this volume's illustrations section.

Arranged: By videodisc frame number.

Captioned: Most with subject.

Finding Aid: 1) Box list. 2) Caption database listing subject and videodisc frame number. Printouts can be obtained for single photographs or caption lists of photographs with related subjects.

Restrictions: The collection, located at the Garber Facility, is available by appointment only.

AS·141

Julian R. Hanley Scrapbook

Dates of Photographs: 1927–1932

Collection Origins

Julian R. Hanley assembled the collection to document historical aircraft. Hanley donated the collection to NASM, where it received accession number XXXX-0304.

Physical Description

There are 75 silver gelatin photoprints (some hand-tinted), mounted in an album.

Subjects

The photographs document historical aircraft and aviation events. Aircraft depicted include American Eagles, Boeing transports, Breese monoplanes, Curtiss Hawks, Curtiss JN-4D2s, De Havilland DH-4s, Douglas World Cruisers, Fairchild monoplanes, Fokker Universals, Loening Cabin Amphibians, Nieuports, Ryan monoplanes including the Ryan NY-P *Spirit of St. Louis,* Spads, Stearman biplanes and monoplanes, Swallows, the Thaden metal monoplane, Thomas Morse Scouts, Travel Air monoplanes including the *City of Oakland* and *Oklahoma,* Waco 10s, and Wright Navy airplanes. Events shown include an airmail plane landing, the Pacific Air Race (1927), a parachute jump, and the transfer of mail from an airplane to a truck. There is also a portrait of Charles A. Lindbergh.

Arranged: No.

Captioned: With name of aircraft or subject.

Finding Aid: No.

Restrictions: The collection, located at the Garber Facility, is available by appointment only.

AS·142

George B. Harrison Collection, 1904–1979

Dates of Photographs: 1910–1921

Collection Origins

Balloonist and businessman George B. Harrison (1873–1930) created the collection to document his aeronautical activities. After graduating from the University of Michigan, Harrison worked for newspapers (1898–1903, 1908–1915), for the Louisiana Purchase Exposition (1903–1905), in printing and lithography (1905–1907), and in the motion-picture industry (1915–1917). He received Fédération Aéronautique Internationale Balloon Certificate no. 32, becoming the first licensed balloon pilot west of St. Louis. In 1910 he helped arrange the first international air meet in the United States, at Dominguez Field in Los Angeles. In 1910 and 1911 he briefly associated with the Wright Airplane Company and Glenn L. Martin Company. Harrison joined the U.S. Army when the United States entered World War I, attending ground school in Texas and balloon school in Nebraska. After being discharged, he served as airport inspector in Los Angeles County (1920–1921) and as director of Universal Institute of Aeronautics until his death. Photographers and studios represented include Jimmy Hare of *Collier's Weekly,* Harris & Ewing, E. Percy Noel, and the U.S. Navy. NASM Archives assigned the collection accession number 1987-0012.

Physical Description

There are 445 photographs including silver gelatin photonegatives and photoprints. Other materials include certificates, charts, correspondence, manuscripts, maps, and newspaper clippings.

Subjects

The photographs document aircraft and aviation events in the 1910s. Activities documented include balloon inflations, other flight preparations, and people erecting a tent. Aircraft depicted include airships, an advertising balloon, an airplane with folded wings, and other airplanes such as a Blériot, a Douglas Cloudster, a Martin seaplane, a Voisin biplane, and a Wright Flyer. Equipment and facilities shown include an airship mooring mast, a car carrying a packed balloon, hangars, and a Lockheed airplane construction shop.

Events documented include air races; crashes; an international race at Asbury Park, New Jersey; the last flight of the balloon *United States;* a night flight with flares; the Panama-Pacific International Exposition in 1916 including fairgrounds and a roller coaster; a record-setting high-altitude flight; and a wedding party ascending in a balloon. People portrayed include aviation expert Augustus M. Post; aviators Frank Clarke, Arch Hoxsey, A. Roy Knabenshue, Phil O. Parmalee, Louis Paulhan, and Blanche Stuart Scott; manufacturer Glenn L. Martin; and George L. Bumbaugh. There are also aerial views of cities such as Los Angeles, San Francisco, and Santa Monica, California; clouds; and landscapes; as well as images of a ship and a train station.

Arranged: By subject.

Captioned: Some with date and subject.

Finding Aid: No.

Restrictions: The collection, located at the Garber Facility, is available by appointment only.

AS·143

Harvard-Boston Air Meet Photographs *A.K.A.* Thomas G. Foxworth Collection

Dates of Photographs: 1992

Collection Origins

Aviation specialist Thomas G. Foxworth assembled the collection to document the 1910 Harvard-Boston Aero Meet. He loaned the collection to NASM, which copied most the images and assigned them accession number 1992-0016.

Physical Description

There are 120 copy silver gelatin photoprints.

Subjects

The photographs document the 1910 Harvard-Boston

Aero Meet. Aviatiors portrayed include Harry Atwood, Glenn H. Curtiss, Cromwell Dixon, Clifford B. Harman, Horace F. Kearny, A.V. Roe, Augustus M. Post, and Charles F. Willard. There are also portraits of a boy with a miniature model airship, spectators including first lady Helen Taft, and time-keepers with watches. Activities documented include painting numbers on the scoreboard and stacking lumber for the grandstand. There are images of aircraft crashes, landings, and take-offs, as well as hangar interiors, a miniature model battleship for bombing demonstrations, and pylons.

Arranged: No.

Captioned: With assigned number and subject.

Finding Aid: Caption list giving assigned number and subject.

Restrictions: The collection, located at the Garber Facility, is available by appointment only.

AS·144

Hawthorne Flying School Collection *A.K.A.* Beverly "Bevo" Howard Collection

Dates of Photographs: 1941–1946

Collection Origins

Aviation promoter and stunt pilot Beverly ("Bevo") Howard (1914–1971) created the collection to document his career as an aviation school administrator. Howard first flew solo in 1931, at the age of 16, and the following year began working at Hawthorne Aviation, becoming president of the company by 1936. For the next two decades the Hawthorne Aviation schools trained thousands of pilots from all over the world, including military pilots from France, Pakistan, and the United States.

In 1936 Howard also began a two-year term with Eastern Airlines, at 21 the youngest airline pilot in the United States. In 1938 Howard performed the first outside loop in a light aircraft. He won the National Lightplane Aerobatic Championship for the next three

years, and won the International Aerobatic Championship in 1946, 1947, and 1949. He died in a crash caused by engine failure during an airshow stunt.

These photographs were published in the Hawthorne Aviation newsletter, *Hawthorne Prop Wash*. Photographers and studios represented include Harold Black, Broody, Hans Groenhoff, P.M. Hannum, Jacobs Photo Service, Reilly, and Sargeant Studios. NASM Archives assigned the collection accession number XXXX-0414.

Physical Description

There are 800 photographs including silver gelatin photonegatives and photoprints. Other materials include class books, newsletters, newspaper clippings, and scrapbooks.

Subjects

The photographs document the activities of the Hawthorne Aviation schools, especially the training of U.S. Army Air Forces pilots during World War II. Activities shown include demonstrating flights with miniature model aircraft; drinking at a bar; exercising; marching in parades; putting on boots, goggles, and other flight gear; purchasing war bonds; riding a company bus; running to airplanes for take-off; tending instruments; and working on aircraft. Aviation school locations shown include Fayetteville, North Carolina; Jennings Airport; and Rocky Mountain Municipal Airport. Equipment and facilities depicted include airfields with aircraft, ambulances, campuses, classrooms with training equipment, control towers, a dining room, a display room, fire trucks, hangars, offices, radio apparatus, and a supply room. There are portraits of students, including Asians and women, in individual and class pictures, and U.S. Army Air Forces enlisted men and officers. Several photographs from this collection are reproduced in this volume's illustrations section.

Arranged: By type of material. Photographs are in box 1.

Captioned: With file number; some also with name or subject.

Finding Aid: Box list.

Restrictions: The collection, located at the Garber Facility, is available by appointment only.

AS·145

Karl G. Henize Papers

Dates of Photographs: 1950s–1980

Collection Origins

Astronomer and astronaut Karl G. Henize (1926–) created the collection to document his career. After serving in the U.S. Naval Reserve (1944–1946) Henize became an observer at the University of Michigan's Lamont-Hussey Observatory in South Africa (1948–1951). He received a Ph.D. from the University of Michigan in 1954 and was a Carnegie post-doctoral fellow at Mount Wilson Observatory in Pasadena, California, from 1954 to 1956. From 1956 to 1959 he served as senior astronomer at a satellite-tracking camera station of the Smithsonian Astrophysical Observatory. He taught astronomy at Northwestern University (1959–1972) and then at the University of Texas.

In 1967 Henize joined NASA as a scientist/astronaut and became senior scientist in 1986. He served as primary investigator on *Gemini 10* through *12* and *Skylab 1* through *3* (1964–1978), as a member of the support crews for *Apollo 15* and *Skylab II* through *IV* (1970–1973), as team leader on Starlab (1974–1978), and as chairman of the working group on the Spacelab wide-angle telescope (1978–1979). He was also a mission specialist on the *ASSESS 2* Spacelab simulation (1976–1977) and Space Shuttle Flight *51F* with *Spacelab 2* (1985). Henize also wrote or contributed to over 30 publications on astronomy. Studios represented include Dearborn Observatory. NASM Archives assigned the collection accession number 1986-0147.

Physical Description

There are 600 photographs including color dye coupler photoprints and silver gelatin photoprints. Other materials include books, computer printouts, correspondence, financial records, magazines, manuals, maps, newspaper clippings, pamphlets, and reports.

Subjects

The photographs document astronomical equipment and celestial phenomena. Equipment and facilities shown include computers, Gemini spacecraft, instruments, and telescopes (including employees at work) at Dearborn Observatory, Johnson Space Center, and Northwestern University. Images of celestial objects and phenomena, made via telescope from the Earth

and from Gemini spacecraft, show an eclipse, the lunar surface, planets, stars, and star spectra.

Arranged: No.

Captioned: A few with date and subject.

Finding Aid: Box list.

Restrictions: The collection, located at the Garber Facility, is available by appointment only.

AS·146

Hensley Photograph Collection

Dates of Photographs: 1944–1945

Collection Origins

The collection was created to document the U.S. Army 40th Photo Squadron in the India-Burma Theater in World War II. The collections are reproduced on NASM's Archival Videodisc 2. For information on how to order the videodisc, see the *Collection Origins* field of *AS·1*.

Physical Description

There are 25 silver gelatin photoprints.

Subjects

The photographs document U.S. Army 40th Photo Squadron operations. Activities illustrated include painting aircraft, repairing engines, and servicing photographic equipment. Airplanes shown include a wrecked Japanese aircraft and a Vickers Wellington.

Arranged: By videodisc frame number.

Captioned: With subject.

Finding Aid: Caption database listing subject and videodisc frame number. Printouts can be obtained for single photographs or caption lists of photographs with related subjects.

Restrictions: No. The collection is located at the NASM Archives on the Mall. Researchers are encouraged to call or write for an appointment.

AS·147

Gerard P. Herrick Papers, 1909–1963

Dates of Photographs: 1912–1951

Collection Origins

Aviation engineer Gerard P. Herrick (1873–1955) created the collection to document his career, particularly the development of his invention, the convertible aircraft. Herrick, who received an L.L.B. from the New York Law School in 1897, served as a captain in the U.S. Army Air Service during World War I. He then pursued a career in aircraft design, inventing the Herrick rotary engine and, in 1937, the Herrick Convertoplane (or Vertoplane), the first aircraft able to fly as either a fixed-wing airplane or as a gyroplane. Herrick formed Convertoplane Corporation to manufacture his inventions, serving as president and working on production plans until his death. Photographers and studios represented include Irwin Dribben and Pan-American Photo Service. NASM Archives assigned the collection accession number XXXX-0097.

Physical Description

There are 30 photographs including silver gelatin photonegatives and photoprints. Other materials include affidavits, articles, correspondence, engineering drawings, magazine clippings, motion-picture film footage, newspaper clippings, notes, and reports.

Subjects

The photographs primarily document the Herrick Convertoplane, including several models and prototypes, as well as reproductions of diagrams. There are also portraits of Gerard P. Herrick; pilot Elmo N. Pickerill and aviation expert Augustus M. Post at the grave of balloonist A. Leo Stevens; A. Leo Stevens; and men with parachutes in an aircraft in 1912; as well as photographic reproductions of plaques awarded to Herrick.

Arranged: By subject.

Captioned: Some with date and subject.

Finding Aid: No.

Restrictions: The collection, located at the Garber Facility, is available by appointment only.

AS·148

Hiller Aircraft Photographs

Dates of Photographs: 1980s

Collection Origins

Hiller Aircraft Company created the collection to document its aircraft. Formed in 1943 in Palo Alto, California, Hiller produced the first American co-axial helicopter, the XH-44, and went on to produce many kinds of rotorcraft. In 1960 Hiller became a subsidiary of Electric Autolite Company; in 1964 it was acquired by Fairchild Stratos Corporation to form the Fairchild Hiller Corporation; and in 1984 Rogerson Aircraft Corporation acquired the company to form the subsidiary Rogerson Hiller Company. Jay Spenser obtained the collection from the Hiller Museum and donated it to NASM, where it received accession number 1989-0122.

Physical Description

There are 50 photographs including color dye coupler photoprints and silver gelatin photoprints (mostly copies).

Subjects

The photographs document Hiller aircraft produced between 1943 and 1964, along with their construction and parts such as rotor blades. There are also photographic reproductions of drawings of aircraft. Hiller aircraft, primarily helicopters, depicted include the 12E, 360, AR-7, HJ-1, HTE-1, OHSA, VH-1, VZ-1E, X-18, and XH-44.

Arranged: Grouped by model.

Captioned: With model or other subject.

Finding Aid: Folder list.

Restrictions: The collection, located at the Garber Facility, is available by appointment only.

AS·149

William Hoffman Scrapbooks

Dates of Photographs: 1914–1917

Collection Origins

William Hoffman created the collection to document his military service in World War I. Hoffman served as a pilot in Belgium and France. NASM Archives assigned the collection accession number XXXX-0218.

Physical Description

There are 75 silver gelatin photoprints, mounted in scrapbooks. Other materials include correspondence, manuals, manuscripts, and maps, also mounted in the scrapbooks.

Subjects

The photographs are World War I military scenes in Belgium or France. There are aerial photographs of battlefields, bombed buildings, and trenches with soldiers. People portrayed include French aircraft crews and officers. There are also images of a military camp including barracks, a dining hall, a hangar with aircraft, machine guns, a motorcycle, offices, and a shooting range.

Arranged: No.

Captioned: No.

Finding Aid: No.

Restrictions: The collection, located at the Garber Facility, is available by appointment only.

AS·150

Edward H. Holterman Scrapbook

Dates of Photographs: 1916–1955

Collection Origins

Pilot Edward H. Holterman (1886–1954) created the collection to document his personal and professional life between 1916 and 1928. After receiving his pilot's license in 1917, Holterman served as a civilian instructor and test pilot in Mineola, New York, and Miami, Florida, during World War I. He then joined the U.S. Army Air Corps and became a 1st lieutenant. During World War II he served as commanding officer at two airfields. Studios represented include *Aero Digest* and the U.S. Army. In 1962 Curtis Day donated the collection to NASM, where it received accession number XXXX-0223.

Physical Description

There are 195 silver gelatin photoprints, mounted in a scrapbook. Other materials, also mounted in the scrapbook, include arm bands, correspondence, and newspaper clippings.

Subjects

The photographs document Edward H. Holterman's activities, aircraft, and colleagues between 1916 and 1923, as well as later aircraft and events through World War II. Airplanes documented include Benoist flying boats, Curtiss seaplanes, a Fokker D.VII, the Langley Aerodrome, a Martin bomber, and North American B-25 Mitchells. Aircraft parts shown include engines and propellers. Other vehicles depicted include automobiles, a motorcycle, and a propeller-driven ice sled.

Facilities and surroundings documented include beaches, Curtiss aviation schools at Miami (Florida) and Mineola (New York), hangars, McCook Field in Ohio, tents, and a WWII military base in India. There are aerial views of Dayton, including Wright-Patterson Air Force Base, and Miami. Activities and events documented include aircraft crashes, aircraft repairs, and the National Air Races of 1928. People portrayed include American Indian soldiers in World War II, a pilot in his aircraft and on crutches after a crash, Edward H. Holterman, instructors and students at Curtiss schools, and a member of the New York City Aerial Police.

Arranged: Chronologically.

Captioned: With date; most also with names or subject (much of the writing is illegible).

Finding Aid: No.

Restrictions: The collection, located at the Garber Facility, is available by appointment only.

AS·151

Marion S. Honeyman Scrapbook

Dates of Photographs: 1914

Collection Origins

Marion S. Honeyman created the collection to document her first airplane flight, taken in 1914. She donated the collection to NASM in 1976.

Physical Description

There are seven silver gelatin photoprints, mounted in a scrapbook. Other materials include newspaper clippings, also mounted in the scrapbook.

Subjects

The photographs show a Benoist aircraft, Marion S. Honeyman in an aircraft with pilot Anthony Jannus, and the opening ceremony of the St. Petersburg-Tampa Airboat Line, the first regularly scheduled passenger airline.

Arranged: No.

Captioned: Some with date and subject.

Finding Aid: No.

Restrictions: The collection is kept in the Ramsey Room at the NASM Archives on the Mall. Researchers must be accompanied by a staff member and are encouraged to call or write for an appointment.

AS·152

Jerome C. Hunsaker Collection, 1916–1969

Dates of Photographs: 1947–1961

Collection Origins

Aeronautical engineer Jerome C. Hunsaker (1886–1984) created the collection to document his academic and business career. Hunsaker began his career in the U.S. Navy, graduating from the U.S. Naval Academy in 1908 and receiving a D.Sc. from the Massachusetts Institute of Technology (MIT) in 1916. From 1916 to 1921 he served as chief of the Aircraft Division, Bureau of Construction and Repair, Navy Department. He then served as chief of the Design Division (1921–1923), where he designed the U.S.S. *Shenandoah,* and assistant naval attaché in Europe (1923–1926).

After resigning his commission in 1926, Hunsaker spent two years at Bell Laboratories as assistant vice president and research engineer, helping to standardize wire and radio service for airlines. He became a vice president at the Goodyear-Zeppelin Corporation (1928–1933), where he supervised the construction of the airships U.S.S. *Akron* and *Macon.* He then returned to MIT to head the Department of Mechanical Engineering and Aerospace Engineering. Hunsaker spent much of his career as a member (including a term as chairman) of the National Advisory Committee for Aeronautics (NACA). In 1964 he donated this collection to the Smithsonian, where it received accession number XXXX-0001. Photographers represented include the U.S. Navy.

Physical Description

There are 110 photographs including color dye coupler photoprints and silver gelatin photoprints. Other materials include correspondence, drawings, journals, manuscripts, and reports.

Subjects

The photographs document Jerome C. Hunsaker's professional activities, primarily with the Goodyear-Zeppelin Corporation. There are photographs of Goodyear executive tours and group shots of professional organizations. Images of a 1947 inspection tour by Goodyear directors and executive officers show the directors arriving on a train, attending meetings, being measured for and wearing Western outfits, staying at the company resort, and touring factories. Photographs of a 1956 Western trip by the Goodyear board portray board members at various functions, including a meal in the desert and a meeting with Governor Ernest W. McFarland of Arizona, and in hotels. Company facilities shown include a cotton gin, factories, and farms in Arizona and Illinois, including employees and equipment.

Aircraft and facilities depicted include an airship, farms, a prefabricated house factory, and a ranch. Group portraits include the Goodyear board of directors, the National Advisory Committee for Aeronautics and Industry Consulting Committee (1955), and the National Research Advisory Committee (1953). Two photographs from this collection are reproduced in this volume's illustrations section.

Arranged: Alphabetically by subject.

Captioned: With subject.

Finding Aid: Folder list.

Restrictions: The collection, located at the Garber Facility, is available by appointment only.

AS·153

John J. Ide Collection

Dates of Photographs: 1911–1951

Collection Origins

Aeronautical engineer John J. Ide (1892–1962) created the collection during his professional career, mainly while gathering technical information on aircraft before and during World War II. Ide received a Certificate of Architecture from Columbia University in 1913, then studied during the next year at the École des Beaux Arts in Paris. He became an architect with H.T. Lindeberg in New York, then joined the National Advisory Committee for Aeronautics (NACA) at the American Embassy in Paris, serving as a technical assistant from 1921 to 1940 and from 1949 until his retirement. During World War II he served in the Bureau of Aeronautics of the U.S. Navy Department. During his career Ide surveyed foreign aircraft, throughout Europe for NACA and in England for the Navy, keeping notebooks and submitting intelligence reports.

Photographers and studios represented include the Air Ministry (England), Bristol Aeroplane Company, De Havilland, Field Navy Department (Eng-

land), Johnny Rogers of the S.S. *Independence,* Topical Press Agency, the U.S. Navy, Vickers Aircraft, and Wide World Photos. NASM Archives assigned the collection accession number XXXX-0070.

Physical Description

There are 2,190 silver gelatin photoprints. Other materials include articles, charts, correspondence, engineering drawings, financial records, manuscripts, maps, newspaper clippings, reports, and scrapbooks.

Subjects

The photographs primarily document aircraft in Europe and the United States from the 1910s through the 1940s. There are also images of events and people involved in aviation, other architectural and technological subjects, and John J. Ide's personal acquaintances, events, and trips.

Early aircraft and manufacturers represented include Blériot, Curtiss seaplanes, Deperdussin, and Sopwith Snipes. International aircraft of the 1920s and 1930s shown include a Breguet-Wibault 670, Bristol transport bomber, De Havilland D.H.88 Comet, Fokker F.XXII and G-1, Hawker Hart and PV 4, Mureaux 190, Potez 62-0, Savoia-Marchetti SM-73, and Vickers PVO, as well as a Soviet ZKB 19. Aircraft factories in England, France, Germany, and Italy are also documented, as well as an airport in Rome being inspected by Benito Mussolini in 1935. There are also images of aircraft parts, especially engines.

There are images of World War II aircraft (bombers, fighters, seaplanes, and transports) used in Britain, including the Bell P-39, Blackburn Firebrand, Brewster SB2A Bermuda, Bristol Beaufighter, Curtiss P-40, De Havilland D.H.98 Mosquito, Fairey Firefly, Grumman TBF Avenger, Handley-Page Halifax II, Hawker Hurricane, North American P-51, Supermarine Spitfire, Vickers Warwick, and Westland Welkin. There are also photographic reproductions of diagrams of these aircraft.

Images of other types of architecture and design include buildings and street scenes in American cities; early automobiles, such as a Mercedes, Rolls Royce, and Singer Sedan; estate houses and gardens in the United States and France; farms in Vermont; and reproductions of student architectural drawings. Other places documented include military facilities such as map rooms; the U.S. Army camp at Plattsburg (1916); the U.S. Naval Air Station in Johnsville, Pennsylvania; and West Point, New York (1917). There is a group of photographs documenting a trip to Germany in 1946, including the cities of Berlin, Frankfurt, Hamburg, Munich, and Nuremburg. The German images show an airport, Berghof (Hitler's house), shipyards, and submarine works. There are also travel photographs of the Grand Canyon and Pike's Peak.

Events documented include an aviation tournament in Mineola, New York (1918); a boat race; car races such as the Astor Cup race (1915); Paris Aviation Salon (1936); San Diego Exposition (1916); and the Stockholm Air Exposition (1936). People portrayed include the American delegation at an air conference in Paris (1929), crews and pilots with aircraft, De Havilland company staff members (1951), military officers in meetings, and soldiers in training and on parade. There are portraits of Ide and of his family and friends at parties and weddings.

Arranged: In ten series by document type. Most of the photographs are filed chronologically with reports.

Captioned: Images of aircraft with date, manufacturer, and model; some others with date and subject.

Finding Aid: Box list.

Restrictions: Many of the images are security classified and unavailable for research use. The collection, located at the Garber Facility, is available by appointment only.

AS·154

India-Burma Headquarters Photograph Collection *A.K.A.* Joseph J. Pace Photograph Collection

Dates of Photographs: 1944–1945, 1989

Collection Origins

Photographer Joseph J. Pace created the collection to document activities at the U.S. Army Air Forces' India-Burma Headquarters during World War II. Pace served as photo chief at the Headquarters, located at Malir, India. Studios represented include OPPS and the U.S. Army Air Forces. NASM Archives assigned the collection accession number 1989-0100.

Physical Description

There are 240 photographs including silver gelatin dry plate photonegatives and silver gelatin photoprints, some copy.

Subjects

The photographs document aircraft, equipment, facilities, leisure activities, and operations at the U.S. Air Forces' India-Burma Headquarters in Malir, India, in 1944 and 1945. Aircraft depicted include bombers and fighters. Equipment and facilities shown include an airfield, cameras, the dispensary, the enlisted men's club, machinery, a maintenance area, the mess hall, the officers' club with a bar and lounge, the replacement depot, and sleeping quarters. Leisure activities documented include baseball; a dance with a band; performances by dancers and singers; card games; Red Cross coffee and doughnut distribution; and a rodeo with bronco busting, bull riding, a parade, rodeo clowns, and roping.

Operations illustrated include construction and repair work such as welding; medal presentations; premission briefings; and training in aircraft recognition, blind rifle assembly, gunnery, radio compasses, and skeet-shooting. There are portraits of pilots reporting for duty and soldiers loading bombs and cameras. Recruits are shown being processed at Landis Field, with men getting a meal, receiving medical treatments such as shots, receiving supplies, and turning in weapons. There are also aerial photographs of Malir and portraits of classes, crews and pilots with their aircraft, and local people.

Arranged: Roughly by subject.

Captioned: Some with subject.

Finding Aid: Item-level transfer list.

Restrictions: The collection, located at the Garber Facility, is available by appointment only.

AS·155

Institute of Aeronautical Sciences Photograph Collection, 1928–1957

Dates of Photographs: 1928–1957

Collection Origins

The Institute of Aeronautical Sciences (IAS) created the collection to document its members. Formed in 1932, IAS sought to establish a society of professionals in aeronautical fields, similar to the British Royal Aeronautical Society. IAS members intended to "advance the art and science of aviation," particularly by producing art, literature, and scientific publications in the field. NASM Archives assigned the collection accession number XXXX-0206.

Physical Description

There are 160 silver gelatin photoprints.

Subjects

The photographs document Institute of Aeronautical Sciences members, mainly aircraft manufacturers, engineers, and pilots. Aircraft executives portrayed include J. Leland Atwood, William B. Bergen, William A.M. Burden, Giovanni G.L. Caproni di Taliedo, Glenn H. Curtiss, Donald W. Douglas, Clairmont L. Egtvedt, Jack Frye, Hugo Junkers, Charles M. Kearns, Jr., William Littlewood, Grover C. Loening, John K. Northrop, William A. Patterson, Mundy I. Peale, Harold Pitcairn, Frederick B. Rentschler, Winthrop C. Rockefeller, Juan T. Trippe, George A. Vaughan, Jr., Eugene E. Wilson, Harry Woodhead, and Burdette S. Wright.

Engineers portrayed include Wellwood E. Beall, Frank W. Caldwell, Virginius E. Clark, Guiseppi Gabrielli, Clarence D. Hanscom, Jerome C. Hunsaker, Everett P. Lesley, Howard M. McCoy, Sanford A. Moss, W. Bailey Oswald, Arthur E. Raymond, Ernest F. Relf, Ralph H. Upson, and Stephen J. Zand. Pilots portrayed include Joseph T. Ames, Charles H. Colvin, Luis de Florez, Charles S. ("Casey") Jones, Emory S. Land, A. Lewis MacClain, A. Elliott Merrill, John L. Pritchard, Philip I. Roosevelt, and Lowell Thomas.

Other people portrayed include flight surgeons John C. Adams and Harry G. Armstrong; glider pioneer Octave Chanute; government officials Robert H. Hinckley, William P. McCracken, Jr., and Edward R. Sharp; meteorologist Willis Ray Gregg; military officers Charles E. Rosendahl, Carl A. Spaatz, James E. Fechet, Benjamin D. Foulois, and David N.W. Grant; physicists Lyman J. Briggs and Hugh L. Dryden; promoter Albert B. Lambert; and scientists Clark B. Millikan and Edward C. Schneider.

Arranged: Alphabetically.

Captioned: Most with name; some also with inscription and studio.

Finding Aid: List of names.

Restrictions: The collection, located at the Garber Facility, is available by appointment only.

AS·156

Evelyn L. Irons Scrapbook

Dates of Photographs: Circa 1912–1915

Collection Origins

Unknown. Evelyn L. Irons bought the collection and donated it to NASM, where it received accession number 1986-0110.

Physical Description

There are 100 silver gelatin photoprints, mounted in an album.

Subjects

The photographs document early aircraft and automobiles, entertainment activities, and people. Activities and events documented include aircraft flights, an automobile race, a picnic, and travel on an excursion ship, as well as women singing at a piano. There are portraits of barnstormers and early pilots.

Arranged: No.

Captioned: Some with subject.

Finding Aid: No.

Restrictions: The collection, located at the Garber Facility, is available by appointment only.

AS·157

Italian Aviation Photographs of World War I

Dates of Photographs: Circa 1918

Collection Origins

Unknown. NASM Archives assigned the collection accession number XXXX-0235.

Physical Description

There are 35 silver gelatin photoprints, mounted in an album.

Subjects

The photographs document Italian World War I aircraft and facilities. Aircraft depicted include airships (one showing the interior of a gondola), a Caproni airplane, and seaplanes, as well as wrecks of Austrian airplanes. Aircraft are shown in flight, landing, and taking off. Facilities documented include hangars and ramps into water. There are also aerial photographs, some composite.

Arranged: By type of aircraft.

Captioned: With subject in Italian.

Finding Aid: No.

Restrictions: The collection, located at the Garber Facility, is available by appointment only.

AS·158

Shakir S. Jerwan Scrapbooks

Dates of Photographs: 1911–1921

Collection Origins

Pioneer aviator Shakir S. Jerwan (1881–1941) created the collection to document his activities in the 1910s. Born in Beirut, Syria, Jerwan came to the United States in 1904. He attended the Moisant International Aviators, Inc., aviation school in Mineola, Long Island, and received pilot's license #54 in August 1911. His classmates included Harriet Quimby, the first American woman to hold a pilot's license; Matilde Moisant, a sister of the school's owners and the second licensed

American woman pilot; and Bernetta Miller, another famous aviator. In May 1912 Jerwan became chief instructor for the Moisant company, and in 1913 he and his brother Fred patented the Aeromotor Boat. From 1915 to 1919 Jerwan served as director of military aircraft for the Guatemalan government. After returning to the United States he became a hotel owner. Studios represented include Hartsook. NASM Archives assigned the collection accession number XXXX-0231.

Physical Description

There are 195 silver gelatin photoprints, mounted in scrapbooks. Other materials include correspondence, drawings, newspaper clippings, and a pamphlet, also mounted in the scrapbooks.

Subjects

The photographs document aircraft, aviation events, and Guatemalan war scenes. Aircraft depicted include the balloon *City of New York,* a Benoist flying boat, Blériot monoplanes, the Langley Aerodrome, a Santos-Dumont Demoiselle monoplane, and a Sikorsky *Grande* biplane. Pilots portrayed include Edmond Audemars, René Barrir, Roland B. Garros, Andrew Houpert, Shakir S. Jerwan, Bernetta Miller, Matilde Moisant, Harriet Quimby, and René Simon. There are also photographs of a man with a circus lion, Monoplane (the flying dog), and people playing polo. Aviation events documented include crashes, races, and stunt flights. Pictures of Guatemala include a fire by railroad tracks, a flooded town, people shooting from behind barricades, soldiers in a field, and soldiers marching.

Arranged: No.

Captioned: Some with date and subject.

Finding Aid: No.

Restrictions: The collection, located at the Garber Facility, is available by appointment only.

AS·159

Walter E. Johnson Scrapbook

Dates of Photographs: 1910–1958

Collection Origins

Florence Johnson, wife of aviation pioneer Walter E. Johnson (1888–1961), assembled the collection to document her husband's career. Walter Johnson attended Syracuse University for two years before he became a mechanic for Glenn H. Curtiss in 1910. Later that year he joined Thomas Brothers as an engineer, pilot, and flight instructor. Leaving Thomas Brothers in early 1914, Johnson briefly operated his own aviation school before going back to work for Curtiss. He flew the Langley Aerodrome during Curtiss's experiments with it in 1915 (see collection *AS·171*) and became chief instructor at the Curtiss aviation school in Hammondsport, New York. In 1916 he left to head the Philadelphia School of Aviation at Essington, Pennsylvania, and he taught flying during World War I. Johnson retired from flying after the war and went into business. He was a member of the Early Birds, a group of pilots who flew before December 17, 1916. NASM Archives assigned the collection accession number 1987-0068.

Physical Description

There are 60 silver gelatin photoprints, mounted in a scrapbook. Other materials include correspondence and newspaper clippings, also mounted in the scrapbook.

Subjects

The photographs primarily document early aircraft and flights with which Walter E. Johnson was involved. Portraits of Johnson show him with his son, with his wife Florence, and flying the Langley Aerodrome during its renovation by Glenn H. Curtiss in 1914 and 1915. Other airplanes documented include a Curtiss JN-4 (wrecked), the Curtiss R, and Thomas biplanes, some of which are seaplanes.

Arranged: No.

Captioned: A few with subject.

Finding Aid: No.

Restrictions: The collection, located at the Garber Facility, is available by appointment only.

AS·160

Ernest Jones Papers, 1906–1932

Dates of Photographs: 1906–1917, 1931–1932

Collection Origins

Aviation historian Ernest L. Jones (1883–1955) assembled the collection to document his research on early aircraft. Jones, who attended Eastman Business College, became editor of the first American aviation journal, *Aeronautics* (1907–1915); a co-founder of the Early Birds, a society of pre-1917 pilots; president of the Aeronautics Manufacturers Association (1912); and a publicity agent for Wright Aeronautical Corporation (1917). During World War I Jones joined the U.S. Army Air Service and served as chief information officer.

After the war he set up the aeronautical branch of the Commerce Department, which later became the Civil Aeronautics Administration and Federal Aviation Administration. Jones also wrote a history of the American Expeditionary Forces air service and edited *National Aeronautical Review* for two years. In the 1930s he became involved in commercial aviation and in 1941 rejoined the U.S. Army Air Forces as an intelligence officer. In 1943 he was transferred to the history division where he remained, as a civilian employee after his retirement in 1949, into the early 1950s.

Photographers and studios represented include H.M. Bonner, Jimmy Hare of *Collier's Weekly*, Edwin Levick, George T. Murray of the *Boston Journal*, M. Rol, and Spooner & Wells. NASM Archives assigned the collection accession number XXXX-0096.

Physical Description

There are 1,800 photographs including collodion gelatin photoprints (POP) and silver gelatin photoprints.

Subjects

The photographs document aircraft, events, and personalities in early aviation, mainly from 1906 to 1917 with some from the early 1930s. Types of aircraft depicted include aircraft carrier airplanes (landing), airships, biplanes, dual-control training airplanes, gliders, and observation balloons. There are images of Etrich, Pfitzber, and Valkyrie monoplanes; Benoist and Burgess-Dunne seaplanes; and Aeromarine and Thomas tractor airplanes. Specific airplane models depicted include the Aerial Experiment Association (A.E.A.) *June Bug*, Antoinette, Baldwin Red Devil, Curtiss Limousine and Oriole, and the Wright 1903 Flyer. There are also images of Alexander Graham Bell's tetrahedral kite, Frank T. Coffyn's seaplane with a motion-picture camera, the Toliver airship, the U.S. Navy airship U.S.S. *Akron,* and a Wright 1908 Army airplane. Other manufacturers represented include Blackburn, Blériot, Breguet, Bristol, Burgess, Euler, Fairchild, and Voisin.

There are also photographic reproductions of drawings of aircraft performing aerobatics. Aircraft equipment and parts shown include ailerons, an air speed indicator, arresting hooks, cockpits, dual controls, engines, flotation gear, fuselages, gun mounts, instrument panels, landing gear, a Sperry synchronized drift set, tanks, windshields, wing structures, and a Wright incidence indicator. Many parts are shown in aircraft under construction. Facilities shown include an airship hangar and training fields as well as a Burgess-Wright aviation school, the Curtiss aviation school in San Diego, Thomas Brothers Aeroplane Company factory, and Triaca's aviation school.

Events documented include airship races (1907); Belmont Park meets (1910, 1915); a Bridgeport, Connecticut, race (1911); George L. Bumbaugh's balloon flights with an automobile and a piano (1913); a Colorado Springs balloon race; Glenn H. Curtiss's flight from Albany to New York City (1910); Curtiss's flights in the Langley Aerodrome (1914–1915); Curtiss's aircraft hauled aboard a ship (1911); Eugene Ely's Curtiss aircraft landing on a battleship (1912); experiments with a motion-picture camera in flight (1911); a fire in Salem, Massachusetts (first aerial news shot, 1914); the first airplane flight (1903); the Gordon Bennett Race in Reims (1909); the first parachute jump from an airplane (1912); kite contests; a Mineola, Long Island, air meet (1909); a Thomas seaplane pilot posing with American Indians; and the Wellman Polar Expedition. Other activites shown include a balloon ascent sequence including transporting equipment, spreading the net and bag, inflating the balloon, and attaching the basket; bombings; christenings; crashes; flight lessons at aviation schools; sanding a propeller; starting engines; and testing aircraft.

Aircraft manufacturers, passengers, pilots, and promoters portrayed include P.Y. Alexander; W.B. Atwater; Lincoln Beachey; Paul W. Beck; Alexander Graham Bell; Louis Blériot; Joe Boquel; Harry Bingham Brown; Vernon Castle; J. Chalker, Jr.; William H. Christmas; Samuel F. Cody; John F. Cooley; Glenn H. Curtiss; C.W. Curzon; Cromwell Dixon; Lewis D. Dozier; Eugene Ely; Henri Farman; Claude Grahame-White; Samuel P. Langley; Hubert Latham; Peggy O'Neill; Louis Paulhan; Joseph Pulitzer; Hugh Robin-

son; Thomas E. Selfridge; Arthur R. Smith; Charles H. Valentine; James Ward; Al Welsh; Charles F. Willard; J. Newton Williams; Orville Wright; and Wilbur Wright. There are group portraits of Aerial Experiment Association (A.E.A.) members and aviation school instructors.

Arranged: By assigned number.

Captioned: With assigned number, date, negative number, and subject.

Finding Aid: No.

Restrictions: The collection, located at the Garber Facility, is available by appointment only.

AS·161

Hattie Meyers Junkin Papers, 1906–1982

Dates of Photographs: 1914–1977

Collection Origins

Aviator Hattie Meyers Junkin created the collection to document her personal and professional activities. In 1917 Meyers married George ("Buck") Weaver, who died in 1924, and in 1925 she married Elwood J. ("Sam") Junkin, who died the following year. George Weaver, Elwood Junkin, and Clayton Bruckner founded the Advance Aircraft Company in 1921, which became Weaver Aircraft Company (1922–1929) and Waco Aircraft Company (1929–1946). Hattie Junkin raised her two children, one from each marriage, in Toledo, Ohio, until 1929, when she married Navy Lt. Commander Ralph S. Barnaby and moved to Washington, D.C. In 1931 she became the first woman to earn a glider class "C" license. She divorced Barnaby in 1934 but remained in Washington to work on a law degree. In 1940 Junkin moved to Garden City, New Jersey, where she lived until the late 1970s, writing articles and a history of Waco. She later moved to Alabama. Photographers represented include Fred T. Loomis. NASM Archives assigned the collection accession number XXXX-0171.

Physical Description

There are 1,200 photographs including collodion gelatin photoprints (POP), color dye coupler photoprints, and silver gelatin photonegatives and photoprints, most mounted in albums. Other materials include articles, correspondence, manuscripts, newspaper clippings, periodicals, and a scrapbook.

Subjects

The photographs are primarily family pictures and images of Hattie Myers Junkin's flying activities. The family photographs portray Junkin; Ralph S. Barnaby, Elwood J. ("Sam") Junkin, and George ("Buck") Weaver, her husbands; George C. Weaver, her son; and Janet Junkin, her daughter. Portraits of associates and friends include Clarence A. Brown, Jr., Richard C. Dupont, Mia Farrow, R.E. Franklin, Gus Haller, Albert E. Hastings, Steve G. McEniry, Mickey McGuire, Jack O'Meara, and Robert M. Stanley. Family and friends are shown in baby pictures, studio portraits, and travel photographs. Activities documented include attending social events, camping, going to beaches, playing tennis, taking photographs, taking movies at a 1929 air meet, and traveling.

Junkin and other pilots are shown in flight clothes and with aircraft. Places shown include Chicago, Illinois; Elmira, New York; Toledo, Ohio (including aerial shots); and Waco, Texas. Events documented include air meets and races, crashes, gliding meets, and the Willard-Dempsey boxing match (1919). Aircraft shown include airplanes made by Aeromarine, Burnelli, Fokker, and Sopwith; gliders; and a sailplane. There are also images of airplane parts such as engines; facilities such as airfields, a flight school in Toledo, hangars, and the Toledo airport; and miniature model airplanes.

Arranged: By subject.

Captioned: Most with date and subject.

Finding Aid: No.

Restrictions: The collection, located at the Garber Facility, is available by appointment only.

AS·162

Hildegard K. Kallmann-Bijl Papers, 1949–1968

Dates of Photographs: Circa 1930–1965

Collection Origins

Geophysicist Hildegard K. Kallmann-Bijl (1908–1968) created the collection to document her career. Born in Germany, Kallmann-Bijl attended college in Berlin and later received a Ph.D. from the University of California in 1955. In 1936 she worked in the spectroscopic laboratory at Zeiss Works in Dresden, but the following year she fled Nazi Germany to Sweden. In 1940 she married Curt Kallmann, who had left Germany with her, and they emigrated to the United States.

While attending the University of California, Kallmann-Bijl taught at the school and served as a consultant for Rand Corporation. In 1958 she joined the Rand Corporation full-time as a specialist in upper atmospheric physics for the U.S. Air Force. She worked at the University of Utrecht Observatory in 1964 and 1965, continuing to write and serve on professional committees until her death. NASM Archives assigned the collection accession number 1989-0042.

Physical Description

There are 80 photographs including silver gelatin photonegatives and photoprints. Other materials include charts, correspondence, magazine clippings, newspaper clippings, and notes.

Subjects

The photographs document Hildegard K. Kallmann-Bijl's professional activities. Activities documented include a book-signing, conferences, a graduation, and a launch of the Aerobee rocket. Facilities shown include the buildings and equipment at the Ankara, Turkey, observatory. There are images of clouds from a weather satellite and photographic reproductions of charts and graphs. Portraits include colleagues of Kallmann-Bijl such as Joseph Kaplan and Umberto Mortucci. There are also a few family photographs including Kallmann-Bijl at a beach and a living room interior.

Arranged: By subject.

Captioned: Some with name or other subject.

Finding Aid: 1) Folder list. 2) List of photographs.

Restrictions: The collection, located at the Garber Facility, is available by appointment only.

AS·163

Virgil Kauffman Collection *A.K.A.* Aero Service Corporation Collection

Dates of Photographs: 1918–1986

Collection Origins

Photographer and photogrammetrist Virgil Kauffman (1898–1925) created the collection to document his World War I service and career at the Aero Service Corporation. During the war Kauffman served as an Air Service unit photographer in aerial reconnaissance. He joined the Aero Service Corporation after the war and later became its president. Founded in 1919, Aero Service specialized in aerial photography, photographic mapping, and remote sensing. The company worked with the Tennessee Valley Authority, the U.S. Geological Survey, and U.S. armed forces in Europe and the Pacific during World War II. NASM Archives assigned the collection accession number 1987-0146.

Physical Description

There are 200 photographs including color dye coupler photoprints and silver gelatin photoprints. Other materials include correspondence, maps, newspaper clippings, pamphlets, and reports.

Subjects

The photographs document Aero Service Corporation operations and World War I military scenes. Aero Service activities documented include flying mapping missions, loading cameras into aircraft, piecing together aerial photographs into large maps, and working with mapping equipment. There are aerial photographs of cities such as New York, Philadelphia, and Pittsburgh; landscapes showing countryside, deserts, and islands; Pitcairn Field; and resolution targets on a football field. Aircraft documented include airplanes such as a Curtiss JN-4, Fairchild monoplane, Fokker D.VII, and Martin bomber; airships; and helicopters. Some of the airplanes shown belong to Aero Service Corporation. War images show aircraft, anti-aircraft guns, bombed buildings, marching soldiers, and trenches. Several photographs from this collection are reproduced in this volume's illustrations section.

Arranged: No.

Captioned: Some with exposure and flight information or subject.

Finding Aid: Item-level transfer list.

Restrictions: The collection, located at the Garber Facility, is available by appointment only.

AS·164

Kennedy Space Center Glass Transparency Collection, 1960s

Dates of Photographs: 1960s

Collection Origins

NASA created the collection to document operations at the Kennedy Space Center, NASA's main Apollo launch site. For a history of NASA and the Apollo program, see *Collection Origins* in AS·45. In the early 1960s NASA upgraded its Atlantic Missile Range at Cape Canaveral, Florida, for use as the United States' primary space launch site, and changed its name to the Kennedy Space Center. NASM Archives assigned the collection accession number 1987-0136.

Physical Description

There are 900 color dye transfer separation photo-transparencies on glass.

Subjects

The photographs document operations at Kennedy Space Center on Cape Canaveral, Florida. There are images of equipment, facilities, and spacecraft, as well as astronauts, scientists, and technicians at work. Activities documented include assembling a booster, attaching a nose section, hoisting the nose section, maneuvering equipment, mating parts, packing a lunar module, and transporting spacecraft, as well as rocket launches and splashdowns. Facilities and spacecraft shown include an equipment assembly area, flight control room, launch pad, lunar module, and a Skylab spacecraft. There are also photographic reproductions

of charts, drawings, and maps.

Arranged: No.

Captioned: With image number and subject.

Finding Aid: List of photographs giving NASA negative number and subject.

Restrictions: The collection, located at the Garber Facility, is available by appointment only.

AS·165

Clement M. Keys Papers, 1918–1951

Dates of Photographs: 1923–1931

Collection Origins

Clement M. Keys (1876–1952), president of the Curtiss and Curtiss-Wright companies from 1920 to 1933, created the collection. Born in Canada, Keys received a B.A. from the University of Toronto in 1897 and taught classics before coming to the United States in 1901. He worked as a reporter and editor at the *Wall Street Journal* from 1901 to 1906 and as financial editor for *World's Work* from 1906 to 1911, when he formed his own investment company, C.M. Keys & Co. In 1916 he gave financial support to Curtiss Aeroplane and Motor Corporation, which appointed him an unsalaried vice president. After buying a controlling interest in Curtiss in 1920, he presided over the company's 1929 merger with Wright Aeronautical Corporation, forming the Curtiss-Wright Corporation, and its expansion into ownership of over 30 companies in every phase of aviation manufacturing, operations, and service. After a struggle for control of the Curtiss-owned Transcontinental & Western Airlines in 1931, Keys resigned as the airline's chairman and withdrew completely from Curtiss-Wright in 1933. Elizabeth Keys Stoney, his daughter, donated the collection to the Smithsonian, where it received accession number XXXX-0091. Studios represented include Russell & Co.

Physical Description

There are 11 silver gelatin photoprints. Other materi-

als include announcements, catalogs, correspondence, engineering drawings, financial records, invitations, maps, newsletters, periodicals, programs, and reports.

Subjects

The photographs document aircraft and aviation facilities. Aircraft depicted include airplanes such as Bellancas, a Dornier Do X, and the Lockheed Vega *Winnie Mae,* as well as a De Bothezat helicopter. Facilities shown include the Glenn Curtiss airport in New York; McCook Field in Ohio; the municipal airport in Kansas City; and a New York City air terminal with an administration building, an automobile parking area, a construction site, and docks. There are also photographic reproductions of a drawing of a "cyclonic-rocket" and maps of Midland Air Express routes.

Arranged: In five series by subject, then by company and type of material. Photographs are in series 2.

Captioned: Most with date and subject.

Finding Aid: No.

Restrictions: The collection, located at the Garber Facility, is available by appointment only.

AS·166

A. Roy Knabenshue Aircraft Photographs (Oversized)

Dates of Photographs: 1904–1906

Collection Origins

Unknown. Photographers represented include F.W. Glasier. NASM Archives assigned the collection accession number XXXX-0370.

Physical Description

There are nine photographs including collodion gelatin photoprints (POP) and silver gelatin photoprints.

Subjects

Most of the photographs document airship pioneer A. Roy Knabenshue flying his airship in a public demonstration, including a stunt with an automobile. There are also images of an engine and of Carl G. Fisher in a balloon.

Arranged: No.

Captioned: No.

Finding Aid: No.

Restrictions: The collection, located at the Garber Facility, is available by appointment only.

AS·167

Paul W. Kollsman Aeronautical Library Scrapbook

Dates of Photographs: Circa 1940–1941

Collection Origins

The collection was assembled to document the establishment of an aeronautical library by inventor and manufacturer Paul W. Kollsman (1900–1982). Born in Germany, Kollsman attended Munich and Stuttgart Universities. After emigrating to the United States in 1923 he worked as a parts inspector at Pioneer Instrument Company. In 1928 he founded Kollsman Instrument Company to manufacture aviation equipment, including an altimeter and other inventions. In 1940 the Square D Company acquired Kollsman Instrument Company, and Kollsman became a vice president of Square D. The same year Kollsman donated money to the Institute of Aeronatical Sciences for an aeronautical library in Rockefeller Center. Kollsman was a member of the Institute, which donated the scrapbook to NASM. NASM Archives assigned the collection accession number XXXX-0319.

Physical Description

There are four silver gelatin photoprints, mounted in a scrapbook. Other materials include newspaper clippings, also mounted in the scrapbook.

Subjects

The photographs include an image of Rockefeller Center in New York City and portraits of Paul W. Kollsman and F.W. Magin, president of Square D Company.

Arranged: No.

Captioned: Some with name.

Finding Aid: No.

Restrictions: The collection, located at the Garber Facility, is available by appointment only.

AS·168

Krainik Ballooning Collection, 1859–1934

Dates of Photographs: 1859–1920s

Collection Origins

Collector Cliff Krainik assembled the collection and sold it to NASM in 1990. Photographers and studios represented include American Views, Edward Anthony, C.D. Arnold, Brady & Co., N.T. Bulkley, T.M.V. Doughty, F.B. Gage, W.H. Jacoby, Johnson and Mentzel, Keystone View Company, B.W. Kilburn, S.A. King, C.L. Pond, Underwood and Underwood, and J.S. Woolley. The photographs are reproduced on NASM's Archival Videodisc 7. For information on how to order the videodisc, see the *Collection Origins* field of *AS·1*.

Physical Description

There are 220 photographs including albumen photoprints, silver gelatin dry plate lantern slides, and silver gelatin photoprints. Formats represented include cabinet cards, cartes-de-visite, and stereographs. Other materials include advertisements, artifacts, graphic prints, photomechanical postcards, and valentine cards.

Subjects

The photographs document 19th and early 20th century ballooning. Activities and events illustrated include amateur ballooning; balloon flights at the Chicago, Portland, and St. Louis expositions; balloon

races from 1905 to 1924; inflations; and parachute jumps. Balloons shown include French tissue "phantom balloons"; Samuel Archer King's *Buffalo;* T.S.C. Lowe's Civil War balloons and his *Great Western;* military balloons of the Boer War, Russo-Japanese War, and World War I; Carl E. Myers's *Aerial;* Félix T. Nadar and Eugène Godard's balloons; smoke balloons in the Klondike during the Gold Rush; and John Wise's *Gannymede.* Balloonists portrayed include John DeLeon, A. Holland Forbes, William Ivy (*A.K.A.* Ivy Baldwin), Samuel Archer King, T.S.C. Lowe, Carl E. Myers, Mary H. Myers (*A.K.A.* Carlotta), and John Wise.

Arranged: In five series by type of material, then by item number. 1) Stereoscopic photographs. 2) Photographs. 3) Postcards, valentines, etc. 4) Prints. 5) Miscellaneous. Photographs are in series 1 and 2.

Captioned: With subject; some also with date and photographer.

Finding Aid: 1) Item list. 2) Caption database listing some dates and photographers, subject, and videodisc frame number. Printouts can be obtained for single photographs or caption lists of photographs with related subjects.

Restrictions: No. The collection is located at the NASM Archives on the Mall. Researchers are encouraged to call or write for an appointment.

AS·169

Lahm Airport Memorial/Dedication Scrapbook

Dates of Photographs: 1967

Collection Origins

The collection was created to commemorate the 1967 ceremony dedicating the Mansfield, Ohio, airport to Frank P. Lahm (1877–1963), the first U.S. Army pilot. Lahm graduated from West Point in 1901, received a balloon pilot's license in 1905, and won the 1906 Gordon Bennett balloon race in Paris. In 1909 Orville and Wilbur Wright taught Lahm and Frederick E. Humphreys to fly the first U.S. Army Wright airplane. In 1912 Lahm became commanding officer of the

Army's aviation school in the Philippines, and during World War I he was an Air Service unit commander. After the war he founded the Air Corps Training Center at Randolph Field, Texas, where he served until 1931. He then served as air attaché and later military attaché to France and Belgium before retiring in 1941. Recipient of the Distinguished Service Medal and the French Legion of Honor, he was also a member of the Early Birds, an organization of pilots who flew before December 17, 1916. In 1967 the Mansfield, Ohio, airport was renamed Lahm Airport, dedicated during a ceremony that included Paul Garber of NASM as a speaker. NASM Archives assigned the collection accession number XXXX-0268.

Physical Description

There are 45 silver gelatin photoprints, mounted in an album.

Subjects

The photographs document the 1967 dedication of the Lahm Airport in Mansfield, Ohio. Activities documented include an air show with formation flying by the U.S. Air Force Thunderbirds, concerts by the Singing Sergeants, the dedication of a bust of Lahm, a display of Air Force aircraft, an exhibit of aviation history paintings, a formal dinner, and speeches. There are portraits of Early Bird members Paul E. Garber, Ernest C. Hull, E.M. Laird, Glenn E. Messer, Martin F. Scanlon, and George H. Scragg. Other participants shown include J. Gilbert Baird, George L. Bell, and Winston P. Wilson.

Arranged: No.

Captioned: With activity or name.

Finding Aid: Caption list.

Restrictions: The collection, located at the Garber Facility, is available by appointment only.

AS·170

Frank P. Lahm Collection

Dates of Photographs: Circa 1880s–1981

Collection Origins

Pioneer aviator Frank P. Lahm created the collection to document his professional and personal life. For a biography of Lahm, see *Collection Origins* in AS·169. Photographers and studios represented include Helen Pierce Breaker, *Life* magazine, NASM, the U.S. Air Force, and Jack Williams. NASM Archives assigned the collection accession number 1986-0044.

Physical Description

There are 100 photographs including albumen photoprints, color dye coupler photoprints, color dye diffusion transfer photoprints, collodion gelatin photoprints (POP), silver gelatin photoprints, and a tintype. Other materials include correspondence, manuscripts, newspaper clippings, pamphlets, and reports.

Subjects

The photographs document Frank P. Lahm's personal and professional activities and other aviation events. Lahm is shown crashing in a seaplane (1913), piloting the first airplane in the Philippines (1912), raising a flag and speaking at a 50th anniversary of flight celebration, receiving awards, and winning the Gordon Bennett balloon race in Paris (1906). Other activities and events documented include balloon flights in Virginia and Washington, D.C.; captive balloon training at Fort Myer, Virginia (1908); and the Wrights' flight at Kitty Hawk (1903).

There are also images of other aircraft such as a sausage balloon and the Wright 1903 Flyer at the Smithsonian Institution's Arts and Industries Building; facilities at a U.S. Army Air Corps training center and at Ft. McKinley in the Philippines; and portraits of Air Corps members' children in costumes, Lahm's family, pilots such as Benjamin D. Foulois, and World War I officers.

Arranged: By subject.

Captioned: Most with date and subject.

Finding Aid: Item-level transfer list.

Restrictions: The collection, located at the Garber Facility, is available by appointment only.

AS·171

Langley Experiments (1914–1915) Scrapbooks

Dates of Photographs: 1914–1915

Collection Origins

Pioneer aviator and engineer Glenn H. Curtiss (1878–1930) created the collection to document his attempt to fly the Langley Aerodrome. For a biography of Curtiss, see *Collection Origins* in *AS·89*. In 1914 and 1915, hoping to prove the invention of a man-carrying airplane prior to that of the Wright brothers, Curtiss proposed to the Smithsonian Institution (SI) that he fly former SI Secretary Samuel P. Langley's Aerodrome. Langley had flown miniature model airplanes in 1896, but his full-scale machine, called the Aerodrome, failed to fly, and the project was abandoned in 1903. Curtiss rebuilt and flew the Aerodrome but made a number of modifications, and the attempt to prove it the first successful airplane failed in the courts. Curtiss donated the collection to the SI. Photographers represented include H.M. Benner, Charles D. Walcott, and Wehman. NASM Archives assigned the collection accession number XXXX-0294.

Physical Description

There are 135 silver gelatin photoprints, mounted in scrapbooks. Other materials include newspaper clippings, also mounted in the scrapbooks.

Subjects

The photographs document Glenn H. Curtiss rebuilding and flying the Langley Aerodrome. There are images of the Aerodrome in Curtiss's shop, in flight, and crashing. The Aerodrome is shown being built, transported, assembled at Lake Keuka (Hammondsport, New York), launched, flown, filmed, and towed out of the water. People portrayed include Glenn H. Curtiss; Elwood Doherty, who piloted the Aerodrome; and Harvey R. Kidney, a Curtiss mechanic working on the Aerodrome. Several photographs from this collection are reproduced in this volume's illustrations section.

Arranged: Chronologically.

Captioned: With date, description of activity, and names of people.

Finding Aid: No.

Restrictions: The collection, located at the Garber Facility, is available by appointment only.

AS·172

Robert Lannen Aircraft Slide Collection

Dates of Photographs: 1965–1972

Collection Origins

Robert Lannen assembled the collection from slides created by the Air-Britain Film Unit for sale to its members. Lannen donated it to NASM, where it received accession number XXXX-0432.

Physical Description

There are 2,000 color dye coupler slides.

Subjects

The photographs document aircraft worldwide, dating from the early 20th century to the early 1970s. Airliners (including many Boeing 727s) shown are from Europe (especially Great Britain) and Latin America. Other civil aircraft shown are from Canada, Great Britain, and the United States. Light aircraft shown are from Europe (especially Italy) and Latin America. Naval aircraft shown are from Great Britain and the United States. Other military aircraft shown include Korean War aircraft, NATO aircraft, Royal Air Force trainers, Royal Air Force operational aircraft, Swiss Air Force aircraft, and vintage military aircraft from around the world.

There are also images of aircraft from Argentina, the Caribbean, Finland, France, Japan, Nepal, South Africa, southeast Asia, and the United Kingdom. There are images of homebuilt aircraft, racing aircraft including midget racers, and seaplanes. Aircraft are also shown from museums such as the U.S. Air Force Museum at Wright-Patterson Air Force Base and from shows and events such as the Biggin Hill Air Fair of 1966, Hannover Air Show of 1966, Jersey Rally of 1966, Paris Air Shows of 1959 and 1967, and Reno Air Races of 1970, as well as aircraft used in movies.

Arranged: In series by subject.

Captioned: With manufacturer and model.

Finding Aid: Lists for each series naming each aircraft.

Restrictions: The collection, located at the Garber Facility, is available by appointment only.

Room at the NASM Archives on the Mall. Researchers must be accompanied by a staff member and are encouraged to call or write for an appointment.

AS·173

Ruth Law Scrapbook

Dates of Photographs: 1911–1921

Collection Origins

Pioneer aviator Ruth Law (1887–1970) created the collection to document her aviation activities in the 1910s and early 1920s. In 1912 Law entered the Burgess aviation school, received her pilot's license, and worked as an exhibition flier until 1915. She was the first woman to perform a loop-the-loop and to fly at night. In 1916 she set a non-stop cross-country record, and during World War I she flew on recruiting tours for the U.S. Army and Navy. After the war Law toured Japan, China, and the Philippines, carrying the first airmail to Manila in 1919. She and Charles A. Oliver, her husband, operated Ruth Law's Flying Circus until she gave up flying in 1922.

Physical Description

There are 210 photographs including cyanotypes and silver gelatin photoprints, mounted in a scrapbook. Other materials include announcements, correspondence, newspaper clippings, a passport, pins, and prize ribbons, also mounted in the scrapbook.

Subjects

The photographs document Ruth Law's activities in the 1910s and early 1920s. Activities and events documented include social events, stunts (such as night flights with flares), a trip to Japan, and World War I recruitment campaigns. There are many images of aircraft, including Law's first airplane, and of automobiles, especially race cars. There are portraits of Law with aircraft and other people.

Arranged: Roughly chronologically.

Captioned: A few with date and subject.

Finding Aid: No.

Restrictions: The collection is kept in the Ramsey

AS·174

Lovell Lawrence, Jr., Papers

Dates of Photographs: 1935–1954

Collection Origins

Lovell Lawrence, Jr. (1915–1971), a pioneer in the rocket propulsion industry, created the collection to document his business affairs and research. Lawrence served as assistant to the chief engineer at IBM from 1933 until 1941, when he left to form the first American rocket propulsion company, Reaction Motors, Inc. (RMI), in collaboration with Hugh Franklin Pierce, John Shesta, and James H. Wyld. He left RMI in 1951 and in 1953 joined Chrysler's Missile Division as manager of power plant design. He then worked on Chrysler's Advanced Project Organization as chief engineer (1959), director (1961), and chief research engineer (1964). Lovell became a member of the American Rocket Society in the 1930s and served as president in 1946.

Photographers and studios represented include Chrysler Corporation, Ellsworth Schell News Picture Service, Reaction Motors, and Taylor Photo Co. In 1972 the collection was donated to NASM, accompanied by a turbosupercharger now in NASM's artifact collection. NASM Archives assigned the collection accession number XXXX-0010.

Physical Description

There are 220 photographs including silver gelatin photonegatives and photoprints. Other materials include brochures, catalogs, correspondence, engineering drawings, financial records, newspaper clippings, patents, and reports.

Subjects

The photographs primarily document the activities, facilities, personnel, and products of Reaction Motors, Inc. Aircraft depicted include helicopters and a Messerschmitt Me 262. There are photographic reproductions of engineering drawings of aircraft and rock-

ets, many labeled in German. Aircraft parts shown include engines, some disassembled, such as an injector engine in operation and ramjets; fuel tanks; and valves. Other apparatus illustrated include an IBM transmitting typewriter, with radio antennas mounted on buildings and on the ground, and other equipment. Facilities documented include offices and a rocket launching ramp. People portrayed include U.S. Navy officer Calvin M. Bolster, Lovell Lawrence, Jr., and employees and executives of Chrysler Corporation, IBM, and RMI. Events documented include U.S. Army Air Forces Day celebrations at Newark Airport in 1947, with an RMI display stand, and a Christmas party. There is also an image of the 1939 New York World's Fair obelisk and sphere.

Arranged: In six series by project. Photographs are in boxes 8–10.

Captioned: Some with date, image number, labeled parts, subject, and test number.

Finding Aid: Item-level accession list.

Restrictions: The collection, located at the Garber Facility, is available by appointment only.

AS·175

Willy Ley Papers, 1859–1969

Dates of Photographs: 1928–1969

Collection Origins

Rocket expert and author Willy Ley (1906–1969) created the collection to document his business activities and research. After studying science at the University of Berlin, in 1927 Ley co-founded the Verein für Raumschiffahrt (Society for Space Travel), a group involved in experimental rocketry, serving as its vice president until 1933. In 1935 the American Interplanetary Society/American Rocket Society arranged his emigration to the United States. From 1940 to 1944 he served as science editor of *PM* magazine and, after becoming a naturalized U.S. citizen, as a research engineer at the Washington Institute of Technology from 1944 to 1947. In the 1950s he served as a consultant to the Office of Technical Services at the U.S. Department of Commerce and taught at Fairleigh Dickinson University. He also became a columnist for *Galaxy* magazine (1952–1969), and when NASA was formed he became a planning consultant, serving in these positions until his death. The Smithsonian purchased the collection from the Willy Ley Estate in 1969 and assigned it accession number XXXX-0098. Studios represented include Boeing, NASA, Rocketdyne, and the U.S. Air Force.

Physical Description

There are 1,200 photographs including color dye coupler photoprints, phototransparencies, and slides and silver gelatin photonegatives and photoprints. Other materials include articles, books, contracts, correspondence, engineering drawings, financial records, manuscripts, newspaper clippings, notes, pamphlets, periodicals, and press releases.

Subjects

The photographs document rockets and space flight, primarily in the United States, with some images from Germany in the 1930s and 1940s. Rocket vehicles shown include the Aerobee-Hi, Blue Scout, Centaur, Hawk, Juno II, Redstone, Saturn I and V, Scout, and Viking. Missiles depicted include the Honest John, Jupiter, Little John, Minuteman, Navaho, Sergeant, Skybolt (on a Boeing B-52G), Thor, Titan, and V-2. Probes and satellites depicted include the *Courier, Discoverer 9, Echo 1, Explorer 1, Lunar Orbiter, Mariner 1* and *2, Nimbus, Pioneer 5, Ranger 6, Telstar,* and *Vanguard.*

Equipment and parts shown include a Goodyear moon vehicle and Hamilton space clock, as well as plastic food packages, reentry cones, rocket engines, space suits, and a supersonic parachute. Facilities shown include generators, large mirrors, observatories, telescopes, water extractors, and wind tunnels, as well as an Aerojet factory, Boardman test site in Oregon, Boeing spaceflight simulator, Cape Canaveral launch pad, Douglas test center, General Electric's solar thermionic electrical power system, NASA's launch complex, North American Aviation assembly plant, Peenemünde after a bombing raid, and Rockwell International assembly room.

Celestial objects and phenomena documented include comets, distant galaxies, the Earth from space, Mars, meteor craters, the Milky Way, the Moon's surface, nebulae, and sunspots. There are also photographic reproductions of artists' conceptions of future space flight, pre-1900 rocketry, and science fiction stories; as well as stills from science fiction motion pictures such as *Destination Moon* (1950).

Individuals portrayed include rocket and space pioneers Willy A. Fiedler, I. Fortikov, Robert H. God-

dard, Virgil I. Grissom, Eugen Sänger, Friedrich Schmiedl, Alan B. Shephard, Jr., Konstantin E. Tsiolkovsky, Max Valier, Wernher von Braun, Edward H. White II on a space walk during *Gemini 4,* and Johannes Winkler. There are also portraits of Willy Ley; Olga F. Ley, his wife; and Sandra and Xenia Ley, their daughters. Groups portrayed include American rocket technicians, the crew of the *Apollo 8,* and scientists at work. Activities illustrated include spacecraft construction, flight stages, launches, recoveries, and transportation.

Arranged: In five series. 1) Subject. 2) Personal. 3) Literary productions. 4) Correspondence. 5) Printed materials. Most photographs are in series 1; some are also in series 3 and 5.

Captioned: With subject; some also with date and photographer.

Finding Aid: Folder list.

Restrictions: Permission to publish material must be obtained from Olga F. Ley as well as the copyright holder. The collection, located at the Garber Facility, is available by appointment only.

AS·176

Liberty Engine Photographs Scrapbook

Dates of Photographs: 1917–1918

Collection Origins

The Nordyke & Marmon Company created the collection to document the construction and operation of its aircraft engine factory during World War I. The company donated the collection to NASM, where it received accession number XXXX-0250.

Physical Description

There are 40 silver gelatin photoprints, bound in a book.

Subjects

The photographs document the construction and oper-

ation of the Nordyke & Marmon Company aircraft engine factory during World War I. Exteriors shown include the factory grounds with early stages of construction and a test shed. Interiors shown include the cylinder department, first aid room, machining rooms, receiving department, soldiers' instruction room, stockroom, women's instruction room, and women's rest area. There are also images of equipment, supplies, and tools. Employees portrayed include a doctor, men and uniformed women working in the same divisions and in segregated areas, a nurse, women relaxing in the rest area, and women welding. Two photographs from this collection are reproduced in this volume's illustrations section.

Arranged: Roughly chronologically.

Captioned: With date and subject.

Finding Aid: Caption list.

Restrictions: The collection, located at the Garber Facility, is available by appointment only.

AS·177

Lighter-Than-Air Collection *A.K.A.* Garland Fulton Collection

Dates of Photographs: 1910s–1960s

Collection Origins

Garland Fulton (1890–1975), a captain in the U.S. Navy, assembled the collection to document lighter-than-air (LTA) aeronautics (primarily airships and balloons), especially in the U.S. Navy. Fulton received an M.S. in Naval Architecture from the Massachusetts Institute of Technology (1916), served in the Brooklyn Navy Yard (1916–1918), did aeronautical work in the Navy Bureau of Construction and Repair (1918–1922), and inspected Naval aircraft at the Zeppelin Company (1922–1924). He then served in the LTA section of the Navy's Bureau of Aeronautics until he retired from the Navy in 1941. During World War II he served as vice president and director of the Cramp

Shipbuilding Company, and after the war he entered private engineering practice, serving as director of several companies. Fulton published articles on LTA and also made several inventions in the field. Studios represented include Kopec Photo Company, U.S. Army Signal Corps, U.S. Navy, and Wide World Photos. NASM Archives assigned the collection accession number XXXX-0101.

Physical Description

There are 670 photographs including color dye coupler photonegatives and photoprints and silver gelatin photonegatives and photoprints. Other materials include books, calendars, correspondence, engineering drawings, manuals, and periodicals.

Subjects

The photographs document lighter-than-air (LTA) aeronautics (airships and balloons) in the first half of the 20th century, primarily in the United States. LTA aircraft documented include the U.S. Navy airships U.S.S. *Akron,* U.S.S. *Los Angeles,* and the Type ZMC-2; and signal balloons. Airships and balloons are shown taking off. Other aircraft depicted include biplanes and seaplanes, and there are also images of aircraft carriers and submerged submarines. Airship parts shown include bomb-dropping apparatuses, controls, engines, and gondolas. There are also images of damage to the *Akron.* Equipment and facilities documented include cables, hangars, a mechanics' school on the Great Lakes with a camouflaged hangar, a model of the Akron Goodyear plant, mooring masts, and railroad cars containing helium. There are portraits of airship crews, a crewman holding a pigeon, Navy officers including Garland Fulton, tennis players, and workers taking airships out of hangars. There are also photographic reproductions of a Curtiss medal, engineering drawings of airships, and meteorological plotting charts.

Arranged: By type of material; photographs are grouped together.

Captioned: Some with date and subject.

Finding Aid: Partial box list.

Restrictions: The collection, located at the Garber Facility, is available by appointment only.

AS·178

Charles A. and Anne Lindbergh Autographed Photographs and Watercolor

Dates of Photographs: 1931

Collection Origins

Charles A. Lindbergh (1902–1974) and Anne Lindbergh (1906–), his wife, created the collection as a gift. Lindbergh began flying as a barnstormer in the early 1920s and served as a mail pilot in 1926. In 1927 he made the first non-stop flight from New York to Paris. After the flight he became a technical advisor for Pan American Airways, often flying with Anne, who was also a pilot. In 1931 the Lindberghs flew to China by way of Alaska and Siberia, the first east-to-west flight by way of the north. During a stop in Tokyo, Tomi Tamura, an employee of the American Embassy, served as their hostess. The Lindberghs presented the collection to Tamura. In 1985 Atsundo Nagao of Tokyo donated the collection to NASM, where it received accession number 1985-0015.

Physical Description

There are two silver gelatin photoprints. Other materials include a watercolor painting.

Subjects

The images are autographed photographs of Charles A. and Anne Lindbergh in 1931.

Arranged: No.

Captioned: With autographs.

Finding Aid: No.

Restrictions: The collection is kept in the Ramsey Room at the NASM Archives on the Mall. Researchers must be accompanied by a staff member and are encouraged to call or write for an appointment.

AS·179

Harvey H. Lippincott Photograph Collection

Dates of Photographs: 1944–1945

Collection Origins

Harvey H. Lippincott created the collection to document his experiences working as a technical representative for Pratt & Whitney (United Aircraft) in Corsica and Italy during World War II. Lippincott maintained RE-2800 engines on Republic P-47 Thunderbolt fighters for the U.S. Army Air Forces 57th, 86th, and 350th Fighter Groups and the 1st Brazilian Fighter Squadron on Corsica and at Grosetto and Pisa, Italy. He used a collapsible Brownie-type camera with a fixed aperture to document his working envronment.

Following the war, Lippincott received a B.S. in mechanical engineering from Georgia Institute of Technology. In 1950 he returned to United Aircraft, which later became United Technologies, where he worked on establishing and maintaining an archives until 1987. In 1959 Lippincott set up the Connecticut Aeronautical Historical Association, serving as its president for seven years. He later served as director of the association's major facility, the New England Air Museum, until 1976. He then served as director of museum development and archivist at the Air Museum.

The photographs are reproduced on NASM's Archival Videodisc 2. For information on how to order the videodisc, see the *Collection Origins* field of *AS·1*.

Physical Description

There are 50 silver gelatin photoprints.

Subjects

The photographs document Allied aircraft in service in Italy during World War II. There are images of De Havilland D.H.98 Mosquitos, Republic P-47 Thunderbolts, and Vultee L-5s, along with examples of nose art. Facilities shown include airfields and buildings, with some aerial views. There are also portraits of pilots and other personnel.

Arranged: By videodisc frame number.

Captioned: With subject.

Finding Aid: Caption database listing subject and

videodisc frame number. Printouts can be obtained for single photographs or caption lists of photographs with related subjects.

Restrictions: No. The collection is located at the NASM Archives on the Mall. Researchers are encouraged to call or write for an appointment.

AS·180

Eric Lundahl Photograph Collection

Dates of Photographs: 1914–1918, 1980s

Collection Origins

Aviation photographer Eric Lundahl created the collection to document the Experimental Aircraft Association's Oshkosh Air Shows and World War I German aircraft. He donated the collection to NASM, where it received accession numbers 1987-0035, 1989-0009, and 1990-0031. The photographs are reproduced on NASM's Archival Videodisc 7. For information on how to order the videodisc, see the *Collection Origins* field of *AS·1*.

Physical Description

There are 435 silver gelatin photoprints.

Subjects

The photographs document German World War I airplane restorations and replicas, as well as many types of experimental aircraft, built from the 1920s to the 1980s, that appeared in the Experimental Aircraft Association's Oshkosh Airshows in Wisconsin. German World War I airplanes shown include a Dornier, Kondor, Roland, Linke Hofmann, Pfalz, and Zeppelin-Lindau. Other aircraft depicted include an Aerocar, AVID Speedwing, Beech D-17, Cirrus UK30, Curtiss JN-4, Curtiss-Wright Travel Air B14B, Jaffe/Swearingen SA-32T, Marco J5, Neico Aviation Lancair 235, Stinson Reliant, Travel Air D4000 Speed Wing, Wheeler Express, and Zenair Zenith.

Arranged: In two series, then by videodisc frame number. 1) Oshkosh Airshow. 2) German WWI aircraft.

Captioned: With manufacturer and model.

Finding Aid: 1) Item-level transfer list to part of the collection. 2) Caption database listing manufacturer, model, and videodisc frame number. Printouts can be obtained for single records or caption lists of related subjects.

Restrictions: No. The collection is located at the NASM Archives on the Mall. Researchers are encouraged to call or write for an appointment.

AS·181

Theodore S. Lundgren Scrapbook

Dates of Photographs: 1916–1948

Collection Origins

Aviator Theodore S. Lundgren created the collection to document his flight experiences in World War I as well as later events. Lundgren joined the U.S. Army in 1917 and trained as a pilot at Rich Field in Texas. After the war he became a movie stuntman and a co-pilot and navigator on early commercial flights on the West Coast. He later became an aircraft corporation executive while continuing to participate in flying events. In 1927 Lundgren entered the Pacific Air Race in a triplane called the *Pride of Los Angeles,* but the aircraft crashed shortly after take-off. After becoming head of sales and trade at Emsco Aircraft Corporation in 1930, he attempted an around-the-world airplane flight in 1931 to beat the Zeppelin time. Lundgren also invented a wind-drift indicator and worked with oil companies in aviation research and development. NASM Archives assigned the collection accession number XXXX-0285.

Physical Description

There are 90 silver gelatin photoprints, mounted in a scrapbook. Other materials include correspondence, magazine clippings, and newspaper clippings, also mounted in the scrapbook.

Subjects

The photographs document Theodore S. Lundgren's

aviation experiences during training at a U.S. Army airfield and in civilian events. Activities and events documented include aircraft crashes into a hangar and a train, aircraft repairs, air races, formation flying, a party, rowing races, and wing walking. Aircraft documented include an Emsco airplane, a flying wing, and the *Pride of Los Angeles.* Places shown include air bases such as Ellington Field in Texas and salt mines in Death Valley, California. Portraits include actor Hoot Gibson, Lundgren, and World War I aviators.

Arranged: No.

Captioned: With name or subject.

Finding Aid: No.

Restrictions: The collection, located at the Garber Facility, is available by appointment only.

AS·182

Frank G. Manson Patent Collection

Dates of Photographs: Circa 1955

Collection Origins

Frank G. Manson created the collection to document his patents for inventions related to parachutes and safety gear. Manson developed some of the inventions in collaboration with James J. Maskey. Studios represented include the U.S. Air Force. NASM Archives assigned the collection accession number 1989-0003.

Physical Description

There are four silver gelatin photoprints. Other materials include books, correspondence, engineering drawings, and patents.

Subjects

The photographs portray Frank G. Manson at a dinner with associates and his wife and as president of the Quarter Century Club with previous presidents.

Arranged: By subject and type of material.

Captioned: One with subject.

Finding Aid: No.

Restrictions: The collection, located at the Garber Facility, is available by appointment only.

AS·183

Martin Clipper Scrapbook

Dates of Photographs: 1931–1936

Collection Origins

The collection was created to document the development of the Martin 130 Clipper, an advanced passenger seaplane. The Glenn L. Martin Company built the Clipper for Pan American Airlines, which issued requirements for the aircraft in 1931 and accepted the Clipper in 1936. NASM Archives assigned the collection accession number XXXX-0316.

Physical Description

There are 25 silver gelatin photoprints, mounted in an album.

Subjects

The photographs document the development of the Martin 130 Clipper seaplane between 1931 and 1936. Construction images show the hull framework, skin application, and the wing structure. Tests documented include the first take-off in 1934, a model in a water channel, a model in a wind tunnel, and a water test. Interior images of the Clipper show the clubroom with bunks, the cockpit, and the flight engineer's position. Images of the Clipper in use include flights over Baltimore and San Francisco and Pan American officials boarding the airplane. There is also a photographic reproduction of a drawing of the aircraft with a clipper ship. A photograph from this collection is reproduced in this volume's illustrations section.

Arranged: Chronologically.

Captioned: With explanation of the event and subject.

Finding Aid: No.

Restrictions: The collection, located at the Garber Facility, is available by appointment only.

AS·184

James V. Martin Aircraft Scrapbooks

Dates of Photographs: Circa 1910–1912

Collection Origins

Pioneer aviator and inventor James V. Martin created the collection to document his activities between 1910 and 1916. Martin received a graduate degree in 1912 from Harvard University, where he organized the Harvard Aeronautical Society in 1908. In 1909 he joined the Herring-Curtiss Company, and in 1911 he became a flight instructor at the Grahame-White School. In 1917, after patenting nine aeronautical inventions including an automatic stabilizer and retractable landing gear, he formed the Martin Aeroplane Company in Elyria, Ohio. As Martin Enterprises, his company relocated to Dayton, Ohio, in 1920 and then to Garden City, New York, as Martin Aeroplane Factory in 1922.

Martin offered free use of his patents to the American aeronautical industry in 1920, but in 1924 he sued the U.S. government and the Manufacturers Aeronautical Association for monopolizing the business. In 1926 his suit was dismissed, but Martin continued to pursue the claim into the 1930s. During World War II Martin commanded a troop transport in the Pacific. After the war he failed in an attempt to produce the Martin Oceanplane, and he later became a consultant to the U.S. Army and the U.S. Rubber Company. NASM Archives assigned the collection accession number XXXX-0236.

Physical Description

There are three silver gelatin photoprints, mounted in scrapbooks. Other materials include newspaper clippings, also mounted in scrapbooks.

Subjects

The photographs document pilots, including James V. Martin, in aircraft and a biplane in flight.

Arranged: No.

Captioned: No.

Finding Aid: No.

Restrictions: The collection, located at the Garber Facility, is available by appointment only.

AS·185

James V. Martin Papers

Dates of Photographs: 1890s–1970s

Collection Origins

Pioneer aviator and inventor James V. Martin created the collection to document his career. For a biography of Martin see *Collection Origins* in *AS·184*. Photographers and studios represented include Joseph Burt, Leet Bros., Henry Miller, Naval Aircraft Factory, and the U.S. Army Air Service. NASM Archives assigned the collection accession number XXXX-0162.

Physical Description

There are 300 photographs including silver gelatin photonegatives and photoprints. Other materials include correspondence, engineering drawings, financial records, identification cards, maps, newspaper clippings, passports, and periodicals.

Subjects

The photographs document James V. Martin's aircraft and other inventions, as well as other types of aircraft and aviation events. Martin aircraft depicted include the Kitten IV, the Oceanplane (drawings), the Scout, and a tractor biplane. Martin's inventions documented include experimental three-wheel cars (1920s), patent models, and retractable landing gear. Other aircraft shown include an Aeromarine biplane, Beachey tractor, Chanute glider, Curtiss biplane and O2C Hell-diver, Dornier seaplane, the first Herring-Burgess airplane, and Wright Flyers. There are also images of kites and ships. Equipment, facilities, and parts shown include engines, factories, fuel tanks, hangars, landing gear, unidentified machinery, and wing struts. Activities and events documented include aircraft construction, refueling, and repairs; crashes; a flight of an 1893

miniature biplane; flight tests at McCook Field (Ohio); glider flights on Plum Island in 1910; and the 1920 Pulitzer Trophy race. People portrayed include James V. Martin; Lily Martin, his wife (also a pilot); Hamilton Martin, their son; and aircraft manufacturer Corliss C. Mosley.

Arranged: No.

Captioned: Some with date, negative number, or subject.

Finding Aid: No.

Restrictions: The collection, located at the Garber Facility, is available by appointment only.

AS·186

Russell L. Maughan Scrapbook

Dates of Photographs: 1917–1929

Collection Origins

Pilot Russell L. Maughan created the collection to document his flying career as well as his family activities. After receiving a B.S. from Utah Agricultural College in 1917, Maughan served in the 139th Aero Squadron in France during World War I. He later flew in a number of aviation contests and races, winning the Pulitzer Trophy race in 1922 and making the first transcontinental flight in less than 24 hours, flying from New York to San Francisco in 21 hours and 48 minutes, in 1924. He also traveled extensively with his family. NASM Archives assigned the collection accession number XXXX-0228.

Physical Description

There are 260 silver gelatin photoprints, mounted in an album.

Subjects

The photographs document Russell L. Maughan's service in World War I as well as his non-military flights and his family activities. War images include aerial views of bombed towns and trenches, as well as por-

Photographs from the Collections at the National Air and Space Museum

Note: Captions were transcribed from the photographs or provided by museum staff.

NASA. *"The Earth from space."* N.D. *Silver gelatin photoprint. Planetary Image Facility Earth Images (AS·1). NASA Negative #AS16-118-018879.*

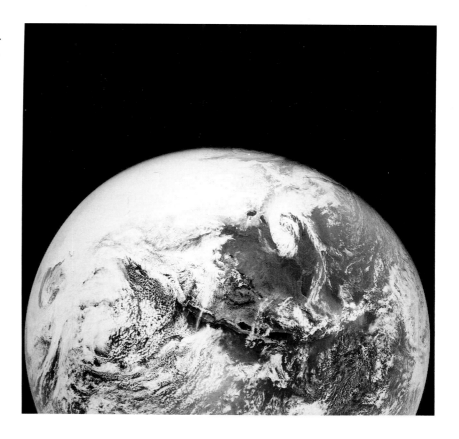

NASA. *"Apollo 17 lunar vehicle."* 1972. *Silver gelatin photoprint. Planetary Image Facility Lunar and Plantary Images (AS·2). NASA Negative #AS17-143-21933.*

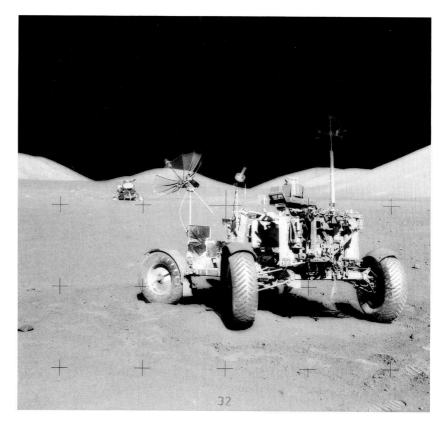

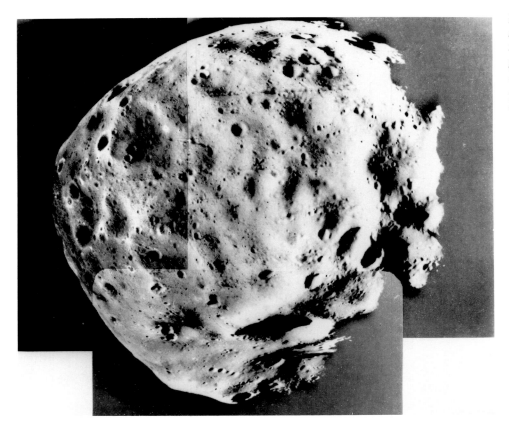

NASA. "Mars' inner satellite Phobos." N.D. Silver gelatin photoprint. Planetary Image Facility Lunar and Plantary Images (AS.2). Negative #P18612.

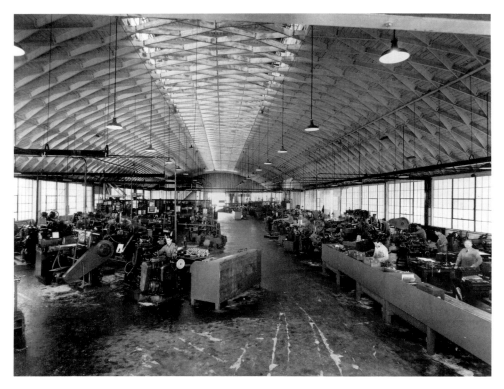

Dick Whittington (Aviation magazine). "View from one end of the Interstate Aircraft & Engineering Corp., El Segundo, California. This plant was a sub-contractor of machine work for various aircraft plants." N.D. Silver gelatin photoprint. Aviation and Aviation Week Photograph and Report Collection (AS.54). Negative #91-8479.

Fred Bottomer (Aviation magazine). "View of many boys, Junior Aviators, flying aircraft models during a contest in Cleveland, Ohio. The contest was held in a baseball stadium." 1937. Silver gelatin photoprint. Aviation *and* Aviation Week Photograph and Report Collection (AS.54). Negative #91-8480.

Anon. (Aviation magazine). "A view of 12 teenage boys building model airplanes. The boys are from class 9B of Latimer Junior High School." 1940. Silver gelatin photoprint. Aviation *and* Aviation Week Photograph and Report Collection (AS.54). Negative #91-8482.

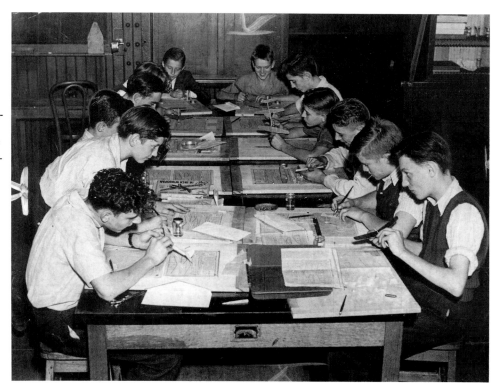

Anon. (Aviation magazine). "View of student, sitting in simulator, and instructor, standing behind simulator to the right, at the University of Michigan's aircraft simulator training class." N.D. Silver gelatin photoprint. Aviation *and* Aviation Week *Photograph and Report Collection (AS·54). Negative #91-8483.*

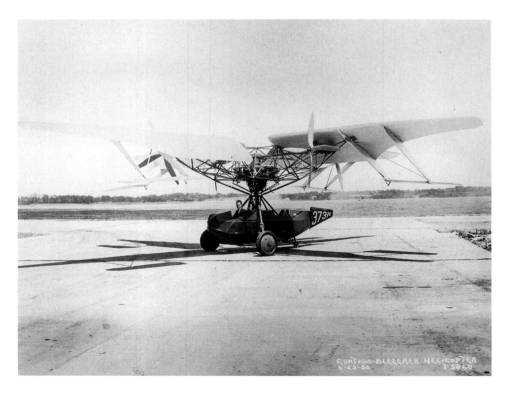

Anon. "One-half left front view of Curtiss-Bleecker Helicopter, with its designer, M.B. Bleecker, at the controls." June 23, 1930. Silver gelatin photoprint. Maitland B. Bleecker Collection (AS·64). Negative #91-14644.

Anon. "Photo of Glenn Curtiss, standing in the middle, with four other unidentified men. Curtiss and another man are standing with motorcycles." N.D. Silver gelatin photoprint. Glenn H. Curtiss Motorcycles Scrapbook A.K.A. Clara Studer Collection (AS·90). Negative #91-14708.

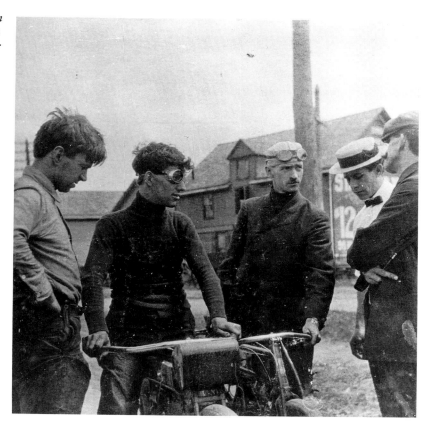

Anon. "George W. Truman accepts bottles of ocean water." 1947. Silver gelatin photoprint. Clifford V. Evans, Jr., and George W. Truman Scrapbook (AS·108). Negative #91-729.

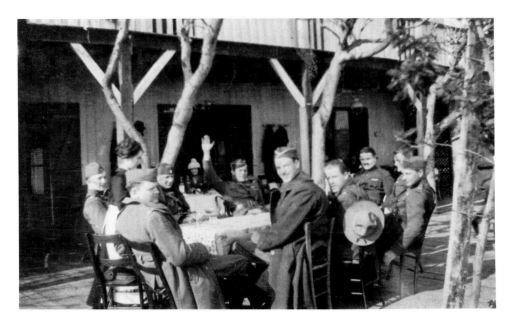

Anon. "View of soldiers seated at an outside table at the Cafe D'Argent, France." 1917–1919. Silver gelatin photoprint. 1st Aero Squadron Scrapbooks A.K.A. Richard T. Pilling Scrapbooks (AS·113). Negative #91-8484.

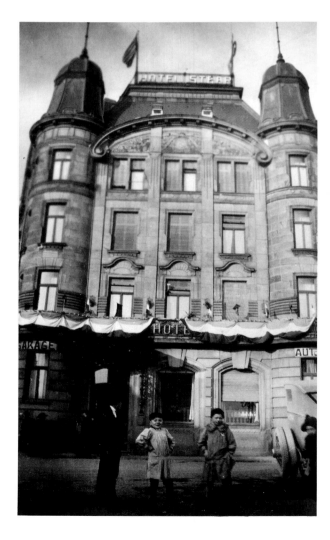

Anon. "View of the front of the Hotel Staar in Luxembourg." 1917–1919. Silver gelatin photoprint. 1st Aero Squadron Scrapbooks A.K.A. Richard T. Pilling Scrapbooks (AS·113). Negative #91-8485.

Anon. "View of the Hohenzollern Bridge in Cologne, Germany. A trolley car is approaching the photographers as it crosses the bridge. The Cologne Cathedral's steeple can be seen in the background." 1917–1919. Silver gelatin photoprint. 1st Aero Squadron Scrapbooks A.K.A. Richard T. Pilling Scrapbooks (AS.113). Negative #91-8486.

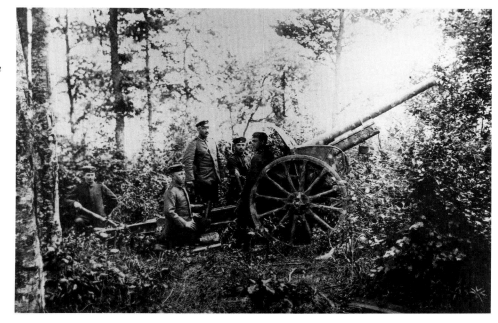

Anon. "Right side view of a German 75mm artillery gun with its crew standing at their positions. One crewman is holding an empty shell casing." 1917–1919. Silver gelatin photoprint. 1st Aero Squadron Scrapbooks A.K.A. Richard T. Pilling Scrapbooks (AS.113). Negative #91-8488.

Anon. "View of a shoeshine stand in the city of Brest. Tents can be seen in the background." 1917–1919. Silver gelatin photoprint. 1st Aero Squadron Scrapbooks A.K.A. Richard T. Pilling Scrapbooks (AS·113). Negative #91-8489.

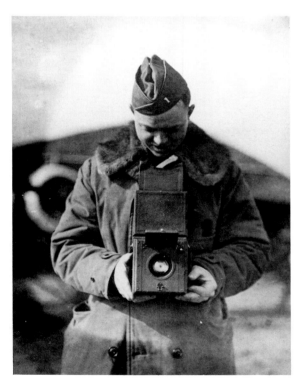

Anon. "View of soldier named 'Bill' holding a camera and preparing to take a picture." 1917–1919. Silver gelatin photoprint. 1st Aero Squadron Scrapbooks A.K.A. Richard T. Pilling Scrapbooks (AS·113). Negative #91-8490.

Luftschiffbau Zeppelin. "LZ-129 reading and writing room." Ca. 1935. Silver gelatin photoprint. German Commercial Zeppelins Scrapbooks (AS·125). Negative #91-726.

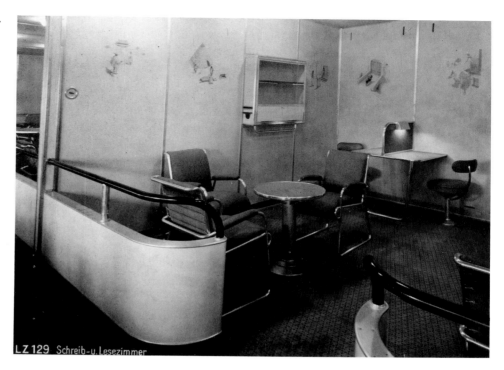

Luftschiffbau Zeppelin. "Tail unit; workers paint cover of LZ-129." Ca. 1935. Silver gelatin photoprint. German Commercial Zeppelins Scrapbooks (AS·125). Negative #91-727.

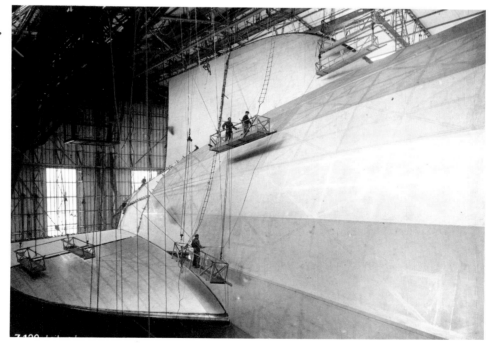

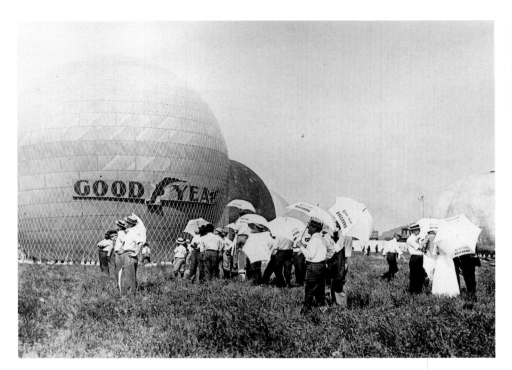

Anon. "Persons holding Goodyear promotional parasols standing beside a Goodyear racing balloon and watching the departure of a balloon at Kansas City (possibly the Gordon Bennett Cup Race)." Ca. 1911. Silver gelatin photoprint. William J. Hammer Collection (AS·140). Negative #90-15720. Videodisc #2A-02136.

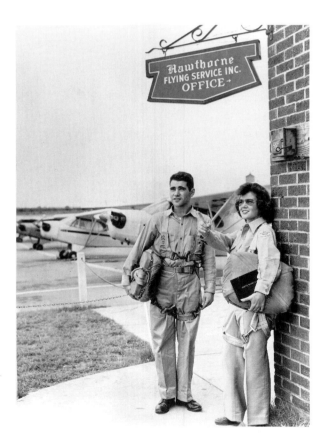

Anon. "Cadet and female flight instructor under sign." N.D. (World War II). Silver gelatin photoprint. Hawthorne Flying School Collection A.K.A. Beverly "Bevo" Howard Collection (AS·144). Negative #91-741.

Anon. "Female flight instructor with female student." N.D. (World War II). Silver gelatin photoprint. Hawthorne Flying School Collection A.K.A. Beverly "Bevo" Howard Collection (AS·144). Negative #91-742.

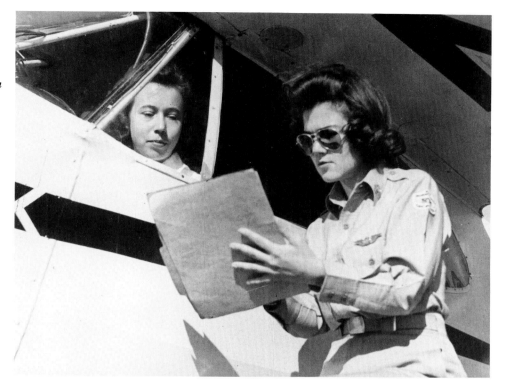

Hans Groenhoff. "Cadet with PT-17s." N.D. (World War II). Silver gelatin photoprint. Hawthorne Flying School Collection A.K.A. Beverly "Bevo" Howard Collection (AS·144): Negative #91-743.

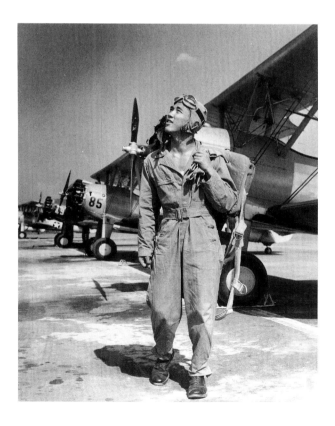

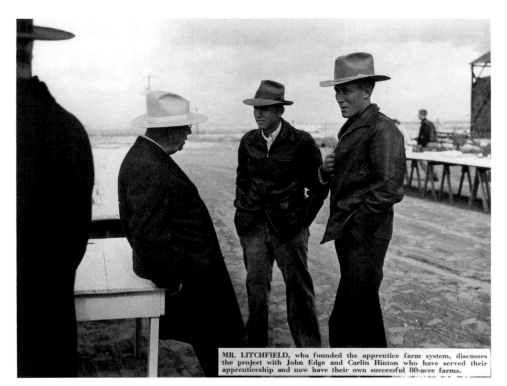

MR. LITCHFIELD, who founded the apprentice farm system, discusses the project with John Edge and Carlin Hinton who have served their apprenticeship and now have their own successful 80-acre farms.

Goodyear Tire and Rubber Company. "Mr. Litchfield, who founded the apprentice farm system, discusses the project with John Edge and Carlin Hinton, who have served their apprenticeship and now have their own successful 80-acre farms (during a Goodyear Tire and Rubber Company executive tour)." 1947. Silver gelatin photoprint. Jerome C. Hunsaker Collection (AS·152). Negative #91-708.

THE EXPERIENCE of sitting atop a real corral is seemingly enjoyed by Mr. Thomas and Mr. Payne.

Goodyear Tire and Rubber Company. "The experience of sitting atop a real corral is seemingly enjoyed by Mr. Thomas and Mr. Payne (during a Goodyear Tire and Rubber Company executive tour)." 1947. Silver gelatin photoprint. Jerome C. Hunsaker Collection (AS·152). Negative #91-709.

Aero Service Corporation. "Low-altitude oblique aerial of New York City." 1957. Silver gelatin photoprint. Virgil Kauffman Collection A.K.A. Aero Service Corporation Collection (AS·163). Negative #91-736.

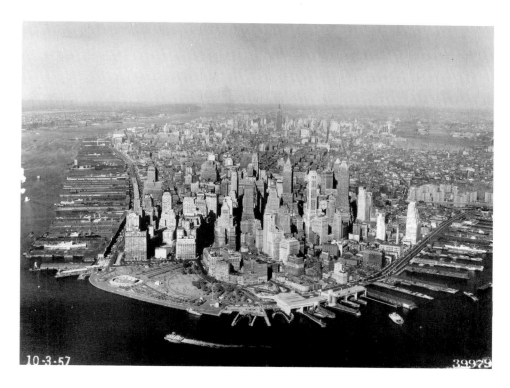

Aero Service Corporation. "Low-altitude oblique aerial of Philadelphia." N.D. Silver gelatin photoprint. Virgil Kauffman Collection A.K.A. Aero Service Corporation Collection (AS·163). Negative #91-737.

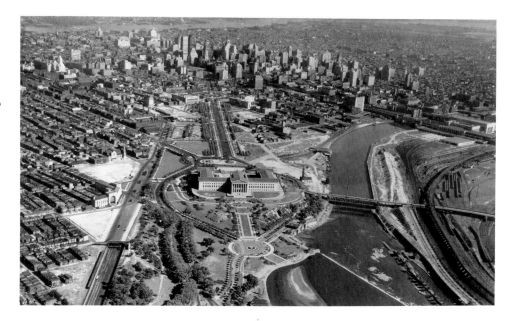

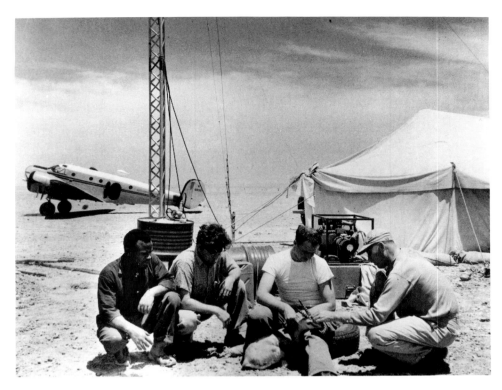

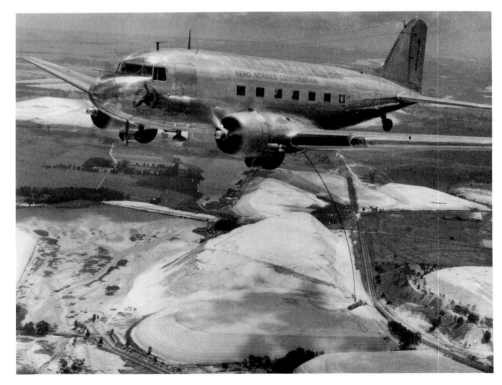

Aero Service Corporation. "Employees assemble photo mosaics using maps." N.D. Silver gelatin photoprint. Virgil Kauffman Collection A.K.A. Aero Service Corporation Collection (AS·163). Negative #91-740.

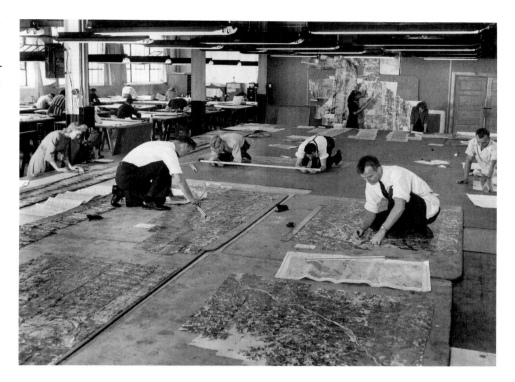

Glenn L. Martin Company. "Construction of Martin 130 Clipper." 1931–1936. Silver gelatin photoprint. Martin Clipper Scrapbook (AS·183). Negative #91-728.

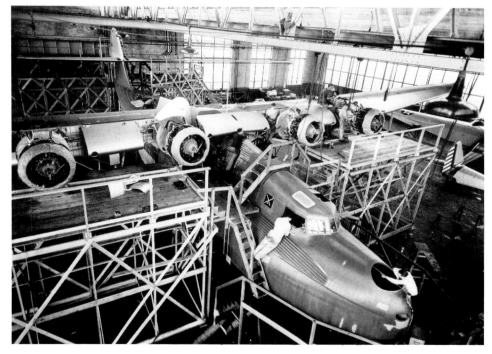

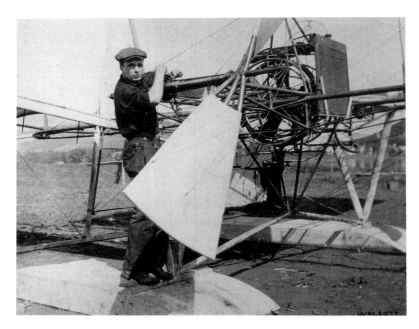

Anon. "Curtiss worker with the Langley Aerodrome." 1914–1915. Silver gelatin photoprint. Langley Experiments (1914–1915) Scrapbooks (AS·171). Negative #80-14642.

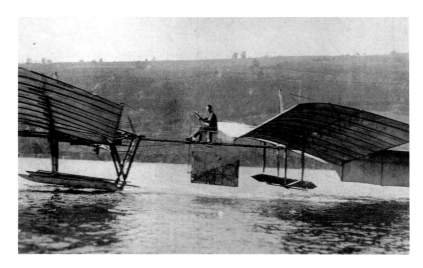

Anon. "Elwood Doherty flying the Langley Aerodrome." 1914–1915. Silver gelatin photoprint. Langley Experiments (1914–1915) Scrapbooks (AS·171). Negative #80-14678.

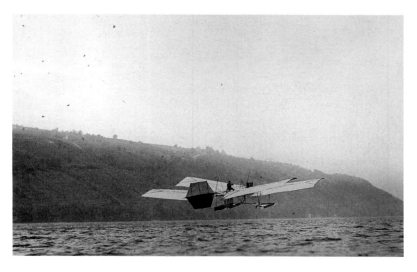

H.M. Benner. "September 17, 1914, flight of the Langley Aerodrome." 1914. Silver gelatin photoprint. Langley Experiments (1914–1915) Scrapbooks (AS·171). Negative #80-14680.

Nordyke & Marmon Co. "View of workers in the miscellaneous small parts machine room of the Nordyke & Marmon Co., Indianapolis, Indiana. Photo shows men and women working at different work stations." 1918. Silver gelatin photoprint. Liberty Engine Photographs Scrapbook (AS·176). Negative #91-14713. Nordyke & Marmon Co. #17579.

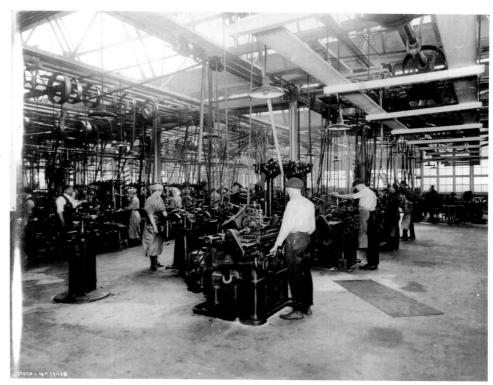

Nordyke & Marmon Co. "View of several female employees in the instruction room for women of the Nordyke & Marmon Co., Indianapolis, Indiana. Photo shows women learning different jobs." 1918. Silver gelatin photoprint. Liberty Engine Photographs Scrapbook (AS·176). Negative #91-14714. Nordyke & Marmon Co. #17634.

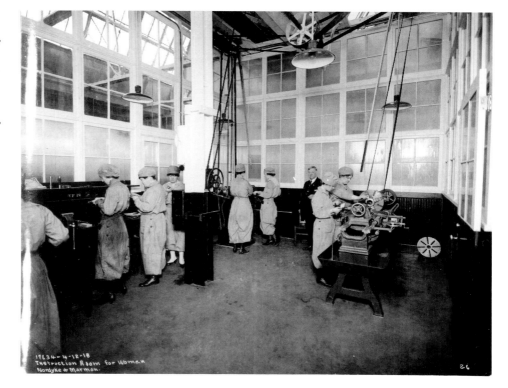

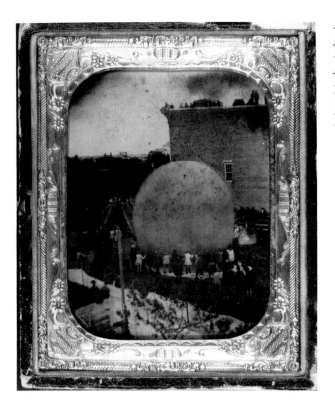

Anon. *"Inflation of John Steiner's balloon, Erie, Pennsylvania."* June 1857. Ambrotype. *Photographic Archives Technical and Videodisc Files (AS·237). Negative #89-11925.*

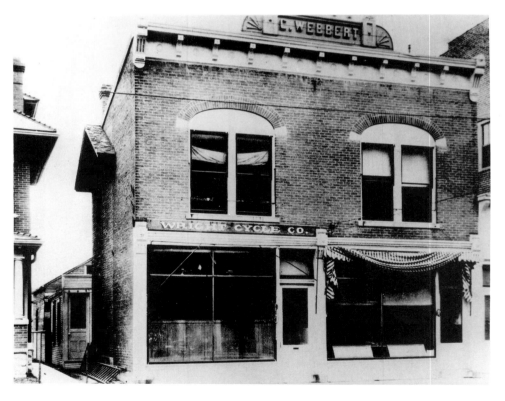

Anon. *"Exterior view of the front of the Wright Cycle Company office in the Webbert building."* N.D. Silver gelatin photoprint. *Photographic Archives Technical and Videodisc Files (AS·237). Negative #86-9864. Videodisc #2B-31359.*

Carl H. Claudy.
"Wright 1908 Military
Flyer being delivered
on an Army wagon for
trials at Ft. Myer,
Virginia." 1908. Silver
gelatin photoprint.
Photographic Archives
Technical and Videodisc
Files (AS·237). Negative
#A 42287 D. Videodisc
#2A-00622.

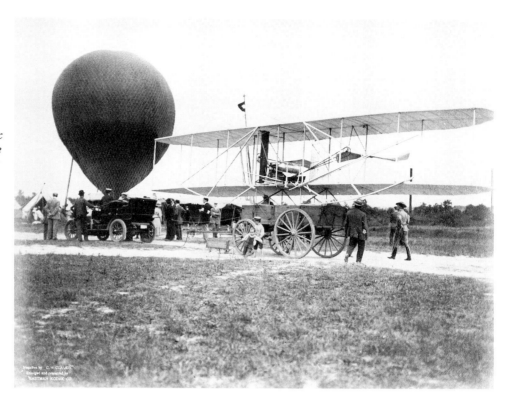

Anon. "One-half right
front view of the Wright
1908 Military Flyer in
flight over buildings
during the 1908 Army
Trials at Ft. Myer, Va.
(The image has been
printed reversed.)"
1908. Silver gelatin pho-
toprint. Photographic
Archives Technical and
Videodisc Files (AS·237).
Negative #86-4112.
Videodisc #2B-30899.

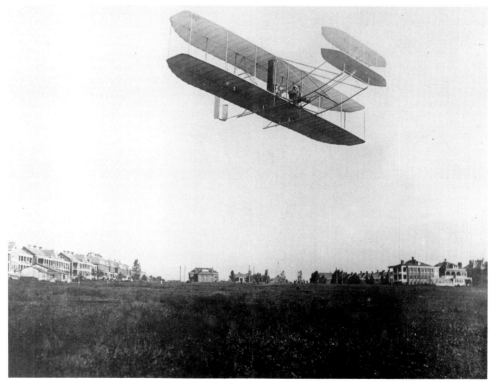

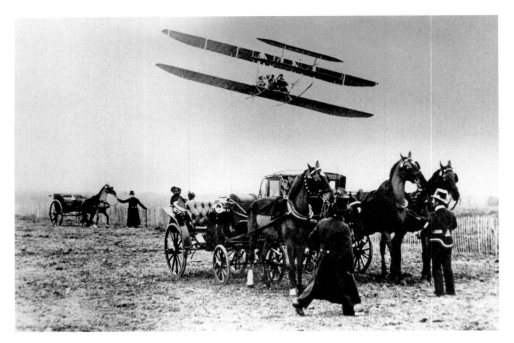

Anon. "Three-quarter right front view from below of a Wright Type A Flyer in flight over a field in France." 1908. Silver gelatin photoprint. Photographic Archives Technical and Videodisc Files (AS·237). Negative #88-8142. Videodisc #2A-00487.

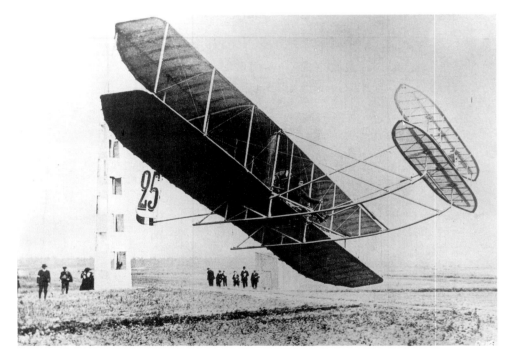

U.S. Army Air Service. "One-quarter front right side view of Eugene Lefebvre's Wright Type A Flyer, competition no. 25, banking at low altitude around a pylon at the Grande Semaine d'Aviation de la Champagne, held August 22-29, 1909, in Reims, France." 1909. Silver gelatin photoprint. Photographic Archives Technical and Videodisc Files (AS·237). Negative #86-9865. Videodisc #2B-31241.

Anon. "Thomas S. Baldwin's airship." N.D. Silver gelatin photoprint. Photographic Archives Technical and Videodisc Files (AS-237). Negative #81-8152. Videodisc #2B-01308.

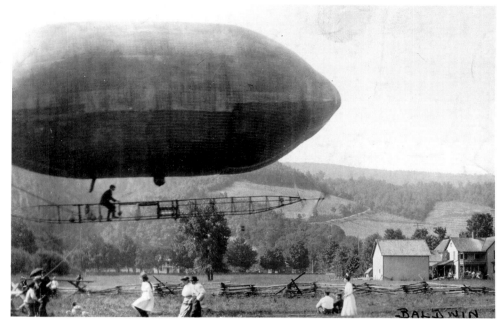

Agence de Reportage Photographique Meurisse. "Jules Védrines." Ca. 1909–1911. Silver gelatin photoprint. Photographic Archives Technical and Videodisc Files (AS-237). Negative #86-6276.

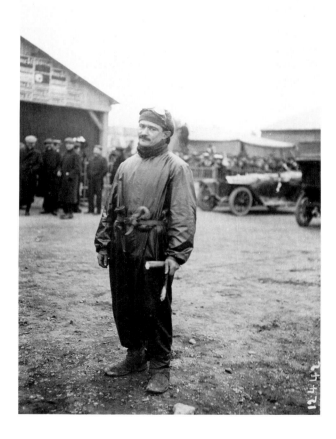

Anon. "Three-quarter left front view from below of Blériot XI bis (50 hp Gnome) in flight during Statue of Liberty Race, part of the International Aviation Tournament, Belmont Park, Long Island, New York. Pilot was John B. Moisant, who won the race. Statue visible at lower right." October 30, 1910. Silver gelatin photoprint. Sherman Fairchild Collection; Photographic Archives Technical and Videodisc Files (AS·237). Negative #93-1858. Videodisc #1B-23536.

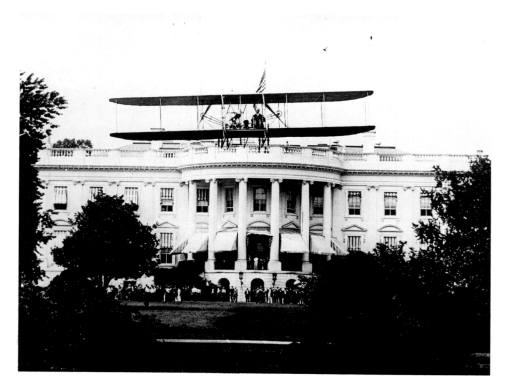

Harris & Ewing. "Head-on view of Harry N. Atwood in flight over the south lawn of the White House in a Wright Model B biplane." July 14, 1911. Silver gelatin photoprint. Photographic Archives Technical and Videodisc Files (AS·237). Negative #A 31291 B. Videodisc #2A-01314.

Anon. "Glenn H. Curtiss seated at controls of an early pusher and holding a dog on his lap. View from left front." N.D. Silver gelatin photoprint. Photographic Archives Technical and Videodisc Files (AS·237). Negative #85-18299. Videodisc #2B-06168.

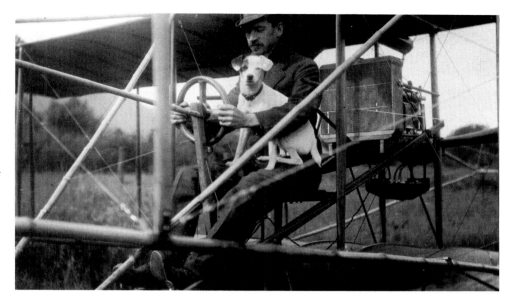

Anon. "Photo of Ruth B. Law (Oliver) flying loops at a night exhibition. Law had been the first person to fly publicly at night in 1913 and she was believed to be the first woman pilot to fly in a loop, 1915. A bust portrait of Law is superimposed in top right corner." Ca. 1915. Silver gelatin photoprint. Photographic Archives Technical and Videodisc Files (AS·237). Negative #77-706. Videodisc #2B-16193.

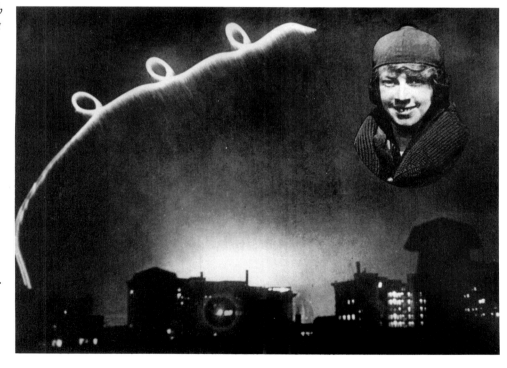

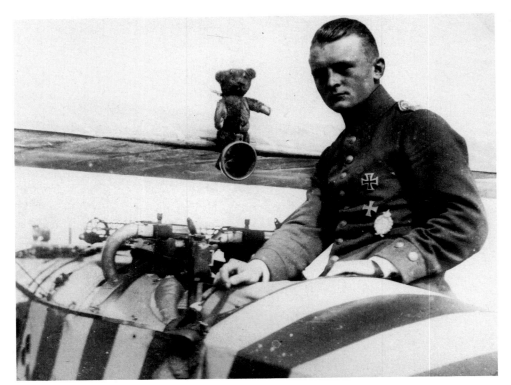

Anon. "Lt. Ulrich Neckel, Commander of Jasta 6, 30 victories." N.D. (World War I). Silver gelatin photoprint. Photographic Archives Technical and Videodisc Files (AS·237). Negative #76·13308. Videodisc #2A-44763.

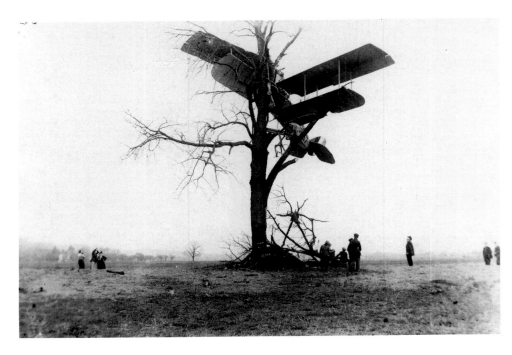

Anon. "Curtiss JN-4 in tree." Ca. 1917–1918. Silver gelatin photoprint. Photographic Archives Technical and Videodisc Files (AS·237). Negative #76-4155. Videodisc #1A-28956.

Anon. "Berliner heli-copter." 1919. Silver gelatin photoprint. Photographic Archives Technical and Videodisc Files (AS.237). Negative #A 4536 B. Video-disc #2B-02317.

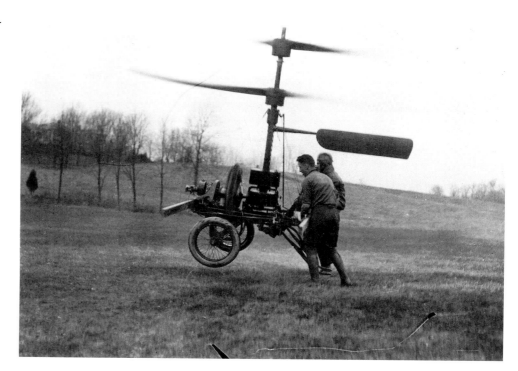

Anon. "Fokker D VIII at Amsterdam factory." 1919. Silver gelatin photoprint. Photographic Archives Technical and Videodisc Files (AS.237). Negative #A 43639 L. Video-disc #7A-24142.

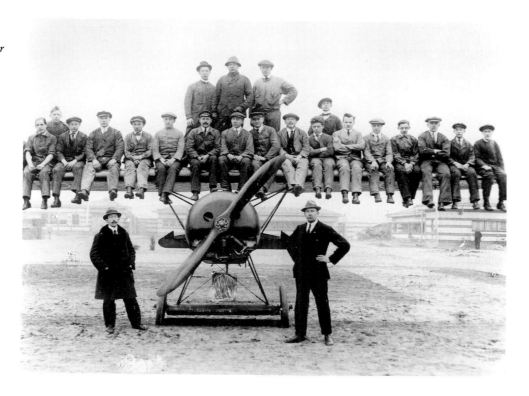

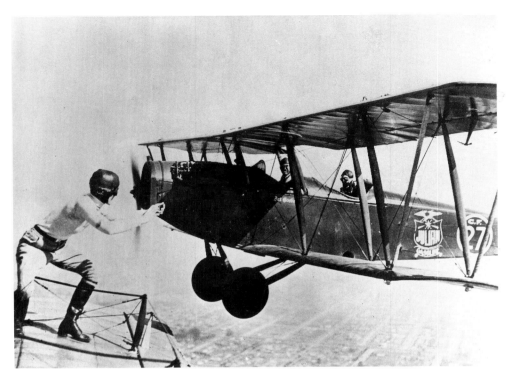

Anon. "One-quarter left side view of Curtiss JN-4 biplane in flight. Visible in the left foreground of the image is an unidentified wingwalker, standing on the wing of the photographer's aircraft." 1920s. Silver gelatin photoprint. Photographic Archives Technical and Videodisc Files (AS·237). Negative #A-4463. Videodisc #1A-28980.

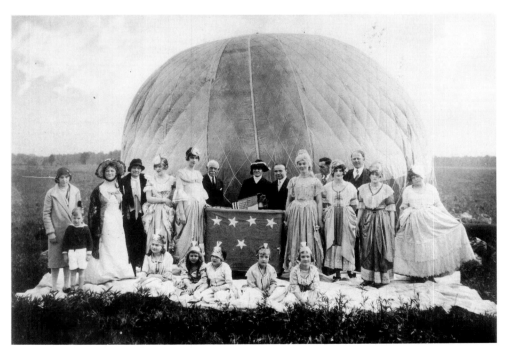

Anon. "Large group poses in front of a partially inflated gas balloon; probably an Independence Day celebration. Man to right of man wearing tricorn (and holding barograph) is Henry Woodhouse of Aero Club of America." 1920s. Silver gelatin photoprint. Photographic Archives Technical and Videodisc Files (AS·237). Negative #93-1856. Videodisc #2A-03244.

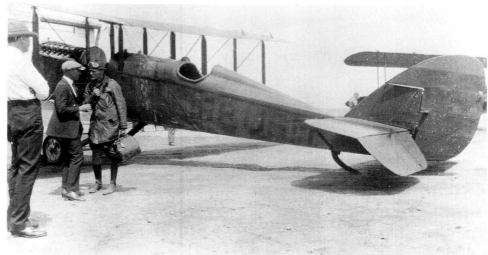

Anon. "One-quarter left rear view of De Havilland DH-4 modified for use as a mail plane." N.D. Silver gelatin photoprint. Photographic Archives Technical and Videodisc Files (AS-237). Negative #A 2005. Videodisc #1A-34334.

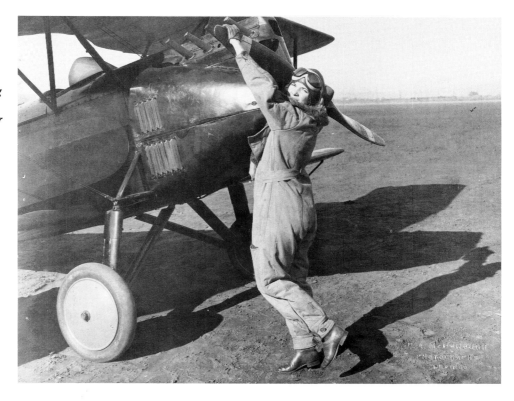

P.A. McDonough Photographs. "Ruth Blaney Alexander, dressed in a flight suit, pulling on the propellor of a Barling NB-3 monoplane in San Diego. Alexander had just set a new women's altitude record for light airplanes of 26,000 feet." July 1930. Silver gelatin photoprint. Photographic Archives Technical and Videodisc Files (AS-237). Negative #89-1189. Videodisc #2B-00217.

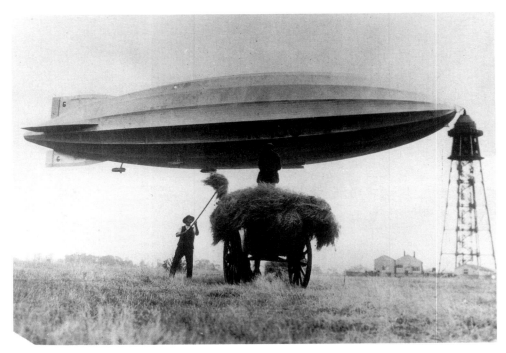

Acme Newspictures. "Right side view from ground level of British airship R 100 (r/n G-FAAV) riding at its mooring mast at the airdrome at Cardington, England, prior to a planned trans-Atlantic flight to Canada. In immediate foreground English farmers load hay onto haywagon." August 6, 1930. Silver gelatin photoprint. Photographic Archives Technical and Videodisc Files (AS·237). Negative #93-1857. Videodisc #2A-05004.

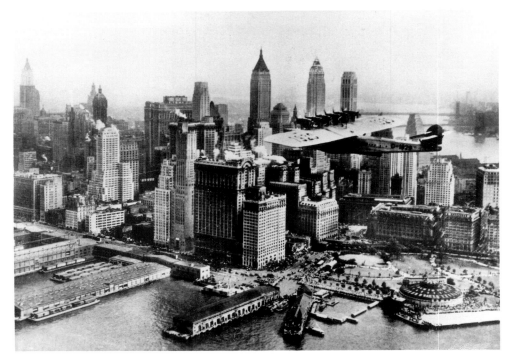

Anon. "One-half left rear view of Deutsche Luft Hansa Dornier DoX (r/n D-1929) in flight over the Hudson River. Visible in background are the skyscrapers of lower Manhattan, New York City; Battery Park visible at lower right." Ca. 1930. Silver gelatin photoprint. Photographic Archives Technical and Videodisc Files (AS·237). Negative #93-1859. Videodisc #1A-36855.

Anon. "Ceremony at a Chicago armory honoring Bessie Coleman; pilots and others posed around a Pietenpol homebuilt aircraft. In 1922 Coleman became the first licensed black pilot in the world." Early 1930s. Silver gelatin photoprint. Photographic Archives Technical and Videodisc Files (AS·237). Negative #92-15383. Videodisc #2B-05297.

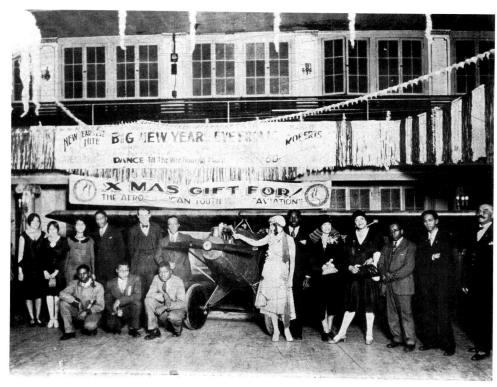

Anon. "Close-up view of Henry H. ('Hap') Arnold sitting in an unidentified aircraft wearing flight gear at March Field." 1934. Silver gelatin photoprint. Photographic Archives Technical and Videodisc Files (AS·237). Negative #92-4070. Videodisc #2B-00956.

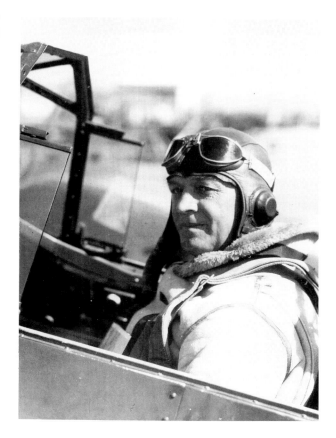

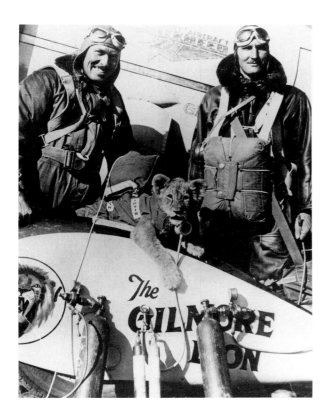

Anon. "Left to right: Col. Roscoe Turner, Gilmore the Lion, and unidentified man, posed behind or on left wheel cover of a Lockheed Air Express. All are wearing parachutes and display oxygen equipment." N.D. Silver gelatin photoprint. Photographic Archives Technical and Videodisc Files (AS.237). Negative #87-16237. Videodisc #2B-27719.

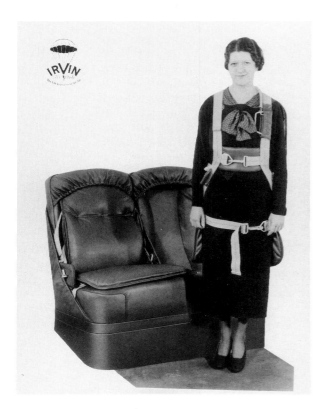

Irvin Air Chute Co. "Woman passenger models the Irvin Chair Chute, a parachute designed to fit into airplane seats; a stowed Chair Chute can be seen in the seat at left. This parachute used a lap-strap harness, rather than leg straps." N.D. Silver gelatin photoprint. Photographic Archives Technical and Videodisc Files (AS.237). Negative #93-1853. Videodisc #2A-40986.

J.C. Allen. "Amelia Earhart leaning against her new 1936 Cord Phaeton automobile which stands in front of her new Lockheed 10E Electra at Purdue University." Ca. 1936. Silver gelatin photoprint. Photographic Archives Technical and Videodisc Files (AS·237). Negative #86-147. Videodisc #2B-27719.

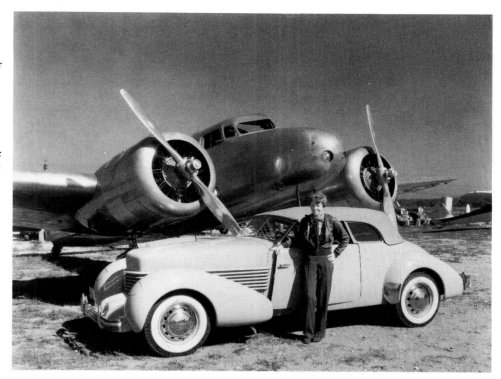

Anon. "View of the Lockheed exhibit at the 1937 Los Angeles Air Show. Centerpiece of the exhibit is the Lockheed 12 Electra Junior (three-quarter right fron view of aircraft)." 1937. Silver gelatin photoprint. Sherman Fairchild Collection; Photographic Archives Technical and Videodisc Files (AS·237). Negative #93-1854. Videodisc #2A-41073.

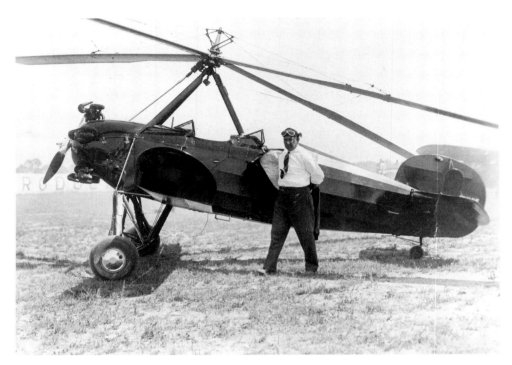

Anon. "Left side view of Pitcairn PA-18 Autogyro on the ground. Man putting on his flight jacket beside autogyro may possibly be Earl Eccles, if this is the 1938 National Air Races, Cleveland, Ohio." Ca. 1938. Silver gelatin photoprint. Photographic Archives Technical and Videodisc Files (AS·237). Negative #93-1850. Videodisc #2A-41235.

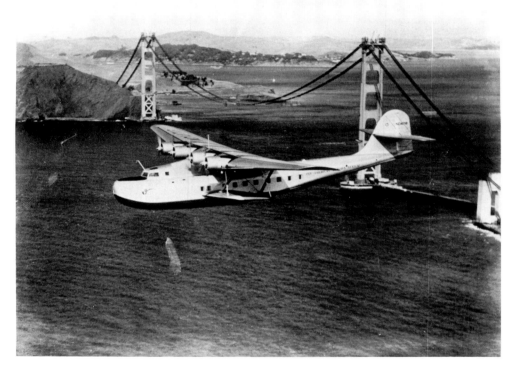

Anon. "Pan American Airways Martin 130 China Clipper in flight over Golden Gate, uncompleted Golden Gate Bridge in the background." 1939. Silver gelatin photoprint. Photographic Archives Technical and Videodisc Files (AS·237). Negative #85-13095. Videodisc #2A-42076.

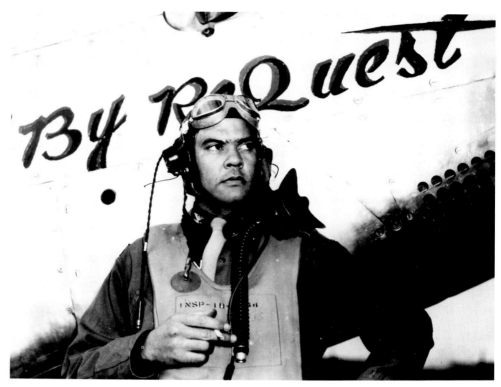

Anon. "Col. Benjamin O. Davis standing in front of his North American P-51D Mustang By Request. Davis is wearing his flight hat, goggles, oxygen mask, and life vest." N.D. Silver gelatin photoprint. Photographic Archives Technical and Videodisc Files (AS·237). Negative #92-7053. Videodisc #2B-06480.

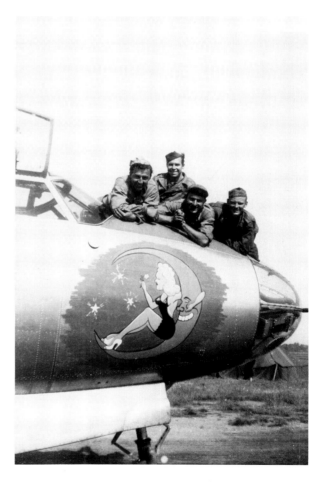

Anon. "Close-up view of right side of nose of Martin B-26 Marauder Classy Chassy (332nd Bomb Group) showing nose art by Ted Simonaitis, who is third from left among four men posed leaning on the nose of the aircraft. Artwork is signed and dated by the artist 6 April 1944." 1944. Silver gelatin photoprint. Photographic Archives Technical and Videodisc Files (AS·237). Negative #93-1849. Videodisc #2A-44273.

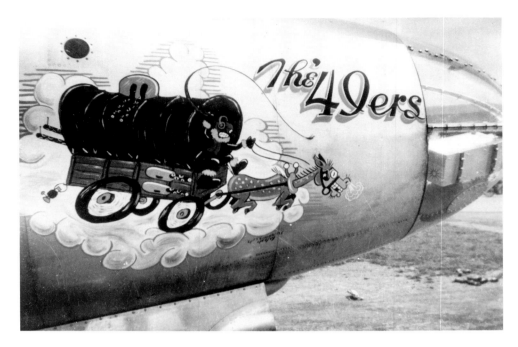

Anon. "Close-up view of right side of nose of Martin B-26 Marauder The '49ers (332nd Bomb Group), showing nose art by Ted Simonaitis. Artwork is signed and dated by the artist 29 June 1944." 1944. Silver gelatin photoprint. Photographic Archives Technical and Videodisc Files (AS·237). Negative #93-1851. Videodisc #2A-44264.

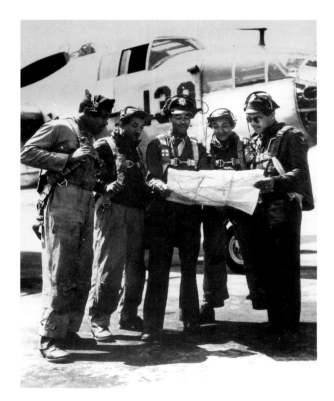

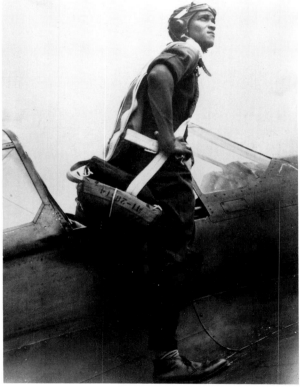

Anon. "Informal full length portrait of a five-man North American B-25 crew of the 477th Bombardment Group consulting on a flight plan before departing on a training mission." 1943–1945. Silver gelatin photoprint. Photographic Archives Technical and Videodisc Files (AS·237). Negative #91-6599. Videodisc #2B-32093.

U.S. Air Force. Cadet William F. Williams steps out of a Curtiss P-40 Warhawk at the Tuskegee Army Air Facility. N.D. (World War II). Silver gelatin photoprint. Photographic Archives Technical and Videodisc Files (AS·237). Negative #91-6597. Videodisc #2B-32090.

Boeing Airplane Co. "View of the women's dressing room installed in the Boeing 377 Stratocruiser. 'One of the features is a generously mirrored powder room w/ upholstered settee and two individual tables.'" Ca. 1950. Silver gelatin photoprint. Photographic Archives Technical and Videodisc Files (AS-237). Boeing photograph #P-8657. Negative #93-1861. Videodisc #1A-14472.

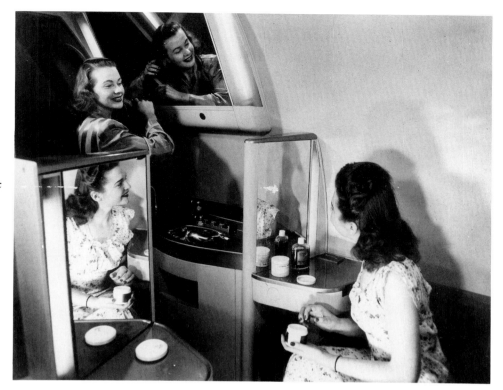

Boeing Airplane Co. "Three-quarter left front view, close-up and from ground level, of Boeing 377 Stratocruiser (r/n NX-90700) taking off from Boeing Field, Seattle, Washington, on its maiden flight. (Registration number was later changed to N1022V.) Left wingtip is out of frame." July 14, 1947. Silver gelatin photoprint. Photographic Archives Technical and Videodisc Files (AS-237). Boeing photograph #P-7047. Negative #93-1862. Videodisc #1A-14537.

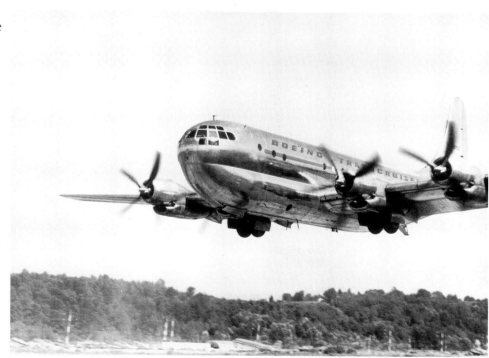

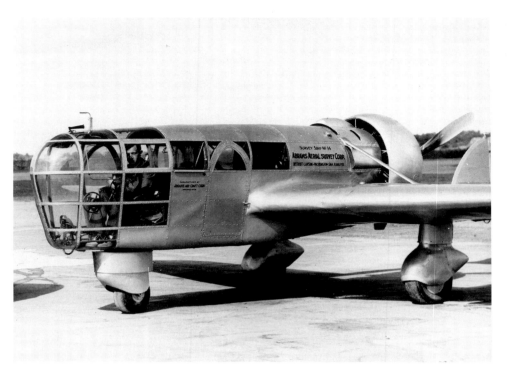

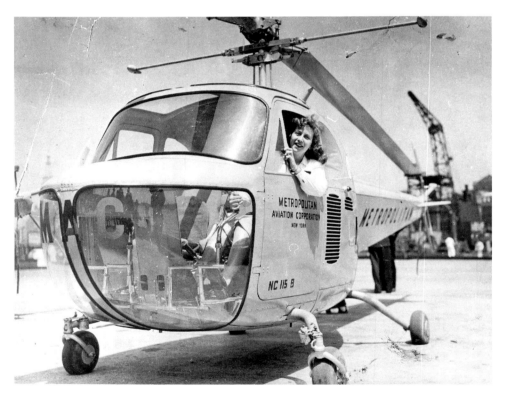

Anon. "Informal photo of Lafayette Escadrille members in front of an American flag." Ca. 1917. Silver gelatin photoprint. Robert Soubiran Collection (AS·272). Negative #78-7888. Videodisc #2A-48231.

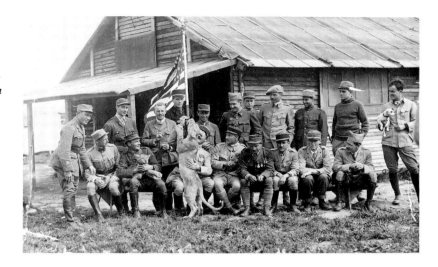

Anon. "Louise Thaden waving from her aircraft." Ca. 1936. Silver gelatin photoprint. Louise M. Thaden Collection (AS·280). Negative #91-705.

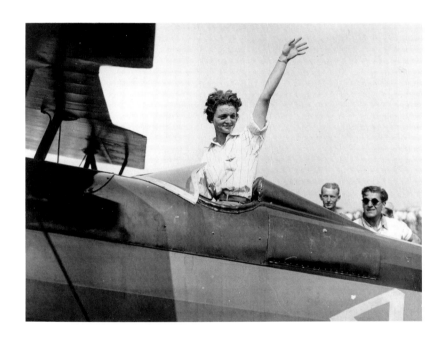

Anon. "Slightly faked photo of contestants at Belmont Park Meet." 1910. Silver gelatin photoprint. U.S. Air Force Pre-1954 Official Still Photograph Collection (AS·295). USAF Negative #318 AC. Videodisc #3B-07213.

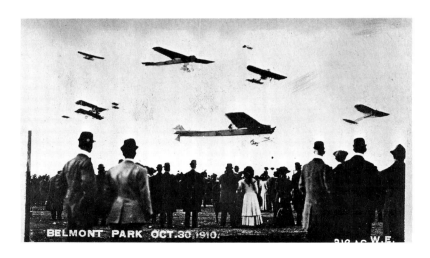

US Army Signal Corps. "General Mason Patrick and Major Edward Steichen. American Expeditionary Force, France." Ca. 1917. Silver gelatin photoprint. U.S. Air Force Pre-1954 Official Still Photograph Collection (AS·295). USAF Negative #122406 AC. Videodisc #4A-03605.

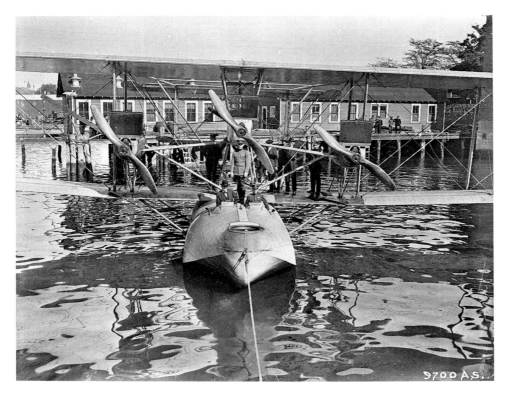

U.S. Army Air Service. "Scene incident to the arrival of NC-4 after flight over Atlantic. (Flight of U.S. Navy NC-4 seaplane from Trepassey, Newfoundland, to Lisbon, Portugal, and thence to Plymouth, England.)" 1919. Silver gelatin photoprint. U.S. Air Force Pre-1954 Official Still Photograph Collection (AS·295). USAF Negative #9700 AC. Videodisc #3B-07239.

U.S. Army Air Service. "Two world cruisers and cutter Haida *at Atka, Alaska; 1924 around-the-world flight." 1924. Silver gelatin photoprint. U.S. Air Force Pre-1954 Official Still Photograph Collection (AS·295). USAF Negative #11533 AC. Videodisc #3B-07984.*

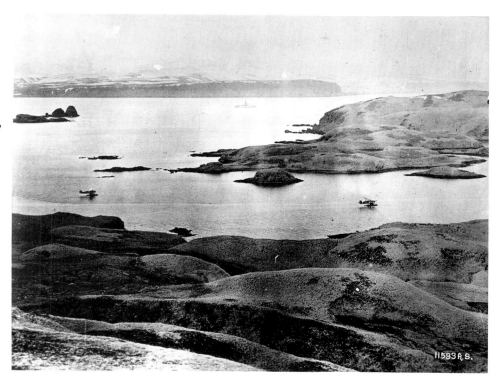

U.S. Army Air Service. "Aerial view of Mines Field, Los Angeles, California, during National Air Races." 1920s. Silver gelatin photoprint. U.S. Air Force Pre-1954 Official Still Photograph Collection (AS·295). USAF Negative #122405 AC. Videodisc #3B-08893.

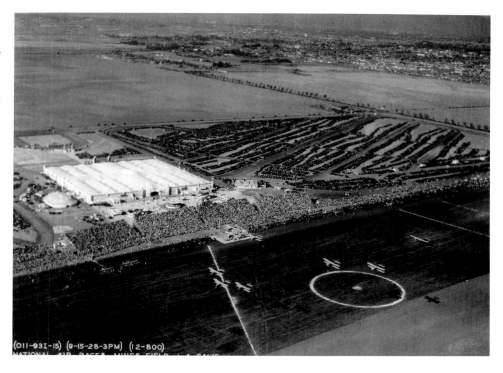

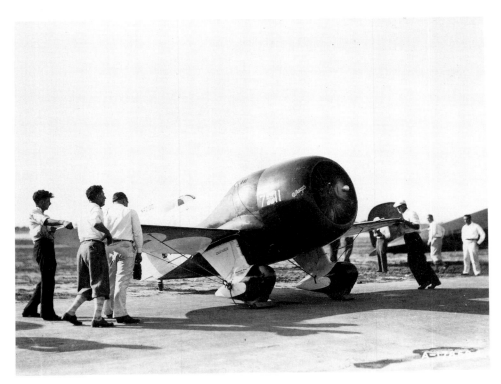

U.S. Army Air Corps. "Warming up the motor in Jimmie Doolittle's Gee Bee Racer. National Air Races, Cleveland, Ohio." 1932. Silver gelatin photoprint. U.S. Air Force Pre-1954 Official Still Photograph Collection (AS-295). USAF Negative #A 17859 AC. Videodisc #3B-09463.

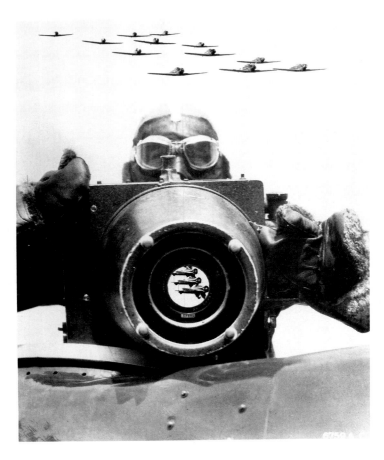

U.S. Army Air Corps. "Aerial cameraman - a composite photo made up from photos 15909, 13412 & 18428 AC. This shows an aerial cameraman with formation flying overhead and formation shown in lens of camera." 1930s. Silver gelatin photoprint. U.S. Air Force Pre-1954 Official Still Photograph Collection (AS-295). USAF Negative #6759 AC. Videodisc #4A-14464.

102nd Photo Section, New York National Guard. "Composite photo." 1930s. Silver gelatin photoprint. U.S. Air Force Pre-1954 Official Still Photograph Collection (AS·295). USAF Negative #13621 AC. Videodisc #4A-14508.

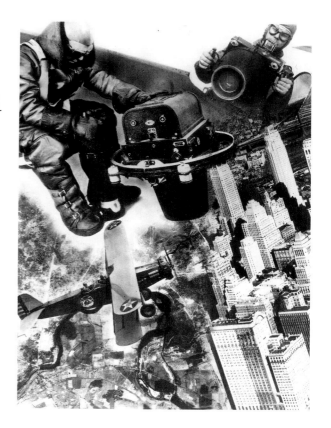

U.S. Army Air Corps. "Major George W. Goddard (standing), Chief of the Army Air Corps Photographic Branch at Wright Field, Dayton, Ohio, and Sgt. A.E. Mathos (kneeling), Army Aerial Photographer, are shown at Jacksonville, Florida, 'warming up' the huge aerial cameras they planned to use April 7 in shooting the ring eclipse of the sun." Ca. 1930s. Silver gelatin photoprint. U.S. Air Force Pre-1954 Official Still Photograph Collection (AS·295). USAF Negative #27110 AC. Videodisc #4A-14505.

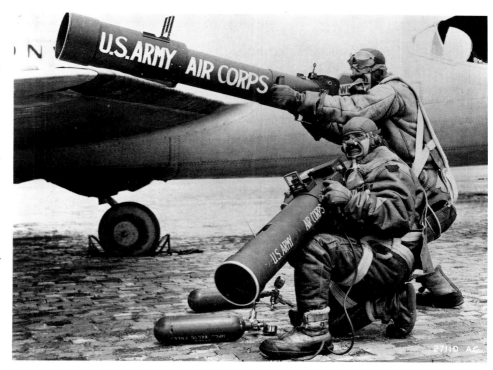

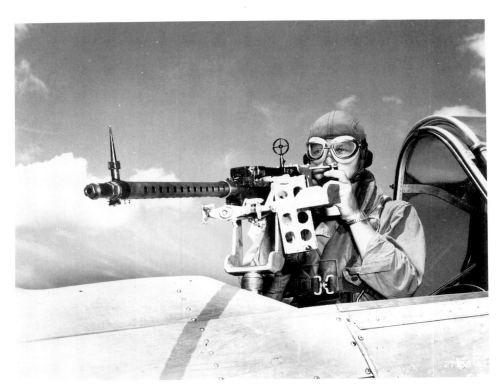

U.S. Army Air Corps. "Aerial machine gunner in a North American AT-6 Texan training aircraft." Early 1940s. Silver gelatin photoprint. U.S. Air Force Pre-1954 Official Still Photograph Collection (AS·295). USAF Negative #27758 AC. Videodisc #4A-14415.

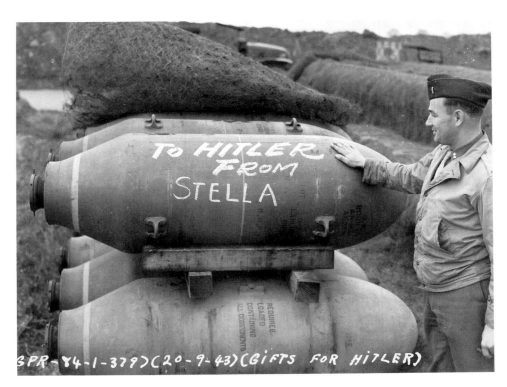

U.S. Army Air Forces. "'To Hitler from Stella,' inscription on a bomb of the 379th Bomb Group, 8th Air Force. England." 1943. Silver gelatin photoprint. U.S. Air Force Pre-1954 Official Still Photograph Collection (AS·295). USAF Negative #62318 AC. Videodisc #4A-40472.

*U.S. Air Force.
"Tuskegee airmen."
N.D. (World War II)
Silver gelatin photo-
print. U.S. Air Force
Pre-1954 Official Still
Photograph Collec-
tion (AS·295). Nega-
tive #84-14783.
Videodisc #2A-46842.*

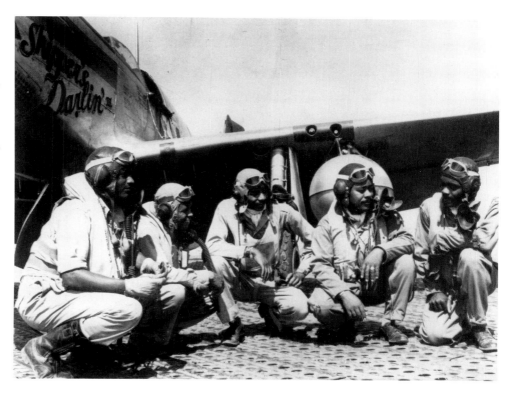

*U.S. Army Air Forces.
"Messerschmitt Me
163 (right side view
on ground). Photo
taken at Wright Field,
Ohio." Ca. 1946.
Silver gelatin photo-
print. U.S. Air Force
Pre-1954 Official Still
Photograph Collec-
tion (AS·295). USAF
Negative #25332 AC.
Videodisc #3B-
34746.*

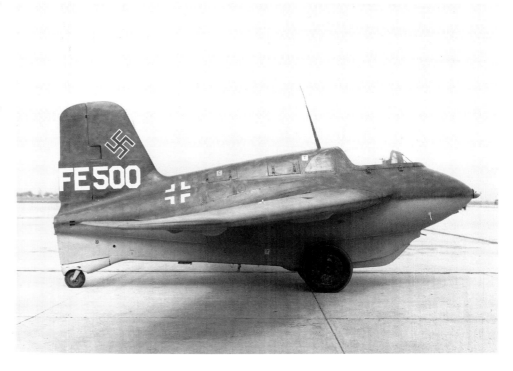

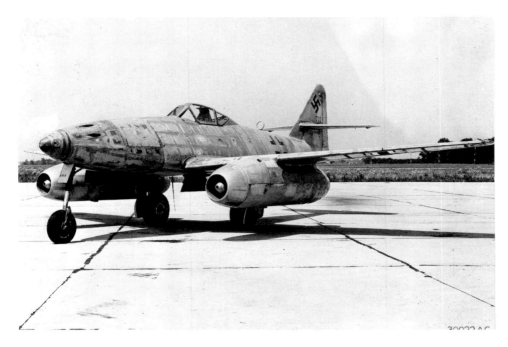

U.S. Army Air Forces. "Wright Field, Ohio. Three-quarter front view of the Messerschmitt 262A-1, German jet-propelled fighter, first of its type to be brought to the United States, which is now being studied by engineers of the Air Technical Service Command." Ca. 1946. Silver gelatin photoprint. U.S. Air Force Pre-1954 Official Still Photograph Collection (AS.295). USAF Negative #30022 AC. Videodisc #3B-34779.

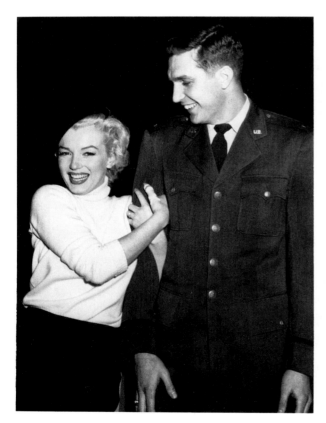

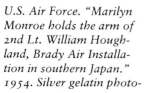

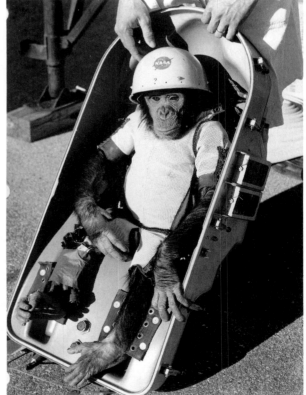

U.S. Air Force. "Marilyn Monroe holds the arm of 2nd Lt. William Houghland, Brady Air Installation in southern Japan." 1954. Silver gelatin photoprint. U.S. Air Force Pre-1954 Official Still Photograph Collection (AS.295). USAF Negative #94598 AC. Videodisc #4A-36681.

NASA. "Full length portrait of primate Ham in his spacesuit being fitted into the couch of the Mercury-Redstone MR-2 capsule #5." 1961. Silver gelatin photoprint. U.S. Space Program Collection (AS.300). Negative #91-14664. NASA Negative #S-63-20801.

NASA. *"Full length informal portrait of Jay North, 'Dennis the Menace,' seen with astronaut Malcolm Scott Carpenter, behind North. All are standing in front of Mercury Spacecraft M.A.-7 Aurora 7, used to orbit the Earth."* 1962. Silver gelatin photoprint. U.S. Space Program Collection (AS.300). Negative #91-14663.

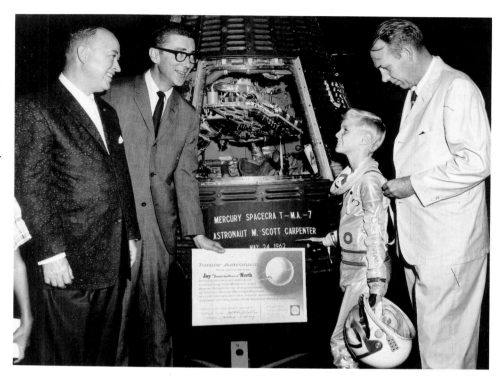

NASA. *"One-half left front view of President John Fitzgerald Kennedy and his motorcade as it passes through Houston, Texas. President Kennedy visited Texas and the Manned Spacecraft Center located in Houston in October of 1962. Large groups of people can be seen along the President's route."* 1962. Silver gelatin photoprint. U.S. Space Program Collection (AS.300). Negative #91-14665. NASA Negative #S-62-5213.

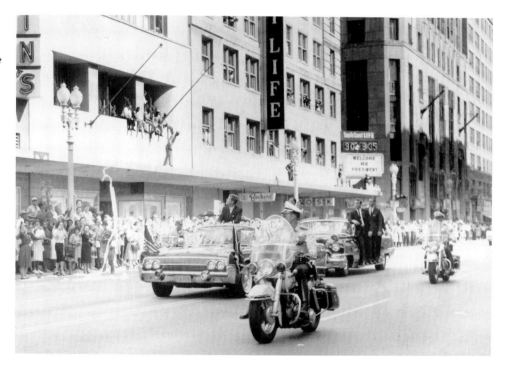

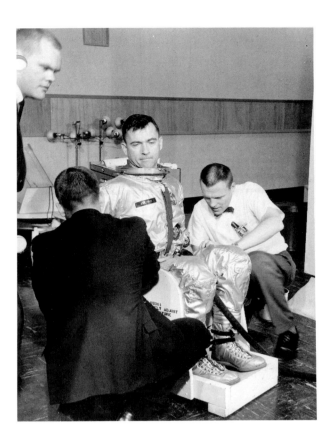

NASA. "Full length informal portrait of J.M. Young, astronaut, being strapped into restraining harness by Northrop Ventura personnel at the Weber Aircraft Corp., Burbank, California, plant. Young is in a Mercury-style spacesuit." 1964. Silver gelatin photoprint. U.S. Space Program Collection (AS·300). Negative #91-14666. NASA Negative #S-64-22364.

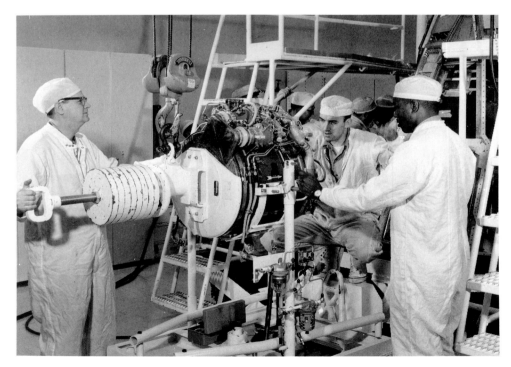

NASA. "View of three McDonnell Aircraft personnel installing the environmental control system into Spacecraft 3A at the St. Louis, Missouri, plant." 1964. Silver gelatin photoprint. U.S. Space Program Collection (AS·300). Negative #91-14667. NASA Negative #S-64-22355.

NASA. "View of Wesly Brenton, Tech. Services, briefing students from Friendswood High School at Building 10 at the Manned Spacecraft Center, Clear Lake, Texas." 1964. Silver gelatin photoprint. U.S. Space Program Collection. Negative #91-14668 (AS·300). NASA Negative #S-64-21959.

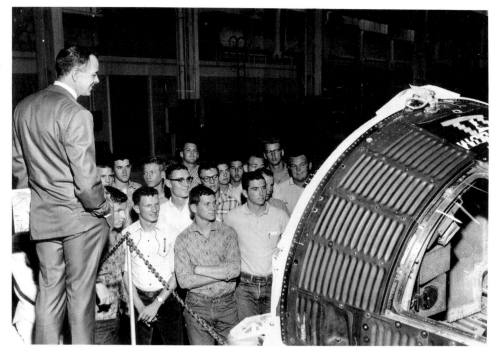

Below: Anon. "Photo showing Japanese prisoners of war (POWs) in India." N.D. (World War II). Silver gelatin photoprint. George W. Wood, Jr., Diaries (AS·317). Negative #91-14715.

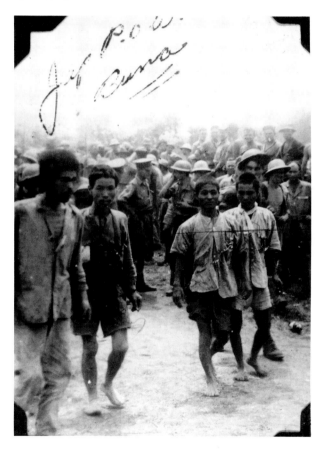

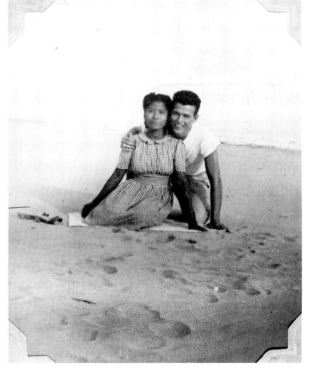

Anon. "Photo of two unidentified persons (American soldier and Filipino) sitting on beach, from the 475th Fighter Group 'Satan's Angels.'" N.D. (World War II). Silver gelatin photoprint. George W. Wood, Jr., Diaries (AS·317). Negative #91-14718.

traits of a dispatch rider on a motorcycle and of 139th Aero Squadron personnel and aircraft. There are also photographs of an American Legion ceremony, a battleship in New York harbor, and a French cathedral. Non-military aviation events documented include crashes; a crowd at the airfield in Albany, New York; Maughan's record-breaking flight from Long Island to San Francisco in 1924; the Pulitzer Trophy race of 1922; and the Transcontinental Race of 1919. There are aerial photographs of Schenectady and Utica, New York, and Niagara Falls. Family photographs include portraits of Maughan's family, especially children, with automobiles, houses, and toys. Travel photographs show campsites; Cooperstown, New York; and a herd of deer in the Grand Canyon.

Arranged: No.

Captioned: Most with subject (handwritten, mostly illegible).

Finding Aid: No.

Restrictions: The collection, located at the Garber Facility, is available by appointment only.

AS·187

Hiram S. Maxim Collection

Dates of Photographs: Circa 1858–1980

Collection Origins

Inventor Hiram S. Maxim (1840–1916) created the collection to document his career. Maxim was an apprentice coachmaker and then worked in an iron works. In 1878, while employed as chief engineer of the U.S. Electric Lighting Company, Maxim lost a priority struggle with Thomas Edison over the invention of the electric light. Shortly afterward he invented the first efficient machine gun. He failed to interest the U.S. government in the invention, so he moved to England in 1881 and established the Maxim Gun Company. In 1896 his company merged with the Nordenfeldt and Vickers Companies to form Vickers Sons and Maxim. After the British War Office adopted his gun, Maxim became a British citizen and was knighted by Queen Victoria. In the mid-1880s Maxim began ex-

perimenting with aeronautics, on which he published a number of books and articles including the following: *Artificial and Natural Flight*. London and New York: Whittaker & Co., 1908. NASM Archives assigned the collection accession number 1989-0031.

Physical Description

There are 60 photographs including albumen photoprints, collodion gelatin photoprints (POP), and silver gelatin photoprints. Other materials include books, correspondence, magazine clippings, manuscripts, and newspaper clippings.

Subjects

The photographs document Hiram S. Maxim and his inventions including an experimental airplane and machine guns. Images of Maxim's airplane (1890) include construction, experiments with the aircraft on rails, and parts such as the engine and propellers. Images of machine guns include British machine gun detachments in the 1890s, Maxim firing a gun, and the Prince of Wales firing a gun.

Arranged: No.

Captioned: Some with subject.

Finding Aid: Item-level transfer list.

Restrictions: The collection, located at the Garber Facility, is available by appointment only.

AS·188

James R. McConnell Scrapbook

Dates of Photographs: Circa 1880–1928

Collection Origins

James M. Truitt assembled the collection to document the life of Lafayette Escadrille pilot James R. McConnell (1887–1917). McConnell attended the University of Virginia, and in 1915 he joined the French Foreign Legion as an ambulance driver. He learned to fly, joined the Lafayette Escadrille, a group of American pilots in France, and served until he was shot

down and killed in 1917. Truitt donated the collection to NASM, where it received accession number XXXX-0232. Photographers and studios represented include Brown & Schroeder, De Vos, Max Platz, and White.

Physical Description

There are 75 photographs including albumen photoprints, collodion gelatin photoprints (POP), and silver gelatin photoprints (some tinted), mounted in a scrapbook. Other materials include correspondence and newspaper clippings, also mounted in the scrapbook.

Subjects

The photographs document the life of James R. McConnell, particularly his activities in the Lafayette Escadrille. McConnell is portrayed as a child and young man, deer-hunting in Florida, and in a kilt with bagpipes. He is later shown acting as a patient during Red Cross practice on a ship bound for France; as an ambulance driver in France, with ambulances and other drivers; and as a Lafayette Escadrille pilot with aircraft, such as Nieuports, and other pilots including Victor Chapman, Raoul Lufbery, and Kiffin Y. Rockwell. Finally, there are images of McConnell's grave and memorials, including his first grave near his crash site with parts of an aircraft and a later grave with a memorial, attended by crowds with flags on Memorial Day 1927; the Lafayette Memorial near Paris where his body was moved in 1928; and a memorial in Carthage, North Carolina.

Arranged: Chronologically.

Captioned: Most with date and subject.

Finding Aid: No.

Restrictions: The collection, located at the Garber Facility, is available by appointment only.

AS·189

Alexis B. McMullen Papers, 1915–1983

Dates of Photographs: 1915–1960s

Collection Origins

Alexis B. McMullen (1896–1980) created the collec-

tion to document his career as an aviator and aviation official. McMullen, who received a B.A. from Valparaiso University in 1917, learned to fly during World War I and became a U.S. Army flight instructor and engineering officer. After the war he barnstormed (with Mabel Cody) and practiced aerial photography, including motion pictures. He then became a partner and operations manager at Shank-McMullen Aircraft Corporation (1923–1925) and president of McMullen Aircraft Corporation (1925–1933).

In 1933 McMullen became Florida's first state director of aviation, constructing 84 new airports and landing strips and publishing the first comprehensive state aviation map. Between 1936 and 1942 he served as chief of the Airports Section of the Bureau of Air Commerce (later Civil Aeronautics Administration). During and after World War II he served in the U.S. Army Air Forces' Air Transport Command in north Africa and the United States. McMullen later established the headquarters of the National Association of State Aviation Officials (NASAO) in Washington, D.C., working with the association until his retirement in 1970. Sarah Lindsey, McMullen's daughter, donated the collection to NASM, where it received accession number 1990-0060. Photographers and studios represented include Francis E. Price, Sikorsky, Edgar B. Smith, and the U.S. Air Force.

Physical Description

There are 1,000 photographs including collodion gelatin photoprints (POP), kallitypes, and silver gelatin photonegatives and photoprints. Other materials include charts, correspondence, manuscripts, maps, newspaper clippings, and reports.

Subjects

The photographs document Alexis B. McMullen's career as a barnstormer and as an official in government aviation service. Activities and events documented include air meets; an aviation conference with exhibits; construction of engines and Mac Airliner aircraft; exhibition flights such as Mabel Cody's transferring from water skis to an aircraft for a movie; a marriage taking place in a two-cockpit biplane in flight; National Association of State Aviation Officials meetings; a National Guard barbecue; recovery of a wrecked aircraft; a visit with a Moroccan official; and WPA aviation exhibits.

There are images of aircraft of the 1920s and 1930s such as a Mac Airliner, McMullen's barnstorming airplane with the sign "The Flying Farmer," and a Sikorsky flying boat with interiors showing the cockpit and passenger seats. Equipment and facilities documented include an aerial camera, airport runways showing markings and inadequate paving, an airship hangar, Florida airports, McMullen's company build-

ings, and McMullen's stations in Africa and the Mediterranean during World War II and training camp in World War I.

Travel photographs include images of Morocco (such as camels, local people, and soldiers marching) and Peru (such as an archeological excavation, architectural ruins, local people, mountains, railroad tracks, soldiers marching, and streets). There are aerial photographs of airports, cemeteries, cities, and coasts. There are also portraits of McMullen and his colleagues, family, and friends, some posing with aircraft.

Arranged: Roughly chronological.

Captioned: Some with date and subject.

Finding Aid: Item-level transfer list.

Restrictions: The collection, located at the Garber Facility, is available by appointment only.

AS·190

James Means Aviation Scrapbooks

Dates of Photographs: 1908–1910

Collection Origins

Aeronautical inventor and publicist James Means (1853–1920) created the collection to document early aviation activities. Means, who attended Phillips Academy and Massachusetts Institute of Technology, opened a shoe factory in 1878 and earned enough to retire in 1893. He began studying aeronautics in the 1880s and published an article called "Manflight" in the *Boston Transcript* in 1884. After retiring from business, he experimented with gliders and kites, making contacts with other pioneer aviators such as Samuel P. Langley and Octave Chanute. Convinced that progress in aeronautical research depended on shared information, Means began publishing *The Aeronautical Annual,* containing articles submitted by several different experimenters, in 1895. The publication ended after the 1897 issue, however, due to a lack of new material. After the turn of the century Means was no longer so closely involved in aeronautical development, but he observed the 1908 Wright Army tests and attended the 1909 International Aviation

Meet at Reims. He also invented an airplane signaling device, launchers, and a control system in 1909 and 1911. NASM Archives assigned the collection accession number XXXX-0343.

Physical Description

There are ten silver gelatin photoprints, mounted in scrapbooks. Other materials include newspaper clippings, also mounted in the scrapbooks.

Subjects

The photographs document aircraft and aviation events between 1908 and 1910. Events documented include the 1908 crash of Thomas E. Selfridge and Orville Wright that killed Selfridge (the first airplane fatality) and Glenn H. Curtiss's flight in the *June Bug.*

Arranged: In five volumes by date and subject. Photographs are in volume 3 (box 1) and volume 5 (box 3).

Captioned: Some with subject.

Finding Aid: No.

Restrictions: The collection, located at the Garber Facility, is available by appointment only.

AS·191

James Means Correspondence Collection

Dates of Photographs: 1890s

Collection Origins

James Means created the collection to document his communication with aeronautical figures such as Octave Chanute, Samuel P. Langley, Otto Lilienthal, and Hiram S. Maxim in the late 19th century. For a biography of Means, see *Collection Origins* in *AS·190.*

Physical Description

There are 15 photographs including albumen photo-

prints, collodion gelatin photoprints (POP), and silver gelatin photoprints. Other materials include correspondence.

Subjects

The photographs document gliding experiments in the 1890s, including Octave Chanute with several of his machines, getting into them, flying, and landing; as well as Otto Lilienthal flying his gliders. There are also some travel photographs showing a cathedral, Egyptian monuments and ruins, a Greek temple, and a mosque.

Arranged: No.

Captioned: A few with subject.

Finding Aid: No.

Restrictions: The collection is kept in the Ramsey Room at the NASM Archives on the Mall. Researchers must be accompanied by a staff member and are encouraged to call or write for an appointment.

AS·192

George Meese Photograph Collection *A.K.A.* Richard Segar Photograph Collection

Dates of Photographs: Circa 1925–1941, Circa 1970s

Collection Origins

George Meese assembled the collection to document aircraft between the wars. Meese served in the armed forces during World War II. In 1986 he sold the collection to Richard Segar, who donated it to NASM in 1990. Photographers and studios represented include Marvin J. Borden, George Meese, Bill Metzger, Reid Patterson, E.J. Rice, the U.S. Navy, Whitman, Gordon S. Williams, and William Yeager.

Physical Description

There are 1,930 photographs including color dye dif-

fusion transfer photoprints (Polaroid) and silver gelatin photonegatives and photoprints.

Subjects

The photographs document aircraft from World War I to World War II, including airliners, German World War I aircraft, 1930s National Air Races entrants, record aircraft, and U.S. Army and Navy inter-war aircraft. Some are shown in ca. 1970s air shows. Manufacturers represented include Curtiss, Curtiss-Wright, De Havilland, Douglas, Fairchild, Fokker, Ford, Gee Bee, Grumman, Junkers, Keystone, Lockheed, Martin, Morane Saulnier, Nieuport, North American, Northrop, Pitcairn, Roland, Ryan, Seversky, Stearman, Stinson, Swallow, Thomas Morse, Travel Air, Verville, Vought, Vultee, Wittman, and Wright. There is also an image of August Piccard's stratospheric balloon gondola. People portrayed include George Meese and aviators James H. Doolittle, Amelia Earhart, Roscoe Turner, and Lewis A. Yancey.

Arranged: Alphabetically by manufacturer.

Captioned: With manufacturer and model or other subject.

Finding Aid: Caption database listing format, source, and subject for each image. Printouts can be obtained for single photographs or caption lists of photographs with related subjects.

Restrictions: No. The collection is located at the NASM Archives on the Mall. Researchers are encouraged to call or write for an appointment.

AS·193

Mercury Program *Big Joe* Installation Records, 1959

Dates of Photographs: 1959

Collection Origins

NASA created the collection to document the development of *Big Joe,* the first successful full-size Mercury

capsule. Shortly after its organization in October 1958, NASA initiated Project Mercury to launch a manned satellite into Earth orbit. Before sending up an astronaut, NASA tested the Mercury spacecraft and launch vehicles in a series of unmanned flights. The *Big Joe* capsule, launched from Cape Canaveral, Florida, on September 9, 1959, reached an altitude of 161 kilometers before reentering the atmosphere. Studios represented include NASA and the U.S. Air Force. NASM Archives assigned the collection accession number XXXX-0189.

Physical Description

There are 150 silver gelatin photoprints. Other materials include correspondence, engineering drawings, manuals, and notes.

Subjects

The photographs document NASA's *Big Joe* satellite, an unmanned Project Mercury capsule, and its construction. Parts shown include connectors, electric circuits, and the frame. Construction activities illustrated include connecting wires, testing parts, and welding. Other activities shown include men operating computers and control panels in a laboratory. There are also photographic reproductions of diagrams.

Arranged: By subject.

Captioned: With subject; many with parts of the capsule labeled.

Finding Aid: Box list.

Restrictions: The collection, located at the Garber Facility, is available by appointment only.

AS·194

Robert B. Meyer, Jr., Papers

Dates of Photographs: Circa 1920–1976

Collection Origins

Robert B. Meyer, Jr. (1920–), first curator of

propulsion in NASM's Aeronautics Department (1959–1980), created the collection to document his curatorial work and research. Among Meyer's publications are the following books that contain photographs from the collection: 1) *The First Airplane Diesel Engine: Packard Model DR-980 of 1928.* Washington, D.C.: Smithsonian Institution Press, 1965. 2) *Langley's Aero Engine of 1903.* Washington, D.C.: Smithsonian Institution Press, 1971. Photographers represented include Lee Fray of Sport Aviation Association, Charlie Lorrig, and OPPS staff. NASM Archives assigned the collection accession number XXXX-0184.

Physical Description

There are 1,150 photographs including color dye coupler photonegatives, photoprints, and slides; cyanotypes; dye diffusion transfer photoprints; and silver gelatin photonegatives and photoprints. Other materials include audiotape cassettes, books, charts, correspondence, engine blades, engineering drawings, magazines, manuscripts, maps, and newspaper clippings.

Subjects

The photographs primarily document aircraft and engines. Aircraft documented include an Antoinette, a Bellanca, a Curtiss Condor, a Curtiss Fledgling, the Langley Aerodrome, and the Ryan NY-P *Spirit of St. Louis,* as well as experimental helicopters. Aircraft engines depicted include an Anzani three-cylinder fan type, Curtiss engines, a Gnome rotary engine, Charles M. Manly's engine for the Langley Aerodrome, Soviet engines, and a Wright 4-cylinder motor. Other engines shown include Stephen M. Balzer's 1894 automobile engine and a steam engine.

Other aircraft parts and equipment depicted include propellers and wind-tunnel models. There are also aerial shots of mountains; images of air shows and exhibits such as NASM's interior in 1976 including the Space Hall; photographic reproductions of aircraft paintings; and portraits of Stephen M. Balzer, Samuel P. Langley, and Charles M. Manly.

Arranged: No.

Captioned: Some with date, negative number, or subject.

Finding Aid: Preliminary box list.

Restrictions: The collection, located at the Garber Facility, is available by appointment only.

AS·195

Thomas Dewitt Milling Papers

Dates of Photographs: 1964

Collection Origins

Thomas Dewitt Milling (1887–1960), the first U.S. Army pilot, created the collection to commemorate several events in his career. Milling graduated from the U.S. Military Academy in 1909 and received his pilot's license in 1912. His early aviation work included testing aerial bombs and machine guns, and he served as a flight instructor during World War I. In 1940 he became a brigadier general. NASM Archives assigned the collection accession number XXXX-0133.

Physical Description

There is one silver gelatin photoprint. Other materials include certificates, correspondence, and flight reports.

Subjects

The photograph is a portrait of Thomas Dewitt Milling taken in 1964.

Arranged: No.

Captioned: With date and name.

Finding Aid: No.

Restrictions: The collection is kept in the Ramsey Room at the NASM Archives on the Mall. Researchers must be accompanied by a staff member and are encouraged to call or write for an appointment.

AS·196

Miscellaneous Oversized Photographs

Dates of Photographs: Circa 1900–1940

Collection Origins

NASM Archives staff assembled the collection from several undocumented acquisitions and assigned it accession number XXXX-0373. In the future the photographs may be separated and added to existing collections. Studios represented include H. Armstrong Roberts and the U.S. Navy.

Physical Description

There are nine photographs including color dye coupler photoprints and silver gelatin photoprints.

Subjects

The photographs primarily document aircraft. Aircraft depicted include a balloon on an urban street, a Loening M-2 Kitten, and a group of Vought SB2U Vindicators in flight. There are also photographic reproductions of an engine diagram and a painting of U.S. Navy admiral and pilot Marc A. Mitscher.

Arranged: No.

Captioned: Some with subject.

Finding Aid: No.

Restrictions: The collection, located at the Garber Facility, is available by appointment only.

AS·197

Miscellaneous Ramsey Room Photographs

Dates of Photographs: Circa 1890s–1940s, 1974

Collection Origins

NASM staff assembled the collection from individual photographs kept in the museum's Ramsey Room. Studios represented include P.F. Collier & Son.

Physical Description

There are 10 photographs including a color dye coupler photoprint and silver gelatin photoprints.

Subjects

The photographs document early aircraft and famous aviators. People portrayed include Lincoln Beachey, Otto Lilienthal, Charles A. Lindbergh (in 1974), and Harriet Quimby. Images of aircraft include an Army aircraft flying over mules at an Army camp in San Antonio (ca. 1910) and an early photograph of a Wright airplane in flight.

Arranged: No.

Captioned: Some with name or subject.

Finding Aid: Inventory to the Ramsey Room listing location of collections and individual items.

Restrictions: The collection is kept in the Ramsey Room at the NASM Archives on the Mall. Researchers must be accompanied by a staff member and are encouraged to call or write for an appointment.

AS·198

William Mitchell Scrapbooks

Dates of Photographs: 1898–1920

Collection Origins

Army officer and aviator William ("Billy") Mitchell (1879–1936) created the collection to document his career during the 1900s and 1910s. Mitchell received an A.B. from George Washington University in 1899 and graduated from Army Staff College in 1909. He joined the U.S. Army Signal Corps, serving on the Mexican border, in Cuba, in the Philippines, and, during World War I, in France. Assistant Chief of Air Service from 1921 to 1926, Mitchell advocated the formation of an independent military air service and participated in aerial bombing tests in 1921 and a group flight to Alaska in 1923. However, when his public criticism of government policy led to a court martial, Mitchell resigned his commission in 1926. Photographers represented include Waldon Fawcett. NASM Archives assigned the collection XXXX-0331.

Physical Description

There are 470 photographs including collodion gelatin photoprints (POP) and silver gelatin photoprints, mounted in scrapbooks. Other materials include certificates, also mounted in the scrapbooks.

Subjects

The photographs document William ("Billy") Mitchell's activities as an officer in the U.S. Army Signal Corps. Other Signal Corps officers are shown on fishing and hunting trips in the Philippines. Signal Corps soldiers are portrayed exercising, laying wire on the Mexican border (1912), marching, repairing harnesses, scaling walls, setting up the first field radio issued to the Army (1906), shoeing horses, and washing clothes. There are also portraits of American and Spanish troops in Havana, Cuba (1898); children riding in aircraft and watching flights; men playing polo; Mitchell as a pilot; Mitchell as a Spanish-American War soldier with other soldiers; Mitchell riding horses; a Signal Corps baseball team; and U.S. generals and the mayor of Milwaukee, Wisconsin, in a parade.

Events documented include air shows; a Carnival parade with floats in Cuba (1907); a Decoration Day Parade with an integrated audience (1904); horse shows; the Pulitzer Trophy race (1920); and a volcano eruption in the Philippines with victims (1911). Equipment and facilities documented include a Dayton, Ohio, airfield with aircraft (1919) and Signal Corps airships, camps, cars, an officers' mess, a radio wagon, and a wire cart. Places documented include Jacksonville after a fire; a Marianao, Cuba, fortress and street; and a Manassas, Virginia, train station (1904).

Arranged: Loosely chronologically.

Captioned: Some with date and subject.

Finding Aid: No.

Restrictions: The collection, located at the Garber Facility, is available by appointment only.

AS·199

Monoplane *America* Christening Scrapbook

Dates of Photographs: 1927

Collection Origins

The collection was created to document the christen-

ing of the Fokker C-2 *America* prior to an attempted transatlantic crossing from New York to Paris in June 1927. The crew included pilots Bert Acosta and Bernt Balchen, navigator Richard E. Byrd, and flight engineer George Neville. Water taken from the Delaware River at the point of George Washington's Revolutionary War crossing was used to christen the aircraft, and an American flag, made by a descendent of Betsy Ross using pieces of cloth from the original material used in the first flag, was carried on board. The *America* failed to complete the flight, however, and landed near Ver-sur-mer, France. Rodman A. Heeren donated the collection to the Smithsonian Institution in 1969, and NASM Archives assigned it accession number XXXX-0076.

Physical Description

There are seven silver gelatin photoprints, mounted in an album.

Subjects

The photographs are of artifacts and documents used in the christening of the Fokker monoplane *America*. Artifacts shown include a bottle of water from the Delaware River, an American flag, and swatches of cloth from the material used in the first American flag made by Betsy Ross and incorporated into a new flag carried on the *America*. Documents reproduced include affidavits verifying the authenticity of the artifacts depicted and a letter concerning the christening. There is also a portrait of Anne Balderson, a descendent of Betsy Ross.

Arranged: No.

Captioned: Some with subject.

Finding Aid: No.

Restrictions: The collection, located at the Garber Facility, is available by appointment only.

Collection Origins

Charles L. Morris (1908–1958) assembled the collection to document the development of helicopters. Morris served as Connecticut commissioner of aeronautics and as sales manager of Helicopter Utilities, a company in Westchester, New York. He was also a helicopter pilot and wrote on the history of helicopters. He later became president of Clark & Clark, a pharmaceutical company. NASM Archives assigned the collection accession number XXXX-0297.

Physical Description

There are six silver gelatin photoprints, mounted in a scrapbook. Other materials include applications, charts, correspondence, diagrams, drawings, financial records, a license, magazines, manuscripts, newspaper clippings, and transcripts of speeches, also mounted in the scrapbook.

Subjects

The photographs show helicopters and people involved with helicopters. Helicopters shown include a two-man craft without an enclosed cabin. Events documented include the first annual dinner of the American Helicopter Society in 1944. There are portraits of a man with an engine and of Charles L. Morris.

Arranged: No.

Captioned: Some with subject.

Finding Aid: No.

Restrictions: The collection, located at the Garber Facility, is available by appointment only.

AS·200

Charles L. Morris Helicopter Scrapbook

Dates of Photographs: 1942–1951

AS·201

Francis L. Moseley Avionics Collection, 1930–1981

Dates of Photographs: 1940s–1950s

Collection Origins

Radio engineer Francis L. Moseley assembled the collection to document the development of all-weather landing systems, radar, and radio (avionics). Working at Collins Radio Company, Moseley helped develop the VHF Omni-Directional Range Navigation System and other all-weather flight control systems. An advocate of radio flight control for all-weather operations, he wrote articles and booklets on automatic control of aircraft landing and on the Sperry flight ray system, a cathode ray flight indicator. The collection was donated to NASM in two parts, by Francis L. Moseley in 1983 and by Peter Moseley in 1986. NASM Archives assigned the collection accession number 1986-0148.

Physical Description

There are 80 silver gelatin photoprints. Other materials include brochures, charts, correspondence, laboratory books, periodicals, and technical reports.

Subjects

The photographs document equipment used in automatic all-weather flight control. Equipment documented includes an automatic radio direction finder, a navigation computer, navigation instruments, a radar screen, radio apparatus, and a truck carrying an automatic landing system. There are also photographic reproductions of radar charts.

Arranged: By subject.

Captioned: Some with subject.

Finding Aid: Box list.

Restrictions: The collection, located at the Garber Facility, is available by appointment only.

AS·202

Joe Mountain Collection

Dates of Photographs: 1934–1936, Circa 1990

Collection Origins

Photographer and pilot Joe Mountain (1902–1970)

created the collection, mainly during an expedition in Saudi Arabia, sponsored by Aramco, in the mid-1930s. After serving in the U.S. Army Air Service just after World War I, Mountain became a professional photographer, working in commercial and forensic areas before specializing in aerial photography. From 1928 to 1933 he worked for the Continental Air Map Company, and in 1934 and 1935 he flew mapping and reconnaissance flights in Saudi Arabia for Aramco.

In 1937 Mountain became an airline pilot for Trans World Airlines, serving during World War II as officer in charge of training for the India-Burma-China Wing of the U.S. Army Air Forces' Air Transport Command. In 1947 he entered the computer field, working for several companies before forming Mountain Systems in 1954. The company built the first computer for *Reader's Digest* magazine. The photographs were published in the following article: William E. Mulligan. "The Life and Times of Joe Mountain." *Al-Ayyam Al-Jamila* (Fall 1990): 12–19. NASM Archives assigned the collection accession number 1991-0018.

Physical Description

There are 900 photographs including silver gelatin photonegatives and photoprints (some recent contact sheets). Other materials include biographical notes, logbooks, and a map.

Subjects

The photographs document Joe Mountain's flying activities for Aramco in Saudi Arabia and also the local inhabitants. Aramco activities shown include aircraft maintenance, flight preparations, flights, and photography. Saudis are shown carrying loads, making sandals, marching with guns and swords, marketing, playing drums, playing games, swimming, traveling in camel caravans, and working on boats. Forms of transportation depicted include aircraft, buses, camels, cars, and donkeys. Images of local surroundings include desert landscapes, housing, ruins, towns, and vegetation. Places shown include Al Hufūf, Al Jubayl, Al Khubar, Al Qatīf, Baghdād, and Līnah.

Arranged: By image number.

Captioned: With image number, location, and subject.

Finding Aid: List of photographs including date, location, number, and title.

Restrictions: No. The collection is located at the NASM Archives on the Mall. Researchers are encouraged to call or write for an appointment.

AS·203

Kenneth M. Murray Collection

Dates of Photographs: 1918–1932

Collection Origins

Aviator and author Kenneth M. Murray created the collection to document his aeronautical activities as well as American participation in the Polish-Russian War of 1919–1921. In 1919 Murray was hired by the Hearst newspapers to fly from Toledo to New York. He then served as a military pilot for Poland in the Kosciusko Squadron of American volunteers until 1921. Murray later collected material on the experience to write the following book: *Wings over Poland: The Story of the 7th (Kosciuszko) Squadron of the Polish Air Service, 1919, 1920, 1921.* New York and London: D. Appleton and Company, 1932. NASM Archives assigned the collection accession number XXXX-0346.

Physical Description

There are 11 silver gelatin photoprints. Other materials include certificates, correspondence, drawings, flight logs, and maps.

Subjects

The photographs document pilots and aircraft between 1919 and 1921, probably involved in the Polish-Russian War. There are images of aircraft in front of a hangar, taking off, and crashed in a field, as well as portraits of Kenneth M. Murray and other pilots. There is also an image of a medal.

Arranged: No.

Captioned: No.

Finding Aid: No.

Restrictions: The collection, located at the Garber Facility, is available by appointment only.

AS·204

Jeanne DeWolf Naatz Autograph Books

Dates of Photographs: 1947–1949

Collection Origins

Jeanne DeWolf Naatz of Cleveland, Ohio, assembled the collection to document aviation personalities of the late 1940s. She collected many of the autographs and photographs at the Cleveland Air Races.

Physical Description

There are 13 silver gelatin photoprints, mounted in scrapbooks. Other materials include autographs and newspaper clippings, also written or mounted in the scrapbooks.

Subjects

The photographs portray several pilots of the late 1940s, including David C. Schilling and Blanche Stuart Scott, who are shown with Jeanne DeWolf Naatz.

Arranged: No.

Captioned: A few with names.

Finding Aid: No.

Restrictions: The collection is kept in the Ramsey Room at the NASM Archives on the Mall. Researchers must be accompanied by a staff member and are encouraged to call or write for an appointment.

AS·205

NASA F-8 Supercritical Wing Collection

Dates of Photographs: 1968–1973

Collection Origins

Dennis W. Bartlett assembled the collection from records at the Langley Research Center to document the development of the supercritical wing, invented by his colleague Richard Whitcomb (1921–). Whitcomb received a B.S. from Worcester Polytechnic Institute in 1943. He produced the original design for a supercritical wing to improve airfoil efficiency at transonic speeds in 1964, and he spent the next five years testing it in NASA's eight-foot Transonic Dynamics Wind Tunnel at the Langley Research Center in Hampton, Virginia. NASA then awarded North American a contract to produce a supercritical wing for testing on a Vought F-8 aircraft. Flight tests in 1970 and 1971 at Edwards Air Force Base in California produced successful results, and further testing was done with a North American T-2 Buckeye and General Dynamics F-111. Studios represented include NASA. NASM Archives assigned the collection accession number XXXX-0104.

Physical Description

There are 580 photographs including color dye coupler photoprints and phototransparencies, dye diffusion transfer photoprints, and silver gelatin photonegatives and photoprints. Other materials include articles, correspondence, financial records, manuscripts, newspaper clippings, notes, plans, and reports.

Subjects

The photographs document the development and testing of the supercritical wing. There are images of wind-tunnel models and tests demonstrating air flow, shock waves, and wing strength. Aircraft depicted include several types of Vought F-8s and other airplanes. There are also images of aircraft construction and details of individual parts.

Arranged: In four series. 1) Background information. 2) Wind tunnel testing. 3) Development and flight testing. 4) Evaluation of the supercritical wing. Photographs are in each series.

Captioned: With negative number.

Finding Aid: Folder list.

Restrictions: The collection, located at the Garber Facility, is available by appointment only.

AS·206

NASA Phototransparencies Collection, 1968–1977

Dates of Photographs: 1968–1977

Collection Origins

NASA created the collection to document its activities for public relations purposes. For a history of NASA, see *Collection Origins* in *AS·45*. The photographs, distributed as press releases, have appeared in many magazines and newspapers. NASM Archives assigned the collection accession number XXXX-0272.

Physical Description

There are 4,800 photographs including color dye coupler phototransparencies and silver gelatin phototransparencies.

Subjects

The photographs document NASA's space programs, including manned orbits and lunar landings, satellite flights, and early Space Shuttle development. Activities documented include astronaut training, equipment construction and tests, post-flight activities, and space walks. Facilities shown include a satellite test laboratory in California and a solar observatory. There are portraits of the crews of the Apollo, Mercury, and Skylab projects, including Charles Conrad, Jr., Richard F. Gordon, Jr., and David R. Scott. Spacecraft depicted include the *Apollo 9* command module; interplanetary probes of the Pioneer, Viking, and Voyager programs; a Saturn 5 rocket; and a Skylab satellite. There are also photographic reproductions of paintings of proposed Space Shuttles. Flights documented include *Apollo 9* through 17 and the Apollo-Soyuz Test Project. There are also photographs of the Earth and Moon from satellites and spacecraft.

Arranged: By assigned number.

Captioned: With description of activity and objects.

Finding Aid: No.

Restrictions: The collection, located at the Garber Facility, is available by appointment only.

AS·207

Nash Collection

Dates of Photographs: Circa 1920s–1960s

Collection Origins

Unknown. The photographs are reproduced on NASM's Archival Videodisc 2. For information on how to order the videodisc, see the *Collection Origins* field of *AS·1*.

Physical Description

There are 65 photographs including color dye coupler photoprints and silver gelatin photoprints.

Subjects

The photographs document several different types of aircraft and aviation activities between the 1920s and 1960s. Aircraft documented include the Aero Space-Lines Super Guppy; the Boeing 377 with images of the interior, landing gear, and propellers; the Boeing B-52 with images of the cockpit and engines; and the Boeing C-97 with interior views; as well as Bell bombers and fighters and early U.S. Navy aircraft at the Naval Aircraft Factory. Activities documented include aircraft christenings, construction, and landings; bombings; and passenger service; as well as extinguishing a burning aircraft.

Arranged: By videodisc frame number.

Captioned: With subject.

Finding Aid: Caption database listing subject and videodisc frame number. Printouts can be obtained for single photographs or caption lists of photographs with related subjects.

Restrictions: No. The collection is located at the NASM Archives on the Mall. Researchers are encouraged to call or write for an appointment.

AS·208

NASM Aircraft Restoration Files

Dates of Photographs: 1970–Present

Collection Origins

NASM's Garber Facility preservation and restoration staff created the collection to document their aircraft restoration work. Staff members add to the collection as they complete individual aircraft. NASM Archives assigned parts of the collection accession numbers 1986-0139 and 1987-0134.

Physical Description

There are 7,000 photographs including color dye coupler photonegatives, photoprints, phototransparencies, and slides; dye diffusion transfer photoprints (Polaroid); and silver gelatin photoprints. Other materials include charts, color samples, correspondence, engineering drawings, financial records, magazines, manuscripts, newspaper clippings, notebooks, notes, reports, stencils, and tracings.

Subjects

The photographs document the parts and structure of aircraft reconstructed at the Garber Facility, including images of the aircraft's original appearances as well as the restoration process. Aircraft shown include an Albatros D.Va, Arado Ar 234, Bell XP-59, Benoist Type XII, Curtiss NC-4, Douglas D-558, Focke-Wulf Fw 190, *Le Minerve* (balloon), Messerschmitt Me 109G and Me 262, North American F-86A and P-51D, Northrop N-1M, Piper PA-12 Supercruiser *City of Washington*, Pitcairn "A" Autogyro and PA-5 Mailwing, Spad XIII, V-2 missile, and a Wiseman-Cooke. There are also images of engines, portraits of Garber staff restoring aircraft, and photographic reproductions of charts and diagrams.

Arranged: In series by aircraft.

Captioned: Most with manufacturer and model or part.

Finding Aid: Preliminary box list.

Restrictions: The collection, located at the Garber Facility, is available by appointment only.

AS·209

NASM Aviation History Project Files, Circa 1983–1985

Dates of Photographs: Early 1980s

Collection Origins

NASM Aeronautics Department curators Tom D. Crouch, Von D. Hardesty, and Dominick A. Pisano assembled the collection while working on the NASM Aviation History Project (AHP). In 1983 the project was initiated to produce a three-volume history of aviation up to the 1980s. However, the project was cancelled in 1985, before the first volume was published. NASM Archives assigned the collection accession number 1988-0009.

Physical Description

There are 45 silver gelatin photoprints (most are copies). Other materials include correspondence, magazine clippings, manuscripts, maps, newspaper clippings, posters, and xerographic copies.

Subjects

The photographs primarily document aviators and their aircraft. People portrayed include European prize sponsor Ernest Archdeacon with gliders, French pilot Eugène-Emile Aubrun, Philippe Fequant, British pilot and manufacturer Charles S. Rolls of Rolls Royce, British pilot and manufacturer Thomas O.M. Sopwith, and U.S. inventor Wilbur Wright (in France in 1908).

Arranged: By subject.

Captioned: Some with subject.

Finding Aid: Item-level transfer list.

Restrictions: The collection, located at the Garber Facility, is available by appointment only.

AS·210

NASM Publications Videodisc Photographs

Dates of Photographs: 1979–1989

Collection Origins

NASM staff assembled the collection from images used in NASM publications. The photographs appear in the following books, all published by Smithsonian Institution Press (Washington, D.C.), except where noted: 1) Walter J. Boyne. *The Messerschmitt Me 262: Arrow for the Future*. 1986. 2) Dorothy Cochrane, Von Hardesty, and Russell Lee. *The Aviation Careers of Igor Sikorsky*. Seattle: University of Washington Press for the National Air and Space Museum, 1989. 3) Tom D. Crouch. *Blériot XI, the Story of a Classic Aircraft*. 1982. 4) Tom D. Crouch. *The Eagle Aloft: Two Centuries of the Balloon in America*. 1983. 5) K.N. Finne. *Igor Sikorsky, the Russian Years*. 1987. 6) Benjamin S. Kelsey. *The Dragon's Teeth? The Creation of United States Air Power for World War II*. 1982. 7) Gregory P. Kennedy. *Vengeance Weapon 2*. 1983. 8) Claudia M. Oakes. *United States Women in Aviation, 1930–1939*. 1985. 9) Jay P. Spenser. *Focke-Wulf Fw 190, Workhorse of the Luftwaffe*. 1987. 10) E.T. Wooldridge. *Focus on Flight: The Aviation Photography of Hans Groenhoff*. 1985. 11) E.T. Wooldridge. *Image of Flight: The Aviation Photography of Rudy Arnold*. 1986. 12) E.T. Wooldridge. *The P-80 Shooting Star: Evolution of a Jet Fighter*. The photographs are reproduced on NASM's Archival Videodisc 7. For information on how to order the videodisc, see the *Collection Origins* field of *AS·1*.

Physical Description

There are 1,460 photographs including color dye coupler photoprints and silver gelatin photoprints.

Subjects

The photographs are illustrations from the books cited in *Collection Origins*. Aircraft documented include a Blériot XI, Focke-Wulfe Fw 190, Lockheed P-80 Shooting Star, Messerschmitt Me 262, Sikorskys, and the V-2 missile, as well as balloons and many primarily inter-war aircraft photographed by Rudy Arnold and Hans Groenhoff. People portrayed include Rudy Arnold, Hans Groenhoff, Igor I. Sikorsky, and women aviators in the 1930s.

Arranged: By appearance in the books.

Captioned: No.

Finding Aid: Caption database listing videodisc frame number. Printouts can be obtained for single photographs or caption lists of photographs with related subjects.

Restrictions: No. The collection is located at the NASM Archives on the Mall. Researchers are encouraged to call or write for an appointment.

AS·211

NASM Restorations Videodisc Photographs

Dates of Photographs: 1974–1988

Collection Origins

NASM staff created the collection to document NASM aircraft restored by the museum's conservators, working at the Garber Facility. The photogaphs are reproduced on NASM's Archival Videodisc 7. For information on how to order the videodisc, see the *Collection Origins* field of *AS·1.*

Physical Description

There are 300 photographs including color dye coupler photoprints and silver gelatin photoprints.

Subjects

The photographs document aircraft restored at NASM's Garber Facility. Most aircraft are shown after they have been restored; some are shown in earlier stages of conservation. Aircraft depicted include an Aeronca C-2, Albatros D.Va, Bellanca CF, Benoist XIII, Blériot XI, Curtiss F9C-2 Sparrowhawk, Curtiss 1912 pusher, De Havilland DH-4, Langley Aerodrome, Lockheed XP-80 Shooting Star, Messerschmitt Me 262A-1A, North American P-51C *Excaliber III,* Northrop N1M, Spad XIII, and the Wright 1903 Flyer. There are also images of parts such as interiors and wings, as well as NASM conservators.

Arranged: By videodisc frame number.

Captioned: With manufacturer and model.

Finding Aid: Caption database listing videodisc frame number, manufacturer, and model. Printouts can be obtained for single photographs or caption lists of photographs with related subjects.

Restrictions: No. The collection is located at the NASM Archives on the Mall. Researchers are encouraged to call or write for an appointment.

AS·212

National Advisory Committee for Aeronautics Aircraft Collection

Dates of Photographs: 1940s

Collection Origins

The National Advisory Committee for Aeronautics (NACA) created the collection to document aircraft it owned or tested in the 1930s and 1940s. Created by Congress in 1915, NACA conducted aeronautical research and directed government aviation policy until the formation of NASA in 1958. Studios represented include Fairchild Aircraft and NACA. NASM Archives assigned the collection accession number 1988-0037.

Physical Description

There are 50 silver gelatin photoprints. Other materials include engineering drawings, magazine clippings, notes, and test reports.

Subjects

The photographs document aircraft used or tested by NAGA in the 1940s. Aircraft depicted include the Boeing B-29, Curtiss XP-42, Douglas DC-3, Fairchild AT-14, Grumman F8F Bearcat, Lockheed P-80 Shooting Star, North American L-17 (Navion), and Northrop P-61 Black Widow. There are also images of aircraft parts such as landing gear and photographic reproductions of diagrams and drawings.

Arranged: By manufacturer and model.

Captioned: Some with manufacturer and model.

Finding Aid: No.

Restrictions: The collection, located at the Garber Facility, is available by appointment only.

AS·213

National Aeronautic Association Records, 1918–1976

Dates of Photographs: 1933–1967

Collection Origins

The National Aeronautic Association (NAA) and its predecessor, the Aero Club of America, created the collection to document the organization's activities between 1918 and 1976. Formed in 1905, the Aero Club was reorganized into the NAA in 1922 with the purpose of advancing the "art and science of aviation" and spreading knowledge of the field. The NAA pursued these goals through newsletters, public events such as competitive aeronautic activities, and space education programs for youths. Many of the photographs in this collection have appeared in the NAA's monthly *National Aeronautics Magazine.* Photographers and studios represented include the *Akron Beacon Journal,* Bahamas News Bureau, *Chicago Daily News,* Del Ankers Photographers, Federal Aviation Administration, John Haworth of Beech Aircraft Corporation, Hollywood Studio, NASA, Parachutes Incorporated, Ray Perry, Jan Rys, U.S. Army, and U.S. Navy. NASM Archives assigned the collection accession number XXXX-0209.

Physical Description

There are 300 silver gelatin photographs. Other materials include awards, business records, correspondence, engineering drawings, forms, manuscripts, minutes, newsletters, newspaper clippings, periodicals, pins, proceedings, programs, reports, resolutions, and scrapbooks.

Subjects

The photographs document aircraft, National Aeronautic Association (NAA) activities, and NAA members and other aviation figures. Aircraft and spacecraft depicted include airplanes such as a Piper PA-23 Aztec, Ryan Flexi-Wing, and a TWA airliner; balloons; helicopters; and Mercury spacecraft such as *Freedom 7.* Other artifacts shown include jeeps, miniature aircraft models, a nuclear fallout survival food packet, a submarine, and trophies. Aviation facilities shown include air race courses with instruments and stations, hangars, and Mitchell Air Force Base in New York.

Events illustrated include award presentations; Gordon Bennett balloon races (Poland, 1930s); Cleveland National Air Races; the launch of a research balloon; NAA meetings; NAA-sponsored races; and a parachute jump. Other activities shown include installing equipment and examining data at races. Individuals portrayed include astronaut Alan B. Shephard, Jr.; event winners Gladys Brogdon, Margo Callaway, Frances Miller, and Edna Gardner Whyte; Mitchell Air Force Base commander John O. Hall; NAA president Jacqueline Cochran; and Pan American president Juan T. Trippe. Groups portrayed include men and women pilots, NAA members, U.S. Navy officers, and technicians attending instruments.

Arranged: No.

Captioned: Some with negative number and subject.

Finding Aid: Folder list.

Restrictions: The collection, located at the Garber Facility, is available by appointment only.

AS·214

National Air Transport Collection, 1927–1937

Dates of Photographs: 1927–1937

Collection Origins

The collection was created, probably by a company pilot, to document the activities and personnel of National Air Transport (NAT), an early airmail carrier. Formed in 1925 by Clement Keys, NAT received the

New York to Chicago airmail route in 1927. Two other early carriers were Stout Air Services, which began carrying mail and passengers from Detroit to Cleveland in 1925, and Boeing Air Transport, which began the Chicago to San Francisco airmail route in 1927. Boeing and several other companies joined in 1929 to form United Airlines, which then also bought Stout and NAT. Joseph D. Hutchinson donated the collection to NASM Archives, where it received accession number 1991-0024.

Physical Description

There 120 silver gelatin photoprints, most mounted in a scrapbook. Other materials, some also mounted in the scrapbook, include audiotape cassettes, correspondence, a newsletter, notes, a weather report, and xerographic copies of newspaper clippings.

Subjects

The photographs document National Air Transport aircraft, construction and maintenance, and personnel. Aircraft shown include the Boeing 95, Curtiss Carrier Pigeon, Curtiss Falcon, Douglas M2, and Ford Trimotors, as well as Travel Air airplanes. Construction and maintenance activities illustrated include applying metal to the fuselage, cleaning surfaces, covering wings, installing engines, painting, and sewing fabric. People portrayed include mechanics, pilots, and a group of women who may be flight attendants. There are also a few images of United Airlines operations.

Arranged: Grouped by topic.

Captioned: Most with date and name or subject.

Finding Aid: Xerographic copy of scrapbook pages.

Restrictions: No. The collection is located at the NASM Archives on the Mall. Researchers are encouraged to call or write for an appointment.

AS·215

National Aviation Clinics Scrapbooks

Dates of Photographs: 1946–1947

Collection Origins

The collection was created to document the fourth and fifth National Aviation Clinics (NACs) held by the National Aeronautic Association. The fourth NAC took place in October 1946 in Oklahoma City and the fifth in November 1947 in Springfield, Illinois. Representatives of commercial and military aviation attended the meetings to discuss topics such as airports, education, manufacturing, and national security. Photographers represented include Ed Sibel. Ralph M. Phelps donated the collection to NASM, where it received accession number XXXX-0312.

Physical Description

There are 30 silver gelatin photoprints, mounted in scrapbooks. Other materials include certificates, correspondence, newspaper clippings, programs, and reports, also mounted in the scrapbooks.

Subjects

The photographs document the fourth and fifth National Aviation Clinics (NACs) held in 1946 and 1947. There are aerial images of Oklahoma City and portraits of NAC participants, many giving speeches.

Arranged: No.

Captioned: Some with subject.

Finding Aid: No.

Restrictions: The collection, located at the Garber Facility, is available by appointment only.

AS·216

Steven P. Nation Photograph Collection

Dates of Photographs: 1964–1976

Collection Origins

Businessman and amateur photographer Steven P. Nation created the collection to document aircraft, primarily jet airliners. Nation took most of the photographs at the Los Angeles airport; he also collected

some images by other photographers. He donated the collection to NASM in several installments beginning in 1988.

Physical Description

There are 10,850 silver gelatin photonegatives.

Subjects

The photographs document commercial jets of the 1960s and 1970s, as well as helicopters, military aircraft, private jets, propeller-driven aircraft, and turboprop aircraft. Commercial jets depicted include the Boeing 727, 737, and 747; Convair 880 and 990; Douglas DC-9; Lockheed L-1011 Tristar; and McDonnell-Douglas DC-10. Helicopters shown include Bell 47, Sikorsky S-55, and Vertol H-21. Military airplanes documented include the Boeing C-97, Curtiss C-46 Commando, De Havilland D.H.100 Vampire, Fairchild PT-19, Grumman J2F Duck, and North American T-28 Trojan. Private jets shown include the Dassault Falcon, Gates Learjet 25, and North American Sabreliner. Propeller-driven aircraft documented include Aero Spacelines Mini-Guppy, Beech 18, Boeing 377, Cessna 340, Douglas DC-6 and DC-7, Fletcher FU-24, Howard 500, and Lockheed C-69 Constellation. Turboprops shown include the Beech King Air, Conroy CL-44-0, De Havilland Canada DHC-6 Twin Otter, Fairchild F-27, Lockheed L-188 Electra, and Vickers Viscount.

Arranged: By type of aircraft, then by manufacturer and model.

Captioned: Most on envelope with date of photograph, location, manufacturer, and model.

Finding Aid: Catalogs listing aircraft type, airline or owner, descriptive remarks, manufacturer, and model.

Restrictions: No. The collection is located at the NASM Archives on the Mall. Researchers are encouraged to call or write for an appointment.

AS·217

Georges Naudet Collection

Dates of Photographs: Circa 1908–1915

Collection Origins

Georges Naudet (1900–1983), a French collector, assembled the collection to document early balloons and aviation in France.

Physical Description

There are 110 silver gelatin photoprints. Other materials include advertising ephemera, catalogs, correspondence, newspaper clippings, pamphlets, and photomechanical prints.

Subjects

The photographs document early French aviation, especially the activities of aviators Louis Blériot and Jules Védrines. Blériot and Védrines are portrayed flying aircraft, preparing for flights, and wearing flight clothing. There are other portraits of Védrines at a picnic and with children. Many aircraft are shown, often in flight over cities and landscapes. There are also images of city streets including a crowd of people and a sign on a building advertising Blériot.

Arranged: No.

Captioned: Some in French with date and subject.

Finding Aid: Partial item lists.

Restrictions: The collection is kept in the Ramsey Room at the NASM Archives on the Mall. Researchers must be accompanied by a staff member and are encouraged to call or write for an appointment.

AS·218

Naval Aviation, Pensacola, Florida, Scrapbook *A.K.A.* A.C. Andreason Scrapbook

Dates of Photographs: 1918–1919

Collection Origins

The collection was created to document training activ-

ities at the Pensacola U.S. Naval Air Station in Florida during World War I. A.C. Andreason of Pensacola donated the collection to NASM, where it received accession number XXXX-0270. Studios represented include the U.S. Naval Air Station, Pensacola.

Physical Description

There are 320 silver gelatin photoprints (some tinted), mounted in an album.

Subjects

The photographs document activities at the Pensacola Naval Air Station and surrounding areas in World War I. Activities documented include extinguishing a fire on base, lifting an aircraft onto a ship with a crane, marching in city streets, playing tug-of-war, salvaging a large French seaplane that crashed in water, swimming, and working in a construction plant. There are portraits of U.S. Navy officers, pilots, and sailors, including women personnel. Aircraft documented include airships, balloons, biplanes, and flying boats such as the Curtiss NC-2 and NC-4. Other transportation shown includes Navy ships and troop trains. Base facilities depicted include barracks and hangars. Surrounding areas shown include aerial views of Pensacola, cityscapes of buildings and streets, and landscapes of the coast. There are also images of an alligator at a zoo and hurricane damage to buildings.

Arranged: No.

Captioned: No.

Finding Aid: No.

Restrictions: The collection, located at the Garber Facility, is available by appointment only.

AS·219

Thomas T. Neill Collection, 1926–1972

Dates of Photographs: 1928–1945

Collection Origins

Aeropropulsion engineer Thomas T. Neill (1903–1988) assembled the collection in preparation for an

unpublished book on aircraft engines produced between World War I and II. After receiving an M.S. from the Massachusetts Institute of Technology in 1926, Neill became an engineer at the Aircraft Engine Research Laboratory of the U.S. Bureau of Standards. He moved to the U.S. Army Air Corps in Dayton, Ohio, in 1939 and to the National Advisory Committee for Aeronautics (NACA) in 1942. He conducted research for NACA and its successor, NASA, until his retirement in 1970. The following year Neill became a consultant at NASM, where he compiled this collection. NASM Archives assigned the collection accession number XXXX-0181. Photographers and studios represented include Victor De Palma, Rode Photo Service, and the U.S. Bureau of Standards.

Physical Description

There are 325 silver gelatin photoprints. Other materials include articles, correspondence, engineering drawings, financial records, logbooks, manuscripts, newspaper clippings, periodicals, and reports.

Subjects

The photographs document aircraft and automobile parts and engine tests. Parts shown include carburetors, circuits, crankshafts, electrical connectors, engines, pistons, spark plugs, switches, and tires. There are images of anti-freeze, fuel, and lubricant tests. Many of the images illustrate corrosion and other damage, as well as microscopic sections of material. There are also photographic reproductions of charts and diagrams of electrical circuits and test data.

Arranged: By subject and date. Most photographs are mounted in reports.

Captioned: Most with figure numbers keyed to reports; some with negative number and subject.

Finding Aid: No.

Restrictions: The collection, located at the Garber Facility, is available by appointment only.

AS·220

Carl N. Nelson Collection

Dates of Photographs: Circa 1940s–1985

Collection Origins

Carl N. Nelson (1921–1982) created the collection to document his career as an aviation mechanic and instructor. After graduating from the Pittsburgh Institute of Aeronautics in 1941, Nelson worked as a mechanic for several companies, then taught at Clarksdale School of Aviation at Fletcher Field, England, from 1942 to 1944. He then worked as a mechanic for American Airlines until he was drafted in 1945, becoming a helicopter instructor in the U.S. Army Air Forces. In 1947 he returned to Pittsburgh Institute, teaching part-time after 1955 while serving as a mechanic for National Steel. Karen A. Nelson donated the collection to NASM, where it received accession numbers 1985-0007, 1986-0009, and 1986-0023. Many of the photographs were copied and returned to the donor. Studios represented include Custer Channel Wing Corporation and OPPS.

Physical Description

There are 30 silver gelatin photoprints (some copies). Other materials include books, class plans, correspondence, examination study guides, manuals, manuscripts, newspaper clippings, and notes.

Subjects

The photographs document activities, aircraft, equipment, and facilities at the airfields and schools where Carl N. Nelson worked. Activities documented include checking an engine, transporting part of an aircraft by truck, using a sewing machine, and working on aircraft. Aircraft depicted include airplanes, such as a Custer Channel Wing experimental aircraft and a Ford Trimotor, and an airship. Airfields and schools shown include Bettis Field, Homestead, Pennsylvania; Carlstrom Field, Arcadia, Florida; Pittsburgh Institute of Aeronautics; and Riddle Aeronautical Institute. Equipment and facilities depicted include classrooms, construction and repair shops, hangars, a headquarters building, and a mess hall. There are also portraits of Carl N. Nelson and officers at Pittsburgh Institute.

Arranged: By subject.

Captioned: Most with negative number and subject.

Finding Aid: Folder list.

Restrictions: The collection, located at the Garber Facility, is available by appointment only.

AS·221

1934 Stratospheric Balloon Flight Scrapbooks

Dates of Photographs: 1934

Collection Origins

The collection was created to document the 1934 experimental stratospheric flight of the *Explorer I* balloon. The project, sponsored by the U.S. Army Air Corps and the National Geographic Society, attempted to send a balloon equipped with monitoring devices into the stratosphere. The balloon ascended on July 28 with a crew of three Army officers, but failed and crashed, although the crew survived. NASM Archives assigned the collection accession number XXXX-0243.

Physical Description

There are 70 silver gelatin photoprints, mounted in scrapbooks. Other materials include correspondence, financial records, manuscripts, newspaper clippings, press releases, reports, and technical plans, also mounted in scrapbooks.

Subjects

The photographs document the construction, flight, and crash of the 1934 stratospheric balloon, the *Explorer I,* as well as the people involved in the project and its surroundings. Construction and assembly activities shown include assembling the load ring, building the gondola, christening the balloon, entering the gondola, hauling hydrogen cylinders by truck, inflating the balloon, laying out the rip panel, tending instruments, transporting the gondola, and unloading cylinders. The balloon is shown ascending, falling, and crashing into a cornfield, with the crew parachuting out.

People portrayed include the advisory committee of scientists; crew members Orvil A. Anderson, William E. Kepner, and Albert W. Stevens; Sioux Indians watching the ascent; and technicians. Surroundings pictured, some in aerial views, include the Goodyear-Zeppelin Corporation factory in Akron, Ohio, where the balloon was constructed; headquarters at the take-off site; and the sawdust field at the take-off site.

Arranged: Chronologically.

Captioned: With a detailed explanation of the subject.

Finding Aid: No.

Restrictions: The collection, located at the Garber Facility, is available by appointment only.

AS·222

Umberto Nobile Papers

Dates of Photographs: 1925

Collection Origins

Italian airship designer and pilot Umberto Nobile (1885–1978) created the collection to document three Italian airships. Nobile designed the airship *Norge* in which he, Lincoln Ellsworth of the United States, and Roald Amundsen of Norway flew over the North Pole in 1926. He also built the airship *Italia* and piloted other exploratory flights. The photographs are reproduced on NASM's Archival Videodisc 7. For information on how to order the videodisc, see the *Collection Origins* field of *AS·1*.

Physical Description

There are 30 silver gelatin photoprints.

Subjects

The photographs document the exteriors and interiors, including cabins and engine gondolas, of the Italian airships N.1, N.4, and Mr.1. There are also images of the airships in flight and photographic reproductions of airship diagrams.

Arranged: By videodisc frame number.

Captioned: With videodisc frame number.

Finding Aid: Caption database listing videodisc frame number. Printouts can be obtained for single photographs or caption lists of photographs with related subjects.

Restrictions: No. The collection is located at the

NASM Archives on the Mall. Researchers are encouraged to call or write for an appointment.

AS·223

Arthur Nutt Papers

Dates of Photographs: Early 1900s–1975

Collection Origins

Aeronautical engineer Arthur Nutt (1895–1983) created the collection to document his career. After receiving a B.S. in mechanical engineering from Worcester Polytechnic Institute in 1916, Nutt began working for Curtiss Aeroplane and Motor Corporation, where he later became chief motor engineer and developed the Curtiss CD12, V-1400, and R-1454 engines. When Curtiss merged with Wright Aeronautical Corporation in 1930, Nutt became vice president of engineering, serving until 1944 when he joined the Packard Motor Car Company.

As director of aircraft engineering at Packard, Nutt continued to work on the development of piston and turbine engines. Between 1949 and 1951 he headed his own engineering sales firm, Arthur Nutt and Associates. He then joined the Lycoming Stratford Division of Avco Corporation, where he served as vice president of engineering until 1975. Studios represented include Avco Corporation. NASM Archives assigned the collection accession number 1987-0115.

Physical Description

There are 810 photographs including color dye coupler photoprints, color dye diffusion transfer photoprints, and silver gelatin photonegatives and photoprints. Other materials include brochures, correspondence, engineering drawings, manuals, manuscripts, and reports.

Subjects

The photographs primarily document aircraft and aircraft engines, as well as Arthur Nutt's personal and professional activities. Aircraft documented include a Curtiss R-4, Robin, Thrush, and XO-18; Dornier Do X; and Martin MO-1. There are images of Curtiss engines made between 1913 and 1939 such as the D-12, and V-1550, as well as a Kirkham engine and a Wright Cyclone 9. Activities and events documented include

Curtiss construction in the 1910s, a dedication ceremony, an executive dinner, a meeting in Berlin in 1936, and Nutt and others traveling on a ship. Family photographs show Nutt, his house, and his parents.

Arranged: In series by subject.

Captioned: Most aircraft images with engine, manufacturer, and model; some others with subject.

Finding Aid: Partial item-level transfer list.

Restrictions: The collection, located at the Garber Facility, is available by appointment only.

AS·224

Hermann Oberth Collection

Dates of Photographs: 1955–1966

Collection Origins

Astronautics pioneer Hermann Oberth (1894–1990) created the collection to document his career. Born in Transylvania, Oberth later moved to Germany, where he published a theoretical work on astronautics: *Die Rakete zu den Planeträumen. (The Rocket into Interplanetary Space).* Munich: R. Oldenbourg, 1923. In 1928 he became president of the German Society for Space Travel, and in 1929 he designed sets for Fritz Lang's movie *Women in the Moon.* Oberth worked on the German rocket program at Peenemünde during World War II, then came to the United States where he worked with Wernher von Braun at Huntsville, Alabama, on developing space rockets for NACA and NASA. He later returned to Germany to continue his career as a writer and lecturer. NASM Archives assigned the collection accession number 1989-0091.

Physical Description

There are six silver gelatin photographs. Other materials include books, correspondence, and newspaper clippings.

Subjects

The photographs portray Hermann Oberth in the mid-

1950s, at a party, receiving an award, and with members of a club.

Arranged: By document type.

Captioned: With subject.

Finding Aid: Item list.

Restrictions: The collection, located at the Garber Facility, is available by appointment only.

AS·225

Rohnald Ohmeyer Collection

Dates of Photographs: 1929–1956, 1992

Collection Origins

Engineer and pilot Rohnald Ohmeyer created the collection to document his work. Ohmeyer served as a civil engineer with the Long Island Aerospace Corporation and worked with the Strategic Bombing Survey. Allan Stoddert donated the collection to NASM, where it received accession number 1991-0053.

Physical Description

There are five silver gelatin photoprints. Other materials include catalogs, charts, correspondence, engineering drawings, financial records, manuals, periodicals, and technical reports.

Subjects

The photographs show Rohnald Ohmeyer in flight clothes, as well as aircraft including a Blériot and a Curtiss P-6 Hawk.

Arranged: No.

Captioned: With subject.

Finding Aid: Item-level transfer list.

Restrictions: The collection, located at the Garber Facility, is available by appointment only.

AS·226

A.J. Ostheimer Autograph and Photograph Collection

Dates of Photographs: Circa 1915–1923

Collection Origins

A.J. Ostheimer and his father assembled the collection to document aviation pioneers from the 1890s to the early 1920s and World War I pilots. The Ostheimers collected items from such people as Octave Chanute, Samuel P. Langley, Otto Lilienthal, Edward V. ("Eddie") Rickenbacker, and the Wright brothers. Photographers represented include H.L. Summerville. NASM Archives assigned the collection accession number XXXX-0115.

Physical Description

There are 24 silver gelatin photoprints. Other materials include correspondence.

Subjects

The photographs are portraits of aviation figures pilots Edmund T. Allen, Alan Cobham, Claude Grahame-White, Georges Guynemer, Corliss C. Mosley, and A. Pingard.

Arranged: No.

Captioned: Some with names.

Finding Aid: List of autographs compiled by Ostheimer.

Restrictions: The collection is kept in the Ramsey Room at the NASM Archives on the Mall. Researchers must be accompanied by a staff member and are encouraged to call or write for an appointment.

AS·227

Oversized Photographs of Aircraft

Dates of Photographs: Circa 1905–1940s

Collection Origins

The collection was assembled to document several types of aircraft. Howard Luker donated it to NASM, where it received accession number XXXX-0358. Studios represented include Goodyear Aircraft Corporation.

Physical Description

There are three photographs including a color dye coupler photoprint and silver gelatin photoprints. Other materials include photomechanical prints.

Subjects

The photographs document two airplanes, a Martin P5M-1 and a large, unidentified propeller aircraft, and a U.S. Navy airship.

Arranged: No.

Captioned: One with manufacturer and model.

Finding Aid: No.

Restrictions: The collection, located at the Garber Facility, is available by appointment only.

AS·228

Phillips W. Page Scrapbook

Dates of Photographs: 1911–1912

Collection Origins

Phillips W. Page (1885–1917) created the collection to

document his first two years as an aviator. Page took his first flights as a passenger while serving as aviation editor of the *Boston Herald* in 1911. Later that year he joined the Wright aviation school in Dayton, Ohio, obtained a pilot's license, and began carrying passengers and participating in exhibition flights in the New York City area. He then became an instructor for the Burgess Company, competed in air meets, test flew military aircraft, and recorded the first aerial motion pictures of Boston. In 1914 Page joined the U.S. Aviation Reserves and, in 1917, enlisted in the Navy, where he taught at the Squantum, Massachusetts, Naval Base, before going to France. He drowned in an accident in the English Channel. NASM Archives assigned the collection accession number 1990-0037.

Physical Description

There are 30 silver gelatin photoprints, mounted in a scrapbook. Other materials include newspaper clippings, also mounted in the scrapbook.

Subjects

The photographs document Phillips W. Page's aviation activities in 1911 and 1912 including air meets and passenger flights. There are many portraits of Page seated in aircraft with passengers, most of whom are women. Aircraft, such as a Burgess seaplane, are shown in flight and on a beach in front of a hotel. There are also aerial photographs of the beach.

Arranged: No.

Captioned: No.

Finding Aid: No.

Restrictions: The collection, located at the Garber Facility, is available by appointment only.

AS·229

Pan American Boeing 314 Preview Flight Scrapbook *A.K.A.* Charles R. Page Scrapbook

Dates of Photographs: 1940

Collection Origins

Insurance executive Charles R. Page created the collection to document his trip on a preview flight of the Boeing 314 Clipper in 1940. Page, president of the Fireman's Fund fire and casualty insurance companies, was one of the passengers invited by Pan American to make the flight. The aircraft, *American Clipper,* flew from San Francisco to Auckland, New Zealand, between August 24 and September 7, making stops at islands along the way. NASM Archives assigned the collection accession number 1988-0110.

Physical Description

There are seven silver gelatin photoprints, mounted in a scrapbook. Other materials include certificates, manuscripts, maps, newspaper clippings, photomechanical postcards, and reprints, also mounted in the scrapbook.

Subjects

The photographs document the Boeing 314 Clipper *American Clipper* and places visited during its 1940 preview flight. The *American Clipper* is depicted moored at Ile de Nou in New Caledonia. Places shown include Auckland in New Zealand and Ile de Nou, including abandoned prison buildings and a Pan American station.

Arranged: Chronologically.

Captioned: With subject.

Finding Aid: No.

Restrictions: The collection, located at the Garber Facility, is available by appointment only.

AS·230

"Parade of Champions" Scrapbook

Dates of Photographs: 1929–1966

Collection Origins

Beech Aircraft Company created the collection to document famous women pilots and Beech aircraft. For a history of Beech, see *Collection Origins* in *AS·59*. NASM Archives assigned the collection accession number XXXX-0311.

Physical Description

There are 50 photographs including color dye coupler photoprints and silver gelatin photoprints, mounted in an album.

Subjects

The photographs document prominent woman pilots from the 1920s through the 1960s, posed with Beech aircraft. People portrayed include Jacqueline Auriol, Frances S. Bera, Jacqueline Cochran, Arlene Davis, Charlotte Frye, Viola Gentry, Elizabeth Gordon, Mildred Harshman, Joan Houbec, Amy Johnson, Lee Ya Ching, Blanche Noyes, Gladys O'Donnell, Nadine Ramsey, Grazia Sartori, Jane Sasala, Louise M. Thaden, Joan Wallick (with Robert Wallick, her husband), Martha Ann Woodrum, and Hideko Yokoyama. Beech aircraft shown include the 17 Staggerwing and 35 Bonanza.

Arranged: No.

Captioned: With name of aircraft and person.

Finding Aid: No.

Restrictions: The collection, located at the Garber Facility, is available by appointment only.

AS·231

Fred Parker Scrapbook

Dates of Photographs: 1916–1918

Collection Origins

Aeronautical engineer Fred Parker (1880–1965) created the collection to document the development of his aircraft. In 1911 Parker helped build and then soloed in an airplane at Dominguez Field, Los Angeles. He helped build the airplane flown by Bob Fowler across the Isthmus of Panama in 1913, and in 1914 and 1915 he worked as shop foreman for Silas Christofferson in San Francisco. In 1917 Parker designed an aircraft for Union Gas Company, which was flown by Stanley Page. He worked as a contractor and builder from 1920 until World War II, when he participated in war production. He retired after the war and later became a member of the Early Birds, an organization of pilots who flew before December 17, 1916. Parker donated the collection to NASM, where it received accession number XXXX-0224.

Physical Description

There are 55 silver gelatin photoprints, mounted in an album.

Subjects

The photographs document aircraft and aircraft parts of the late 1910s, most designed by Fred Parker. Aircraft shown include the biplanes *Firecracker* and *Silver Dart*; a passenger cabin biplane; and a pusher with swept-back wings. Aircraft parts depicted include the Andermat aircraft engine and propellers. There are also aerial views of cities and coasts.

Arranged: No.

Captioned: Some with subject such as name of aircraft.

Finding Aid: No.

Restrictions: The collection, located at the Garber Facility, is available by appointment only.

AS·232

Edwin C. Parsons Scrapbook

Dates of Photographs: 1914–1928

Collection Origins

Edwin C. Parsons (1892–1968) created the collection to document his experiences as an aviator in France during and after World War I. Parsons attended the University of Pennsylvania before learning to fly in California. He joined the Mexican Aviation Corps in 1914 and trained pilots for Pancho Villa. In 1915 he went to France to serve as an ambulance driver, joined the Lafayette Escadrille the following year, and stayed with French forces until the end of the war. Parsons received the French War Cross in 1917 and later the Legion of Honor. Beginning in March 1918, he published 40 installments of war memoirs called "Fighting Men of the Sky" in a weekly newspaper. Parsons served as an FBI agent from 1920 to 1923, then went to Hollywood to become a script writer and technical advisor on films such as *Wings* and *Dawn Patrol*. During World War II Parsons taught flying and served on an aircraft carrier in the Pacific. He retired in 1954 and later donated the collection to NASM, where it received accession number XXXX-0308.

Physical Description

There are 170 silver gelatin photoprints, mounted in scrapbooks. Other materials include correspondence, menus, newspaper clippings, and tickets, also mounted in the scrapbooks.

Subjects

The photographs primarily document World War I scenes in France, as well as Edwin C. Parsons's activities. Activities documented include farm work, funerals, horseback riding, hunting, and military ceremonies. Aircraft depicted include an Albatros and a Spad. Equipment and surroundings shown include anti-aircraft guns, a bombed sugar factory, graves, an observation post, shell craters, trenches, a windmill, and wrecked aircraft (some German). Portraits include a firing squad, German soldiers (taken from a dead German), a group of men (possibly WWI pilots, one is African American) in Paris in 1928, the Lafayette Escadrille with its pet fox and lion cubs Soda and Whiskey, patients in a hospital, people in a city,

Princess Alexis Dolgouruki, prisoners of war, and workers in overalls. There are also images of corpses.

Arranged: No.

Captioned: A few with subject.

Finding Aid: No.

Restrictions: The collection, located at the Garber Facility, is available by appointment only.

AS·233

Peenemünde Aerodynamics Reports *A.K.A.* Ft. Bliss/ Puttkamer Collection, 1940–1951

Dates of Photographs: 1944

Collection Origins

The staff of the German Peenemünde facility created the collection to document their work between 1940 and 1944. Established in the mid-1930s on Germany's North Sea coast, the facility served as a center for research in airplane turn rates, bomb drag, elastic wings, fuels, fuses, guidance, heat transfer, homing devices, launches, materials, rocket engine performance, salvage, spin control, stability, and surface finishes. By the end of the war, Peenemünde scientists had invented their first surface-to-surface guided missile (V-1), first ballistic missile (V-2), and first operational air-to-surface guided missile (He 293). After the war the United States and U.S.S.R. obtained the material and made use of the research, as well as some of the Peenemünde staff, in their space programs. Many of the materials in the collection are copies, made in Ft. Bliss, Texas, of the German originals. In 1974 the collection was transferred to NASM, where it received accession number XXXX-0192.

Physical Description

There are five silver gelatin photoprints, mounted in

reports. Other materials include charts, diagrams, engineering drawings, and reports.

Subjects

The photographs document rocket parts from Peenemünde.

Arranged: Chronologically.

Captioned: In German.

Finding Aid: No.

Restrictions: The collection, located at the Garber Facility, is available by appointment only.

AS·234

Peenemünde Archive Reports, 1938–1945

Dates of Photographs: 1938–1945

Collection Origins

The staff of Germany's Peenemünde facility created the collection between 1938 and 1945 to document their work in rocket development. For a history of Peenemünde, see *Collection Origins* in *AS·233*. NASM Archives assigned the collection accession number XXXX-0193.

Physical Description

There are 135 silver gelatin photoprints, mounted in reports. Other materials include bibliographies, charts, engineering drawings, reports, and transparencies.

Subjects

The photographs document rockets, rocket parts, and rocket tests at Peenemünde. There are images of rockets in flight and photographic reproductions of diagrams showing rocket structures. There are also images of machinery used in rocket construction, operation, or testing.

Arranged: Chronologically.

Captioned: Some in German.

Finding Aid: Bibliographies listing author, date, and subject of the papers.

Restrictions: The collection, located at the Garber Facility, is available by appointment only.

AS·235

Harold G. Peterson Scrapbook

Dates of Photographs: 1917–1920s

Collection Origins

Aviator Harold G. Peterson created the collection to document his personal and professional activities. Peterson experimented with gliders and airplanes from 1912 to 1915 and studied architectural engineering at Valparaiso University from 1914 to 1917. He joined the U.S. Army Air Service in 1917 and served as a flight instructor during the war. In 1919, while stationed in Texas, Peterson made an emergency landing in Mexico and was captured by local bandits; he later escaped. After his discharge in 1920, he established the Harold G. Peterson Aircraft Company, an aviation field and school, in White Bear, Minnesota. NASM Archives assigned the collection accession number 1989-0127.

Physical Description

There are 800 silver gelatin photoprints, mounted in an album.

Subjects

The photographs document Harold G. Peterson's personal and professional activities in World War I, as a pilot in the U.S. Army Air Service, and in the 1920s. Personal photographs include images of a cabin in woods and portraits of family and friends. Aircraft documented include an Albatros, a Curtiss JN-4, and other American and European airplanes, as well as parts such as engines. Military images include aircraft crashes, a camp, cavalry, formation flights, and pilots with their aircraft. There are aerial photographs of Hawaii, Mexico, and Paris, as well as an image of a flooded town.

Arranged: No.

Captioned: No.

Finding Aid: No.

Restrictions: The collection, located at the Garber Facility, is available by appointment only.

AS·236

Philippines Civil Aviation Scrapbook

Dates of Photographs: 1966

Collection Origins

Pilot Edith A. Dizon created the collection to document aviation in the Philippines, especially women pilots. Dizon began flying in 1959 as therapy after the death of her son. She continued to fly and became public relations officer for the Civil Aeronautics Administration. In addition to writing articles for the Administration, she also wrote about women pilots in the Philippines, contacting many of them in an unsuccessful attempt to form a club. Dizon belonged to the National Press Club. NASM Archives assigned the collection accession number XXXX-0281.

Physical Description

There are 12 photographs including color dye coupler photoprints and silver gelatin photoprints, mounted in a scrapbook. Other materials include advertisements, correspondence, magazine clippings, manuscripts, maps, and newspaper clippings, also mounted in the scrapbook.

Subjects

The photographs document aviation in the Philippines including aircraft, events, and pilots. Aircraft shown include Beech Barons (such as the *Philippine Baron,*) Piper Cubs, and Piper PA-22 Tri-Pacers. Events documented include a Christmas party in a hangar. Pilots portrayed include Edith Dizon, Mary Skitch, Joan Wallick, and Robert Wallick.

Arranged: No.

Captioned: With names and subject.

Finding Aid: No.

Restrictions: The collection, located at the Garber Facility, is available by appointment only.

AS·237

Photographic Archives Technical and Videodisc Files

Dates of Photographs: 1860s–Present

Collection Origins

NASM staff assembled the collection to serve as a reference file for exhibits, publications, and research by staff and outside researchers. The collection began in the early 1900s with material assembled by the Division of Mechanical Technology of the Smithsonian's National Museum. NASM later received the collection and in 1980 began reproducing the images on a series of videodiscs, which now contain over 250,000 images. For information on how to order the videodiscs, see the *Collection Origins* field of *AS·1*. The photographs have been published in *Air & Space Magazine,* as well as in numerous books such as the following: Gordon Swanborough and Peter M. Bowers. *United States Military Aircraft since 1909.* Washington, D.C.: Smithsonian Institution Press, 1989.

Physical Description

There are 300,000 photographs including albumen photoprints, ambrotypes, color dye coupler photoprints and slides, cyanotypes, platinum photoprints, silver gelatin dry plate photonegatives, and silver gelatin photonegatives and photoprints. Other materials include advertisements, bibliographies, charts, correspondence, diaries, engineering drawings, magazine clippings, manuscripts, maps, newspaper clippings, pamphlets, photomechanical prints, press releases, programs, and reports.

Subjects

The photographs document the history of aviation,

showing many types of American and foreign aircraft; artifacts and facilities; events; and people. Although beginning with 19th century balloon flight and continuing to the present, the images concentrate on the 1920s through the 1950s, particularly World War II.

Aircraft shown include airships; balloons; commercial and private airplanes such as airliners and racers; experimental vehicles; gliders; helicopters; military craft such as bombers, fighters, and transports; and seaplanes. There are also images of aircraft interiors and parts, especially engines. Equipment and supplies shown includes ammunition, bombs, cameras, clothing, communications devices, field lighting, instruments, navigation aids, parachutes, safety equipment, simulators and other training apparatus, and weapons. Facilities documented include aircraft carriers, airfields, airports, military bases, museums, and schools. There are also images of awards, cargo, insignia, labels, logos, miniature models, silhouettes for recognition training, and trophies.

Activities and events documented include agricultural and industrial uses of aircraft, airline operations throughout the world, airmail delivery, club and organization meetings, construction and maintenance, crashes, exhibition flight such as aerobatics and barnstorming, exhibits and air shows, meets, races, record flights, training, and warfare such as aerial combat, bombing, and strafing. The ambrotype shows John Steiner inflating a balloon in Erie, Pennsylvania, in 1867. There are also images of the National Victory Parade in Washington, D.C., in 1991. People portrayed include aircraft company executives, airline company personnel, astronauts, bomber crews, exhibition fliers, flight attendants, inventors, mechanics, military officers, passengers, pilots, race entrants and winners, record setters, and scientists. Photographs from this collection are reproduced in this volume's illustrations section.

Arranged: In two series. 1) Technical files, arranged by subject heading, then alphabetically or chronologically, containing images not yet reproduced on videodisc and interspersed with documents. 2) Videodisc files, arranged by videodisc side and frame number.

Captioned: Most with subject; some also with date and negative number; videodisc images with videodisc frame number. Images are assigned captions on the caption database when copies are ordered.

Finding Aid: 1) Partial caption database listing location, negative number, notes, source, subject, usage, and videodisc frame number (if on videodisc). Printouts can be obtained for single records or caption lists of related subjects. 2) Shelf list arranged by subject indicating location (file number and videodisc frame number) and whether there are related documents.

Restrictions: Some material subject to copyright restrictions. The collection is located at the NASM Archives on the Mall. Researchers are encouraged to call or write for an appointment.

AS·238

Piaggio Albums

Dates of Photographs: Late 1930s–1945

Collection Origins

Piaggio & Co., an Italian aircraft firm, created the collection to document its operations in the 1930s and 1940s. The company's aircraft included the P.23R, which broke two world records for range in December 1938. The photographs are reproduced on NASM's Archival Videodisc 7. For information on how to order the videodisc, see the *Collection Origins* field of *AS·1*.

Physical Description

There are 110 silver gelatin photoprints, mounted in albums.

Subjects

The photographs document the Italian Piaggio aircraft company's operations just before World War II. Activities shown include aircraft construction and flights. There are many images of aircraft, some seaplanes, including interiors. Aircraft models shown include the CANT Z-501, CANT Z-506B, CANT Z-506S, FN.305, FN.305A, FN.305D, FN.305R, P.16, P.23M, P.23R, P.32, P.50, P.108B, P.108C, P.108T, P.111, and P.119.

Arranged: By videodisc frame number.

Captioned: With negative number and videodisc frame number.

Finding Aid: 1) Lists of aircraft in each album. 2) Caption database listing model and videodisc frame number. Printouts can be obtained for single photographs or caption lists of photographs with related subjects.

Restrictions: No. The collection is located at the NASM Archives on the Mall. Researchers are encouraged to call or write for an appointment.

AS·239

Piaggio P.23R Photographs

Dates of Photographs: Circa 1990

Collection Origins

Joseph Foa, an engineer working for the Piaggio & Co. aircraft company in Italy, created the collection to document the Piaggio P.23R aircraft in the mid-1930s. Piaggio planned to capture the world record for range in unrefueled flight for Italy. The company hired Foa, who was attending the University of Rome, to design and construct the prototype aircraft. Foa received a doctorate in aeronautical engineering in 1933. He worked on the aircraft for over a year, but before the first trial flight from Rome to Patagonia in 1935, he was jailed as a suspected anti-Fascist. He was released after three months, but local authorities kept him from returning to Piaggio for three more years. During that time he worked for the Caproni company on aircraft such as the Reggiane Ca 405 Procellaria and Reggiane P32b. In December 1938, after Foa's return to Piaggio, the R.23R broke two world records. When the king of Italy visited the company to celebrate the records, Foa was barred because he was Jewish. He therefore left the project, which came to an end. In 1939 he came to the United States, where he worked at Bellanca Aircraft Corporation (1939–1940), the University of Minnesota (1940–1942), Curtiss-Wright Corporation (1943–1946), Cornell Aeronautical Laboratory (1946–1952), Rensselaer Polytechnic Institute (1952–1970), and George Washington University (beginning in 1970). He also worked as a consultant, received several patents, and published a number of articles. NASM Archives assigned the collection accession number 1990-0033. The photographs are reproduced on NASM's Archival Videodisc 7. For information on how to order the videodisc, see the *Collection Origins* field of *AS·1*.

Physical Description

There are 45 copy silver gelatin photoprints.

Subjects

Most of the images document the Piaggio P.23R. Other aircraft shown include the Reggiane Ca 405 Procellaria and Reggiane P32b. There are also portraits of aircraft designer Joseph Foa.

Arranged: No.

Captioned: With subject.

Finding Aid: Caption database listing subject. Printouts can be obtained for single photographs or caption lists of photographs with related subjects.

Restrictions: No. The collection is located at the NASM Archives on the Mall. Researchers are encouraged to call or write for an appointment.

AS·240

Project Crossroads Scrapbook *A.K.A.* Donald Putt Scrapbook

Dates of Photographs: 1946

Collection Origins

U.S. Army Air Forces Task Group 1.52 created the collection to commemorate Project Crossroads, the testing of the atomic bomb on Bikini Atoll. Formerly the 58th Bomb Wing, Task Group 1.52 photographed the bomb tests and kept statistics about equipment and personnel. The Task Group made souvenir scrapbooks for people involved with the project, presenting this one to Donald L. Putt, who donated it to NASM. NASM Archives assigned the collection accession number XXXX-0302. Studios represented include the U.S. Army Air Forces.

Physical Description

There are 45 photographs including color dye coupler photoprints (Kodacolor) and silver gelatin photoprints, mounted in a scrapbook. Other materials include charts, correspondence, financial records, illustrations, manuscripts, maps, and reports, also mounted in the scrapbook.

Subjects

The photographs document photographic equipment used in the U.S. Army Air Forces' Project Crossroads and an atomic bomb detonation on Bikini Atoll. Images of photographic equipment show motion-picture

and still picture cameras, their installation in aircraft, and U.S. Army Air Forces staff operating the equipment. Images of the detonation (Atomic Bomb #5, *A.K.A.* the Baker Day Test) show stages of the explosion.

Arranged: By subject.

Captioned: With subject.

Finding Aid: No.

Restrictions: The collection, located at the Garber Facility, is available by appointment only.

aircraft, especially seaplanes, as well as cars, sailboats, streetcars, and trains.

Arranged: No.

Captioned: Some with subject.

Finding Aid: No.

Restrictions: The collection, located at the Garber Facility, is available by appointment only.

AS·241

George B. "Slim" Purington Scrapbook

Dates of Photographs: 1911

Collection Origins

Aircraft mechanic George B. ("Slim") Purington created the collection to document early aircraft and aviation events in the Midwest and West. Purington worked at a Curtiss aviation school. Studios represented include Martin. NASM Archives assigned the collection accession number XXXX-0284.

Physical Description

There are 350 silver gelatin photoprints, mounted in an album.

Subjects

The photographs document early aircraft and events in the Midwest and West, especially those related to the Curtiss aviation schools, as well as other activities of George B. ("Slim") Purington's colleagues and friends. Activities and events documented include air races, crashes, a parade, a picnic, seaplane races, and a train wreck, as well as fencing, fishing from a floating aircraft, and recovering a wrecked aircraft. People portrayed include American Indians in airplanes, aviators, and Curtiss instructor "Lucky Bob" St. Henry and other Curtiss employees. There are many images of

AS·242

John J. Queeny Scrapbook

Dates of Photographs: 1914–1927

Collection Origins

John J. Queeny created the collection to document early aviation at the North Island Naval Air Station and Rockwell Field, California. NASM Archives assigned the collection accession number XXXX-0256.

Physical Description

There are 75 silver gelatin photoprints, mounted in an album.

Subjects

The photographs document aircraft and people at the North Island Naval Air Station and Rockwell Field, California, between 1914 and 1927. Aircraft documented include airships, biplanes, and seaplanes. People portrayed include aviator Julia Clark, a group posing on the wings of a large biplane, a man on a stretcher, pilots, sailors, and soldiers. There are also aerial views of Washington, D.C., and images of cars, a crashed aircraft, and monuments such as the Washington Monument.

Arranged: No.

Captioned: A few with date and subject.

Finding Aid: No.

Restrictions: The collection, located at the Garber Facility, is available by appointment only.

AS·243

Richard Rash Color Slide Collection, 1949–1960s

Dates of Photographs: 1949–1960s

Collection Origins

Marine aviator Richard Rash (1921–) created the collection to document his career after 1949. Rash attended San Diego State College for two years before joining the Navy in 1942, later transferring to the Marine Corps. During World War II he flew Vought F44 Corsairs and Grumman F4F Wildcats on missions in the Pacific. He remained in the service, and in 1946 he went to China, where he was stationed until 1949. He then served on tours of duty in Greece, Turkey, Spain, and Italy. Rash flew combat missions in Korea and later, as a colonel, in Vietnam. He retired in 1973. NASM Archives assigned the collection accession number 1989-0131. The photographs are reproduced on NASM's Archival Videodisc 7. For information on how to order the videodisc, see the *Collection Origins* field of *AS·1*.

Physical Description

There are 290 color dye coupler slides.

Subjects

The photographs document Richard Rash's service as a fighter pilot in China, Korea, and Vietnam. Most are images of equipment and facilities including aircraft carriers; airplanes and helicopters; bases in Korea, the United States, and Vietnam; supplies; and trucks. There are portraits of pilots; soldiers in training; and Vietnamese children, men, and women, often with local buildings.

Arranged: In three series. 1) China. 2) Korea. 3) Vietnam.

Captioned: No.

Finding Aid: Caption database listing videodisc frame number. Printouts can be obtained for single photographs or caption lists of photographs with related subjects.

Restrictions: No. The collection is located at the NASM Archives on the Mall. Researchers are encouraged to call or write for an appointment.

AS·244

Republic Feeder Airlines Collection, 1945–1983

Dates of Photographs: 1963–1967

Collection Origins

A group of airlines that eventually united as Republic created the collection to document their operations. Functioning after World War II in the Midwest and Southwest, the nine small feeder airlines that became Republic were the following: Air West, Bonanza, Hughes Air West, North Central, Pacific, Southern, Southwest, West Coast, and Wisconsin Central. The photographs were created by Bonanza Airlines, mainly for publicity purposes. NASM Archives assigned the collection accession number 1989-0134.

Physical Description

There are 15,000 silver gelatin photonegatives. Other materials include maps, newsletters, notices, postage stamps, press releases, and reports.

Subjects

The photographs document events, operations, and personnel of Bonanza Airlines, many for publicity purposes. Activities and events shown include crashes; deliveries; exhibits; maintenance; social functions such as ground-breaking ceremonies, lunches, meetings, parties, and tours; sports such as baseball, basketball, bowling, and softball; and training such as flight attendant classes. There are images of aircraft such as the Douglas DC-9 and Fokker F-27, showing damage and interiors, as well as airline equipment and facilities.

There are portraits of company sports teams, flight attendants, passengers, and pilots. There are also photographic reproductions of posters.

Arranged: By image number.

Captioned: On envelope with date, image number, and subject.

Finding Aid: Item-level transfer list.

Restrictions: No. The collection is located at the NASM Archives on the Mall. Researchers are encouraged to call or write for an appointment.

AS·245

Richard S. Reynolds Photograph Collection

Dates of Photographs: 1990

Collection Origins

Richard S. Reynolds created the collection while working for the Curtiss Aeroplane and Motor Corporation and the Navy Office in Washington, D.C., during the late 1910s. NASM made copies from the original prints, lent by Christopher Reynolds, Richard S. Reynolds's son, and assigned them accession number 1989-0057.

Physical Description

There are 55 silver gelatin copy photoprints.

Subjects

The photographs document aircraft from 1916 to 1920. Airplanes shown include the Aeromarine 39-A and 40 Sport; Burgess-Dunne AH-1 and AH-7; Caproni CA-44; Curtiss 18-T Wasp, AH-132, F-5L, H-16, HA-1 Dunkirk Fighter, HS-1L, HS-2L, L-2, N-9, NC-1, and R-9 Seaplane; Gallaudet D-4; Loening M-2 Kitten; Sopwith Scout; and Wright Model K. Airships depicted include the Navy Type C-1, DN-1, and F-1.

Arranged: By negative number.

Captioned: With accession number and negative number.

Finding Aid: Caption database and printout listing format, negative number, source, and subject. Printouts can be obtained for single photographs or caption lists of photographs with related subjects.

Restrictions: No. The collection is located at the NASM Archives on the Mall. Researchers are encouraged to call or write for an appointment.

AS·246

Donald J. Ritchie Papers, Circa 1955–1976

Dates of Photographs: 1961–1965

Collection Origins

Missile engineer Donald J. Ritchie assembled the collection to document his research. Ritchie worked as an engineer at Bell Aircraft Corporation (1940–1942) and Wright Air Development Center, Ohio (1942–1945), where he contributed to preliminary designs for jet aircraft. In 1951 he received an M.S. in applied mathematics from Wayne University. Ritchie then began working on missile systems at the research laboratory division at Bendix Corporation. He also worked briefly at Atomic Power Development Associates (1954–1955), Avco Manufacturing Company (1957), and Melpar, Inc., Scientific Analysis Office (1957–1958). After leaving Bendix in 1967, he directed research and taught at the Embry-Riddle Aeronautical Institute (now Embry-Riddle Aeronautical University) and served as a consultant for the U.S. Air Force Foreign Technical Intelligence Division and the National Air and Space Museum. Studios represented include Bendix Corporation, the U.S. Air Force, and the U.S. Navy. NASM Archives assigned the collection accession number XXXX-0088.

Physical Description

There are 250 photographs including color dye coupler photoprints and silver gelatin photoprints. Other materials include articles, books, charts, correspondence, drawings, manuscripts, newspaper clippings, notes, and periodicals.

Subjects

The photographs, many reproductions of images in journals and newspapers, document Soviet technology. Most photographs are cityscapes, including aerial views, showing buildings such the Kremlin, Lenin Sports Stadium, and Moscow University; streets with traffic; and trucks. Facilities depicted include airfields, gas stations, highways, and industrial complexes. Images of Soviet radio and space technology show radar antennas and transmitters, satellites, and space capsules. There are portraits of Soviet cosmonauts, crowds watching a motorcade, students in a classroom studying satellites, and technicians. There are also images of ball lightning and U.S. rockets, as well as photographic reproductions of charts and diagrams.

Arranged: By subject.

Captioned: Some with date and subject.

Finding Aid: Box list.

Restrictions: The collection, located at the Garber Facility, is available by appointment only.

AS·247

Rocket, Space, and Early Artillery History Collection

Dates of Photographs: Circa 1960s

Collection Origins

The staff of NASM's Space Science and Exploration (now Space History) Department assembled the collection to document early artillery, rockets, and space technology for research purposes. The material covers artillery from the Middle Ages to the mid-19th century and rocket development in Austria, England, Germany, Russia, and the United States from the mid-19th century to the 1980s. Photographers include NASA, OPPS, and the U.S. Navy. NASM Archives assigned the collection accession number XXXX-0007.

Physical Description

There are 14 silver gelatin photoprints. Other materi-

als include articles, books, charts, correspondence, journals, manuscripts, and reports.

Subjects

The photographs document the history of artillery, rockets, and space exploration. Objects documented include an Asian war rocket component, a spacecraft on exhibit in the Smithsonian's Arts and Industries Building, and a spacecraft nose cone. There is also a photographic reproduction of an 1865 advertisement for a whale gun.

Arranged: In three series. 1) Early artillery. 2) Rockets. 3) Space technology. Then by author or subject. Photographs are dispersed throughout the collection.

Captioned: Some with subject.

Finding Aid: Folder list.

Restrictions: The collection, located at the Garber Facility, is available by appointment only.

AS·248

Rockwell Collection

Dates of Photographs: Circa 1914–1917

Collection Origins

Unknown. The photographs are reproduced on NASM's Archival Videodisc 2. For information on how to order the videodisc, see the *Collection Origins* field of *AS·1*.

Physical Description

There are 100 silver gelatin photoprints.

Subjects

The photographs document the Lafayette Escadrille, a unit of American pilots serving in the French military before the United States entered World War I. Images include aircraft, aircraft crashes, graves, hangars, the Escadrille's pet lion cubs, pilots, a train station, and a village street.

Arranged: By videodisc frame number.

Captioned: With subject.

Finding Aid: Caption database listing subject and videodisc frame number. Printouts can be obtained for single photographs or caption lists of photographs with related subjects.

Restrictions: No. The collection is located at the NASM Archives on the Mall. Researchers are encouraged to call or write for an appointment.

AS·249

Rockwell HiMAT Remotely-Piloted Research Vehicle Documentation, 1976–1981

Dates of Photographs: 1976–1981

Collection Origins

NASA, Rockwell International, and the U.S. Air Force created the collection to document the development of the Highly Maneuverable Aircraft Technology (HiMAT) program, which produced a reusable, modifiable aircraft to test new aeronautical designs. After initial research in 1975, NASA awarded Rockwell International a contract to produce two HiMAT Remotely-Piloted Research Vehicles. The Rockwell HiMAT carried both canard and tail control surfaces; engine intake and exhaust structures; modular main wings; and control, power, and telemetry systems. The first HiMAT was delivered to NASA in March 1978 and the second in June; the first free flight was conducted in July 1979. The HiMAT was controlled on the ground through television, radar, and telemetry, with back-up systems on chase aircraft and a self-righting system on the vehicle in case of loss of ground control. One of the HiMATs was donated to NASM in 1989 and placed on display. NASM Archives assigned the collection accession number 1989-0059.

Physical Description

There are 120 photographs including color dye cou-

pler photoprints and silver gelatin photoprints. Other materials include charts, computer printouts, correspondence, engineering drawings, and reports.

Subjects

The photographs document Rockwell HiMAT parts including a battery pack, computer circuits, and the frame.

Arranged: By subject and type of material.

Captioned: Some with subject.

Finding Aid: No.

Restrictions: The collection, located at the Garber Facility, is available by appointment only.

AS·250

Rohrbach Photograph Album

Dates of Photographs: Circa 1910s–1920s

Collection Origins

Unknown. The photographs are reproduced on NASM's Archival Videodisc 7. For information on how to order the videodisc, see the *Collection Origins* field of *AS·1*.

Physical Description

There are 30 silver gelatin photoprints, mounted in an album.

Subjects

The photographs document early flying boat and seaplane operations. Activities shown include constructing aircraft and loading cargo. Aircraft are shown in flight and on water; there are also images of aircraft parts. Facilities illustrated include a factory and hangars.

Arranged: By videodisc frame number.

Captioned: With videodisc frame number.

Finding Aid: Caption database listing videodisc frame number. Printouts can be obtained for single photographs or caption lists of photographs with related subjects.

Restrictions: No. The collection is located at the NASM Archives on the Mall. Researchers are encouraged to call or write for an appointment.

AS·251

Romanian Air Meet Scrapbook

Dates of Photographs: Circa 1930

Collection Origins

Standard Oil Company created the collection to document an air meet in Romania and to advertise its product, Stanavo Aviation Engine Oil. The meet, attended by the Romanian royal family, included Czechoslovakian, Italian, and Romanian pilots and aircraft. Standard Oil erected booths on the site and provided refueling trucks. NASM Archives assigned the collection accession number XXXX-0306.

Physical Description

There are 40 silver gelatin photoprints, mounted in an album.

Subjects

The photographs document a ca. 1930 air meet in Romania. People portrayed include Czechoslovakian officials; a Romanian girl making parachute jumps; a Romanian pilot; the Romanian royal family King Carol II, Queen Marie, and Prince Nicholae reviewing foreign officers, riding in a car, and watching flights; and workers servicing aircraft. There are also images of an Italian biplane squadron in flight, the royal platform, Romanian aircraft with Stanavo insignia, Stanavo booths, and Stanavo trucks.

Arranged: Chronologically.

Captioned: With subject.

Finding Aid: No.

Restrictions: The collection, located at the Garber Facility, is available by appointment only.

AS·252

Basil Lee Rowe Collection, 1917–1973

Dates of Photographs: Circa 1917–1960s

Collection Origins

Basil Lee Rowe (1896–1973) created the collection to document his career. In 1914, two years after his high school graduation, Rowe began flying as an apprentice to pilot Turk Adams. He served in the U.S. Air Service in World War I, after which he toured the United States as a barnstormer and racing pilot. In 1925 he moved to the West Indies, where he formed the West Indian Aerial Express two years later. When Pan American Airlines took over West Indian shortly afterward, Rowe became Pan American's senior pilot. During his first ten years with Pan American he surveyed most of the company's new routes, often flying with Charles A. Lindbergh. He served in the military again in World War II, returned to commerical aviation, and retired in 1956. NASM Archives assigned the collection accession number XXXX-0019. The photographs are reproduced on NASM's Archival Videodisc 2. For information on how to order the videodisc, see the *Collection Origins* field of *AS·1*.

Physical Description

There are 110 photographs including color dye coupler photoprints and silver gelatin photoprints, mounted in scrapbooks. Other materials, some also mounted in the scrapbooks, include certificates, logs, magazines, manuscripts, newspaper clippings, pamphlets, posters, and radiograms.

Subjects

The photographs show some of Basil Lee Rowe's activities as a barnstormer and airline pilot. There are images of 1910s and 1920s aircraft and Pan American airliners. Portraits include a wing-walker and Rowe in his pilot's uniform.

Arranged: Roughly chronological.

Captioned: Most with subject in handwriting.

Finding Aid: 1) Item-level transfer list. 2) Box list. 3) Caption database listing subject and videodisc frame number. Printouts can be obtained for single records or caption lists of related subjects.

Restrictions: The collection, located at the Garber Facility, is available by appointment only.

AS·253

Benjamin Ruhe Collection

Dates of Photographs: 1980s

Collection Origins

Boomerang expert Benjamin Ruhe (1928–) assembled the collection to document the history and use of boomerangs. Ruhe, who helped popularize boomerangs in the United States, began a newsletter on boomerangs that later became the newsletter of the United States Boomerang Association. He also served as captain of the U.S. team in the first Australian-American boomerang competition. NASM Archives assigned the collection accession number 1987-0024.

Physical Description

There 35 photographs including color dye coupler photoprints and silver gelatin photoprints. Other materials include audiotape cassettes, books, brochures, correspondence, drawings, magazines, manuscripts, motion-picture film footage, newsletters, newspaper clippings, and videotape cassettes.

Subjects

The photographs show boomerangs and people throwing them. Throwers portrayed include Volker Behrens of Germany, Barnaby Ruhe knocking an apple off his own head, and Benjamin Ruhe.

Arranged: No.

Captioned: Some with subject.

Finding Aid: No.

Restrictions: The collection, located at the Garber Facility, is available by appointment only.

AS·254

Herbert H. Rust Photograph Collection

Dates of Photographs: Circa 1940–1956

Collection Origins

Herbert H. Rust assembled the collection to document aircraft of the 1940s and 1950s. He donated the collection to NASM Archives, where it received accession number 1987-0126. Photographers and studios represented include Bell Aircraft Corporation, Kellet Aircraft Corporation, McDonnell Aircraft Corporation, Piasecki Helicopter Corporation, Hal Pottorf, Herbert H. Rust, and the U.S. Air Force.

Physical Description

There are 350 silver gelatin photoprints. Other materials include photomechanical postcards.

Subjects

The photographs document many types of aircraft, primarily American and European military airplanes, of the 1940s and 1950s. European aircraft shown include a Brewster Buffalo (Belgian); Burnelli UB-14; various De Havilland models; Dornier Do 18E, Do 24, and Do X; Heinkel He 162; Junkers Ju 287; various Messerschmitt models; Saunders-Roe SR-A1; and Zeppelin airships. Helicopters documented include the Kellett XH-10, McDonnell XHJD-1 Whirlaway, Piasecki XHJP-1, and Sikorsky R-5. U.S. aircraft shown include the Beech XA-38; Boeing B-50; Brewster XA-32; Convair B-36, XC-99, and XF-81; Douglas DC-6 and XB-42; Lockheed P2V Neptune and P-38 Lightning; Martin XB-48; Northrop XP-79 Flying Ram; and Republic P-47 Thunderbolt. Other aircraft shown include airliners, early aircraft, rockets, and small civilian aircraft.

Arranged: In nine series by type of aircraft.

Captioned: Most with manufacturer and model.

Finding Aid: Series list.

Restrictions: The collection, located at the Garber Facility, is available by appointment only.

AS·255

SAAB Scrapbook, 1926–1976

Dates of Photographs: 1970s

Collection Origins

Unknown. The photographs are reproduced on NASM's Archival Videodisc 2. For information on how to order the videodisc, see the *Collection Origins* field of *AS·1*.

Physical Description

There are 80 color dye coupler photoprints, mounted in an album.

Subjects

The photographs document SAAB aircraft built from the 1920s to the 1970s. There are also images an Albatros, De Havilland D.H.100 Vampire, and Nieuport. Parts shown include engines and propellers.

Arranged: By videodisc frame number.

Captioned: Most with manufacturer and model or other subject.

Finding Aid: No.

Restrictions: No. The collection is located at the NASM Archives on the Mall. Researchers are encouraged to call or write for an appointment.

AS·256

St. Louis Centennial Scrapbook, October 3–9, 1909

Dates of Photographs: 1909

Collection Origins

The collection was assembled to document the 1909 St. Louis Centennial Exhibition, especially the aviation contests. The exhibition's events included the Centennial air meet, won by Glenn H. Curtiss; a flotilla; and a lecture by North Pole explorer Frederick A. Cook. NASM Archives assigned the collection accession number XXXX-0237.

Physical Description

There are 12 silver gelatin photoprints, mounted in a scrapbook. Other materials include newspaper clippings, also mounted in the scrapbook.

Subjects

The photographs document events at the 1909 St. Louis Centennial Exposition, including flights of airships and biplanes and a flotilla on the Mississippi River including the ship U.S.S. *McDonough*. There are portraits of individuals, probably pilots, and spectators at the events. There are also aerial photographs of downtown St. Louis and images of the waterfront.

Arranged: No.

Captioned: No.

Finding Aid: No.

Restrictions: The collection, located at the Garber Facility, is available by appointment only.

AS·257

Savoia-Marchetti Scrapbook

Dates of Photographs: Circa 1929

Collection Origins

The collection was created to document the Italian Savoia-Marchetti SM-55 and SM-56 aircraft. Some Savoia-Marchetti aircraft were built in the United States by the American Aeronautical Corporation. Studios represented include Court. NASM Archives assigned the collection accession number XXXX-0255.

Physical Description

There are 135 silver gelatin photoprints, mounted in an album.

Subjects

The photographs document the construction and use of Savoia-Marchetti SM-55 and SM-56 aircraft. Activities shown include constructing hangars, touring a factory, transporting aircraft parts on ships, and working in factories, as well as aircraft taking off. Some of the workers are women. Parts shown include cockpits and engines. Surroundings illustrated include coasts (aerial views), docks with a gas pump and a sign advertising a speedboat to the airport, and harbors.

Arranged: No.

Captioned: No.

Finding Aid: No.

Restrictions: The collection, located at the Garber Facility, is available by appointment only.

AS·258

Anton Schlein Portfolio

Dates of Photographs: 1905–1907

Collection Origins

Pioneer balloonist Anton Schlein created the collection to document balloon flights over Pressburg, Austria-Hungary (now Bratislava, Slovakia). Born in Salzburg, Germany, in 1878, Schlein held a Ph.D. in physics and astronomy and worked at the Universitique Prague's observatory. He later joined the Central Institute for Meteorology and Geodynamics in Vienna, where he made his first balloon ascension in 1903. Schlein took a series of aerial photographs from balloons. The photographs are reproduced on NASM's Archival Videodisc 2. For information on how to order the videodisc, see the *Collection Origins* field of *AS·1*.

Physical Description

There are 12 silver gelatin photoprints, in a portfolio.

Subjects

The photogaphs are aerial views taken from balloons over Pressburg, Austria-Hungary (now Bratislava, Slovakia). The aerial views show a gasworks and a river (probably the Danube), as well as other cityscapes and landscapes. There are also images of clouds.

Arranged: No.

Captioned: With date, height of balloon, and location in German; some captions are translated into English on the caption database.

Finding Aid: Caption database listing caption, date, print number, source, subject, and videodisc frame number. Printouts can be obtained for single photographs or caption lists of photographs with related subjects.

Restrictions: No. The collection is located at the NASM Archives on the Mall. Researchers are encouraged to call or write for an appointment.

AS·259

Blanche Stuart Scott Memorabilia, Circa 1935–1969

Dates of Photographs: Circa 1939

Collection Origins

Pioneer aviator Blanche Stuart Scott (1889–1970) created the collection to document her later life. In 1910 Scott made an automobile trip across the United States. The same year she became one of the first three women pilots, making her first solo flight at the Curtiss aviation school in Hammondsport, New York. From 1910 to 1916 she flew with aerial exhibition teams, then retired from flying until 1948, when she flew an Air Force jet copiloted by Charles E. ("Chuck") Yeager. In 1954 she became a public relations consultant for the U.S. Air Force Museum at Wright-Patterson Air Force Base in Ohio. NASM Archives assigned the collection accession number XXXX-0062.

Physical Description

There are two silver gelatin photoprints. Other materials include certificates, identification cards, newspaper clippings, plaques, posters, and ribbons.

Subjects

The photographs portray an unidentified group of men and women with automobiles and a bus.

Arranged: By type of material.

Captioned: No.

Finding Aid: No.

Restrictions: The collection, located at the Garber Facility, is available by appointment only.

AS·260

2nd Aviation Instruction Center, France, Scrapbook

Dates of Photographs: 1917–1918

Collection Origins

Pilot Eugene Danielwicz created the collection to document his experiences as a sergeant at the 2nd Aviation Instruction Center in France during World War I.

Lawrence H. Boteler, a nephew of Danielwicz, donated the collection to NASM, where it received accession number XXXX-0307.

Physical Description

There are 30 silver gelatin photoprints, mounted in an album.

Subjects

The photographs document the activities and facilities at the 2nd Aviation Instruction Center and surrounding areas in France in 1918. Activities documented include infantry troops marching in gas masks, an infantryman getting shot, men laying out a sign reading "U.S." on an airfield, pilots posing with aircraft, and soldiers exercising. Equipment and facilities documented include aircraft, hangars, interiors of buildings at the Center, a tank, and tents. There are aerial shots of French cities and landscapes including Metz and Villers-sur-Meuse. There are also images of a ski slope and bombed towns and villages.

Arranged: No.

Captioned: Some with subject.

Finding Aid: No.

Restrictions: The collection, located at the Garber Facility, is available by appointment only.

AS·261

2nd Mapping Squadron Alaskan Scrapbook *A.K.A.* George H. Fisher, Jr., Scrapbook

Dates of Photographs: 1939–1941

Collection Origins

A detachment of the 2nd Mapping Squadron, U.S. Army Air Corps, operating in Alaska, created the collection to document the members' activities, the local Inupiaq people, and the surroundings. NASM

Archives assigned the collection accession number 1987-0041.

Physical Description

There are 85 silver gelatin photoprints, mounted in an album.

Subjects

The photographs document the activities and surroundings of the 2nd Mapping Squadron, U.S. Army Air Corps, in Alaska, as well as local Inupiaq people. Squadron members are shown conducting maneuvers on snow-covered mountains, flying over a glacier, skiing, and surveying. Members portrayed, shown with their Beech F-2 aircraft, include T.D. Brown, H.E. Hammers, G.G. Northrup, and J.P. Stewart. Images of the built environment in Alaska include a bridge, the cities of Anchorage and Palmer, a dock with ships, a farm, a log cabin, a railroad, roads, a Russian Orthodox graveyard, a snow gauge, and trains. Alaskan natural surroundings shown include icebergs, ice floes, mountains, storms, sunsets, vegetation, and a volcano, as well as animals such as bears and moose. There are also portraits of Inupiaqs including children at school, men, and women doing craftwork, as well as images of their artifacts including ivory work, mukluks, and a totem pole.

Arranged: No.

Captioned: Most with subject.

Finding Aid: No.

Restrictions: The collection, located at the Garber Facility, is available by appointment only.

AS·262

Albert W. Seypelt Collection, 1892–1941

Dates of Photographs: Circa 1915–1930

Collection Origins

Albert W. Seypelt created the collection to document his aviation career, primarily his 1927 European flight. Born in Germany, Seypelt served in the German army during World War I. In 1927, he and George W. Kern toured Europe in an airplane called the *Yankee Doodle.* Beginning in Stuttgart in October, the flight covered over 6,000 miles, including stops in Belgium, France, Italy, and Austria, before returning to Stuttgart in January 1928. Studios represented include Paul Lamm, Photo-Union, Berlin. NASM Archives assigned the collection accession number 1985-0011.

Physical Description

There are 160 silver gelatin photoprints. Other materials include certificates, correspondence, identification cards, licenses, motion-picture film footage, and newspaper clippings.

Subjects

The photographs document Albert W. Seypelt's aviation activities, especially his 1927 European tour, and his experiences in the Germany army during World War I. There are portraits of Seypelt for identification cards and licenses, in flying gear, in uniform, and with a dog, as well as with George W. Kern and the Klemm-Daimler L-20 *Yankee Doodle* during the 1927 flight, often during landings with crowds of spectators. There are also other aircraft shown, especially German aircraft such as Fokkers. There are images of aircraft being towed by a car and by an elephant; an aircraft taking off from Long Island to rescue the stranded crew of the *Bremen,* an airplane that crashed during a long-distance flight attempt; biplanes in flight (possibly in a dogfight); and stunt flights. German World War I scenes include bombed buildings and railroad tracks, a funeral, a military band marching, and street fighting, as well as aerial images of buildings and roads. There are also images of people in costumes.

Arranged: In five series by type of material. 1) Correspondence. 2) Newspaper clippings on the flight of the *Yankee Doodle.* 3) Aviation certificates, licenses, and other memorabilia. 4) Photographs. 5) Newspaper clippings and photographs on the flight of the *Bremen.*

Captioned: A few in German.

Finding Aid: Folder list.

Restrictions: The collection, located at the Garber Facility, is available by appointment only.

AS·263

Charles S. Sheldon II Papers, 1934–1980

Dates of Photographs: 1961–1964

Collection Origins

Charles S. Sheldon II (1917–1981) created the collection to document his career as an economist and aerospace expert. Sheldon worked in the fields of transportation and economics before World War II and received a Ph.D. from Harvard University in 1942. He served in the U.S. Navy (1943–1952) and later the Naval Reserve and taught in the University of Washington's Department of Transportation (1940–1948) and Department of Economics (1949–1955).

Sheldon then joined the Congressional Research Service (CRS) of the Library of Congress as senior specialist on transportation and communications (1955–1958) and participated in several congressional committees, including the Joint Economics Committee, House Committee on Astronautics and Space Exploration, and House Committee on Science and Astronautics (1955–1961). From 1961 to 1966 he served on NASA's professional staff, then returned to CRS where he remained until his death. In 1984 and 1985 Sheldon's wife donated the collection to NASM, where it received accession number XXXX-0141. Photographers and studios represented include Associated Press, Goodyear Aircraft News Service, Los Alamos Research Laboratory, A. Mokletsov, and NASA.

Physical Description

There are 110 photographs including color dye coupler photoprints and silver gelatin photonegatives and photoprints. Other materials include articles, books, charts, correspondence, drawings, manuals, manuscripts, newspaper clippings, notes, periodicals, reports, and speeches.

Subjects

The photographs document American and Soviet satellites, spacecraft, and related equipment, facilities, and people. Satellites and spacecraft depicted include a Cosmos satellite, *Lunik 9, Mars 2* and *3, Molniya 1,* and a Vostok spacecraft. Equipment and facilities documented include a nuclear test reactor at Los Alamos. There are also photographic reproductions of charts, drawings, and models of equipment, flights, missile launch sites, nuclear explosions, relay stations, research buildings, and satellites, as well as a satellite photograph of the Earth. Portraits show Leonid Ivanovich Sedov of the U.S.S.R. Academy of Sciences at a 1955 Soviet Embassy press conference, announcing the Soviet intent to launch a manned satellite, and Wernher von Braun at a Goodyear plant.

Arranged: No.

Captioned: Some with date and subject.

Finding Aid: Partial inventory.

Restrictions: The collection, located at the Garber Facility, is available by appointment only.

AS·264

Dale B. Sigler Early Naval Aviation Scrapbook

Dates of Photographs: 1961

Collection Origins

Pilot Dale B. Sigler (1885–1965) assembled the collection to document early Naval aviation. Sigler joined the U.S. Navy in 1908 and in 1911 became one of the first group of mechanics to join the Navy Aviation Corps. He served at the Wright factory in Dayton, Ohio, then at an airfield at Greenbury Point, Maryland, and finally at North Island, California. He left the Navy in 1912 and later worked for the Southern Pacific Railroad and the Portland General Electric Company. In 1961 Sigler participated in the Navy's celebration of the 50th anniversary of its first airfield, during which he identified the engine from the original Wright B-1, the first Navy aircraft. At the same time he began compiling this collection, which he worked on until his death. NASM assigned the collection accession number XXXX-0295.

Physical Description

There are 45 photographs including a color dye coupler photoprint and silver gelatin copy photoprints,

mounted in a scrapbook. Other materials include manuscripts and maps, also mounted in the scrapbook.

Subjects

The photographs document U.S. Naval aviation in 1911 and 1912. Aircraft depicted include the Curtiss A-1 and A-2 and Wright B-1. Activities and events documented include aircraft crashes and landings, mechanics carrying aviators through the water, salvaging a crashed aircraft, and an unsuccessful flight to Hawaii. Facilities shown include the first Navy airfield at Greenbury Point, Maryland, and the second Navy airfield at North Island, California. People portrayed include Glenn H. Curtiss, Dale B. Sigler, and the first three Naval aviators, Theodore G. Ellyson, John Rodgers, and John H. Towers.

Arranged: Chronologically.

Captioned: With subject.

Finding Aid: No.

Restrictions: The collection, located at the Garber Facility, is available by appointment only.

AS·265

Elton R. Silliman Papers, 1930–1982

Dates of Photographs: 1930s

Collection Origins

Airline executive Elton R. Silliman created the collection to document his career. Silliman helped organize Aerovias Centrales, which operated in Mexico in 1931 and 1932. In 1932 he went to work for Pan American Airways as special representative in Central America, Panama, Venezuela, and the Dutch West Indies. After leaving Pan American in 1943, Silliman became general manager of CIA Mexicana de Aviacion, S.A. Studios represented include Serra. NASM Archives assigned the collection accession number 1989-0050.

Physical Description

There are 125 silver gelatin photoprints. Other materials include correspondence, financial records, membership lists, newspaper clippings, and reports.

Subjects

The photographs document events and facilities of South American airlines, including Aerovias Centrales and Pan American Airways, in the 1930s. Events documented include an aircraft crash in a Honduran jungle and the first airmail flight in Guatemala. Aircraft documented include a Ford Trimotor and Pan American airliners. Facilities documented include airports in Santa Ana, Costa Rica, and in Honduras, as well as buildings and fields in Mexico. There are also aerial views of Panama City and an area near Santa Ana, as well as images of houses and a volcano in Honduras.

Arranged: No.

Captioned: Some with subject.

Finding Aid: No.

Restrictions: The collection, located at the Garber Facility, is available by appointment only.

AS·266

S. Fred Singer Papers

Dates of Photographs: 1948–1970s

Collection Origins

Physicist S. Fred Singer (1924–) created the collection to document his career. After emigrating to the United States from Vienna in 1940, Singer attended Ohio State University and then Princeton University, where he received a Ph.D. in 1948. He worked at the Johns Hopkins University Applied Physics Laboratory (1946–1950), served as the Office of Naval Research scientific liaison officer at the U.S. Embassy in London (1950–1953), and taught at the University of Maryland (1953–1962). Singer also served as director of the National Weather Satellite Center, Department of Commerce (1962–1964); dean of the School of Environmental and Planetary Science, University of Miami (1964–1967); deputy assistant secretary for water quality and research, Department of the Interior (1967–1970); professor of environmental science, University of Virginia (1971–1987); and chief scientist,

Department of Transportation (1987–1989). Throughout his career, Singer participated in formulating public policy and wrote on environmental issues, astrophysics, and space exploration. NASM Archives assigned the collection accession number 1989-0130.

Physical Description

There are 85 photographs including color dye coupler photoprints and silver gelatin photoprints. Other materials include charts, correspondence, financial records, magazine clippings, manuscripts, newspaper clippings, notes, reports, and reprints.

Subjects

The photographs document S. Fred Singer's professional research, including images of equipment, facilities, and scientific data. Equipment and facilities documented include instruments, laboratories, an observatory, TEKTITE (an underwater research vessel), and a Terrapin missile. There are images of clouds taken from weather satellites, Earth from spacecraft, and the lunar surface. There are also photographic reproductions of charts and drawings. People portrayed include Uri Geller, Singer, and Singer's colleagues.

Arranged: By date, subject, and type of material.

Captioned: Some with subject.

Finding Aid: Box list.

Restrictions: The collection, located at the Garber Facility, is available by appointment only.

AS·267

Skylab Collection *A.K.A.* McDonnell-Douglas Astronautics Company Collection

Dates of Photographs: 1969–1972

Collection Origins

McDonnell-Douglas Astronautics Company, which built NASA's Skylab Orbital Workshop, created the collection to document Skylab's construction, transportation, and operation between 1969 and 1974. The Skylab program sent a manned workshop into orbit for long-term missions to test the effects of the space environment on people and equipment, make astronomical observations, and study the Earth from space.

After the May 1973 launch of the unmanned *Skylab I,* NASA conducted three manned missions: *Skylab II* (May 25 to June 22, 1973); *Skylab III* (July 28 to September 25, 1973); and *Skylab IV* (November 16, 1973, to February 8, 1974). McDonnell-Douglas submitted photographs to NASA every month during Skylab's construction, from 1970 to 1972, and daily status reports during Skylab's operation in 1973 and 1974. Photographers represented include McDonnell-Douglas Corporation and John Simpson. NASM Archives assigned the collection accession number XXXX-0090.

Physical Description

There are 170 photographs including color dye coupler photoprints and silver gelatin photoprints. Other materials include engineering drawings and reports.

Subjects

The photographs document the construction, testing, and transportation of the Skylab Orbital Workshop. Construction activities documented include attaching the surface cover, installing instruments, and riveting pieces. Tests illustrated include checking instruments, submerging material in a water tank, and using the equipment and furniture. Skylab is shown being transported on an airplane (the Aero SpaceLines Super Guppy), a boat, and a truck. There are also images of an exhibit and a man giving a speech.

Arranged: No.

Captioned: With negative numbers.

Finding Aid: No.

Restrictions: The collection, located at the Garber Facility, is available by appointment only.

AS·268

Skylab IV Pilot's Flight Data File *A.K.A.* William R. Pogue Collection, 1966–1974

Dates of Photographs: 1974

Collection Origins

NASA created the collection to provide training information to William R. Pogue (1930–), pilot of *Skylab IV*. *Skylab IV*, the longest U.S. manned space flight, began on November 16, 1973, and lasted 84 days. The three-man crew, Pogue, Gerald P. Carr, and Edward G. Gibson, conducted material handling and medical experiments and recorded observations. In 1974 NASA donated the collection to the Smithsonian, and NASM Archives assigned it accession number XXXX-0145. Studios represented include Dudley Observatory.

Physical Description

There are 55 photographs including color dye coupler photoprints and silver gelatin photoprints. Other materials include checklists, manuals, maps, menus, motion-picture film footage, motion-picture films, and schedules.

Subjects

The photographs document damage to spacecraft materials and reproduce a manual on geology. Images of damage show punctures and stains on surfaces. Reproduced pages from the geology manual include information on identifying faults, lakes, and mountain ranges from the air and on kinds of photographs to be taken during missions. There are also photographic reproductions of maps in the manual.

Arranged: No.

Captioned: Damage images with alphanumeric subject code and negative number.

Finding Aid: Box list.

Restrictions: The collection, located at the Garber Facility, is available by appointment only.

AS·269

Ernest Smith and Emory Bronte Flight Scrapbook

Dates of Photographs: 1927–1960

Collection Origins

The collection was assembled to document the flight of Emory Bronte and Ernest Smith from Oakland to Hawaii on July 14 and 15, 1927. Bronte, born in 1902, served in the U.S. Merchant Marines (1918–1923) and worked for the McCormick Steamship Company (1924–1926), Inland Waterways Corporation (1926–1927), and Tidewater Associated Oil Company (1927–1954).

Smith (1893–1963) graduated from the University of California, Berkeley, in 1917. He joined the Army and became a flight instructor, served until 1919, and then worked as a salesman and a pilot. Smith flew an airplane in the movie *Hell's Angels* and later worked as a pilot for Transcontinental Western Airlines (later part of Trans World Airlines) until retiring in 1958.

At the end of their Pacific flight Bronte and Smith crashed in Hawaii, but neither were injured. They both won a Distinguished Flying Cross for the flight.

Physical Description

There are 200 silver gelatin photoprints, mounted in a scrapbook. Other materials include correspondence and newspaper clippings, also mounted in the scrapbook.

Subjects

The photographs document Ernest Smith and Emory Bronte's 1927 flight to Hawaii and the 1927 Pacific Air Race (*A.K.A.* Dole Race). Bronte and Smith are shown preparing for the flight, taking off, meeting the welcoming committee, riding in an outrigger canoe, salvaging parts from the wrecked aircraft, watching a hula dancer, and riding on a ship back to San Francisco. Bronte and Smith are also portrayed at later commemorative events. Aircraft shown include Bronte and Smith's Travel Air *City of Oakland,* in flight and after crashing in Hawaii; Albert Hegenberger and Lester J. Maitland's Fokker C-2 *Bird of Paradise;* and Charles Kingsford-Smith's Fokker F.VII/3M *Southern*

Cross. Other aviators shown include Arthur E. Goebel, Charles Kingsford-Smith, and Charles T.P. Ulm.

Arranged: No.

Captioned: Some with date and subject.

Finding Aid: Partial list of items on each page.

Restrictions: The collection is kept in the Ramsey Room at the NASM Archives on the Mall. Researchers must be accompanied by a staff member and are encouraged to call or write for an appointment.

AS·270

Lowell H. Smith Collection, 1920s–1930s

Dates of Photographs: Circa 1930s

Collection Origins

Aviation pioneer and U.S. Army officer Lowell H. Smith (1892–1945) created the collection to document his career. Smith began flying in 1915 as an aviator in the Mexican Army, and he joined the U.S. Army Air Service in 1917. He pioneered air-to-air refueling in the early 1920s, for which he received the Distinguished Flying Cross. Smith also won a Distinguished Service Medal for taking over command of the Army's 1924 Around-the-World Flight after the original commander crashed in Alaska. Smith set 16 military records for distance, endurance, and speed before he died in a horseback riding accident. Studios represented include Harris & Ewing. NASM Archives assigned the collection accession number XXXX-0407.

Physical Description

There are six silver gelatin photoprints. Other materials include certificates, correspondence, financial records, flight logbooks, manuscripts, military records, newspaper clippings, and scrapbooks.

Subjects

The photographs are studio portraits of Lowell H. Smith.

Arranged: Partly by subject.

Captioned: No.

Finding Aid: Box list.

Restrictions: The collection, located at the Garber Facility, is available by appointment only.

AS·271

Sopwith Aircraft Scrapbooks

Dates of Photographs: 1918–1919

Collection Origins

The Sopwith company created the collection to document Sopwith aircraft built at the end of World War I. NASM Archives assigned the collection accession number XXXX-0260.

Physical Description

There are 340 silver gelatin photoprints, mounted in albums.

Subjects

The photographs document Sopwith aircraft built at the end of World War I, including construction, details, and parts. Sopwith airplanes shown include the Antelope, Bomber, Buffalo, Bulldog, Camel, Cobham, Dolphin, Dove, Dragon, Gnu, Grasshopper, Hippo, Pup, Rhino, Salamander, Snail, Snapper, Snark, Snipe, Transport, and Wallaby. Sopwith aircraft parts shown include armor plating, cockpits, controls, dual controls, engines such as a Hispano-Suiza, exhaust systems, fuselages, gun mounts, gun rings, propellers, struts, tail units, tanks, and wings.

Arranged: By model.

Captioned: With model; some also with name of parts.

Finding Aid: No.

Restrictions: The collection, located at the Garber Facility, is available by appointment only.

AS·272

Robert Soubiran Collection

Dates of Photographs: 1914–1927

Collection Origins

Pilot Robert Soubiran (1887–1949) created the collection to document his experiences in World War I. Formerly an automobile racer, Soubiran joined the French Foreign Legion in 1914 and served in the Lafayette Escadrille when it was established in 1916. He left France in 1919 but stayed in the military, later becoming a major in the U.S. Air Force. During World War II Soubiran worked in airplane production. NASM Archives assigned the collection accession numbers XXXX-0230 and 1989-0070. The photographs are reproduced on NASM's Archival Videodisc 2. For information on how to order the videodisc, see the *Collection Origins* field of *AS·1*.

Physical Description

There are 600 silver gelatin photoprints, some mounted in albums. Other materials include a bravery citation awarded to Soubiran.

Subjects

The photographs primarily document Robert Soubiran's military service in France in World War I. Activities and events documented include aircraft crashes, boxing matches, firing artillery, funerals, marches and maneuvers, and mine explosions, as well as soldiers cutting up a mule. People portrayed include American ambulance drivers, French civilians such as a blacksmith at work in a bombed building, French colonial (Zouave) troops, Lafayette Escadrille pilots with a dog and lion cub mascots, nurses, the 103rd Aero Squadron, and wounded soldiers.

There are images of the following airplanes: Morane Saulnier, Nieuport Type 11, Nieuport Type 17, and Spad, some with the squadron's Indian head insignia. Buildings and surroundings shown include airfields, the American ambulance corps headquarters, the American University at Beaune, battlefields, bombed buildings, a camouflaged base, cemeteries, the Eiffel Tower, French towns and villages, hangars, and hospitals. Equipment and vehicles shown include ambulances, ammunition, automobiles, guns, and tanks. There are also aerial photographs of cities and open land in Europe and of buildings in Washington, D.C., including the Capitol Building, Walter Reed Hospital, and the Washington Monument. A photograph from this collection is reproduced in this volume's illustrations section.

Arranged: Roughly chronological.

Captioned: Most with subject.

Finding Aid: Caption database listing subject and videodisc frame number. Printouts can be obtained for single photographs or caption lists of photographs with related subjects.

Restrictions: The collection is located at the NASM Archives on the Mall. Researchers are encouraged to call or write for an appointment.

AS·273

Charles I. Stanton, Sr., Papers, 1917–1977

Dates of Photographs: 1917–1971

Collection Origins

Charles I. Stanton, Sr. (1893–1986), created the collection to document his career in aviation and government. After receiving a B.S. from Tufts College in 1917, Stanton served in the U.S. Army Air Service's 122nd Aero Squadron during World War I. After the war he became an airmail test pilot and advanced to assistant general superintendent of the U.S. Air Mail Service. From 1922 to 1924 he served as general secretary of the National Aeronautic Association and from 1925 to 1927 as a civil engineer. He then joined the Department of Commerce, serving in the Aeronautics Branch and its successor the Civil Aeronautics Authority in many positions, including acting administrator (1940–1942), administrator of civil aeronautics (1942–1944), and deputy administrator (1944–1948). From 1948 to 1952 he taught at the Technological In-

stitute of Aeronautics of Brazil, served as operational advisor to Bell Laboratories from 1952 to 1956, and then returned to government service, becoming chief of the Airports Division, Research and Development Bureau, of the Federal Aviation Administration in 1958 and serving until his retirement in 1962. Photographers and studios represented include ABC Newspictures, Civil Aeronautics Authority, Graetz Bros., United Airlines, U.S. Coast Guard, and John Walsh. NASM Archives assigned the collection accession number 1987-0076.

Physical Description

There are 350 photographs including color dye coupler phototransparencies and silver gelatin photonegatives and photoprints. Other materials include audiotape cassettes, correspondence, financial records, manuscripts, newspaper clippings, and scrapbooks.

Subjects

The photographs primarily document social events attended by Charles I. Stanton, including award receptions, board meetings, class reunions, dinners, and retirement parties. There are also images of aircraft, such as early airmail planes with their pilots, including one aircraft crashed in a tree; a Taylorcraft glider; and World War I biplanes in dogfights.

Arranged: No.

Captioned: Some with subject.

Finding Aid: Box list.

Restrictions: The collection, located at the Garber Facility, is available by appointment only.

AS·274

Thomas E. Steptoe Scrapbooks

Dates of Photographs: 1911–1953

Collection Origins

Pilot Thomas E. Steptoe assembled the collection to document the establishment of U.S. Air Mail Service and other aviation activities. Around 1910 Steptoe began attending Sloan aviation school, where he

served as an instructor between 1912 and 1915. He then became an exhibition flier, and by 1916 he was an advocate of airmail. During World War I he served as an instructor for the U.S. Army Signal Corps. He belonged to the Early Birds, an organization of pilots who flew before December 17, 1916, and in 1920 received an "Expert Pilot" certificate from the Aero Club of America. NASM Archives assigned the collection accession number XXXX-0229.

Physical Description

There are 70 silver gelatin photoprints (some tinted), mounted in scrapbooks. Other materials include correspondence and newspaper clippings, also mounted in the scrapbooks.

Subjects

The photographs document aircraft and aviation events, including the U.S. Air Mail Service. Aircraft documented include the airship *Hindenburg,* Blériot airplanes, a Curtiss pusher, Deperdussin airplanes, and Sloan airplanes. Images of airmail service show an airmail office in a tent on a field, airmail employees, and mail being loaded onto an aircraft. Events documented include an aircraft christening, Cleveland Air Races (1946), Early Bird reunions, the first parachute jump by a woman, and the 40th anniversary celebration of an early Curtiss flight. There are also images of a 1904 bicycle meet and hangars of a Sloan aviation school in 1912. People portrayed include early aviators such as Alys McKey Bryant, Agnes Firth, Adolphe Pégoud, and Percival Reid.

Arranged: No.

Captioned: Most with date, event, and names.

Finding Aid: No.

Restrictions: The collection, located at the Garber Facility, is available by appointment only.

AS·275

A. Leo Stevens and Edward R. Boland Memorabilia

Dates of Photographs: 1964

Collection Origins

Parachute designers Edward R. Boland (1892–1967) and A. Leo Stevens (1876–1944) created the collection to commemorate their work in aviation safety. Stevens, who worked on an airship at the turn of the century and participated in the first aeronautical exhibition in the United States in 1905, invented the "Stevens Safety Pack," the first backpack-style free-opening parachute, in 1909. He taught ballooning and parachuting for the government from 1917 to 1926, and in 1942 he invented a delayed-opening parachute. Boland, who met Stevens in 1906, demonstrated the Stevens Safety Pack in 1909 and worked with Stevens as a ballooning and parachuting instructor. From 1941 to 1959 he served as a government inspector of textiles and balloon and parachute construction in New England. He contributed to the invention of an elastic parachute line to reduce opening shock. Boland donated the collection to the Smithsonian in 1964, and NASM Archives assigned it accession number XXXX-0063.

Physical Description

There are two dye diffusion transfer photoprints (Polaroid). Other materials include correspondence, medals, a parachute shroud line, magazine clippings, a plaque, posters, a receipt, and reports.

Subjects

The photographs are images of the two medals in the collection: a parachute prize from 1917 and an A. Leo Stevens Memorial Award from 1949, both awarded to Edward R. Boland.

Arranged: By type of material.

Captioned: No.

Finding Aid: No.

Restrictions: The collection, located at the Garber Facility, is available by appointment only.

AS·276

Paul R. Stockton World War I Aviation Scrapbook

Dates of Photographs: 1915–1919

Collection Origins

Pilot Paul R. Stockton created the collection to document his service during World War I. Stockton became a corporal in the U.S. Army Signal Corps in 1898. During World War I he became a lieutenant and taught at a San Diego aviation school. He commanded the 12th Aero Squadron and served in France and Germany until his discharge in 1919. NASM Archives assigned the collection accession number XXXX-0283.

Physical Description

There are 700 silver gelatin photoprints (some tinted), mounted in a scrapbook. Other materials include aircraft fabric, certificates, correspondence, drawings, manuscripts, maps, newspaper clippings, pamphlets, and tickets, also mounted in the scrapbook.

Subjects

The photographs document Paul R. Stockton's World War I service in the U.S. Army's 12th Aero Squadron in Europe and his travels in the United States. Activities documented include cameramen shooting motion-picture film; pilots dropping propaganda leaflets and flying to the front; soldiers at an Army camp boxing, carrying wood for an old woman, fueling aircraft, getting a haircut, playing a guitar, and washing clothes; and workers constructing aircraft.

Events shown include bombings; crashes; the French occupation of Trier, Germany; and people in Metz, France, pulling down a statue of Kaiser Frederick III of Germany. Other people portrayed include an American family on their front steps, American prisoners (photographed by a German), Chinese children, German prisoners, Senegalese soldiers in the French Army, Stockton (often with his dog), Stockton's wife, the 12th Aero Squadron (the original group and survivors after the war), President Woodrow Wilson in Paris, and a woman with a mule cart.

Aircraft documented include Curtiss seaplanes, Nieuport airplanes, Roland airplanes, and Wright airplanes, as well as German aircraft. Equipment and fa-

cilities depicted include barracks, guns including one on a French railroad car, tanks, a test block, a troop ship, and a washroom on base. Places in Europe illustrated include a beach, French towns and villages, and Trier, Germany. European buildings shown include a cathedral in Tours, France; German churches; Roman ruins; and a Zeppelin airship hangar. Other European images include cemeteries, with aviators' crosses built of airplane parts, and trenches. Images of the United States include New York City and Western towns, with structures such as Judge Roy Bean's office, Pueblo Indian buildings, and a zoo. There are aerial photographs of aircraft mission routes, New York City including the Statue of Liberty, and U.S. Army bases.

Arranged: Roughly chronological.

Captioned: Most with names or subject.

Finding Aid: No.

Restrictions: The collection, located at the Garber Facility, is available by appointment only.

AS·277

Paul Studenski Collection

Dates of Photographs: 1910–1914

Collection Origins

Aviator Paul Studenski (1887–1961) created the collection to document his flying career between 1910 and 1913. Born in St. Petersburg, Studenski attended the Imperial University in Russia, moved to Paris in 1908 to study at the Sorbonne, and later received a Ph.D. from Columbia University (1921). In 1910 he joined the École Blériot at Etampes and received a pilot's license from the Aero Club of France. In 1911 he emigrated to the United States, where for the next two years he flew Blériot and Curtiss airplanes. Studenski participated in air races and exhibition flights; taught flying in Galveston, Texas; and piloted experimental airmail flights for the government. He gave up flying in 1913 and later became a professor of economics at New York University. Photographers represented include Harry Houdini; F. Kukol; and Maurer. NASM Archives assigned the collection accession number 1989-0012.

Physical Description

There are 130 photographs including collodion gelatin photoprints (POP) and silver gelatin photonegatives and photoprints, some mounted in scrapbooks. Other materials include correspondence, newspaper clippings, and photomechanical postcards, some also mounted in the scrapbooks.

Subjects

The photographs document Paul Studenski's experiences as an aviator in France and the United States from 1910 to 1913. Activities and events documented include airmail flights, air meets and races, wrecks such as an aircraft caught in a tent pole and a damaged aircraft being pulled by horses, flight lessons in Galveston (Texas), mail flights, the opening of Galveston Causeway, a meal at a Paris restaurant with an aviation mural, and passenger flights. Aircraft documented include Blériot, Curtiss, and Wright airplanes. People portrayed include Harry Houdini; Studenski; Nastia Studenski, his wife; and other aviators such as Charles K. Hamilton, John G. Kaminski, Katherine Stinson, and J.H. Worden; as well as flight students and the staff at the National Aeroplane Company.

Arranged: Part chronologically.

Captioned: Some with name or other subject.

Finding Aid: No.

Restrictions: The collection, located at the Garber Facility, is available by appointment only.

AS·278

George P. Sutton Collection, Circa 1945–1958

Dates of Photographs: 1945–1954

Collection Origins

George P. Sutton (1920–) created the collection to document his work as a rocket development engineer. After receiving an M.S. from the California Institute of

Technology in 1943, Sutton joined the Rocketdyne Division of North American Aviation (now Rockwell International), where he worked until the late 1960s. He also served as Hunsaker Professor of Aeronautical Engineering at Massachusetts Institute of Technology (1958–1959) and chief scientist of the Advanced Research Projects Agency and division director of the Institute of Defense Analysis of the Department of Defense (1959–1960). After leaving Rocketdyne, Sutton joined the staff of the Lawrence Livermore National Laboratory. Studios represented include Aerojet Engineering Corporation, General News Bureau, North American Aviation, Reaction Motors, and the U.S. Navy. NASM Archives assigned the collection XXXX-0009.

Physical Description

There are 120 photographs including silver gelatin photonegatives and photoprints. Other materials include articles, books, correspondence, engineering drawings, journals, manuscripts, newspaper clippings, pamphlets, and reports.

Subjects

The photographs document rockets and missiles, their construction, parts, and performance. Missiles are shown flying and being carried on airplanes, launched from the ground, tested, and transported. Rocket parts depicted include the combustion chamber, fuel valves, and pump system. Aircraft shown include North American B-45 Tornados. Equipment and facilities illustrated include instruments, miniature model rockets, the research laboratory of the National Advisory Committee for Aeronautics in Cleveland, and a test sled. Technicians are portrayed operating equipment, wearing earphones while attending instrument panels, and working on a fuel line.

Arranged: By type of material and subject. Photographs are dispersed throughout the collection.

Captioned: Some with subject.

Finding Aid: Folder list.

Restrictions: The collection, located at the Garber Facility, is available by appointment only.

AS·279

Norman Sweetser Photograph Album

Dates of Photographs: 1969

Collection Origins

The Italian Aviation Ministry created the collection as a record of a 1969 visit to Italy by American pilots who trained there during World War I. It was presented to Norman Sweetser, one of the pilots. The photographs are reproduced on NASM's Archival Videodisc 2. For information on how to order the videodisc, see the *Collection Origins* field of *AS·1*.

Physical Description

There are 35 silver gelatin photoprints, mounted in an album.

Subjects

The photographs show American World War I pilots and their families visiting Italy and participating in commemorative ceremonies.

Arranged: Chronologically.

Captioned: With names.

Finding Aid: No.

Restrictions: No. The collection is located at the NASM Archives on the Mall. Researchers are encouraged to call or write for an appointment.

AS·280

Louise M. Thaden Collection

Dates of Photographs: Circa 1916–1978

Collection Origins

Louise M. Thaden (1905–1979) created the collection to document her aviation career. Thaden set an altitude record of 20,260 feet in 1928, a U.S. women's endurance record of 22 hours aloft, a refueling duration record, a light plane speed record, and an east-west speed record in 1929. In 1929 she also won the National Women's Air Derby in a Travel Air 4000 and in 1936 she became the first woman to win the Bendix Trophy, flying a Wright-powered Beech 17 Staggerwing. A founding member of the Ninety-Nines, a women pilots' club, Thaden later became involved with the Civil Air Patrol and Defense Advisory Committee on Women in the Service (1959–1961).

Photographers and studios represented include Beech Aircraft Corporation; Carlson & Bulla; Dick Whittington Photography; Medcom, Inc.; Staggerwing Photos; and Ed Stone. William Thaden and Pat Thaden Webb, Louise Thaden's children, donated the material to NASM in several parts, which were assigned accession numbers XXXX-0006, 1986-0042, and 1986-0118. Some of the images are reproduced on NASM's Archival Videodisc 2. For information on how to order the videodisc, see the *Collection Origins* field of *AS·1*.

Physical Description

There are 1,150 photographs including color dye coupler photoprints and silver gelatin photonegatives and photoprints. Other materials include brochures, catalogs, correspondence, newspaper clippings, and scrapbooks.

Subjects

The photographs document Louise M. Thaden's aviation activities. Most photographs are portraits of Thaden, showing her attending ceremonies, eating a meal, flying, making a speech, receiving prizes, riding a horse, standing with aircraft, using equipment such as oxygen tanks, and wearing flight suits. Some of the portraits show Thaden in the 1960s and 1970s. Other people portrayed include aviators Florence L. ("Pancho") Barnes, Amelia Earhart, Ruth Elder, and Blanche Noyes (Thaden's copilot) and Beech Aircraft president O.A. Beech. Events documented include the 1936 Bendix race and the 1929 National Women's Air Derby. Aircraft shown include a Beech C-17R Staggerwing, a Travel Air 4000, the Lockheed Vega *Winnie Mae,* and a Porterfield Model 35. There are also images of crowds at the races. A photograph from this collection is reproduced in this volume's illustrations section.

Arranged: Videodisc images by videodisc frame number; the rest unarranged.

Captioned: Some with date and subject.

Finding Aid: Caption database to videodisc images listing date, format, negative number, source, and subject. Printouts can be obtained for single photographs or caption lists of photographs with related subjects.

Restrictions: Part of the collection is located at the Garber Facility, and part is located at the NASM Archives on the Mall. Material at the Garber Facility is available by appointment only; to use material at the Mall, researchers are encouraged to call or write for an appointment.

AS·281

Third Paris Salon Glass Plate Photonegative Collection

Dates of Photographs: Late 1910s

Collection Origins

The collection was created, possibly by George J. Goldthorpe & Company, to document aircraft at the Third Paris Salon, which began on December 16, 1911. In 1963 Manfred A. Parks donated the collection to the Air University Library at Maxwell Air Force Base, Alabama, which in 1965 gave it to the U.S. Air Force Museum at Wright-Patterson Air Force Base. The Air Force Museum gave the collection to NASM Archives, which assigned it accession number 1987-0121.

Physical Description

There are 55 silver gelatin dry plate lantern slides.

Subjects

The photographs document aircraft, primarily French, at the Third Paris Salon, a large exposition with exhibits of aircraft by many manufacturers. Aircraft depicted include an Astra, Aviatik, Besson, Blériot,

Breguet, Bristol, Deperdussin, Farman, Kauffmann, Morane, Nieuport, Paulham, Savary, Tubavion, and Zodiac. Aircraft parts documented include a bomb release mechanism, controls, a stabilizer, and a radio. There are also photographs of airships over a cathedral and over a ship and images of the Salon displays.

Arranged: No.

Captioned: Most with aircraft manufacturer.

Finding Aid: No.

Restrictions: The collection, located at the Garber Facility, is available by appointment only.

AS·282

Time-Life *Epic of Flight* Series Collection

Dates of Photographs: Circa 1945–1983

Collection Origins

Time-Life Books assembled the collection as part of its research for the series *Epic of Flight,* a 20-volume set on the history of flight from the first balloons to the jet age. Each volume covers a specific topic, such as aerial combat during World War I and II; airlines; air mail; airships and balloons; early airplane development; the English, German, and Soviet air forces; and women aviators. The volumes were published between 1980 and 1983, and in 1983 Time-Life donated the collection to NASM, where it received accession number XXXX-0103.

Photographers and studios represented include Fotokhronika Tass; Imperial War Museum; Library of Congress; McDonnell-Douglas; NASA; National Archives; North American Aviation; Public Archives, Canada; Roger-Viollet; the U.S. Air Force; the U.S. Army; the U.S. Navy; and Wright-Patterson Air Force Base. The photographs were published in the series: *Epic of Flight.* Vols. 1–20. Alexandria, Virginia: Time-Life Books, 1980–1983.

Physical Description

There are 3,260 photographs including color dye coupler photoprints, phototransparencies, and slides and silver gelatin photonegatives and photoprints. Other materials include articles, maps, newspaper clippings, posters, and xerographic copies of photographs and published material.

Subjects

The photographs document the history of flight in several countries from the late 18th century through the jet age. There are images of many types of aircraft as well as commercial and military activities, equipment, events, facilities, industries, organizations, and people involved with aviation.

Aircraft documented include airliners, airmail planes, airships, balloons, biplanes, bombers, fighters, gliders, helicopters, jets, seaplanes, Space Shuttles, and transports. There are also images of aircraft carriers and other ships, as well as aircraft parts and equipment such as interior furnishings and weapons. Facilities shown include air bases, airfields, airports, construction plants, hangars, offices, and research laboratories.

Activites illustrated include constructing aircraft and facilities, dropping propaganda leaflets, formation flying, starting propellers, and testing aircraft. Events recorded include aircraft christenings, aircraft crashes, air meets, air races, air shows, battles, the Berlin airlift, bombing raids, early flights, expeditions, and the Japanese surrender in World War II. People portrayed include combat pilots, early flight attendants, flight crews, manufacturers, mechanics, passengers, military officers and soldiers, pioneer aviators, research scientists, spectators, and women pilots.

Arranged: By subject of each volume.

Captioned: With negative number; most also with date, subject, and volume.

Finding Aid: Box list.

Restrictions: The collection, located at the Garber Facility, is available by appointment only. Some of the images are probably copyrighted.

AS·283

Tiros Satellite Documents, 1959–1970

Dates of Photographs: 1960s

Collection Origins

Staff of the Television Infra-Red Observation Satellite (Tiros) programs created the collection to document the development of Tiros. Tiros began as part of the weather satellite program of the U.S. Army Ballistic Missile Agency and Advanced Research Projects Agency, which contracted the Radio Corporation of America (RCA) to build ten satellites in 1958. The following year NASA took over the project and in 1960 began launching the satellites. In 1965 NASA, the U.S. Weather Bureau (later the Environmental Science Services Administration and now the National Oceanic and Atmospheric Administration), and RCA initiated the Tiros Operational Satellite (TOS) program, launching nine satellites between 1966 and 1969. This series was followed by five Improved Tiros Operational System (ITOS) satellites. The Tiros programs provided the first global system for gathering meteorological information on atmospheric pressure, cloud cover, precipitation, and upper-level winds. NASA donated the collection to the Smithsonian in 1965, and NASM Archives assigned the collection accession number XXXX-0199.

Physical Description

There are four photographs including silver gelatin photonegatives and photoprints, mounted in reports. Other materials include manuals, plans, and reports.

Subjects

The photographs are satellite images of weather pattern data.

Arranged: No.

Captioned: With figure numbers keyed to reports.

Finding Aid: No.

Restrictions: The collection, located at the Garber Facility, is available by appointment only.

AS·284

Harold H. Tittman Scrapbook

Dates of Photographs: 1917–1921

Collection Origins

World War I aviator Harold H. Tittman created the collection to document his flight training, service, hospitalization, and return home. Assigned to the 94th Aero Squadron of the U.S. Army Air Service in France, Tittman was shot down during combat, had a leg amputated, and received his discharge in 1918. Harold Tittman, Jr., donated the collection to the Smithsonian in 1972, and NASM Archives assigned it collection number XXXX-0314.

Physical Description

There are 65 silver gelatin photoprints, mounted in a scrapbook. Other materials include correspondence, manuscripts, maps, military records, newspaper clippings, and reports, also mounted in the scrapbook.

Subjects

The photographs document Harold H. Tittman's service in the 94th Aero Squadron and medical treatment in France during World War I. Pilots are shown fishing, swimming, and waiting for an alert. Aircraft depicted include Farman, Nieuport, and Spad airplanes. Facilities shown include air bases at Austin, Texas, and Summit, New Jersey, and the 94th Aero Squadron's lodging in France. There is also an image of a small model of a Red Cross canteen in France. Portraits include Douglas Campbell; Edward V. ("Eddie") Rickenbacker; Tittman at Walter Reed Hospital, in flight clothes, and in uniform; and Alan Winslow.

Arranged: No.

Captioned: Most with name or subject.

Finding Aid: No.

Restrictions: The collection, located at the Garber Facility, is available by appointment only.

AS·285

Henry E. Toncray Scrapbook

Dates of Photographs: Circa 1924

Collection Origins

Henry E. Toncray (1894–1929) created the collection to document his helicopter experiments. Toncray became a pilot in 1913, and in 1921 he organized the Gulf States Aircraft Company, serving as vice president and general manager. He attempted to build a helicopter and in 1924 produced a machine that rose several feet off the ground in short hops. NASM Archives assigned the collection accession number XXXX-0222.

Physical Description

There are 11 silver gelatin photoprints, mounted in a scrapbook. Other materials include newspaper clippings and an obituary, also mounted in the scrapbook.

Subjects

The photographs document Henry Toncray's experimental helicopter, shown flying a few feet above the ground and upside down after a crash. There are portraits of the pilot, his helpers, and spectators with the helicopter and Toncray in a pilot's helmet.

Arranged: No.

Captioned: No.

Finding Aid: No.

Restrictions: The collection, located at the Garber Facility, is available by appointment only.

AS·286

Thomas Towle Ford Trimotor Collection

Dates of Photographs: Circa 1930–1967

Collection Origins

Aeronautical engineer Thomas Towle assembled the collection to support his claim that he designed the Ford Trimotor. After receiving an M.E. from Yale University in 1920, Towle worked as an engineer for several aircraft companies, including Dayton-Wright (1921–1922), Glenn L. Martin Company

(1923–1924), Aeromarine Plane & Motor Company (1924–1925), and Stout Metal Airplane Company (1924–1926). He then joined Ford Motor Company's Airplane Division, where he designed a three-motored aircraft and sold the rights to Ford and Stout in 1925. In 1928 Towle left Ford to form his own company, first called Towle Marine Aircraft and then Towle Aircraft Company. In 1932 Towle went to work for Monocoupe Corporation and then Lambert Aircraft Corporation before leaving the aircraft industry in 1936. Studios represented include American Airlines, O'Neil-Davis, and the *Post-Standard*. NASM Archives assigned the collection accession number XXXX-0102.

Physical Description

There are 19 photoprints including silver gelatin photonegatives and photoprints. Other materials include articles, correspondence, engineering drawings, magazine clippings, manuscripts, newspaper clippings, notes, pamphlets, periodicals, postage stamps, a résumé, and reports.

Subjects

The photographs document the Ford Trimotor and people involved in its productions. Trimotors are shown in flight and on airfields. There is also an image of a TWA Skyliner. Aviation executives John A. Collings, Lawrence G. Fritz, William B. Stout, and Thomas Towle are shown attending a reunion.

Arranged: No.

Captioned: Most with date and subject.

Finding Aid: No.

Restrictions: The collection, located at the Garber Facility, is available by appointment only.

AS·287

TranSlides Aeronautical History Color Slide Collection, 1957–1967

Dates of Photographs: 1967

Collection Origins

The slide set production company TranSlides assembled the collection, a slide set titled "Aero History Colorslide Collection," to document the development of aircraft and manned spacecraft. Serving as a visual history of the products of aircraft manufacturers, the slides were taken to show distinct aerodynamic design features of each aircraft. W. Tom Miller of TranSlides donated the collection to the Smithsonian in 1967, and NASM Archives assigned it accession number XXXX-0167. Photographers include W. Tom Miller.

Physical Description

There are 720 color dye coupler slides.

Subjects

The photographs document aircraft and spacecraft from the 18th century to the 1960s. There are images of aircraft made by such manufacturers as Beech, Bell, Boeing, Cessna, Convair, Curtiss-Wright, De Havilland, Douglas, Fairchild, Fokker, Grumman, Lockheed, Martin, McDonnell, North American, Piper, Republic, Sikorsky, Stinson, Vickers, and Waco. Types of aircraft shown include balloons, biplanes, bombers, fighters, gliders, helicopters, jets, racers, seaplanes, and transports. Some of the historical aircraft shown are reconstructed facsimiles.

Spacecraft documented include a lunar excursion module (1964), Mercury spacecraft (1962), and *Saturn 1* booster (1961). There are also photographic reproductions of paintings of aviation and space flight figures, including Glenn H. Curtiss, James H. Doolittle, Donald W. Douglas, Robert H. Goddard, Charles A. Lindbergh, Edward V. ("Eddie") Rickenbacker, Alan B. Shephard, Jr., Igor I. Sikorsky, Orville Wright, and Wilbur Wright.

Arranged: Alphabetically by manufacturer.

Captioned: Aircraft slides with common name, manufacturer, model designation, slide number, and year of model's initial production; portraits with name of subject and slide number.

Finding Aid: List of aircraft slides recording common name, manufacturer, model, slide number, and year of the model's initial production.

Restrictions: The collection, located at the Garber Facility, is available by appointment only. Commercial rights are reserved by TranSlides. Non-commercial use is permitted with the following credit: "Photo by W.T. Miller, TranSlides."

AS·288

Travel Air Negatives, 1925–1942

Dates of Photographs: 1927–1942

Collection Origins

Travel Air Company created the collection to document its aircraft and operations. Walter H. Beech, Lloyd Stearman, and Clyde V. Cessna founded Travel Air in 1925. Stearman and Cessna left two years later to form their own firms, and in 1929 Curtiss-Wright Corporation bought the company. By then Travel Air had become America's largest producer of commercial aircraft, and it continued to grow as a division of Curtiss-Wright. In 1932 Beech left to form Beech Aircraft, and Curtiss-Wright later dissolved the Travel Air division. NASM Archives assigned the collection accession number XXXX-0197.

Physical Description

There are 650 photographs including silver gelatin photonegatives and photoprints. Other materials include magazine articles and a manuscript.

Subjects

The photographs document Travel Air Company aircraft, operations, and staff. Activities documented include constructing and testing aircraft, crop dusting, and loading cotton, as well as an air show in Cleveland. Travel Air aircraft documented include biplanes, a crop duster, monoplanes, trainers, and transports, including models such as the Challenger, Mystery Ship, Sport, Whirlwind, and Woolaroc. Other aircraft shown include a Boeing airmail plane and Curtiss-Wright airplanes. Parts shown include ailerons, cabin interiors, controls, crop duster tanks, cowlings, engines, fuselages, landing gear, and wings. Facilities shown include factory exteriors and interiors. Individuals portrayed include Walter H. Beech, James H. Doolittle, Arthur E. Goebel, Brice H. Goldsboraugh, Charles A. Lindbergh, Ken Maynard, William D. Parker, and Truman Wadlow. Groups portrayed include the company baseball team, employees, and passengers.

Arranged: Chronologically and by subject.

Captioned: With subject.

Finding Aid: No.

Restrictions: The collection, located at the Garber Facility, is available by appointment only.

AS·289

Juan T. Trippe Collection, 1917–1968

Dates of Photographs: 1935–1968

Collection Origins

Juan T. Trippe (1899–1981), co-founder of Pan American Airways and head of the company for over 50 years, created the collection to document his career. Trippe entered Yale University in 1917 but left to train as a U.S. Navy flier (although the war ended before he was sent overseas). When he returned to school after the war he founded the Yale Flying Club, and after graduating in 1922 he joined other former Yale Flying Club members in 1923 to form Long Island Airways with seven surplus Navy aircraft. The next year Trippe formed Colonial Air Transport, which obtained the first U.S. airmail contract, carrying mail between New York and Boston. In 1926 he left Colonial to start a new company with World War I pilots Cornelius V. Whitney and John A. Hambleton, which won the first international airmail contract, for service between Florida and Cuba. The next year the company merged with Pan American Airways under a holding company called Pan American Airways Corporation, and Trippe served as chairman and president of Pan American from then until 1968.

Under Trippe Pan American established air service over half the world. Using large seaplanes, Pan American began transpacific passenger service in 1935 and transatlantic service in 1939. During World War II Pan American provided airlift service for the United States. After the war, Trippe established lower-cost passenger service and introduced the two-class seating arrangement. In 1949 the Pan American airline and corporation became Pan American World Airways, which introduced Boeing 707 jet liners in 1958 and the first Boeing 747 passenger service in 1966. Trippe resisted efforts to depose him and retained control of the company until his resignation in 1968. He remained as honorary chairman and an active member of the board

until 1975 and continued attending board meetings until suffering a stroke in 1980.

Studios represented include Harris & Ewing, News-Ad, New Orleans *Times-Picayune,* Pan American Airways, *Seattle Times,* and World Brotherhood. NASM Archives assigned the collection accession number XXXX-0179. Some of the photographs are reproduced on the NASM videodiscs. For information on how to order the videodiscs, see the *Collection Origins* field of *AS·1.*

Physical Description

There are 1,140 photographs including color dye coupler photoprints and phototransparencies and silver gelatin photonegatives and photoprints. Other materials include articles, audiotape cassettes, books, contracts, correspondence, financial records, magazine clippings, magazines, maps, motion-picture film footage, newspaper clippings, press releases, reports, scrapbooks, and speeches.

Subjects

The photographs document Juan T. Trippe's tenure as head of Pan American. Aircraft depicted include the Boeing 747 jet, Ford Trimotor, and Martin 130 Clipper including the *Philippine Clipper.* Events documented include directors' inspection tours of the Caribbean, Europe, and the Middle East, with stops in Barbados, Brazil, Colombia, England, India, Israel, Japan, Jordan, Lebanon, Portugal, and Syria; social functions such as ceremonies, luncheons, and receptions; and Trippe's reception of awards such as the French Legion of Honor, the Harmon Trophy, and the Medal for Merit. There are portraits of ambassadors and local officials in many countries such as Liberian president William V.S. Tubman; Juan T. Trippe and Elizabeth (Betty) S. Trippe, his wife; and other Pan American officials and their wives, such as Charles A. and Anne S. Lindbergh.

Travel photographs document a cocoa plantation, iron ore mines, a rubber plantation, and villages in Africa; the Forbidden City and the Temple of Heaven in Peking (Beijing), China; downtown Bogotá, Colombia; bicyclists and a river in France; a mosque in India; Roman ruins in Baalbek, Lebanon; street scenes in Portugal; fishermen in Puerto Rico; and landscapes in Rio de Janeiro, Brazil.

Arranged: By subject.

Captioned: Some with date and subject.

Finding Aid: Folder list.

Restrictions: Part of the collection is kept in the

Ramsey Room at the NASM Archives on the Mall. Researchers must be accompanied by a staff member and are encouraged to call or write for an appointment.

AS·290

Mary E. "Mother" Tusch Scrapbooks

Dates of Photographs: 1918–1949

Collection Origins

Mary E. ("Mother") Tusch (1876–1960) created the collection to document her association with pilots and her collection of aviation artifacts dating from World War I. In 1917 trainees of the School of Military Aeronautics at the University of California, Berkeley, began sending pictures and memorabilia from Europe to Tusch and her family, who lived near the school. One pilot also signed his name on Tusch's wall before going overseas, beginning a tradition to which almost every aviation figure of the period contributed. Tusch's home, called "The Hangar," became a museum, later open to the public, filled with autographs, aviation artifacts, and photographs. NASM's Paul E. Garber (Tusch's son-in-law) evaluated the collection in 1948 and exhibited much of it at the Smithsonian. NASM Archives assigned the collection accession number XXXX-0266. Photographers and studios represented include Berkeley *Daily Gazette,* Del Ankers Photographers, Paul E. Garber, Hartsook, International News, Irving McKee, Don Milton, Paramount Pictures, OPPS, U.S. Air Force, Walkers Studio, and Maurice R. Wallace.

Physical Description

There are 750 photographs including color dye coupler photoprints and silver gelatin photoprints, mounted in scrapbooks. Other materials, most also mounted in the scrapbooks, include an address book, a brass plaque, catalogs, correspondence, financial records, newspaper clippings, periodicals, petitions, and reports.

Subjects

The photographs document activities of pilots during World War I, aviation figures from 1917 through World War II, and Mary E. Tusch's collection of aviation artifacts. World War I activities and facilities documented include a birthday party; crashes; flights; training including gymnastics and other sports; travel on ships and a troop train; and the University of California, Berkeley. There are also images of a gun camera and aerial photographs of Washington, D.C.

Aviation figures portrayed include Henry H. ("Hap") Arnold, Richard E. Byrd (signing the wall), Ruth Elder, Frank M. Hawks, Walter Hinton, Harold B. Kellogg, Reed G. Landis, Ruth Law, Joe Mayer (with Gilmore the lion), Robert Meed, Edgar D. Mitchel, Arthur Morrison, Clyde E. Pangbourne, Jack R. Peterson, Edward V. ("Eddie") Rickenbacker, William B. Stout, and Fred J. Wiseman. There are also portraits of Red Cross nurses, Mary E. ("Mother") Tusch, and her family. Images of Tusch's collection show artifacts on exhibit at the Smithsonian Institution and exteriors and interiors of Tusch's home, including walls covered with artifacts, autographs, and pictures.

Arranged: No.

Captioned: Most with date, names, and subject.

Finding Aid: No.

Restrictions: The collection, located at the Garber Facility, is available by appointment only.

AS·291

United States Women in Aviation, 1940–1985 Photographs

Dates of Photographs: 1971–1986

Collection Origins

Deborah G. Douglas assembled the collection for publication in the following book: Deborah G. Douglas. *United States Women in Aviation, 1940–1985.* Washington, D.C.: Smithsonian Institution Press, 1990. Studios represented include the Women's Advisory Committee on Aviation. NASM Archives assigned the collection accession number 1990-0062.

Physical Description

There are 75 silver gelatin photoprints, most copies.

Subjects

The photographs document women involved in aviation between 1940 and 1985. Activities illustrated include aircraft production during World War II, flight attendants picketing, and pilot training. People portrayed include Barbara Akins, Delphine Bohn, Jacqueline Cochran, Yvonne Dateman, Mary J. Gaffeney, Byrd Howell Granges, Teresa James, Amy Johnson, Nancy H. Love, Phoebe F. Omlie, Pat Pakman, Deanne Shulman, and Cathy Young.

Arranged: In the order the pictures appear in the book.

Captioned: With negative number.

Finding Aid: List of negative numbers and corresponding page numbers.

Restrictions: No. The collection is located at the NASM Archives on the Mall. Researchers are encouraged to call or write for an appointment.

AS·292

United States Women in Aviation through World War I Collection

Dates of Photographs: Circa 1977–1978

Collection Origins

Claudia M. Oakes, former curator at NASM's Department of Aeronautics, assembled the collection from NASM's holdings as well as outside materials in preparation for the following publication: Claudia M. Oakes. *United States Women in Aviation through World War I.* Washington, D.C.: Smithsonian Institution Press, 1978. Studios represented include OPPS and the *St. Petersburg Times.* Photographs were published in the book cited above. NASM Archives assigned the collection accession number XXXX-0424.

Physical Description

There are 70 copy silver gelatin photoprints. Other materials include correspondence, manuscripts, newspaper clippings, and xerographic copies.

Subjects

The photographs document women's involvement in aviation from the beginning of balloon flight through World War I. Pilots portrayed include Ruth Law, Harriet Quimby, Katherine Stinson, and Marjorie C. Stinson. Women are portrayed flying as passengers, piloting aircraft including an airship, watching flights, wearing diving suits, and wearing flight clothing. Other activities and events documented include aircraft crashes and balloons being inflated. There are also photographic reproductions of an advertisement for a stunt show by Blanche Stuart Scott, the Aero Club of America membership card of Matilde Moisant, and a newspaper account of a woman aviator.

Arranged: Partly alphabetical by name.

Captioned: A few with name and subject.

Finding Aid: No.

Restrictions: The collection, located at the Garber Facility, is available by appointment only.

AS·293

United Technologies Corporation Collection, 1929–1984

Dates of Photographs: 1984

Collection Origins

United Technologies Corporation (UTC) and its predecessors United Aircraft and Transport Company (UATC) and United Aircraft Corporation (UAC) created the collection to document the company's business activities between 1929 and 1984. Formed as a holding company in 1928, UATC originally included manufacturers such as Boeing, Chance Vought, Hamil-

ton Standard, Northrop, Pratt & Whitney, Sikorsky, and Stearman, as well as several export and transport lines. In 1934 several of the companies left to form new organizations, and the remaining firms reorganized into UAC. The company later changed its name to UTC to indicate its broader scope of business. Studios represented include Archie and United Technologies Corporation. NASM Archives assigned the collection accession numbers 1985-0008, 1986-0004, 1986-0024, 1986-0111, 1988-0014, and 1988-0079.

Physical Description

There are 80 photographs including color dye coupler photoprints and silver gelatin photoprints. Other materials include annual reports, employee magazines, pamphlets, press releases, reprints, and stockholder magazines.

Subjects

The photographs document aircraft, aircraft parts, and construction equipment used by United Technologies Corporation and its predecessors. Aircraft depicted include the Boeing 727, Boeing 737, and McDonnell-Douglas C-9. Aircraft parts documented include Hamilton Standard's engine and flight control systems between 1947 and 1983 and Pratt & Whitney jet engines such as the J57. Aircraft construction images show employees loading parts and working on computers and robots constructing engines.

Arranged: By subject and date.

Captioned: With subject.

Finding Aid: Folder list.

Restrictions: The collection, located at the Garber Facility, is available by appointment only.

AS·294

Ralph H. Upson Papers, 1911–1968

Dates of Photographs: 1929–1967

Collection Origins

Ralph H. Upson (1888–1968) created the collection to document his career as an aeronautical engineer and pilot. After receiving an M.E. from Stevens Institute of Technology in 1910, Upson won the International Balloon Race and American National Balloon Race in 1913. From 1914 to 1920 he worked as chief engineer in the aeronautical department of Goodyear Tire and Rubber Company, demonstrating the first U.S. Navy coastal patrol airship in 1917. In 1922 he became chief engineer at the Aircraft Development Corporation and also began a two-year term as chairman of the Lighter-Than-Air Division (airship and balloon section) of the Aeronautical Safety Code Commission, U.S. Bureau of Standards.

Between 1928 and 1944 Upson held positions at Aeromarine-Klemm Corporation, H.J. Heinz Company, and other firms, and in 1929 he designed the first successful metal-clad airship, the Navy ZMC-2. He began conducting research and teaching in 1944, working at New York University for two years and the University of Minnesota for the following ten. In 1956 he joined Boeing as a research specialist, retiring in 1964 but continuing as a consultant until his death. Francis A. Upson, his wife, donated the collection to NASM, where it received accession number XXXX-0177.

Physical Description

There are ten silver gelatin photoprints. Other materials include correspondence, engineering drawings, manuscripts, periodicals, and a plaque.

Subjects

The photographs show lighter-than-air aircraft including airships (such as the U.S.S. *Los Angeles* and the metal-clad Navy ZMC-2) and balloons in a laboratory.

Arranged: By subject.

Captioned: Most with subject; some also with date.

Finding Aid: Item list.

Restrictions: The collection, located at the Garber Facility, is available by appointment only.

AS·295

U.S. Air Force Pre-1954 Official Still Photograph Collection, 1861–1953

Dates of Photographs: 1861–1953

Collection Origins

The U.S. Air Force created the collection to document its aircraft and activities as well as outside aviation events, primarily for public relations. Classified as an active Air Force file, the collection is on loan to NASM, where it is used by Air Force personnel, museum staff, and the public. NASM staff have reproduced the entire collection on Archival Videodisc 3 and 4. For information on how to order the videodiscs, see the *Collection Origins* field of *AS·1*.

Physical Description

There are 145,000 photographs including color dye coupler photonegatives, photoprints, phototransparencies, and slides and silver gelatin photonegatives and photoprints.

Subjects

The photographs primarily document U.S. Air Force aircraft and activities, as well as some outside aircraft, events, and people. Activities and events documented include aircraft maintenance such as painting, refueling, and washing; aviation exhibits; bombing; bomb loading; ceremonies; communication; construction of aircraft, airfields, and buildings; funerals; inspections; landings; maneuvers; medical evacuations; medical treatment; races; record flights; recreation; rescues; strafing and combat; testing of equipment and weapons including nuclear weapons; and training.

Aircraft shown include domestic and foreign airships, balloons, civil aircraft, commercial aircraft, military aircraft, missiles, and rockets. There are also images of wrecked aircraft and aircraft parts such as engines, instruments, and propellers. Equipment and facilities shown include air bases, buildings, cameras, camouflage, captured material, clothing, electronics, ground vehicles, parachutes, radios, supplies, and weapons. There are portraits of crews, officers, patients, pilots, prisoners, Women's Army Corps members (WACs), and other Air Force personnel. There are also aerial reconnaissance photographs, airscapes, and

reproductions of artwork, awards, charts, drawings, and maps. Photographs from this collection are reproduced in this volume's illustrations section.

Arranged: In five series, then by subject or date. 1) Pre-1940. 2) Pre-1954 domestic. 3) Pre-1954 nondomestic. 4) World War II. 5) Korea.

Captioned: With negative number and subject; most also with date and location.

Finding Aid: 1) Two interconnected item-level databases, one containing subject heading and identification numbers, the other containing full captions. Printouts can be obtained for single photographs or caption lists of photographs with related subjects. 2) Videodisc indexes, arranged by series and then subject, listing videodisc side and frame numbers. 3) Shelf list.

Restrictions: No. The collection is located at the NASM Archives on the Mall. Researchers are encouraged to call or write for an appointment.

AS·296

U.S. Army Air Service, Engineering Division, Scrapbook *A.K.A.* Horace W. Karr Scrapbook

Dates of Photographs: Circa 1923

Collection Origins

Horace W. Karr assembled the collection to persuade the U.S. Army Air Service to move its Engineering Division to a better location. Originally located at McCook Field near Dayton, Ohio, the Division took a leading role in the design, testing, and modification of aircraft after World War I. It later became part of Wright-Patterson Air Force Base. NASM Archives assigned the collection accession number XXXX-0262.

Physical Description

There are 50 silver gelatin photoprints, mounted in an album.

Subjects

The photographs document the activities, aircraft, and facilities of the Engineering Division at McCook Field in Ohio. Activities documented include bombing tests, parachute jumps, and weight tests. Aircraft documented include a Boeing MB-3A, Curtiss PW-8, Curtiss R-6 Racer, De Havilland DH-4 with an adjustable propeller, Douglas World Cruiser, Fokker T-2, gliders, helicopters, Le Pere biplane, Loening PW-2, Martin bomber, Sperry racer, Vervilles, Witteman-Lewis NBL-1, Wright Flyers, and a Wright Model FS-1.

Parts and equipment depicted include aerial cameras, bombs, bomb sights, engines, gun mounts, guns, instruments, a mobile winch, parachutes, tanks, and wing lights. Facilities shown include a balloon inflation system, chemical testing laboratory, gas generator, heat treating lab, propeller testing lab, test machinery, wind break, and wind tunnel. There are also aerial photographs of McCook Field in Ohio and photographic reproductions of architectural models and charts.

Arranged: By subject.

Captioned: With description or explanation of the subject.

Finding Aid: No.

Restrictions: The collection, located at the Garber Facility, is available by appointment only.

AS·297

U.S. Army Balloons World War I Scrapbook

Dates of Photographs: Circa 1917–1918

Collection Origins

A member of the 79th Balloon Company of the U.S. Army created the collection to document the company's activities during the World War I period. Commanded by Major Henry Rodgers, the company served at Brooks Field, Texas; Travis Field, California; and Fort Omaha, Nebraska.

Physical Description

There are 90 silver gelatin photoprints, mounted in an album.

Subjects

The photographs document the activities and facilities of the U.S. Army's 79th Balloon Company. Aircraft documented include balloons, both round and sausage-shaped, and biplanes. Activities documented include changing observers, changing winches, inflating balloons, and rigging a basket. Aerial images include Army bases, a cemetery, and surrounding farmlands. There are also non-aerial photographs of camp tents; a railroad station at Macon, Georgia; and trains. There are portraits of children in a balloon basket, a local family, and soldiers of the company.

Arranged: No.

Captioned: Some with subject.

Finding Aid: No.

Restrictions: The collection, located at the Garber Facility, is available by appointment only.

AS·298

U.S. Navy ZR-1 Airship Photographs and Scrapbooks *A.K.A.* U.S.S. *Shenandoah* Collection

Dates of Photographs: 1921–1925

Collection Origins

NASM staff assembled the collection to document the U.S. Navy ZR-1 airship, the U.S.S. *Shenandoah,* for NASM's Archival Videodisc 7, where they are reproduced. For information on how to order the videodisc, see the *Collection Origins* field of *AS·1*. Photographers represented include Danlon Duval, Halbert Pennell, and Claude Rowan.

Physical Description

There are 440 silver gelatin photoprints, some mounted in albums.

Subjects

The photographs document the U.S. Navy ZR-1 airship, the U.S.S. *Shenandoah,* used in the early 1920s. Most of the images document construction and the airship's crash in 1925. Crash images show crowds and debris. Facilities documented include the assembly building, hangars, mooring posts, and scaffolding. Parts shown include engines, exterior surfaces, frames, gondolas, and water ballast bags.

Arranged: By videodisc frame number.

Captioned: Most with date and subject.

Finding Aid: Caption database listing date, format, subject, source, and videodisc frame number. Printouts can be obtained for single photographs or caption lists of photographs with related subjects.

Restrictions: The collection is located at NASM Archives on the Mall. Researchers are encouraged to call or write for an appointment.

AS·299

U.S. Organizing Committee for the Bicentennial of Air and Space Flight Records, 1982–1984

Dates of Photographs: 1982–1984

Collection Origins

The U.S. Organizing Committee for the Bicentennial of Air and Space Flight, established by President Ronald Reagan in 1982, created the collection to document its business activities. In collaboration with an international committee, the U.S. Committee organized events to commemorate the 200th anniversary of

the first manned balloon flight (November 1783) and the first flight in the United States (June 1784). Photographers represented include David Bruce, the Prince George *Post,* Nick Sebastian, and the U.S. Department of Commerce. NASM Archives assigned the collection accession number XXXX-0100.

Physical Description

There are 150 photographs including color dye coupler photoprints and slides and silver gelatin photonegatives, photoprints, and phototransparencies. Other materials include audiotape cassettes, correspondence, drawings, financial records, newspaper clippings, and videotape cassettes.

Subjects

The photographs document the activities and symbols of the U.S. Organizing Committee for the Bicentennial of Air and Space Flight. Activities documented include a balloon exhibit, crowds with balloons, functions with speakers including a panel of speakers in France, and a stained-glass window workshop employing developmentally disabled adults. Copies of historical photographs include a balloon event in 1946 and the Paris air exposition of 1909. There are images of a miniature model balloon, as well as photographic reproductions of a 1783 drawing of a balloon and postage stamp commemorating the 200th anniversary of flight.

Arranged: By type of material. Photographs are located with correspondence and with graphic materials.

Captioned: No.

Finding Aid: 1) Box list. 2) Videotape inventory.

Restrictions: The collection, located at the Garber Facility, is available by appointment only.

AS·300

U.S. Space Program Collection, Circa 1950–1974

Dates of Photographs: Circa 1960–1974

Collection Origins

NASM's Space Science and Exploration (now Space History) Department staff assembled the collection to document the U.S. space program from the inception of NASA through the Skylab missions. For a history of NASA, see *Collection Origins* in AS·45. Studios represented include McDonnell-Douglas, NASA, OPPS, and the U.S. Air Force. The Space Science and Exploration Department transferred the collection to NASM Archives, where it received accession numer XXXX-0154.

Physical Description

There are 8,300 photographs including color dye coupler photonegatives and photoprints and silver gelatin photonegatives and photoprints. Other materials include correspondence, manuals, maps, newspaper clippings, periodicals, and press releases.

Subjects

The images, primarily NASA publicity photographs, document the Apollo, Gemini, Mercury, and Skylab programs, including astronauts, equipment, and spacecraft, during flights, tests, and training.

Astronauts portrayed include Neil Armstrong; Alan L. Bean; M. Scott Carpenter; L. Gordon Cooper, Jr.; Charles M. Duke, Jr.; Ronald E. Evans; Edward G. Givens; Joseph P. Kerwin; Thomas K. Mattingly, II; Harrison H. Schmitt; Russell L. Schweickart; David R. Scott; Alan B. Shephard, Jr.; Alfred M. Worden; and John W. Young. The astronauts are shown at ceremonies, during flights, in training, and with their families.

Flight procedures documented include astronauts being picked up after splashdown, emerging from capsules after flight, entering spacecraft, and putting on space suits; boosters and capsules being joined; capsules being retrieved by crane and placed on ships; launches; Moon walks; and space walks. Preparations, tests, and training shown include dehydrated food preparation, engine test firings, spaceflight simulation, space walk practice, test flights, and transportation of spacecraft.

Spacecraft depicted include boosters and capsules from all the Apollo, Gemini, Mercury, and Skylab missions; missiles; and satellites such as lunar modules and an orbiting astronomical observatory. The spacecraft are shown during construction, in flight, and on exhibit. Spacecraft parts shown include connectors, engines, guide rails, heaters, instrument panels, and tubes. Equipment and facilities illustrated include docking tunnels; hangars; the Kennedy Space Center at Cape Canaveral, Florida; laboratories; launch pads; and simulators.

There are images of space-related exhibits displaying cameras, food, harness belts, moon rocks (in an international traveling exhibit), publications on space, spacecraft parts, and space suits and helmets. Other photographs include images of the Moon's surface showing the American flag, footprints, and lunar vehicles. There are also photographic reproductions of mission emblems and artists' conceptions of space activities, as well as stills from television broadcasts of the astronauts, the Earth, and the Moon. Several photographs from this collection are reproduced in this volume's illustrations section.

Arranged: By mission and program.

Captioned: Most with date and subject; some with negative number.

Finding Aid: Box list.

Restrictions: The collection, located at the Garber Facility, is available by appointment only.

AS·301

U.S. Supersonic Transport Collection I A.K.A. Robert K. Friedman Collection, Circa 1960–1975

Dates of Photographs: 1960s

Collection Origins

Robert K. Friedman, chief of the Federal Aviation Administration's Supersonic Transport (SST) program, created the collection to document American SST development during his tenure. Initiated in 1963, the SST program attempted to develop an aircraft able to travel at least at Mach 2, carry 300 passengers with intercontinental range, and compete with the Concorde and Soviet Tu 144 programs. Contracts were awarded to Boeing for the airframe and General Electric for the engines in the late 1960s, but the program was several years behind the European and Soviet efforts. In 1971 Congress cancelled the program because of slow devel-

opment, environmental concerns, high costs, and uncertainty about the commercial feasibility of the aircraft. NASM Archives assigned the collection accession number 1987-0130.

Physical Description

There are four silver gelatin photoprints. Other materials include audiotape reels, brochures, charts, correspondence, manuscripts, newspaper clippings, posters, press releases, proposals, and reports.

Subjects

The photographs reproduce charts of flight information and management organization relating to the U.S. Federal Aviation Administration's Supersonic Transport program.

Arranged: No.

Captioned: With subject.

Finding Aid: No.

Restrictions: The collection, located at the Garber Facility, is available by appointment only.

AS·302

U.S. Supersonic Transport Collection II *A.K.A.* Bernard J. Vierling Collection, Circa 1952–1979

Dates of Photographs: Circa 1960–1970

Collection Origins

Aeronautical engineer and executive Bernard J. Vierling (1914–1983) created the collection to document his work with supersonic transportation development. Vierling, who received an M.E. from Stanford University (1938), coordinated aircraft modification at Douglas Aircraft Company (1936–1939) and directed engineering and maintenance for Pennsylvania Central

Airlines (1939–1947). He ran his own consulting and engineering firm, Aircraft Advisors (1946–1949), then became partner and president of Aircraft Supply Corporation (1954–1962).

Vierling joined the Federal Aviation Administration (FAA) as director of Systems Maintenance Service (1962–1965) and then became deputy director (later acting director) of FAA's Office of Supersonic Transport Development, which operated from 1963 to 1971. A founder and president of the National Aviation Club, Vierling also belonged to the National Aeronautics Association and the Air Force Association. Photographers and studios represented include City News Bureau, Washington, D.C.; Del Ankers Photographers; Federal Aviation Administration; L.A. Airport Photography; and Robert Striar. NASM Archives assigned the collection accession number XXXX-0144.

Physical Description

There are 80 photographs including color dye coupler photoprints and silver gelatin photoprints. Other materials include audiotape cassettes, awards, brochures, correspondence, financial records, minutes, newsletters, programs, and reports.

Subjects

The photographs document sonic boom damage to buildings and Bernard J. Vierling's social activities, primarily with the National Aviation Club. Images of sonic boom damage show broken furniture; cracks in brick and concrete walls, ceilings, and linoleum floors; fallen items in cabinets and on shelves; and peeling plaster; as well as house exteriors. Group portraits include Vierling with members of FAA and the National Aviation Club, as well as other business executives, military officers, and their wives, attending social functions such as award ceremonies, dances, and dinners. There are images of men cutting a cake and holding a model Boeing 727. There is also a portrait of Jewel Maxwell, director of the Office of Supersonic Transport Development.

Arranged: No.

Captioned: No.

Finding Aid: Box list.

Restrictions: The collection, located at the Garber Facility, is available by appointment only.

AS·303

J.D. Van Vliet Photograph Collection

Dates of Photographs: 1912–1933

Collection Origins

Aviator J.D. Van Vliet may have created the collection to document aircraft he and his colleagues flew. Clarence George donated the collection to NASM, where it received accession number XXXX-0364. Photographers represented include H.M. Benner.

Physical Description

There are 60 photographs including silver gelatin photonegatives and photoprints.

Subjects

The photographs document various aircraft of the 1910s through the early 1930s. Airplanes shown include the Curtiss flying boat *America,* a Fokker F.III, the Langley Aerodrome, and the Ryan NY-P *Spirit of St. Louis.* There is also an image of Curtiss Aeroplane Company at Lake Keuka, Hammondsport, New York.

Arranged: No.

Captioned: With date and subject.

Finding Aid: Item-level transfer list.

Restrictions: No. The collection is located at the NASM Archives on the Mall. Researchers are encouraged to call or write for an appointment.

AS·304

Victor Vernon Scrapbooks

Dates of Photographs: 1903–1948

Collection Origins

Aviation pioneer Victor Vernon (1883–1968) created the collection to document his career as a pilot and commercial aviation executive. Vernon attended Syracuse University before working as an exhibition flight pilot in 1914 and 1915. In 1915 he joined the Curtiss aviation school in Toronto, giving classes on piloting seaplanes. During World War I he served as an instructor for the U.S. Army Signal Corps and test pilot for the Naval Aircraft Factory. In 1920 Vernon helped form the Oregon, Idaho and Washington Aeroplane Company, and from 1922 to 1929 he worked as a consultant. In 1930 he joined Colonial Airways, a division of American Airways, where he served as personnel director and assistant to the president until his retirement in 1948. Vernon donated the collection to NASM, where it received accession number XXXX-0221.

Physical Description

There are 160 silver gelatin photographs, mounted in scrapbooks. Other materials, also in scrapbooks, include certificates, charts, correspondence, and newspaper clippings.

Subjects

The photographs document the aircraft, events, facilities, and people involved in Victor Vernon's career with the Curtiss aviation school in Toronto and Colonial Airways, a division of American Airways. Aircraft shown include Curtiss flying boats, such as the *America,* and the Langley Aerodrome. Events documented include aircraft christenings, aircraft crashes (including one at a bathing beach), corporate ceremonies, a parade, and a party on an airplane. Facilities depicted include airfields, a crane and truck moving aircraft, hangars, and offices. There are also aerial views of coastlines; Mt. Hood, Oregon; the Anacostia Naval Air Station in Washington, D.C.; and Newport News, Virginia. Individuals portrayed include Victor Vernon and pilots Bert Acosta, B.R.J. Hassell, and Walter E. Lees. Groups portrayed include airline officials with silver dollars to reward employees, crowds watching flights, the first flight attendants at American Airways, instructors and students at the Curtiss aviation school, passengers, pilots, and Russian visitors at a Curtiss plant.

Arranged: No.

Captioned: Some with subject.

Finding Aid: No.

Restrictions: The collection, located at the Garber Facility, is available by appointment only.

AS·305

Alfred V. Verville Papers, 1911–1968

Dates of Photographs: Circa 1910s–1960s

Collection Origins

Alfred V. Verville (1890–1970) created the collection to document his career in aviation engineering, which included innovations in welded-steel-frame fuselages and retractable landing gear. Verville began work at Curtiss Aeroplane Company in 1914, moved the following year to Thomas Morse Aircraft Company and then General Airplane Company, and joined Fisher Body Corporation's Airplane Division in 1917. From 1918 to 1925 he worked at the U.S. Army Air Service Engineering Division at McCook Field in Dayton, Ohio. He left McCook to co-found the Buhl-Verville Aircraft Company, then operated his own business, the Verville Aircraft Company, from 1928 to 1931. He later held positions with the Bureau of Air Commerce, U.S. Department of Commerce (1933–1936); Douglas Aircraft Company (1937–1938); Curtiss-Wright Corporation (1941–1942); Snead Aircraft (1942); Drexel Aviation Company (1942–1945); the Naval Technical Mission to Europe (1945), and the Navy Bureau of Aeronautics (1946–1961). Studios represented include Fleet Air Photo Lab; General Photographic Service; Kalec, Inc.; MacGregor and Company; OPPS; the U.S. Air Force; and the U.S. Army Air Service. NASM Archives assigned the collection accession number XXXX-0173.

Physical Description

There are 3,930 photographs including color dye coupler photoprints and phototransparencies, cyanotypes, and silver gelatin photonegatives and photoprints. Other material includes charts, correspondence, engineering drawings, financial records, manuscripts, newspaper clippings, periodicals, and reports.

Subjects

The photographs document U.S. Naval aviation, especially Curtiss aircraft, and aircraft designed by Alfred V. Verville. Aircraft documented include an ambulance biplane, Curtiss seaplanes, a Curtiss N-9, jet fighters, a replica of the Curtiss A-1 (the first Navy aircraft), a Verville Aircoach, Verville biplanes, and World War II fighters and transports. Aircraft parts and equipment shown include engines, instrument panels, interiors, a Navy bomb (1915), retractable landing gear, and wings, as well as many parts of the Verville Aircoach. Facilities shown include airfields with advertisements on fences, Curtiss Aeroplane Company property (1910s), a fighter director room on a World War II aircraft carrier, Pensacola (Florida) Aeronautics Station (1914), production plants, and a San Diego (California) air base (1925).

Activities documented include aerial photographs being taken with a Graflex camera in a biplane; aircraft construction and repairs; flight and transportation of the Curtiss A-1 replica; pilot training at Curtiss aviation schools; a test of a radio set in a airplane (1911); and World War II aviation activities including a Japanese aircraft being shot down. Events shown include aircraft crashes; a balloon burning; early aircraft carrier experiments; early flights by Glenn H. Curtiss; historical aviation exhibits; mock aerial bombing at the International Air Races (1920s); an observation flight to Mexico in 1914 (the first "war-like" Navy airplane trip); presentations of aircraft to the Smithsonian Institution; the Pulitzer race of 1922; social events; and a World War I public event at McCook Field, Ohio, with a marching band.

Individuals portrayed include NASM's Paul E. Garber, Navy pilot John Rodgers, and Alfred V. Verville. Groups portrayed include the first Pensacola Naval Air Station graduating class, military officers with women (1930s), pilots (1912–1920), and World War II aircraft and carrier crews.

Arranged: No.

Captioned: Some with date and subject.

Finding Aid: Item list.

Restrictions: The collection, located at the Garber Facility, is available by appointment only.

AS·306

Voyager 2 Uranus Moon and Ring Images

Dates of Photographs: 1984–1986

Collection Origins

NASA created the collection to document the encounter of *Voyager* 2 with Uranus. NASA began the Voyager program in 1972, planning to send two sensing probes to the outer planets while Jupiter and Saturn were aligned in 1977. After construction at the Jet Propulsion Laboratory in Pasadena, California, *Voyager* 1 and *Voyager* 2 were shipped to Cape Canaveral and launched on Titan Centaur boosters in August and September 1977. The spacecraft reached Jupiter in 1979, *Voyager* 1 in March and *Voyager* 2 in July, and then Saturn, *Voyager* 1 in November 1980 and *Voyager* 2 in August 1981. Then *Voyager* 1 was placed on course to exit the solar system, while *Voyager* 2 traveled to Uranus in 1986 and Neptune in 1989, before also leaving the solar system. In each encounter the probes sent back scientific information and photographs. NASA donated the collection in 1986 to NASM's Center for Earth and Planetary Studies, which transferred it to the Archives, where it received accession number 1986-0128.

Physical Description

There are 8,580 photographs including silver gelatin photonegatives and photoprints.

Subjects

The photographs document the major moons and ring system of Uranus, as photographed by *Voyager* 2.

Arranged: In two series. 1) Photoprints, by target (moon or planet), then by frame number. 2) Roll negatives, by target, then by frame number.

Captioned: With camera and exposure information, date, frame number, location, and spacecraft.

Finding Aid: Folder list.

Restrictions: The collection, located at the Garber Facility, is available by appointment only.

AS·307

Charles D. Walcott Scrapbook

Dates of Photographs: 1914–1915

Collection Origins

Paleontologist and Smithsonian Institution (SI) Secretary Charles D. Walcott (1850–1927) created the collection to document Curtiss Aeroplane Company activities and products. Walcott joined the U.S. Geological Survey in 1879, became its director in 1894, and then became Secretary of SI in 1907, serving until his death. Walcott also held positions in the Carnegie Institute, the National Research Council, and the National Academy of Sciences. His aviation activities included contributions to the Air Commerce Act of 1926, the organization of the National Advisory Committee for Aeronautics, the inauguration of U.S. airmail service, and mapping with aerial photography. Photographers represented include H.A. Taylor. NASM Archives assigned the collection accession number XXXX-0225.

Physical Description

There are 25 silver gelatin photoprints, mounted in an album.

Subjects

The photographs document Curtiss Aeroplane Company activities and products. Aircraft shown include Curtiss J and R seaplanes and the Langley Aerodrome. Aircraft parts depicted include engines and the Sperry stabilizer. There are also images of motorboats with Curtiss engines. Activities and events documented include aircraft christenings, flights, and take-offs. Facilities and surroundings shown include buildings, an ice or snow-covered field, and tent hangars on a shore. There are also portraits of crowds, Curtiss employees, and Charles D. Walcott in a seaplane.

Arranged: No.

Captioned: Most with subject (often in illegible handwriting).

Finding Aid: No.

Restrictions: The collection, located at the Garber Facility, is available by appointment only.

AS·308

Charles F. Walsh Scrapbooks

Dates of Photographs: 1909–1912

Collection Origins

Pilot Charles F. Walsh (1877–1912) created the collection to document his activities between 1909 and 1912. With other members of the Aerial Experiment Association, Walsh built an aircraft, the *Silver Dart,* in 1909. In 1910 he began traveling throughout the United States and Cuba, working as an exhibition pilot for Curtiss Aeroplane Company, until he was killed during a stunt flight. Photographers represented include T. Gagnon. NASM Archives assigned the collection accession number XXXX-0046, and the photographs are reproduced on NASM's Archival Videodisc 2. For information on how to order the videodisc, see the *Collection Origins* field of *AS·1.*

Physical Description

There are 200 photographs including collodion gelatin photoprints (POP), cyanotypes, and silver gelatin photoprints, mounted in scrapbooks. Other materials include tickets to events, also mounted in the scrapbooks.

Subjects

The photographs document Charles F. Walsh's flying activities from 1909 to 1912. Activities and events documented include an airplane flying over a train, crashes, fairs, and Walsh flying with passengers. Facilities shown include the Curtiss factory and school at Hammondsport, New York. There are also images of ruins of the battleship *Maine.* Besides Walsh, people portrayed include aviators Thomas S. Baldwin, Lincoln Beachey, Glenn H. Curtiss, Eugene Ely, Arch Hoxsey, Hugh Robinson, and Bob St. Henry; an unidentified American Indian in a feathered headdress sitting in a aircraft; and Walsh's family.

Arranged: No.

Captioned: Some with date and names.

Finding Aid: No.

Restrictions: No. The collection is located at the NASM Archives on the Mall. Researchers are encouraged to call or write for an appointment.

AS·309

Washington, D.C., Aerial Photograph (World War I) Scrapbook

Dates of Photographs: 1918–1919

Collection Origins

William T. Eggers created the collection during experiments with aerial photography. The photographs were taken with various combinations of filter types and shutter speeds. In 1967 Smithsonian anthropologist Clifford Evans donated the collection to NASM, where it received accession number XXXX-0280.

Physical Description

There are 150 silver gelatin photoprints, mounted in an album.

Subjects

The photographs are aerial views of Washington, D.C., and surrounding areas. Views of the city show American University, the Capitol Building, downtown streets, the Potomac River, and the Washington Monument. There are also images of biplanes in flight, farms, and a lighthouse.

Arranged: No.

Captioned: Most with exposure and filter type.

Finding Aid: No.

Restrictions: The collection, located at the Garber Facility, is available by appointment only.

AS·310

E.D. "Hud" Weeks Collection

Dates of Photographs: 1913–1969

Collection Origins

E.D. "Hud" Weeks, a cosmetics manufacturer and aviation enthusiast living in Des Moines, Iowa, assembled the collection as part of his memorabilia on early aviation. Weeks corresponded with a number of aviation personalities, especially members of the Early Birds, an organization of pilots who flew before December 17, 1916. Weeks donated the collection to NASM, where it received accession numbers 1985-0004 and 1985-0006. Studios represented include Air Mail Pioneers, Frederick Weber's Studio of Photography, and E.D. "Hud" Weeks Aviation Memorabilia.

Physical Description

There are 125 photographs including collodion gelatin photoprints (POP), color dye coupler photoprints and slides, and silver gelatin photoprints (some copy), mounted in scrapbooks. Other materials include correspondence, manuscripts, and newspaper clippings, also mounted in the scrapbooks.

Subjects

The photographs document early aviation activities. Aviators portrayed include Lincoln Beachey, Carl H. Duede, Ernest H. Hall, Charles F. Willard, and Roderick M. Wright, along with members of the Early Birds in New York City in 1954. Events documented include air shows, Beachey flying under Niagara Bridge and racing with an automobile, and sailors searching for Beachey's body. There are also images of Beachey's grave and a Nieuport biplane, portraits of E.D. Weeks with early aircraft, and postcards of Cedar Key, Florida, and Lisbon, Portugal.

Arranged: By subject; partly alphabetical by person.

Captioned: Some with SI negative number and subject.

Finding Aid: Item-level transfer list.

Restrictions: The collection, located at the Garber Facility, is available by appointment only.

AS·311

Alfred R. Weyl and Peter Grosz Collection

Dates of Photographs: 1910s–1950s

Collection Origins

Author and aeronautical engineer Alfred R. Weyl (1898–1959) and historian Peter Grosz (1926–) assembled the collection to document aviation in the first half of the 20th century. Weyl studied engineering at the Deutsche Versuchsanstalt für Luftfahrt before and after World War I, serving in a training unit of the German Air Service during the war. In the late 1920s he participated in the design of light aircraft and edited the journal *Illustrierte Flugwelt*. He also designed aircraft instruments at the secret German test center at Lipetsk in the Soviet Union until forced to resign because of disagreements with the management. Unable to find work in Germany, he emigrated to England in 1933, where he worked as an engineer and author until his death. Peter Grosz, a friend of Weyl, contributed to his collection of aviation information and purchased it from the Weyl estate in 1961. David Margoles donated the collection to NASM Archives, where it received accession number XXXX-0092.

Physical Description

There are 1,600 silver gelatin photoprints. Other materials include articles, books, charts, manuscripts, engineering drawings, newspaper clippings, notes, periodicals, plans, and reports.

Subjects

The photographs document aircraft throughout the first half of the 20th century. Aircraft depicted include airships; balloons; guided missiles; racing airplanes; rockets; seaplanes; tail-less aircraft; and World War I and II bombers, fighters, and transports. Manufacturers represented include Arado, Armstrong, Astra, Austin, Bell, Blackburn, Blériot, Caudron, De Havilland, Deperdussin, Dornier, Douglas, Fairchild, Farman, Fiat, Focke-Wulf, Fokker, Handley-Page, Heinkel, Martin, Smolik, Sopwith, Supermarine, Vickers, and Voisin. The aircraft are shown during accidents, construction, flights, landings, races, and take-offs. Parts of aircraft pictured include engines, fuselages, landing gear, mounted guns, propellers, and wings.

Arranged: Alphabetically by subject.

Captioned: Most with subject.

Finding Aid: Inventory.

Restrictions: The collection, located at the Garber Facility, is available by appointment only.

AS·312

Arthur Whitten-Brown Collection *A.K.A.* Nancy Hamilton Donation

Dates of Photographs: Circa 1890s–1960s

Collection Origins

Nancy Hamilton (1909–1985) assembled the collection to document the career of her relative Arthur Whitten-Brown (1886–1948), navigator on the first non-stop transatlantic flight. In World War I Whitten-Brown flew as a Royal Flying Corps (RFC) observer and was shot down, captured, and exchanged because of his wounds. After the war he began working for the Ministry of Aircraft Production, then was chosen to navigate a non-stop transatlantic flight, attempted by the armament company Vickers for a £10,000 prize sponsored by the London *Daily Mail*.

In June 1919, Whitten-Brown and John Alcock, a Vickers test pilot and also a former RFC flyer, flew from Newfoundland to Ireland in approximately 16 hours. Alcock died soon after in a crash, and Whitten-Brown became a squadron commander in the Royal Air Force in World War II. Photographers and studios represented include R.L. Knight, A.M. Powers, and Wakefields. NASM Archives assigned the collection accession number 1986-0011.

Physical Description

There are 135 photographs including albumen photoprints, color dye coupler photonegatives and photoprints, collodion gelatin photoprints (POP), and silver gelatin photonegatives and photoprints. Other materials include books, correspondence, magazines, manuscripts, motion-picture film footage, newspaper clippings, and a phonograph record.

Subjects

The photographs document Arthur Whitten-Brown's family and his 1919 flight from Newfoundland to Ireland. Family photographs include images of Arthur Whitten-Brown, Jr., family members at the beach, houses, and Whitten-Brown's wedding. Images of the 1919 flight include portraits of John Alcock and Whitten-Brown with their aircraft and photographic reproductions of a letter and pages from the flight log. There are also images of a memorial to Alcock and Whitten-Brown and of their graves, as well as an early 1940s helicopter and women soldiers in World War II.

Arranged: No.

Captioned: Some with hand-written subject.

Finding Aid: No.

Restrictions: The collection, located at the Garber Facility, is available by appointment only.

AS·313

Paul H. Wilkinson Papers, Circa 1944–1984

Dates of Photographs: 1946–1977

Collection Origins

Paul H. Wilkinson (1895–1975) assembled the collection during his career as an aviation writer and publisher. Some of the photographs were copied from National Air Museum (the predecessor of NASM) collections. Wilkinson's major work, the series *Aircraft Engines of the World*, became in 1941 a standard reference to specifications of aircraft engines produced throughout the world. At the time of Wilkinson's death, the series was entering its 34th edition. Wilkinson also published three books on diesel aviation engines produced before the 1940s, along with many articles for aeronautical publications.

The photographs have appeared in the following publications by Wilkinson: 1) *Aircraft Diesels*. New York, Chicago: Pitman Publishing Corporation, 1940. 2) *Aircraft Engines of the World*. Washington, D.C.: Paul H. Wilkinson, 1941– . 3) *Diesel Aircraft Engines*. Brooklyn, New York: Paul H. Wilkinson, 1936.

4) *Diesel Aviation Engines.* New York: National Aeronautics Council, 1942. Photographers and studios represented include Blackburn and General Aircraft, British Information Service, General Electric, National Advisory Committee for Aeronautics, OPPS, Rolls Royce, and Paul H. Wilkinson. In 1985 the Eleanor Dies Wilkinson estate donated the collection to NASM, where it received accession number XXXX-0051.

Physical Description

There are 3,950 photographs including color dye coupler photoprints and silver gelatin photonegatives and photoprints. Other materials include books, card files, correspondence, financial records, journals, manufacturers' catalogs, manuscripts, newspaper clippings, pamphlets, and reports.

Subjects

The photographs document aircraft engines produced throughout the world from the 1910s through the early 1970s. Most of the engines are shown separately; some are shown installed in aircraft. There are also images of engine production, people involved in the industry, and propellers.

Engines depicted include the Allison gas turbine, Bristol Siddely Orpheus, Eagle VIII, Gyro rotary, Liberty, Loughead 1911 engine, Packard diesel, Rolls Royce RB 108, Rolls Royce RB 145, Rolls Royce Spey, Rolls Royce Trent, Vulture 1, and Wright Cyclone. Other engine manufacturers represented include Curtiss, General Electric, Hispano-Suiza, and Renault.

There are images of propellers made by Durant & Lesley and Hamilton Standard, as well as propellers for the Curtiss Reid Rambler and Langley Aerodrome. There are portraits of Packard test pilots Fred Brossy and Walter E. Lees, as well as mechanics working on engines. There is also an image of a De Havilland engine showroom, as well as photographic reproductions of charts and diagrams.

Arranged: In two series. 1) Photographs in binders, by country and then alphabetically. 2) Photographs in manufacturer files, alphabetically by manufacturer.

Captioned: With name of engine or propeller and negative number; some with National Air Museum collection name of original photograph.

Finding Aid: Preliminary box list.

Restrictions: The collection, located at the Garber Facility, is available by appointment only.

AS·314

Leo J. Windecker Projects Collection

Dates of Photographs: 1961–1963

Collection Origins

Leo J. Windecker created the collection to document his experimental work in plastic aircraft structures. Windecker received a D.D.S. from the University of Texas and worked as a dentist from 1948 to 1961. While working in Dow Chemical Company clinics, he became interested in aircraft and began designing plastic aircraft forms. Impressed with his designs, Dow provided him with a laboratory in Hondo, Texas. There Windecker experimented with plastic airframes and parts on different types of aircraft. He used these photographs to document experiments and illustrate project reports. Studios represented include Jack Greenberg Studio and Mikro, Inc. NASM Archives assigned the collection accession number XXXX-0176.

Physical Description

There are 160 silver gelatin photoprints. Other materials include correspondence, log books, periodicals, proposals, and reports.

Subjects

The photographs document Leo J. Windecker's research in applying plastic airframes and parts to aircraft at his Dow Chemical Company laboratory in Hondo, Texas. Images of aircraft construction include applying surface materials, assembling parts, and installing plastic foam in wings, as well as repairing damage. Tests documented include damage assessments, preliminary flights, and strength tests. Equipment and facilities depicted include a construction plant, hangar, and tools. There are also portraits of laboratory workers.

Arranged: By subject.

Captioned: Some with date, negative number, photographer, or subject.

Finding Aid: No.

Restrictions: The collection, located at the Garber Facility, is available by appointment only.

AS·315

Wings of Gold: How the Aeroplane Developed New Guinea Collection

Dates of Photographs: 1986–1990

Collection Origins

James P. Sinclair (1928–) assembled the collection for publication in the following book: *Wings of Gold: How the Aeroplane Developed New Guinea.* Sydney: Pacific Publications, 1978. (2nd ed. Bathurst, N.S.W., Australia: Robert Brown & Associates, 1983.) Terry Gwynn-Jones made copy photonegatives of the images and lent them to NASM, which produced copy photoprints to form this collection, assigned accession number 1988-0048.

Physical Description

There are 110 silver gelatin photoprints.

Subjects

The photographs document aviation in Papua, New Guinea, from the early 1920s to the mid-1930s. Aircraft documented include a Breguet 14, a Curtiss MF Seagull, De Havillands, Junkers G-31s, and Junkers W-34s. There are images of airline operations such as Bulolo Goldfield's Aeroplane Services; Guinea Airways, including gold mining and oil exploration; and W.R. Carpenter Air Services; as well as operations by "bush pilots." Expeditions illustrated include the Hurley Expedition of 1922 and the Stirling New Guinea Expedition, which was sponsored by the Smithsonian Institution.

Arranged: By negative number.

Captioned: With negative number; some also with aircraft, airline, description, and file number.

Finding Aid: No.

Restrictions: No. The collection is located at the NASM Archives on the Mall. Researchers are encouraged to call or write for an appointment.

AS·316

Women Flyers of America Collection, 1940–1955

Dates of Photographs: 1940–1954

Collection Origins

Women Flyers of America created the collection to document its organization, members, and activities. Founded in 1940, Women Flyers of America included women interested in all aspects of aviation. In addition to other activities, the organization provided flight training for women who wanted to obtain a pilot's license. The organization disbanded in 1954. NASM Archives assigned the collection accession numbers 1987-0050 and 1988-0058.

Physical Description

There are 30 silver gelatin photographs. Other materials include bylaws, correspondence, financial records, newsletters, and newspaper clippings.

Subjects

The photographs document Women Flyers of America members, in groups and individually (for application forms). Members portrayed include Theresa C. Bloir, Geraldine H. Brandes, Luella F. Davis, Aurilla M. Doerner, Beverly Jones, Etta L. Knight, Laura A. McKibben, and Gail G. Smith. Some people are shown plotting a course for student pilots. There is also a portrait of Amelia Earhart.

Arranged: By type of material.

Captioned: Some with name and subject.

Finding Aid: Item-level transfer list.

Restrictions: The collection, located at the Garber Facility, is available by appointment only.

AS·317

George W. Wood, Jr., Diaries

Dates of Photographs: 1942–1945

Collection Origins

Pilot George W. Wood, Jr., created the collections to document his experiences in the 475th Fighter Group during World War II. A fighter unit of the Fifth Air Force, U.S. Army, the group operated in the Pacific Theater. Wood served as a radio technician in the group's 433rd Fighter Squadron (known as "Satan's Angels"). NASM Archives assigned the collection accession number 1987-0118.

Physical Description

There are 100 silver gelatin photoprints. Other materials include diaries.

Subjects

The photographs document the men and equipment of the 475th Fighter Group of the Fifth Air Force, U.S. Army, as well as Japanese prisoners of war and Pacific Islanders. Equipment and facilities shown include aircraft with squadron insignia, tents, and trucks. Pacific Islanders portrayed are primarily young women, probably in the Philippines, often posing with American soldiers. Two photographs from this collection are reproduced in this volume's illustrations section.

Arranged: No.

Captioned: Most with subject in handwriting.

Finding Aid: No.

Restrictions: The collection, located at the Garber Facility, is available by appointment only.

AS·318

Works Projects Administration Airport Inspection Trip Scrapbook *A.K.A.* George L. Lewis Scrapbook

Dates of Photographs: 1937

Collection Origins

The Works Projects Administration (WPA) created the collection to document a government inspection of airports directed by the Bureau of Air Commerce in October and November 1937. Members of the inspection party included aeronautical association representatives, airline and airport executives, government officials, and U.S. Air Corps officers. The team visited about 35 airports throughout the country. The collection was created for George L. Lewis and donated by the Department of Commerce to NASM, where it received accession number XXXX-0288.

Physical Description

There are 65 silver gelatin photoprints, mounted in a scrapbook. Other materials include maps, also mounted in the scrapbook.

Subjects

The photographs document the WPA airport inspection trip in 1937, including airports visited, events during the trip, and members of the inspection party and local airport representatives. Airports illustrated include those in the following cities: Albuquerque, Birmingham (Alabama), Bristol (Tennessee), Chicago, Dallas, El Paso, Harrisburg (Pennsylvania), Indianapolis, Little Rock, Louisville (Kentucky), Medford (Massachusetts), Memphis, Montgomery (Alabama), New Orleans, Oklahoma City, Omaha, Phoenix, San Francisco, Shreveport (Louisiana), Spokane, St. Louis, and Washington, D.C. Events documented include a banquet in New Orleans, dedication of the administration building in San Francisco built by the Public Works Administration, and dedication of Tri-City Airport in Tennessee. There are portraits of team members speak-

ing with local people and workers repairing the group's aircraft.

Arranged: Chronologically.

Captioned: With subject.

Finding Aid: No.

Restrictions: The collection, located at the Garber Facility, is available by appointment only.

AS·319

World War I Aces Scrapbook

Dates of Photographs: Circa 1960s–1971

Collection Origins

Unknown. Arthur K. Doolittle, a U.S. Army test pilot in World War I, gave the collection to the Smithsonian in 1971. NASM Archives assigned it accession number XXXX-0317.

Physical Description

There are 25 photographs including color dye coupler photoprints and silver gelatin photoprints, most copies, mounted in an album.

Subjects

The photographs primarily portray American World War I aces. Individuals portrayed include Hilbert L. Bair, Charles J. Biddle, Clayton L. Bissell, Arthur R. Brooks, Douglas Campbell, Thomas G. Cassady, Reed M. Chambers, Everett L. Cook, Edward P. Curtiss, Charles R. D'Olive, M.K. Guthrie, Edward M. Haight, Frank Hays, Frank O'D. Hunter, David S. Ingalls, James A. Keating, Reed G. Landis, Kenneth L. Porter, Edward V. ("Eddie") Rickenbacker (reproduction of a painting), Martinus Stenseth, Robert E. Todd, George A. Vaughan, Jr., and Rodney D. Williams, as well as astronaut Michael Collins.

Arranged: Alphabetically.

Captioned: With inscription and name, accompanied by biographical information.

Finding Aid: No.

Restrictions: The collection, located at the Garber Facility, is available by appointment only.

AS·320

World War I Aviators Photographs and Autographs Scrapbook *A.K.A.* Marvin M. Green Scrapbook

Dates of Photographs: 1914–1937

Collection Origins

The collection was assembled in the 1920s and 1930s to record the autographs and portraits of prominent international aviators of World War I. In 1983 Marvin M. Green donated the collection to NASM, where it received accession number XXXX-0315.

Physical Description

There are 21 photographs including platinum photoprints and silver gelatin photoprints, mounted in a scrapbook. Other materials include correspondence and newspaper clippings, also mounted in the scrapbook.

Subjects

The photographs portray prominent World War I aviators, often posing with aircraft. People portrayed include Arthur R. Brooks and Robert S. Rockwell of the United States, Julius Buckler of Germany, and Boris Sergievsky of the U.S.S.R. There are also images of the gravestones of Raoul Lufberry of the United States and Manfred von Richthofen of Germany and of a medal awarded to Willy Coppens of Belgium.

Arranged: By nationality.

Captioned: Most with autograph and name.

Finding Aid: No.

Restrictions: The collection, located at the Garber Facility, is available by appointment only.

AS·321

World War II Aerial Reconnaissance Photographs *A.K.A.* James A. Hedgpeth, Jr., Collection

Dates of Photographs: 1944

Collection Origins

Unknown. James A. Hedgpeth, Jr., donated the collection to NASM Archives, where it received accession number 1989-0078.

Physical Description

There are 75 silver gelatin photoprints.

Subjects

Most of the images are aerial photographs of World War II bombing in France and Germany. There are also ground photographs of bomb damage, as well as of an aerial mapping room and a Lockheed F-5 Lightning photo reconnaissance aircraft in flight.

Arranged: No.

Captioned: No.

Finding Aid: No.

Restrictions: The collection, located at the Garber Facility, is available by appointment only.

AS·322

World War II Army Surplus Collection, 1944–1945

Dates of Photographs: 1944–1945

Collection Origins

U.S. government workers created the collection to document the sales of surplus military aircraft after World War II. Norman Malaney donated the collection to NASM in 1990, and it received accession number 1991-0071. Studios represented include Del Ankers.

Physical Description

There are six silver gelatin photoprints. Other materials include charts, correspondence, memoranda, and reports.

Subjects

The photographs are reproductions of charts documenting surplus World War II aircraft.

Arranged: By type of material.

Captioned: With information on surplus aircraft sales.

Finding Aid: No.

Restrictions: No. The collection is located at the NASM Archives on the Mall. Researchers are encouraged to call or write for an appointment.

AS·323

World War II Photograph Collection *A.K.A.* Harry Brosius Photograph Collection

Dates of Photographs: 1990

Collection Origins

Harry Brosius created the collection to document his World War II experience. A technician fifth grade in the 1897th Engineer Battalion, Brosius served in the Pacific Theater and witnessed the surrender of Japan. Florence Decker, Brosius's niece, lent the original photographs to NASM, which made copy images and assigned them accession number 1990-0049.

Physical Description

There are 50 silver gelatin copy photoprints.

Subjects

Most of the photographs document aircraft nose art and military insignia and signs. There are images of aircraft made by Consolidated, Douglas, Mitsubishi, and North American. People portrayed include American mechanics and pilots, the Japanese delegates to the 1945 peace conference, and South Pacific islanders. There are also images of cemeteries and occupied Japanese cities.

Arranged: By negative number.

Captioned: With negative number.

Finding Aid: Caption database and printout listing negative number, subject, and source for each image. Printouts can be obtained for single records or caption lists of related subjects.

Restrictions: No. The collection is located at the NASM Archives on the Mall. Researchers are encouraged to call or write for an appointment.

AS·324

Wright Brothers' 1903 Flyer Restoration Albums

Dates of Photographs: 1980s

Collection Origins

NASM assembled the collection to document restoration of the Wright 1903 Flyer. The 1903 Flyer arrived at the Smithsonian in 1948, after being exhibited in places such as the Massachusetts Institute of Technology and the Science Museum of London and undergoing several preservation treatments. The Flyer hung in the Smithsonian's Arts and Industries Building until 1975, when it was moved to the new National Air and Space Museum. In 1985 NASM completely restored the aircraft. There are copies of the collection in the Ramsey Room and at the Garber Facility. The photographs are reproduced on NASM's Archival Videodisc 7. For information on how to order the videodisc, see the *Collection Origins* field of *AS·1*.

Physical Description

There are 280 silver gelatin photoprints, mounted in albums.

Subjects

The photographs document the restoration of the Wright 1903 Flyer at various places since its original flight, including its most recent restoration at NASM in 1985. The images show damage to the aircraft as well as repairs. There are details of parts of the Flyer including cords, the engine, joints, pulleys, seams, and wing surfaces.

Arranged: Roughly chronological.

Captioned: No.

Finding Aid: No.

Restrictions: No. The collection is located at the NASM Archives on the Mall. Researchers are encouraged to call or write for an appointment.

AS·325

Wright Brothers' 1903 Flyer Restoration Files

Dates of Photographs: 1984–1986

Collection Origins

NASM Aeronautics Department personnel created the collection to document their restoration of the Wright 1903 Flyer in 1985, as well as the history of the aircraft. For a history of the Flyer's restoration, see *Collection Origins* in AS·324. Some of the photographs are copies of original 1903 flight images held at the Library of Congress, including some taken by Orville Wright. Other photographers include Mark Avino of OPPS. NASM Archives assigned the collection accession number 1990-0058.

Physical Description

There are 620 photographs including color dye coupler photonegatives, photoprints, and phototransparencies, and silver gelatin photoprints. Other materials include charts, correspondence, engineering drawings, financial records, magazines, manuscripts, newspaper clippings, newspapers, and reports.

Subjects

The photographs document the Wright 1903 Flyer during its 1985 restoration at NASM as well as its history. Restoration images show the aircraft before, during, and after treatment. Most images depict parts of the Flyer including the engine, the chain drive, gas line, and struts, some showing damage. There are portraits of NASM staff working on the aircraft, as well as photographic reproductions of engineering drawings. Historical images show the aircraft during its 1903 flights, on exhibit at the Massachusetts Institute of Technology and the Science Museum of London, being restored in the 1920s and 1930s, and being transferred to the Smithsonian Institution in 1948. There are portraits of Charles E. Taylor, producer of the engine, and Orville and Wilbur Wright.

Arranged: By subject and type of material. Most of the photographs are arranged sequentially in binders in box 3.

Captioned: Most with date, negative number, and subject.

Finding Aid: Folder list.

Restrictions: The collection, located at the Garber Facility, is available by appointment only.

AS·326

Wright Field Propeller Test Reports, Circa 1921–1946

Dates of Photographs: 1939–1943

Collection Origins

The U.S. Army Air Service Engineering Division (later Air Materiel Division and Air Materiel Command) near Dayton, Ohio, created the collection to document tests of aircraft propellers. Established at McCook Field by the U.S. Army Air Service in 1917, the Engineering Division moved to nearby Wright Field in 1927 to become the Air Forces Materiel Division and Air Materiel Command. The division designed some aircraft and tested all aircraft equipment, materials, and parts for the U.S. Army and Air Force, operating until the formation of Wright-Patterson Air Force Base in 1948. NASM Archives assigned the collection accession number XXXX-0417.

Physical Description

There are 630 silver gelatin photoprints, mounted in reports. Other materials include engineering drawings and plans.

Subjects

The photographs document aircraft propeller testing done at Wright Field, showing test equipment, procedures, and results—often damage to propeller blades. Tests documented include a calibration test, water spray test, weight test, and whirl test. There are images of aircraft parts including blade fairings, engines, and propeller hubs, as well as propellers made by many manufacturers including Curtiss.

Arranged: By report number.

Captioned: Most with test and type of part or propeller.

Finding Aid: No.

Restrictions: The collection, located at the Garber Facility, is available by appointment only.

AS·327

Wright Field Technical Documents Library, Circa 1915–1955

Dates of Photographs: 1930s–1950s

Collection Origins

The U.S. Army Air Service Engineering Division (later Air Materiel Division and Air Materiel Command) near Dayton, Ohio, assembled the collection from its own records and outside materials to serve as a reference library. For a history of the division, see *Collection Origins* in AS·326. When Wright Field combined with Patterson Field to become Wright-Patterson Air Force Base, the library was transferred to the Air Force Museum at Wright-Patterson, which later donated it to NASM. NASM Archives assigned the collection accession number XXXX-0428.

Physical Description

There are 5,000 silver gelatin photoprints. Other materials include books, charts, correspondence, diagrams, engineering drawings, manuals, manuscripts, pamphlets, and reports.

Subjects

The photographs primarily document tests conducted by the U.S. Army Air Forces Engineering Division. Tests illustrated include examinations of durability and performance of all types of aircraft parts, such as engines, propellers, wheels, and wings; of equipment such as guns; of materials such as metals, plastics, and wood; and of supplies such as ammunition and fuel. The photographs also document buildings and grounds of airfields, airports, and military bases.

Arranged: By subject according to Wright Field classification system.

Captioned: Most with subject.

Finding Aid: 1) Key to Wright Field subject classification system. 2) Card index arranged by subject, listing description of the document and the Wright Field classification number.

Restrictions: The collection, located at the Garber Facility, is available by appointment only.

AS·328

Wright/McCook Fields Aircraft Project Books, 1920–1925

Dates of Photographs: 1920–1925

Collection Origins

The U.S. Army Air Service Engineering Division (later Air Materiel Division and Air Materiel Command) near Dayton, Ohio, created the collection to document its aircraft development and testing projects. For a history of the Division, see *Collection Origins* in AS·326. Division staff produced project books to contain contracts, inspection and test reports, and specifications for each aircraft. NASM Archives assigned the collection accession number XXXX-0058.

Physical Description

There are 2,520 silver gelatin photonegatives. Other materials include contracts, correspondence, engineering drawings, reports, and specifications.

Subjects

The photographs document aircraft tested by the U.S. Army Air Service. Aircraft depicted include the Aeromarine PG-1; Boeing DH-4M, GA-1, GA-2, PW-9, and XP-4; Cox-Klemin A-1; Curtiss NBS-4, O-1, P-1, P-2, PN-1, PW-8, R-6, R-8, XO-1, and XP-3; Dayton Wright PS-1, TA-3, and TA-5; Douglas C-1, O-2, World Cruiser, and XNO; Elias NBS-3 and TA-1; Fokker PW-5, T-2, and V-40; Gallaudet DB-1 and PW-4; Huff-Daland TA-6, XHB-1 Cyclops, and XLB-1 Pegasus; Loening PW-2, PW-2A, and PW-2B; Martin NBL-2 and NBS-1; Orenco PW-3; Thomas

Morse MB-3, R-5, S-9, TM 23(PW), TM 24(CO), and XO-6; Travel Air 2000; Verville-Sperry Messenger; and Wright Aircraft XO-3. There are also images of Engineering Division experimental aircraft.

Arranged: No.

Captioned: No.

Finding Aid: Folder list.

Restrictions: The collection, located at the Garber Facility, is available by appointment only.

AS·329

Wright/McCook Fields Still Photograph Collection, 1918–1971

Dates of Photographs: 1918–1971

Collection Origins

Personnel at the U.S. Army bases at McCook Field and Wright Field (now Wright-Patterson Air Force Base) near Dayton, Ohio, created the collection to document the development of aircraft and facilities at the bases. For the early history of the bases, see *Collection Origins* in AS·326. After World War II Wright Field combined with Patterson Field to become Wright-Patterson Air Force Base. Base personnel designed, developed, and tested military aircraft; developed emergency and survival equipment; and investigated aircraft accidents. Most of the photographs were used to illustrate investigation and test reports.

In 1973, when the collection became too large to be kept at the base, parts were given to the Air Force Museum at Wright-Patterson, the Air Force Central Still Photographic Depository (now part of the Department of Defense Still Media Records Center), and the Experimental Aircraft Association in Franklin, Wisconsin. In 1975 the latter facility transferred its material to the University of Wisconsin, which donated it to NASM in 1981. NASM Archives assigned the collection accession number XXXX-0172.

Physical Description

There are 300,000 photographs including color dye coupler photoprints, silver gelatin dry plate photonegatives, and silver gelatin photonegatives and photoprints.

Subjects

The photographs document the U.S. Army and Air Force's activities, aircraft, and facilities at McCook Field, Wright Field, and Wright-Patterson Air Force Base. Activities documented include construction of aircraft and facilities, crash investigations, demolition (including dynamiting) of facilities, a fair, and tests of aircraft parts and equipment. Aircraft documented include biplanes, bombers, fighters, helicopters, seaplanes, trainers, and transports. Facilities shown include an assembly shop, balloon shed, barracks, control tower, field radio laboratory, gasoline fueling system, guard house, gun range, hangars, machine shop, mess halls, meteorological station, offices, railroad tracks, research laboratories, runways, stables, storage buildings, torque stand, wind tunnels, and a wood-working machine. There are also aerial views of the bases and portraits of soldiers, workmen, and a group at Orville Wright's home on the anniversary of the first flight (1936).

Arranged: By date and assigned number.

Captioned: With subject; most also with date.

Finding Aid: Partial box list.

Restrictions: The collection, located at the Garber Facility, is available by appointment only.

AS·330

Wright Medal Presentation Scrapbook

Dates of Photographs: 1908–1909

Collection Origins

The Aero Club of America (1905–1922) created the collection to commemorate its presentation of medals to Wilbur and Orville Wright. Formed to advance avi-

ation and spread information about the field, the Aero Club was reorganized as the National Aeronautic Association in 1922. President William Howard Taft presented the Aero Club medals to the Wrights on June 16, 1909. Many newspapers gave copies of their articles, cartoons, and editorials about the event to the Club, which included them in this commemorative book. NASM Archives assigned the collection accession number XXXX-0324.

Physical Description

There are 11 photographs including kallitypes and silver gelatin photoprints, mounted in a scrapbook. Other materials include correspondence, newspaper clippings, and speeches, also mounted in the scrapbook.

Subjects

The photographs document Wright aircraft, their flights, and the presentation of Aero Club medals to Wilbur and Orville Wright. Flights documented include Wilbur Wright flying in France and Virginia. There are also portraits of Orville Wright with other people and photographic reproductions of the Aero Club medals.

Arranged: No.

Captioned: With date and subject.

Finding Aid: No.

Restrictions: The collection, located at the Garber Facility, is available by appointment only.

AS·331

Alexa Von Tempsky Zabriskie Scrapbook

Dates of Photographs: 1940–1946, 1970s

Collection Origins

Alexa Von Tempsky Zabriskie (1893–1975) created the collection to document World War II servicemen stationed at the Naval Air Station Kahuli, near her home in Hawaii. During the 1940s Zabriskie opened her home to the servicemen, keeping photographs of many of the Navy units.

Physical Description

There are 1,500 silver gelatin photoprints, mounted in an album.

Subjects

The photographs portray World War II Navy servicemen stationed in Hawaii who visited Alexa Von Tempsky Zabriskie's home, shown individually and in groups. There are also images of Zabriskie and her house and land. Navy units portrayed include Air Group 52, Bombing 19, CAG 50, CARDIV 22, CVG-10, VB-6, VC-66, VF-1, VF-2, VF-8, VF-9, VF-86, VF-21, VJ-3, VS-66, VT-3, VT-9, VT-13, and VT-22.

Arranged: No.

Captioned: Some with individual's or unit's name.

Finding Aid: List of Navy units portrayed.

Restrictions: The collection is kept in the Ramsey Room at the NASM Archives on the Mall. Researchers must be accompanied by a staff member and are encouraged to call or write for an appointment.

AS·332

Zeppelin Photographs

Dates of Photographs: 1930s

Collection Origins

NASM assembled the collection to document Zeppelin airships in the 1930s. The Zeppelin company produced some of the images for publicity portfolios. The photographs are reproduced on NASM's Archival Videodisc 7. For information on how to order the videodisc, see the *Collection Origins* field of *AS·1*.

Physical Description

There are 160 silver gelatin photoprints, including a stereograph. Other materials include advertisements, drawings, forms, newspaper clippings, and photomechanical prints.

Subjects

The photographs document the operations of Zeppelin airships in the 1930s, especially the LZ-130. Activities and events documented include airship construction, fires, and meal services, as well as flights in various places such as across oceans and over ships. Airship facilities shown include hangars and passenger cabins. There are portraits of airship crews, crowds, and passengers. There are also aerial views of landscapes taken from the airships, as well as photographic reproductions of engineering drawings.

Arranged: By videodisc frame number.

Captioned: With videodisc frame number.

Finding Aid: Caption database listing videodisc frame number. Printouts can be obtained for single photographs or caption lists of photographs with related subjects.

Restrictions: No. The collection is located at the NASM Archives on the Mall. Researchers are encouraged to call or write for an appointment.

Planetarium

Albert Einstein Planetarium
National Air and Space Museum
Smithsonian Institution
Washington, D.C. 20560
James H. Sharp, Director
Geoffrey R. Chester, Production Resources Manager
(202) 357-1529
Hours: Monday–Friday, 10 a.m.–5 p.m.

Scope of the Collection

There is one photographic collection with approximately 10,000 images.

Focus of the Collection

The photographs document astronomical objects, from meteors to distant galaxies, and the technology used to study them.

Photographic Processes and Formats Represented

There are color dye coupler slides and silver gelatin photoprints and slides.

Other Materials Represented

No.

Access and Usage Policies

Available by appointment only. Some of the images are restricted to internal use. Researchers should call or write in advance, describing their research topic, the type of material that interests them, and their research aim.

Publication Policies

Researchers must obtain permission from the Smithsonian Institution and may also have to obtain permission from the copyright holder, which is not necessarily the Smithsonian. Images from other sources must be obtained directly from the original source. The preferred credit line is "Courtesy of the National Air and Space Museum, Smithsonian Institution." The photographer's name, if known, also should appear.

AS·333

Planetarium Slide Collection

Dates of Photographs: 1960s–Present

Collection Origins

NASM Planetarium staff assembled the collection for use in Planetarium presentations and other lectures. Photographers and studios represented include Geoffrey Chester, Dixon Spacescapes, Hale Observatories, Lick Observatory, Mt. Wilson Observatory, NASA, OPPS, Palomar Observatory, and the Smithsonian Astrophysical Observatory.

Physical Description

There are 10,000 photographs including color dye coupler slides and silver gelatin photoprints and slides.

Subjects

The photographs primarily document astronomical objects such as asteroids, comets, and meteors; the Earth's solar system including the Moon, the planets, and the Sun; and stars including clusters, constellations, galaxies, and nebulae. There are also views of the Earth from space. There are images of atmospheric features, eclipses, physical properties, and surface features of the Moon, the Sun, and each planet. Images of astronomical technology include manned spacecraft, observatories, planetariums, satellites, and telescopes. There are also portraits of astronauts and astronomers, as well as photographic reproductions of charts, computer images, diagrams, and space art.

Arranged: Grouped by subject.

Captioned: With Planetarium slide number and subject; most also with date and source.

Finding Aid: Directory to half the collection, listing subject of each slide tray, posted on the slide cabinet.

Restrictions: Available by appointment only. Some images are for internal use only; copies of images from other sources must be obtained from the original source.

Public Affairs Office

Public Affairs Office
National Air and Space Museum
Smithsonian Institution
Washington, D.C. 20560
Diane Kanauka, Public Affairs Program Specialist
(202) 357-1663
Hours: Monday–Friday, 10 a.m.–5 p.m.

Scope of the Collections

There are two photographic collections with approximately 20,900 images.

Focus of the Collections

The photographs document NASM activities, artifacts, events, facilities, and galleries. There are also images of historical aeronautics and space flight events.

Photographic Processes and Formats Represented

There are color dye coupler photonegatives, photoprints, phototransparencies, and slides and silver gelatin photoprints.

Other Materials Represented

The office also contains press releases.

Access and Usage Policies

The collections are available to members of the press only. Other researchers are referred to similar images in the NASM Archives and other collections listed in this volume. Press representatives should call or write the Public Affairs Office, describing the types of images that interest them.

Publication Policies

Researchers must obtain permission from the Smithsonian Institution. The preferred credit line is "Courtesy of the National Air and Space Museum, Smithsonian Institution." The photographer's name, if known, also should appear.

AS·334

Public Affairs Press Photograph Collection

Dates of Photographs: 1960s–Present

Collection Origins

NASM Public Affairs staff created the collection as a source of publicity images for press coverage of the museum. Staff photographers took most of the images; outside studios represented include Lockheed Corporation and NASA.

Physical Description

There are 3,200 photographs including color dye coupler photonegatives, photoprints, phototransparencies, and slides and silver gelatin photoprints. Other materials include press releases.

Subjects

The photographs primarily document NASM artifacts and galleries, as well as historical aerospace events. NASM space artifacts depicted include the Apollo command module *Columbia,* the Lunar Module, the Lunar Orbiter, lunar rocks, the Mercury capsule *Friendship 7,* a model of the Apollo-Soyuz Test Project, a model of the solar system, the Skylab Orbital Workshop, space suits, and the Viking lander. Other NASM aircraft shown include the *Double Eagle II* balloon, the *Enola Gay,* Goddard rockets, helicopters, jets, the Langley Aerodrome, the North American X-15, the Ryan NY-P *Spirit of St. Louis,* a V-2 missile, and the Wright 1903 Flyer. NASM facilities shown include the Garber Facility, Langley Theater, museum exterior, Planetarium, and restaurant. NASM galleries documented include Exploring the Planets, the Golden Age of Flight, Sea-Air Operations, Social Impact of Flight, Stars, and World War I Aviation. There are also photographic reproductions of NASM murals.

Activities and objects documented outside of NASM include aircraft carrier operations; the Concorde; early airplane flights; the Goodyear blimp; hang gliders; Korean War planes; NASA programs such as Apollo, Skylab, and the Space Transportation System; Sikorsky helicopters; and V-2 missile development. People portrayed include inventor Igor I. Sikorsky and pilots Charles A. Lindbergh, Wiley Post, and Charles E. ("Chuck") Yeager, as well as African American World War II pilots, NASA astronauts, and women pilots.

Arranged: By NASM gallery or other topic.

Captioned: Most with OPPS negative number and subject.

Finding Aid: No.

Restrictions: Available to members of the press only.

AS·335

Public Affairs Press Slide Collection

Dates of Photographs: 1970s–Present

Collection Origins

NASM Public Affairs staff created the collection as a source of publicity photographs for use by the press.

Physical Description

There are 17,700 color dye coupler slides.

Subjects

The slides document NASM activities, events, facilities, and galleries. Activities and events shown include artifact conservation, building construction, a Garber Facility open house, NASM's opening day in 1976, and visits by people such as Chinese premier Deng Xiaoping. Facilities depicted include the Garber Facility, the Langley Theater, lobbies (with murals), the Planetarium, and the tour desk. Galleries documented include Apollo to the Moon, Balloons and Airships, Early Flight, Flight Technology, Flight Testing, the Golden Age of Flight, the Hall of Air Transportation, Jet Aviation, Milestones of Flight, Pioneers of Flight, Rocketry and Space Flight, and World War I Aviation.

Arranged: By gallery or other facility.

Captioned: Most with SI negative number; some also with subject.

Finding Aid: List of slide trays by subject.

Restrictions: Available to members of the press only.

Publications Office

Publications Office
National Air and Space Museum
Smithsonian Institution
Washington, D.C. 20560
Patricia J. Graboske, Chief
(202) 357-1838
Hours: Monday–Friday, 10 a.m.–4 p.m.

Scope of the Collection

There is one photographic collection with approximately 900 images.

Focus of the Collection

Most of the photographs are reproductions of the covers of NASM books. Other images are used in NASM publications, documenting NASM activities and artifacts, as well as non-NASM artifacts and historical aerospace events.

Photographic Processes and Formats Represented

There are color dye coupler photoprints, phototransparencies, and slides and silver gelatin photonegatives and photoprints.

Other Materials Represented

No.

Access and Usage Policies

Available to SI staff only. Researchers should first go to NASM Archives, which has duplicates of much of the material. Images from Harry N. Abrams, Inc., publications are for NASM staff use only; outside researchers must obtain these images directly from Abrams.

Publication Policies

Researchers must obtain permission from the Smithsonian Institution and may also have to obtain permission from the copyright holder, which is not necessarily the Smithsonian. The preferred credit line is "Courtesy of the National Air and Space Museum, Smithsonian Institution." The photographer's name, if known, also should appear.

AS·336

Publications Office Photographs

Dates of Photographs: 1960s–Present

Collection Origins

NASM Publications Office staff created the collection from photographs reproducing covers of NASM books, as well as those used in or considered for NASM publications. The photographs appeared in many NASM publications, including director's reports, pamphlets, research reports, and monographs such as the following: 1) C.D.B. Bryan. *The National Air and Space Museum*. New York: Harry N. Abrams, Inc., 1979. 2) Deborah G. Douglas. *United States Women in Aviation, 1940–1985*. Washington, D.C.: Smithsonian Institution Press, 1991. 3) Florence C. Mayers. *ABC: The National Air and Space Museum*. New York: Harry N. Abrams, Inc., 1987.

Physical Description

There are 900 photographs including color dye coupler photoprints, phototransparencies, and slides and silver gelatin photonegatives and photoprints (some contact sheets).

Subjects

Most of the photographs reproduce the covers of NASM publications; others illustrate NASM activities, artifacts, and galleries. NASM activities documented include ceremonies, conservation work, festivals, research, and video disc operation. Other activities illustrated include balloon and aircraft flights, spacecraft launches, and Space Shuttle operations. NASM and other artifacts shown include aircraft such as NASA satellites and spacecraft, World War I and World War II fighters, and the Wright 1903 Flyer; flight clothing and space suits; instruments such as control panels and telescopes; and weapons such as guns and rockets.

NASM facilities shown include the Garber Facility, the IMAX theater, lobbies, the museum shop, the Planetarium, and the Ramsey Room. NASM galleries documented include Apollo to the Moon, Balloons and Airships, Exploring the Planets, the Golden Age of Flight, and Milestones of Flight. There are also IMAX motion-picture film stills and images of planets and stars.

Arranged: By publication or topic.

Captioned: Some with OPPS negative number, page number, and publication information; a few also with subject.

Finding Aid: No.

Restrictions: Available to SI staff only. Images from Harry N. Abrams, Inc., publications are for NASM staff use only; outside researchers must obtain these images directly from Abrams.

Registrar's Office

Registrar's Office
National Air and Space Museum
Smithsonian Institution
Washington, D.C. 20560
Ellen Folkama, Registrar of Loans (202) 357-2883
Natalie Rjedkin Lee, Registrar of Collections (202) 357-2717
Hours: Monday–Friday, 8 a.m.–4 p.m.

Scope of the Collection

There is one photographic collection with approximately 60,000 images.

Focus of the Collection

The images document many of NASM's accessioned objects, including accession, conservation, installation, and promotional photographs.

Photographic Processes and Formats Represented

There are color dye coupler photoprints and slides and silver gelatin photoprints.

Other Materials Represented

The office also contains accession records and correspondence.

Access and Usage Policies

Researchers should first contact the NASM Archives, whose staff will assist them in obtaining necessary Registrar's records as well as copy images. Registrar's Office staff will answer telephone and written inquiries about collection objects.

Publication Policies

Researchers must obtain permission from the Smithsonian Institution and may also have to obtain permission from the copyright holder, which is not necessarily the Smithsonian. The preferred credit line is "Courtesy of the National Air and Space Museum, Smithsonian Institution." The photographer's name, if known, also should appear.

AS·337

Registrar's Accession Files

Dates of Photographs: 1970s–Present

Collection Origins

Registrar's Office staff created the collection to document NASM's accessioned objects for collections management, conservation, and publicity purposes.

Physical Description

There are 60,000 photographs including color dye coupler photoprints and slides and silver gelatin photoprints. Other materials represented include accession records and correspondence.

Subjects

The photographs document many of NASM's accessioned objects, especially aircraft, some during conservation treatment and in exhibits. Objects shown include autogyros, balloons, experimental aircraft, helicopters, kites, military aircraft, racers and record-making aircraft, rockets, sailplanes, and satellites and spacecraft. There are images of aircraft parts such as cockpits, engines, and propellers; flight clothing such as military uniforms and space suits; and weapons such as bombs and machine guns. There are also photographic reproductions of aviation and space art.

Arranged: By accession number.

Captioned: With accession number and negative number; some also with subject.

Finding Aid: 1) Inventories listing all objects by category, including accession number and description. 2) Computer database in progress, which will also include OPPS negative numbers of all images of the object.

Restrictions: To use the files for research and to order copy images, contact NASM Archives (see the Archives section above).

Special Events Office

Special Events Office
National Air and Space Museum
Smithsonian Institution
Washington, D.C. 20560
Kathie Spraggins, Special Events Manager
(202) 357-4022
Hours: Monday–Friday, 10 a.m.–5 p.m.

Scope of the Collection	There is one photographic collection with approximately 270 images.
Focus of the Collection	The photographs document special events held at NASM, primarily during the last two years.
Photographic Processes and Formats Represented	There are color dye coupler slides and photoprints and silver gelatin photoprints.
Other Materials Represented	The office also contains agendas, correspondence, invitations, mailing lists, pamphlets, and programs.
Access and Usage Policies	Available by appointment only. Some of the images are for reference only and may not be duplicated. Researchers should call or write in advance, describing their research topic, the type of material that interests them, and their research aim.
Publication Policies	Researchers must obtain permission from the Smithsonian Institution and may also have to obtain permission from the copyright holder, which is not necessarily the Smithsonian. The preferred credit line is "Courtesy of the National Air and Space Museum, Smithsonian Institution." The photographer's name, if known, also should appear.

AS·338

Special Events File

Dates of Photographs: 1979–Present

Collection Origins

NASM Special Events staff created the collection to document activities arranged by the office. Most of the files are kept for two years, after which they are sent to SI Archives. Some of the images have been published in the SI employee newsletter, the *Torch*.

Physical Description

There are 270 photographs including color dye coupler photoprints and slides and silver gelatin photoprints (some contact sheets). Other materials represented include agendas, correspondence, invitations, mailing lists, pamphlets, and programs.

Subjects

The photographs document NASM special events, including images of the preparations, decorations, and activities. Events illustrated include award dinners, government ceremonies, motion-picture film screenings, presidential inaugural balls, and receptions. People portrayed include generals, NASM officials, presidents such as George Bush and Ronald Reagan, and senators.

Arranged: Chronologically.

Captioned: Most with OPPS negative number, some also with subject.

Finding Aid: No.

Restrictions: Available by appointment only. Some images are for reference only and may not be duplicated.

Creators Index

The creators index lists individuals and groups who produced or assembled images in Smithsonian Institution photographic collections. Creators include photographers, studios, distributors, manufacturers, curators, researchers, donors, artists, and collectors. Collection names or titles also are listed in this index because they sometimes provide the only existing clues to the collection's origins.

All creators' names appearing in the *Collection Origins* field of this volume are listed in this index. Since this book is not an item-level survey, some photographers and studios whose work is represented in the National Air and Space Museum may not appear in the text. The names of the photographers who are listed were checked against the following authorities:

William L. Broecker, ed. *International Center of Photography Encyclopedia of Photography.* New York: Crown Publishers, Inc., 1984.

Andrew H. Eskind and Greg Drake, eds. *Index to American Photographic Collections.* Boston, Massachusetts: G.K. Hall & Co., 1990.

Colin Naylor. *Contemporary Photographers.* Chicago, Illinois: St. James Press, 1988.

The creators index, like the subject and forms and processes indexes, is arranged according to letter-by-letter alphabetization. Phrases beginning with numerals are alphabetized as if they were spelled out; for example, "1st Aero Squadron" is listed under "F." Photographers are listed alphabetically by surname. Photographers associated with a studio may be listed under both the studio name and their personal name. Corporate creators are listed in strict alphabetical order. For example, "P.F. Collier & Son" is listed under "P" rather than under "C," although there is a cross-reference from "Collier" to "P.F. Collier & Son." Individuals shown in a photograph are listed in the subject index.

Information in parentheses following a name is generally a fuller form of the same name. Cross-references beginning with the instruction *See* indicate alternate forms of the same name that are used for indexing. *See also* references indicate additional names under which related information may be found.

Researchers unable to find a creator's name should check for possible pseudonyms or alternative spellings. (These are provided when known.) Next, check the names of related studios, employers, or organizations.

The collection codes indicate the location of the collection entry within the volume. For example, *AS-2* indicates that the reader should check the second collection report.

ABC Newspictures, AS273
A.C. Andreason Scrapbook, AS218
Accessions Photograph File, AS32
Acme, AS61
Aerial Photographic Reconnaissance
 Collection *A.K.A.* Samuel L.
 Batchelder Collection, AS35
Aero Club of America, AS213, AS330
Aero Digest, AS150, AS219
Aerojet Engineering Corporation, AS30,
 AS76, AS278
Aeronautical History Scrapbooks,
 AS36
Aeronautics Department Aviation
 Clothing File, AS3
Aeronautics Department Curators' File,
 AS4
Aero Service Corporation Collection,
 AS163
A. Francis Arcier Collection, AS48
Air-Britain Film Unit, AS172
Aircraft of NASM Photograph
 Collection, AS5
*Aircraft of the National Air and Space
 Museum* Collection, AS37
Aircraft of the 1930s Photograph
 Collection *A.K.A.* Lois Kuster
 Scrapbook, AS38
Aircraft Radio Corporation, AS39
Aircraft Radio Corporation Records
 A.K.A. Gordon White Collection,
 AS39
Aircraft Recognition Training Materials
 A.K.A. U.S. Navy Recognition
 Training Slides Collection, AS40
Aircraft Scrapbook Material *A.K.A.*
 Claude A. Grimm Collection, AS41
Air Force. *See* U.S. Air Force.
Air Force Central Museum, AS49
Air Mail Pioneers, AS310
Air Materiel Command. *See* U.S. Army
 Air Service Engineering Division.
Air Ministry (England), AS153
Air Technical Service Command, AS48
Air University Library. *See* Maxwell Air
 Force Base.
A.J. Ostheimer Autograph and
 Photograph Collection, AS226
Akron Beacon Journal, AS213
Albert W. Seypelt Collection, AS262
A. Leo Stevens and Edward R. Boland
 Memorabilia, AS275
Alexa Von Tempsky Zabriskie
 Scrapbook, AS331
Alexis B. McMullen Papers, AS189
Alfred R. Weyl and Peter Grosz
 Collection, AS311
Alfred V. Verville Papers, AS305
Allen, James G., AS43
Allison Photograph Collection, AS42
American Airlines, AS286
American Astronautical Society, AS43
American Astronautical Society Records,
 AS43
American Rocket Society, AS76
American Views, AS168

American Volunteer Group, AS44,
 AS119
American Volunteer Group Collection
 A.K.A. Larry Pistole Collection, AS44
Andreason, A.C., AS218
Andrew G. Haley Papers, AS138
Ankers, Del. *See* Del Ankers
 Photographers.
Anthony, Edward, AS168
Anton Schlein Portfolio, AS258
AP. *See* Associated Press.
Apollo Mission Images Collection, AS45
Apollo Program Mission Files, AS46
Apollo-Soyuz Test Project Images
 Collection, AS47
Applied Physics Laboratory, AS14
Aramco, AS202
Archie, AS293
Archivo General de las Indias (Spain),
 AS29
Arcier, A. Francis, AS48
Armament Files, AS49
Army Air Corps. *See* U.S. Army Air
 Corps.
Army Air Forces. *See* U.S. Army Air
 Forces.
Army Air Service. *See* U.S. Army Air
 Service.
Arnold, C.D., AS168
Arnold, Leslie P., AS50
Arnold, Rudy, AS51
Arnold Egeland Airlines Collection,
 AS105
A. Roy Knabenshue Aircraft
 Photographs (Oversized), AS166
Arrow Studio, AS68
Art Department Photograph Collection,
 AS11
Arthur Nutt Papers, AS223
Arthur Raymond Brooks Collection,
 AS70
Arthur Whitten-Brown Collection
 A.K.A. Nancy Hamilton Donation,
 AS312
Ashmore, L. Badford, Jr., AS23
Associated Photographers, AS110
Associated Press, AS125, AS263
Autographed Photograph Collection,
 AS52
Avco Corporation, AS223
Avery, William, AS53
Aviation and *Aviation Week* Photograph
 and Report Collection, AS54
Aviation History Project, AS209
Aviation Manufacturing Corporation,
 AS107
Aviation Societies and Clubs Scrapbook,
 AS55
Aviation Training Schools Scrapbooks
 A.K.A. Theodore C. Macaulay
 Collection, AS56
Avino, Mark, AS11, AS325
Aviodome (Netherlands), AS24

Bachman, Al, AS106
Bahamas News Bureau, AS213

Barnaby, Ralph S., AS57
Bartlett, Dennis W., AS205
Basil Lee Rowe Collection, AS252
Batchelder, Samuel L., AS35
Baum, William, AS14
Beatty, George W., AS58
Beech Aircraft, AS59
Beech Aircraft and Gates Learjet Public
 Relations Collection *A.K.A.* Vern
 Modeland Collection, AS59
Beech Aircraft Company, AS230
Beech Aircraft Corporation, AS85,
 AS213, AS280
Beech Model 17 Photographs, AS60
Bell Aircraft Corporation, AS37, AS66,
 AS254
Bendix Air Races Collection, AS61
Bendix Corporation, AS61, AS246
Benjamin Ruhe Collection, AS253
Benner, H.M., AS171, AS303
Berkeley Daily Gazette, AS290
Berliner, Emile, AS62
Berliner, Henry A., AS62
Berliner Helicopter Scrapbooks, AS62
Bernard J. Vierling Collection, AS302
Beverly "Bevo" Howard Collection,
 AS144
"Beyond the Limits" Photograph
 Collection, AS12
B.F. Goodrich Rubber Company, AS36
Biblioteca Nacional (Spain), AS29
Bicentennial of Air and Space Flight. *See*
 U.S. Organizing Committee for the
 Bicentennial of Air and Space Flight;
 U.S. Organizing Committee for the
 Bicentennial of Air and Space Flight
 Records.
Bigelow, Bruce M., AS86
Birkett, F.N., AS58
Black, Harold, AS144
Blackburn and General Aircraft, AS313
"Black Wings" Collection, AS63
Blanche Stuart Scott Memorabilia,
 AS259
Blazek, AS120
Bleecker, Maitland B., AS64
Bodie, Catherine C., AS65
Bodie, Warren M., AS65
Bodine, John, AS66
Boedecker, Kenneth J., AS84
Boeing, AS29, AS37, AS175
Boen, Herbert P., AS67
Boland, Edward R., AS275
Bonanza Airlines, AS244
Bonner, H.M., AS160
Bonwick, Rosie, AS137
Borden, Marvin J., AS192
Boston Journal, AS160
Boteler, Lawrence H., AS260
Bowman, Leslie, AS68
Bowman, Lorraine, AS68
Bowman, Marguerite, AS68
Boyne, Walter J., AS69
Brady & Company, AS168
Breaker, Helen Pierce, AS170
Bristol Aeroplane Company, AS153

British Air Ministry. *See* Air Ministry (England).

British Field Navy Department. *See* Field Navy Department (England).

British Information Service, AS313

Bronte, Emory B., AS269

Broody, AS144

Brooks, Arthur Raymond, AS70

Brosius, Harry, AS323

Brown & Schroeder, AS188

Brown Bros., AS104

Bruce, David, AS299

Buck, G.V., AS140

Bulkley, N.T., AS168

Bureau of Standards. *See* U.S. Bureau of Standards.

Burke, E. Woodward, AS71

Burke, Stephen W., AS71

Burt, Joseph, AS58, AS185

California Institute of Technology, AS29

Campbell, Thomas F., AS58

Caproni di Taliedo, Giovanni G.L., AS72

Carey, D.H., AS73

Carl H. Claudy Collection, AS77

Carl N. Nelson Collection, AS220

Carlson & Bulla, AS280

Cauch, C.O., AS120

Caunter, Cyril F., AS74

Central News Photo Service, AS49

Ceruzzi, Paul E., AS12

Charles, Mary, AS75

Charles A. and Anne Lindbergh Autographed Photographs and Watercolor, AS178

Charles Collyer Scrapbook and Memorabilia, AS81

Charles D. Walcott Scrapbook, AS307

Charles F. Walsh Scrapbooks, AS308

Charles I. Stanton, Sr., Papers, AS273

Charles L. Morris Helicopter Scrapbook, AS200

Charles R. Page Scrapbook, AS229

Charles S. Sheldon II Papers, AS263

Charles W. Chillson Papers, AS76

Chicago Daily News, AS213

Chillson, Charles W., AS76

Chrysler Corporation, AS174

City News Bureau, AS302

Civil Aeronautics Authority, AS273

Clara Studer Collection, AS90

Claude A. Grimm Collection, AS41

Claudy, Carl H., AS77

Clemens, Alpha R., AS88

Clemens, Anna B., AS88

Clement M. Keys Papers, AS165

Clifford V. Evans, Jr., and George W. Truman Scrapbook, AS108

Clinedinst, AS121

Coanda, Henri-Marie, AS78

Coast Guard. *See* U.S. Coast Guard.

Coffyn, Frank T., AS79

Cole, Keith. *See* Keith Cole Studio.

College Park Airport Collection *A.K.A.* Fred C. Knauer Collection, AS80

Collier, P.F. *See* P.F. Collier and Son.

Collier's Weekly, AS142, AS160

Collyer, Charles B.D., AS81

Commerce, Department of. *See* U.S. Department of Commerce.

Computer History Slide Set, AS13

Computer Museum, AS13

Continental, Inc., AS82

Continental, Inc., Records, AS82

Convair, AS26, AS65

Coon, Nelson, AS112

Copland, Harry D., AS83

Court, AS257

Cross Section of Aviation Personnel Scrapbooks *A.K.A.* Kenneth Boedecker Scrapbooks, AS84

Crouch, Tom D., AS85, AS209

Cunningham, E.H., AS122

Curran Machine Works, AS57

Curtis, John S., AS86

Curtiss, Glenn H., AS89, AS90, AS171

Curtiss, Glenn H., Jr., AS89

Curtiss Aerophoto, AS57

Curtiss Aeroplane and Motor Company, AS9, AS87

Curtiss Eagle Sightseeing Flights Scrapbook *A.K.A.* George A. Page, Jr., Scrapbook, AS87

Curtiss Flying School Photograph Collection *A.K.A.* Alpha R. Clemens Photograph Collection, AS88

Curtiss La Q. Day Scrapbooks, AS96

Curtiss NC-4 Collection *A.K.A.* Richard K. Smith Collection, AS91

Curtiss NC-4 Design, Construction, and Testing Reports, AS92

Curtiss-Wright Corporation, AS93, AS94

Curtiss-Wright Corporation Propeller Division Records, AS93

Curtiss-Wright Corporation Records, AS94

Custer Channel Wing Corporation, AS220

Cyril F. Caunter Collection, AS74

DACOWITS. *See* Defense Advisory Committee on Women in the Services.

Dale B. Sigler Early Naval Aviation Scrapbook, AS264

Danielwicz, Eugene, AS260

Davenport, William M., AS95

Davis, Benjamin O., Jr., AS63

Day, Curtis, AS150

Day, Curtiss La Q., AS96

Decker, Florence, AS323

Defense Advisory Committee on Women in the Services (DACOWITS), AS97

Defense Advisory Committee on Women in the Services (DACOWITS) Collection, AS97

De Havilland, AS153

Del Ankers Photographers, AS213, AS290, AS302, AS322

De Palma, Victor, AS219

Department of Commerce. *See* U.S. Department of Commerce.

Deutsches Museum, AS14

DeVorkin, David, AS14, AS22, AS27

De Vos, AS188

D.H. Carey Scrapbooks, AS73

Dick Whittington Photography, AS54, AS280

Dizon, Edith A., AS236

Donald J. Ritchie Papers, AS246

Donald Putt Scrapbook, AS240

Doolittle, Arthur K., AS319

Dornier Do X Aircraft Scrapbook, AS98

Doughty, T.M.V., AS168

Douglas, Deborah G., AS291

Dow, William, AS14

Dow Chemical, AS22

Drashpil, Boris V., AS9

Dribben, Irwin, AS147

Dudley Observatory, AS268

Durant, Frederick C., III, AS99

Duval, Danlon, AS298

Eagle Squadron Photograph Collection, AS100

Eaker, Ira C., AS101

Early Aviation (Circa 1910) Scrapbook, AS102

Early Aviation Photographs *A.K.A.* Frank H. Russell Collection, AS103

Early Aviation Scrapbook, AS104

Early Rocketry Photograph Collection, AS14

Eck, William J., AS114

Edgeworth, AS122

E.D. "Hud" Weeks Aviation Memorabilia, AS310

E.D. "Hud" Weeks Collection, AS310

Edmondson, F.K., AS26

Edward H. Holterman Scrapbook, AS150

Edward J. Steichen World War II Navy Photograph Collection, AS10

Edwin C. Parsons Scrapbook, AS232

Egeland, Arnold, AS105

Eggers, William T., AS309

Eglin Air Force Base Phototransparency Collection, AS6

Ellington Field Scrapbooks *A.K.A.* W.H. Frank Scrapbooks, AS106

Elliott, Derek W., AS17, AS18, AS20, AS21

Ellsworth Schell News Picture Service, AS174

Elton R. Silliman Papers, AS265

Engine Design Reports, AS107

Engineering Division, Army Air Service. *See* U.S. Army Air Service Engineering Division.

Enterprise Photograph Collection, AS15

Eric Lundahl Photograph Collection, AS180

Ernest Jones Papers, AS160

Ernest Smith and Emory Bronte Flight Scrapbook, AS269

Evans, Clifford, AS309

Evelyn L. Irons Scrapbook, AS156
E. Woodward Burke Scrapbook, AS71
Exhibition Flight Collection, AS109
Experimental Aircraft Association, AS329

FAA. *See* Federal Aviation Administration.
Fairchild Aircraft, AS212
Fairchild Camera and Instrument Corporation, AS111
Fairchild Industries, AS110
Fairchild Industries, Inc., Collection, AS110
Fairchild KS-25 High Acuity Camera System Documentation, AS111
Fawcett, Waldon, AS198
Federal Aviation Administration (FAA), AS213, AS302
Feik, Mary, AS57
Field Navy Department (England), AS153
Field Studios, AS75
58th Aero Squadon Scrapbook A.K.A. Nelson Coon Scrapbook, AS112
Finne, K.N., AS9
1st Aero Squadron Scrapbooks A.K.A. Richard T. Pilling Scrapbooks, AS113
First Pan American Airways Transatlantic Passenger Flight Scrapbook A.K.A. William J. Eck Scrapbook, AS114
Fiske, Gardiner H., AS115
Fleet Air Photo Lab, AS305
Flight Safety Foundation, AS116
Flight Safety Foundation Collection A.K.A. Jerome Lederer Collection, AS116
Flodin Photograph Collection A.K.A. Isle of Grain Photograph Collection, AS117
Flying Allens Scrapbook, AS118
Flying Tigers Photographs A.K.A. Walter W. Pentecost Collection, AS119. *See also* American Volunteer Group.
Foa, Joseph, AS239
Folland Aircraft, AS65
Ford Library, AS26
Forsythe, Albert E., AS63
Fort Bliss, AS233
Fotokhronika Tass, AS282
Fowler, Harold S., AS120
Fowler World War I Scrapbook, AS120
Foxworth, Thomas G., AS143
Francis L. Moseley Avionics Collection, AS201
Frank, W.H., AS106
Frank G. Manson Patent Collection, AS182
Frank H. Russell Collection, AS103
Franklin Institute, AS22, AS57
Frank P. Lahm Collection, AS170
Frank T. Coffyn Scrapbooks, AS79
Fravel, Ira F., AS121
Fray, Lee, AS194
Fred C. Knauer Collection, AS80

Frederick C. Durant III Collection, AS99
Frederick Weber's Studio of Photography, AS310
Fred Parker Scrapbook, AS231
French Pictorial Service, AS74
Friedman, Robert K., AS301
Fulton, Garland, AS177
Furrow, George C., AS122
Furrow, L.D., AS122

Gage, F.B., AS168
Gagnon, T., AS308
Garber, Maurey, AS140
Garber, Paul E., AS290
Gardiner H. Fiske Scrapbook, AS115
Garland Fulton Collection, AS177
Gatchina Days: Reminiscences of a Russian Pilot Photographs, AS123
Gately, J. Rome, AS124
Gately, William R., AS124
Gates-Day Aircraft Corporation, AS140
Gates Learjet, AS59
General Dynamics, AS29
General Electric, AS29, AS313
General News Bureau, AS278
General Photographic Service, AS305
George, Clarence, AS303
George A. Page, Jr., Scrapbook, AS87
George B. Harrison Collection, AS142
George B. "Slim" Purington Scrapbook, AS241
George C. Furrow Papers, AS122
George H. Fisher, Jr., Scrapbook, AS261
George J. Goldthorpe & Company, AS281
George L. Lewis Scrapbook, AS318
George Meese Photograph Collection A.K.A. Richard Segar Photograph Collection, AS192
George P. Sutton Collection, AS278
Georges Naudet Collection, AS217
George W. Beatty Papers, AS58
George W. Wood, Jr., Diaries, AS317
Gerard P. Herrick Papers, AS147
German Commercial Zeppelins Scrapbooks, AS125
German World War I Scrapbook, AS126
G. Harry Stine Collection, AS78
Gill, Howard W., AS127
Gilpatric, J. Guy, AS128, AS129
Giovanni G.L. Caproni di Taliedo Collection, AS72
Glasier, F.W., AS166
Glenn H. Curtiss Collection, AS89
Glenn H. Curtiss Motorcycles Scrapbook A.K.A. Clara Studer Collection, AS90
Glenn H. Curtiss Museum of Local History, AS9
Glenn L. Martin Company, AS130
Glenn L. Martin Company Photograph Archives, AS130
Goddard, Robert H., AS131
Goddard Report of August 1929 Photographs, AS131

Goldthorpe, George J. *See* George J. Goldthorpe & Company.
Goodrich Rubber Company. *See* B.F. Goodrich Rubber Company.
Goodyear Aerospace Collection, AS132
Goodyear Aerospace Corporation, AS132, AS134
Goodyear Aircraft Corporation, AS227
Goodyear Aircraft News Service, AS263
Goodyear Balloon School Collection, AS133
Goodyear Tire and Rubber Company, AS133
Goodyear ZPG-3W Collection, AS134
Gordon White Collection, AS39
Gott, Edgar N., AS66
Graetz Brothers, AS273
Graphic Studio, AS110
Greater Manchester Museum of Science and Industry, AS24
Green, Marvin M., AS320
Greenberg, Jack. *See* Jack Greenberg Studio.
Grimm, Claude A., AS41
Groenhoff, Hans, AS135, AS144
Grosz, Peter, AS9, AS311
Grumman Corporation, AS26
Grumman SA-16 Albatross Crash Research Collection, AS136
Guard-Lee, Inc., AS23
Gwynn-Jones, Terry, AS137, AS315

Haley, Andrew G., AS138
Hall, Randolph F., AS139
Hamilton, Nancy, AS312
Hammer, William J., AS140
Hanley, Julian R., AS141
Hannum, P.M., AS144
Hans Groenhoff Photograph Collection, AS135
Hardesty, Von D., AS9, AS63, AS209
Hardy, Joseph, AS63
Hare, Jimmy, AS79, AS142, AS160
Harold G. Peterson Scrapbook, AS235
Harold H. Tittman Scrapbook, AS284
Harris & Ewing, AS66, AS142, AS270, AS289
Harrison, George B., AS142
Harry Brosius Photograph Collection, AS323
Harry D. Copland Slides, AS83
Hartsook, AS158, AS290
Harvard-Boston Air Meet Photographs A.K.A. Thomas G. Foxworth Collection, AS143
Harvey H. Lippincott Photograph Collection, AS179
Hattie Meyers Junkin Papers, AS161
Haworth, John, AS213
Hawthorne Flying School Collection A.K.A. Beverly "Bevo" Howard Collection, AS144
Hedgpeth, James A., Jr., AS321
Heeren, Rodman A., AS199
Henize, Karl G., AS145

Henri-Marie Coanda Papers *A.K.A. G. Harry Stine Collection*, AS78
Henry E. Toncray Scrapbook, AS285
Hensley Photograph Collection, AS146
Herbert H. Rust Photograph Collection, AS254
Herbert P. Boen Lockheed Collection, AS67
Herken, Gregg F., AS30
Hermann Oberth Collection, AS224
Herrick, Gerard P., AS147
Hildegard K. Kallmann-Bijl Papers, AS162
Hiller Aircraft Company, AS148
Hiller Aircraft Photographs, AS148
Hiller Museum, AS148
Hiram S. Maxim Collection, AS187
Hoffman, William, AS149
Hollywood Studio, AS213
Holterman, Edward H., AS150
Honeyman, Marion S., AS151
Horace W. Karr Scrapbook, AS296
Houdini, Harry, AS277
Howard, Beverly "Bevo," AS144
Howard W. Gill Scrapbooks, AS127
Hughes Aircraft Company, AS19
Hunsaker, Jerome C., AS152
Hurd, Harold, AS63
Hurrel, AS75
Hutchison, Joseph D., AS214

Ide, John J., AS153
Imperial War Museum, AS282
Independence. See S.S. Independence.
India-Burma Headquarters Photograph Collection *A.K.A. Joseph J. Pace Photograph Collection*, AS154
Institute of Aeronautical Sciences, AS48, AS55, AS155, AS167
Institute of Aeronautical Sciences Photograph Collection, AS155
International Commercial Photo Company, AS68
International Film Service, AS36, AS49
International News, AS54
International Space Hall of Fame, AS24
International Space Programs Slide Collection, AS16
Ira C. Eaker Collection, AS101
Ira F. Fravel Collection, AS121
Irons, Evelyn L., AS156
Isle of Grain Photograph Collection, AS117
Italian Aviation Ministry, AS279
Italian Aviation Photographs of World War I, AS157

Jack Greenberg Studio, AS314
Jacobs Photo Service, AS144
Jacoby, W.H., AS168
Jakmides, Thomas R., AS134
James A. Hedgpeth, Jr., Collection, AS321
James A. Van Allen Photograph File, AS28

James Means Aviation Scrapbooks, AS190
James Means Correspondence Collection, AS191
James R. McConnell Scrapbook, AS188
James V. Martin Aircraft Scrapbooks, AS184
James V. Martin Papers, AS185
J.D. Van Vliet Photograph Collection, AS303
Jeanne DeWolf Naatz Autograph Books, AS204
Jerome C. Hunsaker Collection, AS152
Jerome Lederer Collection, AS116
Jerwan, Shakir S., AS158
Jet Propulsion Laboratory (California Institute of Technology), AS29
J. Guy Gilpatric Photograph Collection, AS128
J. Guy Gilpatric Scrapbooks, AS129
Joe Mountain Collection, AS202
John Bodine Autographed Photograph Collection, AS66
John J. Ide Collection, AS153
John J. Queeny Scrapbook, AS242
John S. Curtis Collection, AS86
Johns Hopkins University, AS26
Johnson, Charles, AS14
Johnson, Florence, AS159
Johnson, Frances, AS14
Johnson and Mentzel, AS168
Jones, Ernest L., AS160
Joseph J. Pace Photograph Collection, AS154
J. Rome Gately Scrapbook, AS124
Juan T. Trippe Collection, AS289
Julian R. Hanley Scrapbook, AS141
Junkin, Hattie Meyers, AS161

Kalec, Inc., AS305
Kallmann-Bijl, Hildegard K., AS162
Karl G. Henize Papers, AS145
Karr, Horace W., AS296
Kauffman, Virgil, AS163
Keith Cole Studio, AS110
Kellet Aircraft Corporation, AS254
Kennedy Space Center Glass Transparency Collection, AS164
Kenneth Boedecker Scrapbooks, AS84
Kenneth M. Murray Collection, AS203
Keys, Clement M., AS165
Keystone View Company, AS168
Kilburn, B.W., AS168
King, S.A., AS168
Knauer, Fred C., AS80
Knight, R.L., AS312
Kollsman, Paul W., AS167
Kopec Photo Company, AS177
Krainik, Cliff, AS168
Krainik Ballooning Collection, AS168
Krause, Ernst, AS14
Kukol, F., AS277
Kuster, Lois, AS38

L.A. Airport Photography, AS302

Laboratory for Astrophysics Digitized Image Collection, AS31
Lahm, Frank P., AS170
Lahm Airport Memorial/Dedication Scrapbook, AS169
Lamm, Paul. *See Photo Union Paul Lamm.*
Lane, A.P., AS58
Langley Experiments (1914–1915) Scrapbooks, AS171
Lannen, Robert, AS172
Larry Pistole Collection, AS44
Law, Ruth, AS173
Lawrence, Lovell, Jr., AS174
Lawson-Bell, Susan, AS11
Lederer, Jerome F., AS116
Leet Brothers, AS185
Leo J. Windecker Projects Collection, AS314
Lerick, Edwin, AS140
Leslie and Marguerite Bowman Papers, AS68
Leslie P. Arnold Douglas World Cruiser Scrapbook, AS50
Levick, Edwin, AS160
Lewis, Cathleen S., AS16
Lewis, George L., AS318
Ley, Willy, AS175
Libbey, Eleanor Scott, AS81
Liberty Engine Photographs Scrapbook, AS176
Library of Congress, AS29, AS282, AS325
Life AS170
Lighter-Than-Air Collection *A.K.A. Garland Fulton Collection*, AS177
Lindbergh, Anne Morrow, AS178
Lindbergh, Charles A., AS178
Lippincott, Harvey H, AS179
Lockheed Corporation, AS67
Lockheed Missiles & Space Company, AS19
Lois Kuster Scrapbook, AS38
Loomis, Fred T., AS61, AS161
Lorrig, Charlie, AS194
Los Alamos Research Laboratory, AS263
Los Angeles Airport Photography. *See L.A. Airport Photography.*
Louise M. Thaden Collection, AS280
Lovell Lawrence, Jr., Papers, AS174
Lowell H. Smith Collection, AS270
Ludwig Lab, AS39
Luker, Howard, AS227
Lundahl, Eric, AS180
Lundgren, Theodore S., AS181

Macauley, Theodore C., AS56
MacCartee, C.J., Sr., AS85
MacGregor and Company, AS305
Maitland B. Bleecker Collection, AS64
Malaney, Norman, AS322
Manned Space Flight Exhibit Photographs, AS17
Manned Space Flight Exhibit Subject Files, AS18

Manson, Frank G., AS182
Margoles, David, AS311
Marion S. Honeyman Scrapbook, AS151
Martin (studio), AS241
Martin, Glenn L., AS130
Martin, James V., AS184, AS185
Martin, R.R., AS66
Martin Clipper Scrapbook, AS183
Martin Marietta Corporation, AS18, AS29
Marvin M. Green Scrapbook, AS320
Mary Charles Papers, AS75
Mary E. "Mother" Tusch Scrapbooks, AS290
Maughan, Russell L., AS186
Maurer, AS277
Maxim, Hiram S., AS187
Maxwell Air Force Base, AS281
McCook Field, AS329
McDonnell Aircraft Corporation, AS69, AS254
McDonnell-Douglas, AS267, AS282, AS300
McDonnell-Douglas Astronautics Company, AS267
McDonnell-Douglas Astronautics Company Collection, AS267
McGraw-Hill, AS54
McKee, Irving, AS290
McMullen, Alexis B., AS189
Means, James, AS190, AS191
Medcom, Inc., AS280
Meese, George, AS192
Mercury Program Big Joe Installation Records, AS193
Metzger, Bill, AS192
Meyer, Robert B., Jr., AS194
Mikesh, Robert C., AS109
Mikro, Inc., AS314
Miller, Henry, AS185
Miller, W. Tom, AS287
Milling, Thomas Dewitt, AS195
Milton, Don, AS290
Miscellaneous Oversized Photographs, AS196
Miscellaneous Photographs A.K.A. Allan A. Needell Miscellaneous File, AS19
Miscellaneous Ramsey Room Photographs, AS197
Mitchell, William ("Billy"), AS198
Modeland, Vern, AS59
Moklestov, A., AS263
Monoplane America Christening Scrapbook, AS199
Morris, Charles L., AS200
Moseley, Francis L., AS201
Moseley, Peter, AS201
Mountain, Joe, AS202
Movie Newsreels, AS20
Multicultural Outreach Events Photograph Notebook, AS33
Multicultural Outreach IMAX Theater Photograph Notebook, AS34
Murray, George T., AS160
Murray, Kenneth M., AS203
Museo del Ejercito (Spain), AS29

NAA. See National Aeronautic Association.
Naatz, Jeanne DeWolf, AS204
NACA. See National Advisory Committee for Aeronautics.
Nagao, Atsundo, AS178
Nancy Hamilton Donation, AS312
NASA, AS1, AS2, AS15, AS17–AS20, AS24–AS26, AS29, AS45–AS47, AS99, AS164, AS175, AS193, AS194, AS205, AS206, AS213, AS247, AS249, AS263, AS268, AS282, AS283, AS300, AS306. See also National Advisory Committee for Aeronautics.
NASA F-8 Supercritical Wing Collection, AS205
NASA Historical Photograph Collection, AS20
NASA Phototransparencies Collections, AS206
Nash Collection, AS207
NASM See National Air and Space Museum.
NASM Activities Photographs A.K.A. Derek W. Elliot Work Photographs, AS21
NASM Aircraft Restoration Files, AS208
NASM Aviation History Project Files, AS209
NASM Publications Videodisc Photographs, AS210
NASM Restorations Videodisc Photographs, AS211
NAT. See National Air Transport.
Nation, Steven P., AS216
National Advisory Committee for Aeronautics, AS212. See also NASA.
National Advisory Committee for Aeronautics Aircraft Collection, AS212
National Aeronautic Association, AS54, AS213, AS215. See also Aero Club of America.
National Aeronautic Association Records, AS213
National Aeronautics and Space Administration. See NASA.
National Air and Space Museum, AS3–AS5, AS7, AS9, AS11, AS12, AS14–AS27, AS29–AS34, AS49, AS208–AS211, AS247
National Air Races Photograph Collection, AS7
National Air Transport, AS214
National Air Transport Collection, AS214
National Archives, AS49, AS282
National Aviation Clinics Scrapbooks, AS215
National Geographic Society, AS22, AS221
National Maritime Museum (London), AS9, AS29
National Museums of Canada, AS24, AS74

Naudet, Georges, AS217
Naval Aircraft Factory, AS185
Naval Aviation, Pensacola, Florida, Scrapbook A.K.A. A.C. Andreason Scrapbook, AS218
Naval Research Laboratory, AS14
Navy. See U.S. Navy.
Neal, Valerie, AS29
Needell, Allan A., AS19, AS28
Neill, Thomas T., AS219
Nelson, Carl N., AS220
Nelson, Karen A., AS220
Nelson Coon Scrapbook, AS112
New Orleans Times-Picayune, AS289
News-Ad, AS289
Nichols Studio, AS66
1934 Stratospheric Balloon Flight Scrapbooks, AS221
Nobile, Umberto, AS222
Noel, E. Percy, AS142
Nordyke & Marmon Company, AS176
Norman Sweetser Photograph Album, AS279
North American Aviation, AS54, AS278, AS282
Northrop Aircraft, AS138
Nutt, Arthur, AS223

Oakes, Claudia M., AS37, AS109, AS292
Oberth, Hermann, AS224
Ohmeyer, Rohnald, AS225
O'Neil-Davis, AS286
O'Neill, James A., AS136
Operation Linebacker II, AS42
Ostheimer, A.J., AS226
Oversized Photographs of Aircraft, AS227

Pace, Joseph J., AS154
Page, Charles R., AS229
Page, George A., Jr., AS87
Page, Phillips W., AS228
Pan American Airways, AS54, AS289
Pan American Boeing 314 Preview Flight Scrapbook A.K.A. Charles R. Page Scrapbook, AS229
Pan-American Photo Service, AS147
Panoramic Camera Company, AS70
Parachutes Incorporated, AS213
"Parade of Champions" Scrapbook, AS230
Paramount Studios, AS66, AS290
Parker, Fred, AS231
Parks, Manfred A., AS281
Parsons, Edwin C., AS232
Patrick Air Force Base, AS24
Patterson, Reid, AS192
Paul H. Wilkinson Papers, AS313
Paul R. Stockton World War I Aviation Scrapbook, AS276
Paul Studenski Collection, AS277
Paul W. Kollsman Aeronautical Library Scrapbook, AS167
Peenemünde Aerodynamics Reports A.K.A. Ft. Bliss/Puttkamer Collection, AS233

Peenemünde Archive Reports, AS234
Penland, Dane, AS21
Pennell, Halbert, AS298
Pensacola Naval Air Station, AS218
Pentecost, Walter W., AS119
Perkin-Elmer, AS26
Perry, Ray, AS213
Peterson, Harold G., AS235
P.F. Collier & Son, AS197
Phelps, Ralph M., AS215
Philippines Civil Aviation Scrapbook, AS236
Phillips W. Page Scrapbook, AS228
Photographic Archives Technical and Videodisc Files, AS237
Photo Union Paul Lamm, AS262
Piaggio Albums, AS238
Piaggio & Co., AS238, AS239
Piaggio P.23R Photographs, AS239
Piasecki Helicopter Corporation, AS254
Piercey, Stephen, AS8
Pilling, Richard T., AS113
Pisano, Dominick A., AS63, AS209
Pistole, Larry, AS44
Pix Incorporated, AS54
Planetarium (Ireland), AS24
Planetarium Slide Collection, AS333
Planetary Image Facility Earth Images, AS1
Planetary Image Facility Lunar and Planetary Images, AS2
Platz, Max, AS188
Pogue, William R., AS268
Pond, C.L., AS168
Post-Standard, AS286
Potter, AS96
Pottorf, Hal, AS254
Power, Martha Heller, AS126
Power House Museum, AS24
Powers, A.M., AS312
Powers, Arthur, AS35
Price, Francis E., AS189
Prince George Post, AS299
Project Crossroads, AS240
Project Crossroads Scrapbook A.K.A. Donald Putt Scrapbook, AS240
Public Affairs Press Photograph Collection, AS334
Public Affairs Press Slide Collection, AS335
Public Archives, Canada, AS282
Publications Office Photographs, AS336
Purington, George B. ("Slim"), AS241
Putt, Donald L., AS240

Queeny, John J., AS242

Race to the Stratosphere Photograph Collection, AS22
Ralph H. Upson Papers, AS294
Ralph S. Barnaby Papers, AS57
Randolph F. Hall Papers, AS139
Rash, Richard, AS243
Ray, Peter, AS66
Reaction Motors, AS174, AS278
Registrar's Accession Files, AS337

Reilly, AS144
Republic Airlines, AS244
Republic Feeder Airlines Collection, AS244
Reynolds, Christopher, AS245
Reynolds, Richard S., AS245
Riaboff, Alexander, AS123
Rice, E.J., AS192
Richard K. Smith Collection, AS91
Richard Rash Color Slide Collection, AS243
Richard Segar Photograph Collection, AS192
Richard S. Reynolds Photograph Collection, AS245
Richard T. Pilling Scrapbooks, AS113
Ritchie, Donald J., AS246
Robert B. Meyer, Jr., Papers, AS194
Robert K. Friedman Collection, AS301
Robert Lannen Aircraft Slide Collection, AS172
Roberts, H. Armstrong, AS196
Robert Soubiran Collection, AS272
Rocketdyne, AS175
Rocket, Space, and Early Artillery History Collection, AS247
Rockwell Collection, AS248
Rockwell HiMAT Remotely-Piloted Research Vehicle Documentation, AS249
Rockwell International, AS25, AS249
Rode Photo Service, AS219
Rodina Historical Museum, AS9
Rogers, Johnny, AS153
Roger-Viollet, AS282
Rohnald Ohmeyer Collection, AS225
Rohrbach Photograph Album, AS250
Rol, M., AS160
Rolls Royce, AS313
Romanian Air Meet Scrapbook, AS251
Rowan, Claude, AS298
Rowe, Basil Lee, AS252
Rudy Arnold Photograph Collection, AS51
Ruhe, Benjamin, AS253
Russell, Frank H., AS103
Russell, J.L., AS26
Russell & Company, AS165
Russell L. Maughan Scrapbook, AS186
Russian/Soviet Aeronautical Archives, AS9
Russo, Caroline, AS11
Rust, Herbert H., AS254
Ruth Law Scrapbook, AS173
Rys, Jan, AS213

SAAB Scrapbook, AS255
SAIC, AS29
Saint Louis Centennial Photographs, AS256
Saint Petersburg Times, AS292
Samuel L. Batchelder Collection, AS35
Sargeant Studios, AS144
Savoia-Marchetti Scrapbook, AS257
Scheffelin, Margaret M., AS97
Schlein, Anton, AS258

Schneide, Karl, AS49
Schomberg Center, AS63
Science House, AS17
Science Museum (England), AS24
Science Service, AS22
Scott, Blanche Stuart, AS259
Seattle Times, AS289
Sebastian, Nick, AS299
2nd Aviation Instruction Center, France, Scrapbook, AS260
2nd Mapping Squadron Alaskan Scrapbook A.K.A. George H. Fisher, Jr., Scrapbook, AS261
Segar, Richard, AS192
Serra, AS265
79th Balloon Company (U.S. Army), AS297
Seypelt, Albert W., AS262
S. Fred Singer Papers, AS266
Shakir S. Jerwan Scrapbooks, AS158
Sheldon, Charles S. II, AS263
Sibel, Ed, AS215
Siemens Archives, Munich, AS74
Sigler, Dale B., AS264
Sikorsky, AS189
Silliman, Elton R., AS265
Simpson, John, AS267
Sinclair, James P., AS315
Singer, S. Fred, AS266
Skinner, Kevin, AS126
Skylab Collection A.K.A. McDonnell-Douglas Astronautics Company Collection, AS267
Skylab IV Pilot's Flight Data File A.K.A. William R. Pogue Collection, AS268
Smith, Edgar B., AS189
Smith, Ernest L., AS269
Smith, Howard A., AS31
Smith, Lowell H., AS270
Smith, Richard K., AS91
Sopwith Aircraft Scrapbooks, AS271
Sopwith Company, AS271
Soubiran, Robert, AS272
Soviet Naval Museum, AS9
Space History Department Artifact Replica Files, AS23
Space History Department Artifact Request Files, AS24
Space History Department Slide Collection, AS25
Space Telescope History Project Image Collection, AS26
Special Events File, AS338
Spencer, Nelson, AS14
Spenser, Jay, AS148
Spooner & Wells, AS160
Sport Aviation Association, AS194
S.S. Independence, AS153
Staggerwing Photos, AS280
Stamback, Maureen, AS118
Standard Oil Company, AS251
Stanton, Charles I., Sr., AS273
Starr Staff, AS114
Stars Gallery Working File, AS27
Steichen, Edward J., AS10
Stephen Piercey Slide Collection, AS8

Steptoe, Thomas E., AS274
Steven P. Nation Photograph Collection, AS216
Stevens, A. Leo, AS275
Stine, G. Harry, AS78
St. Louis Centennial Photographs, AS256
Stockton, Paul R., AS276
Stoddert, Allan, AS225
Stone, Ed, AS280
Stoney, Elizabeth Keys, AS165
Striar, Robert, AS302
Studenski, Paul, AS277
Studer, Clara, AS90
Studio Bondy, AS78
Stuppe, Willy, AS126
Sullivan, J.M., AS65
Summerville, H.L., AS70, AS226
Sutton, George P., AS278
Sweeting, C.G., AS49
Sweetser, Norman, AS279
Swiss Transport Museum, AS24

Taliedo, Giovanni G.L. Caproni di. See Caproni di Taliedo, Giovanni G.L.
Tamura, Tomi, AS178
Tass. See Fotokhronika Tass.
Tatarewicz, J.N., AS26
Taylor, H.A., AS307
Taylor Photo Company, AS174
Television Infra-Red Observation Satellite. See Tiros.
Terry Gwynn-Jones Slide Collection, AS137
Thaden, Louis M., AS280
Thaden, William, AS280
Theodore C. Macaulay Collection, AS56
Theodore S. Lundgren Scrapbook, AS181
Third Paris Salon Glass Plate Photonegative Collection, AS281
Thomas Dewitt Milling Papers, AS195
Thomas E. Steptoe Scrapbooks, AS274
Thomas G. Foxworth Collection, AS143
Thomas T. Neill Collection, AS219
Thomas Towle Ford Trimotor Collection, AS286
Time-Life Epic of Flight Series Collection, AS282
Time-Life, Inc., AS9, AS282
Tiros, AS283
Tiros Satellite Documents, AS283
Tittman, Harold H., AS284
Tittman, Harold J., Jr., AS284
Tom D. Crouch Collection, AS85
Toncray, Henry E., AS285
Topical Press Agency, AS153
Towle, Thomas, AS286
TranSlides, AS287
TranSlides Aeronautical History Color Slide Collection, AS287
Trans World Airlines, AS110
Travel Air Company, AS288
Travel Air Negatives, AS288
Trippe, Juan T., AS289

Truitt, James M., AS188
Tusch, Mary E. ("Mother"), AS290
TWA. See Trans World Airways.

Uitgoff, Victor V., AS9
Umberto Nobile Papers, AS222
Underwood and Underwood, AS36, AS49, AS168
Union-Carbide, AS18
United Aircraft Corporation. See United Technologies Corporation.
United Airlines, AS273
United Press International, AS37, AS99
United States Air Force. See U.S. Air Force.
United States Army. See U.S. Army.
United States Navy. See U.S. Navy.
United States Women in Aviation, 1940–1985 Photographs, AS291
United States Women in Aviation through World War I Collection, AS292
United Technologies Corporation, AS293
United Technologies Corporation Collection, AS293
University of Colorado, AS43
University of Illinois, AS22
University of Iowa, AS28
University of Michigan, AS14
University of Wisconsin, AS26, AS329
UPI. See United Press International.
Upson, Francis A., AS294
Upson, Ralph H., AS294
U.S. Air Force, AS4, AS14, AS37, AS42, AS63, AS65, AS66, AS69, AS80, AS101, AS170, AS175, AS182, AS189, AS193, AS194, AS246, AS249, AS254, AS282, AS290, AS295, AS300, AS305. See also Maxwell Air Force Base; Patrick Air Force Base; U.S. Army Air Corps; U.S. Army Air Forces; U.S. Army Air Service.
U.S. Air Force Museum. See Wright-Patterson Air Force Base.
U.S. Air Force Pre-1954 Official Still Photograph Collection, AS295
U.S. Army, AS146, AS150, AS282, AS297, AS329.
U.S. Army Air Corps, AS221.
U.S. Army Air Forces, AS100, AS154, AS240.
U.S. Army Air Forces Task Group 1.52, AS240
U.S. Army Air Service, AS185, AS296, AS305, AS326, AS327, AS329.
U.S. Army Air Service Engineering Division, AS236, AS327, AS328
U.S. Army Air Service, Engineering Division, Scrapbook A.K.A. Horace W. Karr Scrapbook, AS296
U.S. Army Balloons World War I Scrapbook, AS297
U.S. Army 40th Photo Squadron, AS146
U.S. Army Signal Corps, AS36, AS70, AS177

U.S. Bureau of Standards, AS219
U.S. Coast Guard, AS273
U.S. Department of Commerce, AS299, AS318
U.S. Naval Academy, AS24
U.S. Naval Air Station, Pensacola, AS218
U.S. Navy, AS19, AS28, AS37, AS40, AS54, AS66, AS76, AS91, AS92, AS109, AS133, AS136, AS142, AS152, AS153, AS177, AS192, AS196, AS218, AS246, AS247, AS278, AS282, AS298
U.S. Navy Recognition Training Slides Collection, AS40
U.S. Navy ZR-1 Airship Photographs and Scrapbooks A.K.A. U.S.S. Shenandoah Collection, AS298
U.S. Organizing Committee for the Bicentennial of Air and Space Flight Records, AS299
U.S. Space Program Collection, AS300
U.S.S. Shenandoah Collection, AS298
U.S. Supersonic Transport Collection I A.K.A. Robert K. Friedman Collection, AS301
U.S. Supersonic Transport Collection II A.K.A. Bernard J. Vierling Collection, AS302

Van Allen, James A., AS28
Van Rossen, AS65
Van Vliet, J.D., AS303
Vern Modeland Collection, AS59
Vernon, Victor, AS304
Verville, Alfred V., AS98, AS305
Vestby, A., AS66
Vickers Aircraft, AS153
Victor Vernon Scrapbooks, AS304
Vierling, Bernard J., AS302
Virgil Kauffman Collection A.K.A. Aero Service Corporation Collection, AS163
Voyager 2 Uranus Moon and Ring Images, AS306

Wakefields, AS312
Walcott, Charles D., AS171, AS307
Walkers Studio, AS290
Wallace, Maurice R., AS290
Walsh, Charles F., AS308
Walsh, John, AS273
Walsh, Kathie J., AS121
Walter E. Johnson Scrapbook, AS159
Walter J. Boyne Papers, AS69
Walter W. Pentecost Collection, AS119
Warren M. and Catherine C. Bodie Collection, AS65
Washington, D.C., Aerial Photograph (World War I) Scrapbook, AS309
Webb, Pat Thaden, AS280
Weber, Frederick. See Frederick Weber's Studio of Photography.
Weeks, E.D. "Hud," AS310
Wehman, AS171
Welzenbach, Don, AS111

Western Newspaper Union, AS49
Western State Aviation, AS110
Weyl, Alfred R., AS311
"Where Next Columbus?" Exhibit File, AS29
W.H. Frank Scrapbooks, AS106
Whitcomb, Richard, AS206
White, AS188
White, Gordon, AS39
Whitman, AS192
Whitten-Brown, Arthur, AS312
Whittington, Dick. *See* Dick Whittington Photography.
Wide World Photos, AS22, AS61, AS66, AS110, AS153, AS177
Wilkinson, Eleanor Dies, AS313
Wilkinson, Paul H., AS313
William Avery Collection, AS53
William Hoffman Scrapbooks, AS149
William J. Eck Scrapbook, AS114
William J. Hammer Collection, AS140
William M. Davenport Photographs, AS95
William Mitchell Scrapbooks, AS198
William R. Pogue Collection, AS268
Williams, Gordon S., AS192
Williams, Jack, AS170
Willy Ley Papers, AS175
Wilscheusn, Fred, AS14

Windecker, Leo J., AS314
Wings of Gold: How the Aeroplane Developed New Guinea Collection, AS315
Winter, Frank H., AS25
Women Flyers of America, AS316
Women Flyers of America Collection, AS316
Women's Advisory Committee on Aviation, AS291
Wood, George W., Jr., AS317
Woolley, J.S., AS168
Works Projects Administration (WPA), AS80, AS318
Works Projects Administration Airport Inspection Trip Scrapbook *A.K.A.* George L. Lewis Scrapbook, AS318
World Brotherhood, AS289
World War I Aces Scrapbook, AS319
World War I Aviators Photographs and Autographs Scrapbook *A.K.A.* Marvin M. Green Scrapbook, AS320
World War II Aerial Reconnaissance Photographs *A.K.A.* James A. Hedgpeth, Jr., Collection, AS321
World War II Army Surplus Collection, AS322
World War II Photograph Collection

A.K.A. Harry Brosius Photograph Collection, AS323
WPA. *See* Works Projects Administration.
Wright Brothers' 1903 Flyer Restoration Albums, AS324
Wright Brothers' 1903 Flyer Restoration Files, AS325
Wright Field, AS326–AS329
Wright Field Propeller Test Reports, AS326
Wright Field Technical Documents Library, AS327
Wright/McCook Fields Aircraft Project Books, AS328
Wright/McCook Fields Still Photograph Collection, AS329
Wright Medal Presentation Scrapbook, AS330
Wright-Patterson Air Force Base, AS24, AS281, AS282
W-17 Sensor Photographs, AS30

Yeager, William, AS192
Young, Amanda J., AS23

Zabriski, Alexa Von Tempsky, AS331
Zeppelin Company, AS332
Zeppelin Photographs, AS332

Forms and Processes Index

The forms and processes index lists examples of physically distinct types of photographic formats (size, shape, and configuration of an image); processes (final image material, binder, base, and production process); techniques (specific manipulative procedures for obtaining visual effects in a variety of processes); and modifiers (additional information on format, process, or technique, when available). The index also includes other audiovisual formats, such as audiotapes, microfilm, motion-picture film, videodiscs, and videotapes, when they form part of a photographic collection.

The index contains cross-references to assist researchers with minimal knowledge of photographic processes and formats. For example, all photoprint processes and formats are listed under their individual names as well as under "photoprints."

Describing photographic processes is a challenge, since thousands of process variants exist. In this volume, processes are described with as much of the following information as possible: 1) final image material; 2) binder; 3) image format or configuration; 4) base (not noted if a photoprint is on paper or if a photonegative or phototransparency is on film, as these are the routine or default values); 5) DOP or POP (developing-out-print or printing-out-print); 6) chemical process variant; 7) trade name; and 8) other descriptive or technical details.

Descriptive elements 4 through 8 are enclosed within parentheses, for example, "silver gelatin photoprint (DOP chloride Velox gaslight paper)."

On occasion, vernacular or generic descriptive process terms (such as tintypes and ambrotypes) are used if they provide an adequate description. Use of the phrases "photoprint," "photonegative," and "phototransparency" is based on the descriptive standards found in the following publication: Elisabeth Betz Parker and Helena Zinkham. *Descriptive Terms for Graphic Materials: Genre and Physical Characteristic Headings*. Washington, D.C.: Library of Congress, 1986. In addition, project staff generated an in-house glossary of photographic terms culled from 28 source publications. Many of the terms in this glossary have since appeared in the following publication: *Art and Architecture Thesaurus*. New York: Oxford University Press, 1990.

The forms and processes index, like the subject and creators indexes, is arranged according to letter-by-letter alphabetization. Researchers unable to find a process, format, or other physical description term should check alternative spellings and both broader and narrower variant terms.

Collection codes indicate the location of the collection entry within the volume. For example, *AS·2* indicates that the reader should check the second collection report.

Albumen photoprints, AS35, AS36, AS79, AS101, AS168, AS170, AS187, AS188, AS191, AS237, AS311; stereographs, AS36

Albums, AS35, AS38, AS56, AS73, AS84, AS87, AS98, AS101–AS103, AS106, AS112, AS113, AS126, AS141, AS156, AS161, AS168–AS170, AS176, AS183, AS186–AS188, AS191, AS199, AS218, AS230, AS231, AS235, AS238, AS241, AS242, AS250, AS251, AS255, AS257, AS260, AS261, AS271, AS272, AS279, AS296– AS298, AS307, AS309, AS319, AS331. *See also* Scrapbooks.

Ambrotypes, AS237

Audiotapes, AS59, AS69, AS194, AS214, AS253, AS273, AS289, AS299, AS302

Binocular photographs. *See* Stereographs.
Black-and-white photographs. *See* Albumen photoprints; Ambrotypes; Collodion gelatin photoprints; Kallitypes; Platinum photoprints; Silver gelatin; Tintypes.
Blueprint photographs. *See* Cyanotypes.
Bromide photoprints. *See* Silver gelatin.
Bromoil photoprints. *See* Silver gelatin.

Cabinet cards, AS168
Calling card photoprints. *See* Cartes-de-visite.
Card photographs. *See* Albumen photoprints; Cabinet cards; Cartes-de-visite; Postcards; Stereographs.
Cartes-de-visite, AS168
Cased images. *See* Ambrotypes; Tintypes.
CCD images. *See* Charge coupled device images.
Cellulose diacetate. *See* Silver gelatin.
Cellulose nitrate. *See* Silver gelatin.
Cellulose triacetate. *See* Silver gelatin.
Charge coupled device images, AS31
Chromogenic processes. *See* Dye coupler photonegatives; Dye coupler photoprints; Dye coupler phototransparencies; Dye coupler slides.
Collodio-chloride phototransparencies. *See* Silver gelatin dry plate lantern slides.
Collodion gelatin photoprints, AS62, AS80, AS85, AS90, AS140, AS160, AS161, AS166, AS170, AS187–AS189, AS191, AS198, AS277, AS308, AS310, AS312
Collotypes. *See* Photomechanicals.
Color dye coupler. *See* Dye coupler.
Color processes. *See* Dye coupler; Dye diffusion transfer photoprints; Dye transfer separation phototransparencies. *See also* Tinted photographs.
Color separation photographs. *See* Dye transfer separation phototransparencies.

Composite photographs, AS157, AS163
Contact photoprints, AS33, AS135, AS202
Copy photographs. *See* Dye coupler copy photoprints; Dye coupler copy phototransparencies; Dye coupler copy slides; Silver gelatin copy photonegatives; Silver gelatin copy photoprints.
Cyanotypes, AS48, AS53, AS90, AS125, AS173, AS194, AS237, AS305, AS308

Digitized images, AS31
Direct positive photographs. *See* Ambrotypes; Tintypes.
Dry plates. *See* Silver gelatin dry plate lantern slides; Silver gelatin dry plate photonegatives.
Dye coupler
—copy photoprints, AS28, AS29
—copy phototransparencies, AS27, AS29
—copy slides, AS8, AS16, AS18, AS29
—photonegatives, AS1, AS2, AS4, AS9, AS15, AS17, AS21, AS24, AS47, AS80, AS177, AS194, AS208, AS295, AS300, AS312, AS325
—photoprints, AS1, AS2, AS4, AS9, AS12, AS15, AS17–AS21, AS23, AS24, AS26, AS29–AS31, AS34, AS39, AS45–AS47, AS52, AS53, AS57, AS59, AS66, AS68, AS70, AS71, AS80, AS85, AS97, AS99, AS101, AS105, AS110, AS118, AS130, AS132, AS134, AS136, AS140, AS145, AS148, AS152, AS161, AS163, AS170, AS175, AS177, AS194, AS196, AS197, AS205, AS207, AS208, AS210, AS211, AS223, AS227, AS230, AS236, AS237, AS240, AS246, AS249, AS252, AS253, AS255, AS263, AS264, AS266–AS268, AS280, AS282, AS287, AS289, AS290, AS293, AS295, AS299, AS300, AS302, AS305, AS310, AS312, AS313, AS319, AS325, AS329
—phototransparencies, AS1, AS2, AS4–AS6, AS9–AS12, AS17–AS19, AS25–AS27, AS29, AS31, AS35, AS45, AS47, AS51, AS61, AS80, AS110, AS135, AS175, AS205, AS206, AS208, AS273, AS282, AS289, AS295, AS305, AS325
—slides, AS2, AS4, AS9, AS12, AS13, AS15, AS16, AS20, AS21, AS24– AS26, AS29, AS80, AS110, AS136, AS137, AS172, AS175, AS194, AS208, AS237, AS243, AS282, AS287, AS295, AS299, AS310
Dye diffusion transfer photoprints, AS18, AS21, AS24, AS68, AS97, AS170, AS192, AS194, AS205, AS208, AS223, AS275
Dye transfer separation phototransparencies, AS164

Ektachrome. *See* Dye coupler slides.
Ektacolor paper type C. *See* Dye coupler photoprints.
Ektacolor paper type R. *See* Dye coupler photoprints.

Ferro-prussiate process. *See* Cyanotypes.
Ferrotypes. *See* Cyanotypes.
Film. *See* Motion-picture film footage; Motion-picture films; Videotapes.
Formats. *See* Albums; Audiotapes; Cabinet cards; Cartes-de-visite; Composite photographs; Contact photoprints; Lantern slides; Motion-picture film footage; Motion-picture films; Oversize photoprints; Phonograph records; Photomechanicals; Postcards; Radiograms; Scrapbooks; Slides; Stereographs; Videotapes.

Gaslight photoprints. *See* Silver gelatin.
Gelatin. *See* Collodion gelatin photoprints; Silver gelatin.
Gelatin collodion photographs. *See* Collodion gelatin photoprints.
Gelatin silver photographs. *See* Silver gelatin.
Glass plates. *See* Ambrotypes; Silver gelatin lantern slides; Silver gelatin dry plate photonegatives.

Halftones. *See* Photomechanicals.
Hand-colored photographs. *See* Tinted photographs.
Hand-tinted photographs. *See* Tinted photographs.

Instant photographs. *See* Dye diffusion transfer photoprints.
Iron process. *See* Cyanotypes.

Kallitypes, AS189, AS330
Kodachrome. *See* Dye coupler slides.
Kodak Dye Transfer photographs. *See* Dye transfer separation photoprints.
Kodak Ektacolor paper type C. *See* Dye coupler photoprints.
Kodak Ektacolor paper type R. *See* Dye coupler photoprints.
Kodak Instant Color photoprints. *See* Dye diffusion transfer photoprints.

Lantern slides. *See* Silver gelatin dry plate lantern slides.

Magic lantern slides. *See* Silver gelatin dry plate lantern slides.
Magnetic tape. *See* Audiotapes; Videotapes.
Matte collodion printing-out-prints. *See* Collodion gelatin photoprints.
Monochrome photoprints (one color). *See* Albumen photoprints; Ambrotypes; Collodion gelatin photoprints; Cyanotypes; Platinum photoprints; Silver gelatin; Tintypes.

Motion-picture film footage, AS39, AS45, AS47, AS59, AS94, AS147, AS253, AS262, AS268, AS289, AS312

Motion-picture films, AS110, AS268

Mounts. *See* Albumen photoprints; Cabinet cards; Cartes-de-visite; Postcards; Stereographs; Tintypes.

Moving images. *See* Motion-picture film footage; Motion-picture films; Videotapes.

Negatives. *See* Dye coupler photonegatives; Silver gelatin copy photonegatives; Silver gelatin dry plate photonegatives.

Oversize photoprints, AS95

Permanent photoprints. *See* Photomechanicals.

Phonograph records, AS110, AS312

Photomechanicals, AS217, AS227, AS237, AS332. *See also* Postcards.

Photonegatives. *See* Dye coupler photonegatives; Silver gelatin copy photonegatives; Silver gelatin dry plate photonegatives.

Photoprints. *See* Albumen photoprints; Albumen stereographs; Ambrotypes; Cabinet cards; Cartes-de-visite; Collodion gelatin photoprints; Contact photoprints; Cyanotypes; Dye coupler copy photoprints; Dye coupler photoprints; Dye diffusion transfer photoprints; Kallitypes; Platinum photoprints; Silver gelatin copy photoprints; Stereographs; Tinted photographs.

Phototransparencies. *See* Dye coupler copy phototransparencies; Dye coupler copy slides; Dye coupler phototransparencies; Dye coupler slides; Dye transfer separation phototransparencies; Silver gelatin dry plate lantern slides; Silver gelatin phototransparencies; Silver gelatin slides.

Platinotypes. *See* Platinum photoprints.

Platinum photoprints, AS237, AS320

Polaroid instant prints. *See* Dye diffusion transfer photoprints.

Polaroid SX-70. *See* Dye diffusion transfer photoprints.

POP photoprints. *See* Collodion gelatin photoprints; Silver gelatin.

Postcards, AS104, AS120, AS125, AS127, AS168, AS229, AS254, AS277

Printing-out-paper photoprints. *See* Collodion gelatin photoprints; Silver gelatin.

Prints. *See* Photomechanicals; Photoprints.

Processes. *See* Albumen; Collodion gelatin; Cyanotypes; Dye coupler; Dye diffusion transfer; Dye transfer separation; Kallitypes; Photomechanicals; Platinum; Silver gelatin.

Radiograms, AS252

Safety film. *See* Silver gelatin.

Safety negatives. *See* Silver gelatin.

Scrapbooks, AS36, AS41, AS48, AS50, AS55, AS58, AS62, AS64, AS70, AS71, AS75, AS79–AS81, AS90, AS96, AS104, AS108, AS114, AS115, AS120, AS122, AS124, AS125, AS127, AS129, AS138–AS140, AS144, AS149–AS151, AS153, AS158, AS159, AS161, AS167, AS171, AS173, AS181, AS184, AS188, AS190, AS198, AS200, AS204, AS213–AS215, AS221, AS228, AS229, AS232, AS236, AS240, AS252, AS256, AS264, AS269, AS270, AS273, AS274, AS276, AS277, AS280, AS284, AS285, AS289, AS290, AS304, AS308, AS310, AS318, AS320, AS330. *See also* Albums.

Silver albumen. *See* Albumen photoprints.

Silver collodion. *See* Collodion gelatin photoprints.

Silver gelatin (Silver gelatin photoprints and photonegatives can be found in most collections. Specific process and format variants are indexed here.)
—copy photonegatives, AS14, AS22, AS27, AS29, AS82
—copy photoprints, AS14, AS22, AS27–AS29, AS44, AS45, AS82, AS91, AS92, AS106, AS118, AS140, AS148, AS154, AS209, AS220, AS291, AS292, AS310, AS319
—dry plate lantern slides, AS53, AS78, AS83, AS168
—dry plate photonegatives, AS53, AS77, AS86, AS94, AS154, AS237, AS329
—phototransparencies, AS1, AS2, AS45, AS48, AS111, AS299
—slides, AS20, AS25, AS40, AS61, AS80

Silver prints. *See* Albumen photoprints; Collodion gelatin photoprints; Silver gelatin.

Slides. *See* Dye coupler copy phototransparencies; Dye coupler copy slides; Dye coupler phototransparencies; Dye coupler slides; Dye transfer separation phototransparencies; Silver gelatin dry plate lantern slides; Silver gelatin phototransparencies; Silver gelatin slides.

Stereo cards. *See* Stereographs.

Stereograms. *See* Stereographs.

Stereographs, AS36, AS332

Tape. *See* Audiotapes; Videotapes.

Techniques. *See* Charge coupled device images; Contact photoprints; Copy photographs; Tinted photographs.

Tinted photographs, AS141, AS188, AS218, AS274, AS276

Tintypes, AS170

Videotapes, AS69, AS110, AS253, AS299

Subject Index

The subject index provides topical access to the Smithsonian photographic collections, which include documentation of material culture (such as aircraft, buildings, museums, ships, and tools); geographical places (cities, countries, regions, and continents both contemporary and historical); people (individuals, associations, corporations, culture groups, and nationalities); occupations; activities; and events. Index terms also include photographic genres (aerial photographs, cityscapes, and landscapes) and topics (agriculture, education).

The source terminology for the index came both from the photographic documentation itself and from a series of published sources. Broad terms used for index entries and cross-references were taken from the following publications: Elizabeth Betz Parker and Helena Zinkham. *L.C. Thesaurus for Graphic Materials: Topical Terms for Subject Access.* Washington, D.C.: Library of Congress, 1987. *Art and Architecture Thesaurus.* New York: Oxford University Press, 1990. Names and technical language were standardized using the following sources:

Enzo Angelucci. *The Rand McNally Encyclopedia of Military Aircraft, 1914–1980.* Chicago: Rand McNally & Company, 1981.

Enzo Angelucci. *World Encyclopedia of Civil Aircraft from Leonardo da Vinci to the Present.* New York: Crown Publishers, Inc., 1981.

Kathleen Brooks-Pazmany. *United States Women in Aviation, 1919–1929.* Washington, D.C.: Smithsonian Institution Press, 1983.

C.D.B. Bryan. *The National Air and Space Museum.* 2d edition. New York: Harry N. Abrams, Inc., Publishers, 1988.

Tom D. Crouch. *The Eagle Aloft: Two Centuries of the Balloon in America.* Washington, D.C.: Smithsonian Institution Press, 1983.

Bill Gunston. *Jane's Aerospace Dictionary.* 3d edition. Coulsdon, Surrey, England: Jane's Information Group, Ltd., 1988.

Terry Gwynn-Jones. *Farther and Faster: Aviation's Adventuring Years, 1909–1939.* Washington, D.C.: Smithsonian Institution Press, 1991.

Von Hardesty and Dominick Pisano. *Black Wings: The American Black in Aviation.* Washington, D.C.: Smithsonian Institution Press, 1983.

International Encyclopedia of Aviation. David Mondey, general editor. London: Octopus Books Limited, 1977.

International Handbook of Aerospace Awards and Trophies. Washington, D.C.: Smithsonian Institution Press, 1978.

Jane's All the World's Aircraft. 1956–1957 edition. London: Jane's All the World's Aircraft Publishing Co., Ltd., 1957.

Jane's Encyclopedia of Aviation. 5 vols. Michael J.H. Taylor, ed. London: Jane's, 1980.

Verlerie Moolman. *Women Aloft.* Alexandria, Va.: Time-Life Books, 1981.

NASA Thesaurus. 3 vols. Washington, D.C.: NASA, 1988.

National Aeronautical Institute. *Who's Who in Aviation and Aerospace.* U.S. edition. Boston and New York: Warren, Gorham & Lamont, Inc., 1983.

Jan Van Nimmen. *NASA Historical Data Book.* Vols. 1–3. Washington, D.C.: NASA, 1988.

Claudia M. Oakes. *United States Women in Aviation, 1930–1939.* Washington, D.C.: Smithsonian Institution Press, 1985.

Claudia M. Oakes. *United States Women in Aviation through World War I.* Washington, D.C.: Smithsonian Institution Press, 1978.

Leyson K. Phillips. *Airlines of the World.* New York: Gordon Press, 1977.

Henry Ladd Smith. *Airways: The History of Commercial Aviation in the United States.* Washington, D.C.: Smithsonian Institution Press, 1991.

Gordon Swanborough and Peter M. Bowers. *United States Military Aircraft since 1909.* Washington, D.C.: Smithsonian Institution Press, 1989.

The Times Atlas of the World. 7th comprehensive edition. Edinburgh: James Bartholemew & Son Limited, 1988.

Helen T. Wells, Susan H. Whiteley, and Carrie E. Karegeannes. *Origins of NASA Names.* Washington, D.C.: NASA, 1976.

Who's Who in American Aeronautics. New York: The Gardner, Moffat Co., 1922.

Who's Who in American Aeronautics. 3d edition. Compiled by Lester D. Gardner. New York: Aviation Publishing Corporation, 1928.

Who's Who in Aviation. Chicago and New York: Ziff-Davis Publishing Company, 1942.

Who's Who in Aviation. New York: Harwood & Charles Publishing Co., 1973.

Who's Who in World Aviation. Vol. 1. Washington, D.C.: American Aviation Publications, Inc., 1955.

Who Was Who in American History—The Military. Chicago: Marquis Who's Who, Inc., 1975.

The subject index, like the creators and forms and processes indexes, is arranged according to letter-by-letter alphabetization. Index entries followed by *See* refer the reader from an indexing term which is not used to a term that is used, for example, "Authors. *See* Writers." Index entries followed by *See also* refer the reader to another indexing term such as a synonym, antonym, related term, or narrower term, for example, "Executives. *See also* Businessmen."

To pull together all information on a single area, regardless of time period, geographical references are listed under the current country name and cross-referenced from non-current versions of the name used in the text, for example, "Persia. *See* Iran."

Information in parentheses after an index entry modifies or clarifies ambiguous or technical terms, for example, "U.S.S. *Macon* (airship)." Names of aircraft and publication titles are in italics. Titles of exhibits and slide sets are in quotes.

Researchers unable to find a particular term should check the cross-references. Variant terms, including broader and narrower terms, technical and popular terminology, and alternative spellings, should also be checked.

Several of NASM's large collections, *AS*.237, 282, 295, and 329, contain photographs (especially images of aircraft, aerial photographs, and portraits) which do not appear as specific items in this index. Researchers should read the summary descriptions provided in the *Subjects* field of these collections to determine whether they are likely to contain the desired image. These collections are accessible through their individual finding aids (described in the *Finding Aids* field). Researchers may also contact NASM Archives staff for additional information.

The collection codes show the location of the collection entry within the volume. For example, *AS*.2 indicates that the reader should check the second collection report in this volume.

Accidents. *See* Crashes.
Aces (World War I), AS319, AS320. *See also* Pilots; World War I.
Acosta, Bert, AS304
Acrobatics. *See* Aerobatics.
Activities. *See* specific activities (such as Bombing, Construction, Space walks), events, groups, individuals.
Actors, AS65, AS122, AS181
Adami, Valerio: art works by, AS11
Adams, John C., AS155
Adjustable propellers, AS296
Advertisements, AS26, AS54, AS60, AS68, AS81, AS217, AS251, AS292, AS305. *See also* Publicity.
Aerial (balloon), AS168
Aerial advertisements, AS54, AS81
Aerial cameras, AS160, AS189, AS296, AS305
Aerial combat, AS10, AS42, AS113, AS120, AS237, AS305. *See also* Combat; Fighter aircraft; Strafing; specific wars.
Aerial Experiment Association, AS160; aircraft, AS89, AS160, AS190, AS231
Aerial photographs, AS51, AS58, AS80, AS113, AS124, AS128, AS129
—cityscapes, AS56, AS125, AS126, AS142, AS163, AS189, AS231, AS235, AS258, AS272, AS304
—first aerial news photograph, AS160
—from balloons, AS258
—landscapes, AS1, AS56, AS79, AS113, AS125, AS126, AS258, AS297, AS332; mountains, AS1, AS194, AS304
—locations: Africa, AS35; Austria, AS35; Azores islands, AS114; Bahamas, AS135; Barbados, AS135; Belgium, AS35; Berlin (Germany), AS35; California, AS122, AS142; China, AS1; Curaçao, AS135; Dayton (Ohio), AS150; Egypt, AS1; England, AS35, AS73; Ethiopia, AS35; Europe, AS35, AS113, AS115, AS116, AS120, AS126, AS272; Florida, AS135, AS150; France, AS35, AS70, AS113, AS114, AS140, AS149, AS235, AS321; Germany, AS35, AS116, AS126, AS321; Hawaii, AS106, AS235; Isle of Grain (Great Britain), AS73; Italy, AS35, AS157; Jamaica, AS135; London (England), AS73; Angeles (California), AS142; Louisiana, AS35; Massachusetts, AS160; Mexico, AS70, AS235; Miami (Florida), AS150; Newark (New Jersey), AS135; New York, AS110, AS114, AS135, AS163, AS186, AS276; Niagara Falls, AS186; Oregon, AS304; Panama City (Panama), AS265; Paris (France), AS114, AS140, AS235; Pennsylvania, AS163; Pensacola (Florida), AS218; Portugal, AS114; Russia, AS9, AS246; St. Louis (Missouri), AS256; St. Petersburg (Russia), AS9; Slovakia,

AS258; Texas, AS56, AS70, AS106; Toledo (Ohio), AS161; Trinidad, AS135; Tunis (Tunisia), AS35; Virginia, AS304; Washington, D.C., AS54, AS56, AS87, AS242, AS272, AS290, AS304, AS309
—mapping, AS321
—subjects: airports, AS189; balloon launch sites, AS221; bombing, AS49, AS113, AS321; cemeteries, AS189, AS297; expositions, AS73; houses, AS111; military bases, AS106, AS276, AS296, AS297, AS304, AS329; mission routes, AS276
—waterscapes, AS56, AS79; beaches, AS228; coasts, AS35, AS125, AS189, AS231, AS257, AS304; rivers, AS258, AS309
—World War I, AS35, AS70, AS115, AS128, AS262, AS272
—World War II, AS35, AS179, AS321
Aerial reconnaissance, AS9, AS115, AS128, AS129, AS295, AS321
Aerobatics, AS56, AS70, AS109, AS129, AS160, AS237. *See also* Exhibition flight; Stunt flights.
Aerobee rockets, AS14, AS162, AS175
Aeroboat. *See* Loening Aeroboat.
Aerocar (aircraft), AS180
Aero Club de France, AS55
Aero Club of America, AS292, AS330
Aero Club of Michigan, AS79
Aero Club von Deutschland, AS55
Aerodrome (London), AS58
Aerodrome, Langley. *See* Langley Aerodrome.
Aerodynamics. *See* Design; Missiles; Research and development; Rockets; Spacecraft.
Aerojet company, AS30, AS175
Aeromarine aircraft, AS160, AS161; 39-A, AS245; 40 Sport, AS245; biplanes, AS185; PG-1, AS328
Aeronautical schools. *See* Aviation schools.
Aeronca aircraft, AS51; C-2, AS211; C-3, AS135; Chief, AS135
Aero Policewomen's Association of California, AS75
Aero Service Corporation, AS163
Aero SpaceLines aircraft: Mini-Guppy, AS216; Super Guppy, AS207, AS267
Aero squadrons, AS112, AS113, AS115, AS186, AS272, AS276, AS284; insignia, AS115
Aerovias Centrales (airline), AS265
Africa, AS35, AS289; aircraft, AS172. *See also* specific countries.
African Americans, AS25, AS33, AS63, AS198, AS232, AS334. *See also* specific occupations, names.
Agordat (Ethiopia). *See* Āk'ordat.
Agricultural aviation, AS237
Agriculture, AS78. *See also* Farms; Plantations.

Ailerons, AS60, AS94, AS106, AS160, AS288
Air and Space Museum. *See* National Air and Space Museum.
Air bases, AS42, AS73, AS97, AS112, AS150, AS282, AS284, AS295; Great Britain, AS73, AS112; Guam, AS42; Korea, AS243; Russia, AS9; United States, AS6, AS94, AS97, AS106, AS150, AS165, AS181, AS243; Vietnam, AS243. *See also* Airfields; U.S. Air Force; specific locations, military branches, names of air bases, wars.
Air battles. *See* Aerial combat.
Aircoach. *See* Verville Aircoach.
Aircraft. *See* specific countries, manufacturers, models, names, types, wars.
Aircraft carriers, AS9, AS10, AS94, AS117, AS160, AS177, AS218, AS237, AS243, AS282, AS305, AS334; aircraft, AS160
Aircraft companies. *See* specific companies.
Aircraft Radio Corporation, AS39
Air fairs, AS172. *See also* Air meets; Air shows.
Airfields, AS42, AS56, AS70, AS110, AS135, AS150, AS161, AS163, AS237, AS282, AS295; Great Britain, AS73, AS117; India, AS154; Italy, AS179; Russia, AS9, AS246; United States, AS56, AS94, AS106, AS135, AS150, AS163, AS165, AS186, AS198, AS220, AS264, AS286, AS304, AS305, AS327; World War I, AS56, AS70, AS113, AS120, AS260, AS272; World War II, AS179. *See also* Airfields; Airports; U.S. Air Force; specific locations, military branches, wars.
Air forces. *See* U.S. Air Force; specific countries.
Airframes, AS56, AS60, AS77, AS104
Air hostesses. *See* Flight attendants.
Air India (airline), AS84
Air induction systems, AS107
Airliners, AS8, AS37, AS38, AS40, AS67, AS68, AS81, AS105, AS172, AS192, AS213, AS214, AS237, AS252, AS254, AS265, AS282, AS286. *See also* specific airlines, manufacturers, models.
Airlines, AS84, AS105, AS114, AS151, AS214, AS237, AS244, AS265, AS289, AS304, AS315; employees, AS84, AS214, AS237, AS244, AS252, AS304; executives, AS183, AS213, AS289, AS304. *See also* Airliners; Flight attendants; specific airlines.
Airmail, AS80, AS125, AS141, AS237, AS273, AS274, AS277, AS282; aircraft, AS80, AS110, AS141, AS273, AS288; South America, AS265. *See also* U.S. Air Mail Service.

Air meets, AS96, AS161, AS189, AS228, AS237, AS277, AS282; Aero Club of Michigan (1911), AS79; Asbury Park (New Jersey, 1910), AS79; Belmont Park (New York), AS102, AS160; Bridgeport (Connecticut, 1911), AS160; Chicago (Illinois), AS102; College Park (Maryland), AS58; Harvard-Boston Aero Meet (1910), AS143; International Aviation Tournament (Belmont Park, New York), AS102; Mineola (New York), AS58, AS160; Princeton (New Jersey), AS58; programs, AS102; Romania, AS251. See also Air fairs; Air races; Air shows; Glider meets.

Airphibian. See Continental Airphibian.

Airplanes. See specific countries, manufacturers, models, names, types, wars.

Airports, AS54, AS86, AS189, AS237, AS282, AS318, AS327. See also Air bases; Airfields.
—buildings, AS50, AS83
—inspections, AS318
—locations: Chicago (Illinois), AS84, AS318; College Park (Maryland), AS58, AS80; Florida, AS189; France, AS114; Germany, AS153; Iran, AS84; Iraq, AS50; Kansas City, AS165; Newark (New Jersey), AS135, AS174; Rome, AS153; South America, AS265; Toledo (Ohio), AS161
—names: Detroit City Airport, AS84; Dulles International, AS15; Glenn Curtiss Airport (New York), AS165; La Guardia Field (New York City), AS71, AS84, AS135; Lahm Airport (Mansfield, Ohio), AS169
—personnel, AS84, AS318
—runways, AS189, AS329

Air races, AS38, AS68, AS109, AS127, AS137, AS153, AS158, AS161, AS172, AS181, AS237, AS277, AS295, AS311. See also Air meets; Racing aircraft; specific races.
—airplanes vs. automobiles, AS109, AS310
—airships, AS160
—balloons, AS160, AS168, AS170, AS213
—courses, AS213
—cross-country, AS57, AS186
—events: Bendix air races, AS61, AS280; Gordon Bennett races, AS160, AS170, AS213; International Air Races, AS305; National Air Races, AS7, AS79, AS135, AS150, AS213, AS274; National Women's Air Derby, AS280; Pacific Air Race, AS269; Pulitzer Trophy races, AS185, AS186, AS305
—locations: Asbury Park (New Jersey), AS142; Bridgeport (Connecticut), AS160; Chicago (Illinois), AS79;

France, AS160, AS170; Reno (Nevada), AS172
—National Aeronautic Association, AS213
—seaplanes, AS241

Air raids, AS116

Air routes, AS165, AS276

Airships, AS4, AS37, AS75, AS83, AS85, AS94, AS104, AS118, AS124, AS140, AS142, AS160, AS163, AS166, AS198, AS220, AS237, AS256, AS274, AS281, AS282, AS294, AS295, AS311. See also specific names of airships.
—construction, AS36, AS134, AS332
—crews, AS125, AS177, AS332
—events: crashes, AS36, AS120, AS125, AS282, AS298; races, AS160
—flights, AS36, AS77, AS125, AS134, AS332; landings, AS125; launches, AS36, AS125, AS134, AS177
—France, AS36
—hangars, AS36, AS113, AS125, AS134, AS135, AS160, AS177, AS189, AS276, AS298, AS332
—inflations, AS77, AS127
—interiors, AS36, AS125, AS134, AS157, AS222, AS332
—Italy, AS36, AS157, AS222
—miniature models, AS143
—mooring masts, AS36, AS142, AS177, AS298
—parts, AS125, AS177, AS298
—passengers, AS332
—U.S. Navy, AS89, AS134, AS160, AS177, AS218, AS227, AS242, AS245, AS294, AS298
—Zeppelins, AS36, AS113, AS125, AS129, AS254, AS332

Air shows, AS56–AS58, AS80, AS103, AS109, AS110, AS127, AS192, AS194, AS198, AS237, AS282, AS310. See also Air fairs; Air meets.
—events: Hannover Air Show (1966), AS172; National Aircraft Show, AS48; Oshkosh (Wisconsin) Airshow, AS180; Stockholm Air Exposition (1936), AS153
—locations: New Jersey, AS71; Paris (France), AS104, AS153, AS172; Pennsylvania, AS71

Air speed indicators, AS160

Airstream biplanes. See Kinner airstream biplanes.

Air terminals. See Airports.

Air Yacht. See Loening Air Yacht.

Akins, Barbara, AS291

Āk'ordat (Ethiopia), AS35

Akron (airship). See U.S.S. Akron.

Akron (Ohio), AS177, AS221

Alabama, AS318

Alaska, AS50, AS168, AS261

Albany (New York), AS160, AS186

Albatros (Octave Chanute's glider), AS53

Albatros aircraft, AS73, AS232, AS235, AS255; D.Va, AS208, AS211

Albatross (aircraft). See Grumman SA-16 Albatross.

Albuquerque (New Mexico), AS318

Alcock, John, AS52, AS312

Alcohol, AS115. See also Bars; Beverages; Drinking.

Aldrin, Edwin E., Jr., AS21

Aleutian Islands (Alaska), AS50

Aleut Indians, AS50

Alexander, P.Y., AS160

Alexander Mikhailovich (grand duke), AS9

Alexis Dolgouruki (princess), AS232

Al Hufūf (Saudi Arabia), AS202

Al Jubayl (Saudi Arabia), AS202

Al Khubar (Saudi Arabia), AS202

All-American Air Maneuvers (Miami, Florida), AS135

Allen, Arlene, AS118

Allen, Eddie, Jr., AS118

Allen, Edmund T., AS226

Allen, Edward, AS118

Allen, Florence, AS118

Allen, Gloria, AS118

Alligators, AS218

Allison gas turbine engines, AS313

Alpha. See Northrop Alpha.

Al Qatīf (Saudi Arabia), AS202

Altimeters, AS14

Altitude data. See Barographs.

Amazing Stories magazine, AS25

Ambassadors, AS289

Ambulance drivers, AS188, AS272

Ambulances, AS54, AS60, AS70, AS188, AS272; aircraft, AS54, AS60

America (aircraft), AS89, AS199, AS303, AS304

American Airlines, AS84

American Airways, AS304

American Astronautical Society, AS43

American Clipper (aircraft), AS229

American Eagle (aircraft), AS141

American Helicopter Society, AS200

American Indians, AS50, AS150, AS160, AS221, AS241, AS308. See also Inupiaqs; Pueblo Indian buildings.

American Legion, AS57, AS186

American Rocket Society, AS76

American University (Beaune, France), AS272

American University (Washington, D.C.), AS309

American Volunteer Group, AS44, AS119

Ames, Joseph T., AS155

Ammunition, AS32, AS35, AS49, AS94, AS120, AS237, AS272

Amphibian aircraft, AS95

Amundsen, Roald, AS52

Anacostia Naval Air Station (Washington, D.C.), AS304

Anchorage (Alaska), AS261

Andermat engines, AS231

Andersen Air Force Base (Guam), AS42

Anderson, C. Alfred, AS63

Anderson, Orvil A., AS22, AS221

Animals. See Zoos; specific animals.

Ankara (Turkey), AS162

Anniversary celebrations, AS170, AS274, AS329. See also Ceremonies; Parties.

Announcement boards, AS102

Antennas, AS26, AS174. See also Radios.

Anti-aircraft guns, AS9, AS32, AS49, AS163, AS232

Anti-freeze, AS219

Antoinette aircraft, AS102, AS137, AS160, AS194

Anzani engines, AS194

Apollo program, AS1, AS17, AS18, AS20, AS24, AS45, AS46, AS99, AS175, AS206, AS300; astronauts, AS18, AS206, AS300; exhibits, AS17; guidance systems, AS12; lunar landings, AS29; spacecraft, AS18, AS23, AS45, AS46, AS85, AS99, AS164, AS300, AS334; space walks, AS18, AS29, AS99

Apollo-Soyuz Test Project, AS1, AS47, AS206, AS334

Apollo to the Moon (National Air and Space Museum gallery), AS335, AS336

Arachnids, AS122

Arado aircraft, AS311; Ar 234, AS208

Aramco, AS202

ARC. See Aircraft Radio Corporation.

Arcadia (Florida), AS220

Arc du Triomphe de L'Étoile (Paris), AS121

Archdeacon, Ernest, AS209

Archeological excavations, AS189. See also Ruins.

Arches, AS121

Architectural drawings, AS80, AS153

Architecture, AS55, AS153, AS191; France, AS70, AS113, AS114, AS121, AS153, AS186, AS276; Germany, AS121, AS126, AS153, AS276; United States, AS56, AS87, AS111, AS153, AS167. See also Buildings; Cityscapes; Houses; Ruins; Street scenes; specific buildings, locations.

Arcier, A. Francis, AS48

Argentina, AS172

Arizona, AS152, AS153, AS318

Arkansas, AS318

Arlt, Paul: art works by, AS11

Armaments. See Ammunition; Bombs; Cannons; Guns; Tanks; Weapons.

Armed forces. See Military officers; Sailors; Soldiers; specific countries, military branches, wars.

Armies. See U.S. Army; specific countries.

Armor plating, AS271

Armstrong, Frank A., Jr., AS101

Armstrong, Harry G., AS155

Armstrong, Neil, AS300

Armstrong aircraft, AS311

Army-Navy football game, AS122

Arnold, Henry H. ("Hap"), AS79, AS80, AS101, AS290

Arnold, Leslie P., AS50

Arnold, Rudy, AS51, AS210

Around-the-world flights, AS50, AS67, AS81, AS108

Arrow Sport (aircraft), AS135

Art, AS11, AS32, AS169, AS295; artists' conceptions, AS19, AS29, AS300; aviation, AS11, AS32, AS169, AS295, AS337; space, AS11, AS21, AS25, AS27, AS32, AS333, AS337. See also Drawings; Emblems; Logos; Murals; Nose art; Paintings; Portraits; Sculptures; Totem poles.

Articles: magazine, AS26, AS138; newspaper, AS22, AS26

Artificial satellites. See Satellites, artificial.

Artillery, AS32, AS35, AS49, AS117, AS122, AS128, AS149, AS163, AS247, AS272. See also Guns.

Artillery ranges, AS122. See also Shooting ranges.

Artists' conceptions (spacecraft), AS19, AS29, AS300

Arts and Industries Building (Smithsonian Institution), AS85, AS170, AS247

Asbury Park (New Jersey), AS79, AS142

Ascensions (balloons), AS9, AS160, AS213, AS221. See also Launches.

Asia: aircraft, AS172; students, AS56. See also specific countries.

Assembly lines, AS60

Associated Press, AS84

Associations. See Clubs and organizations.

Asteroids, AS333

Astor Cup races, AS153

Astra aircraft, AS281, AS311

Astronauts, AS15–AS18, AS20, AS21, AS25, AS26, AS33, AS46, AS52, AS63, AS164, AS206, AS213, AS300, AS319, AS333, AS334. See also Cosmonauts; specific individuals, spacecraft.

Astronomers, AS27, AS145, AS333. See also specific individuals.

Astronomical equipment, AS27, AS29, AS145. See also Observatories.

Astronomy, AS27, AS28. See also Astronomers; Observatories; Telescopes.

Astrophysics, AS31

Atlantic Missile Range. See Cape Canaveral (Florida); Kennedy Space Center.

Atlantis (Space Shuttle), AS18

Atlas missiles, AS65

Atmospheric features, AS333. See also Clouds; Weather.

Atomic bombs, AS240

Atwater, W.B., AS160

Atwood, Harry, AS143

Atwood, J. Leland, AS155

Aubrun, Eugène-Emile, AS209

Audemars, Edmond, AS158

Aukland (New Zealand), AS229

Auriol, Jacqueline, AS230

Austin (Texas), AS284

Austin aircraft, AS311

Australia, AS137

Austria, AS35, AS157

Austria-Hungary, AS258

Autogyros, AS38, AS86, AS208, AS337. See also specific manufacturers, models.

Automobiles, AS70, AS72, AS73, AS90, AS115, AS122, AS127, AS142, AS150, AS153, AS156, AS160, AS166, AS173, AS186, AS241, AS242, AS251, AS259, AS272, AS310; childrens' pedal cars, AS122; experimental, AS185; jeeps, AS44, AS213; military, AS198; parts, AS194, AS219; race cars, AS79, AS127, AS153, AS156, AS173; races, AS109, AS127, AS153, AS156, AS310; Saudi Arabia, AS202. See also Ambulances; Buses; Jeeps; Trucks.

Avenger. See Grumman TBF Avenger.

Avery, William, AS53

Aviatik aircraft, AS281

Aviation (magazine): employees, AS84

Aviation associations. See Clubs and organizations.

Aviation Instruction Center (France), AS260

Aviation schools, AS56, AS58, AS79, AS160, AS220, AS237. See also Classes; Flight instructors; Pilot training; Students.
—Burgess-Wright, AS160
—Curtiss, AS56, AS88, AS94, AS129, AS150, AS160, AS241, AS304, AS308
—Curtiss-Wright, AS63
—facilities, AS56, AS88
—Gatchina (Russia), AS9, AS123
—Hawthorne, AS144
—locations: Canada, AS56, AS129; England, AS58; Garden City (New Jersey), AS129; Hempstead (New York), AS129; Miami (Florida), AS150; Mineola (New York), AS129, AS150; Toledo (Ohio), AS161
—Sloan, AS274
—students, AS56, AS129, AS144, AS150
—Triaca, AS160

Aviators. See Aces; Pilots; specific countries, individuals, wars.

AVID Speedwing (aircraft), AS180

Aviodome (Netherlands), AS24

Avionics, AS201

Award presentations, AS35, AS48, AS154, AS170, AS213, AS224, AS273, AS289, AS302, AS330, AS338

Awards, AS100, AS147, AS289, AS295.
 See also Medals; Trophies; specific
 awards.
Azores islands, AS114

B-52. See Boeing aircraft.
Baalbek (Lebanon), AS289
Babies, AS161. See also Children;
 Families.
Bader, Franz: art works by, AS11
Bad Kissingen (Germany), AS35
Baggage, AS94, AS115
Baggage compartments, AS50
Baghdād (Iraq), AS50, AS202
Bagpipes, AS188
Bags, AS44. See also Baggage.
Bahamas, AS135
Bair, Hilbert L., AS319
Baird, J. Gilbert, AS169
Bakelite Corporation, AS84
Baker Day Test, AS240
Balchen, Bernt, AS66
Balderson, Anne, AS199
Baldwin, Ivy. See Ivy, William.
Baldwin, Thomas S., AS77, AS308
Baldwin aircraft, AS102; Red Devil,
 AS160
Ballast, AS298
Ball lightning, AS246
Balloonists, AS118, AS147, AS168
Balloons, AS4, AS37, AS56, AS57,
 AS73, AS83, AS85, AS101, AS104,
 AS118, AS120, AS126, AS127,
 AS140, AS142, AS158, AS166,
 AS168, AS196, AS208, AS210,
 AS213, AS218, AS237, AS282,
 AS287, AS294, AS295, AS297,
 AS311, AS334, AS336. See also
 Gondolas; Rockoons; Stratospheric
 balloons; specific countries, names of
 balloons.
—construction, AS22
—crews, AS22, AS221
—deflations, AS70
—equipment, AS160; inflation systems,
 AS296
—events, AS299; competitions, AS140;
 crashes, AS22; races, AS160, AS168,
 AS170, AS213; stunt flights, AS118;
 weddings, AS142
—flights, AS22, AS77, AS118, AS133,
 AS160, AS168, AS170; ascensions,
 AS9, AS160, AS213, AS221; high-
 altitude, AS22, AS142, AS192,
 AS221; landings, AS22
—hangars, AS9, AS133
—inflations, AS9, AS36, AS77, AS142,
 AS160, AS168, AS221, AS237,
 AS292, AS297
—locations: Germany, AS113, AS126;
 Great Britain, AS36, AS73; Russia,
 AS9, AS22, AS168
—military: Boer War, AS168; Civil War,
 AS168; Russo-Japanese War, AS168;
 U.S. Army, AS121, AS297; World
 War I, AS168

—on ships, AS9
—parts: gondolas, AS22, AS133,
 AS160, AS192, AS297; rigging, AS36,
 AS160, AS297
—training, AS36, AS133, AS170
—types: aerial gunnery, AS70; captive,
 AS106, AS170; observation, AS113,
 AS160, AS297; research, AS213;
 sausage, AS170, AS297; signal,
 AS177; smoke, AS168; tissue
 phantom balloons, AS168
Balloons and Airships (National Air and
 Space Museum gallery), AS335,
 AS336
Balls, inaugural, AS338
Baltic Sea (Russia), AS9
Baltimore (Maryland), AS183
Balzer, Stephen M., AS194
Bands (musical), AS68, AS113, AS154;
 marching, AS106, AS262, AS305. See
 also Concerts; Performances.
Bangkok (Thailand), AS50
Bankers. See Financiers.
Banning, James Herman, AS63
Banquets, AS48, AS318. See also
 Ceremonies; Dinners; Luncheons.
Barbados, AS135, AS289
Barbecues, AS189. See also Picnics.
Barges, AS113
Barnaby, Ralph S., AS57, AS161
Barnes, Florence L. ("Pancho"), AS75,
 AS280
Barnstormers, AS156, AS181, AS189,
 AS252. See also Aerobatics; Pilots;
 specific individuals.
Barnstorming, AS109, AS189, AS237,
 AS252. See also Aerobatics;
 Exhibition flight; Stunt flights.
Barographs, AS102
Baron (aircraft). See Beech Baron.
Barracks, AS72, AS106, AS113, AS122,
 AS124, AS149, AS218, AS276,
 AS329
Barricades, AS158
Barrir, René, AS158
Bars, AS125, AS154. See also Alcohol;
 Drinking; Restaurants.
Baseball, AS154, AS244
Baseball teams, AS90, AS154, AS198,
 AS288
Basketball, AS244
Baskets (balloon). See Gondolas.
Battlefields, AS129, AS149, AS272.
 See also Trenches.
Battles. See Bombing; Combat; specific
 locations, wars.
Battleships, AS9, AS70, AS160, AS186,
 AS308; miniature models, AS143.
 See also Aircraft carriers.
Beaches, AS70, AS122, AS150, AS161,
 AS162, AS228, AS276, AS304,
 AS312
Beachey, Lincoln, AS56, AS88, AS94,
 AS160, AS197, AS308, AS310;
 aircraft, AS185; flights, AS57, AS310;
 grave, AS310

Beall, Wellwood E., AS155
Bean, Alan L., AS300
Bean, Roy: office, AS276
Bearcat. See Grumman F8F Bearcat.
Bears, AS53, AS261
Beatty, George W., AS58
Beaune (France), AS272
Beauvais (France), AS35
Beck, Paul W., AS160
Bedrooms, AS55, AS134. See also
 Barracks; Interiors.
Beds, AS113, AS134
Beech, O.A., AS280
Beech, Walter H., AS52, AS288
Beech aircraft, AS287; 17 Staggerwing,
 AS135, AS230; 18, AS216; 35
 Bonanza, AS230; AT-10, AS59;
 Baron, AS236; Bonanza, AS59;
 C-17R Staggerwing, AS280; D-17,
 AS180; F-2, AS261; King Air,
 AS216; Philippine Baron, AS236;
 Super 18, AS59; U-21, AS59; XA-38,
 AS254
Beech Aircraft Corporation, AS84,
 AS280
Beggs, James M., AS43
Behrens, Volker, AS253
Beijing (China), AS289
Belgium, AS35, AS149, AS254, AS320
Bell, Alexander Graham, AS77, AS160;
 tetrahedral kite, AS140, AS160
Bell, George L., AS169
Bell, Lawrence D., AS52
Bell aircraft, AS153, AS207, AS287,
 AS311; 47 helicopter, AS216; P-39,
 AS153; XP-59, AS208
Bellanca aircraft, AS38, AS165; CF,
 AS211
Bell Telephone Laboratories, AS84
Belmont Park (New York), AS102,
 AS160
Bendix air races, AS61, AS280
Bennett, James Gordon, Jr., AS85
Benoist aircraft, AS57, AS85, AS151;
 XII, AS208; XIII, AS211; flying boats,
 AS104, AS129, AS150, AS158,
 AS160
Benson, Frank W.: art works by, AS11
Bera, Frances S., AS230
Bergen, William B., AS155
Berghof (Hitler's house), AS153
Berkeley (California), AS290
Berlin (Germany), AS35, AS125, AS153;
 Berlin airlift, AS282
Berliner, Emile: helicopters, AS62
Berliner, Henry A., AS80; helicopters,
 AS62
Bermuda (aircraft). See Brewster SB2A
 Bermuda.
Bernardi, Mario de, AS52
Besson aircraft, AS281
Best, Fred, AS26
Bettis Field (Pennsylvania), AS220
Beverages: alcohol, AS115; coffee,
 AS154; in space, AS18. See also Bars;
 Drinking; Eating.

"Beyond the Limits: Flight Enters the Computer Age" (National Air and Space Museum exhibit), AS12
B.G. Spark Plugs, AS84
Bicycles, AS44, AS274, AS289
Biddle, Charles J., AS319
Bielefeld (Germany), AS35
Biggin Hill Air Fair, AS172
Big Joe satellite, AS193
Bikini Atoll, AS240
Biltmore Travel Agency, AS84
Biplanes, AS38, AS58, AS68, AS104, AS118, AS124, AS135, AS141, AS142, AS158–AS160, AS177, AS184, AS218, AS231, AS242, AS251, AS256, AS262, AS282, AS287, AS297, AS309, AS329; Aeromarine, AS185; Beech, AS60; Caproni, AS72; Curtiss, AS83, AS87, AS89, AS94, AS185; Martin, AS185; Nieuport, AS310; Travel Air, AS288; Verville, AS305; Wright, AS83. *See also* Monoplanes; specific manufacturers, models.
Bird of Paradise (aircraft), AS269
Birds, AS83, AS120
Birmingham (Alabama), AS318
Birthday parties, AS290
Bissell, Clayton L., AS319
Black Americans. *See* African Americans.
Blackburn aircraft, AS160, AS311; Firebrand, AS153
Black Sea (Russia), AS9
Blacksmiths, AS272
"Black Wings: The American Black in Aviation" (National Air and Space Museum exhibit), AS33, AS63
Bleecker, Maitland B., AS64
Blériot, Louis, AS51, AS137, AS160, AS217
Blériot aircraft, AS58, AS102, AS103, AS137, AS140, AS142, AS153, AS158, AS160, AS225, AS274, AS277, AS281, AS311; XI, AS210, AS211
Bless, Robert C., AS26
Blimps. *See* Airships; Goodyear.
Bloir, Theresa C., AS316
Blue Scout rockets, AS175
Bluford, Guion S., Jr., AS18, AS33, AS63
Blum, Johnny, AS68
Boarding aircraft, AS183
Boardman test site (Oregon), AS175
Board meetings, AS273
Boats, AS9, AS122, AS202, AS241, AS267; canoes, AS269; ferry barges, AS113; kayaks, AS50; motor boats, AS62, AS307; racing, AS153, AS181; rowboats, AS73, AS181
Boeing aircraft, AS110, AS137, AS287; 95, AS214; 247, AS86; 307 Stratoliner, AS85, AS135; 314 Clipper *American Clipper*, AS229; 377, AS207, AS216; 707, AS8; 727,

AS172, AS216, AS293; 737, AS12, AS216, AS293; 747, AS15, AS216, AS289; B-29, AS212; B-50, AS254; B-52, AS69, AS132, AS207; B-52 Stratofortress, AS42; C-97, AS207, AS216; DH-4M, AS86; F4B, AS86; GA-1, AS328; GA-2, AS328; mailplanes, AS288; MB-3A, AS296; PW-9, AS328; transports, AS141; XP-4, AS328
Boeing Airplane Company, AS84
Boeing spaceflight simulator, AS175
Boer War, AS168
Bogotá (Colombia), AS289
Bohn, Delphine, AS291
Boland, Edward R.: medals, AS275
Bolden, Charles F., Jr., AS63
Bolster, Calvin M., AS174
Bombardment squadrons, AS63
Bomber aircraft, AS37, AS40, AS42, AS49, AS72, AS94, AS153, AS154, AS163, AS207, AS237, AS282, AS287, AS295, AS311, AS329. *See also* specific countries, manufacturers, models, wars.
Bombing, AS9, AS10, AS49, AS73, AS160, AS207, AS237, AS282, AS295, AS305; aerial photographs, AS49, AS113, AS321; bombed buildings, AS70, AS113, AS120, AS126, AS128, AS129, AS149, AS163, AS232; craters, AS129; demonstrations, AS143; Vietnam, AS42; World War I, AS70, AS115, AS120, AS126, AS129, AS149, AS163, AS186, AS232, AS260, AS262, AS272, AS276; World War II, AS10, AS49, AS116, AS321
Bombs, AS32, AS49, AS73, AS154, AS237, AS296, AS337; atomic, AS240; equipment, AS49; loading, AS9, AS42, AS63, AS126, AS154, AS295; releases, AS32, AS49, AS177, AS281; sights, AS32, AS49, AS296; tests, AS73, AS296; World War I, AS115, AS126, AS129
Bona, Joseph C. De. *See* De Bona, Joseph C.
Bonanza. *See* Beech aircraft.
Bonanza Airlines, AS244
Bonestell, Chesley: art works by, AS11
Bonn (Germany), AS35
Books, AS55; National Air and Space Museum, AS37, AS210
Boomerangs, AS253
Boosters (rocket), AS164
Boots, AS3. *See also* Flight clothing; Shoes.
Boquel, Joe, AS160
Borders (Mexican), AS122, AS198
Borglum, Gutzon, AS52
Boston (Massachusetts), AS143
Bouroff, Valery Chkalov, AS9
Bowman, Leslie, AS68
Bowman, Lorraine, AS68
Bowman, Marguerite, AS68

Boxers, AS63, AS125
Boxing, AS161, AS272, AS276
Boys. *See* Children.
Brandes, Geraldine H., AS316
Braniff Airways, AS84
Bratislava (Slovakia), AS258
Braun, Wernher von, AS12, AS28, AS82, AS85, AS175, AS263
Brazil, AS289
Breese aircraft, AS141
Breguet aircraft, AS58, AS113, AS160, AS281; 14, AS140, AS315
Breguet-Wibault 670 (aircraft), AS153
Brewster aircraft, AS51; Buffalo, AS254; F2A Buffalo, AS71; SB2A Bermuda, AS71, AS153; SB2A Buccaneer, AS71, AS85; XA-32, AS254
Brides, AS126. *See also* Weddings.
Bridgeport (Connecticut), AS160
Bridges, AS35, AS56, AS113, AS261
Briefings, AS42, AS154
Briggs, Lyman J., AS155
Bristol (England), AS94
Bristol (Tennessee), AS318
Bristol Aeroplane Company, AS48
Bristol aircraft, AS113, AS160, AS281; Beaufighter, AS153; Britannia, AS8; fighters, AS73; transport bombers, AS153
Bristol Sidely Orpheus engines, AS313
Britain. *See* England; Great Britain.
Britannia. *See* Bristol Britannia.
Brittany (France), AS113
Brock, Walter L., AS58
Brogdon, Gladys, AS213
Bronte, Emory, AS269
Brookins, Walter, AS79
Brooks, Arthur R., AS70, AS319, AS320
Brooks, Sidney, AS63
Brossy, Fred, AS313
Brown, Arthur Whitten. *See* Whitten-Brown, Arthur.
Brown, Charles, AS7
Brown, Clarence A., Jr., AS161
Brown, Francis T., AS61
Brown, Harold N., AS140
Brown, Harry Bingham, AS160
Brown, Jesse L., AS63
Brown, T.D., AS261
Brown, Willa B., AS63
Brown, William E., Jr., AS63
Bryant, Alys McKey, AS274
Buccaneer. *See* Brewster SB2A Buccaneer.
Buckholtz, Gene, AS26
Buckler, Julius, AS320
Buck Rogers comics, AS25
Buffalo (aircraft). *See* Brewster aircraft.
Buffalo (balloon), AS168
Buffalo (New York), AS94
Building. *See* Construction.
Buildings, AS25, AS44, AS55, AS153; aircraft companies, AS86, AS189; airports, AS50, AS58, AS83, AS84, AS86, AS114, AS135, AS161, AS165,

AS169, AS174; aviation schools,
AS88, AS133; France, AS70, AS113,
AS114; military, AS106, AS113,
AS122, AS124, AS149, AS295,
AS329; Morocco, AS96; Myanmar,
AS119; Russia, AS246; Virginia,
AS112; Washington, D.C., AS56,
AS87. *See also* Architecture; Barracks;
Hangars; specific locations, structures.
Bullfights, AS129
Bulolo Goldfield's Aeroplane Services,
AS315
Bumbaugh, George L., AS142; balloon
flights, AS160
Bunks, AS134, AS183. *See also* Barracks.
Burden, William A.M., AS155
Burgess aircraft, AS103, AS160;
seaplanes, AS79, AS228
Burgess-Dunne aircraft: AH-1, AS245;
AH-7, AS245; seaplanes, AS160
Burgess-Wright aviation schools, AS160
Burgess-Wright seaplanes, AS85
Burke, E. Woodward, AS71
Burma. *See* Myanmar.
Burnelli aircraft, AS161; UB-14, AS254
Buses, AS144, AS202, AS259
Bush, George, AS338
Businesses. *See* specific names, types of
business.
Business executives. *See* Executives;
Financiers; Manufacturers; specific
companies, names.
Business offices, AS103, AS104, AS127,
AS130, AS174
Bussy, Arthur C., AS51
Butler, Howard Russell: art works by,
AS11
Byrd, Richard E., AS52, AS290

Cabins, AS235; airship, AS222
Cables, AS177
Cactus, AS112, AS122
CAD/CAM computers, AS12
Cafes, AS113. *See also* Restaurants.
Cakes, AS302
Caldwell, Cy, AS79
Caldwell, Frank W., AS155
California, AS142; Aero Policewomen's
Association of California, AS75;
aviation schools, AS56, AS160;
Berkeley, AS290; Death Valley,
AS181; Los Angeles, AS142, AS161;
military bases, AS56, AS97, AS242,
AS264, AS305; mountains, AS136;
San Diego, AS56, AS122, AS153,
AS160, AS305; San Francisco, AS142,
AS183, AS318; Santa Monica, AS142;
University of California, AS290
Callaway, Margo, AS213
Calle, Paul: art works by, AS11
Callisto (moon of Jupiter), AS19
Cambrai (France), AS35
Camel (aircraft). *See* Sopwith aircraft.
Camel caravans, AS202
Camels, AS189, AS202
Camera operators, AS276

Cameras, AS26, AS76, AS154, AS161,
AS237, AS240, AS290, AS295; aerial,
AS160, AS163, AS189, AS296,
AS305; equipment, AS26, AS67,
AS240; Fairchild, AS111; Graflex,
AS305; Hasselblad, AS99; motion-
picture, AS79, AS160, AS276. *See
also* Photography.
Camouflage, AS60, AS177, AS272,
AS295
Campbell, Douglas, AS284, AS319
Camps, AS161, AS186; military, AS70,
AS129, AS149, AS153, AS198. *See
also* Tents; specific locations, military
branches, wars.
Campuses, AS144. *See also* Aviation
schools; Schools; Universities.
Camshafts, AS94
Canada: aircraft, AS40, AS172; aviation
schools, AS56, AS129; flight clothing,
AS3; museums, AS24; Royal Flying
Corps, AS70; Toronto, AS129, AS304
Cannons, AS32, AS49
Canoes, AS269
Canopies, AS56
Cans, AS18
Cape Canaveral (Florida), AS164,
AS175, AS300
Capital Airlines, AS84
Capitol Building (Washington, D.C.),
AS56, AS87, AS272, AS309
Caproni aircraft, AS140, AS157;
biplanes, AS72; CA-44, AS245
Caproni di Taliedo, Giovanni G.L. *See*
Taliedo, Giovanni G.L. Caproni di.
Captive balloons, AS106, AS170
Caravans, AS202
Carburetors, AS54, AS219
Card games, AS124, AS154
Cargo, AS68, AS250. *See also* Baggage;
Transport aircraft.
Caribbean, AS135, AS172
Carlotta. *See* Myers, Mary H.
Carlstrom Field (Florida), AS220
Carnivals, AS68, AS113, AS198. *See
also* Fairs; Festivals.
Carol II (king of Romania), AS251
Carpenter, M. Scott, AS300
Carpenter shops, AS112
Carrier Pigeon (aircraft). *See* Curtiss
Carrier Pigeon.
Carrying loads, AS202, AS276
Cars. *See* Automobiles; Jeeps; Trucks.
Carthage (North Carolina), AS188
Cartographic records. *See* Globes; Maps.
Cartoonists, AS135
Cartoons, AS125
Carts, AS44, AS114, AS198, AS276
CAS "Charm" high altitude rockets,
AS138
Cassady, Thomas G., AS319
Castle, Vernon, AS160
Castles, AS113
Cathedrals, AS113, AS121, AS186,
AS191, AS276, AS281

Cathode ray tubes, AS13
Cats, AS73
Catskill Mountains, AS135
Cattle, AS122
Caudron aircraft, AS311
Cavalry, AS70, AS126, AS235
CBS (Columbia Broadcasting System),
AS38
CCDs (charge-coupled devices), AS31
Cedar Key (Florida), AS310
Celebrations. *See* Ceremonies; Parties;
specific events (such as Birthday
parties, Christenings).
Celestial objects, AS19, AS27, AS145,
AS175. *See also* Asteroids; Satellites;
Stars.
Celestial phenomena, AS145, AS175
Cemeteries, AS70, AS115, AS120,
AS261, AS272, AS276, AS323; aerial
photographs, AS189, AS297. *See also*
Funerals; Graves.
Census tabulators, AS13
Centaur rockets, AS175
Century of Progress Exposition
(Chicago, 1933), AS22
Ceremonies, AS73, AS80, AS186,
AS273, AS280, AS289, AS300,
AS302, AS304; aircraft presentations,
AS305; airlines, AS151, AS244;
commemorative, AS269, AS279;
dedications, AS169, AS223, AS318;
government, AS338; military, AS232,
AS295; National Air and Space
Museum, AS336. *See also* Award
presentations; Church services;
Weddings.
Cernan, Eugene, AS46
Certificates. *See* Awards; Trophies.
Cessna aircraft, AS110, AS287; 340,
AS216; Skymaster, AS135
Chalker, J., Jr., AS160
Challenger (Space Shuttle), AS18
Chambers, Reed M., AS319
Chanute, Octave, AS53, AS155; gliders,
AS53, AS185, AS191
Chapman, Victor, AS188
Charge-coupled devices, AS31
Charles, Mary, AS75
Charts, AS73, AS102, AS162, AS164,
AS208, AS219, AS246, AS266,
AS295, AS296, AS313, AS333; flight
data, AS73; meteorological, AS177
Châteaudun (France), AS115
Cherisienne Escadrille, AS96
Chevolair D-6 engines, AS74
Chicago (Illinois), AS22, AS161; airports,
AS84, AS318; aviation events, AS79,
AS102, AS168; expositions, AS22
Chief (aircraft). *See* Aeronca Chief.
Children, AS87, AS122, AS124, AS143,
AS161, AS170, AS186, AS198,
AS297; at the National Air and Space
Museum, AS21, AS33; China, AS276;
France, AS217; Germany, AS126;
Inupiaq, AS261; model aircraft
contests, AS54; Vietnam, AS243

China, AS44, AS243; architecture, AS289; Landsat photographs, AS1; landscapes, AS44, AS50; people, AS101, AS276; spacecraft, AS24
China Air Task Force, AS44
Christenings: aircraft, AS89, AS108, AS160, AS199, AS207, AS274, AS282, AS304, AS307; stratospheric balloons, AS221. *See also* Ceremonies; Dedication ceremonies.
Christensen, Frederick, Jr., AS65
Christ-Janer, Albert W.: art works by, AS11
Christmas, William H., AS160
Christmas celebrations, AS174, AS236 *See also* Santa Claus.
Christy, Howard C.: art works by, AS11
Chrysler Corporation, AS174
Churches, AS276. *See also* Mosques; Temples.
Church services, AS9
Circuits (electrical), AS39, AS219
Cirrus UK30 (aircraft), AS180
Cities. *See* Aerial photographs; Cityscapes; specific cities, countries.
City Lights program, AS33
City of Angels (aircraft), AS108
City of New York (aircraft), AS81
City of New York (balloon), AS158
City of Oakland (aircraft), AS141, AS269
City of Washington (aircraft), AS108, AS208
Cityscapes, AS70, AS113, AS153, AS189, AS218, AS276; Alaska, AS261; Beaune (France), AS272; Bogotá (Colombia), AS289; China, AS44; Germany, AS113, AS126, AS153; Japan, AS323; Lisbon (Portugal), AS91, AS114, AS310; Los Angeles (California), AS142; Marseilles (France), AS114; Mexico, AS70; Myanmar, AS44; Nancy (France), AS113; New Orleans (Louisiana), AS112; Newport News (Virginia), AS112; New York (New York), AS114, AS163, AS167; Paris (France), AS70, AS74, AS113, AS114, AS232, AS235, AS277; Philadelphia (Pennsylvania), AS163; Pittsburgh (Pennsylvania), AS163; Richmond (Virginia), AS112; Russia, AS246; San Antonio (Texas), AS70, AS112; San Francisco (California), AS142; Santa Monica (California), AS142; Slovakia, AS258; Tours (France), AS113; Verdun (France), AS113; Versailles (France), AS113; Washington, D.C., AS56, AS87, AS272. *See also* Aerial photographs; Street scenes.
Civil Aeronautics Authority, AS84
Civil aircraft, AS172, AS295. *See also* Airliners; Commercial aircraft; specific manufacturers, models.
Civil servants, AS66, AS94, AS155. *See also* Government officials; specific countries, names.
Civil wars: Russia, AS123; United States, AS35, AS168
Clark, Julia, AS242
Clark, Virginius E., AS155
Clark Aircraft Corporation, AS84
Clarke, Frank, AS142
Classes: gunnery, AS106. *See also* Aviation schools; Pilot training; Training.
Class pictures, AS144, AS305
Class reunions, AS273
Classrooms, AS106, AS144, AS220, AS246
Cleland, Cook, AS7
Cleveland Air Races. *See* National Air Races.
Clipper. *See* Boeing 314 Clipper; Martin aircraft.
Clocks and watches, AS143, AS175
Clothing and dress, AS32, AS44, AS72, AS144, AS188; cowboy outfits, AS110, AS152; flight jackets, AS32, AS44. *See also* Flight clothing; Pressure suits; Space suits; Uniforms.
Clouds, AS1, AS47, AS83, AS126, AS142, AS258; weather satellite images, AS162, AS266, AS283
Cloudster. *See* Douglas Cloudster.
Clowns, AS154
Clubs and organizations, AS55, AS75, AS125, AS152, AS154, AS189, AS237; Aero clubs, AS55, AS79, AS292, AS330; American Astronautical Society, AS43; American Helicopter Society, AS200; American Rocket Society, AS76; Early Birds, AS57, AS58, AS169, AS274, AS310; Golden Eagles, AS57; National Aeronautic Association, AS213; National Aviation Club, AS302; Tuskegee pilots, AS63; Wings Club, AS57; Women Flyers of America, AS316; youth organizations, AS125
Clusters (star), AS27, AS333
Coasts, AS218; aerial photographs, AS35, AS122, AS189, AS231, AS257, AS304. *See also* Harbors; Waterfronts.
Cober, Alan E.: art works by, AS11
Cobham, Alan, AS226
Cochran, Jacqueline, AS7, AS52, AS61, AS66, AS135, AS213, AS230, AS291
Cockpits, AS8, AS83, AS94, AS98, AS134, AS183, AS189, AS257, AS271, AS337; helicopters, AS64
Cocoa plantations, AS289
Code, Arthur D., AS26
Cody, Mabel, AS189
Cody, Samuel F., AS160
Coffee, AS154
Coffey, Cornelius R., AS63
Coffyn, Frank T., AS66, AS79, AS135, AS160; aircraft, AS160

Coleman, Bessie, AS63
College Park (Maryland) airport, AS58, AS80
Collier, Robert J., AS52
Collings, John A., AS286
Collins, Michael, AS52, AS319
Collyer, Charles B.D., AS81
Cologne Cathedral, AS121
Colombia, AS289
Colonial Airways, AS304
Colorado, AS153, AS160
Colorado Springs balloon race, AS160
Columbia (Apollo spacecraft), AS334
Columbia (Space Shuttle), AS18
Columbia Broadcasting System (CBS), AS38
Columbus (Ohio), AS94
Colvin, Charles H., AS155
Combat, AS128, AS262, AS282, AS295; aerial, AS10, AS42, AS113, AS120, AS237, AS305. *See also* Bombing; Soldiers; Trenches; specific military branches, wars.
Combustion chambers, AS278
Comet (aircraft). *See* De Havilland D.H.88 Comet.
Comets, AS19, AS333
Commedians. *See* Humorists.
Commemorative ceremonies, AS269, AS279
Commercial aircraft, AS65, AS85, AS216, AS237, AS295. *See also* Airliners; specific companies, countries, manufacturers, models.
Committees, AS63, AS152. *See also* Meetings.
Communications: equipment, AS32, AS70; in space, AS18; in trenches, AS120; radio, AS18, AS28, AS39, AS41, AS70, AS86, AS92. *See also* Radios; Signals.
Companies. *See* Factories; Manufacturers; specific companies.
Company aircraft, AS38, AS67. *See also* specific companies.
Company sports teams, AS90, AS244, AS288
Compasses, AS154. *See also* Navigational instruments.
Composers, AS52. *See also* specific names.
Composite photographs, AS157, AS163
Computer images, AS333. *See also* CCDs.
Computers, AS12, AS13, AS193, AS293
Concerts, AS33, AS113, AS169. *See also* Performances.
Concorde (aircraft), AS334
Condor (aircraft). *See* Curtiss Condor.
Conferences, AS162. *See also* Meetings; Seminars.
Connecticut, AS160
Connecting rods, AS54
Conrad, Charles, Jr., AS206
Conroy CL-44-0 (aircraft), AS216

Conservation, AS92, AS211, AS335–AS337. *See also* Restoration.
Conservators, AS211
Consolidated aircraft, AS38, AS323
Constellation (aircraft). *See* Lockheed aircraft.
Constellations, AS333
Construction
—aircraft, AS9, AS54, AS56, AS83, AS85, AS98, AS103, AS127, AS129, AS171, AS189, AS207, AS214, AS237, AS250, AS282, AS295, AS311, AS329; Beech, AS59, AS60; Curtiss, AS92, AS94, AS223; experimental aircraft, AS187, AS205, AS314; Fairchild, AS110; Lockheed, AS142; Martin, AS130, AS183, AS185; National Air Transport, AS214; Piaggio, AS238; Savoia-Marchetti, AS257; Sopwith, AS271; Travel Air Company, AS288; United Technologies Corporation, AS293; World War I, AS106, AS276; World War II, AS154, AS291
—airfields, AS134, AS295
—airships, AS36, AS134, AS152, AS332
—automated, AS12
—buildings, AS25, AS295, AS329; hangars, AS257; National Air and Space Museum, AS25, AS335
—computers, AS12
—engines, AS54, AS74, AS176, AS189, AS293, AS313
—helicopters, AS62, AS148
—missiles, AS278
—radios, AS39
—rockets, AS14, AS28, AS234, AS278
—shops, AS41, AS56, AS94, AS103, AS127, AS142, AS171, AS220
—space telescopes, AS26
—spacecraft, AS18, AS28, AS175, AS193, AS206, AS267, AS300
—stratospheric balloons, AS22, AS221
Containers (used in space), AS18, AS32
Contests. *See* Aerobatics; Air races; Races.
Continental aircraft, AS82; Airphibian, AS82
Continental, Inc., AS82
Continents, AS1
Control panels, AS336
Control rooms, AS305; airships, AS125; spacecraft, AS164
Controls: aircraft, AS107, AS271, AS281; airships, AS177; helicopters, AS64
Control towers, AS144, AS329
Convair aircraft, AS287; 880, AS216; 990, AS216; B-36, AS254; XC-99, AS254; XF-81, AS254
Convertible aircraft, AS147
Convertoplane. *See* Herrick Convertoplane.
Cook, Everett L., AS319

Cooke, Hereward Lester: art works by, AS11
Cooley, John F., AS160
Cooper, L. Gordon, Jr., AS300
Cooper, Mario: art works by, AS11
Cooperstown (New York), AS186
Coppens, Willy: medal, AS320
Coronagraphs, AS27
Corpses, AS120, AS128, AS129, AS232. *See also* Funerals; Graves.
Corrigan, Douglas, AS51
Corrosion, AS30, AS107, AS219
Corsair. *See* Vought aircraft.
Cosmonauts, AS246. *See also* Astronauts; specific individuals.
Cosmos satellites, AS263
Costa Rica, AS265
Costumes, AS170, AS262. *See also* Clothing and dress.
Cotton, AS288
Cotton gins, AS152
Council rooms, AS55
Courier (satellite), AS175
Cowboys, AS68; clothing, AS110, AS152
Cowlings, AS59, AS60, AS94, AS288
Cox-Klemin A-1 (aircraft), AS328
Coyotes, AS122
Craftwork, AS202, AS261
Cranes, AS56, AS104, AS218, AS304
Crank cases, AS54
Crankshafts, AS56, AS219
Crashes: aircraft, AS9, AS38, AS51, AS56, AS58, AS70, AS96, AS101, AS103, AS113, AS120, AS126, AS129, AS135, AS142, AS143, AS146, AS150, AS157–AS161, AS181, AS185, AS186, AS203, AS235, AS237, AS241, AS242, AS244, AS248, AS264, AS265, AS269, AS272, AS273, AS276, AS277, AS290, AS292, AS295, AS304, AS305, AS308, AS311, AS329; airships, AS36, AS120, AS125, AS282, AS298; helicopters, AS62, AS285; Italy, AS72; Langley Aerodrome, AS171; seaplanes, AS170, AS218; stratospheric balloons, AS22, AS221; Thomas E. Selfridge, AS77, AS190; trains, AS241. *See also* Recovering aircraft.
Craters, AS129
Cray-1 computer, AS12
Crews: aircraft, AS37, AS42, AS79, AS149, AS153, AS154, AS282, AS295, AS305; aircraft carriers, AS305; airships, AS125, AS177, AS332; construction, AS129; stratospheric balloons, AS22, AS221. *See also* Pilots.
Crop dusting aircraft, AS8, AS288
Crops, AS78. *See also* Farms; Gardens; Rice paddies.
Crosswell, William J., AS94
Crowds, AS186, AS188, AS280, AS298, AS299, AS304, AS307, AS332;

France, AS217; Russia, AS246. *See also* Cityscapes; Spectators.
Crutches, AS150
Crystal Palace (London), AS73
Cub. *See* Piper Cub.
Cuba, AS198
Cunningham, Randy, AS52
Curaçao, AS135
Curators, AS52, AS169, AS305. *See also* specific individuals.
Curtiss, Edward P., AS319
Curtiss, Glenn H., AS9, AS77, AS85, AS88–AS90, AS94, AS137, AS143, AS155, AS160, AS171, AS264, AS308; flight demonstrations in Russia, AS9; flights, AS160, AS190, AS305; Langley Aerodrome, AS88, AS160, AS171, AS307; motorcycles, AS90; painting of, AS287
Curtiss Aeroplane and Motor Company, AS129
Curtiss Aeroplane Company, AS303, AS305, AS307; baseball team, AS90; factories, AS94, AS304, AS308
Curtiss aircraft, AS51, AS80, AS90, AS94, AS102, AS103, AS192, AS277; 18-T Wasp, AS245; A-1, AS264, AS305; A-2, AS264; AH-132, AS245; *America*, AS89, AS303, AS304; biplanes, AS83, AS89, AS185; C-46 Commando, AS216; Carrier Pigeon, AS214; Condor, AS86, AS194; D, AS88; E, AS88; Eagle, AS87; F, AS88; F-5L, AS245; F7C-1, AS86; F9C-2 Sparrowhawk, AS211; Falcon, AS86, AS214; Fledgling, AS86, AS194; flying boats, AS56, AS85, AS303, AS304; G, AS88; H-16, AS245; HA-1 Dunkirk Fighter, AS245; Hawk, AS141; HS-1L, AS245; HS-2L, AS245; J seaplane, AS307; JN-2, AS129; JN-3, AS129; JN-4, AS109, AS129, AS159, AS163, AS180, AS235; JN-4D2, AS141; L-2, AS245; Limousine, AS160; McCormick, AS88; MF Seagull, AS315; N-9, AS245, AS305; NBS-4, AS328; NC-1, AS91, AS245; NC-2, AS218; NC-3, AS91; NC-4, AS70, AS91, AS92, AS208, AS218; O-1, AS328; O2C Helldiver, AS185; Oriole, AS160; P-1, AS68, AS328; P-2, AS328; P-6 Hawk, AS225; P-40, AS153; P-40 Warhawk, AS119; PN-1, AS328; pushers, AS88, AS211, AS274; PW-8, AS296, AS328; R, AS159, AS307; R-4, AS223; R-6, AS296, AS328; R-8, AS328; R-9 Seaplane, AS245; replicas, AS305; Robin, AS86, AS223; SB2C Helldiver, AS10; seaplanes, AS9, AS88, AS150, AS153, AS245, AS276, AS305, AS307; Tadpole, AS88; Thrush, AS223; tractors, AS88; Travelair, AS86; triplanes, AS88; XO-1, AS328; XO-18, AS223; XP-3, AS328; XP-42, AS212

Curtiss aviation schools, AS88, AS94, AS129, AS150, AS241, AS308; Hammondsport (New York), AS88; Newport News (Virginia), AS56; San Diego (California), AS160; Toronto (Canada), AS304

Curtiss-Bleecker helicopters, AS64

Curtiss engines, AS90, AS194, AS223, AS313

Curtiss flying schools. *See* Curtiss aviation schools.

Curtiss-Wright Aeronautical School, AS63

Curtiss-Wright aircraft, AS192, AS287, AS288; Curtiss-Bleecker helicopter, AS64; Travel Air B14B, AS180

Curtiss-Wright Corporation, AS64, AS84, AS94

Custer Channel Wing (aircraft), AS220

Cutting hair, AS276

Cyclops. *See* Huff-Daland XHB-1 Cyclops.

Czars, AS9

Czechoslovakia, AS138, AS251. *See also* Slovakia.

DACOWITS, AS97

Dallas (Texas), AS56, AS318

Damage, AS30, AS107, AS268, AS302. *See also* Crashes.

Dancers, AS154, AS269

Dances, AS44, AS73, AS101, AS154, AS302

Danube River, AS258

Dassault aircraft: Falcon, AS5, AS216; Mirage V, AS110

Dateman, Yvonne, AS291

Dauntless. *See* Douglas SBD Dauntless.

Davenport, William M., AS95

Davis, Arlene, AS230

Davis, Benjamin O., Jr., AS33, AS63

Davis, Douglas, AS61

Davis, Luella F., AS316

Day, Curtiss La Q., AS96

Dayton (Ohio), AS198. *See also* McCook Field; Wright Field; Wright-Patterson Air Force Base.

Dayton Wright aircraft, AS328

DC-3. *See* Douglas DC-3.

Dearborn Observatory, AS145

Death. *See* Cemeteries; Corpses; Funerals; Graves.

Death Valley (California), AS181

De Bona, Joseph C., AS7, AS61

De Bothezat helicopters, AS165

Decoration Day celebrations, AS198

Decorations (National Air and Space Museum), AS338

Decorative art objects, AS11

Dedication ceremonies, AS169, AS223, AS318. *See also* Christenings.

Deer, AS186

Defense Advisory Committee on Women in the Services (DACOWITS), AS97

Deflations (balloons), AS70

De Florez, Luis. *See* Florez, Luis de.

De Havilland aircraft, AS192, AS254, AS287, AS311, AS315; Canada DHC-6 Twin Otter, AS216; DH-4, AS141, AS211, AS296; D.H.88 Comet, AS153; D.H.98 Mosquito, AS153, AS179; D.H.100 Vampire, AS216, AS255

De Havilland company, AS153, AS313

Dehydrated food, AS300

Deimos (moon of Mars), AS2

Deinzer, Vernon W., AS39

DeLeon, John, AS168

Deliveries, AS68, AS244. *See also* Cargo; Transportation; Trucks.

Demoiselle (aircraft), AS102

Demolition, AS329

Demonstration flights, AS9, AS68, AS104

Demonstrations, AS21; bombing, AS143

Deng Xiaoping, AS335

Deperdussin aircraft, AS58, AS137, AS153, AS274, AS281, AS311

Deserts, AS152, AS163, AS181, AS202

Design (aircraft), AS12, AS48, AS60

Designers: aircraft, AS12, AS48, AS84, AS147; airships, AS82, AS125. *See also* specific names.

Desks, AS21. *See also* Offices; Schools.

Destination Moon (motion picture), AS175

Deterioration. *See* Damage; Restoration.

Detroit (Michigan), AS84

Detroit News aircraft, AS67

Diagrams, AS25, AS26, AS246, AS333; aircraft, AS83, AS92, AS147, AS153, AS208, AS212; airships, AS222; balloons, AS22; electrical circuits, AS219; engines, AS73, AS196, AS313; flight paths, AS83; infrared missile sensors, AS230; rockets, AS14; spacecraft, AS19, AS20, AS28, AS193; spectrographs, AS14, AS131

Dictators, AS125, AS153

Diesel engines, AS313

Digging, AS44

Dining rooms, AS106, AS122, AS144, AS149; airships, AS125. *See also* Mess halls.

Dinners, AS169, AS223, AS273, AS302. *See also* Banquets; Eating; Luncheons; Meals.

Dirigibles. *See* Airships.

Disaster recovery, AS15. *See also* Crashes; Recovering aircraft; Rescues.

Discoverer 9 (satellite), AS175

Discovery (Space Shuttle), AS18

Discs. *See* Magnetic discs.

Disney Productions, AS84

Dispensaries, AS154

Displays, AS39, AS44, AS113, AS145, AS174. *See also* Advertisements; Exhibits; Showrooms.

Distinguished Flying Cross, AS100

Distributors, AS83

District of Columbia. *See* Washington, D.C.

Di Taliedo, Giovanni G.L. Caproni. *See* Taliedo, Giovanni G.L. Caproni di.

Diving suits, AS292. *See also* Pressure suits.

Dixie Airlines, AS84

Dixie Clipper (aircraft), AS114

Dixon, Cromwell, AS143, AS160

Dizon, Edith, AS236

Docks, AS50, AS56, AS165, AS257, AS261. *See also* Harbors.

Doctors. *See* Physicians.

Documents, AS199. *See also* Ephemera; Manuscripts; Maps.

Dodd, Lamar: art works by, AS11

Doerner, Aurilla M., AS316

Dogfights, AS273. *See also* Aerial combat.

Dogs, AS158, AS262, AS272, AS276

Doherty, Elwood, AS171

Dole Race. *See* Pacific Air Race.

Dolgouruki, Princess Alexis, AS232

D'Olive, Charles R., AS319

Donkeys, AS202. *See also* Mules.

Doolittle, James H., AS52, AS61, AS101, AS192, AS288; painting of, AS287

Doors (helicopter), AS64

Dornier aircraft, AS180, AS311; Do 18E, AS254; Do 24, AS254; Do X, AS36, AS98, AS165, AS223, AS254; Russian models, AS9; seaplanes, AS185

Double Eagle II (balloon), AS334

Douglas, Donald W., AS155; painting of, AS287

Douglas aircraft, AS38, AS51, AS110, AS137, AS192, AS287, AS311, AS323; C-1, AS328; Cloudster, AS142; D-558, AS208; DC-3, AS86, AS212; DC-4 prototype, AS135; DC-6, AS8, AS216, AS254; DC-7, AS216; DC-9, AS216, AS244; M2, AS214; O-2, AS328; SBD Dauntless, AS10; World Cruiser, AS141, AS296, AS328; XB-42, AS254; XNo, AS328

Douglas Aircraft Company, AS84, AS175

Doughnuts, AS154

Dow Chemical Company, AS314

Dozier, Lewis D., AS160

Drafting rooms, AS54

Drawings, AS11, AS26, AS29, AS164, AS266, AS295; aircraft, AS11, AS48, AS160, AS183, AS212; aircraft engines, AS73; architectural, AS80, AS153; balloons, AS299; celestial objects, AS19; engineering, AS60, AS174, AS177, AS332; rockets, AS165; spacecraft, AS19, AS20. *See also* Art; Diagrams; Paintings; Plans.

Drift meters, AS108. *See also* Navigational instruments.

Drills (ship evacuations), AS70

Drinking, AS144; in space, AS18. *See also* Bars; Beverages.

Drogues, AS41

Drums, AS202
Dryden, Hugh L., AS155
Dry dock, AS10
Dual-control training aircraft, AS56, AS160, AS271
Duck (aircraft). *See* Grumman J2F Duck.
Duede, Carl H., AS310
Dugan, Thomas B., AS65
Duke, Charles M., Jr., AS300
Dulles International Airport Space Center, AS15
Dunkirk Fighter. *See* Curtiss Dunkirk Fighter.
Dupont, Richard C., AS161
Durant & Lesley propellers, AS313

Eagle (aircraft). *See* Curtiss Eagle.
Eagle engines, AS73, AS313
Eagle Squadrons, AS100
Eaker, Ira C., AS101
Earhart, Amelia, AS38, AS52, AS61, AS66, AS75, AS192, AS280, AS316
Early Birds (club), AS57, AS58, AS169, AS274, AS310
Early Flight (National Air and Space Museum gallery), AS335
Earphones, AS278
Earth: exploration, AS29; from space, AS1, AS16, AS20, AS29, AS45, AS47, AS99, AS175, AS206, AS263, AS266, AS333; solar system, AS2
Eastern Airlines, AS84
Eating, AS18, AS113. *See also* Banquets; Barbeques; Dinners; Drinking; Food; Luncheons; Meals; Picnics.
Echo 1 (satellite), AS175
Eckener, Hugo, AS125
Eclipses, AS145, AS333
Edison, Thomas A., AS52
Editors, AS84
Education. *See* Aviation schools; Classes; Pilot training; Training.
Eglin Air Force Base (Florida), AS6
Egtvedt, Clairmont L., AS155
Egypt, AS1, AS138, AS191
Eiffel Tower, AS70, AS272
Eighth Air Force, AS101
Eisenhower, Dwight D., AS52, AS63
Elder, Ruth, AS75, AS280, AS290
Electra. *See* Lockheed aircraft.
Electronic records. *See* CCDs; Computers; Video discs.
Elephants, AS262
Elias aircraft, AS328
Ellington Field (Texas), AS106, AS181
Elliott, Derek W., AS21
Ellyson, Theodore G., AS264
Elmira (New York), AS135, AS161
El Paso (Texas), AS318
Ely, Eugene, AS94, AS160, AS308; aircraft, AS160
Emblems, AS21, AS44. *See also* Insignia.
Emergencies. *See* Crashes; Disaster recovery; Rescues.
Emergency equipment, AS32, AS56

Emett, Rowland: art works by, AS11
Emsco aircraft, AS181
Endurance flights. *See* Record flights.
Engine controls, AS107
Engineering drawings, AS60, AS174, AS177, AS332
Engineers, AS78, AS82, AS94, AS129, AS155
Engines, AS78. *See also* specific manufacturers, models.
—aircraft, AS8, AS32, AS54, AS56, AS59, AS60, AS73, AS74, AS77, AS83, AS92, AS94, AS104, AS107, AS153, AS160, AS161, AS174, AS185, AS187, AS194, AS208, AS219, AS223, AS235, AS237, AS255, AS288, AS295, AS296, AS305, AS307, AS311, AS313, AS326, AS327, AS337; Allison, AS313; Andermat, AS231; Anzani, AS194; Bristol, AS313; Chevolair, AS74; Curtiss, AS90, AS194, AS223, AS313; diesel, AS313; Eagle, AS73, AS313; General Electric, AS313; Gnome, AS74, AS194; Gyro, AS313; Hispano-Suiza, AS54, AS271, AS313; jet, AS293; Kirkham, AS223; Liberty, AS176, AS313; Martin, AS54; Packard, AS54, AS313; Pratt & Whitney, AS293; Renault, AS313; Rolls Royce, AS54, AS313; rotary, AS74, AS194, AS313; Siemens-Shuckert, AS74; Soviet, AS194; Sunbeam, AS73; Wright, AS194, AS223, AS313, AS324, AS325
—airship, AS166, AS177, AS298
—automobile, AS194, AS219
—boat, AS307
—construction, AS54, AS176, AS189, AS293, AS313
—development, AS54
—diagrams, AS73, AS196
—maintenance and repair, AS56, AS146, AS220
—rocket, AS32, AS76, AS93, AS175
—spacecraft, AS300
—steam, AS194
—tests, AS74, AS107, AS219
England, AS35, AS112, AS289. *See also* Great Britain.
—aircraft, AS104, AS172
—airports, AS58
—factories, AS94, AS153
—landscapes, AS111
—locations: Bristol, AS94; Liverpool, AS115; London, AS58, AS73, AS325; Manchester, AS24; Plymouth, AS91; Rochester, AS73; Salisbury, AS112; Sheerness, AS73
—museum exhibits, AS24
—parades, AS91
—World War I, AS112, AS115
Engravings, AS25
Enlisted men. *See* Soldiers; specific countries, military branches.
Enola Gay (aircraft), AS334

Enterprise (Space Shuttle), AS15, AS18, AS21
Entertainment, AS39, AS156; performances, AS63, AS122, AS126, AS154, AS169. *See also* Concerts; Games; Motion pictures; Recreation; Sports.
Ephemera (aviation), AS9. *See also* Advertisements; Emblems; Insignia; Maps; Posters; Propaganda leaflets; Sheet music; War bonds.
Equipment, AS29, AS30, AS49; aircraft, AS3, AS32, AS73, AS86, AS102, AS133, AS160; airport, AS54; astronomical, AS27, AS29, AS145; balloon, AS36; bomb, AS49; camera, AS26, AS67, AS240; communications, AS32, AS145; construction, AS130, AS152, AS176; farm, AS152; military, AS30, AS35, AS100, AS101, AS106, AS113, AS120, AS122, AS129, AS154, AS198; radio, AS28, AS39, AS70, AS86, AS92, AS106, AS125, AS174, AS198, AS201; rocket, AS76, AS131; safety, AS3, AS32, AS54, AS56, AS86, AS237; spacecraft, AS12, AS17, AS24, AS29, AS46, AS99, AS164; test, AS26, AS64, AS94, AS107; training, AS24, AS32, AS49, AS144. *See also* specific types of equipment.
Ericson, Frithiof G., AS129
Erie (Pennsylvania), AS237
Eskimos. *See* Inupiaqs.
Estes, Richard: art works by, AS11
Eta Carinae (nebula), AS27
Ethiopia, AS35
Etrich aircraft, AS58, AS160
Euler aircraft, AS160
Europe, AS49, AS121, AS137; aircraft, AS137, AS172; air races, AS137; bombing, AS49; buildings, AS55, AS120; cityscapes, AS129; landscapes, AS120; space programs, AS16; villages, AS112, AS129; World War I, AS35, AS49, AS115, AS120; World War II, AS35, AS49, AS179. *See also* specific countries.
Evacuations, AS70, AS295
Evans, Clifford V., Jr., AS108
Evans, Ronald E., AS300
Evans All-Steel Glider, AS41
Events. *See* specific events (such as Air races, Award presentations, Banquets, Festivals).
Excaliber III (aircraft), AS211
Executives, AS39, AS66, AS79, AS84, AS94, AS110, AS130, AS135, AS152, AS155, AS167, AS213, AS280, AS289, AS302, AS304. *See also* Businessmen; Manufacturers; specific companies.
Exercising, AS198, AS260. *See also* Gymnastics.
Exhaust systems, AS8, AS271

Exhibition flight, AS189, AS237. *See also* Aerobatics; Barnstorming.

Exhibits, AS12, AS17, AS24, AS33, AS267; aircraft engines, AS68; aviation, AS129, AS140, AS169, AS189, AS194, AS237, AS244, AS281, AS295, AS305; balloons, AS299; Crystal Palace (London), AS73; miniature model aircraft, AS107; Smithsonian Institution, AS85, AS109, AS170; spaceflight, AS17, AS300; U.S. Army Air Service, AS70. *See also* Air shows; Displays; Expositions; National Air and Space Museum.

Expeditions, AS160, AS282, AS315

Experimental aircraft, AS38, AS85, AS187, AS237, AS328, AS337; Custer Channel Wing, AS220; Experimental Aircraft Association, AS180; helicopters, AS62, AS80, AS194, AS285; HiMAT Remotely-Piloted Research Vehicles, AS249; plastic, AS314. *See also* Homebuilt aircraft; specific inventors, manufacturers, models.

Experimental Aircraft Association, AS180

Experiments. *See* Research and development.

Exploration, AS29, AS160; Moon, AS45. *See also* Expeditions.

Explorer 1 (satellite), AS175

Explorer I (stratospheric balloon), AS22, AS221

Explorer II (stratospheric balloon), AS22

Explorers, AS29, AS52. *See also* specific individuals.

Exploring the Planets (National Air and Space Museum gallery), AS334, AS336

Explosions, AS10, AS272. *See also* Bombing.

Expositions, AS168; Century of Progress Exposition (Chicago, 1933), AS22; Crystal Palace (London), AS73; Louisiana Purchase Exposition (1904), AS53, AS168, AS256; New York World's Fair (1939), AS174; Panama-Pacific International Exposition (1916), AS142; Paris (France), AS104; San Diego Exposition (1916), AS153; Stockholm Air Exposition (1936), AS153

Extinguishing fires, AS207, AS218. *See also* Fire trucks.

Extractive industries. *See* Mines; Wells.

Extra-vehicular activity, AS18. *See also* Space walks.

Fabric, AS103

Facilities. *See* specific military branches, types of facilities.

Factories. *See also* Construction; Machine shops.

—aircraft, AS9, AS54, AS67, AS85, AS98, AS127, AS153, AS160, AS218, AS250, AS282, AS305, AS314; Aerojet, AS175; Curtiss, AS94, AS304, AS308; Fairchild, AS110; Gill-Dash, AS127; Goodyear, AS152; Lockheed, AS67, AS142; Martin, AS130, AS185; North American Aviation, AS175; Piper, AS135; Rockwell International, AS175; Savoia-Marchetti, AS257; Thomas Brothers, AS160; Travel Air Company, AS288

—airship, AS54, AS134

—engine, AS176

—locations: England, AS94, AS153; France, AS153; Germany, AS116, AS153; Italy, AS153; Russia, AS9

—prefabricated housing, AS152

—stratospheric balloon, AS221

—submarine, AS153

—sugar, AS232

—workers, AS54, AS67, AS94, AS98, AS103, AS134, AS176, AS257

—World War I, AS176, AS232

—World War II, AS116

Fahey Committee, AS63

Fairchild aircraft, AS110, AS160, AS192, AS287, AS311; 12E4, AS110; 24, AS135; 341, AS110; 1099, AS110; AT-14, AS212; C-119 Flying Boxcar, AS110; F-27, AS110, AS216; F-105, AS110; FC-2, AS110; FH-1100, AS110; J-5, AS110; M-230, AS110; monoplanes, AS141, AS163; PT-19, AS216; Tip Turbojet, AS110; UH-5, AS110; XF-84H, AS110

Fairchild Hiller Corporation, AS148

Fairchild Industries, Inc., AS110

Fairchild KS-25 High Acuity Camera System, AS111

Fairey aircraft, AS73; Firefly, AS153

Fairs, AS142, AS308, AS329. *See also* Air fairs; Carnivals; Expositions; Festivals.

Falcon (aircraft). *See* Curtiss Falcon; Dassault Falcon.

Families, AS56, AS73, AS101, AS122, AS123, AS142, AS162, AS276, AS297, AS300, AS308, AS312. *See also* Children; Houses; Weddings; specific countries.

Farman, Henri, AS160

Farman aircraft, AS58, AS102, AS129, AS137, AS281, AS284, AS311; Russian models, AS9

Farms, AS56, AS78, AS113, AS152, AS153, AS232, AS261, AS297, AS309; France, AS113; houses, AS112, AS113; workers, AS78, AS232. *See also* Crops; Gardens.

Farré, Henri: art works by, AS11

Farrow, Mia, AS161

Fayetteville (North Carolina), AS144

Fechet, James E., AS155

Federal Aviation Administration, AS301, AS302

Felsenthal slide rules, AS12

Fences, AS241, AS305

Fequant, Philippe, AS209

Ferris, Keith: art works by, AS11

Ferris wheels, AS70

Ferry barges, AS113

Festivals, AS336. *See also* Carnivals; Fairs.

Fiat aircraft, AS311

Fiber art, AS11

Fiedler, Willy A., AS175

Field lights, AS83, AS106, AS237

Field radios, AS106, AS198, AS329

Fields. *See* Airfields; Landscapes.

Field trips (National Air and Space Museum), AS33

Fifth Air Force, AS317

Fighter aircraft, AS37, AS40, AS73, AS94, AS136, AS141, AS153, AS154, AS207, AS237, AS282, AS287, AS295, AS305, AS311, AS329, AS336; British, AS54. *See also* specific countries, manufacturers, models, wars.

Fighter groups, AS65, AS317

Fighter pilots, AS282. *See also* Pilots.

Fighter squadrons, AS63, AS65

Fighting. *See* Aerial combat; Combat; Soldiers; specific military branches, wars.

Films. *See* Motion pictures.

Financiers, AS82

Finland, AS172

Firebrand. *See* Blackburn Firebrand.

Firecracker (aircraft), AS231

Fire extinguishers, AS54. *See also* Extinguishing fires.

Firefly (aircraft). *See* Fairey Firefly.

Fires, AS158, AS160, AS198, AS218; aircraft, AS207; airships, AS332; balloons, AS305

Fire trucks, AS54, AS73, AS144. *See also* Extinguishing fires.

Fireworks, AS25

Firing guns, AS187, AS272

Firing squads, AS232

First aid, AS106

First Day Bombardment Group, AS115

First Ladies, AS63, AS143

Firsts: aerial news photograph, AS160; airline, AS151; airplane flight (1903), AS160; machine gun fired from aircraft, AS80; parachute jump from aircraft, AS160

Firth, Agnes, AS274

Fisher, Carl G., AS166

Fisher, Herbert O., AS66

Fishermen, AS289

Fishing, AS110, AS198, AS284; from aircraft, AS54, AS241

Fiske, Gardiner H., AS115

Fitzgerald, Ella, AS63

Flags, AS32, AS120, AS188, AS199, AS300

Flares, AS49, AS109
Fledgling (aircraft). *See* Curtiss Fledgling.
Fletcher, James L., AS26
Fletcher FU-24 (aircraft), AS216
Flexi-Wing. *See* Ryan Flexi-Wing.
Flight attendants, AS84, AS114, AS214, AS237, AS244, AS282, AS291, AS304
Flight clothing, AS3, AS32, AS44, AS56, AS71, AS124, AS161, AS217, AS225, AS237, AS280, AS284, AS292, AS295, AS336, AS337; flight jackets, AS32, AS44; World War I, AS3, AS72; World War II, AS3. *See also* Pressure suits; Safety equipment; Space suits.
Flight control equipment, AS164, AS201, AS293
Flight crews. *See* Crews, aircraft.
Flight instructors, AS56, AS63, AS68, AS128, AS150, AS160. *See also* Aviation schools.
Flight jackets, AS32, AS44
Flight preparations, AS108, AS202, AS217, AS269
Flights: around-the-world, AS50, AS67, AS81, AS108; birds, AS83; international, AS9, AS52, AS63, AS262; Pacific, AS269; record, AS109, AS142, AS186, AS192, AS237, AS295; transatlantic, AS70, AS91, AS114; transcontinental, AS186. *See also* Aerobatics; Night flights; Stunt flights; Tests, flight; specific aircraft, locations, pilots.
Flight schools. *See* Aviation schools.
Flight simulators, AS12, AS32, AS237, AS300
Flight suits. *See* Flight clothing; Uniforms.
Flight surgeons, AS155
Flight Technology (National Air and Space Museum gallery), AS335
Flight Testing (National Air and Space Museum gallery), AS335
Flight tests. *See* Tests.
Flight training. *See* Pilot training.
Floats (parade), AS198
Floodlights, AS83
Floods, AS158, AS235
Florez, Luis de, AS12, AS52, AS135, AS140, AS155
Florida, AS135, AS150, AS188; airports, AS189; All-American Air Maneuvers (Miami), AS135; Arcadia, AS220; Cedar Key, AS310; Kennedy Space Center, AS164, AS175, AS300; Miami, AS135, AS150; military bases, AS6, AS218, AS305; St. Petersburg-Tampa Airboat Line, AS151
Flotation gear, AS117, AS160
Flotillas, AS256
Flowers, AS87
Flyers. *See* Wright aircraft.
Flying Allens, AS118
Flying boats, AS85, AS89, AS91, AS92, AS98, AS114, AS189, AS218, AS250; Benoist, AS104, AS129, AS150, AS158, AS160. *See also* Amphibian aircraft; Seaplanes; specific manufacturers, models.
Flying Boxcar. *See* Fairchild C-119 Flying Boxcar.
Flying magazine, AS84
Flying schools. *See* Aviation schools.
Flying Tigers, AS44. *See also* American Volunteer Group.
Flywheels, AS107
FNRS (balloon), AS22
Foa, Joseph, AS239
Foam (plastic), AS314
Foch, Ferdinand, AS120
Focke-Wulf aircraft, AS51, AS311; Fw 190, AS208, AS210
Foggia (Italy), AS72
Fokker aircraft, AS113, AS137, AS161, AS192, AS262, AS287, AS311; *America*, AS199; C-2 *Bird of Paradise*, AS269; D.VII, AS150, AS163; F.III, AS126, AS303; F.VII/3M *Southern Cross*, AS269; F.XXII, AS153; F-27, AS244; G-1, AS153; PW-5, AS328; T-2, AS296, AS328; Universal, AS141; V-40, AS328
Food: in space, AS17, AS18, AS24, AS32, AS175, AS300; nuclear survival packets, AS213; on airships, AS125; Red Cross service, AS70, AS154. *See also* Banquets; Barbeques; Dinners; Eating; Luncheons; Meals; Picnics; Restaurants; specific foods.
Football, AS122, AS163
Footlockers, AS113
Footprints, AS300
Footware. *See* Boots; Flight clothing; Mukluks; Sandals; Shoes.
Forbes, A. Holland, AS168
Forbidden City (Beijing, China), AS289
Ford, Christopher W., AS52
Ford, Gerald R., AS26
Ford aircraft, AS192; Trimotor, AS68, AS86, AS214, AS265, AS286, AS289
Fordney, Chester, AS22
Fordrickson engines, AS54
Forsythe, Albert E., AS63
Fortikov, I., AS175
Fort McKinley (Philippines), AS170
Fort Myer (Virginia), AS170
Forts, AS170, AS198
Fort Worth (Texas), AS56
Foulois, Benjamin D., AS80, AS155, AS170
Fowler, Harold, AS120
Foxes, AS232
Foyers, AS55
France, AS70, AS96
—aircraft, AS36, AS40, AS54, AS104, AS172, AS217, AS281
—ambulances, AS188
—architecture, AS70, AS113, AS114, AS121, AS153; cafes, AS113; cathedrals, AS113, AS186; factories, AS153; universities, AS272
—aviation events, AS104, AS140, AS153, AS160, AS170, AS172, AS281, AS299; early aviation, AS217
—cityscapes, AS70, AS114, AS121, AS129, AS217, AS260, AS272, AS276; street scenes, AS70, AS113, AS217
—flight clothing, AS3
—funerals, AS106
—landscapes, AS70, AS113, AS121, AS153, AS217, AS260; gardens, AS153
—locations: Beaune, AS272; Beauvais, AS35; Brittany, AS113; Cambrai, AS35; Châteaudun, AS115; Marseilles, AS114; Metz, AS260, AS276; Nancy, AS113; Paris, AS70, AS74, AS113, AS114, AS121, AS140, AS153, AS170, AS172, AS235, AS272, AS277, AS281, AS299; Reims, AS160; Tours, AS113, AS276; Verdun, AS113; Versailles, AS70, AS113; Villers-sur-Meuse, AS260; Wizernes, AS35
—parades, AS70
—people, AS113, AS115, AS120, AS217, AS272, AS276, AS289; aviation associations, AS55; military officers, AS149; pilots, AS209, AS217, AS277; Wilbur Wright visit, AS330
—waterscapes, AS70, AS113, AS289; rivers, AS289
—weapons, AS49
—World War I, AS70, AS96, AS113, AS115, AS120, AS129, AS149, AS188, AS232, AS260, AS272, AS276, AS284
—World War II, AS321
Frankfurt (Germany), AS125, AS153
Franklin, R.E., AS161
Fravel, Ira F., AS121
Fredrickson engines, AS54
Freedom 7 (spacecraft), AS213
Freeman, Fred: art works by, AS11
Freight, AS54. *See also* Cargo; Transport aircraft.
Friedrichshagen (Germany), AS116
Friendship 7 (spacecraft), AS20, AS46
Frisbee aircraft, AS102
Fritz, Lawrence G., AS286
Frostbite, AS126
Fruit, AS78
Frye, Charlotte, AS60, AS230
Frye, Jack, AS155
Fuel, AS219
Fueling aircraft, AS50, AS94, AS185, AS276, AS295
Fuel tanks, AS50, AS64, AS106, AS174, AS185, AS271
Fuel valves, AS278
Fuller, Burdette D., AS75
Fuller, Frank W., Jr., AS51, AS61
Fulton, Garland, AS177

Fulton, Robert E.: aircraft, AS82
Funerals, AS70, AS106, AS113, AS125, AS232, AS262, AS272, AS295. *See also* Cemeteries; Graves.
Furniture, AS21, AS174. *See also* Interiors; specific pieces.
Furrow, George C., AS122
Fuselages, AS83, AS94, AS271, AS288, AS311; helicopters, AS64

Gable, Clark, AS65
Gabrielli, Guiseppi, AS155
Gaffeney, Mary J., AS291
Galaxies, AS27, AS31, AS333
Galileo probe carrier, AS19
Gallaudet aircraft: D-4, AS245; DB-1, AS328; PW-4, AS328
Galleries (National Air and Space Museum), AS12, AS21, AS194, AS334–AS336. *See also* Exhibits.
Galveston (Texas), AS277
Games: Army-Navy football game, AS122; cards, AS124, AS154; Saudi Arabia, AS202; tug-of-war, AS56, AS218. *See also* Recreation; Sports.
Gamma. *See* Northrop Gamma.
Gannymede (balloon), AS168
Garber, Paul E., AS52, AS169, AS305
Garber Facility, AS208, AS211, AS334–AS336
Garden City (New Jersey), AS129
Gardens, AS83, AS153. *See also* Crops; Farms.
Garros, Roland B., AS158
Gas cells (airship), AS125
Gas generators, AS296
Gaskets, AS54
Gas masks, AS260
Gas pumps, AS257
Gas stations, AS246
Gas tanks. *See* Fuel tanks.
Gas trucks, AS106
Gasworks, AS258
Gatchina Military Flying School (Russia), AS9, AS123
Gately, J. Rome, AS124
Gates Learjet 25 (aircraft), AS216
Gauges, AS83, AS107
Gears, AS54, AS64, AS94
Gee Bee aircraft, AS192. *See also* Granville aircraft.
Geller, Uri, AS266
Gemini program, AS18, AS20, AS24, AS99, AS300; astronauts, AS17, AS18; *Gemini 4*, AS175; guidance systems, AS12; spacecraft, AS18, AS23, AS24, AS99, AS145
General Electric Corporation, AS14, AS175, AS313
Generals, AS33, AS79, AS80, AS120, AS198, AS338. *See also* specific countries, names, wars.
Generators, AS9, AS54, AS175
Genova (Italy), AS35
Gentry, Viola, AS230
Geographic features, AS1, AS129. *See also* Landscapes; specific countries,

geographic features (such as Volcanoes, Waterfalls).
Germany, AS126
—aircraft, AS73, AS104, AS180, AS192, AS262, AS276
—architecture, AS113, AS121, AS126, AS153; Berghof (Hitler's house), AS153; churches, AS276; factories, AS116, AS153
—balloons, AS113, AS126
—Berlin airlift, AS282
—cityscapes, AS113, AS121, AS126, AS129, AS153
—flight clothing, AS3
—landscapes, AS113, AS121, AS126
—locations: Bad Kissingen, AS35; Berlin, AS35, AS125, AS153; Bielefeld, AS35; Bonn, AS35; Frankfurt, AS125, AS153; Friedrichshagen, AS116; Hamburg, AS153; Munich, AS35, AS153; Nuremburg, AS153; Peenemünde, AS14, AS175, AS233, AS234; Solingen, AS116; Stuttgart, AS35; Trier, AS276
—people, AS28, AS113, AS126, AS232, AS262; aviation associations, AS55; pilots, AS262, AS320
—waterscapes, AS121, AS126, AS153
—weapons, AS49, AS120
—World War I, AS113, AS115, AS120, AS126, AS129, AS192, AS262, AS276
—World War II, AS14, AS321
Gibson, Hoot, AS181
Gill, Howard W., AS127
Gill-Dash aircraft, AS127
Gilmore (the lion), AS290
Gilpatric, J. Guy, AS128, AS129
Girls. *See* Children.
Givens, Edward G., AS300
Glenn, John H., Jr., AS52, AS66
Glenn Curtiss Airport (New York), AS165
Glenn L. Martin Company, AS84, AS130. *See also* Martin, Glenn L.; Martin aircraft.
Gliders, AS4, AS37, AS41, AS68, AS83, AS85, AS94, AS140, AS160, AS161, AS209, AS237, AS273, AS282, AS287; Albatros, AS53; equipment, AS41, AS53; Evans, AS41; hangars, AS41; meets, AS41, AS68, AS135, AS161; Octave Chanute, AS53, AS185, AS191; Otto Lilienthal, AS53, AS191. *See also* Hang gliders.
Globes, AS29. *See also* Maps.
Gloves, AS3. *See also* Flight clothing.
Gnome engines, AS74, AS194
Godard, Eugène: balloons, AS168
Goddard, Robert H., AS20, AS76, AS131, AS175; experiments, AS25, AS131; painting of, AS287; rockets, AS32, AS131, AS334
Goebel, Arthur E., AS137, AS269, AS288
Goggles, AS144

Golden Age of Flight (National Air and Space Museum gallery), AS334–AS336
Golden Eagles (club), AS57
Gold mining, AS315
Gold Rush (Klondike), AS168
Goldsboraugh, Brice H., AS288
Gondolas: airships, AS125, AS157, AS177, AS298; balloons, AS133, AS160, AS297; stratospheric balloons, AS22, AS192, AS221
Gooden, F.W., AS58
Goodyear Aerospace Corporation, AS132
Goodyear aircraft: blimp, AS135, AS334; ZPG-3W airship, AS134
Goodyear factories, AS54, AS221, AS263
Goodyear moon vehicles, AS175
Goodyear Tire and Rubber Company, AS133, AS134
Goodyear-Zeppelin Corporation, AS152, AS221
Gordon, Elizabeth, AS230
Gordon, Richard F., Jr., AS206
Gordon Bennett races, AS160, AS170, AS213
Gotha G.IV (aircraft), AS126
Government officials, AS66, AS84, AS94, AS155, AS189, AS251, AS289. *See also* Civil servants; specific countries, individuals.
Governors, AS152
Graduations, AS162
Graflex cameras, AS305
Graf Zeppelin (airship), AS36, AS125
Grahame-White, Claude, AS58, AS66, AS137, AS160, AS226; flights, AS102
Grain, AS78. *See also* Crops; Farms.
Grain, Isle of, AS73, AS117
Grand Canyon, AS153, AS186
Grand dukes, AS9
Grande (Sikorsky aircraft), AS158
Grandstands, AS143
Granges, Byrd Howell, AS291
Grant, David N.W., AS155
Granville aircraft: Gee Bee, AS52, AS109; Gee Bee R-1, AS86
Grapes, AS78
Graphic prints, AS11, AS29. *See also* Posters.
Graphs, AS26, AS162. *See also* Charts; Diagrams; Drawings.
Grasshopper. *See* Piper L-4 Grasshopper.
Graves, AS113, AS120, AS188, AS232, AS248, AS276, AS310, AS312, AS320. *See also* Cemeteries; Funerals.
Graves, Morris: art works by, AS11
Graveyards. *See* Cemeteries.
Great Britain, AS35; aircraft, AS40, AS73, AS104, AS117, AS172; airfields, AS73; airships, AS36; aviation associations, AS55; balloons, AS36, AS73; flight clothing, AS3; Isle of Grain, AS73, AS117; military bases, AS73, AS112; military officers, AS36, AS73; pilots, AS209; Royal Air

Force, AS73, AS172; ships, AS73;
 weapons, AS49, AS187. *See also*
 England.
Greater Manchester Museum of Science
 and Industry (England), AS24
Great Western (balloon), AS168
Greece, AS191
Greene, John W., Jr., AS63
Gregg, Willis Ray, AS155
Gregory, Frederick D., AS20
Grigorovich aircraft, AS9
Grissom, Virgil I., AS52, AS175
Groenhoff, Hans, AS210
Gromov, Mikhail M., AS9
Grooms, AS126. *See also* Weddings.
Ground-breaking ceremonies, AS244.
 See also Dedication ceremonies.
Ground crews, AS79
Grumman aircraft, AS51, AS192,
 AS287; F4F Wildcat, AS136; F6F
 Hellcat, AS10; F8F Bearcat, AS109,
 AS212; Gulfhawk, AS135; J2F Duck,
 AS216; J4F Widgeon, AS95; SA-16
 Albatross, AS136; TBF Avenger,
 AS153; X-29, AS12
Grumman Aircraft Engineering
 Corporation, AS84
Grumman Large Space Telescope, AS26
Grumman X-Ray Telescope, AS26
Guam, AS42
Guard houses, AS329
Guatemala, AS158, AS265
Guggenheim, Harry F., AS76
Guided missiles, AS311
Guinea Airways, AS315
Guitars, AS276
Gulfhawk. *See* Grumman Gulfhawk.
Gulf Refining Company, AS84
Gun cameras, AS290
Gun emplacements, AS113
Gun mounts, AS160, AS271, AS296
Gun rooms, AS106
Guns, AS32, AS44, AS49, AS94, AS113,
 AS120, AS122, AS129, AS154,
 AS202, AS247, AS272, AS276,
 AS296, AS336, AS337; aircraft,
 AS73, AS311; anti-aircraft, AS32,
 AS49, AS163, AS232; machine guns,
 AS32, AS49, AS92, AS117, AS149,
 AS187, AS337; mortar guns, AS35.
 See also Artillery; Cannons; Shooting;
 Shooting ranges.
Gun turrets, AS32, AS49, AS94
Guthrie, M.K., AS319
Guynemer, Georges, AS226; funeral,
 AS106
Gymnastics, AS290. *See also* Exercising.
Gyro rotary engines, AS313

Haight, Edward M., AS319
Hair cutting, AS112
Haizlip, James H., AS61, AS66
Halberstadt aircraft, AS113
Haley, Andrew G., AS138
Hall, Charles B., AS63
Hall, Ernest H., AS310

Hall, John O., AS213
Hall aircraft, AS51
Haller, Gus, AS161
Halley's Comet, AS19
Hall of Air Transportation (National Air
 and Space Museum gallery), AS335
Halls of fame, AS24
Hamburg (Germany), AS153
Hamilton, Charles K., AS277
Hamilton aircraft, AS102
Hamilton space clock, AS175
Hamilton Standard propellers, AS293,
 AS313
Hammer, William J., AS140
Hammers, H.E., AS261
Hammondsport (New York), AS88,
 AS171, AS303, AS308
Hancock, Theodore: art works by, AS11
Handley-Page aircraft, AS311; Halifax
 II, AS153
Hanford Airlines, AS84
Hangars
—aircraft, AS9, AS36, AS41, AS54,
 AS56, AS73, AS80, AS86, AS88,
 AS94, AS102–AS104, AS106, AS113,
 AS117, AS119, AS128, AS137,
 AS142, AS144, AS149, AS150,
 AS157, AS161, AS181, AS185,
 AS203, AS213, AS248, AS250,
 AS257, AS260, AS272, AS282,
 AS304, AS307, AS314, AS329;
 seaplane, AS117
—airship, AS36, AS113, AS125, AS134,
 AS135, AS160, AS177, AS189,
 AS276, AS298, AS332
—balloon, AS9, AS133
—glider, AS41
—interiors, AS143, AS236
—spacecraft, AS300
—U.S. Navy, AS218, AS298
Hang gliders, AS32, AS53, AS85, AS334
Hannover Air Show, AS172
Hannoveraner aircraft, AS113
Hanriot aircraft, AS58
Hanscom, Clarence D., AS155
Harbors, AS98, AS125, AS257; New
 York City, AS95, AS186; Pearl
 Harbor (Hawaii), AS10; Vladivostok
 (Russia), AS9
Harman, Clifford B., AS143
Harnesses, AS198
Harris, Arthur T., AS101
Harrisburg (Pennsylvania), AS318
Harshman, Mildred, AS230
Harvard-Boston Aero Meet (1910),
 AS143
Hasselblad cameras, AS99
Hassell, B.R.J., AS304
Hastings, Albert E., AS161
Hats, AS3, AS44
Havana (Cuba), AS198
Hawaii, AS106, AS122, AS235, AS269;
 Pearl Harbor, AS10; World War II,
 AS331
Hawk (aircraft). *See* Curtiss aircraft.
Hawker aircraft: Hart, AS153;

Hurricane, AS100, AS153; P.1127,
 AS110; PV 4, AS153
Hawk rockets, AS175
Hawks, Frank M., AS52, AS290
Hawthorne Aviation schools, AS144
Hay wagons, AS70
Hays, Frank, AS319
Headgear, AS3, AS44, AS300. *See also*
 Flight clothing.
Heating systems, AS54
Heinkel aircraft, AS311; He 162, AS254
Heinrich aircraft, AS129
Helicopters, AS4, AS6, AS37, AS85,
 AS94, AS163, AS174, AS200, AS213,
 AS237, AS243, AS282, AS287,
 AS296, AS312, AS329, AS334,
 AS337. *See also* specific
 manufacturers, models.
—construction, AS62, AS148
—crashes, AS62, AS285
—experimental, AS62, AS80, AS194,
 AS285
—manufacturers: Bell, AS216; Berliner,
 AS62, AS80; Curtiss-Bleecker, AS64;
 De Bothezat, AS165; Hiller, AS110,
 AS148; Kellett, AS254; McDonnell,
 AS71, AS254; Piasecki, AS254;
 Sikorsky, AS9, AS39, AS216, AS254,
 AS334; Vertol, AS216.
Helium, AS177
Hellcat. *See* Grumman F6F Hellcat.
Helldiver. *See* Curtiss aircraft.
Helmets, AS3, AS300. *See also* Flight
 clothing.
Hempstead (New York), AS129
Hensley, Ernest S., AS66
Herbert, Stanley, AS71
Herrick, Gerard, P., AS147
Herrick Convertoplane, AS147
Herring, Augustus M., AS53
Herring-Burgess aircraft, AS185
Higgins, Mary, AS75
High Acuity Camera, AS111
High-altitude flights, AS22, AS142. *See
 also* Stratospheric balloons.
High-gain antennas, AS26
Highways, AS246
Hiller helicopters, AS110, AS148
HiMAT Remotely-Piloted Research
 Vehicles, AS249
Hinckley, Robert H., AS155
Hindenburg (airship), AS125, AS274
Hines, William, AS43
Hinton, Walter, AS290
Hispano-Suiza engines, AS54, AS271,
 AS313
Hitler, Adolf, AS125, AS153
Hoelzer, Helmut, AS12
Hoften, James D.A. van, AS18
Hollerith, Herman: census tabulator,
 AS13
Holterman, Edward H., AS150
Homebuilt aircraft, AS172. *See also*
 Experimental aircraft.
Hondo (Texas), AS314
Honduras, AS265

Honest John missiles, AS175
Honeyman, Marion S., AS151
Honolulu (Hawaii), AS122
Honors. *See* Awards; Medals; Trophies.
Horse races, AS121
Horses, AS56, AS70, AS112, AS121, AS126, AS154, AS198, AS232, AS277, AS280. *See also* Cavalry; Riding horses.
Horse shows, AS113, AS198
Hospital corps, AS106
Hospitals, AS106, AS154, AS272, AS284; Germany, AS126; World War I, AS70, AS113, AS232
Hotchkiss machine guns, AS49
Hotels, AS113, AS152, AS228
Houbec, Joan, AS230
Houdini, Harry, AS277
Houpert, Andrew, AS158
Houses, AS70, AS73, AS111, AS113, AS119, AS120, AS122, AS152, AS153, AS186, AS223, AS261, AS265, AS312; France, AS153; Germany, AS121, AS153; military, AS119; Saudi Arabia, AS202. *See also* Cityscapes; Interiors; Villages.
Housing developments, AS111
Howard, Ben O., AS61
Howard 500 (aircraft), AS216
Hoxsey, Arch, AS79, AS102, AS142, AS308
Hubble, Edwin, AS27
Hubble Space Telescope, AS23, AS26
Hudson Motor Car Company, AS54
Huff-Daland aircraft, AS94, AS328
Hughes, Howard, AS51, AS67, AS135, AS137; aircraft, AS67
Hughes Aircraft Company, AS84
Hula dancers, AS269
Hull, Ernest C., AS169
Humorists, AS66
Hunsaker, Jerome C., AS152, AS155
Hunt, Roy O., AS75
Hunter, Frank O'D., AS319
Hunting, AS110, AS120, AS188, AS198, AS232
Hurd, Peter: art works by, AS11
Hurley Expedition (1922), AS315
Hurricane (aircraft). *See* Hawker Hurricane.
Hurricanes, AS218
Hydrogen cylinders, AS221
Hydrogen generators, AS9

IBM, AS13, AS174
Icebergs, AS261
Ice floes, AS261
Iceland, AS50
Ice sleds, AS150
Ide, John J., AS153
Ignitions, AS54
Ile de Nou (New Caledonia), AS229
Illinois, AS56, AS152; air meets, AS102; airports, AS84, AS318; Chicago, AS22, AS79, AS84, AS102, AS161, AS168, AS318; expositions, AS22

Illustrations (science fiction), AS25, AS175. *See also* Art; Artists' conceptions; Drawings; Graphic prints; Paintings.
Ilya Murometz (aircraft), AS9
IMAX theater, AS34, AS336
Impact tests, AS94
Imperial Russian Army, AS9
Imperial Russian Navy, AS9
Inaugural balls, AS338
India, AS150, AS154, AS289
India-Burma headquarters (U.S. Air Force), AS154
Indiana, AS318
Indianapolis (Indiana), AS318
Indian motorcycles, AS58, AS90
Industry. *See* Construction; Factories; Mines; Wells.
Industry Consulting Committee, AS152
Infantry, AS128, AS260. *See also* Soldiers.
Inflations: airships, AS77, AS127; balloons, AS9, AS36, AS77, AS142, AS160, AS168, AS221, AS237, AS292, AS297
Infrared stars, AS31
Ingalls, David S., AS319
Injection systems (rocket), AS93
Insignia, AS3, AS9, AS32, AS44, AS115, AS272, AS317, AS323. *See also* Emblems; Nose art.
Inspections, AS26, AS36, AS39, AS153, AS289, AS295
Installing parts, AS213, AS214. *See also* Construction.
Institute of Aeronautical Sciences, AS55, AS155
Instructors. *See* Flight instructors; Teachers.
Instrument panels, AS60, AS73, AS83, AS86, AS94, AS107, AS160, AS305
Instruments, AS78, AS213, AS266; aircraft, AS14, AS32, AS54, AS92, AS201, AS213, AS237, AS295, AS296, AS336; astronomical, AS27, AS29, AS145; helicopter, AS64; navigational, AS32, AS201, AS237; radio, AS28, AS39, AS41; rocket, AS14; spacecraft, AS18, AS24, AS300
Interiors: aircraft, AS37, AS60, AS67, AS83, AS110, AS183, AS189, AS207, AS211, AS237, AS238, AS244, AS282, AS288, AS305; airships, AS36, AS125, AS134, AS157, AS222, AS332; aviation schools, AS41, AS56, AS144; balloon gondolas, AS22; buildings, AS54, AS55, AS103, AS120, AS162; military facilities, AS9, AS42, AS100, AS106, AS149, AS260. *See also* Rooms; specific buildings.
International (manufacturer) aircraft, AS38
International Air Races, AS305
International Aviation Tournament, AS102

International Business Machine (IBM), AS13, AS174
International Space Hall of Fame, AS24
Inupiaqs, AS261
Inventors, AS28, AS64, AS77, AS79, AS185, AS187, AS237. *See also* specific individuals.
Iran, AS84
Iraq, AS50, AS202
Iron ore mines, AS289
Islands, AS163, AS185; Aleutian, AS50; Azores, AS114; Barbados, AS135, AS289; Bikini, AS240; Cuba, AS198; Curaçao, AS135; Great Britain, AS73, AS117; Guam, AS42; Pacific Ocean, AS49; Plum Island, AS185; Puerto Rico, AS56
Isle of Grain (Great Britain), AS73, AS117
Italy, AS35, AS153; aircraft, AS179, AS238, AS239, AS251, AS279; airships, AS36, AS157, AS222; factories, AS153; flight clothing, AS3; rulers, AS153; weapons, AS49; World War I, AS72, AS157; World War II, AS179; youth organizations, AS125
Ivory work, AS261
Ivy, William, AS168

Jackets, AS32, AS44. *See also* Flight clothing.
Jacksonville, AS198
Jaffe/Swearingen SA-32T (aircraft), AS180
Jamaica, AS135
James, Daniel, Jr., AS63
James, Teresa, AS291
Jamieson, Mitchell: art works by, AS11
Jannus, Anthony, AS151
Japan, AS173, AS289; aircraft, AS146, AS172, AS305; architecture, AS83; cityscapes, AS323; flight clothing, AS3; people, AS83, AS323; prisoners of war, AS317; rivers, AS83; space program, AS16; weapons, AS49
Jazz musicians, AS63
Jeeps, AS44, AS213
Jemison, Mae, AS33
Jennings Airport, AS144
Jenny (aircraft). *See* Curtiss JN-4.
Jensen, Pete, AS94
Jersey Rally, AS172
Jerusalem, AS289
Jerwan, Shakir S., AS158
Jet aircraft, AS6, AS59, AS94, AS174, AS216, AS282, AS287, AS305, AS334. *See also* specific manufacturers, models.
Jet Aviation (National Air and Space Museum gallery), AS335
Jet engines, AS293
Jezierski, Chet: art works by, AS11
JN-4. *See* Curtiss JN-4.
Johnson, Amy, AS230, AS291
Johnson, Florence, AS159
Johnson, Lyndon B., AS17

Johnson, Walter E., AS159
Johnson Space Center, AS145
Johnsville Naval Air Station (Pennsylvania), AS153
Jones, Beverly, AS316
Jones, Charles S. ("Casey"), AS52, AS155
Jordan, AS289
Journal articles, AS26, AS138
Jumps (parachute). See Parachute jumps.
June Bug (aircraft), AS160, AS190
Junkers, Hugo, AS155
Junkers aircraft, AS113, AS192, AS315
Junkin, Elwood J. ("Sam"), AS161
Junkin, Hattie Myers, AS161
Junkin, Janet, AS161
Juno II (rocket), AS175
Jupiter (planet), AS2, AS19; moons, AS2
Jupiter missiles, AS175

Kaiser, Henry J., AS71
Kaisers, AS120
Kallmann-Bijl, Hildegard K., AS162
Kaminski, John G., AS277
Kansas City, AS165
Kaplan, Joseph, AS162
Kármán, Theodore von, AS82
Kauffmann aircraft, AS281
Kayaks, AS50
Kearns, Charles M., Jr., AS155
Kearny, Horace F., AS143
Keating, James A., AS319
Kellett XH-10 (helicopter), AS254
Kellogg, Harold B., AS290
Kennedy, John F., AS20
Kennedy Space Center, AS164, AS175, AS300
Kentucky, AS318
Kepner, William E., AS22, AS221
Kern, George W., AS262
Kerwin, Joseph P., AS300
Keystone aircraft, AS94, AS192
Kidney, Harvey R., AS171
Kilts, AS188
Kimbal, James H., AS52
King, Samuel Archer, AS168
King Air. See Beech King Air.
Kings, AS82, AS251. See also Czars; Dictators; Grand dukes; Kaisers.
Kingsford-Smith, Charles, AS269
Kingston (Jamaica), AS135
Kinner Airstream biplanes, AS68
Kipfer, Paul, AS22
Kirkham engines, AS223
Kitchens, AS125, AS134
Kite balloons, AS106
Kites, AS4, AS32, AS185, AS337; contests, AS160; man-lifting, AS9, AS140; tetrahedral, AS140, AS160
Kitten (aircraft). See Loening M-2 Kitten; Martin Kitten IV.
Kitt Peak National Observatory, AS27
Kitty Hawk (North Carolina), AS170
Klemm-Daimler L-20 *Yankee Doodle* (aircraft), AS262
Klep, Rolf: art works by, AS11

K.L.M. (Royal Dutch Airlines), AS84
Klondike, AS168
Knabenshue, A. Roy, AS77, AS79, AS142, AS166
Knauer, Fred C., AS80
Knight, Etta L., AS316
Kollsman, Paul W., AS135, AS167
Kollsman Instrument Company, AS84
Kondor aircraft, AS180
Kopal, Vladimir, AS138
Korea, AS243
Korean War aircraft, AS172, AS334
Kremlin, AS246

L1048 infrared star, AS31
Laboratories, AS78, AS104, AS266, AS278, AS294, AS296; aircraft research and development, AS64, AS130, AS282, AS296, AS314, AS329; NASA, AS193, AS206, AS300; rocket development, AS131
Laboratory workers, AS314
Ladders, AS15
Lafayette Escadrille, AS128, AS188, AS232, AS248, AS272
La Guardia Field (New York), AS71, AS84, AS135
Lahm, Frank P., AS170; sculptures of, AS169
Lahm Airport (Mansfield, Ohio), AS169
Laidman, Hugh: art works by, AS11
Laird, E.M., AS169
Laird aircraft, AS38; LC-DW-500 Super Solution, AS109
Lake Keuka (Hammondsport, New York), AS171, AS303
Lambert, Albert B., AS155
Lambie, Jack H., AS52
Land, Emory S., AS155
Landing gear, AS50, AS56, AS59, AS60, AS64, AS104, AS160, AS185, AS212, AS288, AS311; retractable, AS94, AS185, AS305
Landings: aircraft, AS10, AS56, AS79, AS88, AS94, AS103, AS143, AS157, AS207, AS262, AS264, AS295, AS311; airships, AS125; balloons, AS22; gliders, AS191; on aircraft carriers, AS160; spacecraft, AS18, AS29, AS300
Landis, Reed G., AS290, AS319
Landis Field, AS154
Landsat satellite, AS1
Landscapes, AS1, AS50, AS53, AS120, AS142, AS153
—aerial photographs, AS1, AS35, AS49, AS56, AS79, AS113, AS122, AS125, AS126, AS142, AS189, AS231, AS257, AS258, AS297, AS304, AS332
—geographic features: coasts, AS218; deserts, AS152, AS163, AS181, AS202; islands, AS50, AS114, AS135, AS163, AS185; mountains, AS1, AS98, AS194; volcanoes, AS198, AS261, AS265

—locations: Alaska, AS50, AS261; Brazil, AS289; China, AS44, AS50; Costa Rica, AS265; Cuba, AS198; England, AS35, AS112, AS289; Europe, AS120; France, AS70, AS113, AS121, AS153, AS217, AS260; Germany, AS113, AS121, AS126; Morocco, AS96; Myanmar, AS44; Saudi Arabia, AS202; Slovakia, AS258; United States, AS56, AS112, AS124, AS135, AS136, AS153, AS304
Langley, Samuel P., AS160, AS194
Langley Aerodrome, AS94, AS150, AS158, AS159, AS194, AS211, AS303, AS304, AS334; Glenn H. Curtiss's flights, AS88, AS160, AS171, AS307; propellers, AS313
Langley Theater, AS334, AS335
Lansing, Bill, AS71
Latham, Hubert, AS137, AS160
Lathes, AS103
Latin America, AS172, AS265
Launches: airships, AS36, AS125, AS134; Langley Aerodrome, AS171; missiles, AS65, AS130, AS278; rockets, AS14, AS162, AS164; spacecraft, AS18, AS99, AS164, AS175, AS300, AS336; space telescopes, AS26. See also Ascensions; Take-offs.
Launching rails, AS104, AS187
Launch pads, AS175, AS300
Launch vehicles, AS16, AS25, AS26
Law, Ruth, AS122, AS173, AS290, AS292
Lawrence, Lovell, Jr., AS174
Laying wire, AS198
Leaflets (propaganda), AS276, AS282
Lear Jet aircraft, AS59
Lear Jet Corporation, AS59
Lebanon, AS289
Lectures, AS33. See also Seminars.
Lees, Walter E., AS94, AS304, AS313
Lee Ya Ching, AS230
LeMay, Curtis E., AS101
Le Minerve (balloon), AS208
Lenin Sports Stadium, AS246
Leopards, AS122
Le Pere aircraft, AS113, AS296
Lesley, Everett P., AS155
Lester, C.D., AS63
Letord 4 (aircraft), AS129
Levnensky, Sigismund, AS9
Ley, Olga F., AS175
Ley, Willy, AS66, AS175
Liberia, AS289
Liberty engines, AS313
Libraries, AS55
Life jackets, AS56. See also Safety equipment.
Life magazine: employees, AS84
Life rafts, AS108
Light baffles, AS26
Lighter-than-air aircraft. See Airships; Balloons.

Lighthouses, AS309
Lightning (aircraft). *See* Lockheed aircraft.
Lights: field, AS83, AS106, AS237; searchlights, AS49, AS120; signal, AS54; wing, AS296
Lilienthal, Otto, AS191, AS197; gliders, AS53
Lilienthal Gesellschaft (aviation association), AS55
Limousine (aircraft). *See* Curtiss Limousine.
Linah (Saudi Arabia), AS202
Lindbergh, Anne, AS178, AS289
Lindbergh, Charles A., AS52, AS65, AS68, AS76, AS82, AS94, AS141, AS178, AS197, AS288, AS289, AS334; painting of, AS287
Linebacker II. *See* Operation Linebacker II.
Linke Hofmann aircraft, AS180
Lions, AS158, AS232, AS248, AS272, AS290
Lippold, Richard: art works by, AS11
Lisbon (Portugal), AS91, AS114, AS310
Little John missiles, AS175
Little Rock (Arkansas), AS318
Littlewood, William, AS155
Liverpool (England), AS115
Living rooms, AS120, AS162
Loading cargo, AS250; bombs, AS9, AS42, AS63, AS126, AS154, AS295; cotton, AS288; mail, AS274; parts, AS293
Lobbies, AS335, AS336
Locker rooms, AS41
Lockheed aircraft, AS38, AS51, AS67, AS192, AS287; 14 airliner, AS67; C-69 Constellation, AS216; Electra, AS135; F-5 Lightning, AS35, AS321; L-188 Electra, AS216; L-1011 Tristar, AS216; Orion, AS67; P2V Neptune, AS254; P-38 Lightning, AS35, AS254; P-80 Shooting Star, AS210, AS212; Sirius, AS5; SR-71, AS12; Super Constellation, AS8; VC-121 Presidential Constellation, AS67; Vega, AS65, AS81, AS135; Vega *Winnie Mae,* AS38, AS165, AS280; XP-80 Shooting Star, AS211
Lockheed Aircraft company, AS67, AS84
Loening, Grover C., AS155
Loening aircraft, AS94; Aeroboat, AS104; Air Yacht, AS52; Cabin Amphibian, AS141; M-2 Kitten, AS196, AS245; PW-2, AS296, AS328; PW-2A, AS328; PW-2B, AS328
Log cabins, AS261
London (England), AS58, AS73, AS325
Longhorn cattle, AS122
Long Island (New York), AS262
Long Island-to-San Francisco flight (1924), AS186
Los Alamos (New Mexico), AS263
Los Angeles (airship). *See* U.S.S. *Los Angeles.*

Los Angeles (California), AS142
Los Angeles Airways, AS84
Loughead engines, AS313
Louis, Joe, AS63
Louisiana, AS35, AS112, AS318
Louisiana Purchase Exposition (St. Louis World's Fair), AS53, AS168, AS256
Louisville (Kentucky), AS318
Love, Nancy H., AS291
Loving, Neal, AS63
Lowe, T.S.C., AS80, AS168; balloons, AS168
LTA (lighter-than-air). *See* Airships; Balloons.
Lubricants, AS219
Lucid, Shannon W., AS26
Lufbery, Raoul, AS66, AS188; grave, AS320
Luggage. *See* Baggage.
Lumber, AS143
Lunar landings, AS29, AS45, AS206. *See also* Moon.
Lunar modules, AS18, AS21, AS24, AS164, AS334
Lunar Orbiter, AS175, AS334
Lunar rocks, AS32, AS300, AS334
Lunar vehicles, AS29, AS300
Luncheons, AS289. *See also* Banquets; Dinners; Eating; Meals; Restaurants.
Lundgren, Theodore S., AS181
Lunik 9 (spacecraft), AS263
L.V.G. C.III (aircraft), AS126
Lyn, Art, AS94

Mac Airliner aircraft, AS189
MacArthur, Douglas, AS101
MacClain, A. Lewis, AS155
Machine gunners, AS126, AS187
Machine guns, AS32, AS49, AS92, AS117, AS149, AS337; Maxim, AS49, AS187; training, AS70
Machinery, AS78, AS154. *See also* Equipment; specific types of machinery.
Machine shops, AS54, AS94, AS106, AS113, AS329
Macon (airship). *See* U.S.S. *Macon.*
Magazines, AS25, AS26, AS138
Magin, F.W., AS167
Magnetic discs, AS13
Mail. *See* Airmail.
Mailwing. *See* Pitcairn aircraft.
Maine (ship), AS308
Maintenance and repair: aircraft, AS42, AS50, AS60, AS63, AS94, AS144, AS154, AS181, AS185, AS202, AS214, AS220, AS237, AS244, AS251, AS295, AS305, AS318; engines, AS56, AS146, AS220; harnesses, AS198; photographic equipment, AS146; spacecraft, AS18
Malir (India), AS154
Manassas (Virginia), AS198
Manchester (England), AS24
Maneuvers, AS261, AS272, AS295; cavalry, AS70

Manipulated images, AS31. *See also* CCDs; Composite photographs.
Man-lifting kites, AS9, AS140
Manly, Charles M., AS52, AS194; Langley Aerodrome engine, AS194
Manned spacecraft. *See* Spacecraft; specific programs.
Mansfield (Ohio), AS169
Manson, Frank G., AS182
Mantz, Myrtle, AS68
Mantz, Paul, AS61
Manufacturers, AS84, AS142, AS167, AS185, AS209, AS237, AS280, AS282, AS288. *See also* specific companies, individuals.
Manufacturing. *See* Construction.
Manuscripts, AS29. *See also* Documents.
Mapping, AS163
Mapping squadrons, AS261
Map rooms, AS153, AS321
Maps, AS29, AS44, AS108, AS115, AS164, AS268, AS295; air routes, AS165; pieced aerial photographs, AS163. *See also* Composite photographs; Globes.
Marauder. *See* Martin B-26 Marauder.
Marching, AS35, AS158, AS163, AS198, AS202, AS218, AS260, AS262, AS272. *See also* Infantry; Soldiers.
Marching bands, AS106, AS305
Marco J5 (aircraft), AS180
Marianao (Cuba), AS198
Marie (queen of Romania), AS251
Mariner 1 (probe), AS175
Mariner 2 (probe), AS175
Marketing, AS202
Marks, L.T., AS94
Marriages. *See* Weddings.
Mars (aircraft). *See* Martin Mars.
Mars (planet), AS2, AS29, AS175
Mars 2 (spacecraft), AS263
Mars 3 (spacecraft), AS263
Marseilles (France), AS114
Marshals, AS120
Mars rovers, AS29
Martin, Glenn L., AS142. *See also* Glenn L. Martin Company.
Martin, Hamilton, AS185
Martin, James V., AS184, AS185
Martin, Lily, AS185
Martin aircraft, AS51, AS94, AS130, AS192, AS287, AS311; 130 Clipper, AS183, AS289; 130 Clipper *Philippine Clipper,* AS289; 139W, AS130; 156 Clipper, AS130; 170, AS130; A-30, AS130; AM-1 Mauler, AS130; B-10, AS135; B-10B, AS130; B-26 Marauder, AS54, AS130; B-57 Canberra, AS130; bombers, AS150, AS163, AS296; Kitten IV, AS185; Mars, AS8; MO-1, AS223; NBL-2, AS328; NBS-1, AS328; Oceanplane, AS185; P5M-1, AS227; PB2M, AS130; Scout, AS185; seaplanes, AS142; tractor biplanes, AS185; XB-48, AS254; XB-51, AS130; XBTM, AS130

Martin engines, AS54
Martinsyde aircraft, AS58
Maryland, AS58, AS80, AS183
Massachusetts, AS160, AS318; Harvard-
 Boston Aero Meet, AS143
Massachusetts Institute of Technology,
 AS325; computers, AS12, AS13
Masts (mooring), AS36, AS142, AS177,
 AS298
Mattingly, Thomas K. II, AS300
Maughan, Russell L., AS186
Mauler. See Martin AM-1 Mauler.
Maxim, Hiram S., AS187
Maxim machine guns, AS49, AS187
Mayer, Joe, AS290
Maynard, Ken, AS288
Mayors, AS198
McCall, Robert T.: art works by, AS11
McCandless, Bruce, AS26
McConnell, James R., AS188
McCook Field (Ohio), AS94, AS150,
 AS165, AS185, AS296, AS305,
 AS328, AS329. See also Wright Field.
McCormick (aircraft). See Curtiss
 McCormick.
McCoy, Howard M., AS155
McCoy, John T.: art works by, AS11
McCoy, S.C., AS52
McCracken, William P., Jr., AS155
McCurdy, John A.D., AS129
McDonnell aircraft, AS287; F-4
 Phantom, AS69; FD-1 Phantom,
 AS71; XHJD-1 Whirlaway, AS71,
 AS254; XP-67, AS71; XRH-1 Assault
 Helicopter, AS71
McDonnell-Douglas aircraft: C-9,
 AS293; DC-10, AS216
McDonough (ship). See U.S.S.
 McDonough.
McEniry, Steve G., AS161
McFarland, Ernest W., AS152
McGordon, Steve, AS94
McGuire, Mickey, AS161
McKibben, Laura A., AS316
McKitten, Ben, AS7
McMahon, Franklin: art works by, AS11
McMullen, Alexis B., AS189
McNair, Ronald E., AS18
Meals, AS154, AS280, AS332. See also
 Banquets; Dinners; Eating; Food;
 Luncheons; Picnics; Restaurants.
Mears, John Henry, AS81
Mechanics, AS88, AS94, AS171, AS214,
 AS237, AS264, AS282, AS313,
 AS323
Medals, AS3, AS32, AS91, AS100,
 AS177, AS203, AS275, AS320,
 AS330. See also Awards; Ceremonies.
Medford (Massachusetts), AS318
Medical aircraft, AS54, AS60
Medical equipment, AS18, AS32
Medical personnel, AS126. See also
 Nurses; Physicians; Red Cross.
Medical treatments, AS295. See also
 Hospitals; specific problems (such as
 Frostbite).
Mediterranean, AS189

Meed, Robert, AS290
Meese, George, AS192
Meetings, AS110, AS152, AS223,
 AS237, AS273; airline personnel,
 AS244; aviation associations, AS57,
 AS189, AS200, AS213, AS274. See
 also Clubs and organizations;
 Conferences; Seminars.
Meets..See Air meets.
Megabit memory chips, AS12
Memorial Day celebrations, AS188
Memorials. See Cemeteries; Monuments
 and memorials.
Memphis (Tennessee), AS318
Mercedes automobiles, AS153
Mercury (planet), AS2
Mercury program, AS18, AS20, AS24,
 AS99, AS206, AS300; astronauts,
 AS18, AS206; Big Joe satellite,
 AS193; Freedom 7 spacecraft, AS213;
 spacecraft, AS18, AS23, AS46, AS99,
 AS287
Merrill, A. Elliott, AS155
Merrill, Richard, AS51, AS52
Messer, Glenn E., AS169
Messerschmitt aircraft, AS254; Me
 109G, AS208; Me 262, AS174,
 AS208, AS210; Me 262A-1A, AS211
Mess halls, AS106, AS112, AS122,
 AS154, AS198, AS220, AS329;
 airships, AS125
Meteorological charts, AS177
Meteorological stations, AS329
Meteorologists, AS52. See also specific
 names.
Meteors, AS333; craters, A6175
Meters, drift, AS108
Metz (France), AS260, AS276
Mexico, AS70, AS122, AS198, AS235,
 AS265, AS305; people, AS122
Meyers, Dale: art works by, AS11
Miami (Florida), AS135, AS150
Michigan, AS79, AS84
Microcircuits, AS39
Microscopic sections, AS219
Midas program, AS30
Midget racing aircraft, AS172
Midland Air Express, AS165
Milestones of Flight (National Air and
 Space Museum gallery), AS335, AS336
Military aircraft, AS4, AS9, AS38,
 AS40, AS65, AS94, AS101, AS115,
 AS129, AS186, AS216, AS237,
 AS254, AS276, AS284, AS337. See
 also specific countries, manufacturers,
 military branches, models, types of
 aircraft, wars.
Military bases, AS101, AS115, AS129,
 AS154, AS186, AS237, AS276,
 AS284, AS296, AS297, AS304,
 AS327, AS329. See also specific bases,
 locations, military branches, wars.
Military officers, AS94, AS101, AS144,
 AS153, AS155, AS237, AS282,
 AS295, AS302, AS305. See also
 Soldiers; specific countries, military
 branches, wars.

Milky Way galaxy, AS175
Miller, Bernetta, AS158
Miller, Frances, AS213
Millikan, Clark B., AS155
Milling, Thomas Dewitt, AS195
Milwaukee (Wisconsin), AS198
Mineola (New York), AS58, AS129,
 AS150, AS153, AS160
Mines: gold, AS315; iron ore, AS289;
 salt, AS181
Mines (weapons), AS272
Miniatures. See Models (miniature);
 Wind tunnel models.
Mini-Guppy (aircraft), AS216
Minstrel troupes, AS122
Minuteman program, AS12, AS175
Mirage (aircraft). See Dassault Mirage.
Mirrors, AS175; polishers, AS26
Missile Infrared Detection and
 Surveillance (Midas) Program, AS30
Missiles, AS4, AS12, AS32, AS49, AS76,
 AS175, AS266, AS278, AS295,
 AS300; guided, AS311; launches,
 AS65, AS130, AS278; sensors, AS30;
 V-2, AS14, AS25, AS175, AS208,
 AS210, AS334
Mississippi River, AS256
Missouri, AS53, AS94, AS168, AS256,
 AS318
MIT. See Massachusetts Institute of
 Technology.
Mitchel, Edgar D., AS290
Mitchell, William ("Billy"), AS52,
 AS198
Mitchell (aircraft). See North Amercian
 B-25 Mitchell.
Mitchell Air Force Base (New York),
 AS213
Mitscher, Marc A.: painting of, AS196
Mitsubishi aircraft, AS323
Mock air battles, AS113. See also Tests;
 Training.
Models (miniature): aircraft, AS32,
 AS44, AS48, AS54, AS55, AS61,
 AS107, AS110, AS144, AS147,
 AS161, AS185, AS213, AS302;
 airships, AS143; buildings, AS296;
 cameras, AS26; rockets, AS99, AS278;
 ships, AS29, AS143; solar system,
 AS334; spacecraft, AS20, AS23, AS24,
 AS32, AS334; telescopes, AS23, AS26.
 See also Wind tunnel models.
Models, patent, AS88, AS185
Moisant, Matilde, AS75, AS158;
 membership cards, AS292
Molniya 1 (spacecraft), AS263
Monoplanes, AS38, AS94, AS141,
 AS160. See also Biplanes; specific
 manufacturers, models.
Montgomery (Alabama), AS318
Monuments and memorials, AS121,
 AS242, AS312; Egypt, AS191; New
 York World's Fair obelisk and sphere,
 AS174; Paris (France), AS114, AS121;
 Washington Monument, AS56, AS87,
 AS242, AS272, AS309; World War I,
 AS188. See also Cemeteries; Graves.

Moon, AS2, AS25, AS45, AS99, AS145, AS175, AS206, AS266, AS300, AS333; moon walks, AS300; rocks, AS32, AS45, AS300, AS334; vehicles, AS29, AS300. See also Lunar landings.

Moons. See Satellites, natural.

Mooring masts (airship), AS36, AS142, AS177, AS298

Moose, AS261

Morane aircraft, AS137, AS281

Morane Saulnier aircraft, AS58, AS192, AS272; Parasol, AS128

Morocco, AS96, AS189

Morris, Bud, AS57

Morris, Charles L., AS200

Morrison, Arthur, AS290

Mortar guns, AS35

Mortucci, Umberto, AS162

Moscow-to-San Franciso flight, AS9

Moscow University, AS246

Mosley, Corliss C., AS185, AS226

Mosley, Zack T., AS135

Mosques, AS191, AS289. See also Churches; Temples.

Mosquito (aircraft). See De Havilland D.H.98 Mosquito.

Moss, Sanford A., AS155

Motion pictures: actors, AS65, AS122, AS161; aircraft from, AS172; aircraft stunts, AS189; cameras, AS79, AS160; filming, AS161, AS276; science fiction, AS25, AS175; screenings, AS338; stills, AS336; theaters, AS34, AS336

Motor boats, AS62, AS307

Motorcades, AS246

Motorcycles, AS56, AS73, AS120, AS126, AS149, AS150, AS186; Curtiss, AS90; Indian, AS58, AS90

Motte, Oscar L., AS80

Mountain, Joe, AS202

Mountains, AS1, AS98, AS194; Alaska, AS261; Catskill, AS135; Mount Hood (Oregon), AS136, AS304; Panamint (California), AS136; Peru, AS189; Pike's Peak (Colorado), AS153. See also Aerial photographs; Landscapes; specific locations.

Mount Hood (Oregon), AS136, AS304

Mount Wilson Observatory, AS27

Movies. See Motion pictures.

Moving. See Transporting.

Mr.1 (airship), AS222

Mukluks, AS261

Mules, AS197, AS272, AS276. See also Donkeys.

Munich (Germany), AS35, AS153

Municipal Airport (Chicago), AS84

Munitions dispensers, AS132

Murals, AS277, AS334, AS335

Mureaux 190 (aircraft), AS153

Murray, Kenneth M., AS203

Museums, AS24, AS172, AS237, AS325. See also Exhibits; National Air and Space Museum; Smithsonian Institution; specific exhibits, museum names.

Museum shops, AS336

Musical instruments, AS44, AS156, AS188, AS202, AS276. See also specific instruments.

Musicians, AS44, AS63, AS68, AS106, AS154, AS156, AS169, AS262, AS305. See also Concerts; Minstrel troupes; Performances.

Mussolini, Benito, AS153

Myanmar, AS44, AS119

Myers, Carl E., AS168

Myers, Mary H., AS168

N.1 (airship), AS222

N.4 (airship), AS222

NAA. See National Aeronautic Association.

Naatz, Jeanne DeWolf, AS204

Nabisco (National Biscuit Company), AS84

NACA. See National Advisory Committee for Aeronautics.

Nadar, Félix: balloons, AS168

Naming aircraft. See Christenings.

Nancy (France), AS113

NASA, AS164, AS206; equipment, AS29, AS46, AS99, AS193; exhibits, AS17; facilities, AS20, AS25, AS164, AS175, AS193, AS206, AS300; personnel, AS17, AS20, AS46, AS52, AS206; programs, AS18, AS20, AS25, AS29, AS45, AS206, AS334; spacecraft, AS46, AS99, AS164, AS193, AS336; training, AS99, AS206. See also Astronauts; Satellites; specific names, programs (Apollo, Gemini, Mercury, Skylab, Space Transportation System), and spacecraft.

Nash, Grover C., AS63

NASM. See National Air and Space Museum.

National Advisory Committee for Aeronautics, AS152, AS212, AS278

National Aeronautic Association, AS213

National Aeronautics and Space Administration. See NASA.

National Aeroplane Company, AS277

National Air and Space Museum. See also Exhibits; specific programs, staff names.
—accessions, AS4, AS5, AS18, AS21, AS24, AS32, AS334, AS336, AS337; art works, AS11
—activities, AS33, AS335, AS336
—building, AS34, AS335; lobbies, AS335, AS336; restaurant, AS334; shops, AS336; tour desk, AS335
—conservation and restoration, AS4, AS70, AS92, AS208, AS211, AS324, AS325, AS335–AS337
—employees, AS21, AS208, AS211, AS325, AS338

—events, AS33, AS335, AS336, AS338; opening day, AS335
—exhibits, AS5, AS12, AS17, AS21, AS33, AS46, AS63, AS70, AS85, AS194, AS337
—galleries, AS12, AS21, AS194, AS334–AS336
—Garber Facility, AS208, AS211, AS334–AS336
—IMAX theater, AS34, AS336
—Langley Theater, AS334, AS335
—murals, AS334, AS335
—Planetarium, AS334–AS336
—publications, AS210, AS336
—Ramsey Room, AS336
—visitors, AS33, AS70, AS335, AS338

National Aircraft Show, AS48

National Airlines, AS84

National Air Museum, AS46. See also National Air and Space Museum.

National Air Races, AS7, AS61, AS79, AS135, AS150, AS213, AS274; aircraft, AS61, AS192

National Air Transport, AS214

National Association of State Aviation Officials, AS189

National Aviation Clinics, AS215

National Aviation Club, AS302

National Biscuit Company (Nabisco), AS84

National Guard, AS189

National Museum of Science and Technology (Canada), AS24

National Parks, AS153

National Research Advisory Committee, AS152

National Victory Parade, AS237

National Women's Air Derby, AS280

Native Americans. See American Indians; Inupiaqs.

Navaho missiles, AS175

Naval Aircraft Factory, AS207

Naval air stations. See U.S. Navy.

Navies. See U.S. Navy; specific countries.

Navigational instruments, AS32, AS201, AS237. See also Compasses; Drift meters.

Navion. See Ryan Navion.

NC-4. See Curtiss NC-4.

Nebraska, AS318

Nebulae, AS27, AS175, AS333

Neely, William H., AS113

Neico Aviation Lancair 235 (aircraft), AS180

Nelson, George D., AS18, AS26

Nepal, AS172

Neptune (aircraft). See Lockheed P2V Neptune.

Neptune (planet), AS2

Nesbitt, Lowell: art works by, AS11

Newark (New Jersey), AS135, AS174

New Caledonia, AS229

New Guinea, AS315

New Jersey: air bases, AS284; airports, AS135, AS174; aviation events, AS58,

AS71, AS79, AS142; aviation schools, AS129
New Mexico, AS263, AS318
New Orleans (Louisiana), AS112, AS318
Newport News (Virginia), AS56, AS112, AS304
Newspapers, AS22, AS26
New York (state). *See also* New York City.
—air bases, AS213
—airports, AS71, AS84, AS135, AS165
—aviation events, AS58, AS102, AS135, AS160
—aviation schools, AS129, AS150
—Curtiss-Wright Corporation, AS94
—exhibits, AS71
—locations: Albany, AS160, AS186; Buffalo, AS94; Elmira, AS135, AS161; Hammondsport, AS88, AS171, AS303, AS308; Hempstead, AS129; Lake Keuka, AS171, AS303; Long Island, AS262; Mineola, AS58, AS129, AS150, AS153, AS160; Niagara Falls, AS53, AS186; Plattsburg, AS153; Schenectady, AS186; Utica, AS186
New York City, AS110, AS114, AS135, AS160, AS163, AS174, AS276; Aerial Police, AS150; airports, AS71, AS84, AS135, AS165; harbor, AS95, AS186; Rockefeller Center, AS167
New York University, AS84
New York World's Fair (1939), AS135, AS174
New Zealand, AS229
Niagara Bridge, AS310
Niagara Falls, AS53, AS186
Nicaragua, AS54
Nicholae (prince of Romania), AS251
Nicholas II (czar of Russia), AS9
Nichols, Ruth, AS135
Nieuport aircraft, AS73, AS113, AS129, AS141, AS188, AS192, AS255, AS276, AS281, AS284, AS310; Russian models, AS9; Type 11, AS272; Type 17, AS272; Type 20, AS52
Night flights, AS109, AS142, AS173
Niles Looper (aircraft), AS129
Nimbus (satellite), AS175
Noel, Louis, AS58
North American (manufacturer) aircraft, AS51, AS192, AS287, AS323; B-25 Mitchell, AS150; B-45 Tornados, AS278; F-86A, AS208; L-17, AS212; P-51, AS153; P-51C *Excaliber III*, AS211; P-51D, AS208; Sabreliner, AS216; T-28 Trojan, AS216; X-15, AS5, AS334
North American Aviation, AS175
North Carolina: Carthage, AS188; Fayetteville, AS144; Kitty Hawk, AS170
North Island Naval Air Station (California), AS242, AS264

Northrop, John K., AS66, AS155
Northrop aircraft, AS192; Alpha, AS86; Gamma, AS5; MX-324, AS138; N1M, AS208, AS211; P-61 Black Widow, AS212; XP-79 Flying Ram, AS254; YB-49, AS12
Northrup, G.G., AS261
Northwest Airlines, AS84
Northwestern University, AS145
Nose art, AS94, AS179, AS323. *See also* Insignia.
Noyes, Blanche, AS61, AS230, AS280
Nuclear reactors, AS263
Nuclear survival food packets, AS213
Nuclear weapons, AS295. *See also* Atomic bombs.
Nuevo Laredo (Mexico), AS70
Nuremburg (Germany), AS153
Nurses, AS113, AS176, AS290
Nutt, Arthur, AS223

Oberth, Hermann, AS26, AS224
Observation balloons, AS113, AS160, AS297
Observation flights, AS305
Observatories, AS27, AS145, AS175, AS206, AS266, AS333
Occupations. *See* specific occupations (such as Astronomers, Pilots, Scientists, Surgeons).
Oceanplane. *See* Martin Oceanplane.
Oceans, AS1. *See also* Waterscapes.
Odessa (Russia), AS123
Odom, James B., AS26
O'Donnell, Eugene, AS71
O'Donnell, Gladys, AS68, AS75, AS230
Officers. *See* Military officers; specific countries, military branches.
Officers' clubs, AS154
Offices, AS282; business, AS103, AS104, AS127, AS130, AS174, AS304; military, AS144, AS149, AS329
Ohio. *See also* National Air Races.
—airfields, AS94; McCook Field, AS94, AS150, AS165, AS185, AS296, AS305, AS328, AS329; Wright Field, AS326, AS327, AS329; Wright-Patterson Air Force Base, AS150, AS172, AS329
—airports, AS161, AS169
—aviation schools, AS161
—factories, AS94, AS177, AS221
—locations: Akron, AS177, AS221 Columbus, AS94; Dayton, AS198; Toledo, AS161
Ohmeyer, Rohnald, AS225
Oil, AS251; systems, AS60; wells, AS50, AS112, AS315
Oklahoma, AS215, AS318
Oklahoma (aircraft), AS141
Oklahoma City (Oklahoma), AS215, AS318
Olympics, AS125
Omaha (Nebraska), AS318
O'Meara, Jack, AS161

Omlie, Phoebe F., AS68, AS291
O'Neill, Peggy, AS160
Opel, Fritz von, AS82
Open houses, AS39, AS335
Operation Linebacker II (Vietnam War), AS42
Optical Telescope Assembly, AS26
Orbiting Astronomical Observatory, AS26
Orbits. *See* Spacecraft.
Ordnance, AS32, AS35, AS49, AS120, AS132. *See also* Ammunition; Bombs; Guns; Weapons.
Oregon, AS136, AS168, AS175, AS304
Orenco PW-3 (aircraft), AS328
Organizations. *See* Clubs and organizations.
Oriole (aircraft). *See* Curtiss Oriole.
Orion (aircraft). *See* Lockheed Orion.
Orion (nebula), AS27
Oshkosh (Wisconsin) Airshows, AS180
Oswald, W. Bailey, AS155
Otero, Alejandro: art works by, AS11
Outreach activities, AS33
Ovington, Earl, AS52, AS79
Oxcarts, AS44, AS114
Oxen, AS113
Oxygen and hydrogen rocket engines, AS76
Oxygen equipment, AS3
Oxygen tanks, AS280

P-38 Lightning. *See* Lockheed P-38 Lightning.
P-40. *See* Curtiss P-40.
P-47 Thunderbolt. *See* Republic P-47 Thunderbolt.
P-51. *See* North American aircraft.
Pacific Airmotive, AS84
Pacific Air Race (1927), AS269
Pacific islands, AS49; people, AS317, AS323
Packages: airmail, AS125; food, AS17
Packard engines, AS54, AS313
Page, Phillips W., AS228
Paint, AS94
Painting, AS143; aircraft, AS94, AS146, AS214, AS295
Paintings, AS29; aircraft, AS194; aviation, AS11, AS169; portraits, AS29, AS109, AS196, AS287, AS319; spacecraft, AS206. *See also* Art; Drawings.
Paint shops, AS127
Pakman, Pat, AS291
Palermo (Italy), AS35
Palmer (Alaska), AS261
Palmer, Robert, AS113
Palm trees, AS122
Panama City (Panama), AS265
Panama-Pacific International Exposition (1916), AS142
Pan American Airways, AS229, AS265, AS289; aircraft, AS81, AS114, AS252; employees, AS84, AS183; first transatlantic flight, AS114

Pan-American flights, AS52, AS63
Panamint Mountains (California), AS136
Pangbourne, Clyde E., AS52, AS290
Papana, Alex, AS135
Papua (New Guinea), AS315
Parachute jumps, AS56, AS86, AS141, AS213, AS221, AS251, AS274, AS296; first jump from an airplane, AS160
Parachutes, AS133, AS147, AS237, AS295, AS296; drogues, AS41; supersonic, AS175
Parachutists, AS147
Parades, AS101, AS127, AS144, AS198, AS237, AS241, AS304; England, AS91; France, AS70
Parasol (aircraft). See Morane Saulnier Parasol.
Paratroopers, AS135
Paris (France), AS74, AS113, AS114, AS121, AS232, AS235, AS277; Arc du Triomphe de L'Étoile, AS121; aviation events, AS104, AS140, AS170, AS172, AS299; Eiffel Tower, AS70, AS272; salons, AS153, AS281
Park, J.B., AS94
Parker, Fred: aircraft, AS231
Parker, William D., AS288
Parking lots, AS165
Parks, AS153
Parmalee, Phil O., AS142
Parnall Puffin (aircraft), AS73
Parrish, Noel F., AS63
Parson, Edwin C., AS232
Parties, AS153, AS174, AS181, AS224, AS236, AS244, AS273, AS290, AS304
Parts: aircraft, AS4, AS8, AS32, AS54, AS59, AS85, AS119, AS153, AS185, AS205, AS208, AS211, AS212, AS237, AS250, AS271, AS282, AS295, AS311, AS337; airship, AS177; helicopter, AS64, AS148; motorcycle, AS90; rocket, AS93, AS131, AS164, AS233, AS234, AS278; spacecraft, AS164, AS193, AS300. See also Engines; Instruments; Propellers; other specific parts.
Passenger cabins (airships), AS125, AS332. See also Interiors.
Passengers, AS37, AS79, AS81, AS94, AS109, AS114, AS151, AS160, AS166, AS207, AS228, AS237, AS244, AS277, AS282, AS288, AS304, AS308; airship, AS332; children, AS198; motorcycle, AS90; women, AS228, AS292
Patches. See Insignia.
Patent models, AS88, AS185
Patents, AS12
Patients, AS232, AS242, AS272, AS284. See also Hospitals; Medical treatments.
Patrons. See Financiers.
Patterson, William A., AS155

Paul E. Garber Facility, AS208, AS211, AS334–AS336
Paulham aircraft, AS281
Paulhan, Louis, AS137, AS142, AS160
Paulson B-2 (aircraft), AS129
Peace treaties, AS70
Peale, Mundy I., AS155
Pearl Harbor (Hawaii), AS10
Pedal cars, AS122
Peenemünde (Germany), AS14, AS175, AS233, AS234. See also V-2 missiles.
Pegasus. See Huff-Daland XLB-1 Pegasus.
Pégoud, Adolphe, AS274
Peking (China). See Beijing (China).
Pennsylvania: airports, AS318; aviation events, AS71, AS237; military bases, AS153, AS220; Philadelphia, AS163; Pittsburgh, AS163, AS220
Pennsylvania Central Airlines, AS84
Pensacola (Florida), AS218, AS305
Pensacola Naval Air Station, AS218
Performances, AS63, AS122, AS126, AS154, AS169. See also Bands; Concerts; Dancers; Singers.
Perlmutter, Jack: art works by, AS11
Perry, Charles: art works by, AS11
Pershing, John J., AS80, AS120
Personal computers, AS13
Peru, AS189
Peterson, Harold G., AS235
Peterson, Jack R., AS290
Petrone, Rocco, AS26
Pfalz aircraft, AS180
Phantom. See McDonnell aircraft.
Philadelphia (Pennsylvania), AS163
Philippine Baron (aircraft), AS236
Philippine Clipper (aircraft), AS289
Philippines: aircraft, AS170, AS236; Fort McKinley, AS170; people, AS101; pilots, AS236; U.S. Army Signal Corps activities, AS198; volcanoes, AS198
Phillips, William S.: art works by, AS11
Phillips Petroleum Company, AS84
Phobos (moon of Mars), AS2
Phoenix (Arizona), AS318
Photographers, AS168
Photography, AS202; aerial, AS305; equipment, AS26, AS67, AS146, AS240; laboratories, AS106. See also Aerial photographs; Cameras.
Photometers, AS26
Photo-realist art, AS11
Photo squadrons, AS146
Physicians, AS113, AS126, AS176. See also Surgeons.
Physicists, AS155
Piaggio aircraft, AS238, AS239
Pianos, AS156, AS160
Piasecki XHJP-1 (helicopter), AS254
Piccard, Auguste, AS22; stratospheric balloon, AS192
Pickerill, Elmo N., AS147
Picketing, AS291

Pickford, Mary, AS122
Picnics, AS73, AS156, AS217, AS241. See also Barbecues.
Piers, AS117
Pigeons, AS177
Pike's Peak (Colorado), AS153
Pilcher, Percy, AS53
Pilots, AS12, AS37, AS38, AS44, AS50, AS52, AS54, AS56, AS58, AS65, AS66, AS68, AS77, AS79, AS80, AS82, AS86, AS88, AS94, AS102, AS135, AS137, AS140, AS142, AS143, AS147, AS150, AS151, AS153, AS155, AS156, AS158, AS160, AS170, AS184, AS237, AS256. See also Crews; specific countries, groups, military branches, names, wars.
—African Americans, AS33, AS63, AS334
—places of origin: Belgium, AS320; France, AS137, AS209, AS217, AS277; Germany, AS126, AS320; Great Britain, AS73, AS137, AS209; Philippines, AS236; Soviet Union, AS9, AS320
—types: airline, AS114, AS214, AS244, AS252; airmail, AS273; airship, AS66, AS125, AS166; balloon, AS166, AS168; barnstormers, AS109, AS156, AS189; glider, AS53; military, AS50, AS96, AS101, AS122, AS203; racing, AS7, AS61, AS68; stunt, AS109, AS118; test, AS313
—women, AS60, AS63, AS66, AS68, AS75, AS94, AS122, AS210, AS213, AS230, AS236, AS280, AS282, AS291, AS292, AS316, AS334
—World War I, AS9, AS72, AS96, AS120, AS126, AS128, AS129, AS181, AS186, AS188, AS235, AS248, AS260, AS272, AS276, AS279, AS284, AS290, AS319, AS320
—World War II, AS9, AS37, AS44, AS65, AS101, AS144, AS154, AS179, AS312, AS317, AS323, AS331, AS334
Pilot training, AS54, AS56, AS63, AS79, AS133, AS144, AS160, AS277, AS291, AS304, AS305, AS316; World War II, AS68. See also Aviation schools; Flight instructors.
Pinedo, Francesco de, AS52
Pingard, A., AS226
Pioneer program, AS206; Pioneer 5, AS175
Pioneers of Flight (National Air and Space Museum gallery), AS335
Piper aircraft, AS135, AS287; around-the-world-flight, AS108; Cub, AS108, AS135, AS236; PA-12 Supercruiser City of Washington, AS208; PA-22 Tri-Pacer, AS236; PA-23 Aztec, AS213
Piper factories, AS135
Pipes (tobacco), AS44
Pistons, AS54, AS219
Pitcairn, Harold, AS155

Pitcairn aircraft, AS51, AS192; "A" Autogyro, AS208; PA-5 Mailwing, AS208; Sport Mailwing, AS86
Pitcairn Aviation, AS84
Pitcairn Field, AS163
Pittsburgh (Pennsylvania), AS163, AS220
Pittsburgh Institute of Aeronautics, AS220
Pitts Special (aircraft), AS5
Planes. See specific countries, manufacturers, models, types.
Planetariums, AS24, AS333; National Air and Space Museum, AS334–AS336
Planets, AS2, AS20, AS25, AS29, AS145, AS306, AS333, AS336. See also specific planets.
Plans, AS92
Plantations, AS289
Plants, AS112, AS122. See also specific plants.
Plaques, AS147
Plastic aircraft parts, AS314
Plattsburg Army camp, AS153
Playing games: cards, AS124, AS154; tug-of-war, AS56, AS88. See also Recreation; Sports; specific games and sports.
Playing musical instruments, AS44; drums, AS202; guitars, AS276
Plotting courses, AS316
Plows, AS113
Plum Island, AS185
Plymouth (England), AS91
Pocket computers, AS13
Polar bears, AS53
Police, AS150
Polish-Russian War, AS203
Polo, AS70, AS158, AS198
Pond, Clayton: art works by, AS11
Pontoon bridges (Civil War), AS35
Pontoons, AS50, AS60
Popular Aviation magazine: employees, AS84
Porter, Kenneth L., AS319
Porterfield Model 35 (aircraft), AS280
Portland (Oregon), AS168
Portraits: graphic prints, AS29; paintings, AS29, AS109, AS196, AS287, AS319; sculptures, AS17, AS169
Portugal, AS289; Lisbon, AS91, AS114, AS310
Post, Augustus M., AS77, AS142, AS143, AS147
Post, Wiley, AS51, AS65, AS334; aircraft, AS65
Postage stamps, AS9, AS299
Posters, AS25, AS55; Russian aviation, AS9; World War I, AS56. See also Graphic prints.
Posts (mooring). See Mooring masts.
Potez 62-0 (aircraft), AS153
Potomac River, AS309
Povey, Leonard, AS66

Powell, William J., AS63
Power House Museum (Australia), AS24
Power tools, AS103
Pratt & Whitney engines, AS293
Preddy, George E., AS65
Prefabricated housing, AS152
Preparing food, AS17
Preservation. See Conservation.
Presidents, AS17, AS20, AS26, AS63, AS70, AS276, AS289, AS338; presidential aircraft, AS67. See also specific countries, organizations.
Pressburg (Austria-Hungary). See Bratislava (Slovakia).
Press conferences, AS263
Pressure suits, AS3, AS32. See also Space suits.
Pressurized balls, AS46
Pride of Los Angeles (aircraft), AS181
Prince of Wales, AS187
Princes, AS187, AS251
Princesses, AS232
Princeton (New Jersey), AS58
Princeton (ship). See U.S.S. Princeton.
Prisoners of war, AS232, AS276, AS295, AS317
Prisons, AS229
Pritchard, John L., AS155
Private aircraft, AS65
Prizes. See Awards; Medals; Trophies.
Probes, AS28, AS175, AS206. See also Satellites.
Processions (funeral), AS113
Product displays, AS39
Professional organizations. See Clubs and organizations.
Programs (to aviation events), AS102
Project Apollo. See Apollo program.
Project Bumper, AS14
Project Crossroads, AS240
Project Gemini. See Gemini program.
Project Mercury. See Mercury program.
Projectors (motion-picture), AS34
Promoters, AS160
Propaganda leaflets, AS276, AS282
Propellers, AS8, AS83, AS104, AS160, AS194, AS231, AS255, AS271, AS295, AS311, AS313, AS326, AS337; adjustable, AS296; Curtiss, AS92, AS94, AS326; experimental aircraft, AS187
Publications, AS336. See also Books; Ephemera; Maps.
Publicity, AS54; photographs, AS48, AS68, AS108, AS244, AS300; skywriting, AS81. See also Advertisements.
Pueblo Indian buildings, AS276
Puerto Rico, AS56
Puffin (aircraft). See Parnall Puffin.
Pulitzer, Joseph, AS160
Pulitzer Trophy races, AS185, AS186, AS198, AS305
Pumps (rocket), AS93, AS278
Pureoil Company, AS84
Purington, George B. ("Slim"), AS241

Pusher aircraft, AS231. See also Biplanes; specific manufacturers, models.
Pylons, AS143

Quarter Century Club, AS182
Queens, AS251
Quimby, Harriet, AS75, AS158, AS197, AS292

Race cars, AS79, AS127, AS153, AS156, AS173
Racers. See Racing aircraft.
Races: aircraft vs. automobiles, AS109, AS310; Astor Cup races, AS153; boat, AS153, AS181; foot, AS113; horse, AS121. See also Air meets; Air races.
Racing aircraft, AS68, AS172, AS237, AS287, AS296, AS311, AS337; jets, AS94; midget, AS172. See also specific manufacturers, models.
Radar, AS42, AS54, AS201, AS246
Radiators, AS127
Radio astronomy, AS28
Radio compasses, AS154
Radios, AS86, AS237; aircraft, AS92, AS281, AS295, AS305; circuits, AS39; equipment, AS70, AS86, AS92, AS106, AS125, AS144, AS174, AS198, AS201; field, AS106, AS198, AS329; instruments, AS28, AS39, AS41
Radio Shack computers, AS12
Rafts. See Life rafts.
Railroads, AS56, AS94, AS261; anti-aircraft batteries on railroad cars, AS9; bridges, AS35; Myanmar, AS119; stations, AS56, AS113, AS124, AS142, AS198, AS248, AS297; tracks, AS44, AS158, AS189, AS262, AS329; World War I, AS70, AS113, AS115, AS276. See also Trains.
Rails (for launching aircraft), AS104
Ramjets, AS174
Ramps, AS157, AS174
Ramsey, Nadine, AS230
Ramsey Room (National Air and Space Museum), AS336
Ranches, AS152. See also Farms; Plantations.
Ranger 6 (probe), AS175
Rangoon. See Myanmar.
Rangsdorf Aviation Club, AS55
Rash, Richard, AS243
Rattlesnakes, AS122
Rausenberger engines, AS54
Rawlins, Albert, AS52
Raymond, Arthur E., AS155
Reaction Motors, Inc., AS174
Reagan, Ronald, AS338
Receivers (radio), AS28
Receptions, AS33, AS289, AS338. See also Award presentations; Ceremonies.
Reconnaissance photography, AS9, AS35, AS128. See also Aerial photographs.

Reconstruction. *See* Restoration.
Record flights, AS109, AS142, AS186, AS192, AS237, AS295. *See also* specific flights, pilots.
Recovering aircraft, AS189, AS218, AS241, AS264, AS269
Recreation, AS44, AS56, AS122, AS154, AS295. *See also* Games; Sports; specific activities, games.
Recruitment campaigns, AS173
Red Arrow. *See* Simplex Red Arrow.
Red Cross, AS70, AS113, AS154, AS188, AS284, AS290
Red Devil. *See* Baldwin Red Devil.
Redstone rockets, AS175
Refueling. *See* Fueling.
Reggiane aircraft, AS239
Reid, Marshall, AS94
Reid, Percival, AS274
Reims (France), AS160
Reitsch, Hanna, AS66
Relf, Ernest F., AS155
Reliant. *See* Stinson Reliant.
Religion. *See* Churches; Church services; Funerals; Mosques; Weddings.
Remote sensing, AS1
Renault engines, AS313
Rentschler, Frederick B., AS155
Repairs. *See* Maintenance and repair.
Repair shops, AS220
Replicas (aircraft), AS180, AS287
Reptiles, AS122
Republic aircraft, AS51, AS287; P-47 Thunderbolt, AS179, AS254
Republic Steel Corporation, AS84
Rescues, AS15, AS262, AS295. *See also* Crashes; Disaster recovery.
Research and development, AS78; aircraft, AS12, AS130; missiles, AS76, AS130; rockets, AS14, AS25, AS76, AS93; spacecraft, AS16, AS18
Research balloons, AS213. *See also* Stratospheric balloons.
Resolution targets, AS163
Resorts, AS152
Restaurants, AS113, AS277, AS334. *See also* Banquets; Bars; Cafes.
Restoration (aircraft), AS70, AS180, AS208, AS211, AS324, AS325. *See also* Conservation.
Retirement parties, AS273
Retractable landing gear, AS94, AS185, AS305
Reunions, AS286
Rhine river (Germany), AS113, AS121
Rhönsperber sailplanes, AS135
Riaboff, Alexander, AS123
Rice paddies, AS50
Richards, Paul, AS43
Richmond (Virginia), AS112
Richthofen, Manfred von: grave, AS320
Rickenbacker, Edward V. ("Eddie"), AS52, AS66, AS284, AS290; painting of, AS287, AS319
Riddle Aeronautical Institute, AS220

Riding horses, AS198, AS232, AS280. *See also* Cavalry; Horses; Polo.
Rifles, AS154
Rigging (balloons), AS36, AS297
Rings of Saturn, AS2
Rio de Janeiro (Brazil), AS289
Rites and ceremonies. *See* Ceremonies; Church services; Funerals; Weddings.
Rivers: France, AS289; Germany, AS113, AS121, AS126; Japan, AS83; Slovakia, AS258; United States, AS256, AS309. *See also* specific rivers.
Riveting, AS267
RMI. *See* Reaction Motors, Inc.
Roadable aircraft, AS82. *See also* Continental Airphibian; Herrick Convertoplane; Pitcairn aircraft.
Roads, AS129, AS261
Roberts, George S., AS63
Roberts engines, AS54
Robin (aircraft). *See* Curtiss Robin.
Robinson, Hugh, AS160, AS308
Robinson, John C., AS63
Robots, AS12, AS293
Rochester (England), AS73
Rockefeller, Winthrop C., AS155
Rockefeller Center (New York City), AS167
Rocketry and Space Flight (National Air and Space Museum gallery), AS335
Rockets, AS32, AS49, AS76, AS85, AS138, AS164, AS165, AS174, AS175, AS206, AS246, AS247, AS254, AS278, AS295, AS311, AS336, AS337; construction, AS14, AS28, AS234, AS278; engines, AS32, AS73, AS76, AS93, AS175; Goddard, AS32, AS131, AS334; history, AS25; launches, AS14, AS162, AS164; launching ramps, AS174; parts, AS93, AS131, AS164, AS175, AS233, AS234, AS278; research and development, AS14, AS25, AS76, AS93, AS131, AS175; tests, AS93, AS234, AS278. *See also* Missiles; Rockoons; Spacecraft.
Rocket scientists, AS12, AS20, AS25, AS28, AS76, AS175
Rockoons (balloon/rockets), AS28
Rocks, Moon, AS32, AS300, AS334
Rockwell, Kiffin Y., AS188
Rockwell, Norman: art works by, AS11
Rockwell, Robert S., AS320
Rockwell, Willard F., Jr., AS43
Rockwell Field (California), AS242
Rockwell HiMAT Remotely-Piloted Research Vehicles, AS249
Rockwell International, AS175
Rocky Mountain Municipal Airport, AS144
Rodeos, AS154
Rodgers, John, AS264, AS305
Roe, A.V., AS143
Rogers, Will, AS41, AS66
Roland aircraft, AS180, AS192, AS276
Roller coasters, AS142

Rolls, Charles S., AS209
Rolls Royce: automobiles, AS153; employees, AS84; engines, AS54, AS313
Roma (airship), AS36
Romaine, Ralph O., AS71
Romania, AS251
Roman ruins, AS112, AS276, AS289
Rooms: bedrooms, AS55, AS134; control, AS125, AS164, AS305; dining, AS106, AS125, AS144, AS149; display, AS144; kitchens, AS125, AS134; living, AS120, AS162, locker, AS41; military buildings, AS106, AS122, AS153, AS154; YMCA buildings, AS106. *See also* Classrooms; Interiors; Supply rooms; specific buildings.
Roosevelt, Eleanor, AS63
Roosevelt, Philip I., AS155
Roosevelt, Quentin: grave, AS120
Ropes, AS15
Rosendahl, Charles E., AS155
Rotary aircraft. *See* Autogyros; Helicopters.
Rotary engines, AS194, AS313
Rotor blades, AS64, AS148
Routes (air), AS165
Rovers (Mars), AS29
Rowboats, AS73
Rowe, Basil Lee, AS252
Royal Aero Club, AS55
Royal Aeronautical Society, AS55
Royal Air Force, AS73, AS172
Royal Dutch Airlines. *See* K.L.M. (Royal Dutch Airlines).
Royal Flying Corps (Canada), AS70
Royalty, AS9, AS82, AS187, AS232, AS251
Rubber plantations, AS289
Rudders, AS77
Ruhe, Barnaby, AS253
Ruhe, Benjamin, AS253
Ruins, AS112, AS120, AS128, AS129, AS276, AS289; Egypt, AS191; Peru, AS189; Saudi Arabia, AS202
Rulers. *See* Czars; Dictators; Governors; Grand dukes; Kaisers; Kings; Mayors; Presidents; Princes; Princesses; specific individuals.
Running, AS144
Runways, AS189, AS329
Russia, AS9, AS123, AS246; balloons, AS9, AS22, AS168; civil war, AS123; Gatchina Military Flying School, AS9, AS123; Odessa, AS123; people, AS304; Siberia, AS35; weapons, AS49; World War I, AS9, AS123. *See also* Polish-Russian War; Soviet Union.
Russian Revolution, AS123
Russo-Japanese War, AS168
Ryan aircraft, AS192; Flexi-Wing, AS213; monoplanes, AS141; Navion, AS68; NY-P *Spirit of St. Louis*, AS85, AS141, AS194, AS303, AS334; SC, AS135

SAAB aircraft, AS255; 35 Draken, AS99
Sabreliner. *See* North American Sabreliner.
Safety equipment, AS3, AS32, AS54, AS56, AS108, AS237
Sailboats, AS241
Sailors, AS134, AS218, AS242, AS310. *See also* U.S. Navy.
Sailplanes, AS135, AS161, AS337
Salem (Massachusetts), AS160
Salisbury (England), AS112
Salons (Paris), AS153, AS281
Salt mines, AS181
Salzburg (Austria), AS35
Sample, Paul: art works by, AS11
San Antonio (Texas), AS70, AS112, AS197
San Benito (Texas), AS122
Sandals, AS202
San Diego (California), AS56, AS122, AS153, AS160, AS305
San Diego Exposition (1916), AS153
San Francisco (California), AS142, AS183, AS186, AS318
Sänger, Eugen, AS175
Santa Ana (Costa Rica), AS265
Santa Claus, AS122. *See also* Christmas celebrations.
Santa Monica (California), AS142
Santos-Dumont, Alberto, AS66
Santos-Dumont Demoiselle (aircraft), AS102
Sartori, Grazia, AS230
Sasala, Jane, AS230
Satellites
—artificial, AS16–AS18, AS24, AS25, AS32, AS99, AS175, AS206, AS263, AS300, AS333, AS334, AS336, AS337; construction, AS28, AS193; Galileo, AS19; Landsat, AS1; Mercury *Big Joe*, AS193; *Pioneer*, AS175, AS206; Soviet, AS28, AS246, AS263; *Surveyor*, AS17; Viking, AS206; *Voyager*, AS19, AS29, AS206, AS306. *See also* Probes; Spacecraft; specific programs.
—natural, AS2, AS19, AS306. *See also* specific planets.
Saturn (planet), AS2
Saturn program, AS24, AS26, AS175, AS206, AS287
Saudi Arabia, AS202
Saunders-Roe SR-A1 (aircraft), AS254
Sausage balloons, AS170, AS297
Savary aircraft, AS281
Savoia Amphibian (aircraft), AS135
Savoia-Marchetti aircraft, AS153, AS257
Scaffolding, AS298
Scanlon, Martin F., AS169
Scheffelin, Edward, AS97
Scheffelin, Julia, AS97
Scheffelin, Margaret M., AS97
Schenectady (New York), AS186
Schiller, H. von, AS125
Schilling, David C., AS204
Schmelling, Max, AS125

Schmiedl, Friedrich, AS175
Schmitt, Harrison H., AS300
Schmitt, Jack, AS21
Schneider, Edward C., AS155
Schools, AS261; mechanics, AS177. *See also* Aviation schools; Classes; Classrooms; Pilot training; Training.
Schweickart, Russell L., AS300
Science fiction: illustrations, AS25, AS175; motion pictures, AS25, AS175; television programs, AS25
Science Museum of London, AS325
Scientists, AS12, AS26, AS28, AS66, AS82, AS155, AS162, AS164, AS221, AS237, AS282. *See also* Astronomers; Physicists; Rocket scientists; specific names.
Scoreboards, AS143
Scott, Blanche Stuart, AS142, AS204; advertisements, AS292
Scott, David R., AS206, AS300
Scout rockets, AS175
Scragg, George H., AS169
Sculptures: aviation, AS11; ivory pieces, AS261; portraits, AS17, AS169. *See also* Totem poles.
SDTV (space telescope), AS26
Sea-Air Operations (National Air and Space Museum gallery), AS334
Seagull (aircraft). *See* Curtiss MF Seagull.
Seaplanes, AS9, AS38, AS41, AS79, AS85, AS104, AS117, AS153, AS157, AS172, AS177, AS237, AS241, AS242, AS250, AS282, AS287, AS311, AS329; Boeing, AS229; Burgess, AS79, AS85, AS160, AS228; crashes, AS170, AS218; Curtiss, AS9, AS245, AS276, AS305, AS307; Dornier, AS185; Grigorovich, AS9; Martin, AS142, AS183; Piaggio, AS238. *See also* Amphibian aircraft; Flying boats; specific manufacturers, models.
Searchlights, AS49, AS120
Seascapes. *See* Waterscapes.
Secretaries, AS84
Sedov, Leonid Ivanovich, AS263
Selfridge, Thomas E., AS77, AS160, AS190
Seminars, AS215. *See also* Conferences; Lectures; Meetings.
Senators, AS338
Senegalese soldiers, AS276
Sensors, AS30
Sequential photographs, AS39
Sergeant missiles, AS175
Servicemen. *See* Soldiers; specific military branches.
Settle, T.G.W., AS22
Sevastopol Naval Air Station (Ukraine), AS9
Seversky aircraft, AS192; BT-8, AS110
Seversky Aviation Corporation, AS84
Sewing, AS94, AS103, AS127, AS134, AS214, AS220. *See also* Fiber art.

Seypelt, Albert W., AS262
Sharp, Edward R., AS155
Sheep, AS112
Sheerness (England), AS73
Sheet music, AS9. *See also* Ephemera.
Shell craters, AS232. *See also* Bombing.
Shenandoah (airship). *See* U.S.S. *Shenandoah*.
Shephard, Alan B., Jr., AS66, AS175, AS213, AS300; painting of, AS287
Ships, AS40, AS73, AS101, AS122, AS142, AS185, AS223, AS257, AS261, AS269, AS281, AS282; battleships, AS9, AS70, AS160, AS186, AS308; evacuations, AS70; excursion, AS156; military, AS10, AS44, AS56, AS113, AS124, AS218, AS256, AS276; miniature models, AS29, AS143; Soviet, AS9; spacecraft recovery, AS46; transporting aircraft, AS91; with airships, AS36; World War I, AS70, AS113, AS120, AS188, AS290. *See also* Aircraft carriers.
Shipyards, AS124, AS153
Shoeing horses, AS198
Shoes, AS3, AS113. *See also* Boots; Mukluks; Sandals.
Shooting, AS113. *See also* Guns.
Shooting ranges, AS149, AS329. *See also* Artillery ranges.
Shooting Star. *See* Lockheed aircraft.
Shops. *See* Construction; Machine shops; Museum shops.
Showrooms, AS313. *See also* Advertisements; Displays.
Shreveport (Louisiana), AS35, AS318
Shulman, Deanne, AS291
Siberia, AS35
Siemens-Shuckert engines, AS74
Sigler, Dale B., AS264
Signal balloons, AS177
Signal Corps. *See* U.S. Army Signal Corps.
Signal lights, AS54
Signal panels, AS113
Signals, AS10
Sikorsky, Igor I., AS9, AS210, AS334; painting of, AS287
Sikorsky aircraft, AS51, AS210, AS287; flying boats, AS189; *Grande*, AS158; helicopters, AS9, AS39, AS216, AS254, AS334; Ilya Murometz, AS9; R-5, AS254; S-40, AS110; S-55, AS216; XR-4, AS5
Silicon wafers, AS13
Silver Dart (aircraft), AS89, AS231
Simon, René, AS158
Simplex Red Arrow (aircraft), AS68
Simulators (flight), AS12, AS32, AS175, AS237, AS300
Singer, S. Fred, AS266
Singers, AS63, AS154, AS156, AS169. *See also* Concerts.
Singer Sedan automobiles, AS153
Singing Sergeants, AS169
Sinkings (submarines), AS120

Sioux Indians, AS221
Sirius. *See* Lockheed Sirius.
Sketchbooks, AS11
Sketchpad computers, AS12
Skete, Betty, AS7
Skid tests, AS94
Skiing, AS260, AS261
Skitch, Mary, AS236
Skybolt missiles, AS175
Skylab program, AS1, AS18, AS20,
 AS300; astronauts, AS17, AS18; Sky-
 lab Orbital Workshop, AS267, AS334;
 spacecraft, AS18, AS164, AS206
Skyliner (aircraft), AS286
Skymaster. *See* Cessna Skymaster.
Skywriting, AS81. *See also*
 Advertisements.
Sleds, AS150
Sleighs, AS138
Slide rules, AS12, AS13
Slides, AS15
Sloan aircraft, AS129, AS274
Sloan aviation schools, AS274
Sloane, Eric: art works by, AS11
Slovakia, AS258
Smith, Arthur R., AS129, AS160
Smith, Ernest, AS269
Smith, Gail G., AS316
Smith, Lowell H., AS50, AS66, AS270
Smith, Rex: aircraft, AS80
Smith, Richard T., AS94
Smith, William R., AS101
Smithsonian Institution: aircraft
 presentations, AS305, AS325; Arts
 and Industries Building, AS85, AS170,
 AS247; exhibits, AS85, AS109;
 expeditions, AS315; Wright 1903
 Flyer, AS170. *See also* National Air
 and Space Museum.
Smoke balloons, AS168
Smoking rooms, AS125
Smolik aircraft, AS311
Snakes, AS122
Snark missiles, AS12
Snipe (aircraft). *See* Sopwith Snipe.
Snow gauges, AS261
Social Impact of Flight (National Air
 and Space Museum gallery), AS334
Soda, AS18
Softball, AS244
Solar observatories, AS206
Solar power systems, AS175
Solar sails, AS29
Solar system, AS2, AS333; models,
 AS334; moons, AS2. *See also* specific
 planets.
Soldiers, AS14, AS35, AS56, AS79,
 AS121, AS122, AS198, AS242,
 AS243, AS282, AS329. *See also*
 Military officers; specific countries,
 military branches, wars.
—African Americans, AS63, AS334
—American Indians, AS150
—dead, AS128, AS129
—place of origin: France, AS96, AS260,
 AS272; Germany, AS113, AS126,

AS232, AS262; Great Britain, AS73,
 AS187; Guatemala, AS158; Morocco,
 AS96, AS189; Saudi Arabia, AS202;
 Senegal, AS276; Zouave, AS272
—Spanish-American War, AS198
—women, AS97, AS218, AS295, AS312
—World War I, AS57, AS70, AS106,
 AS113, AS115, AS120, AS124,
 AS126, AS128, AS129, AS149,
 AS163, AS218, AS232, AS260,
 AS272, AS276, AS284, AS297
—World War II, AS37, AS44, AS63,
 AS144, AS150, AS154, AS312, AS331
—wounded, AS70, AS126, AS150,
 AS154
Solingen (Germany), AS116
Solovioff, Nicholas: art works by, AS11
Sonic boom damage, AS302
Sopwith, Thomas O.M., AS58, AS209
Sopwith aircraft, AS113, AS137, AS161,
 AS271, AS311; Scout, AS245; Snipe,
 AS153
Soubiran, Robert, AS272
Soucek, Zeus, AS71
Sousa, John Philip, AS52
South Africa, AS172
South America. *See* Latin America;
 specific countries.
Southeast Asia, AS172
Southern Cross (aircraft), AS269
Soviet Embassy, AS263
Soviet Union, AS9, AS35, AS246;
 aircraft, AS9, AS40, AS153; balloons,
 AS22; engines, AS194; flight clothing,
 AS3; pilots, AS9, AS320; spacecraft,
 AS18,.AS20, AS24, AS28, AS47,
 AS246, AS263; space program, AS16,
 AS20, AS25, AS47; weapons, AS9,
 AS49. *See also* Russia.
Soyuz spacecraft, AS18. *See also*
 Apollo-Soyuz Test Project.
Spaatz, Carl A., AS155
Space art, AS11, AS21, AS25, AS27,
 AS32, AS333, AS337
Spacecraft, AS16, AS18–AS20, AS24,
 AS25, AS29, AS45, AS46, AS138,
 AS164, AS263, AS287, AS300,
 AS336, AS337. *See also* Satellites;
 Space Shuttles; specific programs
 (Apollo, Gemini, Mercury, Skylab).
—Apollo-Soyuz Test Project, AS1, AS47,
 AS206
—artists' conceptions, AS19, AS300
—construction, AS18, AS175, AS206,
 AS267, AS300
—damage, AS268
—diagrams, AS19, AS20, AS28, AS193
—flights: launches, AS18, AS99, AS164,
 AS175, AS300, AS336; recoveries,
 AS175
—guidance systems, AS12
—manned maneuvering units, AS18
—miniature models, AS20, AS23, AS24,
 AS32, AS334
—parts, AS164, AS193, AS300
—photographs from, AS1, AS2, AS20

—Soviet Union, AS18, AS20, AS24,
 AS28, AS47, AS246, AS263
—transportation, AS164, AS175,
 AS267, AS300
Spaceflight simulators, AS12, AS175
Space food, AS17, AS18, AS24, AS32,
 AS175, AS300
Space Hall (National Air and Space
 Museum gallery), AS194
Space programs, AS20, AS25, AS46,
 AS164, AS247; China, AS24; Europe,
 AS16; Japan, AS16; Soviet Union,
 AS16, AS20, AS24, AS25, AS47. *See
 also* specific program names (Apollo,
 Gemini, Mercury, Skylab, Space
 Transportation System).
Space Shuttles, AS1, AS15, AS18, AS20,
 AS21, AS25, AS26, AS206, AS282,
 AS336; miniature models, AS23,
 AS24. *See also* Space Transportation
 System.
Space suits, AS18, AS23–AS25, AS29,
 AS32, AS175, AS300, AS334, AS336;
 prototypes, AS99
Space telescopes, AS23, AS26
Space Transportation System, AS1,
 AS18, AS20, AS24, AS206, AS334,
 AS336; astronauts, AS17, AS18. *See
 also* Space Shuttles.
Space walks, AS18, AS29, AS99, AS175,
 AS206, AS300
Spad aircraft, AS113, AS140, AS141,
 AS232, AS272, AS284; XIII, AS129,
 AS208, AS211; Russian models, AS9
Spanish-American War, AS198
Spark plugs, AS219
Sparrowhawk. *See* Curtiss F9C-2
 Sparrowhawk.
Spartan aircraft, AS51
Spectators, AS6, AS88, AS98, AS102,
 AS143, AS256, AS262, AS282,
 AS285. *See also* Crowds.
Spectra (stars), AS145
Spectrographs, AS14, AS31
Speeches, AS169, AS215, AS267,
 AS280, AS299
Speed record flights. *See* Record flights.
Spencer, Chauncey E., AS63
Sperry aircraft, AS296
Sperry Gyroscope Company: employees,
 AS84; instruments, AS54, AS160,
 AS307
Spiders, AS122
Spirit of Booker T. Washington
 (aircraft), AS63
Spirit of St. Louis (aircraft), AS85,
 AS141, AS194, AS303, AS334
Spitfire. *See* Supermarine Spitfire.
Spitzer, Lyman, AS26
Splashdowns, AS300. *See also* Landings.
Spokane (Washington), AS318
Sport aircraft, AS38. *See also* specific
 manufacturers, models.
Sports, AS125, AS290; baseball, AS90,
 AS154, AS198, AS244, AS288;
 basketball, AS244; boxing, AS161,

AS272, AS276; football, AS122,
AS163; gymnastics, AS290; polo,
AS70, AS158, AS198; skiing, AS260,
AS261; softball, AS244; stadiums,
AS246; tennis, AS73, AS161, AS177.
See also Fishing; Hunting; Running.
Squadron insignia, AS70, AS115,
AS272, AS317
Square D Company, AS167
S series helicopters. *See* Sikorsky
aircraft.
SST. *See* Supersonic transport.
Stables, AS329
Stacking lumber, AS143
Stadiums, AS246
Staggerwing. *See* Beech aircraft.
Stairs, AS15
Stamps. *See* Postage stamps.
Standard Oil Company, AS251
Stands (display), AS174
Stanley, Robert M., AS161
Stanovo oil, AS251
Stanton, Charles I., AS273
Stars, AS27, AS31, AS145, AS333,
AS336; clusters, AS27, AS333;
spectra, AS31, AS145. *See also* Sun.
Stars (National Air and Space Museum
gallery), AS334
Starting propellers, AS282
"Star Trek" television show, AS25
Statue of Liberty, AS276
Statues, AS276. *See also* Busts;
Monuments and memorials;
Sculptures.
Steam engines, AS194
Stearman aircraft, AS141, AS192
Steiner, John, AS237
Stenseth, Martinus, AS319
Stevens, Albert W., AS22, AS221
Stevens, A. Leo, AS147
Stewardesses. *See* Flight attendants.
Stewart, J.P., AS261
Stewert, Robert L., AS18
St. Henry, "Lucky Bob," AS241,
AS308
Stills: motion-picture, AS336; television,
AS25, AS300
Stinis, Andy, AS51
Stinson, Katherine, AS277, AS292
Stinson, Marjorie C., AS292
Stinson aircraft, AS192, AS287; R,
AS86; Reliant, AS135, AS180;
Voyager, AS68
Stirling New Guinea Expedition, AS315
St. Louis (Missouri): airports, AS318;
Curtiss-Wright Corporation, AS94;
expositions, AS53, AS168, AS256
St. Louis World's Fair. *See* Louisiana
Purchase Exposition.
Stockholm (Sweden), AS153
Stockholm Air Exposition, AS153
Stockrooms, AS176. *See also* Supply
rooms.
Stockton, Paul R., AS276
Stonehenge, AS112
Storage buildings, AS329

Storms, AS112, AS261. *See also*
Hurricanes.
Stout, William B., AS286, AS290
St. Petersburg (Russia), AS9
St. Petersburg-Tampa Airboat Line,
AS151
Strafing, AS237, AS295. *See also* Aerial
combat.
Straightwing. *See* Waco Straightwing.
Stratofortress. *See* Boeing B-52
Stratofortress.
Stratoliner. *See* Boeing aircraft.
Stratospheric balloons, AS22, AS192,
AS221. *See also* High-altitude flights.
Streetcars, AS101, AS113, AS241
Streetscapes. *See* Cityscapes; Street
scenes.
Street scenes, AS113, AS128, AS153,
AS196, AS218; Bangkok (Thailand),
AS50; Cuba, AS198; France, AS70,
AS113, AS129, AS217; Germany,
AS129; Guatemala, AS158; Peru,
AS189; Portugal, AS289; Washington,
D.C., AS309. *See also* Cityscapes.
Stretchers, AS242
Strikes, AS291. *See also* Bombing.
Structures. *See* Architecture; Buildings;
Interiors; specific structures (such as
Churches, Lighthouses).
Struts, AS94, AS104, AS271
Studenski, Nastia, AS277
Studenski, Paul, AS277
Students, AS56, AS58, AS88, AS129,
AS133, AS144, AS150, AS246,
AS277, AS316. *See also* Aviation
schools; Children; Pilot training;
Training.
Stunt flights, AS56, AS70, AS96, AS109,
AS158, AS160, AS166, AS173,
AS189, AS262, AS292; balloons,
AS118, AS160; night flights, AS109,
AS142, AS173; races between aircraft
and automobiles, AS109, AS310;
wing-walking, AS181, AS252. *See
also* Aerobatics; Barnstorming;
Exhibition flight; Formation flights.
Stunt pilots, AS156. *See also* Aerobatics;
Barnstorming; specific individuals.
Stuppe, Alfred, AS126
Stuppe, Willy, AS126
Sturtevant engines, AS54
Stuttgart (Germany), AS35
Submarines, AS9, AS40, AS113, AS120,
AS177; factories, AS9, AS153
Suburbs, AS111
Sugar factories, AS232
Suits, space. *See* Space suits.
Summit (New Jersey), AS284
Sun, AS27, AS333
Sunbeam engines, AS73
Sunsets, AS261
Sunspots, AS175
Super Constellation. *See* Lockheed Super
Constellation.
Supercritical wings, AS205
Super Guppy (aircraft), AS207, AS267

Supermarine aircraft, AS109, AS311;
S.6 racer, AS36; Spitfire, AS100,
AS153
Super Solution. *See* Laird LC-DW-500
Super Solution.
Supersonic parachutes, AS175
Supersonic transport, AS301, AS302
Super Wasp radio sets, AS86
Supplies, AS32, AS119, AS176, AS221,
AS237, AS295, AS327. *See also*
specific items.
Supply rooms, AS56, AS144, AS154.
See also Stockrooms.
Surgeons, flight, AS155. *See also*
Physicians.
Surplus aircraft, AS322
Surrenders, AS282
Surveying, AS261
Surveyor 3 (satellite), AS17
Survival gear. *See* Safety equipment.
Swallow aircraft, AS141, AS192
Swann, Ingo: art works by, AS11
Sweden, AS153
Swimming, AS44, AS56, AS202, AS218,
AS284
Swiss Air Force, AS172
Swiss American Aviation Corporation.
See Lear Jet Corporation.
Swiss Transport Museum (Switzerland),
AS24
Switches, AS219
Swords, AS44, AS202
Syria, AS289

Tactical munitions dispensers, AS132
Tadpole (aircraft). *See* Curtiss Tadpole.
Taft, Helen, AS143
Tail-less aircraft, AS311
Take-offs, AS10, AS56, AS79, AS94,
AS103, AS143, AS144, AS157,
AS183, AS203, AS257, AS262,
AS269, AS307, AS311; gliders, AS41,
AS53; Langley Aerodrome, AS171.
See also Ascensions; Launches.
Taliedo, Giovanni G.L. Caproni di,
AS52, AS155
Tampa (Florida), AS151
Tanks (armored fighting vehicles), AS35,
AS113, AS120, AS122, AS129,
AS260, AS272, AS276, AS296
Taper Wing. *See* Waco CTO Taper
Wing.
Tarantulas, AS122
Targets, AS163
Tatarewicz, J., AS26
Taylor, Charles E., AS325
Taylorcraft gliders, AS273
Teachers, AS84. *See also* Flight
instructors.
Teaching, AS160. *See also* Aviation
schools; Classes; Pilot training;
Training.
Teams (sports), AS244. *See also* specific
sports.
Technicians, AS164, AS175, AS213,
AS246, AS278

TEKTITE (research vessel), AS266

Teleki, Charles, AS26

Telescopes, AS14, AS23, AS26, AS27, AS32, AS145, AS175, AS333, AS337; construction, AS26; miniature models, AS23, AS26

Television programs, AS25, AS300

Telliers aircraft, AS73

Telstar (satellite), AS175

Temple of Heaven (Beijing, China), AS289

Temples, AS83, AS191, AS289. *See also* Churches; Mosques.

Tennessee, AS318

Tennis, AS73, AS161, AS177

Tents, AS42, AS56, AS133, AS150, AS260, AS297, AS307, AS317

Terrapin missiles, AS266

Test equipment, AS26, AS64, AS82, AS94, AS107, AS131

Test pilots, AS313. *See also* Pilots; specific individuals.

Tests: aircraft, AS57, AS85, AS94, AS160, AS183, AS282, AS288, AS295, AS296, AS328, AS329; aircraft parts, AS94, AS327, AS329; bombs, AS240, AS296; cameras, AS111; engines, AS74, AS107, AS219; equipment, AS18, AS295, AS327, AS329; experimental aircraft, AS187, AS314; flight, AS68, AS185; helicopters, AS64; materials, AS94, AS219, AS327; missiles, AS278; propellers, AS326; radios, AS39; rockets, AS93, AS131, AS234, AS278; space telescopes, AS26; spacecraft, AS15, AS193, AS206, AS267, AS300; supercritical wings, AS205; weapons, AS49, AS295

Test sites (Oregon), AS175

Tetrahedral kites, AS140, AS160

Texaco, AS38

Texas, AS122; airports, AS318; Austin, AS284; aviation schools, AS56, AS277; Dallas, AS56; Fort Worth, AS56; Galveston, AS277; Hondo, AS314; military bases, AS106, AS181, AS284; San Antonio, AS70, AS112, AS197; Waco, AS161

Thaden, Louise M., AS52, AS61, AS230, AS280

Thaden metal monoplanes, AS141

Thailand, AS50

Theaters, AS34, AS113, AS334–AS336

Third Paris Salon, AS281

Thomas, Alma W.: art works by, AS11

Thomas, Lowell, AS155

Thomas aircraft, AS159, AS160

Thomas Brothers Aeroplane Company, AS160

Thomas Morse aircraft, AS192, AS328

Thor missiles, AS175

Thrush (aircraft). *See* Curtiss Thrush.

Thrust chambers (rocket), AS93

Thunderbirds (U.S. Air Force), AS169

Thunderbolt. *See* Republic P-47D Thunderbolt.

Tiger emblems, AS44

Time-keepers, AS143

Tires, AS219

Tissue phantom balloons, AS168

Titan missiles, AS175

Tittman, Harold H., AS284

Tobacco pipes, AS44

Todd, Robert E., AS319

Toledo (Ohio), AS161

Toliver airship, AS160

Toncray, Henry, AS285

Tools, AS26, AS32, AS41, AS103; agricultural, AS78; aircraft construction, AS110, AS314. *See also* Construction; Equipment.

Topographic features, AS1, AS2. *See also* Aerial photographs; Cityscapes; Landscapes.

Tornado (aircraft). *See* North Amercian B-45 Tornado.

Toronto (Canada), AS129, AS304

Torque stands, AS329

Totem poles, AS261

Tours, AS110, AS152, AS244, AS257

Tours (France), AS113, AS276

Towers, John H., AS264

Towing. *See* Transporting.

Towle, Thomas, AS286

Towns, AS113, AS276; Saudi Arabia, AS202. *See also* Cityscapes; Street scenes; Villages; specific locations.

Toys, AS186. *See also* Models.

Tractor aircraft, AS88, AS160, AS185. *See also* specific manufacturers, models.

Trainers. *See* Training aircraft.

Training, AS9, AS237, AS244; astronauts, AS12, AS24, AS206, AS300; balloon, AS36, AS133, AS170; military, AS35, AS56, AS63, AS68, AS70, AS72, AS79, AS144, AS154, AS170, AS243, AS290, AS295; paratroopers, AS135. *See also* Aviation schools; Classes; Pilot training; Simulators; Workshops.

Training aircraft, AS288, AS329

Training equipment, AS24, AS32, AS49, AS144. *See also* Simulators.

Training fields, AS160

Trains, AS106, AS113, AS122, AS124, AS152, AS177, AS241, AS261, AS297, AS308; crashes, AS241; military, AS9, AS70, AS218, AS290. *See also* Railroads.

Transatlantic flights, AS70, AS91, AS114

Transcontinental race (1919), AS186

Transistors (computer), AS13

Transmitting typewriters, AS174

Transport aircraft, AS6, AS8, AS40, AS141, AS153, AS237, AS282, AS287, AS288, AS295, AS305, AS311, AS329

Transportation. *See* specific vehicles.

Transporting objects: aircraft, AS12, AS56, AS60, AS88, AS220, AS257, AS262, AS277, AS304, AS305; balloons, AS142, AS221; equipment, AS26, AS49; missiles, AS278; space telescopes, AS26; spacecraft, AS164, AS175, AS267, AS300. *See also* Trucks.

Transports. *See* Transport aircraft.

Transport ships, AS113

Trans World Airlines (TWA), AS84, AS213, AS286

Travel, AS110, AS156, AS161, AS173, AS223, AS290. *See also* Travel photographs; specific locations, vehicles.

Travel Air aircraft, AS137, AS192, AS214, AS280, AS288; *City of Oakland*, AS141, AS269; D4000 Speed Wing, AS180; monoplanes, AS141; *Oklahoma*, AS141. *See also* Curtiss Travelair.

Travel Air Company, AS288

Travel photographs, AS153, AS161, AS186, AS189, AS191, AS289. *See also* specific locations.

Travis Air Force Base (California), AS97

Treaty of Versailles (1919), AS70

Trees, AS122

Trenches, AS70, AS113, AS120, AS126, AS128, AS129, AS149, AS163, AS186, AS232, AS276

Triaca aviation school, AS160

Tri-City Airport (Tennessee), AS318

Trier (Germany), AS276

Trieste (Italy), AS35

Trimotor. *See* Ford Trimotor.

Trinidad, AS135

Tri-Pacer. *See* Piper PA-22 Tri-Pacer.

Triplanes, AS94

Trippe, Elizabeth S., AS289

Trippe, Juan T., AS155, AS213, AS289

Trips. *See* Travel.

Tristar. *See* Lockheed L1011 Tristar.

Trojan. *See* North American T-28 Trojan.

Troop trains, AS218, AS290

Trophies, AS61, AS68, AS213, AS280, AS289, AS295. *See also* Air races; Awards.

Trout, Evelyn ("Bobbie"), AS52

Trucks, AS15, AS44, AS70, AS106, AS113, AS201, AS220, AS221, AS243, AS251, AS267, AS317; fire trucks, AS54, AS73, AS144. *See also* Transporting objects.

Truman, George W., AS108

Truman, Harry S, AS63

Tsiolkovsky, Konstantin E., AS175

Tubavion aircraft, AS281

Tubes. *See* Cathode ray tubes; Vacuum tubes.

Tubman, William V.S., AS289

Tug-of-war games, AS56, AS218

Tunis (Tunisia), AS35
Turboprop aircraft, AS216
Turkey, AS162
Turner, Roscoe, AS7, AS38, AS61, AS66, AS75, AS192
Turrets. *See* Gun turrets.
Tusch, Mary E. ("Mother"), AS290
Tuskegee Institute, AS63
TWA (Trans World Airlines), AS84, AS213, AS286
Typewriters, AS174

Ukraine, AS9
Ulm, Charles T.P., AS269
Uniforms, AS44, AS72, AS252, AS262, AS284, AS337; international, AS3, AS32. *See also* Flight clothing; Insignia; specific groups, occupations, wars.
Union Station (Washington, D.C.), AS56
United Airlines, AS84, AS214
United Service Organizations. *See* USO.
United States. *See* U.S.; specific locations, military branches.
United States (balloon), AS142
United Technologies Corporation, AS293
Universal. *See* Fokker Universal.
Universities, AS63, AS145, AS246, AS290
University of California, Berkeley, AS290
Upson, Ralph H., AS155
Uranus, AS2, AS306
U.S. Air Force, AS295
—aircraft, AS6, AS67, AS169, AS329; crashes, AS136
—bases, AS6, AS42, AS97, AS150, AS154, AS213, AS329
—China Air Task Force, AS44
—equipment, AS28, AS30, AS49
—personnel, AS6, AS33, AS42, AS295
—Thunderbirds, AS169
—Vietnam War, AS42
U.S. Air Force Museum (Wright-Patterson Air Force Base), AS172
U.S. Air Mail Service, AS274. *See also* Airmail.
U.S. Army
—aircraft, AS57, AS60, AS128, AS160, AS192, AS197, AS329; balloons, AS121, AS297
—bases, AS112, AS122, AS153, AS181, AS197, AS276, AS297, AS329
—events: Army-Navy football game, AS122; Pan American flight (1926), AS52; social events, AS101
—facilities, AS101, AS112, AS122
—personnel, AS14, AS113, AS297; officers, AS26, AS94, AS122; pilots, AS128
—units: aero squadrons, AS112, AS113, AS276; photo squadrons, AS146; squadrons, AS122

—World War I, AS101, AS111, AS113, AS122, AS128, AS129, AS181, AS297
—World War II, AS101
U.S. Army Air Corps, AS84, AS170, AS261
U.S. Army Air Forces
—aircraft, AS44, AS154, AS317
—personnel, AS44, AS63, AS145
—Project Crossroads, AS240
—units: Eagle Squadron, AS100; Eighth Air Force, AS101; Engineering Division, AS326, AS327, AS329; Fifth Air Force, AS317; fighter groups, AS63, AS65, AS317; India-Burma Headquarters, AS154
U.S. Army Air Forces Day (1947), AS174
U.S. Army Air Service: aircraft, AS328, AS329; around-the-world flight (1924), AS50; exhibits, AS70; pilots, AS50, AS235; World War I, AS128, AS129
U.S. Army Signal Corps, AS198; airships, AS198; balloons, AS36; baseball teams, AS198; personnel, AS79, AS198
U.S. Coast Guard, AS84
U.S. Department of Commerce, AS84
U.S. Navy
—aircraft, AS10, AS95, AS141, AS192, AS207, AS242, AS264, AS305; airships, AS89, AS134, AS160, AS177, AS218, AS227, AS242, AS245, AS294, AS298
—air stations, AS218, AS242, AS264
—equipment, AS28
—facilities, AS124, AS218
—Naval Aircraft Factory, AS207
—personnel, AS10, AS84, AS134, AS218, AS242, AS331; officers, AS26, AS68, AS134, AS174, AS177, AS213, AS218; pilots, AS218, AS242, AS264, AS305; training, AS68; women, AS218
—ships, AS10, AS56, AS218; aircraft carriers, AS10
—World War I, AS124
—World War II, AS10
USO, AS63
U.S. Organizing Committee for the Bicentennial of Air and Space Flight, AS299
U.S.S. *Akron* (airship), AS36, AS140, AS160, AS177
U.S.S. *Los Angeles* (airship), AS36, AS177, AS294
U.S.S. *Macon* (airship), AS75
U.S.S. *McDonough* (ship), AS256
U.S.S. *Princeton* (ship), AS46
U.S.S.R. *See* Soviet Union.
U.S.S. *Shenandoah* (airship), AS36, AS298
Utica (New York), AS186

V-2 missiles, AS14, AS25, AS175, AS208, AS210, AS334. *See also* Peenemünde (Germany).
Vacuum tubes, AS13
Valentine, Charles H., AS160
Valier, Max, AS82, AS175
Valkyrie aircraft, AS160
Valparaiso (Florida), AS6
Valves, AS94, AS174
Vampire. *See* De Havilland D.H.100 Vampire.
Van Allen, James A., AS28
Vanguard (satellite), AS175
Van Hoften, James D.A. *See* Hoften, James D.A. van.
Vaniman, Melvin, AS82
Variable-pitch propellers. *See* Propellers.
Vaughan, George A., Jr., AS155, AS319
Védrines, Jules, AS52, AS137, AS217
Vehicles. *See* specific vehicles (such as Airships, Automobiles, Carts).
Venus, AS2
Verdun (France), AS113
Vernon, Victor, AS304
Versailles (France), AS70, AS113
Vertol H-21 helicopters, AS216
Vertoplane. *See* Herrick Convertoplane.
Verville, Alfred V., AS305
Verville aircraft, AS192, AS296; Aircoach, AS305; biplanes, AS305
Veterinarians, AS68
Vibration tests, AS94
Vickers aircraft, AS137, AS287, AS311; PVO, AS153; Viscount, AS216; Warwick, AS153; Wellington, AS146
Vickers machine guns, AS49
Victor Emmanuel III (king of Italy), AS82
Video discs, AS336
Vierling, Bernard J., AS302
Vierrier, Pierre, AS58
Vietnam War, AS42, AS243
Viking Flying Boat Company, AS86
Viking missiles, AS130
Viking program, AS29, AS206; rockets, AS14, AS175
Villages, AS248; Africa, AS289; China, AS44; England, AS112; Europe, AS129; France, AS272, AS276; Iceland, AS50; Myanmar, AS44
Villers-sur-Meuse (France), AS260
Vindicator. *See* Vought SB2U Vindicator.
Virden, Ralph, AS65
Virginia: Fort Myer, AS170; Manassas, AS198; Newport News, AS56, AS112, AS304; Richmond, AS111
Viscount. *See* Vickers Viscount.
Vladivostok (Russia), AS9
Voisin aircraft, AS113, AS129, AS142, AS160, AS311
Volcanoes, AS198, AS261, AS265
Von Braun, Wernher. *See* Braun, Wernher von.
Von Kármán, Theodore. *See* Kármán, Theodore von.

Von Schiller, H. *See* Schiller, H. .von.
Vostok spacecraft, AS263
Vought, Chance M., AS82
Vought Aircraft: employees, AS84
Vought aircraft, AS51, AS192; F4U
 Corsair, AS71; F-8, AS205; O2U
 Corsair, AS86; SB2U Vindicator,
 AS196
Voyager (aircraft). *See* Stinson Voyager.
Voyager program, AS19, AS29, AS206,
 AS306
Vultee aircraft, AS192; L-5, AS179
Vulture 1 engines, AS313

W-17 infrared early warning sensors,
 AS30
Waco (Texas), AS161
Waco aircraft, AS287; 10, AS141; C,
 AS68; C-6, AS86; CTO Taper Wing,
 AS135; F, AS68; F-7, AS86; OX
 biplane, AS135; RNF, AS86;
 Straightwing, AS86; UEC, AS86
Waco Aircraft Company, AS84
Wade, Leigh, AS68
Wadlow, Truman, AS288
Wagons, AS70, AS77, AS112, AS113,
 AS120, AS198. *See also* Carts; Sleds;
 Sleighs.
Walcott, Charles D., AS307
Wallick, Joan, AS230, AS236
Wallick, Robert, AS230, AS236
Walls, AS198
Walsh, Charles F., AS82, AS308
Walt Disney Productions, AS84
Walter Reed Hospital, AS272, AS284
War bonds, AS144
Ward, James, AS160
Warfare. *See* Combat; specific wars.
Warhawk (aircraft). *See* Curtiss P-40
 Warhawk.
Warner, Arthur P., AS79
Warning devices, AS30
Wars. *See* specific wars (such as Boer
 War, Polish-Russian War, Spanish-
 American War).
Warwick. *See* Vickers Warwick.
Washing clothes, AS198, AS276
Washington (state), AS318
Washington, D.C.: aerial photographs,
 AS54, AS56, AS87, AS242, AS272,
 AS290, AS304, AS309; airports,
 AS318; balloon flights, AS170;
 Capitol Building, AS56, AS87, AS272,
 AS309; Executive Avenue, AS102;
 parades, AS237; school children,
 AS33; Union Station, AS56
Washington Monument, AS56, AS87,
 AS242, AS272, AS309
Watches, AS143
Watching aircraft flights, AS198. *See
 also* Spectators.
Water extractors, AS175
Waterfalls, AS53, AS186
Waterfronts, AS56, AS256
Waterscapes, AS9, AS50, AS56, AS122;
 aerial photographs, AS56, AS79,

AS113, AS122, AS125; Azores
 islands, AS114; New York; AS95;
 Niagara Falls, AS53, AS186. *See also*
 Beaches; Coasts; Docks; Harbors;
 Rivers.
Weapons, AS14, AS29, AS32, AS35,
 AS44, AS49, AS94, AS113, AS120,
 AS122, AS128, AS129, AS149,
 AS154, AS163, AS295, AS336,
 AS337. *See also* Bombs; Cannons;
 Guns; Missiles; Swords; Tanks; spe-
 cific countries, wars.
Weather: maps, AS83; satellite
 photographs, AS162, AS266, AS283.
 See also Clouds; Hurricanes; Storms.
Weaver, George ("Buck"), AS161
Weaver, George C., AS161
Weaving. *See* Fiber art.
Webb, James E., AS17
Weddings, AS73, AS126, AS142,
 AS153, AS189, AS312
Wedell, James, AS61
Weeks, E.D. "Hud," AS310
Weighing baggage, AS94
Welding, AS54, AS154, AS176, AS193
Wellington. *See* Vickers Wellington.
Wellman Polar Expedition, AS160
Wells (oil), AS50, AS112, AS315
Welsh, Al, AS52, AS160
Western United States, AS152
Westland Welkin (aircraft), AS153
Wheeler Express (aircraft), AS180
Wheels. *See* Landing gear.
Whirlwind computer, AS12
Whisner, William T., Jr., AS61
White, Claude Grahame. *See*
 Grahame-White, Claude.
White, Dale L., AS63
White, Edward H. II, AS175
Whitten-Brown, Arthur, AS52, AS312
Whyte, Edna Gardner, AS213
Widgeon. *See* Grumman J4F Widgeon
Wildcat. *See* Grumman F4F Wildcat.
Wilhelm II (kaiser of Germany), AS120
Willard, Charles F., AS143, AS160,
 AS310
Willard-Dempsey boxing match (1919),
 AS161
Williams, Alford J., AS135
Williams, J. Newton, AS160
Williams, Linkwood, AS63
Williams, Rodney D., AS319
Wilson, Eugene E., AS155
Wilson, Winston P., AS169
Wilson, Woodrow, AS70, AS276
Winches, AS296
Windecker, Leo J.: research, AS314
Windmills, AS113, AS114, AS232
Wind-tunnel models, AS32, AS54,
 AS64, AS67, AS183, AS194, AS205
Wind tunnels, AS54, AS64, AS94,
 AS175, AS183, AS296, AS329
Wing lights, AS296
Wings, AS83, AS288, AS311
Wings Club, AS57
Wing struts, AS185

Wing-walking, AS181, AS252
Winkler, Johannes, AS175
Winners (race), AS7, AS61, AS213,
 AS230. *See also* Air races; Trophies.
Winnie Mae (aircraft), AS38, AS165,
 AS280
Winslow, Alan, AS284
Wire carts, AS198
Wisconsin, AS180, AS198
Wise, John, AS168
Wiseman, Fred J., AS290
Wiseman-Cooke aircraft, AS208
Witteman-Lewis NBL-1 (aircraft),
 AS296
Wittman aircraft, AS192
Wizernes (France), AS35
Women, AS87, AS124, AS228. *See also*
 specific names.
—culture groups: Inupiaq, AS261;
 Pacific Islanders, AS317; Vietnamese,
 AS243
—First Ladies, AS63, AS143
—motorcycle riders, AS90
—occupations: flight attendants, AS84,
 AS114, AS214, AS237, AS244,
 AS282, AS291, AS304; nurses,
 AS113, AS176, AS290; pilots, AS63,
 AS66, AS68, AS75, AS94, AS210,
 AS213, AS230, AS236, AS280,
 AS282, AS291, AS292, AS316,
 AS334; singers, AS63, AS156;
 soldiers, AS97, AS218, , AS295,
 AS312; student pilots, AS144; work-
 ers, AS103, AS134, AS176, AS257,
 AS291
—organizations, AS75, AS97, AS316
Women Flyers of America, AS316
Women's Air Reserve, AS75
Women's Army Corps, AS295
Woodhead, Harry, AS155
Woodrum, Martha Ann, AS230
Wootton, Frank: art works by, AS11
Worden, Alfred M., AS300
Worden, J.H., AS277
Workers, AS232, AS251, AS329;
 aircraft companies, AS48, AS90,
 AS103, AS110, AS129, AS153;
 airlines, AS84, AS214, AS237, AS244,
 AS252, AS304; airship, AS125,
 AS134, AS177; factory, AS54, AS67,
 AS94, AS98, AS134, AS176, AS257;
 field, AS78; government, AS84;
 technicians, AS164, AS175, AS213,
 AS246, AS278; women, AS103,
 AS134, AS176, AS257, AS291. *See
 also* specific companies, occupations.
Workshops, AS299, AS329
Works Projects Administration (WPA),
 AS189, AS318
World Cruiser. *See* Douglas World
 Cruiser.
World's fairs, AS135, AS142, AS174.
 See also Expositions.
World War I
—aerial photographs, AS35, AS70,
 AS115, AS128, AS262, AS272

—aircraft, AS9, AS70, AS74, AS106, AS115, AS120, AS124, AS128, AS157, AS163, AS186, AS192, AS235, AS248, AS260, AS271, AS272, AS276, AS284, AS311, AS320, AS336; balloons, AS70, AS120, AS168; construction, AS74, AS276; German, AS106, AS126, AS180, AS232
—battlefields, AS129, AS272
—battleships, AS70, AS106
—bombing, AS70, AS115, AS120, AS126, AS129, AS149, AS163, AS186, AS232, AS260, AS262, AS272, AS276
—buildings, AS106, AS113, AS124, AS272, AS276; hospitals, AS70, AS113, AS126, AS232, AS272, AS284
—equipment, AS3, AS9, AS49, AS70, AS106, AS129, AS163, AS272, AS276
—flight clothing, AS3, AS72
—locations: Africa, AS35; Belgium, AS149; England, AS112, AS115; Europe, AS35, AS115, AS120, AS129; France, AS70, AS96, AS113, AS115, AS149, AS188, AS232, AS260, AS272, AS276, AS284; Germany, AS113, AS115, AS126, AS262, AS276; Italy, AS72, AS157, AS279; Russia, AS9, AS123
—military bases, AS101, AS115, AS129, AS186, AS276, AS284; airfields, AS56, AS70, AS106, AS113, AS120, AS260, AS272; Naval air stations, AS218
—military units: aero squadrons, AS111, AS113, AS115, AS272, AS284; cavalry, AS235; Cherisienne Escadrille, AS96; Lafayette Escadrille, AS128, AS188, AS232, AS248, AS272
—motorcycles, AS186, AS126
—people: corpses, AS120, AS128, AS232; officers, AS170; pilots, AS9, AS72, AS96, AS120, AS126, AS128, AS129, AS181, AS186, AS188, AS235, AS248, AS260, AS272, AS276, AS279, AS284, AS290, AS319, AS320; prisoners, AS232, AS276; soldiers, AS57, AS70, AS106, AS113, AS115, AS120, AS124, AS126, AS128, AS129, AS149, AS163, AS218, AS232, AS260,

AS272, AS276, AS284, AS297; training, AS70, AS72, AS115, AS186, AS189
—posters, AS56
—public events, AS305
—recruitment campaigns, AS173
—trenches, AS113, AS126, AS128, AS129, AS163, AS186, AS232, AS276
World War I Aviation (National Air and Space Museum gallery), AS334, AS335
World War II
—aerial photographs, AS35, AS179, AS321
—aircraft, AS9, AS10, AS54, AS94, AS101, AS153, AS179, AS192, AS237, AS291, AS305, AS311, AS322, AS323, AS336
—bombing, AS10, AS49, AS116, AS321
—combat, AS10, AS282
—Eagle Squadron, AS100
—flight clothing, AS3
—locations: Africa, AS35, AS189; Asia, AS44; China, AS44; China-Burma-India theater, AS44; Europe, AS35, AS49; France, AS321; Germany, AS14, AS116, AS153, AS321; India, AS154; Italy, AS179; Mediterranean, AS189; Myanmar, AS44; Pacific Islands, AS49; Pearl Harbor, AS10; Russia, AS9
—military bases, AS101, AS154; airfields, AS179
—peace conference, AS323
—people: African American soldiers, AS63, AS334; aircraft crews, AS37; American Indian soldiers, AS150; pilots, AS9, AS37, AS44, AS65, AS101, AS144, AS154, AS179, AS237, AS282, AS317, AS323, AS334; prisoners, AS317; soldiers, AS37, AS44, AS63, AS144, AS150, AS154, AS179, AS312, AS317, AS323, AS331; training, AS68, AS144, AS154; women soldiers, AS312
—weapons, AS14, AS25, AS49, AS154
Wounded soldiers, AS70, AS126, AS150, AS154
WPA (Works Projects Administration), AS189, AS318
W.R. Carpenter Air Services, AS315
Wrecks. See Crashes.
Wright, Burdette S., AS94, AS155

Wright, Orville, AS52, AS79, AS160, AS325, AS330; crashes, AS190; house, AS329; painting of, AS287
Wright, Roderick M., AS310
Wright, Theodore P., AS94
Wright, Wilbur, AS52, AS79, AS140, AS160, AS209, AS325, AS330; painting of, AS287
Wright Aeronautical Corporation, AS84
Wright aircraft, AS58, AS83, AS102, AS103, AS192, AS197, AS276, AS277, AS329; 1903 Flyer, AS160, AS170, AS211, AS324, AS325, AS334, AS336; 1908 Army airplane, AS160; B-1, AS264; Flyers, AS80, AS140, AS142, AS185, AS296; Model B, AS79; Model FS-1, AS296; Model K, AS245; Navy airplanes, AS141
Wright engines, AS194, AS223, AS313, AS324, AS325
Wright Field (Ohio), AS326, AS327, AS329. See also McCook Field; Wright-Patterson Air Force Base.
Wright incidence indicators, AS160
Wright-Patterson Air Force Base (Ohio), AS150, AS329; U.S. Air Force Museum, AS172
Writers, AS79
Wyeth, James: art works by, AS11
Wyoming Air Service, AS84

Xiaoping, Deng. See Deng Xiaoping.

Yaak, Ed, AS52
Ya Ching, Lee. See Lee Ya Ching.
Yancey, Lewis A., AS192
Yankee Doodle (aircraft), AS262
Yeager, Charles E. ("Chuck"), AS334
YMCA buildings, AS106
Yokoyama, Hideko, AS230
Young, Cathy, AS291
Young, John W., AS46, AS300
Young, Stan, AS94
Youth organizations, AS106, AS125

Zabriskie, Alexa Von Tempsky, AS331
Zand, Stephen J., AS155
Zenair Zenith (aircraft), AS180
Zeppelin, Ferdinand von, AS52
Zeppelin airships, AS36, AS113, AS125, AS129, AS254, AS332
Zodiac aircraft, AS281
Zoos, AS124, AS218, AS276
Zouave soldiers, AS272

AS.200	Charles L. Morris Helicopter Scrapbook	136
AS.201	Francis L. Moseley Avionics Collection, 1930–1981	136
AS.202	Joe Mountain Collection	137
AS.203	Kenneth M. Murray Collection	138
AS.204	Jeanne DeWolf Naatz Autograph Books	138
AS.205	NASA F-8 Supercritical Wing Collection	138
AS.206	NASA Photorransparencies Collection, 1968–1977	139
AS.207	Nash Collection	140
AS.208	NASM Aircraft Restoration Files	140
AS.209	NASM Aviation History Project Files, Circa 1983–1985	141
AS.210	NASM Publications Videodisc Photographs	141
AS.211	NASM Restorations Videodisc Photographs	142
AS.212	National Advisory Committee for Aeronautics Aircraft Collection	142
AS.213	National Aeronautic Association Records, 1918–1976	143
AS.214	National Air Transport Collection, 1927–1937	143
AS.215	National Aviation Clinics Scrapbooks	144
AS.216	Steven P. Nation Photograph Collection	144
AS.217	Georges Naudet Collection	145
AS.218	Naval Aviation, Pensacola, Florida, Scrapbook	145
AS.219	Thomas T. Neill Collection, 1926–1972	146
AS.220	Carl N. Nelson Collection	146
AS.221	1934 Stratospheric Balloon Flight Scrapbooks	147
AS.222	Umberto Nobile Papers	148
AS.223	Arthur Nutt Papers	148
AS.224	Hermann Oberth Collection	149
AS.225	Rohnald Ohmeyer Collection	149
AS.226	A.J. Ostheimer Autograph and Photograph Collection	150
AS.227	Oversized Photographs of Aircraft	150
AS.228	Phillips W. Page Scrapbook	150
AS.229	Pan American Boeing 314 Preview Flight Scrapbook A.K.A. Charles R. Page Scrapbook	151
AS.230	"Parade of Champions" Scrapbook	152
AS.231	Fred Parker Scrapbook	152
AS.232	Edwin C. Parsons Scrapbook	153
AS.233	Peenemünde Aerodynamics Reports A.K.A. Ft. Bliss/Puttkamer Collection, 1940–1951	153
AS.234	Peenemünde Archive Reports, 1938–1945	154
AS.235	Harold G. Peterson Scrapbook	154
AS.236	Philippines Civil Aviation Scrapbook	155
AS.237	Photographic Archives Technical and Videodisc Files	155
AS.238	Piaggio Albums	156
AS.239	Piaggio P.23R Photographs	157
AS.240	Project Crossroads Scrapbook A.K.A. Donald Putt Scrapbook	157
AS.241	George B. "Slim" Purington Scrapbook	158
AS.242	John J. Queeny Scrapbook	158
AS.243	Richard Rash Color Slide Collection, 1949–1960s	159
AS.244	Republic Feeder Airlines Collection, 1945–1983	159
AS.245	Richard S. Reynolds Photograph Collection	160
AS.246	Donald J. Ritchie Papers, Circa 1955–1976	160
AS.247	Rocket, Space, and Early Artillery History Collection	161
AS.248	Rockwell Collection	161
AS.249	Rockwell HiMAT Remotely-Piloted Research Vehicle Documentation, 1976–1981	162
AS.250	Rohrbach Photograph Album	162

AS·151 Marion S. Honeyman Scrapbook 107
AS·152 Jerome C. Hunsaker Collection, 1916–1969 108
AS·153 John J. Ide Collection 108
AS·154 India-Burma Headquarters Photograph Collection
 A.K.A. Joseph J. Pace Photograph Collection 109
AS·155 Institute of Aeronautical Sciences Photograph
 Collection, 1928–1957 110
AS·156 Evelyn L. Irons Scrapbook 111
AS·157 Italian Aviation Photographs of World War I 111
AS·158 Shakir S. Jerwan Scrapbooks 111
AS·159 Walter E. Johnson Scrapbook 112
AS·160 Ernest Jones Papers, 1906–1932 113
AS·161 Hattie Meyers Junkin Papers, 1906–1982 114
AS·162 Hildegard K. Kallmann-Bijl Papers, 1949–1968 114
AS·163 Virgil Kauffman Collection
 A.K.A. Aero Service Corporation Collection 115
AS·164 Kennedy Space Center Glass Transparency Collection, 1960s 116
AS·165 Clement M. Keys Papers, 1918–1951 116
AS·166 A. Roy Knabenshue Aircraft Photographs (Oversized) 117
AS·167 Paul W. Kollsman Aeronautical Library Scrapbook 117
AS·168 Krainik Ballooning Collection, 1859–1934 118
AS·169 Lahm Airport Memorial/Dedication Scrapbook 118
AS·170 Frank P. Lahm Collection 119
AS·171 Langley Experiments (1914–1915) Scrapbooks 119
AS·172 Robert Lannen Aircraft Slide Collection 120
AS·173 Ruth Law Scrapbook 121
AS·174 Lovell Lawrence, Jr., Papers 121
AS·175 Willy Ley Papers, 1859–1969 122
AS·176 Liberty Engine Photographs Scrapbook 123
AS·177 Lighter-Than-Air Collection
 A.K.A. Garland Fulton Collection 123
AS·178 Charles A. and Anne Lindbergh Autographed
 Photographs and Watercolor 124
AS·179 Harvey H. Lippincott Photograph Collection 125
AS·180 Eric Lundahl Photograph Collection 125
AS·181 Theodore S. Lundgren Scrapbook 126
AS·182 Frank G. Manson Patent Collection 126
AS·183 Martin Clipper Scrapbook 127
AS·184 James V. Martin Aircraft Scrapbooks 127
AS·185 James V. Martin Papers 128
AS·186 Russell L. Maughan Scrapbook 128
AS·187 Hiram S. Maxim Collection 129
AS·188 James R. McConnell Scrapbook 129
AS·189 Alexis B. McMullen Papers, 1915–1983 130
AS·190 James Means Aviation Scrapbooks 131
AS·191 James Means Correspondence Collection 131
AS·192 George Meese Photograph Collection
 A.K.A. Richard Segar Photograph Collection 132
AS·193 Mercury Program *Big Joe* Installation Records, 1959 132
AS·194 Robert B. Meyer, Jr., Papers 133
AS·195 Thomas Dewitt Milling Papers 134
AS·196 Miscellaneous Oversized Photographs 134
AS·197 Miscellaneous Ramsey Room Photographs 134
AS·198 William Mitchell Scrapbooks 135
AS·199 Monoplane *America* Christening Scrapbook 135

AS·104 Early Aviation Scrapbook 81
AS·105 Arnold Egeland Airlines Collection 82
AS·106 Ellington Field Scrapbooks *A.K.A.* W.H. Frank Scrapbooks 82
AS·107 Engine Design Reports, 1927–1946 82
AS·108 Clifford V. Evans, Jr., and George W. Truman Scrapbook 83
AS·109 *Exhibition Flight* Collection, Circa 1911–1973 83
AS·110 Fairchild Industries, Inc., Collection, 1919–1980 84
AS·111 Fairchild KS-25 High Acuity Camera System
 Documentation, 1956–1967 85
AS·112 58th Aero Squadron Scrapbook *A.K.A.* Nelson Coon Scrapbook 85
AS·113 1st Aero Squadron Scrapbooks
 A.K.A. Richard T. Pilling Scrapbooks 86
AS·114 First Pan American Airways Transatlantic Passenger Flight
 Scrapbook *A.K.A.* William J. Eck Scrapbook 87
AS·115 Gardiner H. Fiske Scrapbook 87
AS·116 Flight Safety Foundation Collection
 A.K.A. Jerome Lederer Collection, 1925–1965 88
AS·117 Flodin Photograph Collection
 A.K.A. Isle of Grain Photograph Collection 88
AS·118 Flying Allens Scrapbook, Circa 1933–1979 89
AS·119 Flying Tigers Photographs *A.K.A.* Walter W. Pentecost Collection 89
AS·120 Harold Fowler World War I Scrapbook 90
AS·121 Ira F. Fravel Collection, 1917–1932 90
AS·122 George C. Furrow Papers, 1916–1968 91
AS·123 *Gatchina Days: Reminiscences of a Russian Pilot* Photographs 91
AS·124 J. Rome Gately Scrapbook 92
AS·125 German Commercial Zeppelins Scrapbooks 92
AS·126 German World War I Scrapbook 93
AS·127 Howard W. Gill Scrapbooks 93
AS·128 J. Guy Gilpatric Photograph Collection 94
AS·129 J. Guy Gilpatric Scrapbooks 95
AS·130 Glenn L. Martin Company Photograph Archives 95
AS·131 Goddard Report of August 1929 Photographs 96
AS·132 Goodyear Aerospace Collection, 1968–1983 96
AS·133 Goodyear Balloon School Collection 97
AS·134 Goodyear ZPG-3W Collection 97
AS·135 Hans Groenhoff Photograph Collection 98
AS·136 Grumman SA-16 Albatross Crash Research
 Collection, 1951–1985 99
AS·137 Terry Gwynn-Jones Slide Collection 99
AS·138 Andrew G. Haley Papers, 1939–1967 100
AS·139 Randolph F. Hall Papers, 1917–1970 100
AS·140 William J. Hammer Collection 101
AS·141 Julian R. Hanley Scrapbook 102
AS·142 George B. Harrison Collection, 1904–1979 102
AS·143 Harvard-Boston Air Meet Photographs
 A.K.A. Thomas G. Foxworth Collection 103
AS·144 Hawthorne Flying School Collection
 A.K.A. Beverly "Bevo" Howard Collection 103
AS·145 Karl G. Henize Papers 104
AS·146 Hensley Photograph Collection 105
AS·147 Gerard P. Herrick Papers, 1909–1963 105
AS·148 Hiller Aircraft Photographs 106
AS·149 William Hoffman Scrapbooks 106
AS·150 Edward H. Holterman Scrapbook 107

AS·60	Beech Model 17 Photographs	56
AS·61	Bendix Air Races Collection, 1931–1982	57
AS·62	Berliner Helicopter Scrapbooks	57
AS·63	"Black Wings" Collection	58
AS·64	Maitland B. Bleecker Collection, 1926–1937	59
AS·65	Warren M. and Catherine C. Bodie Collection	59
AS·66	John Bodine Autographed Photograph Collection	60
AS·67	Herbert P. Boen Lockheed Collection	60
AS·68	Leslie and Marguerite Bowman Papers, 1923–1987	61
AS·69	Walter J. Boyne Papers, Circa 1950s–1985	61
AS·70	Arthur Raymond Brooks Collection	62
AS·71	E. Woodward Burke Scrapbook	63
AS·72	Giovanni G.L. Caproni di Taliedo Collection	63
AS·73	D.H. Carey Scrapbooks	64
AS·74	Cyril F. Caunter Collection, 1902–1986	64
AS·75	Mary Charles Papers, 1931–1965	65
AS·76	Charles W. Chillson Papers	65
AS·77	Carl H. Claudy Collection	66
AS·78	Henri-Marie Coanda Papers *A.K.A.* G. Harry Stine Collection, 1920–1961	66
AS·79	Frank T. Coffyn Scrapbooks	67
AS·80	College Park Airport Collection *A.K.A.* Fred C. Knauer Collection, 1903–1986	68
AS·81	Charles Collyer Scrapbook and Memorabilia	68
AS·82	Continental, Inc., Records, 1941–1955	69
AS·83	Harry D. Copland Slides	69
AS·84	Cross Section of Aviation Personnel Scrapbooks *A.K.A.* Kenneth Boedecker Scrapbooks	70
AS·85	Tom D. Crouch Collection, Circa 1906–1983	71
AS·86	John S. Curtis Collection	71
AS·87	Curtiss Eagle Sightseeing Flights Scrapbook *A.K.A.* George A. Page, Jr., Scrapbook	72
AS·88	Curtiss Flying School Photograph Collection *A.K.A.* Alpha R. Clemens Photograph Collection, Circa 1912–1915	72
AS·89	Glenn H. Curtiss Collection	73
AS·90	Glenn H. Curtiss Motorcycles Scrapbook *A.K.A.* Clara Studer Collection	73
AS·91	Curtiss NC-4 Collection *A.K.A.* Richard K. Smith Collection, Circa 1918–1969	74
AS·92	Curtiss NC-4 Design, Construction, and Testing Reports, Circa 1918–1969	75
AS·93	Curtiss-Wright Corporation Propeller Division Records, Circa 1940–1957	75
AS·94	Curtiss-Wright Corporation Records	76
AS·95	William M. Davenport Photographs	77
AS·96	Curtiss La Q. Day Scrapbooks	77
AS·97	Defense Advisory Committee on Women in the Services (DACOWITS) Collection, 1975–1987	78
AS·98	Dornier Do X Aircraft Scrapbook	78
AS·99	Frederick C. Durant III Collection	79
AS·100	Eagle Squadron Photograph Collection	79
AS·101	Ira C. Eaker Collection	80
AS·102	Early Aviation (Circa 1910) Scrapbook	80
AS·103	Early Aviation Photographs *A.K.A.* Frank H. Russell Collection	81

AS·22 *Race to the Stratosphere* Photograph Collection 29
AS·23 Space History Department Artifact Replica Files 29
AS·24 Space History Department Artifact Request Files 30
AS·25 Space History Department Slide Collection 30
AS·26 Space Telescope History Project Image Collection 31
AS·27 Stars Gallery Working File 32
AS·28 James A. Van Allen Photograph File 32
AS·29 "Where Next, Columbus?" Exhibit File 33
AS·30 W-17 Sensor Photographs 33

Laboratory for Astrophysics 35

AS·31 Laboratory for Astrophysics Digitized Image Collection 36

Collections Maintenance Division 37

AS·32 Accessions Photograph File 38

Multicultural Outreach Office 39

AS·33 Multicultural Outreach Events Photograph Notebook 40
AS·34 Multicultural Outreach IMAX Theater Photograph Notebook 40

NASM Archives 41

AS·35 Aerial Photographic Reconnaissance Collection A.K.A.
 Samuel L. Batchelder Collection 43
AS·36 Aeronautical History Scrapbooks 43
AS·37 *Aircraft of the National Air and Space Museum* Collection 44
AS·38 Aircraft of the 1930s Photograph Collection
 A.K.A. Lois Kuster Scrapbook 44
AS·39 Aircraft Radio Corporation Records
 A.K.A. Gordon White Collection, Circa 1924–1982 45
AS·40 Aircraft Recognition Training Materials A.K.A. U.S. Navy
 Recognition Training Slides Collection, 1950s 45
AS·41 Aircraft Scrapbook Material A.K.A. Claude A. Grimm Collection 46
AS·42 Allison Photograph Collection 46
AS·43 American Astronautical Society Records, 1953–1977 47
AS·44 American Volunteer Group Collection
 A.K.A. Larry Pistole Collection 47
AS·45 Apollo Mission Images Collection, 1968–1972 48
AS·46 Apollo Program Mission Files 48
AS·47 Apollo-Soyuz Test Project Images Collection, 1975 49
AS·48 A. Francis Arcier Collection, 1890–1969 49
AS·49 Armament Files 50
AS·50 Leslie P. Arnold Douglas World Cruiser Scrapbook 51
AS·51 Rudy Arnold Photograph Collection 51
AS·52 Autographed Photograph Collection 52
AS·53 William Avery Collection 52
AS·54 *Aviation* and *Aviation Week* Photograph and Report Collection 53
AS·55 Aviation Societies and Clubs Scrapbook 54
AS·56 Aviation Training Schools Scrapbooks
 A.K.A. Theodore C. Macaulay Collection 54
AS·57 Ralph S. Barnaby Papers 55
AS·58 George W. Beatty Papers 55
AS·59 Beech Aircraft and Gates Learjet Public Relations Collection
 A.K.A. Vern Modeland Collection, 1965–1975 56

Contents

Acknowledgments xiv

Introduction to the Volume 1

The Photographic Imagery of Air and Space Flight 6

Introduction to the National Air and Space Museum 11

Center for Earth and Planetary Studies 12
AS·1 Planetary Image Facility Earth Images 13
AS·2 Planetary Image Facility Lunar and Planetary Images 13

Department of Aeronautics 15
AS·3 Aeronautics Department Aviation Clothing File 16
AS·4 Aeronautics Department Curators' File 16
AS·5 Aircraft of NASM Photograph Collection 17
AS·6 Eglin Air Force Base Phototransparency Collection 17
AS·7 National Air Races Photograph Collection 17
AS·8 Stephen Piercey Slide Collection 18
AS·9 Russian/Soviet Aeronautical Archives 18
AS·10 Edward J. Steichen World War II Navy Photograph Collection 19

Department of Art 21
AS·11 Art Department Photograph Collection 22

Department of Space History 23
AS·12 "Beyond the Limits" Photograph Collection 24
AS·13 Computer History Slide Set 24
AS·14 Early Rocketry Photograph Collection 25
AS·15 *Enterprise* Photograph Collection 25
AS·16 International Space Programs Slide Collection 26
AS·17 Manned Space Flight Exhibit Photographs 26
AS·18 Manned Space Flight Exhibit Subject Files 27
AS·19 Miscellaneous Photographs *A.K.A.* Allan A. Needell
 Miscellaneous File 27
AS·20 NASA Historical Photograph Collection 28
AS·21 NASM Activities Photographs *A.K.A.* Derek W. Elliott
 Work Photographs 28

© 1995 by the Smithsonian Institution
All rights reserved

Library of Congress Cataloging-in-Publication Data

Smithsonian Institution.
 Guide to photographic collections at the Smithsonian
Institution.

 Includes indexes.
 Contents: v. 1. National Museum of American History —
[etc.] — v. 3. Cooper-Hewitt Museum, Freer Gallery of Art,
Hirshhorn Museum and Sculpture Garden, National Museum
of African Art, National Museum of American Art, National
Portrait Gallery, Arthur M. Sackler Galler, Office of Horticul-
ture — v. 4. National Air and Space Museum.
 1. National Museum of American History (U.S.)—
Photograph Collections. I. Redding, Joan. II. O'Connor,
Diane Vogt.
Q11.S79 1989 026.'779'074753
89-600116
ISBN 0-87474-927-1 (v. 1 : alk. paper)
ISBN 1-56098-033-8 (v. 2 : alk. paper)
ISBN 1-56098-188-1 (v. 3 : alk. paper)
ISBN 1-56098-414-7 (v. 4 : alk. paper)

British Library Cataloguing-in-Publication Data is available

Cover photo: National Air Museum, Smithsonian Institution.
"Lindbergh's *Spirit of St. Louis* as exhibited in the north hall of
the Arts and Industries Building." Silver gelatin photoprint.
Photographic Archives Technical and Videodisc Files (AS·237).
Negative #A32911-A. Videodisc #2B-44710.

Manufactured in the United States of America
02 01 00 99 98 97 96 95 5 4 3 2 1

⊗ The paper used in this publication meets the minimum
requirements of the American National Standard for
Permanence of Paper for Printed Library Materials Z39.48-1984.

GUIDE TO
Photographic Collections
AT THE SMITHSONIAN INSTITUTION

National Air and Space Museum

VOLUME IV

Joan Redding
and
Diane Vogt O'Connor

Smithsonian Institution Press

Washington and London

GUIDE TO
Photographic Collections
AT THE SMITHSONIAN INSTITUTION